WAKE UP
DOWN THERE!

The
Excluded
Middle
Collection

WAKE UP DOWN THERE!

The Excluded Middle Collection

Edited by Greg Bishop

"I shall not commit the fashionable stupidity of regarding everything I cannot explain as a fraud."

—Carl Jung

Adventures Unlimited Press
Kempton, IL

"At 8 A.M. on March 24, 1961, two women in Prospect, Oregon, a town of about three hundred people, were talking together on the phone when suddenly a strange man's voice broke into the line and snapped, **"WAKE UP DOWN THERE**!" One of the ladies regarded this as an affront and she proceeded to express a very strong opinion. The voice started to rattle on in a rapid-fire language that sounded like Spanish but the line seemed to be dead. The two women could not hear each other. After the man suddenly stopped, the line became live again..."

From *The Mothman Prophecies* by John Keel

THE EXCLUDED MIDDLE
PO Box 481077
Los Angeles, CA 90048
exclmid@primenet.com
www.excludedmiddle.com

ISBN 0-932-813-82-8

Wake Up Down There! The Excluded Middle Collection

Book design by Bettina Fizz.

First Printing 10 9 8 7 6 5 4 3 2 1

Published By
Adventures Unlimited Press
One Adventure Place
Kempton, IL 60946
USA
auphq@frontiernet.net

Acknowledgements

"Without Whom None of this Would Have Been Necessary..."

Dedicated to two good friends and personal inspirations who have surely transitioned to Nirvana at their passing: Dr. Karla Turner and Dr. Mario Pazzaglini. We are lucky to have shared this life with them.

Thanks are due to many people who help to make tEM a reality. Foremost are the writers and artists who donated their talents for nothing or next to nothing: Brian Anderson, Jeremy Bate, Ian Blake, Ralph Coon, Scott Corrales, Ken DeVries, Beth Escott, John Carter, Adam Gorightly, Hellswami John Hagen-Brenner, Linda Hayashi, Dean James, Donna Kossy, Kathy Kasten, Melinda Leslie, Martin Kottmeyer, Holly Lange, Paul Mavrides, Darren McGovern, Jerry Modjeski, Wes Nations, Will Parks, Al Ridenour, Hal Robins, Ken Ruzic, Paul Rydeen, Acharya S, Richard Sarradet, John Shirley, Ivan Stang, J. T. Steiny, Bennett Theissen, Doug Whaley, Bebe Williams, and Robert Anton Wilson.

Support, encouragement, and assistance was given freely by Skylaire Alfvegren, Jack Boulware, Jim Brandon, Tim Brigham, Lyn Buchanan, Peter Jordan, S. Miles Lewis, Jim Martin, Richard Metzger, Bill Moore, James Moseley, Ted Oliphant, Dave Reimer, Scott Sawyer, Jamie Shandera, Dennis Stacy, Mick Taylor, James Tunis, Elton Turner, Jonathan Vankin, Amy Wexo, The Artist Formerly Known as Mike, and the Texufornia Illuminaughty.

Spirits of note include Sun Ra, William Blake, Lenny Bruce, Danny Casolaro, George Van Tassel, William Burroughs, Duke Ellington, Dr. Tim Leary, Gray Barker, Dr. Wilhelm Reich, Bob Wills, Bill Hicks, Terence McKenna, Orfeo Angelucci, and Andy Kaufman.

Kenn Thomas pretty much got this book out of the wishing stage, and there is no proper way to really thank him, but I'll try. Robert Sterling helped Kenn complete my parapolitical training. Now I'm more wacko than ever.

The two other "halves" of tEM: Robert Larson and Peter Stenshoel were there to make it a reality from the beginning with sweat, spiritual strength, and financial partnership. They are truly the two brothers I never had.

My parents of course. And my sister Lisa.

And thank you Lia for your support and love, even though most of the time you had no idea what the hell I saw in all of this stuff.

—Greg Bishop

Music listened to during writing, editing, and layout: Beatles, Beck, Bikini Kill, Junior Brown, Captain Beefheart, Johnny Cash, Cibo Matto, Combustible Edison, Fibonaccis, Geraldine Fibbers, Iggy, Le Tigre, The Muffs, Liz Phair, Pizzicato 5, Perez Prado, Public Enemy, Rebirth Brass Band, Red Aunts, S.C.O.T.S., Frank Sinatra, Sleater Kinney, Squirrel Nut Zippers, 13th Floor Elevators, and the Who.

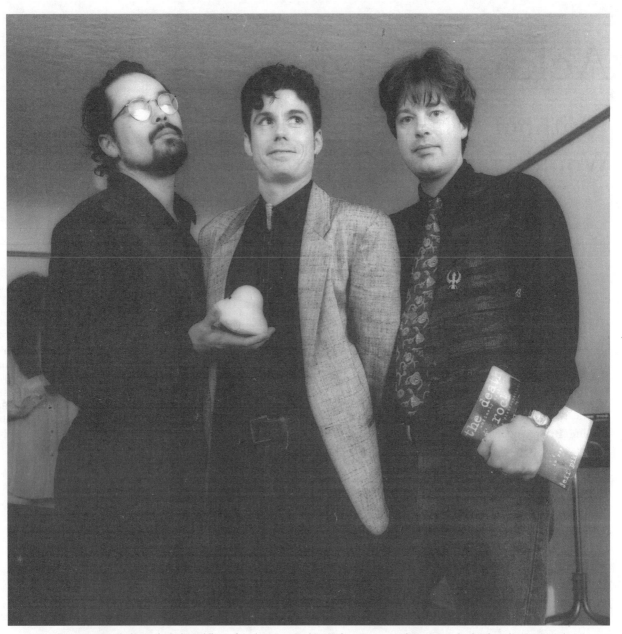

The three Men In Black: Excluded Middle *co-founders Greg Bishop, Robert Larson, and Peter Stenshoel.(Photo by Scott Lindgren)*

Table of Contents

Issue #4

Issue #5

Issue #6

Issue #7

Issue #8

Issue #9

Virtual Issue

Preface
Muddy Thinking

Peter Stenshoel

Muddy thinking has long been decried as a shameful idiot's pasttime, and the bane of science and progress in general. Clear thinking is the obvious goal.

Should it be? What if we should decide that mud provides nutrients, growth, therapeutic properties, and myriad connection between otherwise disparate elements? The thought practiced therein may well grow into some noble future far better than the thought produced in an airtight vacuum, clear of debris, but also sterile, and cut off. Maybe enough muddy thoughts would create a Science which would not need bloody academic revolutions in order to advance; rather it could nurture a self-evolving organic framework which would willingly harbor studies of the artifacts, overlooked effects, and anomalously affected persons in its midst.

While we can realize that this is a metaphor, not to be over-stretched, in another way it indicates the problem of describing a new order of perception. Part of my mind cries out in protest against defending "muddy thinking," even if it's just used for simple illustration. The part of me which wants all these anomalies to be taken seriously is worried that our pathological debunker friends will latch on to this and say, "Aha! See? SEE? They WANT to be muddy thinkers! They HATE clear thinking!"

But, as Brother Martin Luther informed the self-appointed brain police of *his* day, "here I stand. I can do no other." I accept that in a way, the "laws of physics" crowd need their glasses of clear water. For them to switch to muddy water will mean that they are ready to invite all the uncertainty, ambivalence, ambiguity, and paradox with which we've been happily living for years. It comes down to one's constitution. Not all are able to digest pure mud, or, to continue the Luther analogy, a Diet of Würms.

The pieces in this book are written by an unwieldy bunch of misfits including a few spooks who slipped in to tell us how we're all barking up trees of illusion. I hope you will find some genuine insights amid the droll tone

Drink deep of this muddy thinking. It's anything but sterile and tastes surprisingly good."

throughout. The three of us who founded this magazine are pleased that the *Excluded Middle* has found a book audience.

Drink deep of this muddy thinking. It's anything but sterile and tastes surprisingly good!

Sai Ram, Om Namah Shivaya, and Jesus Loves You the Best,

— Peter Stenshoel

Mar Vista

May 25, 2000

Introduction

It's a Weird Job, but Someone's Got to Do It

Kenn Thomas

The card with the Dallas postmark shows the sniper's nest view from the sixth floor of the Texas School Book Depository. Only a box rests near the window sill, looking down on cars riding along Elm Street. "Just like it was on that day..."reads the scribble across the top of the card. Along the sill, pointing to the box, Greg Bishop writes, "No one here!" The last card he sent came from Death Valley, a view of the Furnace Creek Inn, where he was staying. Greg circled the location of his room on the card and drew an arrow to a spot in the distance, labeling it "Manson Camp."

These cards continue an ongoing exchange we have while travelling. Knocking off a letter is the surest way to make time pass when waiting for a plane to depart, just as reading material in a car makes traffic lights change from red to green faster.

By my estimation, I began a relationship with Greg Bishop four times. The first time we met was at something called UFO Expo West, the one-time quite popular Los Angeles UFO convention, where I was giving a presentation on Wilhelm Reich. I got swept away by the tide of events at that one and did little more than acknowledge the introduction. Then Ron Bonds of IllumiNet Press sent me a photocopy of *The Excluded Middle*, the zine from which the current volume is assembled, making the obvious connection to what I was doing with *Steamshovel Press*. Some time after that, I started getting cryptic e-mail notes from Greg soliciting approval for his summaries of the Danny Casolaro saga in fortune cookie slogans. These pithy paraphrases eventually appeared on the back cover of issue #7 of *Excluded Middle*. Greg introduced himself again at another Laughlin event, and thereafter we have traded notes and stories on a regular basis.

Before, in-between and since I have been regaled by Greg's zine, which displays even more fully his grasp of cultural peculiarities and arcane history. *The Excluded Middle* has always captured the perfect balance of alternative science, psychedelia, ufology, urban legends, parapolitics, even rock'n'roll. As this anthology shows, Greg (and for the first five issues his co-editors Robert Larson

and Peter Stenshoel) regularly assemble and edit commentary and analysis of high weirdness made visible by the magazine's perspective, articulated in the first issue's "Declaration Of Principles" and reprinted here. That editorial vision has pulled together and kept together disparate aspects of vital American popular culture that would have otherwise been discarded by the larger media. The great satirist/novelist/philosopher Robert Anton Wilson, for instance, appears semi-regularly, both as interview subject and writer, as does James Moseley, the honored publisher of *Saucer Smear* and other ufological newsletters stretching back four decades, also interviewed in this anthology. Even without the kind of Art Bell Show-type interest in all things UFO, such figures would enjoy near-cult status for their extraordinary creative output. *The Excluded Middle*, however, provides the broader context, including also in its pages late alien abduction researcher Karla Turner, "Aviary" spy ally Bill Moore, parapsychologist Dean Radin, the late alien-writing deconstructionst Mario Pazzaglini, international mind control murder suspect Ira Einhorn and many others. Any given issue would beat any given Art Bell/ Mike Segal broadcast for depth, clarity and for the true assault it represents on normal paradigms of science and life. The book reviews alone cover the important and enduring secondary paranormalist literature of the last several years. At the same time primary sources, like RFK's letter to Gray Barker on UFOs, and analysis (the editor himself examines Wilhelm Reich, Roswell and ruminates on why contactees are better than abductees) not only are never in short supply but presented in a context that makes their oddness and humor resonate.

The Excluded Middle is a damn good zine and a good zine is hard to find, even harder in these days of the internet. Zinesters like Greg and me have become dinosaurs in many ways, although at one point small circulation magazines and newsletters were the only "internet" available. The late Jim Keith's *Dharma Combat* zine remains the most well-known example of a zine phenomenon that fueled a cottage industry. The list of names was long: *Boing Boing; Crash Collusion; Popular Reality; Stark Fist; Ganymedean Slime Mold; Notes from the Hangar; Lobster*. Some, like *Journal of Borderland Research*, have been around since the 1940s. Others, like *Film Threat*, actually secured serious advertising accounts and went mainstream for a while. Still others, like *Lies of The Times*, worked tirelessly to document the various distortions found regularly in the *New York Times* and other standard press, until they burned out and disappeared. Standard bearers like *Nexus*, Vicki and Don Ecker's *UFO Magazine* and the UK's *Fortean Times* occupy a nether space between underground, cognoscenti awareness and actual commercial success. Many of the great zines, like *Boing Boing*, once touted as the world's best neurozine, and *Crash Collusion*, along with its editor Wes Nations have long vanished into mainstream America. The printed zine phenomenon remains big enough still to sustain *Factsheet Five* on the web at www.factsheet5.com, the zine-about-zines begun in the early days of modern zinedom by Mike Gunderloy, having passed through Luce family interests to its present incarnation under R. Seth Friedman. Although *Factsheet Five* has stopped publication, others have moved in to fill the void such as, *Zine Guide*, POB 5467, Evanston, IL 60204.

Greg and I share this history, as well as the post cards and letters exchange from weird points across the country, and the only too rare occasions of in-person meetings. We never did take a photo under the marquis of a Los Angeles topless bar that read "Nude Luncheon," which may (at least in our minds) have been an intentional allusion to my late neighbor, *Naked Lunch* author William S. Burroughs, buried now just a few blocks from my present apartment. We did, however, scheme with the *Konformist*'s Robert Sterling to crash the off-limits Ambassador Hotel, where RFK was shot. Sterling has an unfortunate resemblance to Sirhan Sirhan, Greg looks like Lance Ito of OJ Simpson trial fame, and I'm told that Salman Rushdie is my twin, so it was quite a trio eyeing the barbed wired fence around the Ambassador. Greg, Robert, and I later stayed up to the godawful hours at a LA pirate radio station discussing the assassination and its mind control dimensions.

On another occasion, we stopped at the Philosophical Research Society in Los Feliz, a metaphysical library and bookstore started by Manly Palmer Hall in the 1930s. Sirhan hung out there at one time, as did William Jennings Bryan, (Former L.A. mayor) Sam Yorty and, according to rumor, Dr. Bernard Diamond, suspected by some as Sirhan's–and Mark David Chapman's–hypnotist handler/programmer. The place had a nice, bizarre, Los Angeles kind of a vibe to it, but my attention focused on an offering among the used books in the book store.

The book was entitled *The Circle of Guilt* (New York: Rhinehart & Co., Inc., 1956), by the psychiatrist Frederic Wertham, MD. Wertham became the first person to pan a book by Wilhelm Reich in the popular American press (an otherwise highly regarded Reich classic, *The Mass Psychology of Fascism*), but was most noted for spearheading the blue-nosed backlash against comic books in the 1950s with his book *Seduction of the Innocent*. Wertham argued that the origins of social violence could be found in the comic books corrupting youth. *Seduction of the Innocent* included close-up reproductions of the cross-hatching in a drawing of a pectoral muscle, suggesting that it was in reality a subliminal suggestion on a vagina designed to inspire youthful lust. Batman and Robin, according to Wertham, were closet gays (and for a long time the name "Bruce"-as in Batman's secret identity, Bruce Wayne-became associated with gays, to the extent that *Saturday Night Live* developed its parody, "The Ambiguously Gay Duo"), and so on. Wertham had a demonstrably dumb thesis that nevertheless took hold and led to widespread censorship with no consequent reduction in violence.

However, this book, *The Circle of Guilt*, examined a slightly different subject: violence among Puerto Rican youth in New York. Wertham, of course, was still blaming comic books, illustrating his thesis with *Superman* drawings by Frank Santana, a killer from the Puerto Rican street culture. Oddly enough, songwriter Paul Simon devoted a Broadway musical and CD, *The Capeman*, to the same subject, so my interest in the book was doubly bound. It was not the first time Wertham's 1950s crankiness resonated in the more contemporary popular culture. His last book, *The World of Fanzines*, (Carbondale IL, Southern Illinois Univ. Press, 1973) actually examined the zine world and came away with a positive conclusion about zines as spontaneous communication and

creativity. Wertham did not even note the contradiction, that the zines were produced by young adult versions of the children he found so hopelessly corrupted by comic books.

I thought of *Circle of Guilt* again while boating in San Francisco bay with Greg and Jim Martin, who publishes another great zine of the age, *Flatland*. There but for the grace of a zine connection sat three would-be juvenile delinquents. There also sat Robert Sterling, whose e-zine and website, Konformist.com, has more recent roots and has never appeared in pulp paper form. What would Frederic Wertham have thought of the cyberculture? Here, literally thousands of zine-like entities float about, competing with commercial counterparts, some quite consciously provoking violence, some, like Rob's, stimulating radical dissent, and others, like Greg's *Excluded Middle*, which preserves and promotes arcane ufological and parapolitical history, even as it "drags science kicking and screaming into the new century." *The Excluded Middle* has a web presence, of course-www.excludedmiddle.com-as do *Steamshovel Press*-www.steamshovel-press.com-and *Flatland*-www.flatlandbooks.com. Would Wertham understand that such an atmosphere of no-holds-barred mass communication grew from the zine world? Would he think that was good or bad? What value would that opinion have? After all, Wertham became a silly footnote in studies of mainstream social science gone bad. The first victim of his opinionating, Wilhelm Reich, became a *cause celebre* of the alternative science and high weirdness scene that the *The Excluded Middle* serves and is reflected in these pages.

The moment on Jim Martin's boat seemed like it came right out of one of Greg's post cards. Serene, but with an edge. Gulls started flapping up from the rear of the boat, looking for food. I made a gesture to duck and cover, assuming that the tranquility might be disturbed by bird launch. "They're not going to do that," said Greg, unflappable in his fog coat. "It's not in their Buddha nature." He was right. The man is a good judge of Buddha natures, as the reader of this volume will soon discover.

Kenn Thomas
42nd birthday

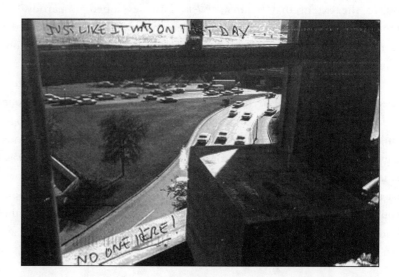

Foreword

Wonder by Attrition

An Introduction to *The Excluded Middle* Collection

Greg Bishop

In a radio interview, UFO/ paranormal researcher Peter Jordan said, "The problem with the UFO research community is that they are uncomfortable with ambiguity." This places *The Excluded Middle* squarely outside the mainstream rank-and-file of Ufology. The writers, editors and readers of our zine revel in ambiguity. The more undecided and unclassifiable, the better. Exactitude is fine when flying a plane or baking a pie, but where is the measure for consciousness, perception, emotion, or experience? This kind of question used to be laughed off as "mixing religion and science," but these fields are starting to come together again. "Again" because so-called enlightenment-era scientists mixed astrology and astronomy, chemistry and alchemy, laboratory and inner (mind) space, and didn't see any divisions. Since we are emotional, spiritual and analytic animals, there is no reason why one trait should rule the others. Denial of either aspect turns you into a doctrinaire know-it-all, or an addle-headed new-age twit, and we don't want to invite *those* people to the party, now do we?

The Excluded Middle was conceived out of the same need that many weird and oftentimes pointless projects are begun: a sense of indignant frustration. Back when small press publications were learning how to use their flippers to walk on land, Peter Stenshoel, Robert Larson and I were sitting in Peter's front yard, drinking beer and complaining that the Ufological names we were weaned on were never mentioned anywhere. John Keel, Jacques Vallee, Dennis Stillings, Michael Grosso, etc. were not part of the mainstream UFO discourse. We were going to change that somehow. In the process, we hoped to someday meet these giants or at least, make them aware of our presence. Along the way, we also wanted to attract a group of like-minded people and form a nexus for discussion of uncategorizable phenomena that stood away from the "aliens from another planet" class of crap. We succeeded beyond our expectations, and made many life-long friends. Viva el Texufornia Illuminaughty!

But UFOs are only part of the spectrum of what is known as "anomalous phenomena." The fortean, parapsychological, and dare we say it "conspiracy"

> "The writers, editors, and readers of this magazine revel in ambiguity. The more undecided and unclassifyable, the better."

worlds are more closely allied than most people think, *The X-Files* notwith-standing. (An aside here: I could never work up much enthusiasm for that program. It seems that the writers draw from the same font of information that the UFO consumer uses, but the stories, while intriguing and quite well written, seem to miss the point in favor of dramatic continuity, and leaves many of us with the feeling that some of it could have been done so much better.)

Much more palatable to this end was the paranoia engendered by *Nowhere Man*, a one-season series that followed the misfortunes of an American photog-rapher who had captured an image of a dirty covert operation in a jungle some-where, and moved from town to town, trying to evade some shadowy group of intelligence operatives bent on retrieving the negative. Like the growing discom-fort of Thomas Veil, the protagonist, we began to see and lift the "veil" of illusions and realize the "vale of tears." The halting stream of information coming through our PO box began to make us more and more uneasy as the illusion of our society and its base assumptions began to falter. Some transformative aphorisms that come to mind at this point in the magazine's evolution might include:

- No matter how much the arbiters of reality tell us that it's all figured out, there is much that awaits critical, but open-ended scientific and philosophical scrutiny.

- People and groups with enough money and/ or power will do ANYTHING to hold onto it in the sneakiest, most ruthless, and quietest ways possible.

- These same people own many of the public (and not so public) information conduits, like the news media. (Where do you think Matt Drudge got his start? Insider information, my ass.)

- They only care about you to the extent that they can separate you from more of your money and individuality.

- There is a system in place that supports all of the above, agreed upon by popular consensus and unwritten decree. The highest achievement anyone can attain is to join this elite. Violators face ridicule and banishment from the discussion/ contest.

and

- UFOs (most of 'em anyway) probably aren't from outer space.

Weird things happen when you start down this path. It's a bit like Robert Anton Wilson's "Chapel Perilous" where you face yourself and your fears before coming out the other end transformed. One of the early magazine name changes suggested was "That's Just What They Want You To Think," but this was rejected as unwieldy. Paranoia just seemed to accrete as time went on, and it didn't seem too weird after awhile.

There was the early morning phone call from a man calling himself "James Edward." He asked for me in a badly staged Arabic accent. He could have picked a more foreign-sounding moniker for himself, but once he had confirmed who he was talking to, he refused to say how he'd found my unlisted number and proceeded to ask me who I knew. "You know Bob Lazar? You know Bill Lear? You know Jacques Vallee? Bill Moore? Bobby Ray Inman?" and on and on. He wanted to know how to get in touch with them, and seemed to be feeling out just who was in the network. I sort of felt sorry for him because, with the exception of two or three people he mentioned, I had never even

talked to anyone on his long list of suspects. Whoever he worked for, he was obviously trying to find out where we got our articles and info. I had to tell him that he should write to their publishers like we did. Strangely enough, he gave me an address and got a free subscription for awhile until the issues came back "returned to sender." I hope he got promoted. (A strange coda to this episode is the fact that many of the names he grilled me about have since been rumored to be part of a consortium called the "Advanced Theoretical Physics Working Group." They're supposedly involved in cutting-edge propulsion physics, parapsychology, and UFO info/ disinfo. The subjects are related—think about it.) See chapter nine for details on this.

Mail tampering is the darling of clinical paranoids, but nearly every piece of mail that the late researcher/abductee Karla Turner sent to the PO box looked like it had been tampered with or opened. Since this is easy to do without having to be obvious, we figured someone was interested in her work enough to make it clear that she was being monitored. She took to putting a piece of transparent tape over the flap and writing "sealed by sender" on it. Karla pretty much took it for granted after awhile, and suggested I do likewise. The same mail problems later cropped up with a cattle mutilation researcher. Our postal and even e-mail exchanges were often a marvel of missed and misrouted communications. He recently suggested that we back off our discussions for awhile for reasons he would not talk about.

Then there were the endless hang-up calls. "★69" never worked with any of them. These came in sometimes five to ten times (or more) a day. If we picked up the receiver, there was static or silence.

Who needs therapy when you've got all this? Or paradoxically, perhaps it's a suitable case for the shrinks. Hand me that aluminum foil beanie, please.

There's been other zaniness afoot that I really don't want to get into, but what the hell gives here? Is a silly little UFO zine worth any attention? Well, maybe. Just think of all the wasted effort and money that our government puts out to justify a salary or political pecadillo. With unlimited cash flow plus idle hands and an intel operative's pet paranoia in charge, we begin to see why this might not be so far-fetched. Perhaps they're even looking at you just for buying this book.

"Boo."

In the face of all this, how does one keep from standing on a street corner dressed in nothing but a sandwich board and boxer shorts yelling about it to frightened passersby?

Although the phrase "Excluded Middle" was taken from a skit that Peter Stenshoel wrote for his *Little City In Space* syndicated radio show, over the past few years the term has taken on a life of its own. It's a path we have carved for ourselves in the wilderness of doubt, fear, and ambiguity. It's a way to entertain opposing points of view or cognitively dissonant concepts and still be entertained. The history of many religious traditions sing the praises of the "middle way." The Buddhists have the "middle path," the western occultists have the "middle pillar" and so on. Even the semi-mysterious UMMO documents,

purported wisdom from aliens across the galaxy, refer to "the third excluded term—the excluded middle—enunciated by Aristotle" and warn that "Unless you yourselves clarify your forms of informative communication, the process of seeking the truth will be very slow."

What a revelation.

Namu Amida Butsu,

Greg Bishop
5/5/2000 C.E. –
Los Angeles, CA.

No. 1

A Declaration of Principles

When Robert, Peter and I got together to discuss this little rag, we were all responding to an unfulfilled need for non dogmatic discussion of issues we're all interested in. That is: Paranormal phenomena, UFOs, fortean studies, mysticism, and the occult. To varying degrees, we feel that there is a common thread running through these areas, a tenuous cloth which has been largely ignored by various periodicals and groups which concern themselves with these subjects. Some of the titles we "threw up" for discussion will give an idea of our thinking:

Cosmic Cookie
Below Top Secret
Simonton's Pancake
Anomalomaniacs
Flying Saucers And The Three Men
Magonians Anonymous

A few of the phrases on the list should convey our sense of humor. Anyone who wishes to deal seriously with the weird (and I do mean in a non-armchair way) would do well to have or develop the ability to laugh about it all when the going gets TOO damn weird. Laughter seems the best "banisher" to keep the way-out-worlders at bay. Another sanity-saving technique is that old standby-(healthy) skepticism. By this we do not mean a pathological need to reject everything that doesn't fit into your philosophy...only to keep an open mind in the broadest sense.

My personal problem (or blessing) is a complete lack of filtering apparatus when receiving information. Unfortunately, this is coupled with deficient retention skills, which necessitates a tape recorder at all interviews. This is most pronounced in conversation. A person could inform me that, secretly they were the Prince of the Pleiades, and at that moment, I would accept it as a perfectly normal thing to say. After walking away/ driving home/ etc., the "what the hell?" reaction takes over, but the initial impression remains. This leads to a wonderful way of jumping between the believe/ don't believe that excites all of us (the editors).

Based on that, here is a guiding principle (so called) that will steer the editorial policy of *The Excluded Middle:* Accept and/or reject. Argue until the Rapture carries us all away, but always be prepared to steep in other points of view for awhile. Believe in both or all, but never reject anything out of hand...UNLESS IT REALLY ANNOYS YOU!

Still wondering what "excluded middle" means? Consider the language of computers; binary-meaning on or off. Binary language is for computers. Real humans must learn to reject the binary, Aristotelian thought of the last 2000 years as apocryphal, and reconsider it as the only way of reaching solutions. This year's election illustrates this only too well. We don't have to be milquetoasts just because we listen past our personal shells. It's a razor's edge to walk, but it's all too easy and unprofitable to cling to old paradigms. *The Excluded Middle* bridges the on/off yes/no believe/don't believe chasm. Peter, Robert, and I are trying to build and walk that bridge. Join us.

—Greg Bishop

Flying Saucers, the Mind, and Other Absurdities

By Robert Larson

It may be just that it is an unsolved mystery possessing a peculiar sense of humor. It may be that only a very peculiar person is even able to see this.

Flying Saucers, Flying Discs, UFOs, Alien Visitations, Abductions, Contactees, Men in Black, Grays, Invisible College... These are some of the buzz words of a genre of inquiry that is sometimes referred to as ufology. To many people these buzz words don't mean much. Or they are an invitation to ridicule those who utter them. But for some of us, these words are charged — charged with the energy of a mystery begging for attention. It's got our attention and it won't let go. I'm not sure we know why. It may be just that it is an unsolved mystery possessing a peculiar sense of humor. It may be that only a very peculiar person is even able to see this. I don't know. I do know that I don't meet many people who intuit the levels of implications these phenomena induce in me. But I sense there are some of you out there. I see these pages as a vehicle to make contact (pun intended) with you.

I'd like this to be an ongoing process of educating ourselves. It seems that this area of inquiry is a strange and possibly unique opportunity for learning. There is something going on, but what? I think it's rather open to interpretation at this stage. There's this large gulf between the ludicrous supermarket tabloid handling of it and the boring proclamations of unimaginative orthodox scientists that more or less say, "Since we can't explain it, it doesn't exist." That large gulf, that "excluded middle", is what interests me. There are many ideas there I'd like to throw around:

It is my feeling that what Carl Jung had to say regarding this issue is still worth considering. Whether or not these things have an autonomous reality, they seem to carry a symbolism that may be quite valuable. Michael Grosso, Dennis Stillings, Terence McKenna and Keith Thompson have run with this line of thinking in some rather fascinating ways.

There's the idea of UFO as mandala, a symbol of wholeness at a time when culture and the eco-system can be seen to be disintegrating. This symbolic communication from the collective unconscious, it is suggested, will increase in times of catastrophic change, upheaval and imbalance. What better symbolized an initiation of such a time than the atom bomb of 1945? How

interesting that the modern flying saucer era began in 1947.

The classic flying saucer shape can be symbolically interpreted as female. Is this a counterbalance to thousands of years of patriarchy and male dominance epitomized by our own phallic-shaped rocket ships?

If one really examines the stories, characters and behavior–not only in UFO lore but among ufologists themselves–one can notice parallels to many classic and ancient myths. Keith Thompson, in his book Angels and Aliens, does a marvelous job of pointing out this mythic nature of UFOs.

Thompson has also noticed that the classic UFO abduction experience has many similarities to shamanic initiatory processes of more "primitive cultures": symbolic death and rebirth, transformation, and messages from extraordinary beings. Could this be compensatory for a lack of proper rituals and initiations in our society?

There is another hypothesis that there is a realm of existence parallel or orthogonal to ours that we don't normally perceive because our brain chemistry tunes us to this here and now frequency that we've chauvinistically assigned pre-eminence. There is a certain class of mind altering substances (the tryptamines)—with a history of shamanic usage in their plant forms–that at certain doses seem to induce UFO-type experiences in the perception of some users. Terence McKenna talks about tryptamine use introducing one to a world of "crackling, electronic, hyper-dimensional, interstellar, extraterrestrial, saucerian landscapes filled with highly polished curved surfaces, machines undergoing geometric transformations into beings and thoughts that condense into visible objects." It must be noted that these tryptamines that are ingested to induce such experiences do occur naturally in the human brain and may be activated under certain circumstances. Do check out Mr. McKenna for more on this.

Psychologist and research scientist Michael A. Persinger has discovered a seeming correlation between the geographic location of UFO activity and disturbances in the earth's magnetic field caused by plate movements. And an individual's proximity to the field disturbance seems to have a relation to the perceived intensity of the experience. Magnetic fields are known to affect human nervous systems.

One of my favorite interpretations is: UFOs as our descendants returning in time machines.

Jacques Vallee has noticed that many UFO encounters have the look of "staged" events —events staged with some sophisticated but not necessarily other-worldly technology. Well, it's known that the CIA has access to some rather sophisticated technology. There's been talk of a CIA program to create staged quasi-religious, supernatural events in third world countries ostensibly for mind control experimentation. Think about it.

These are just some of the notions about this puzzle that I find captivating. I hope I've sparked interest in those of you out there who have been touched by this the way I have. It is my desire to engage in dialogue, discussion and debate about all this and more. The intention is that we'll educate each other and maybe gain some fascinating insights into the big questions about who we are, what we are and, "Why was Joe Simonton given pancakes?"

References:

Angels, Aliens and Archetypes. Conference featuring Michael Grosso, Kenneth Ring, Terence McKenna, Jacques Vallee, Keith Thompson, Richard Grossinger Whitley Strieber, Alise Agar (audio tape) (Mill Valley: Sound Photosynthesis, 1988)

ReVision magazine vol. 11 no. 3 1989

ReVision magazine vol. 11 no.4 1989

Carl Jung, *Flying Saucers: A Modern Myth of Things Seen in the Skies* (New York: Princeton University Press, 1959)

Terence McKenna, *The Definitive UFO Tape* (Berkeley: Dolphin Tapes, 1983)

Michael Grosso, "UFOs and the Miraculous" UFO magazine vol.5, no.2

Keith Thompson, *Angels and Aliens, UFOs and the Mythic Imagination* (Redding, MA: Addison/Wesley 1991)

Dennis Stillings, "The Chopper and the Psyche" *UFO* magazine vol. 4, no. 1 1989

Michael A. Persinger / Gyslaine F. Lafreniere, *Space-Time Transients and Unusual Events* (Chicago: Nelson-Hall 197Interview with Robert Anton Wilson—2/15/92

Interview with Robert Anton Wilson

Gregory Bishop

Quit complaining, get off your ass, and select your reality! Robert Anton Wilson needs no introduction for the readers of this magazine, so suffice it to say that this short talk was a perfect first interview. He can rightfully be called the original Godfather of *The Excluded Middle*.

Q: In the recent book Angels and Aliens, *author Keith Thompson cites what he calls "metapatterns", which are repeated patterns in seemingly dipsarate phenomena which connect them. Do you entertain this concept, and if so, how?*

WILSON: Yeah, I see metapatterns between evolution and human history. I see an acceleration of information throughout evolution and you can see a similar acceleration of information throughout human history moving faster than the evolutionary one, and I think cosmic—if you consider the universe as evolving—there's another accumulation of information over time on a bigger scale. That's one of the metapatterns I've found useful.

Q: You don't think that's just because we're noticing it, that the universe is ticking on its merry way?

WILSON: Well that's the deepest question of all! I don't know. John Archibald Wheeler thinks it's because we're noticing it. He thinks that we're fine tuning the big bang every time we measure it, or at least a measurement on a sufficiently small scale, so we're selecting this universe out of all possible universes by the measurements we make, but I don't know whether I believe that or not.

Q: Thompson also compares the UFO phenomenon and people that study it to absurdist theater such as Waiting For Godot *where the waiting becomes robotic entertainment...*

WILSON: Well, I think it's more like a little film by Idries Shah—*The Dermis Probe*—it's a dense leathery something and these voices arguing about it. The camera keeps moving back as the voices find more and more details and more and more to argue about, until finally the camera moves back enough so that you can see it's an

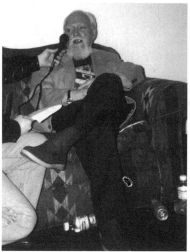

Robert Anton Wilson

The world is full of things that puzzle me. I'm not quite sure what they are and how to classify them.

elephant. It's an adaptation of an old Sufi tale. I think it's more like the UFO mystery than any of Beckett's plays. Everybody gets ahold of their favorite end and...

Q: ...won't let go...
WILSON: That's what it is! ..."It's extraterrestrials" "It's angels" "It's demons...hallucinations..."

Q: Faries and elves...
WILSON: ...faries and elves...yeah I like that theory because it's very hard for anybody to take it literally, so it gets one thinking on a different level.

Q: Where did you first hear about that theory?
WILSON: From Jacques Valee in 1976.

Q: Around the time of Passport to Magonia?
WILSON: Around that time, yeah. I met him and then I ran right out and got the book and read it, and then I read *Invisible College*, which was the next book he brought out.

Q: Do you see UFOs as an experiment or at least a fly in the ointment of modern (last 50 years or so) consciousness or at least ideas of consensus reality?
WILSON: Oh yes, very definitely. That's what I like about it. I like the metaphor that Brad Steiger used although I don't take it literally: In the reality game, every time we think we understand it, the player on the other side introduces some new move that in all of infinity has never been done before, so we've got to start thinking again and trying to figure out the rules of the game all over. I like that as a metaphor because the UFO is very much like that—it's a new move that the universe has made. That explains why a lot of people don't want to think about it at all.

Q: It forces people to change their ways of thinking, and that's scary.... What is your feeling that many of our major religions are the result of contact with the "alien" the "other", or at least what we now regard as anomalous experience?
WILSON: Well, major religions of all sorts, from shamanic to the most "advanced" (which is what they call themselves—the more successful ones with millions of followers). All religions seem to be based on some sort of encounter with an alien presence, or what seems like an alien presence. According to one theory, it's just the other half of our brain.

Q: Like the miracle of Fatima.
WILSON: At Fatima the number of people seeing odd things increased with each visitation until there were about 100,000 witnesses from all over Portugal who saw parts of the last one which was "a light brighter than a thousand suns and petals falling out of the sky" or something like that. Really it sounds like a cosmic Houdini was putting on a show for them.

Q: What would you think would have happened if this had happened in say, China, Japan, or India?

WILSON: Oh, It would have been dragons fighting dragons in the sky...these things always...on going through the human nervous system they get adapted to the local belief system.

Q: *Do you think they would have taken it just as seriously as the Catholic church did?*
WILSON: Oh sure. Whatever it was, it certainly struck a lot of people very hard, so it would have been a religious event wherever it happened. I was at a conference in Georgia a few months ago called Phenomicon and this was the first time I ever saw this: We had two eyewitnesses in the room in this final panel discussion. Two eyewitnesses to this UFO sighting that was seen by quite a few people in Atlanta. One of them saw a spaceship with portholes and the other one saw a weather balloon. I found that absolutely fascinating. This was the subject of my PhD dissertation—how our perceptions are adjusted to fit our belief systems. This was a fascinating example to watch. Neither one had any doubt—they were both women—which is irrelevant, but I have to say that to explain my grammar. Each one was convined that what she saw was what was "really there" in the external world. Neither of them had any awareness that their brain had taken thousands and maybe millions of energy-events in space-time and correlated them in their brains to put together this picture and project it outward. Leach has said that none of us realize what great artists we are. This is a prime example.

Q: *There was a case in Kentucky where two people had been riding along in a car. One saw a craft land and typical aliens get out and abduct them, and the other saw a schoolbus going by. They both swore up and down that that's what they had seen.*
WILSON: (Laughter) I think I've seen more UFOs than most people because I have no dogmas about this, and so I'm always noticing weird things that I don't quite know what they are. I've seen UFOs, but I see UNFOs too—"Unidentified Non-Flying Objects." The world is full of things that puzzle me. I'm not quite sure what they are and how to classify them.

Q: *I read your last book* (Cosmic Trigger Part 2) *and it seemed very pessimistic or even paranoid. I probably shouldn't ask this now because you'll get offended.*
WILSON: Well, now I'm curious.

Q: *Well, your last book seemed very cynical. Anyway, if you say we're the artists of our own reality, do you enjoy painting pictures of insane government figures and their plots to ruin our lives?*
WILSON: That's a very good question and that book presents various ways of looking at reality. Sometimes the world does look that way to me. Some people see the world that way all the time. What I was trying to do in that book is show that we can see the world that way part of the time, but you don't have to get hung up on seeing it that way all the time.

Q: *It was startling because I had never read anything that dark in your books.*
WILSON: Well in my novels—you probably read only my non-fiction. People who have read only my novels tend to think I have tragic and somewhat paranoid view of the world. People who have read only my non-fiction think I'm unrealistically optimistic. I try different reality tunnels in different books.

In the reality game, every time we think we understand it, the player on the other side introduces some new move that in all of infinity has never been done before, so we've got to start thinking again and trying to figure out the rules of the game all over.

All religions seem to be based on some sort of encounter with an alien presence, or what seems like an alien presence. According to one theory, it's just the other half of our brain.

Q: What made you start doing that, do you think?

WILSON: The Kennedy assasination. I was reading all the controversial literature and I got to see more and more how everybody in that debate, on all sides, how they were adjusting the data to fit their prejudices. So in *Illuminatus*, my first long novel (in collaboration with Bob Shea) we gave a couple of dozen alternative scenarios and everybody in the book figures it out differently, and the reader has to figure out which version they're going to believe, or are they going to become agnostic.

Later I realized it was not just the Kennedy assasination, I could apply that to the whole world. That attitude is called Model Agnosticism and it's very popular in modern physics, and to some extent it's reaching the other sciences too. It's the idea that the model is useful for a time, but you don't ever believe in it the way people used to believe in religious dogma.

Q: Here's one a bit off the track...What are your two or three favorite films and why?

WILSON: *The Trial* by Orson Welles, because it's an unsolvable mystery. If it was solveable, I'd lose interest eventually, as it is, I can look at it over and over and always have a new attitude towards it. I always find something new in it.

Q: And...?

WILSON: Another one by Orson Welles, *F Is For Fake*, which is a documentary about the impossibility of making a documentary. It's a documentary in which everybody is lying, including Welles himself. You never can figure out who's the worst liar and how much you can believe. Some of it is true, but you can never be sure which part. Other documentaries are terribly dishonest, compared to that one, which admits it's lying. A documentary that admits it's lying is honest, a documentary that prentends to be honest is lying... And *Stardust Memories*, by Woody Allen.

Q: That's one of my favorites.

WILSON: That's very much like *F Is For Fake*. You never know what's real and what's part of one of his movies. Sometimes the characters seem to escape from his movies into so-called "reality", except reality itself is a movie that we're watching, right? His hostility escapes from his movie into reality...

Q: And attacks his ex-wife and mother and it's about to get his psychiatrist...

WILSON: (Laughs) It gets one of his fans too. It suddenly reappears when somebody is asking him about the sexuality of artists and "have you ever had intercourse with a horse".

Q: Yeah "with some kind of wild animal" or something like that.

WILSON: And his hostility suddenly appears on screen and drags the guy off! (laughs)

Q: What is "utopia" and do you still see it as a possibility in the next few decades or so? (Relatively anyway).

WILSON: Utopia is a world where there's no nuclear arms race. Where I don't

wake up every morning wondering whether the Soviet Union or the government that alleges it's mine are going to start hurling nuclear weapons at each other. So we've already achieved utpoia. That's obviously not going to happen.

Q: It'll be another country that's buying weapons off the Soviet Union.
WILSON: I refuse to worry about that. They scared me most of my life. Now they're claiming there's holes in the ozone and I'm supposed to worry about that. I am too old, I refuse to fall for this crap anymore. The rest of my life I'm going to enjoy myself and I'm not going to let them scare me anymore with these...the Russians turned out to be...they just fell apart. They never had any plan to attack this country. They were afraid of this country all along.

Q: Well, it kept a lot of people going on fear.
WILSON: And I won't worry about the ozone layer. It'll fix itself, or we'll learn how to fix it. I'm not going to ruin the rest of what I've got left of life with worrying about that.

Q: It seems like there's a different finding every week. "No, it's not going as fast as we thought", "Yes, it's going much faster, time to take steps" etc. I don't sense you have as much hope in the future as you once did. Is this incorrect? And do you agree with Israel Regardie's statement that things will get worse before they get any better?
WILSON: I think I'm as optomistic as I ever was in the long-run evolutionary perspective. This idea that we have to go through some horror before we're cured, if that were true, we'd have been cured long ago. We've been through enough horrors, especially in this century. After Hitler's death camps and Hiroshima and Viet Nam, how many horrors do we have to go through before we're ready to be happy? I think we're ready to be happy right now. I'm not going to let Regardie stop me.

Q: Well he can't object now. Do you think all this is "millenium jitters" or is the shit really going to hit the fan?
WILSON: I regard myself and my friends as the power elite. That way I don't have to worry if someone else is manipulating me. They're trying, but we're outsmarting them every step of the way. Most people want to believe somebody else is in charge. Then they don't have to take responsibility. Then they have the supreme pleasure of perpetually complaining that somebody else is in charge, and it would be better if only they were in charge. As long as I think I'm in charge, I've got nothing to complain about. I've got to take the responsibility for all of it. How can I go on? (laughs) Well, some of us have more balls than others. I'm sixty years old. In any traditional society I would have been hanged long ago.

> I regard myself and my friends as the power elite. That way I don't have to worry if someone else is manipulating me. They're trying, but we're outsmarting them every step of the way.

Tales from the Shelf: A Secret Life Lived in Twilight

Peter Stenshoel

> I contend that poets, lyricists, and artists of all types can more easily speak the unvarnished truth when they want to (and are able to), than folks of more prosaic callings, because nobody is expected to measure the power of an artist's words and images against a scientifically approved yardstick.

This is my first column, so allow a brief introduction: I am an artist who deals primarily in music composition, poetry, sound collage and, yes, humor, to convey my ideas. I have been fascinated with UFOs ever since I was old enough to grasp the mystery of what were then called flying saucers ("then" being circa 1960. I was born in 1954.) Since I have chosen the arts as my form of expression, I have had the luxury of leaving scientific proofs, disclosure of strange facts, and the world of ontology to others more gifted in those realms.

Paradoxically, I contend that poets, lyricists, and artists of all types can more easily speak the unvarnished truth when they want to (and are able to), than folks of more prosaic callings, because nobody is expected to measure the power of an artist's words and images against a scientifically approved yardstick. A journalist who gets the names wrong under a news photo will be immediately chastised. Ph.D. candidates, even in such artistic fields as literary criticism, must show precedents for their conclusions or face ridicule. Politicians are expected to live up to their promises (well, sometimes), and researchers—scholarly or otherwise—must proceed at a snail's pace if they expect to maintain credibility in the public eye.

Artists, on the other hand, are free to use that dreaded pariah of the science world, "anecdotal evidence," any old which way they please. Intensely secret personal experiences can become the stuff of iambic pentameter or acrylic on canvas. Confessions which could otherwise land you in a state facility for mental disorder can land you accolades if you have the knack to present them in a creatively engaging way. Bearing that in mind, I find it a great pleasure to read works of poetry and listen to lyrics for the truth which might be quite close beneath the surface. Brian Eno's lovely song, "Spider and I," (from *Before and After Science*) can be imagined as an entirely real world. The Byrds' "5D," short stories by Franz Kafka, the entire Hunter/Garcia canon recorded by the Grateful Dead, Martin Buber's *Tales of the Hasidim*, tons of Bob Dylan ditties, Hank Snow's "Islands in the Sky," certainly the halcyon phrases of Blake, Whitman, Emerson, Wordsworth, and Coleridge can all be perceived as descriptions of something

fundamentally real, perhaps things the authors experienced in this plane or another.

The proceeding paragraphs are my way of preparing to rip off my artists' overalls, strip out of my poetic underclothes, and doff my mask of allegory aside, to appear before you as naked as the colors on a 1950's comic book cover. This column is my attempt to talk straightforwardly to a few friends, without benefit of artistic liscence, and to ponder the sword of Damocles hovering over my persona lo these many years. That sword has consistently cut a path of unexplainable events in an entire life of questions. I don't hold claim on the truth. I don't have dogma nor doctrines nor diets I can recommend. I do have anecdotes. If you are spiritually fulfilled, as I am, by digesting other folks' unexplainable anecdotes, this column is dedicated to you. If you are confused by events in your own experience, or on the verge of piecing together a rather incredible scenario of your life so far, this column could provide you with the occasional pinch which assures you: This is no dream.

I call it *Tales from the Shelf* because I believe we all have little incidents that are so out of context that we figuratively put them on the shelf where they get dusty and can remain unexamined. Even people who complain, "Nothing unusual ever happens to me," if you persist, eventually will dredge up items which they have discounted all these years: "Oh, well, yeah, I did have a prophetic dream, but that's because [fill in your favorite anomaly-busting rationalization]" I was thinking of being cute by calling my column, *Confessions of a Fantasy-Prone Personality*. I'm well aware of the theories which conveniently do away with troublesome phenomena simply by labeling the percipient. I have two thoughts about this. First, having met some people diagnosed as schizophrenics and having done some studies on the subject in college, I will admit that there seem to be people to whom hallucination is totally self-created. What one does with their claims of anomalous encounters is problematic, and one must maintain a sense of judgment and caution. However, and this is my second thought, much in the way that modern treatment of depression includes simple injections of vitamins which the patient has lacked previously, could there be a much more basic relationship between perception and the ability to perceive? Are some folks, otherwise normal people, endowed with an extra shot of "vitamin Z," and thereby capable of tuning in Radio Anomaly much more readily than the rest of us? Is Evolution churning out prototypes of the 21st Century model? If this is the case, then the moniker, "fantasy-prone personality," is on the right track. Just substitute the words "wider reality reception" for "fantasy" and you have the solution. Such persons' bandwidth receptors are bigger than the norm.

Well, that's the muddled-class where I hang my hat. I don't have stories of splendid trips to Venus or Jupiter (I wish I did), but somewhere on the potentiometer I seem to have been receiving signals of larger bandwidth. I will leave you with one such story. If the words, "anecdotal evidence," translate as "obviously untrue" to you, you can stop reading here. Although the following is not one of my UFO anecdotes, I will begin this series with it because it is among that grand and hoary genre, the ghost story. In some ways ghosts are the most ancient anomalies in the history of humankind:

I call it Tales from the Shelf because I believe we all have little incidents that are so out of context that we figuratively put them on the shelf where they get dusty and can remain unexamined.

The Lamplighter

This took place in the small Southern Minnesota community of Rushford, around 1971. My brothers and I were sprawled out in sleeping bags in the living room of my uncle's house. The house is a beautiful two-story wood-frame affair, with plenty of large windows looking out to the street. Since it was night, the white plastic shades had been drawn, allowing Rushford's electric street lamps to provide fairly uniform illumination on the surface of those shades. I awoke around 3:00 in the morning to the typical cloak of quiet a small midwestern town enjoys. Without warning I saw a sight which caused my heart to beat wildly: Casting a silhouette against the shade closest to me was what appeared to be an old stooped man, carrying a ladder. What I could gather from the silhouette was that his clothes were of an old-fashioned sort. He walked slowly and methodically and silently along where the sidewalk would be.

The pronounced incongruity of an old man with a ladder making a post-midnight trek in a sleeping small town was odd enough, but what caused my extreme terror was the complete and utter silence of his walk. There is no doubt that, had the shadow some substance behind it, I would have heard the footsteps! I wished to awake my two sleeping brothers, but fear paralyzed me until the vision passed. And then, by God, I did waken them, probably to their sleepy protestations. I don't think my story impressed them at the time. There was no way for them to know I hadn't been dreaming.

Because the old man carried a ladder with him, I theorized that I was seeing a ghost of a lamplighter who used to walk the streets of Rushford in the days before electricity. I find interesting the fact the figure was a silhouette. What that means, in effect, is that if this was a ghost, it was casting a shadow. Or was it the shadow itself? Throughout history, ghosts have been called shadows enough that I think we can assume a link between the word and the nature of the specter. Has anybody else seen the little old lamplighter? Let us know. Next issue, more anecdotal evidence from the excluded middle section of *The Shelf.*

My Bias Filter is Better than Your Bias Filter

Or, Why I like Contactees Better Than Abductees

Gregory Bishop

Astrange statement about a strange subject. Not to invalidate or belittle traumatic experience, but it seems that recently many people feel compelled to play the "victim" in a public forum. A discordant chorus has sprung up in vying for the title of the "most abused/ traumatized/ or neglected" and that we must know and sympathize with every victim of injustice—real or perceived. Public therapy has, in the last decade, replaced patriotism as "the last refuge of the scoundrel" somewhere between 60 Minutes and Oprah Winfrey. NO, I'm not insensitive. I am as politically correct as the next guy (I mean PERSON), but when too many voices clamor for attention, it becomes a cacophony rather than a legitimate complaint.

The UFO abduction scenario begs for this sort of attention. Among the ufological ranks I sense in microcosm the same problems I have been ranting about. Now that it's "OK to be traumatized", a chorus of individuals has arisen crying "alien abduction." I am not saying that I don't believe that they believe, but the recent publicizing of abductions could be a convenient Rorschach blot for the same reason thousands are now claiming "satanic child abuse."

Buried memory is not always a reliable thing. I remember almost drowning in a deep, hot Japanese bath when I was about three years old. My father fished me out. I also remember a train going by outside. I am not sure whether parts of this "memory" were filled in later by myself, or if I made up or dreamed some or all of it later. If I had come across a rash of parents dipping their children in hot water in a satanic ritual in the early '60s...well, you know.

The point is, I feel a public revelation of buried traumatic experience may only be somewhat accurate at best in most cases, and in the present media climate can only serve negatively sensationalistic purposes. If it sounds as if I am pining for the "old days" perhaps this is true. The "old days" when people "shot straight", "minded their own business", and "played by the rules" is perhaps only a wish for what may have been or what I perceive to have been before I was able to rant like this. My own view is that, until Barney and Betty Hill's seminal abduction case was publicized in the mid-1960s, rather than posit that thousands

> **A discordant chorus has sprung up in vying for the title of the "most abused/ traumatized/ or neglected" and that we must know and sympathize with every victim of injustice—real or perceived.**

suddenly came out with buried trauma, wouldn't it also be valid to assume that many were provided with a framework for other experiences—vaguely remembered—that were not necessarily abductions? Now, perhaps a victim has never heard of an "abduction scenario." Perhaps (and this is where I leave the scientific-fundamentalist road) a shift in the post-nuclear "collective unconscious" was signaled by many things, such as the cold war, or at present, ecological disaster and other unspecified fears we are forced to accept and deal with.

Researchers and authors like Jacques Vallee and Keith Thompson have already pointed out the parallels between abductions and the legends of fairies, the "little people," etc. Perhaps Swift's *Gulliver's Travels* was in part inspired by this legend. The point about abductions is, although they might be grounded in legitimate experience, and thousands have been affected by a phenomenon we still know little about, the popularization of the abductee has probably contaminated the field beyond most efforts at objectivity.

On the other hand...

Objectivity is not a real problem when dealing with the ol' Space Brothers. You believe, reject, or suspend your disbelief. However, the most information, enjoyment, and even wisdom can be gained from adopting the latter attitude. Perhaps it can be easier for us to accommodate this state of mind than it was in the "heyday" of the contactees. We are forced to do this every time we watch a film or television show, especially animated or heavily effects-laden stories. In fact, I'd venture to say that lovers and aficionados of the most outlandish in animation art are prepared to accept the contactees' claims at face value in the manner I mentioned in the "Declaration Of Principles" article (belief at the moment of encounter.)

I intuit from all available artifacts (TV, movies, publications) that the United States in the 1950s was an era of the popularization of the "rational" as the highest achievement of the human species. It was the era of the mass acceptance of the Freudian school as the "final" model for behavior. To me, the application of the Freudian method probably causes more harm than good with its emphasis on an understanding of the human mind as a strict cause-and-effect/linear relationship, and the application of "cures" guided by this principle. The contactees, consciously or otherwise, rejected the zeitgeist in favor of their own cosmic world view (or universe-view).

Nearly all discussions of the UFO contactees start with George Adamski, the most accomplished of the lot. He even got an audience with and blessing from the Pope (or devoutly wished everyone to believe he had, since history is unclear on this point.) Adamski also, like all the other well-known contactees of the era, came from the legion of the "great unwashed" underclass who probably didn't have much stake in the popular cultural paradigm to begin with. Perhaps the scientific rationalism of the time hadn't penetrated their social circle as a template of experience or even improved their lot in the most basic ways. Adamski hadn't finished elementary school, so propaganda and filmstrips about "Our Friend Magnesium Oxide" etc. didn't get a hold on his psyche.

It is safe to assume that the thousands who attended contactee seminars and services and bought their literature (and continue to do so) were cut from the

George Van Tassel

The "little old ladies who sent Van Tassel their Social Security checks were only part of the vast spectrum of the bored bourgeoisie who could be counted on to be there when the Space Brothers roll was called up yonder.

same cloth as their gurus. In fact, this is not idle speculation, since on a recent trip out to the high desert near Joshua Tree and 29 Palms, Robert and I met with an old caretaker who had witnessed some of the activities and Saucer Conventions given by George Van Tassel at his Universal College of Wisdom in the 1950s, as well as glimpses of his public life in the community. Inquiring about the subject, the man told us that he used to see Van Tassel "coming into town to cash his checks from all the little old ladies who always sent him money." The old ladies, along with the terminally bored, were the backbone of the contactees' flock.

Boredom must be factored into the equation for the contactees' success, and provides further answers to the question: "Why did so many listen to these obvious crackpots?" It is my opinion that along with frustration, boredom and the methods available for alleviating it has been one of the greatest agents for change in history. Particularly in the latter part of the 20th century where we have witnessed some of the most important molders of public opinion (film, television, video games, and talk show and fitness gurus, etc.) gain an unbreakable grip on our lives, the boredom factor becomes very important. The "little old ladies" who sent Van Tassel their Social Security checks were only part of the vast spectrum of the bored bourgeoisie who could be counted on to be there when the Space Brothers roll was called up yonder. The working underclass of the 1950s and early '60s who felt left out of the cultural equation could also gain solace that even if success and perhaps more importantly, spiritual attainment had left them behind, a more "modern" brand of savior was ready to lead the willing into the 21st century.

The main reason why I "like contactees better" than abductees is that either through choice or ignorance, they decided to file their experiences, either real, imagined, or in between, in the "ENLIGHTENED" file...in a positive light. High profile UFO kookiness in the 1950s for the most part was a pseudo-religious experience (at least as far as the major media was concerned). In the last 15 years or so, this profile has almost disappeared to be replaced with desperate pleas for understanding from the UFO abductees. The contactees never asked for understanding or even respectability. Perhaps as religious belief, they felt their profiles were above scientific scrutiny, as indeed they were (at least in fields other then psychology or sociology.)

Perhaps my motives for increased interest in Saucer Saints are the same as the likes of Donald Menzel, Phil Klass, and the lot and their pathological efforts to reduce the phenomenon to a narrow field of 20th century science. In other words, FEAR OF THE UNKNOWN! The problems of alien abduction and the sinister motives behind such a usually terrifying experience may be too complicated and beyond our present understanding to even attempt to understand. Leo Sprinkle, Budd Hopkins, and the others might be our pioneering voyagers into 21st century interdisciplinary psychology, and I'm too scared to jump into the hot tub with them. I don't know. I think the conflict we are still dealing with was spelled out 30 years ago on the Long John Nebel all night radio show when George King, founder of the Aetherius Society, was a guest. Well known (at least among UFO enthusiasts) flying saucer aficionado Jackie Gleason called in to have it out with the Master George, and illustrates how much the argument is still at cross-purposes to this day:

GLEASON: How are you?

KING: Very well, thank you.

GLEASON: Are these people from outer space friends of yours?

KING: I believe that they are friends of mine, yes.

GLEASON: Could you call upon them for assistance? For instance, if you were in some sort of legal difficulty, embracing some part of their recognition of you, would they come to your aid?

KING: Under those circumstances, they would help, yes.

GLEASON: If I were, for instance, to say to you that you are a bare-faced liar, now you know you could sue me for libel, right?

KING: Yes yes.

GLEASON: Now you think you could get any legal assistance from them in a case like this?

KING: No, I don't.

GLEASON: Why?

KING: Why should they help?

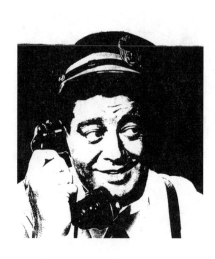

GLEASON: Well, you're championing their cause.

KING: No, No I'm not. I'm trying to give a spiritual message, which I believe to be good for all people...

GLEASON: Why do we need a spiritual message from someone in a flying saucer? Don't we have enough from Christ, Buddha, Moses, men like that?

KING: Do we live by those teachings?

GLEASON: I do.

KING: You do? Then you're the first Christian I've ever seen.

GLEASON: You mean that no one lives by the laws of Buddha, Christ, or...

KING: I never met anyone.

GLEASON: By the way, do you know that every time you are uncertain when you say something, you cough? Do you know what that means psychologically? In other words, you cough every time you tell a lie.

KING: Do I?

GLEASON: Now George, look at the juicy opportunity you have. Here's a guy that you're talking to that's got a lot of dough. You can sue me for maybe a million dollars, and maybe get it. All you have to do to get it is to bring one of your friends from Mars to OK this thing. And then you win.

KING: I've already answered this question. There isn't a man on Earth who could do this.

GLEASON: In other words, you have absolutely no proof from these people whom you are championing? You have absolutely no backing from anybody in outer space for what you say?

KING: Just a moment please. Just one minute.

GLEASON: I'm waiting, and cough a little bit.

KING: I shall put this phone down in a moment.

GLEASON: Yes?

KING: I'm a guest here, you see.

GLEASON: Not in my house, you're not a guest. I think you're a phony!

KING: C L I C K !

No. 2

Editorial

Welcome to issue number two. We've made it to the almost exclusive ranks of small independent zines that actually produce a second issue. All this while one of us frantically completes a master's degree, one of us suffers a life shattering / transforming experience and all of us struggle to maintain gainful employment in economically challenged Southern California. Thanks to all of you for the positive feedback on issue number one. Those of you who've been patiently waiting for more, well, we're not too far behind schedule. However, we trust you'll find this expanded middle (double the pages) worth the wait. Let's see, what do we have on tap this time to expand your middle if not your mind? Greg Bishop delivers another dynamite interview - this time with controversial UFO writer / researcher Bill Moore. You may be surprised. *The Excluded Middle* (tEM) is always interested in the folkloric precursors to the modern grey ufonauts. So we're rather excited by Ian Blake's article that presents a new twist on this. For all you conspiracy buffs, check out Greg's provocative piece on JFK assassination related shenanigans. It's sure to annoy some of you. But wait, what's this doing in TEM? The way we've been going, you probably thought we were a UFO magazine. Sure, that's a big focus for us but only in the larger focus of the strange, bizarre, weird, unexplained and mystical. JFK assassination/ conspiracy stuff more or less falls under that but more importantly, it is fertile ground for seeing how people create their own realities by selective filtering. It's a great example of myth / folklore in the making. That's just some of the exclusive dribble from deluded twiddles. Lap it up and enjoy.

—Robert Larson

Aliester Crowley and
The Lam Statement

Ian Blake

Thus far in my articles on the paranormal I have tried to convey an impression of pragmatism and common sense, dealing almost exclusively with the brain, its functions and—more especially—its dysfunctions. My aim has always been to explain various types of phenomena without explaining them away. Magic and the occult have been mentioned on a number of occasions, but only in passing, as a side issue, as it were. In the main I have confined myself to "armchair Ufology", leaving the wider implications (magical, spiritual, etc.) to other, possibly more capable hands. It is a fact however, that one seldom gets very far in these areas without coming across occult doctrine in one form or another, usually updated and translated into "new age" jargon. In this article I intend to examine some of the more esoteric aspects of Ufology, hopefully laying the groundwork for further investigation.

UFO research, even of the armchair variety, calls for a high degree of mental flexibility. One can draw up general rules to assist in analysis, but it is necessary to keep an open mind at all times, and be prepared for the exception that cuts across all previous theories. This is especially true of the contactee syndrome, which serves as a crystallization point for all manner of complexes and repressed desires. My limited experience has led me to the realization that most contactees are basically no different from the rest of us. They are in fact perfectly ordinary human beings suffering from familiar symptoms, particularly those of boredom, alienation and sheer lack of purpose. But what of the exceptions to this rule? What, for instance of the occultist who strives by an effort of will to establish contact with trans-spatial entities? According to a recent edition of the OTO (Ordo Templi Orientis) journal *Khabs*, "the central concern of magic is communion with discarnate or extraterrestrial intelligences." It is to this end that much contemporary occultism is predicated. As long ago as 1918 Aleister Crowley conducted a series of experiments in what would today be termed channeling, or "induced contacteeism." (This is of course a simplification of what actually took place, employed here for the sake of convenience.) Since then, several occultists, notably Michael Bertiaux in the 1960s and a group of OTO initiates in the 1970s, have carried out similar magical workings.

Under the influence of hashish and opium she described to Crowley a series of archetypal visions involving (among others) a king, a small boy and a wizard who introduced himself as "Amalantrah" — who delivered exhortations to "find the egg."

What is more their efforts in many cases have been crowned with remarkable success — at least if the official OTO party line is to be believed. This in turn raises quite serious implications for the entire field of UFO research. In order to place these implications in their proper context, it is first of all necessary to say a few words regarding Aleister Crowley's Amalntrah Working, a series of visions and trance-communications received circa January through March 1918 by the oddly-named Roddie Minor, who was at that time acting as Crowley's Scarlet Woman.

It is not my intention in writing this article to provide an introduction to the wider field of occultism, or to Thelemic doctrine per se. For readers who would prefer a clear and reasonably objective summary of the Amalantrah Working, Crowley's own *Magical Record* is invaluable. So too are Roddie Minor's own thoughts on the matter. Readers who do not have access to either of these are best advised to consult John Symonds' *The Great Beast*, which gives a well-balanced and coherent account of what actually took place.

The facts of the matter are briefly as follows: At the outbreak of WWI, Crowley set sail from his native England aboard the Lusitania, bound for the USA. Arriving in high spirits, he took up residence in an apartment on New York's bustling West 36th street and there divided his time more or less equally between acts of sex magic and the composition of crackpot pro-German propaganda for The Fatherland. Following an expedition to Vancouver via San Francisco and New Orleans he returned to New York and moved into furnished rooms on Central Park West. Roddie Minor, a married woman living apart from her husband, joined him there circa September or October 1917 and together they set about exploring the wilder shores of magica sexualis.

Crowley's personal record for October 1, 1917 describes Minor as "big, muscular, (and) sensual." John Symonds adds that she was "broad-shouldered and pleasant-faced." In addition to these homely attributes, she also possessed a well-developed clairvoyant faculty. Under the influence of hashish and opium she described to Crowley a series of archetypal visions involving (among others) a king, a small boy and a wizard who introduced himself as "Amalantrah"—who delivered exhortations to "find the egg." The reaction of most people would no doubt be to view these accounts as nothing more than drug-induced hallucinations having no wider significance, but Aliester Crowley was no ordinary man. According to Symonds, he "made no attempt to interpret this material in terms of unconsciousness. To him the characters and incidents of mescal visions were more real than anything reality or the ego could provide. He would not have been surprised to meet…Amalantrah strolling up Fifth Avenue. The wizard would have descended onto the plane of illusion, that is all."

At length, feeling that Amalantrah had nothing further to impart, Crowley decamped for Europe, leaving Roddie Minor to her own devices. It would be beyond my competence to provide a complete and faithful account of the Amalantrah Working and its aftermath, and the last word on the subject will probably never be written. Crowley was not interested in ideas for their own sake, but in results. The details are unclear, but it seems that at some stage during the proceedings he underwent a form of contactee experience involving a large-headed entity now known to occultists as Lam.

Lam, (whose name derives from the Tibetan word for "way" or "path")

The details are unclear, but it seems that at some stage during the proceedings he underwent a form of contactee experience involving a large-headed entity now known to occultists as Lam.

Lam as drawn by Crowley

later became the subject of a portrait by Crowley, drawn from life and imbued with a haunting inner quality of its own. The original was first exhibited in New York in 1919 and has been reproduced several times since then. Although lacking the crude power of Crowley's more extravagant canvases and murals, it is nevertheless a remarkable piece of work. The subject is depicted in extreme close-up and appears somehow dwarfish, despite the fact that there is no indication of scale in the overall composition. The head is large, smooth and hairless, tapering to a pointed chin. The mouth is slitlike; the eyes extend partways around the sides of the face. There is no suggestion of clothing beyond what appears to be a cloak buttoned at the neck, nor does the entity have any ears. In short, Lam resembles nothing so much as a typical UFO occupant of the "examiner" type (what Americans would call "greys".)

Crowley's portrait of Lam passed into the hands of Kenneth Grant circa 1945 following an astral working in which he and Crowley were jointly involved. Grant, who was authorized in the early '50s to work the first three grades of the OTO, is now widely perceived as Crowley's natural heir and successor. His interest in CETI-type phenomena is of long-standing duration. In 1955 for instance, he announced the discovery of a trans-plutonian planet called Isis, and simultaneously established an order called the New Isis Lodge OTO for the purpose (among others) of contacting higher intelligences. A similar situation arose some 30 years later in the late 1980s, when Grant allegedly received 'strong intimations' to the effect that Crowley's portrait of Lam "is the present focus of an extraterrestrial - and perhaps trans-plutonic- energy which the OTO is required to communicate at this critical period..." I have no idea as to the nature of these 'intimations', besides which, writing about magic is a dubious enterprise at best, fraught with semantic difficulties. Perhaps the best option in this brief article is to quote directly from *The Lam Statement*, a text circulated among OTO initiates with a view to "regularizing the mode of rapport and constructing a magical formula for establishing communication with Lam." We are told first of all that:

It has been considered advisable by the Sovereign Sanctuary to regularize and to examine results achieved by individual members of the OTO who have established contact with the magical entity known as Lam. We are therefore founding an Inner Cult of this dikpala for the purpose of amassing precise accounts of such contacts...

The portrait of (Lam) which is reproduced in *The Magical Revival* may be used as the visual focus, and can serve as the Yantra of the Cult; the name Lam is the Mantra; and the Tantra is the union with the dikpala by entering the Egg of Spirit represented by the Head. Entry may be affected by projecting consciousness through the eyes...And elsewhere, in a section titled *The Magical Procedure*:

> The Mode of Entering the Egg may proceed as follows. Each votary is encouraged to experiment and evolve his own method from the basic procedure:
> 1) Sit in silence before the portrait.
> 2) Invoke mentally my silent repetition the Name.
> 3) If response is felt to be positive...enter the Egg and merge with That which is within, and look out through the entity's eyes on what appears now to the votary an alien world.
> 4) Seal the Egg, i.e., close the eyes of Lam and await developments.

The Remainder of *The Lam Statement* deals with the practicalities of invocation and banishing in a ritual context. Some parts of the text are esoteric, having to do with the Cabala and other such difficult matters (my knowledge of occultism is largely theoretical; I have very little practical experience); others are remarkably straightforward. It is difficult to assess whether the claims made for "LAMeditation" have any basis in fact. Certain objections inevitably remain open. Nevertheless, we should be cautious about assuming that it is all pure imagination. There is a definite residue of data here that cannot be dismissed out of hand. The real question now facing us is simply: what exactly happens at times like this? What is the basis of these extraordinary accounts? Do we, in order to explain them, need to invoke the concept of 'trans-plutonian entities', or are we dealing instead with archetypes dredged up from the collective unconscious? There is pervasive evidence to support both alternatives. All it takes is a willingness to look at the facts.

Perhaps the most important point arising from *The Lam Statement* is simply that contactee type experiences can be induced at will. There are in fact a number of important parallels between "LAMeditation" and the broader issue of "contacteeism" in general. Consider: John Keel once remarked that "in most contactee events the percipient is alone...when the UFO contact occurs." This observation might equally apply to the abductee syndrome. Once again the vast majority of all cases are uncorroborated by hard evidence. Independent witness testimony is so rare as to be virtually unknown. In short, whatever else it may be, "alien contact" (I am loth to use the phrase without quotes) is essentially a solitary experience. And so too is LAMeditation. *The Lam Statement* makes this point in no uncertain terms, warning that group working is considered inadvisable. "Each votary should work in isolation," it stresses, "or only with his or her magical partner...1X° Working is held to be <u>extremely dangerous</u> (sic emphasis) in this area, even if both partners are officially 1X°." The precise nature of this danger is not specified, but we are left in no doubt as to its reality.

Nor do the similarities (with the contactee experience) end there. In common with most forms of magical procedure, rapport with Lam requires stern self-discipline and dedication to a higher purpose. Referring back to *The Lam Statement* we find that "adumbrations of identity with Lam may be experienced as a strong sense of the unreality or unfamiliarity of the "objective" universe. There is a definite parallel here with the curious sense of dissociation experienced by very many witnesses. In recent years there has been an increasing acceptance that this sort of thing is not pure delusion. Jenny Randles for instance, refers to it as the "Oz Effect". Writing in The *Pennine UFO Mystery* she describes a typical case in which the witnesses "said that they were not afraid: indeed they were very strangely calm and subdued...isolated in time and space as if removed from the real world and melded with the UFO above them; only they and it existed..." Having personally experienced this odd sensation on two separate occasions I am reluctant to dismiss it merely as the subjective reaction of a highly-strung temperament. On the other hand, however I am equally reluctant to interpret it as some form of rapport with extraterrestrial entities. I suspect that most investigators would share my reluctance. (There is a tendency nowadays, particularly among UFO researchers here in the U.K., to dismiss the

ETH [Extraterrestrial Hypothesis] as little more than a form of American cultural imperialism, rather on par with Coca Cola, McDonald's, and Ninja Turtles.) It is far more likely that we are dealing here with some form of psychic response, the precise nature of which is at present a mystery.

In magical terms it is possible to identify Lam with the Dwarf Self, the Silent Self, Harpocrates, Hadit, and perhaps most significantly, the Babe In The Egg. Here I quote from Michael Staley's forward to *The Lam Statement* in *Starfire* vol. 1 no. 3: "The Amalantrah is in many ways a continuation of the Abuldiz Working of several years previous. In both of these Workings the symbolism f the egg featured prominently. One of the earlier versions of the Amalantrah Working ended with the sentence, 'It's all in the egg.' During the final surviving version of this Working, in reference to a question about the egg, Crowley was told: 'Thou art to go this way.'"

There is a certain danger in constructing theories based on intuitive or "inspired" source material. At this point I may be allowing my knowledge of Ufology to influence my interpretation of the Lam text. (Inevitably some of my assertions may seem to cross the line into pure fantasy; I can only ask the reader to bear with me.) I can't help seeing in Roddie Minor's channeled references to "the egg" a parallel with various issues relating to UFO research in general.

Egg-shaped UFOs are of course by no means uncommon. There are dozens of examples on file. The famous Soccoro, New Mexico case (April 24, 1964) springs readily to mind. So too do the Salem, Massachusetts (July 16, 1952), Saigon, Vietnam (April 17, 1967), Levelland, Texas (November 3, 1967), and White Sands, New Mexico (also November 3, 1967) sightings. Space and brevity preclude going into these cases at length. Besides which, it would be to little purpose—a tenuous connection at best. Far more significant are those cases where the witness seemingly enters what psychologists would term an "altered state of consciousness". Testimonies abound in this respect. For instance: "The room is whitish," abductee Stephen Kilburn recalled under hypnosis in 1978; "it's curved on the inside...I don't think there are any angles in the room. Everything is kind of milky or misty or something. It doesn't shine, but everything has that metallic glow to it." Accounts like this are by no means uncommon, and it is unlikely that all are pure fabrication. But what is the alternative? We seem to be dealing here with something very similar to the process of LAMeditation which, it will be recalled, entails "entering the egg and merging with that which is within." This recognition is important, for it leads us once again to the suspicion that the abduction syndrome may have something in common with what is traditionally called "magic".

Before we allow ourselves to be convinced however, it is worth taking into account John Rimmer's observation that the witness in this case, "one of a number investigated by Budd Hopkins, had no conscious memory of an abduction before the investigation." The phrase I have underlined is important, not least because the Lam procedure also involves a form of hypnosis, albeit self-administered and -regulated. Rimmer adds that "the UFO abduction as a distinct phenomenon exists as a result of the process of hypnotic regression." And again: "...to a very great extent the evidence for alien abductions stands or falls on the reliability of memories recalled through regression, and the techniques of

hypnosis themselves." [There are widespread accounts that many abduction events are recalled without the aid of hypnosis-but bear with Mr. Blake here-ed.]

These comments obviously go to the very heart of the matter. In real terms most accounts gained under hypnosis are so vague and imprecise as to be virtually worthless. The sensible reaction to them must inevitably be that they contain a certain amount of "confabulated" material, expressing the repressed desires of the unconscious mind. Hilary Evans seems to be referring to something of this sort in *Visions* ★ *Apparitions* ★ *Alien Visitors* when he asks, "Are we to suppose that, subconsciously, all the witnesses...were unconsciously seeking their encounter? And in that case do we have to suppose that every UFO percipient is also responding to some subconscious motivation?" I suspect so— at least as a broad percept. I suspect furthermore, just as the vampires of eighteenth century Hungary were unable to cross a threshold uninvited, so the UFO entities of contemporary folklore are bound by a similar constraint. I am forced reluctantly to conclude that they too are unable to cross the threshold of human experience without first being "invited" in some way.

In writing this article I have experienced none of the satisfaction from seeing a range of facts fall neatly into place. At the end of it all I am left feeling just as bewildered as ever. In order to assess *The Lam Statement* fully, it is necessary to consider the possibility that there may indeed be such a thing as genuine alien contact. Is it conceivable that some students of Thelema have indeed established contact with non-human entities? I believe that it is. I am not however, convinced that these entities are necessarily "trans-plutonian". There is a certain amount of evidence (internal consistency, cross-correspondences) to support such a contention, but the matter by its very nature cannot be proved scientifically. No matter. More than anything else, *The Lam Statement* testifies to the power of the unconscious mind. Translated out of occult terminology into the language of conventional psychology, we can see that it describes a process of self-exploration leading to a greater realization of inner potential. Perhaps this is the best way to view it.

Molding Clay:
Two Views of the Shaw Trial

Not Really A Book Review

Greg Bishop

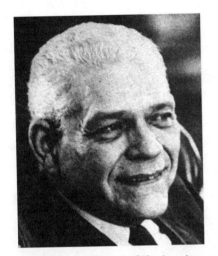

Shaw from On the Trail of The Assassins

If the situations presented in the book and film conform to our cosmology, then they are "facts". If we disagree, then they become "errors" or even "lies" and the product of "conspiracy theorists"

Readers were warned that this magazine would treat many subjects to the Excluded Middle once-over. Synchronicity hit recently as I was wondering if there was ever anything written which gave another point of view on the Jim Garrison *JFK* conspiracy trial. Garrison's book seemed a little too "pat"(sy) to me, and in the midst of this speculation, Robert Larson handed me a copy of James Kirkwood's *American Grotesque*, an account of the Clay Shaw trial brought by Garrison in 1969.

If you have seen the film *JFK* or read the Garrison book that Oliver Stone extrapolated from and are unfamiliar with the original case, it is fairly easy-I daresay mandatory-that one form an opinion, since you now have a host of "facts" to call upon and back yourself up. This can become dangerous if one is in a position of authority or even drunk at a party. *JFK* was one of the best examples of propaganda ever made. (The use of that word is not necessarily intended as negative.) If the situations presented in the book and film conform to our cosmology, then they are "facts". If we disagree, then they become "errors" or even "lies" and the product of "conspiracy theorists". Kirkwood makes it pretty clear from the start that he is on Clay Shaw's side. He became an occasional friend and confidant of the defendant in the months leading up to the trial. Beginning from this position immediately attracted my attention, since most recent media exposure of this issue discusses only the Stone/ Garrison view, or pooh-poohs it with worn arguments.

Kirkwood, as a member of the press at the time probably wanted to appear just as smug as his comrades in the news biz in condemning Garrison's investigation. It is the natural inclination of a good reporter to scratch the patina of appearance and see what's underneath. Although the arrest of Clay Shaw seems us to have been the story behind the *JFK* assassination, mistrust of the Warren Report was already identified with the fringe element in 1967 when Garrison started his investigation. Until recently (and some would argue still) most reporters shied away from the fringe in any controversy. For the purpose of my argument, the "fringe" category includes opinions not backed by what most

people would consider more than anecdotal evidence. Kirkwood was well within the area of acting as a "responsible reporter" with his efforts to dog Garrison and his staff. It is therefore interesting to compare Garrison's and Kirkwood's versions of the Clay Shaw trial as published in their respective tomes; while Kirkwood deals almost exclusively with the trial, Garrison concentrates more on the events that led to it, spending only one chapter on this subject. Since I am unqualified and unwilling to open the *JFK* can of worms, it is best to stick to the trial proper as my premise deals with perception, not "facts". As David Byrne said, "Facts don't come with points of view/ Facts don't do what I want them to."

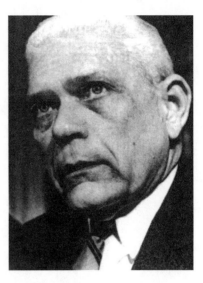

Shaw from American Grotesque

Perception is all-important in the forum of a jury trial. In fact, it is much of the definition of "verdict". It is an attorney's job to influence the opinions and perception of a jury or judge. Unfortunately for Garrison and his team, this perception did not result in a guilty verdict. Whether or not this was due to tampering with evidence, incompetence, or perjury will not concern me here. What is interesting and educational to observe is the accounts of witness testimony and arguments in light of each author's motivations. Garrison put his reputation on the line in furtherance of his opinion that a conspiracy was involved in the assassination. Kirkwood argues (and I tend to agree on at least this point) is that even if there were more than "one lone nut" involved, the evidence for Clay Shaw's involvement in it was difficult to convince a jury, and efforts to this end were better spent in other areas. Garrison did his best with what he had though, and succeeded in bringing many important issues surrounding the assassination into a public forum.

Without stooping to an exhaustive examination of minutiae, Garrison's and Kirkwood's observations and opinions of the trial witnesses sound at times like descriptions of completely different people. The first notable time the Discrepancy Monster (Can you tell me how to get to Ontology Street?) rears its ugly head is at the appearance of the star witness for the prosecution, Perry Russo. Apart from the fact that Garrison didn't attend the trial during Russo's testimony or cross-examination, (indeed, he only appeared in court 3 or 4 times during the month-long trial) and to the extent that we can trust his second-hand impressions of this witness on the stand, the differences with Kirkwood's characterization are telling. While the District Attorney crowns him as , "A tough minded young man with a high degree of curiosity", Kirkwood devotes an entire two chapters to Russo's testimony, one entitled "The Loneliness Of The Long Distance Talker." Continually referring to his tendency to over-answer a question when a simple yes or no would do, and at times even offering testimony damaging to the prosecution, Russo is characterized as a sometime embarrassment to Garrison (at least among the press corps). Kirkwood's on-the-spot account describes Mr. Russo's speeches as a "shuffle-hop hedge-step", and relates his admission of "a flat error on my part" when asked about sighting Shaw and suspected co-conspirator David Ferrie together. This "error" was supposed to place the two together before the assassination or even the alleged "party" where Ferrie outlined an assassination plot (1962), but Russo later corrected his faulty recall and admitted that his sighting of the two together at a gas station occurred after November, 1963. Garrison

makes no reference to these discrepancies, possibly due to the fact that he wasn't there when Russo made these remarks. This fact doesn't stop him from commenting on the proceedings, however. The general conclusion on this issue is that the D.A. depicts Russo as absolutely sure of his statements, while the reporter endlessly brings up his uncertainty. The jury was there and Kirkwood was there, so it's not surprising that they came to the same conclusions.

Charles Speisel, a witness for the prosecution, is quickly disposed of by Garrison as a government "plant" sent to destroy his case. Since we are dealing in perceptions, one wonders why the prosecution team didn't check him out more thoroughly before he got on the stand with statements regarding "50 or 60 people" who had tried to hypnotize him and detectives who had "followed him down" from New York. Kirkwood documents the incredulous reactions to these paranoid remarks, which left both sides shaking their heads and/or laughing. Garrison said he was swept by a "feeling of nausea" when he heard Speisel's spouting, but Kirkwood's account is conspicuous for it's absence of any reaction from the D.A. (or even mention of his presence), so we are faced again with two versions of "reality".

When characterizing the defendant, the authors' language again filters the proceedings. After two years of investigation, Shaw was finally brought to face his accusers. On the first day of testimony, Garrison:

> ...glanced over at the defendant and his staff of attorneys. Shaw was as imperious as ever, his cigarette tilted upward as he always held it, smoke spiralling toward the ceiling. His nobility of manner, every gesture courtly, made me think that this must have been the way that Louis XVI had been at his trial. He seemed detached, even slightly bored, by the mundane proceedings around him.

Kirkwood defends the defendant in a few sentences: "(Shaw would) react virtually the same to any moment of identification. Head up, he would look his identifier in the eye-not with belligerence or even disbelief-simply look at him." In these short passages, the focus of the problem is revealed. Having seen the film *JFK*, (since most of us could not have been there) we are struck by Tommy Lee Jones' literal portrayal based on Garrison's descriptions, but these mannerisms could just as easily be interpreted as a man with nothing to hide (or even with a sure sense of the verdict). Keeping in mind Kirkwood's view of the proceedings, I would tend more towards Garrison's depiction.

It offended me that Oliver Stone used the inference of Shaw's alleged homosexuality to color the audience perception, i.e.gay=shady and dishonest, and portrayed him as a drug-huffing weirdo parading around in gold body paint with young boys. In any case, what would that have to do with the charges against him (besides Ferrie's reported penchant for young men)? This suggestion however, was confirmed by a man whom I met last month who told me that he grew up In New Orleans, and worked in the mail room of the International Trade Mart (the building and company owned by Shaw) in the mid- to late 1960s. According to his account, it was common knowledge that Shaw was gay, and was often seen in the French Quarter in "way too tight pants". In spite of the unappetizing image this calls up, it makes me wonder why noone was called to testify to this fact. Perhaps it was seen as "hitting below the belt" tactics to bring Shaw's proclivities into a public forum. If this was the case, perhaps we should be thankful.

"They Told Me To Say This!" An Interview with Ufologist Bill Moore

Greg Bishop

Bill Moore in his fabulously appointed office

I have known Bill Moore since 1988. In that time I have seen him go from prominence as the "discoverer" (along with Jamie Shandera) of the MJ12 documents to emerging as an even more controversial figure in the UFO community. This was the result of a speech he made at the MUFON (Mutual UFO Network) convention in Las Vegas in 1989 wherein he intimated that most of what all the other researchers had been told by their government intelligence contacts was pure fabrication.

The publisher of a well-known magazine left the room in tears, and I saw Bill English (one of the "aliens-are-eating-us-while-they-take-over-the-world" UFO personalities) run past me hollering "I'm going to get a fire hose!" The conference host came to the podium more than a few times to call for order. This initiation into the primate pecking-order of Ufology convinced me beyond a doubt that many members of MUFON were just like anyone else with a mouth full of words and an empty mind—push the right buttons and they explode. What was it that caused so much emotion? I finally cornered Bill at his office to find out the details of what "made him do it" and who really pulls the levers.

At no time during the interview or since I have known him has he ever been rude, evasive, or secretive (at least in the "I know something you don't" mold.) Only the most paranoid (or gullible?) person would suspect much ulterior motive in his coversation. To me he has always been intelligent and compassionate. In fact, while we walked to a restaurant for lunch, he told me the stories of two homeless people we met. Apparently he looks out for them in the rough neighborhood around his office, and has a genuine interest in their welfare. I was told one man whom we met was the bodyguard for the American Indian leader who was imprisoned in the aftermath of the Wounded Knee fiasco of the early 1970s. I asked how Moore knew this. "He and I knew some of the same people before we met" he said, I suppose referring to intelligence agents in the government. "There's a story there when he's ever ready to tell it." Leaving this bit of intrigue for the moment, we sat down to talk spy stuff over spicy Thai food...

> **I had a choice: either you play, or you don't play. If you do, you play by their rules. If you don't play, then they get somebody else who will. It's that simple.**

Q: This has been gone over many times, but what is it that pissed off so many people in Las Vegas at MUFON 1989?

MOORE: I think that they were outraged that someone would get up there and tell them that they'd been had.

Q You don't think that could have happened to you?

MOORE: Sure it could have. And maybe it has. That was exactly the point. If they [government agencies] could manipulate a situation like the Bennewitz affair the way they did, and plant information which was at that point the hottest thing in the UFO grapevine, which a lot of people were really interested in and remain interested in to this day...

Q: Bennewitz was the one who thought he was receiving highly secret transmissions from an air force base in New Mexico, and was scared by what he heard or thought he heard?

MOORE: Yes. That was it. The whole story of Government/alien involvement, treaties with aliens, underground bases, a plot to take over the planet, implants, two different races of aliens, one hostile and one friendly, etc. was all cooked up by the counter-intelligence people for the purpose of discrediting Bennewitz. He bought it, and a lot of other people in the UFO community bought it, and they continue to buy it today. Dulce, New Mexico is still a catch word. All of that stuff was cooked up as part of the operation against Bennewitz. Bennewitz was meeting with everybody who was anybody and telling that story to anyone who would listen. John Lear, and ultimately through him to Bill Cooper, Bill English, Wendelle Stevens...they all revolved around that information. It was the kind of paranoia that they wanted to hear. And so here's John Lear, organizer and host of the conference in Vegas, one of the chief proponents of that kind of information, staking his so-called reputation on the fact that it was all true. Linda Howe has gotten in over her head over it, all those people prepared to tell their stories, and become important forces for good in the UFO research community. Then I get up and tell them, "Folks, you've been had. And here's how I know. It isn't that I've heard it, I was part of it. I was there. I watched it happen. I knew who was doing it, and I was privy to it."

Q: Were you inferring by that statement that they could have found out the same thing if they did as you did?

MOORE: No, they couldn't have. That was the point.

Q: Why not?

MOORE: Because they weren't a part of it.

Q: That's why they were angry.

MOORE: It was because I had allowed them to be hooked before I got up and said , "Hey folks, you've been had." I could have kept them informed all along.

Q: That would have tainted any information that you were getting, though.

MOORE: Well, of course. It would have destroyed my ability to get anything. I couldn't tell anybody. I was just as upset at what happened to Bennewitz as they were. But they

> **All of that stuff was cooked up as part of the operation against Bennewitz. Bennewitz was meeting with everybody who was anybody and telling that story to anyone who would listen.**

couldn't begin to understand why. According to them, I (Moore) did it to him. I didn't do it. I was only fortunate enough to be in a position where I could see it.

Q: So are these (government) contacts who you made then still talking to you?
MOORE: Some of them are.

Q: Why only "some"?
MOORE: I don't know. I still have a very solid network of contacts within the (government intelligence) community. I still have a strong flow of information and the ability to verify things, and I still feel that there is a lot more to this whole picture than anybody else has even begun to look at. I still see disinformation going around in the UFO circles that originates with these people. Not with my people, but within the counter-intelligence community, and the UFO people still fall for it. In other words, nothing has changed.

Q: Why is it made up in the first place?
MOORE: That is the question, isn't it? I know why they did it in Bennewitz' case-to discredit him. Why did they feel they had to do that? Because he was on to something that they didn't want him to be on to. I never knew what that something was. I just know that he was detecting radio signals, picking up on things that were going on from within the confines of the Sandia-Manzano-Kirtland (AFB and research) complex, and he had categorically refused to cooperate with the government in maintaining security on whatever it was. He told people he was on to the truth, that it was something really important.

Q: And he didn't realize the consequences.
MOORE: They called him in and had a big high-level meeting with him. They asked him to cooperate and told him he was on to some national security items and that it was extremely important that he protect the national security by cooperating with them and maintaining his silence. It was like waving a red flag in front of a bull. Instead of cooperating, he told them to all go to hell and proceeded to try to tell everybody. He was writing letters to the president, the Congress, Senators, newspeople, everybody imaginable who came along and even banged on his door, he told them.

Q: To the effect of what?
MOORE: That there were aliens coming and that there was some kind of project going on at Kirtland...
Q: When was this?
MOORE: Early 80s. 1979 to '81.

Q: How did you happen to get in touch with him?
MOORE: I was on the APRO (Aerial Phenomena Research Organization) board. Bennewitz communicated everything that was going on to APRO by means of long communiques and reports. He called it project Beta. Today, there's a story going around that was a government project and that was what he was on to. That's not

true. Project Beta was his own project, that's the name that he gave it. He was sending all this stuff to APRO and I was reading it and wondering "who was this guy, and what's going on here?" And then I was approached obstensibly for the purpose of getting involved in a project to systematically release some information to the public.

Q: Weren't you suspicious of this?
MOORE: Of course. I still am. I had a choice: either you play, or you don't play. If you do, you play by their rules. If you don't play, then they get somebody else who will. It's that simple. Linda Howe was one of the people that they had considered, among others, for the role I played. She didn't work out for some reason, and they dumped a load of disinformation in her lap and pissed her off. To this day she refuses to believe that. To this day she thinks she was privy to some interesting stuff. I think that they thought whatever she was told she would immediately run her mouth to anyone, and that she couldn't be trusted.

Q: So what have you been doing about all of this in the last couple of years? I haven't heard anything from your office in awhile.
MOORE: I've been very busy. Aside from a lot of personal problems that I've had, I was continuing the work I was doing before. It's basically just a quiet effort to see what I can learn. One thing that I find the most outrageous...actually there are two things. One is that most of the people who are into UFO research are their own worst enemies. They sabotage their own efforts before they even get under way through ignorance in how to proceed. Through a preconceived position of "well this is what I'm going to find, so if I find anything that doesn't fit, I'll ignore it." and by broadcasting far and wide exactly what they're doing, and by their blind belief that in what the Freedom Of Information Act is going to get them. What happens is when you tell somebody what you know, it immediately shows up on the (UFO rumor) grapevine. If you've told your friends, you've told everybody. If there's anything to it, people who are custodians of the information can detect where it came from immediately, and will rush to protect it.

Q: Why tell anyone?
MOORE: Well I don't anymore.
Q: No, I mean why tell (from the government agent's point of view) a UFO researcher?
MOORE: Ego.

Q: As "leaks" it makes them feel important?
MOORE: To some extent.

Q: They've told you this, or you're guessing?
MOORE: I'm guessing. I think there's an organized plan to let some of this stuff out too. I just think honestly a lot of them don't know what to do with it.

Q: Well, if they have access to the information, obviously they are supposed to be doing something with it.
MOORE: The other thing that bothers me is that the greater portion of the UFO community exists to feed off itself. In other words, they don't want to

> **I still have a very solid network of contacts within the (government intelligence) community. I still have a strong flow of information and the ability to verify things, and I still feel that there is a lot more to this whole picture than anybody else has even begun to look at.**

find an answer-they want to find more questions.

Q: If they "figured out" what "it" was, then they'd have to find something else to do.

MOORE: Yes. I think that the next thing we are going to see in relatively short order is an open feud between MUFON and CUFOS [Center For UFO Studies -founded by J. Allen Hynek.]

Q: Why do you say this?

MOORE: I think CUFOS is just waiting for Walt Andrus (director of MUFON) to lose control. And then they're going to move to be the number one organization. I think that's been their motive all along, and I think that's why they usurped the Roswell investigation-not because they're interested in getting to the bottom of it, but that it's a vehicle by which they can push their organization into a position of prominence.

Q: Were they supporting Schmitt and Randle? (Two UFO researchers who recently completed another book about the Roswell UFO crash-Bill Moore published his in 1981).

MOORE: Yeah. Consider: Before they espoused Roswell, where were they? Hynek had died, and had put their organization into disrepute because of his association with a couple of contactees in Phoenix of questionable reputation. Their magazine was ready to fold. They had to do something to keep going. I think what they decided to do was make themselves the center of attention by working on what they regarded as the hottest case of the week. And my getting up and saying what I did in Vegas proved useful to them because it provided them with a way to trash me.

Q: Did you receive letters from them or see evidence in the UFO media that they were trying to refute your claims, or what?

MOORE: They certainly didn't spare any effort to attack me when they had a chance. They knew what was going on. They knew what I was going to say.

Q: How did they know?

MOORE: Because I had been in touch with Don Schmitt, who had lied to me. He had come to me on the pretext of them cooperating with me. They were not interested in publishing anything of their own, they were only interested in helping with my investigation.

Q: This was after your Las Vegas speech?

MOORE: Before. Their whole espousal of the Roswell case amounts to nothing more than an effort to save their own asses. I think they knew exactly what it was they were going to find before they started. They had already decided what story they were going to tell. Whatever fit was fine, whatever didn't they would change.

Q: I'm at a loss here, because I didn't read their book.

MOORE: You didn't miss a lot.

Q: What was it, a rehash of your book?

MOORE: Basically a rehash, with some of their own stuff thrown in. They never

And then I was approached obstensibly for the purpose of getting involved in a project to systematically release some information to the public.

gave me credit for anything that I had done. To hear them tell it, they had done everything and I had done nothing-there was no prior investigation before them. Don Schmitt gave his MUFON paper in 1990, I think. The whole paper, an entire thing on Roswell, and didn't once mention me. No one mentioned that there was a prior investigation, never once mentioned that anything had come out before their own work. To read that paper, and know nothing about it, one would assume that they had uncovered the whole thing and done all the work.

Q: Did Stan (Friedman) help them out? He did another thing with someone else, right?
MOORE: Yeah. For a while they wooed Stan in, then they kicked him out. And he went on to do his own book which has now been thoroughly discredited by the very same people who went after me. I think the whole Vegas deal came down to one thing. That is that a lot of people who had their own egos on the line were horrified that somebody might be on to something that they didn't know about, and they couldn't deal with it, so I had to be the bad guy.

Q: That was certainly the impression when I was sitting there. (At the MUFON convention).
MOORE: I've been roundly accused, and continue to be accused of being one of the principal "disinformers" in the country. According to some people, I orchestrated the whole project against Bennewitz. I'm the spreader of disinformation. Not one of them has pointed to anything that I've spread that was supposed to be disinformation. Not one of them.

Q: Not to change the subject too quickly, but about a year ago I had talked to you and you said you had discovered what you thought was the answer to the men in black enigma, and you had published it in your magazine. Would you elaborate?
MOORE: It hasn't been published yet. The truth is that I haven't yet had the time to sit down and write the whole thing up the way I feel it needs to be done. I have talked about it publicly.

Q: I hope I'm not scooping your efforts by asking you to explain now.
MOORE: No, it's OK. It basically stems from a covert group within the military community who are very good at playing games. And one of the games that they devised was this men in black thing in order to obtain information and leave behind a legacy of mystery which would be good cover for them. There is a group, I've worked with some of them.

Q: So all the strangeness associated with them is a result of confusion and fear generated by the encounter?
MOORE: Or by people who have written about these occurrences and have added to the mystery because they want a mystery. There really are men in black-or were. They perpetuate the image deliberately as a cover. They are part of a special unit out of the counterintelligence community which employs a whole array of strange people-from safecrackers to con artists, to fast talkers...

Q: With the understanding that they will stay out of trouble if they cooperate.
MOORE: Yes. They recruit a lot of these people from the prisons and make

> The other thing that bothers me is that the greater portion of the UFO community exists to feed off itself. In other words, they don't want to find an answer-they want to find more questions.

deals with them that if they will serve so many years, they'll be given a clean bill of health and a new identity. And somewhere way back when, they cooked up this men in black thing as a device for enabling them to get information out of people, particularly physical evidence without having to give them a government receipt for it. They were involved with Bennewitz. I knew it. I knew a couple of them, and as far as I know the group, although it's changed its name, it is still very much alive. It's not the only thing they do of course, and they operate all over the world.

Q: *It seems a rather expensive joke just to get some information out of people.*
MOORE: How?

Q: *In the sense of creating a mythology and keeping with it, and keeping up the rigmarole and theatrics, as you describe it.*
MOORE: First of all, don't make the assumption that getting UFO information was all they did. That was a very small part of their activities. Very insignificant. Most of their efforts were directed in other areas.

Q: *So you're saying the paranormal activities associated with them that have been written about have all been the result of fanciful writers?*
MOORE: As far as I know. It's a mythology that has grown up.
Q: *I thought there were precedents for this kind of thing long before the present.*
MOORE: Well, there were-back to the '50s anyway.

Q: *No, I mean like the Alchemists who "got too near the truth" and were supposedly harassed by them.*
MOORE: Oh yeah.

Q: *Is that something that these people are aware of and capitalize on?*
MOORE: What do you mean?

Q: *It's a phenomenon that people have had experiences with for many centuries in some form or another, and perhaps this group have tapped into the collective fear that we have of that kind of image, and capitalize on it. Is that one of the motivations for behaving like they do?*
MOORE: What they do is plan and base it on things that have worked in the past. If you are a professional cat burglar, with 30 years of experience, and the government says, "We need cat burglars. We have a use for such people-safe crackers, con artists, what have you. We'll make a deal with you. You come work for us, and we'll get you out of the slammer. You're our slave for seven years. You do your job well, and when the time is up, we'll give you a new identity and a certain amount of money, and goodbye. If you fuck up, you go back to jail and the records show you were transferred briefly from one prison to another, it didn't work out, and you were sent back. You want to come work for us, or stay in jail? Take your pick." What do you do?
Q: *You know what my choice would be. Fun and adventure.*
MOORE: Sure. "So all right. You come work for us. There's these people in Michigan. They've got some film we're interested in. Go get it. You're not to leave

any indication that it was the government that got it. You're not to leave any traces as to who you are. If they won't give it to you outright, find some other way to get it, but get it." What do you do? You sit and plan with other people how you're going to do this. What they came up with was this whole men in black thing.

Q: *What about people who are visited before they even tell anyone about it?*
MOORE: Perhaps somebody knew what they had done, even though they hadn't told anyone. It may be that the image they got wasn't a UFO at all, but an experimental craft of some kind. Somebody saw them land. Who knows how the information ultimately gets to its destination? Once they have it, they decide, "What's the best response?" They tried to use me one time to get footage out of somebody who had it and wouldn't give it up. I couldn't do it. They wouldn't give it to me either (as a UFO investigator.) They ultimately got that film. I don't know how they got it, but I know they did. The assumption on the part of a lot of people is that, "If Bill Moore was knowingly involved in that kind of activity, automatically Bill Moore has to be the bad guy." I wouldn't do things like that. My point is if I hadn't cooperated, if I hadn't gotten to know how these things work, nobody would know about it to this day. You don't learn how to swim unless you get into the water. You can read all the books you want, you can listen to all the people you want, but until you get into the water, you don't learn how. It's the same way in projects like these. Until you get involved with them, you don't know what happens. When you do get involved, there are rules. And they're not your rules. You either play by them, or they very quickly find somebody else who will. Then they dump your ass out with a load of shit, and if you go public with the load of shit, you look like an idiot. This is what Linda Howe did.

Q: *Are there little people with glasses on typing out these stories to be given to dupes?*
MOORE: I don't know. There are 30 or 50 people that work out of that office.

Q: *"That" office?*
MOORE: The one that was orchestrating the Bennewitz affair. They had about that many people working in it who did nothing but cook up wild-eyed schemes to accomplish what they needed to. In other words, a think tank.

Q: *There are a set of circumstances, and "what do we need to tell this guy to jibe with the facts as he sees them, as well as leading him off the track."?*
MOORE: Yes. They do a complete psychological profile. They know exactly what they're dealing with, they know exactly what to feed him that he will believe, and they know exactly how to do it, and they do it.

Q: *You do realize that they could and might very well be doing this to you.*
MOORE: Sure. I've always known that.

Q: *But is it interesting and entertaining enough to continue to play?*
MOORE: First of all, there is something to the subject that is so important that they're devoting all this time and effort to it. They wouldn't devote it to stories about Hitler being alive in Antarctica. It says there's something there: What?

> I think the whole Vegas deal came down to one thing. That is that a lot of people who had their own egos on the line were horrified that somebody might be on to something that they didn't know about, and they couldn't deal with it, so I had to be the bad guy.

Q: That's what I was about to ask.
MOORE: I don't know. Whatever the secret is, it's such a high magnitude of importance and would have such an impact on the mundane day-to-day circumstances of our society that anyone who gets close enough to see what it is says, "Oh my God. We can never tell anyone this. Because if we do, it will bring down the whole fabric of our society." That to me automatically suggests certain things.

Q: Such as...?
MOORE: Most of them either seem to have economic or religious implications.

Q: And the only conclusion you draw from that is extraterrestrial contact of some sort?
MOORE: No. Either there are aliens and they are coming here-there is a limited interaction with this race, and whatever lies behind that is of such earth-shattering proportions that if the truth came out about it it would shatter Christianity to its very foundations-maybe. Or somebody (plural) in a very highly placed position with a lot of assets at their disposal is desperately manipulating events to try and make it appear that way. I tend to favor the former more than the latter.

Q: Why?
MOORE: It fits more with the parameters involved. The latter one, first of all to support that, you have to go back a long way. You have to assume a concerted effort on the part of someone that goes back to at least WWII. And you have to assume that they've never made a mistake. They've had to orchestrate all these events somehow without being exposed in the process. And why I rule that out, human nature being what it is, is that if it were human-inspired they would have made enough mistakes by now or had enough of an ego or frustration that something would have come out about it. Something more than speculation. There's too much in this that is seemingly beyond the capability of ordinary humans. Especially if you assume those capabilities in the late 1940s.

Q: Such as what in the late 1940s?
MOORE: The quality of UFO sightings and especially close encounter cases back then. Today a sophisticated group might be able to stage something like that. They might be able to stage a Bentwaters (UFO landing at a military base in England) or a Cash-Landrum affair (two women in Texas injured in a close encounter) or even a Gulf Breeze. I don't see how they could have done that in the 1940s or '50s or '60s. We have a lot of cases from that time which are just rock solid. So I tend to say that it is more reasonable to assume that is is more out of our hands more than in our hands. Part of the reason for the secrecy is that you can't tell the world that this is out of your hands and you have no control over it. There's a school of thought which says that if you can unite the planet against a threat from outer space, then you're one step closer to ruling the world-the "One World Government." And that works only if you put it in a limited context.

Q: How limited?
MOORE: In time. If you run that kind of an operation for 40 years, it gets old real fast. Somebody's going to tell about it-make a mistake. It's the same with the

CIA and its black helicopters. Yes, there are cattle mutilations. Yes, there are black helicopters. However, if you assume that it is the CIA doing these cattle mutilations, what are the odds that some irate rancher is going to shoot down one of these helicopters and embarrass the whole thing? No matter how you plan, there is no way to guard against all possibilities. They would be risking an awful lot. If you are a project officer, are you going to risk that? This suggests to me that there is something going on beyond that. They might try it once or twice, but they're not going to try that kind of shit over 30 years-it's too dangerous.

Q: How does the crop circle phenomenon fit in with all this?
MOORE: I don't know. I don't know what to make of crop circles. I've never seen any. I have a completely open book on that subject. The one side of that says that it is created by a group of people who are out to create clever hoaxes. The other side says there is something very mystical about it all. And in the middle is me. I don't know. I can't imagine why the intelligence community would perpetuate something like that, but then I can't imagine why they would perpetuate a lot of things.

Q: I've heard Jacques Vallee theorize that the only thing that can bend the crops as they are are microwaves and the heat involved.
MOORE: How does he know that?

Q: With known human technology. Well, but why wouldn't they just practice in a field on a military base? It seems a lot of trouble for something that they would like to keep secret.
MOORE: Or they could keep a herd of cattle! I agree.

Q: Where do UFO encounters and sightings and abductions fit in with all you have been telling me so far?
MOORE: The bottom line is, there is something going on. There are aspects of it that are beyond the pale. Until we know more about it, I don't think it's safe to speculate. The minute people start speculating, and others quote them, they're locked into defending that position at all costs. I don't like to be in that position. I think in the case of the Roswell crash, the explanation that best fits the evidence is that it was something extraterrestrial. But that's predicated on the evidence at hand-here and now. Something could turn up tomorrow to completely change that position, and if it did I'd be the first one to say so. It's not the only explanation, but it's the one that best fits with the information that's been uncovered so far. The extraterrestrial one fits all the criteria. It doesn't leave any objections.

Q: In that case.
MOORE: Yes. But then, since we don't have all the pieces of the puzzle, maybe the ones that are missing would change the whole picture.

> **When you do get involved, there are rules. And they're not your rules. You either play by them, or they very quickly find somebody else who will. Then they dump your ass out with a load of shit, and if you go public with the load of shit, you look like an idiot.**

Indian Mounds and Forteana

Book Review: Jim Brandon's
The Rebirth of Pan: Hidden Faces of the American Earth Spirit

Reviewed by Paul Rydeen

Jim Brandon's original claim to fame was Weird America, the first in a blossoming genre of travel guides to off-beat attractions like dinosaur-shaped truckstops, UFO landing pads, and weinermobile museums. This, his second volume, takes it title from the Greek legend; the great god Pan is not dead, only sleeping. He takes his rest in pastoral Arcadia where the sacred river runs underground, awaiting the day when the stars are right and he will be free to roam the Earth once more. Brandon thinks this may already have occurred.

Brandon's career began as an amateur filmmaker. His lifelong fascination with forteana inspired him to make a documentary about hunting for Bigfoot; not an enviable task by any means. After a few chilly nights in the Pennsylvania woods, he realized what a formidable project and elusive subject he had chosen. The film remains unfinished.

A long-standing interest of Brandon's is Indian mounds. As a boy Brandon was fascinated by the things; he often played in a field near his home containing dozens of the enigmatic structures. When he grew older he learned of the many claims of anomalies associated with the mounds, and began serious research. To his surprise, these two parallel areas of study - Indian mounds and forteana - soon crossed paths and became irrevocably linked.

Much of the first few chapters describe in fascinating detail the many elusive mysteries found in North America. Indian mounds, earthen effigies, forged artifacts, and curious scripts all play their part. Taken separately they were easily denounced as fakes or the work of some more advanced proto-Indians - despite the fact that the natives who greeted the Spanish conquistadores and early settlers had no tradition about them at all. They were as much a mystery to them as to us, though admittedly their history may have been lost. We have

288 pp illustrated w/ foreword, index, bibliography, notes. Firebird Press – P.O. Box 69, Dunlap, IL 61525 (Out of print - try Bibliofind.com or Alibris.com to request a search)

written history going back thousands of years; look how little we really know of the past. Without the benefit of writing, twenty millennia of American Indian history seem to have disappeared; this is understandable and highly regrettable.

Brandon makes a good case for the presence of Pre-Columbian Caucasians on the continent. Besides the well-publicized tales of Viking exploration, we also have tablets inscribed with Latin, Hebrew, Ogham, Cuneiform, Greek, Egyptian hieroglyphics and demotic. The messages are rife with error, though; modified script, missing words, poor grammar and extraneous material make translation difficult at best. While subject matter experts like local university professors have been quick to denounce these findings as amateur dabbling, Brandon shows that genuine rock carvings in Europe contain the same errors. Many of the runestones still surviving in Scandinavian countries are entirely unreadable for this reason. I find it increasingly hard to believe that they didn't stumble onto this country long before Columbus, and if a band of runaway Jews did land with a few survivors, who could say what their half-indian great-grandchildren would remember of the Hebrew alphabet? Occam said that the simplest solution is usually the best, and the difficulty required to hoax some of these finds, or indeed all of them serves to limit the chances of none being authentic. Maybe the Mormons were right after all; ascribing these hoaxes to renegade Latter-Day Saints seems rather extremist in my opinion.

Brandon uncovers some interesting lore in the course of his research, including Indian tales of a long-lost white race who slept by day and worked by night. They were noted for their "moon-eyes" and may have been albinos. Other stories of giants and dwarfs were also recorded. Brandon doesn't come right out and say they were connected with the mounds, but he does lean toward their origin as being terrestrial despite the tales of beings from Sirius having visited. Like UFO contactees they usually relate reports of warfare with other with other aliens, often from a star in Orion, but I find it more plausible that mythologizers draw from a common pool of archetypes rather than sharing visits with the same forgotten spacemen.

Brandon skirts the whole issue rather well, attributing fortean activities to a natural force he identifies with the mischievous Pan. He proposes a geologic origin for the mounds, even complicated shapes like Ohio's famed Serpent mound, as well as such phenomena as Death Valley's moving rocks, ley lines and non-native soil deposits. Drawing on the theories of Wilhelm Reich, Brandon proposes these areas to be the location of natural energy fields propitious to anomalous events. He goes on to say that study of Alchemical symbolism (i.e. the mystical conjunction of opposites) and the magica sexualis of Aleister Crowley (as loosely proclaimed Outer Head of the OTO in England, Kenneth Grant) leads him to believe that these forces may also be attracted when sexual energy is generated. This, he explains, is the reason for the frequency of sightings at "lover's lane" locations; Bigfoot encounters with menstruating women, and saucer occupants' preoccupation with gynecology. This energy - call it orgone if you prefer - is present in water and certain stones. The astronomical alignments of pre-Columbian monuments are a natural outgrowth of this energy manifesting itself on the surface, not some sort of ancient astronaut landing site. While perhaps not literally true, I believe this may be symbolically so; consider the human tendency

to find patterns in the most random material and you'll realize how this could be. Some internal "force" may draw us to certain anthropocentric conclusions whenever confronted with seemingly meaningless data patterns.

I'd like to propose a theory of my own. Since the earthen structures are best viewed aerially, perhaps they were used by the later Indians - no matter who their builders were - for astral viewing. This would eliminate the need for flying saucers or vimana-style aircraft while still retaining an element of mystery and the fantastic. Maybe an initiate would be tested by the local shaman; a decent description of the monument from the air would indicate success.

Another frequent setting of anomalous events is trailer parks. Many readers may have noticed the marked frequency with which mobile homes are demolished by tornadoes; Brandon provides data to show their inhabitants are frequently visited by Bigfoot and his kin as well. He postulates the homes are a sort of orgone accumulator, but here too I would like to impose an alternate theory. I agree with Brandon's assertion that some sort of geographical effects may be at work, but I feel it is a geography not sacred, but profane. Most large cities - and many smaller ones - are built on rivers, hence on low ground. Trailers parks are typically built on the outskirts of town, where property is less expensive. Unfortunately for the owners, the land in these areas is also higher in elevation because of the distance from the river. It is a valid meteorological observation that geography influences local weather conditions; tornadoes are more likely to touch down on high land than the river valleys. If mobile homes are typically built at higher elevations, they will be hit more frequently. Their flimsy construction ensures more destruction than if it had been a wood-frame house. As for the multiplicity of Bigfoot sightings, perhaps the residents of trailer parks live on the outskirts of human perception as well.

Chapters 5 and 6 take a rather odd turn, as Brandon diverges to make a brief study of numerological connections. After discussing a few obscure American Masons of the 19th century, he concludes that certain names and/or numbers may indeed have "magic" power of some sort. Apparently his source for this is Robert Anton Wilson's books, for he proposes that the number 23 found to be so fateful by William S. Burroughs does indeed show up more than coincidentally in regards to forteana. He also reports the significance of the Masonic 33 and various forms of the word fay : fe', fee, fayette, Lafayette, Fayetteville, etc. (This is discussed extensively by fortean researcher Loren Coleman in his book, *Mysterious America* -ed.) While I couldn't begin to discuss how many times the number 23 has reared its ugly head since I first read Burroughs, I do have a hard time understanding what role these numbers could play in nature as quantitative values. For instance, when studying astrology one finds that 29 is sacred to Saturn. This is easily explained by the fact that the planet named for the god takes as many years to orbit the sun. Yet when Brandon finds significance in Alexander the Great's death on June 13, 323 B.C., I can't help but wonder if he realizes that the Gregorian calendar wasn't used in America until two millenia later; the old Roman calendar began in the eighth century, B.C. If an angle measures 23 degrees, such as the approximate tilt of the Earth's axis, one may take comfort in the fact that the angular measurement of degrees has a physical basis. The solar year was originally thought to contain 360 days, giving rise to the 360 degrees in a circle. The year was later amended to the more accurate 365, but the

number of divisions in the circle remained at 360, perhaps for the easy mathematical division this symmetry allowed. A 23rd part of 360 is only a fraction of a degree more than a 23rd of 365, so perhaps this could indicate some sort of terran/solar fluctuation. But to say that the distance between two megaliths is 23 feet is arbitrary and meaningless, unless mental concepts are the trigger – an idea too metaphysical for proof. Perhaps the initial notion of 23's importance makes all further occurrences stand out that much more; it's a self-fulfilling prophecy.

This is where it really gets weird (as if it hasn't already). Brandon's concluding chapter puts forth several wild theories to tie this all together. He believes the mounds were formed by natural forces; these forces are still present in the structures, and have something to do with spatial-temporal anomalies. Brandon claims changes have been noted within them, as if still growing. It is through these structures that mother Earth vis a vis the Gaia hypothesis manifests Pan. The moon-eyes knew this and used these sites for alchemical operations long before the Indians showed up; Brandon feels these moon-eyes may be the Lost Tribe of Israel as the Mormons believe. Because of their unique properties, the Indian mounds act as gateways to the stars, and it is through them that the good Sirians and the evil Orinians visit us (the dog as psychopomp, and Orion the cattle mutilator). The Choctaw say their ancestors first arrived on Earth at the site of one mound complex, but where they were before that is problematic. However, the nature of the alchemical operations leads Brandon to speculate on their creation from Earth by natural forces or the moon-eyes. The giant skeletons found therein are not fossilized remains, but new life emerging from the pregnant Earth. This pregnancy was brought to term by alchemical operations, but lately we've been inducing miscarriages. The reason the Pan force has manifested itself so viciously of late is entirely due to man's secularization and control of nature under Orinian sway. Nuclear explosions and chemical pollutants have angered Gaia, and the 23/33/fay signature is her way of letting us know where it's coming from. Brandon is quick to qualify this as a possible system of natural checks and balances rather than a literal intelligence, but the message is clear: things are certainly not as they seem, humanity is under the influence of outside forces beyond our comprehension, and we're messing up.

Will the evil Orinians win control? Will Pan be forced to wipe us out? Or will the Sirians restore balance once and for all, and save out hides? Maybe it's all a grand Machiavellian scheme, and the aliens are merely playing good cop/bad cop with us. Stay tuned...

No. 3

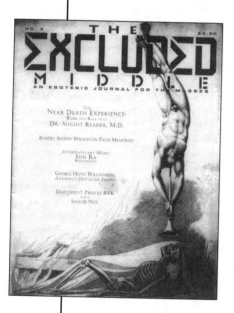

Editorial

Investigating reality is not a piece of cake. If you are scientific enough to really observe of the world, you soon run headlong into conflict. Friends and family hint that you are wasting time. Schools and academies try to convince you that you are being led astray by quack thinking, perhaps because the academy has little or nothing to say regarding the true nature of such observation. Religion either ignores it or appropriates it in a weak attempt to bolster insupportable theology. Knowing our universe has never been an easy thing, at least during recorded history. But in this present century we have the added burden of fashionable cynicism. Real Cynicism which flourished in ancient Greece has nothing to do with the fashionable cynicism of our day. Today's cynicism can be illustrated by the scornful remark, "Oooh, cosmic," which someone will inevitably make whenever another one is attempting to come to terms with the ground of being. This official cool stance, which translates into all fields of human endeavor equally, is a puerile attempt to do away with serious questions. It is that thin veneer which, if cracked through, would force us to redefine matters of life, death, money, religion, and society.

The latest news is that we will have to redefine all these things anyway, possibly through natural disaster, possibly through the standard human-caused deals like over population, chemical farming, and air pollution.

The same philosophers and scientists who began to jump onto the "no meaning" bandwagon were all running from the "horrible" truth: There are many meanings ! There is no single right answer to the question, "What is truth?" This lack of solidity apparently threatens some folks more than absolute nothing; some are apparently reassured by the assumption that life is just a bad joke. I suggest that the joke is not a pointless one. The joke has as many punchlines as the sky has stars. Each punchline is one more truth about the universe.

So join us in searching to find the *Excluded Middle.* We continue to exclude it at our peril.

Our collective knowledge of death is expounded by Dr. Reader in this issue. In light of this. I would like to dedicate *The Excluded Middle* number 3 to the observance of Timothy Maxxwell-Smith's transit through the tunnel on 17 December 1993.

–Peter Stenshoel

United States Senate

WASHINGTON, D.C.

May 9, 1968

Mr. Gray Barker
Publisher, Saucer News
Box 2228
Clarksburg, West Virginia 26301

Dear Readers:

As you may know, I am a card carrying member of
the Amalgamated Flying Saucers Association. Therefore,
like many other people in our country I am interested
in the phenomenon of flying saucers.

It is a fascinating subject that has initiated
both scientific fiction fantasies and serious scientific
research.

I watch with great interest all reports of uniden-
tified flying objects, and I hope that some day we will
know more about this intriguing subject.

Dr. Harlow Shapley, the prominent astronomer,
has stated that there is a probability that there is other
life in the universe.

I favor more research regarding this matter, and
I hope that once and for all we can determine the true facts
about flying saucers. Your magazine can stimulate much
of the investigation and inquiry into this phenomenon
through the publication of news and discussion material.
This can be of great help in paving the way to a know-
ledge of one of the fascinating subjects of our contemp-
orary world.

Sincerely,

Robert F. Kennedy

Purporting to be a letter from RFK to famed UFO researcher Gray "They Knew Too Much About Flying
Saucers" Barker. It has not yet been determined to be a hoax.

The Persistence of False Memory

Robert Anton Wilson

Preposterous Perception has received almost as much publicity lately as the claim by Prof. Jesus Magdalena La Puta (University of Madrid) that, via computer enhancement, he positively identified the "face on Mars" as the late Moe Howard, or possibly Moe's brother, Shemp. Nonetheless, despite some fair-minded academic debate, PP remains the area of science most beset by emotional, and often scandalously acrimonious, controversy-even more so than La Puta's alleged Howard Head. The doctrine of PP holds, you see, that almost all of us see crazy and "unbelievable" things most of the time — almost *all* the time — even when we're not on acid. Why don't we remember this? Because we repress the memory in order to fit into a repressive society.

Many experts — or "pseudo-experts" as their critics call them — vehemently deny that PP exists at all. Other experts — or "pseudo-experts" as the other side prefers to say — claim that denying PP marks one as akin to those who deny the greenhouse effect or the Second Law of Thermodynamics.

In fact, the whole PP feud has opened a "can of worms" that begins to look more like a can of cobras. We face here the almost unthinkable question: who has the objectivity to distinguish Skepticism (in the scientific sense) from Denial (in the neurotic sense)? Or even from Denial (in the legal sense)?

Perhaps the problem began with Whitley Streiber. As professor H.H. Sheissenhosen (University of Heidelberg) has written, " Maybe somewhere out in space, on a galaxy far away, some especially perverted little aliens do exist. Maybe these vicious little buggers (I speak precisely) occasionally get their hands or tentacles on some especially nefarious drug, something combining the worst of PCP and the old 'King Kong' or 'White Lightning' home-brew distilled in the American Ozarks.

Maybe after these aliens have become totally "wasted" or "stoned out of their gourds" (as our students' argot has it) one of them cries "Hey, fellas, let's hop in the flying saucer and buzz over to Earth and have another go at some of that sweet Whitley Strieber ass." And *maybe* they whiz across billions and billions of light years just to ram the poor man's rectum with weird instruments one more time..

> **Almost all of us see crazy and "unbelievable" things most of the time-almost all the time-even when we're not on acid. Why don't we remember this? Because we repress the memory in order to fit into a repressive society.**

Maybe. Nonetheless, some doubts arise in any dispassionate contemplation of this scenario.

Dr. David Jacobs (Temple University, Philadelphia), on the other hand, insists that, after careful study of extraterrestrial sexual abuse, he believes that these people have indeed literally suffered alien rape, an experience so much more traumatic than ordinary rape that most victims block out the memory entirely–until Dr. Jacobs skillfully helps them recall it.

Dr. Richard Boylan, [see interview in chapter 6] meanwhile, continually circulates an exasperated letter warning that Dr. Jacobs lacks training in psychotherapy. Boylan also urges the American Psychological Association to "denounce" Jacobs as "untrained" and "unlicensed." Dr. Jacobs, according to Boylan and other critics of his work, has his doctorate in history and thus has no more qualification to deal with borderline mental states than a Certified Public Accountant would have.

Curiously, when Jacobs appeared on the Joan Rivers T.V. show, whoever writes the subtitles attributed an M.D. to him. Did he acquire an M.D. sometime, in addition to his Ph.D. in history? If so, would that "qualify" him to claim more expertise than a mere historian in judging whether hypnotic visions belong in the category of the real or the hallucinatory?

Don't expect me to answer such questions. Maybe "the Shadow knows," but I'm as uncertain as Hamlet after he got home from studying philosophy at college and encountered what seemed to him a possible appearance of his father's ghost.

Budd Hopkins, a chap who doesn't even bother to claim psychotherapeutic training, supports Dr. Jacobs. But Budd claims to have hypnotically uncovered memories of extraterrestrial sexual molestations not just in 80 people, like Jacobs, but in "hundreds." The experts (or pseudo-experts) on the other side, of course, claim that Hopkins did not exactly unearth these memories, but implanted them.

In the April/May 1993 *Fortean Times*—a magazine devoted to free and open discussion of the most heated, and fetid, disputes in science and/or "pseudo-science"—Dennis Stacy of MUFON notes that "early" (pre-Hopkins) UFO abduction allegations lacked the sexual element that has entered the field since Hopkins started probing the unconscious of hypnotized subjects. But since Hopkins' books got into print, and then got picked up on TV, Stacy indicates, it now seems impossible to find an "abductee" who doesn't claim genital or rectal molestation.

Stacy implies that this evolution in the contents of memory should give us pause, and ambiguously concludes that abduction experiences do not take place "in real space and time."

I do not feel confident that I understand what kind of space and time Stacy thinks the abductions *do* occur in.

Meanwhile, reports continue to multiply. One chap, David Huggins, even sells paintings of the numerous extraterrestrial females he has had sex with. They all posed nude for him. You can find one of Huggins' paintings on the first page of the May 15th issue of Jim Moseley's *Saucer Smear*,. The ladies look a lot like

Playmates of the Month from the neck down, but above the chin, they have that faceless, large-eyed look typical of interplanetary sex maniacs.

Incidentally, the same issue of *Saucer Smear* has an impassioned letter from a female victim of this cosmic invasion, one Christa Tilton, who writes (in part): "I was outraged by Dr. Richard Neal's offer...of a $500 pay-off for absolute proof that women abductees are becoming pregnant and losing their fetuses after an abduction experience that many of them are unaware that they experienced...I would pay $500 to any doctor that could prove to me and all other female victims...that we were *not* abducted and artificially inseminated ..." (Italics in the original letter.)

On the other hand, perhaps the real memory mystery began not with these Alien Abductors, but with the Mc Martin Pre-School Follies in Southern California.

As you may remember, that malign fiesta broke loose in 1983 when a woman in Manhattan Beach alleged that a Satanic child abuse cult had infiltrated that part of Southern California. The same woman later alleged that an AWOL Marine had sodomized her dog. This latter detail, and the fact that the woman received welfare as a paranoid schizophrenic, led the police to doubt her story originally, but meanwhile the Satanic cult rumor had galvanized parents all over the area.

At the height of the excitement, over 100 teachers at nine schools, and the minister at a local Episcopal church, had all suffered accusations of child molestation, Satanism, ritual human- and animal sacrifice, and playing rock records backwards. Small (pre-school) children claimed they could *remember* seeing these things-after consultation with certain psychologists. The police and D.A. could not ignore all that, and eventually placed charges against seven out of the more than a hundred teachers (and one preacher) originally accused by rumor.

Nine schools closed, due to the legal expenses and the loss of funds because parents withdrew children. The Episcopal church also closed.

Eventually, the D.A.'s office decided to release four out of the seven they had originally arrested, citing lack of substantial evidence. Later, charges were dropped against one more. Finally, two out of the hundred alleged "Satanists" stood trial-a mother and her son. (Both came from the Mc Martin Pre-School, and that name got attached to the case thereafter.) The jury refused to convict either of them. The D. A. then brought the son to trial again. The second jury also refused to convict.

The case then more or less died, although in the last two years three of the accused successfully sued some of their accusers for libel and collected over $250,000.

To many, it seems that the most significant fact about this case consists in the "authentication" of the "memories" of the children involved as *real memories*, not hallucinations, by a group of (youngish) psychologists who have somewhat better training than Mr. Hopkins or Dr. Jacobs. Kind of makes you wonder about the "experts" and "pseudo-experts", doesn't it?

Sociologist Jeffrey Victor of Jamestown Community College has written that at least 33 "rumor panics" similar to the Mc Martin case have occurred in 24 states in the last decade. The FBI Behavioral Science Unit (which deals with serial killers) says that it has investigated numerous "mass graves" where victims of

Satanic sacrifice allegedly lie buried, and found no bodies in any of the "graves." Not even a shin bone.

Of course, those who have a really fervent belief in the Satanic cult's real existence in real space-time now believe "the FBI is in on the cover-up." Why not? Those who believe in the UFO sodomites claim that the whole damned government has conspired together in that truly cosmic cover-up.

Memory seems a kind of silly-putty as one reads deeper in this literature. (Incidentally, the L.A. Times reported, on April 23, 1991 that Radical Feminists and Protestant Fundamentalists show greater belief in the alleged Satanic child molestation cult than the majority of citizens.)

All this led to the formation of the False Memory Syndrome Foundation, funded by skeptical psychotherapists-and 3,700 families who had experienced some or all of the trauma of accusation, hatred, public disgrace, and (sometimes) actual arrest and trial when a therapist "helps" a patient "remember" these fiendish doings. Many of these families have passed lie detector tests, won acquittals in court, or later had the accusing "adult child" recant the accusation after consulting with a different therapist with a different orientation.

The FMFS attempts to educate the public about the simple fact that many "memories"-even (or some would say especially) those activated under hypnosis-do not always correspond with real events in real space-time. That is, "memories" can derive from hallucinations, from hypnotic suggestion, or even (as in one famous experiment) from simply hearing about an alleged event from many sources one trusts.

Dr. Jean Piaget, generally considered the world's leading authority on developmental psychology, relates how he "remembered" an alleged (non-violent and non-sexual) event in his childhood all his life-until he learned that he had only *heard* about it from his parents, who *heard* it from a maid, who had invented it to avoid admitting a minor malfeasance.

At this point, Preposterous Perception appeared in the literature, thanks to Professor Timothy F.X. Finnegan of Trinity College, Dublin. I should mention at once that Prof. Finnegan serves as president of CSICON -The Committee for Surrealist Investigation of Claims of the Normal-and has developed, in several books, the system known as Patapsychology (not Parapsychology, although that error seems ubiquitous). Scholars trace Patapsychology to Alfred Jarry's Pataphysics and Jacques Derrida' Deconstructionism, but Prof. Finnegan has always insisted he got his basic inspiration from one Sean Murphy of Dalkey (a suburb on the southern coast of Dublin Bay). Murphy's first fundamental finding (as Finnegan always called it) states succinctly, "I have never met a normal man or woman; I have never experienced an average day."

Nothing else definitive appears on the record about this Sean Murphy of Dalkey, except a remark attributed to one Nora Dolan: "Sure, the only hard work that Murphy fellow ever did was picking himself up off the floor and getting back on the bar stool, once a night."

As developed by Prof. Finnegan and his associates in CSICON, Murphy's principle holds that the "normal" and "average" exist only in mathematics-i.e. "in pure fiction," Finnegan always adds-and that daily life in ordinary space-time (Marx's sensory-sensual reality) consists of nothing but enormities, aberrations,

eccentricities, oddities, weirdities, anomalies, and a few occasional "approxima-tions to the normal." In the last sentence of his *Golden Hours* Finnegan concludes: "The 'normal' labels that fictitious abstraction which nobody and no event ever *exactly* exemplifies."

Finnegan's work has won great acceptance among general Semanticists, surrealists, militant gays, sci-fi writers, libertarians, acid-heads, the Vertically Challenged Liberation Front (those we used to call midgets), and some *really* strange people, such as iguanaphiliacs, necrophiles, and lycanthromaniacs. On the other hand, Finnegan has become *persona non grata* with most academic philoso-phers, with the Fundamentalist Materialist wing of orthodox science and, espe-cially, with the religious of all sects.

The Finneganoid or Patapsychological "school" (which includes such writers as De Selby, J.R. "Bob" Dobbs, S. Moon, Wildeblood and as a posthu-mous recruit, Foucault) holds that Preposterous Memories do not have any less "validity" than any other memories, since (in De Selby's words), "All that we know derives from A) our own perceptions, which a thousand well-known experiments have proven fallible and uncertain, and from B) the instinct to gossip, sometimes called Public Opinion, which sociologists now consider equally unreliable." (The "instinct to gossip" plays the same panchrestonal role in De Selby as the "will to power" in Nietzche, or "the id" in Freud.)

La Tourneur of the University of Paris has argued (*Finnegan: Homme ou Dieu?*) that the enigmatic Murphy played a larger role in Finnegan's intellectual development than the mere statement of the First Fundamental Finding implies. Attempting a sketchy translation (I cannot capture La Tourneur's crisp-ness), the French *savant* speculates :

"The more time the overly-analytical pedant Finnegan spent in the same pub with the unsophisticated 'naive realist' Murphy, and the more pints of Guinness they consumed, the easier it became for the philosopher to perceive what Murphy had discovered first: that nobody in Ireland looked like a normal Irishman, that no room in any house formed a precise 90° rectangle, that nobody's life story made sense in any dramatic, novelistic, or even logical way and, most noteworthy, after leaving the pub, that every street contained myste-rious and vaguely inhuman shadows, especially after a 14-pint evening."

In Finnegan's own words (*Archaeology of Cognition*, p. 23), "A world where most men prefer sex with little children to sex with grown women, most allegedly Christian parents secretly engage in bloody Satanic rituals, and every third person has suffered anal, genital, and other harassments by demonic dwarfs from Outer Space makes just as much sense-and just as little sense-where the world is run by the ghost of a crucified Jew, George Bush had rational reasons (which nobody can now remember) for Bombing Iraq again two days before leaving the White House, and the barbaric, bloody-handed English Army still occupies six of Ireland's 32 counties without Mr. Bush or any other American Policeman-of-the-World ever threatening to bomb *them* back to the Stone Age."

On the other hand, La Puta (of the Moe Howard computer enhancements) argues (*La Estupidez de la Tourneur*) that Finnegan had merely rediscovered the proto-existentialism of Edmund Husserl, which does not accord any superiority

in "realness" to any kind of perception over any other kind of perception. The letter bomb sent to La Puta from Paris shortly after this has never been traced to La Tourneur, despite the scandalous polemics of Prof. Ferguson (Alabama Creation Science University and Four Square Tabernacle)–who also claims to have seen the Moe Howard head on Mars with his own computer "enhancement."

Ferguson's later writings, with their unsubstantiated attempts to link Finnegan with Sinn Fein and the Irish Republican Army, merely illustrate mindless madness, a strange cultish submission to the doctrines of La Puta and a Presbyterian inability to understand robust Irish humor. However, this does not mean we should naively accept de Selby's counter-claims, attempting to find "sinister and signifi-cant" links between Ferguson, the late Clay Shaw, and the Bilderbergers.

Meanwhile, Prof. Finnegan continues to champion the Linda Napolitano case, on the grounds that "since this sounds *on the surface* like the most absurd UFO story of all, it has the greatest probability of proving true eventually." Under hypnosis by the egregious Budd Hopkins, Ms. Napolitano remembered (or *thought* she "remembered"–as you will) an abduction in which she got teleported or schlurped, out of her New York apartment, into a UFO, and then the Little Grey Bastards performed their usual molestations. She also remembered (or "remembered") two CIA agents who later kidnapped her and attempted to drown her–part of the Cover Up, you know.

On the other hand, Jerome Clark, one of America's leading UFO investiga-tors, lately sends out tons of mail, (or so it seems) denying that he ever endorsed the Napolitano case–although others claim to have documentary evidence that Clark did endorse the whole Napolitano yarn less than a year ago. Clark now says that all this alleged documentation–circulated by rival UFO investigators–amounts to malicious libel perpetuated just to make him look like a fool.

I don't know what it all means, but, like Ms. Tilton, I'll gladly pay $500.00 to anybody who can prove that *none* of this weird shit ever happened, since I feel sure every bit of it did happen, although not necessarily in ordinary space-time.

A shocking photo, recently produced by Prof. Ferguson, shows Clark, Oliver Stone, La Tourneur, and Jim Moseley (editor of *Saucer Smear*) standing with G. Gordon Liddy on the Grassy Knoll as the Kennedy death car pulls near. Moseley holds a Confederate flag, La Tourneur appears to have some hood on his head–whether Satanic black or Ku Klux white does not appear clearly, due to shadows–and Liddy, of course, has a Smoking Gun in his hand.

Almost all the "experts" have denounced this photo as an obvious scissors-and-paste forgery. The one dissident voice belongs to Professor H.H. Hanfkopf, who in his book, *The CIA: Pawn of the Interstellar Bankers* attempts to demonstrate that all the conspiracy theories of this century served only as misdirections to conceal the fact that paper money contains highly addictive drugs to make us hopeless slaves of the Green Slime Entities of Algol.

That's why you never feel you have enough money, Hanfkopf says, and continually need to increase the dose a little bit more than you could survive on last month. In reality, not in metaphor, the Green Stuff has addicted us.

As the more restrained Sheissenhosen would say, "*Maybe.*"

The Cosmic Reader

An Opthamologist Examines his Near Death Experience

R.G. Larson and Greg Bishop

About a year and a half ago, I met a man at a gathering of the Claremont Jung Society. During the time when the formal discussion of the group had ended and one on one conversations produce some of the best information flow-he spoke about a physician in Los Angeles who had written a noteworthy article on the Near Death Experience (NDE). "He's an ophthalmologist. Call him at his office and he'll send you copy." So I called.

That was my auspicious introduction to Dr. August Reader. He seemed pleased to pass along his essay to anybody who was interested. *The Internal Mystery Plays: The Role and Physiology of the Visual System in Contemplative Practices* is remarkable. Never has someone explained so much of the human physiology behind this phenomenon without reducing it to just brain functions.

Reader's own NDE was the impetus for his writing. His dramatic recounting of the experience is compelling and commendable. Like most people, he was really "thrown for a loop" by the experience. His method of coping with this was to absorb all the literature he could find on the subject. As an MD., he was able to locate and utilize many obscure and technical articles dealing with physiology, brain chemistry and the visual pathways. He seemed to be thinking "Maybe science can put this in a neat package."

The Internal Mystery Plays begins with a well footnoted exploration of the classic NDE, explaining the stages in terms of neuro-physiological conditions, and incorporating a very reductionist flow that would have fundamentalist materialists salivating. But Reader finds certain nagging aspects that won't fall into place: Perhaps the brain/body is creating it. But there's something else—mind/consciousness/spirit-involved. It's not one or the other. It's that damned "excluded middle" again.

Dr. August Reader

Dr. Reader has published a more recent article *The Psychophysiology of Religious Experience: Roots of Spiritual, Psychological and Physical Healing* that appears in a Jewish-oriented journal of psychology. Although it has a more spiritual slant, it still pays homage to the "middle."

August Reader's voice needs to be heard. He is a bridge between

orthodox science and mysticism/spirituality. The good doctor was able to find a few hours in his busy schedule (a thriving ophthalmology practice: consulting on managed health care; and, of course, the study of spirituality) to talk to *The Excluded Middle*. Enjoy and incorporate.

— **Robert Larson**

This is the closest experience we can to have to the divine in this lifetime. We cannot get closer to a universal spirit or a feeling of a universal spirit except through an NDE. "

Q: What is it that you're saying about the Near Death Experience that is different from what others have said?

READER: This is the closest experience we can to have to the divine in this lifetime. We cannot get closer to a universal spirit or a feeling of a universal spirit except through an NDE. Mainly because the NDE is the final experience that one has just prior to actually dying. There's been enough evidence of this in the literature that has looked at people who have had them. They've been the foundation of the world's religions. They've really been the source of shamanic practices around the world. And shamanism has been the source of medicine, psychology, the sciences, arts, and literature. Everything started with shamanic practices about forty thousand years ago. So NDEs are the one event that any human being can have that puts them as close to the divine aspect of nature as you possibly can without actually dying. And with that, if you get into a NDE and transit it successfully, with good psychological integration, there is usually a very profound healing-from a physical stand point, a psychological standpoint, and a spiritual standpoint. Because basically, the person has been reborn-in the true sense of the word. This is what was referred to as the virgin birth. This is the same metaphor that we find in Osiris in Egypt and the shamanic dismemberment of Osiris, and then his being put together by Isis. All of these events are metaphors, at least in the masculine, for the man getting in touch with his feminine nature. Men's desires for women are really a desire for the divine. They are actually trying to find the divine. When you find it in a NDE or some other esoteric practice that culminates in a similar experience, the person typically opens up their masculinity. They become vulnerable; they become emotional; they become empathetic and compassionate. This is really the source of compassion and love for most societies in the world-through these types of experiences.

Q: Is this brink of death factor important? People do have shamanic type experiences or psychedelic experiences where they don't necessarily transit right next to death, but they feel a connection with the divine. Do you think the brink of death aspect is necessary?

READER: It's not necessary. These other paths are just that. They are paths that will lead to NDEs because anything that uses a drug is basically a toxin. This is a poison for our bodies and taken in high enough dosages, they will actually kill the person-including hallucinogens and any of the medicines that we use to induce near death states. So even in the shamanic practices, yes, you get a sense of the divine. Most of the shamanic states really do mimic the near death state-quite accurately. The stages are: fighting off the demons (which is the first stage of the NDE); a life review; usually, going down into the underworld(which is the tunnel); and then entering into a new world (which is the other world.) The metaphor's the same. It follows along Stanislov Grof's perinatal matrices as well.

You know, the four stages of birthing: the final two being through the tunnel, (the birth canal), and into the light.

Q: In your paper, The Internal Mystery Plays, *you seem to start off by reducing the NDE to neuro-physiological phenomena. However, you don't completely reduce it to that. What specific aspects of the NDE don't seem to fit into the physiological model?*
READER: My papers really become quite reductionistic. My lectures on the subject are even more reductionistic. I mean, I get very much into detail on what's happening in the brain during these states–but I feel that what happens in the brain and what we're experiencing and how those experiences are there are because they are put there. They were meant to be that way. And I think that our physiology evolved around the experiences; not that our physiology causes the experiences. I think that the experiences are there first.

Q: I didn't get that message from the paper, you see.
READER: It's a message that has taken me a long time to develop and it's still not fully developed. I'm still growing with it at this point in time. I would say that it is not a reductionistic system. This is not something that is merely in the brain process–because there is something much more there. I say that only because of my own experiences in that realm– not only the initial one but the ones that I subsequently induced in myself. They all follow the same fairly typical pattern.

Q: For a very materialistic skeptic, is there one factor that you would think, maybe, you could present to that person that wouldn't fit into a materialist model?
READER: In this part of the experience–it's in the initial stages where you are caught in this horrible place where you have hurt everybody: All the people you've hurt in your life; all the people you've lied to, cheated, or stolen from– or whatever. Even minor things. They show up in this one space in the first part of the NDE. It's extremely painful. That's the equivalent of hellfire and brimstone in most theologies. But most people get stuck in that space mainly because they don't surrender their conscious will to a higher authority. That's the part that you cannot reduce to science. Here is a conscious mind that's totally dissociated from the body at this point and it's stuck in this space of horrible pain and suffering. And the only way that they can release out of that and move into the process of bliss and compassionate love, is by surrendering their will into the process and saying as I said in my paper, "Let go and let God." It doesn't have to be in those terms. You don't have to call it God. You can call it Brahma or whatever.

Q: Now that you say it, I was thinking while reading your first paper, that it was very reductionistic. But I don't know if you can reduce will to a physiological…You can't. Consciousness can't explain itself, not totally. It just doesn't seem that it ever will be able to.
READER: We'll never know. And that's why it's called a mystery. This is why it's called the inner mysteries. They're learning more and more about them. I'm firmly convinced that within the next twenty years we're going to learn about energy fields that affect the human body that we had no idea affected us. We're already finding that electromagnetic fields and radio frequency fields of all sorts

I feel that what happens in the brain [during an NDE] and what we're experiencing and how those experiences are there are because they are put there. They were meant to be that way. And I think that our physiology evolved around the experiences; not that our physiology causes the experiences.

can effect healing and suffering, etc. I think that it's going to be just a matter of time before we'll have the instruments where we're going to be able to find the healing energy that gets generated by hands-on healers. They'll put their hand up and you can actually measure how much healing energy they're putting out. You can objectively test your hands-on healers in the future instead of just relying on hearsay or faith. I was trying to avoid the word "faith" because you do need to have it. There is an aspect of faith in all these things.

Q: The Institute of Noetic Sciences and a couple of other groups are setting up programs to objectively study these things.
READER: I got a paper from a group called MISAHA. They're putting together some protocols to look at some alternative therapies using physicians as the monitors to really judge if these alternative healers are doing as they claim to be doing. They're taking patients who have run the entire gamut of allopathic medicine. They've done everything possible and are still in a great deal of suffering. The physicians will analyze them; see what their problems are; give them objective analysis; send them off to the hands-on healer or whatever. Then follow these patients objectively; scientifically and see what happens. I think they're going to come up with some really phenomenal numbers. Jean Achteberg, who is the president of the Transpersonal Society, is also the chairman of the research grant committee for the new NIH [National Institutes of Health] division for alternative medicine.

Q: There's a division in NIH ?!
READER: It started this year [1993]...There's a division for alternative therapy.

Q: Isn't that a government agency?
READER: Yeah, it's a government agency. They've got several million dollars. A guy named Jonathan Jacobs is running this. He is a Native American Indian; obviously into this sort of alternative therapy realm. He's heading up the group. And Jean is the head of the research grant committee. She was very encouraging to me to submit some grant proposals for the ketamine study. I'm looking forward to that.

Q: You said you were involved in ketamine research with AIDS patients-treating them in an empathetic therapy? What do you mean?
READER: Empathetic in that the physician and psychologist counselors will lecture and counsel these patients for several sessions before they actually give them the ketamine experience. Basically to talk about NDEs; talk about the death process; give them some level of comfort of what to expect when they do die. Because one of the things that affects healing is the fear of death. When someone has a tremendous amount of fear, their sympathetic nervous system is extremely turned on. Fear is one of the biggest reactors to sympathetic stress. We know that when sympathetic stress is high, especially chronic stress, the immune system gets beaten to death. There's a drop in natural killer cells by as much as seventy percent in chronic stress conditions. That alone is going to make the person more vulnerable to diseases. A number of other things happen to the immune system under stressful conditions. If someone has a NDE and

> **I think that it's going to be just a matter of time before we'll have the instruments where we're going to be able to find the healing energy that gets generated by hands-on healers. They'll put their hand up and you can actually measure how much healing energy they're putting out.**

suddenly realizes that death is not such a horrible, painful, terrible thing—and the fear of death is gone-then usually a lot of subservient fears go away with it. I mean, if you're not afraid of dying, what in the world is there to be afraid of?

Q: *There's this talk by Ram Dass,* Death is not an Outrage...
READER: That was another group of interesting people I met at this conference. I mentioned Jack Kornfield who was there. He was one of this group. These are a number of Jewish men and women who are in their mid-forties now, who back in the sixties dropped out like I did. These people were all from New York and they all went to Thailand and Burma and Nepal and Tibet and actually went into Buddhist monasteries. Jack spent seven years in a Buddhist monastery in Thailand. I met this woman who spent two years as a Tibetan nun in a monastery. They now re-label themselves as "Buish". Buddhist Jews. If you've never met Jack Kornfield, he's one of the most loving, kind, compassionate, empathetic people I've ever met in my life. As were all these people. It was almost like being in the presence of His Holiness The Dalai Lama. They were very much along those lines of compassion.

Q: *Our idea is that memory and experience involve not just the reaction to external events and stimuli, but the interaction between the phenomena and the senses of the percipient. Do you see NDEs as a process of interaction or simply reaction to physiological process?*
READER: Definitely it's an interaction. It's not a reaction because I think the physiological process has evolved along the lines that the universal spirit has wanted it to evolve so that we can have these experiences. In that sense, I think that it is not a reaction but an interaction with some force that we cannot detect or measure scientifically—which really puts us back to the Cartesian mind-body separation which I don't believe in.

Q: *Michael Grosso, in his book* The Final Choice, *talks about a "global near death" that we as a species are going through. "Mind at Large" or the collective unconscious or something is spewing forth strange phenomena-UFO encounters, visions of the Virgin Mary, etc.-in an attempt to cause an evolutionary shift of a species that has put an entire planet near death with nuclear weaponry. Do you have any thoughts on that?*
READER: I agree with him wholeheartedly—absolutely wholeheartedly. In fact, what we're noticing is more and more and individuals are having NDEs. I think this is another sign of the times. As our toxic environment grows in on us and there's a lack of air and there's more crowding. These are conditions that we know experimentally will induce near death states in animals. So why not in man? NDEs engender a community soul within the individual so that they want to do more for others than for themselves. I'm of the feeling that these things are essential and absolutely necessary right now for the evolution of human beings-to get beyond this toxic, environmentally destroying track that we're on right now. Once you've had a NDE, you're very in tune to the spirit of nature and not destroying it. "This is our home and if we screw up that ten mile layer of air, we're done for." And that's what we're doing now.
Q: *Do you see the NDE as an increasingly spontaneous occurrence but one which could*

If someone has a NDE and suddenly realizes that death is not such a horrible, painful, terrible thing—and the fear of death is gone-then usually a lot of subservient fears go away with it. I mean, if you're not afraid of dying, what in the world is there to be afraid of?

transform societies by attrition-the effect of which being that less and less people will be resistant to change?

READER: I think that there will be a shift. My hope is that more and more people will have NDEs. I think that if we practiced the old ways-I'm talking about the old hunter gatherer societies where there were initiation rites at the various stages of life most of the problems we have with the environment wouldn't be here if we had a real initiation for men and women through the various stages of life.

Q: That sounds like something that would even change how people view each other socially because you would feel like you had a stake in your society and would feel a part of it.

READER: The NDE does give you a sense of community spirit. You come out of it with that. Most of the initiation rites of aboriginal peoples utilize some method of inducing the near death state-especially for young men around age thirteen when they go into training to become healers. They put them through excessive ordeals to the point that they have so much pain and suffering, that they usually have to give up their will and fall into some sort of trance. When they fall into a trance, that's a near death state. Then they wake out of that really connected to their tribe; connected to nature and able to live with in the environment instead of against it.

Q: Could you talk about Wilder Penfield's work a little bit?

READER: Wilder Penfield was a neurosurgeon up in Canada. His heyday was in the 1940s. This was in the era of neurosurgery being done under local anesthesia They would have to do it under local anesthesia because most of the patients that Penfield was working on were intractable epilepsy patients. These were patients that had severe epilepsy and could not be treated with medication. What they were doing was called "electro-evolation." They would go in the brain and find the point that was causing the seizures, then go in with an electrical probe and literally fry that little area of the brain so that it would be dead. It would just basically kill the epileptic focus. What Penfield did (since these were all done under local anesthetic and the patient was wide awake during surgery) was he decided to map the brain. So he would take his little electrical probe with just a small current -enough just to stimulate the brain- and just went in one or two millimeter steps across whole surfaces of the brain and asked the patients what they would experience as he would do this. What was interesting was when he got to the temporal lobe on the right side. In this one area they would see angels; visions of the Virgin Mary; visions of Jesus; all these religious metaphors. What was interesting was they weren't necessarily religious people but they were getting these religious images. But that doesn't mean that their parents or their grandparents weren't religious. I'm of the feeling that a lot of these images that we have stored in our brain are religious archetypes; some of Jung's archetypes of the collective unconscious that are genetically passed down. So many of these images are stored in our brain and have evolved and changed and sort of been molded by our genetics over thousands of years. So someone who is not necessarily religious might have religious imagery there. I've been unable to go into his stuff in any detail to find out if the imagery changed with the ethnicity of the

Most of the initiation rites of aboriginal peoples utilize some method of inducing the near death state-especially for young men around age thirteen when they go into training to become healers. They put them through excessive ordeals to the point that they have so much pain and suffering, that they usually have to give up their will and fall into some sort of trance.

individual. Most of the patients he was dealing with were French Canadians and so therefore they were Catholics—hence: Jesus and the Virgin Mary.

Q: So there was a specific spot in the brain that did seem to contain these images?
READER: Yes, and that part of the brain is part of the brain that still gets its blood supply from the basilar artery during the NDE.

Q: You talked about using ketamine in your study. Why ketamine as opposed to, say, psilocybin, DMT, or mescaline?
READER: First of all, ketamine is readily available. It's a non-schedule drug, which means any physician can go out and write a prescription for it. You don't have to have any special FDA approval to use it. The other advantage to ketamine is that, in doing scientific studies, we have to have control groups. In most research, you have placebos. It's a little difficult with psychedelics. I mean, if someone gets a psychedelic, they usually know it. If someone gets put to sleep, they know it. Ketamine is a local anesthetic. When you administer it, they basically just go under as if they were having general anesthesia. But while in this catatonic state, they have a NDE. You can take another group and use a different agent, say, pentothal which will put them to sleep. But they'll just sleep and they won't know the difference. So there you've got your control. This will be a better control study than with using any other kind of psychedelic because we can actually give a placebo that will mimic many of the aspects of the ketamine. The only difference is, they won't have the hallucinogenic experience.

Q: The UFO contact experience in some of its imagery and its after effects on individuals seems to share common ground with the NDE. Do you have any comments on that?
READER: I think the UFO experience is probably a NDE in many people. I've talked to a number of UFO abductees about their experience and basically what they're describing as their aliens are very similar in nature to what I saw in my near death states. The entities on the other side. Sort of silver and white, crystalline beings that have these fluid movements and egg shaped bodies or heads. [Note: See *Aliester Crowley And Lam Statement* in tEM #2 for more on this] It's all purely archetypal. Carl Jung, in his book, *Flying Saucers*, was sort of hinting at this same thing that a lot of the UFO experiences were transcendent states that were coming from the deep unconscious. Until proven otherwise, that's as good an explanation as any. Now, I personally feel that we are not alone. When I get into a really cosmic mode in my meditations, it's quite obvious to me, that we are really the dregs of the universe. Humankind is probably the laughingstock of all sentient beings in the universe-because of our stupidity. I mean, here we are killing ourselves with our environment. I'm sure all the other aliens are out there laughing at us, saying, "I wonder if they are going to survive or not?"

Q: They probably went through the same thing.
READER: Exactly.

Q: Like grownups laughing at children, more like.

> I think the UFO experience is probably a NDE in many people. I've talked to a number of UFO abductees about their experience and basically what they're describing as their aliens are very similar in nature to what I saw in my near death states.

READER: Yes. So that's my perspective on UFOs. I would hope that someday in my lifetime that we will make contact.

Q: Would your idea be that there is more of a psychic than physical contact? Because for a physical one there's too much energy expenditure. If some body is that advanced, it would probably be a lot easier through the sea that all consciousness swims; to make contact that way. Terence McKenna has talked about it.
READER: You were reading my mind. He has a very different view. I think it's a very valid metaphor. These experiences are actually just a communication mode. This is the way they communicate with us: through our minds; through mental images. That may very well be the case, for all we know. By the same token, if these images that we're getting in our brains are actually alien images that are being projected there, then that accounts for all the mythology, gods and goddesses and the whole bit.

Q: In what way?
READER: In that probably these aliens have been communicating with us through our brains for thousands of years. And of course, these images seen by more primitive people would be interpreted as anthropomorphically; as gods and goddesses. Because these are strange beings that are much smarter than us.

Q: Earlier you said you had your NDE and then you alluded to later "induced ones." Now what do you mean by that?
READER: When I had this NDE, there was such a profound sense of "oneness" and of attachment to the universe. Then of course, there's this beautiful sense of bliss that hangs around for days afterwards. I got into Buddhism; meditations. Within four months after my first NDE, I induced another one using just some breathing techniques; slowing my breathing down to the point where I would stop my breath. I took a very long exhalation and breathed everything out of my lungs and held it. I'm a scuba diver, and I have been for many years, so I imagined being eaten by a shark. And so between not being able to breathe, and forcibly having a constricted chest, I immediately went into another near death state. What was so interesting about the second one was that I didn't have that fear, what I did was that I immediately surrendered my will-"This is not me, it's up to you Lord"- however you want to phrase it. I still use Christian metaphors because that's what I grew up with. I know that they're just names, that the names mean nothing, just so that that Universal Spirit knows that I'm talking to it.

Q: The Cabalistic "Ain Soph"…
READER: Exactly, all those realms above Kether (on the tree of life) that are unnameable. At that point it literally exploded into pure light.

Q: There was no "tunnel" that time?
READER: Very little that time. I was letting my breath out, and as I imagined the jaws of the shark coming down across me, I went from a very short tunnel immediately into a white light. I think this is what the whole idea of meditation

Within four months after my first NDE, I induced another one using just some breathing techniques; slowing my breathing down to the point where I would stop my breath.

is about. It's the whole idea of prayer practice...striving for that experience, and having your mind prepared to the point that you know that you could die at any time. Say, if all of a sudden I see a train coming at me, instead of going "ahh!", I just find my space, and when I get hit, I will feel no pain, no suffering, I will just go immediately to the light and have bliss. That is what all these esoteric practices do is try to get people to that space of mind where they can immediately move into the divine. I just feel blessed that I have gotten that in this lifetime. That is what my mission is now-as soon as I can maneuver my way out of practicing everyday medicine, I will be doing either research or teaching along these principles for the rest of my life. Right now I perform a Rose and Cross-type of ritual every morning since that is in the Christian tradition which I was raised in.

The reason I do that is that Carl Jung, in all of his writings dealing with the collective unconscious made an important point that people should not try to venture outside their own heritage when looking for religion. For a westerner to try to get in touch with Buddhist imagery is really kind of ludicrous. The thing that interests me about esoteric practices in the history of religion, is that there is very good historical evidence that the 18 years that are "unaccounted for" in Jesus' life were spent in India and Nepal and Tibet, and that he probably was a Buddhist. Most of the teachings he came back with are essentially the teachings of Buddha, put into a Judaic metaphor. I mentioned this to one of my patients who was "born again" after her NDE, and I have never seen such a reaction-her mouth dropped open and she went white as a sheet. I didn't think I would get such a strong reaction. She came back today with some Christian literature for me-"The Only Way Is Through Christ" or some such stuff-and I accepted it and thanked her for it. She's still a patient and coming back to see me.

Q: She's on a mission to save you.
READER: I went back to Texas for my grandmother's funeral and my aunt sat down with me for hours at a time and tried to convince me that I was going to go to hell because I had given up on Christianity. What was interesting was that at the end of three days, I almost had her becoming a Buddhist.

Q: "Clutching" is not faith.
READER: Yes it's just pure belief and trust. I'm finding that the Buddhist traditions seem to be the most compatible in my life. I have basically evolved into a Vipasna/Zen type of Buddhist practice. I sort of walk with it all the time.

Q: Has Gnosticism been much of an influence?
READER: It's an area of great interest to me. I have studied it and read several books on the subject. Basically it's just another metaphor. I know that Jung was a Gnostic himself, which probably promulgated his interest in the book of Job, and why he wrote that book called *The Answer to Job*, which I cite in my paper. This is again a metaphor for men in mid-life or older getting in touch with the deep masculine which is in fact a feminine aspect of the male psyche of feeling and expressing emotions which gets pressed into the subconscious during adolescence when we're supposed to be learning the "hero" mode. This is why we have mid- life crises, and

> **Carl Jung, in all of his writings dealing with the collective unconscious made an important point that people should not try to venture outside their own heritage when looking for religion. For a westerner to try to get in touch with Buddhist imagery is really kind of ludicrous.**

men start looking for younger women, etc., when in fact what they're seeking union with the divine. This is called "sofia" in the Gnostic tradition, the "shekinah" in the Jewish tradition, and it's the divine feminine in ourselves which we try to get out into the world-it's a rebirth with a new sense of purpose and "at onement." The way our world is going now is just indicative of the patriarchal "hero" mode of thinking has outlived it's usefulness. It's time for the patriarch to die off and revert back to the more primitive state which is in fact the "hunter"-the hunter/shaman/trickster. That's what happens in the near death experience. The hunter is the hero, but he's the compassionate hero. He knows when to kill and when not to kill. He knows when to deceive rather than be killed. That's lacking in society right now. When the hero grows up, he becomes a patriarch. The patriarch never grows out of that mode, they just become older and grumpier patriarchs.

Q: That's when they start hurling missiles at other people.
READER: Exactly. They haven't learned to integrate their own insides. The only way that they can reach any happiness in themselves is doing things to others. The papers I write on these subjects are basically my integration into the rebirth process... *The Internal Mystery Plays* article was not accepted by the *Journal Of Transpersonal Psychology* as something that would be appropriate, however, I think I could rework it to be published in a journal of Jungian psychology because it has a lot of symbolism that would be interesting to them.

Q: Is DMT (Dimethyl Tryptamine) much of a factor in the NDE?
READER: Possibly. It's one of the neurotransmitters stored in the hypothalamus that is probably released in high concentrations during the near death state. It looks like DMT is one of the neurochemicals essential to the experience, because the inhibition of certain pathways-especially the seratonin pathways-is released by DMT. It probably gets released the same time that the beta endorphins get released, which is about 5-10 seconds into the experience which is when there is fear and pain and the stress reaction goes up tremendously. I think there are many other neurochemicals are involved as well, but we've only figured out a little part of it.

Six months ago in Israel, scientists discovered that there was a receptor in rat brains specifically for cannabis and marijuana derivatives. When they looked at the human brain, they found the same receptor. Why is this? They actually found a chemical in the brain that stimulates this receptor, and they called it anandamide-the word is a combination of the chemical term and "ananda", the Hindu term for enlightenment. We don't exactly know what it does and what it's role is in the brain, but it's almost sure that it has some role in the ecstatic experience.

Q: The enlightenment chemical! Do you think it evolved along with the brain because of the availability of the drug, or perhaps it was dormant and only became active after the "discovery" of cannabinol?
READER: Well, the plants were around long before animals appeared, so it should have been present in both rat and human ancestors 50 million years ago, because the first mammals were 65 million years ago-before a meteorite

> **It looks like DMT is one of the neurochemicals essential to the experience, because the inhibition of certain pathways-especially the seratonin pathways-is released by DMT.**

supposedly crashed near Yucatan and killed off the dinosaurs.

Q: *That's apparently the best model at this point...*
READER: It was supposedly 10 miles in diameter, and would have caused weather changes, etc. from the impact and debris. There's a theory that there were more than one at a time. We know that the galaxy is rotating along an axis, and the Earth proceeds along this orbit each year, so that every 2200 years we're in a new sign of the zodiac. Right now, we're moving out of the age of Pisces into Aquarius. And there's many other cycles that the galaxy goes through, so I look at paleontology, and there are cycles in extinction patterns. These cycles usually run between 65 and 100 million years. Maybe there is something in the galactic cycle that pulls us every so often into a huge meteor shower, which is perhaps God's way of cleaning house every so often.

Q: *...Which could be the origin of the Atlantis legend...*
READER: And Mu, and so forth, yes.

Q: *Do you know of any research into brain functions which revealed any spontaneously recalled imagery besides religious and mythical archetypes when certain areas of the frontal lobes were stimulated?*
READER: Well, there were childhood memories, happy memories, sad memories...

Q: *These all had definite "areas" where the information was stored?*
READER: The best description I could give you is that they are almost like "fractal chaotic fields" in the brain. They're organized through thoughts rather than dedicated "passageways." What we were all taught in science classes is that the eyes send the image to the optic nerves, and they send the message to the brain, which interprets everything. What we have found now is that when the images get halfway back there, the information is already starting to spread to other associative areas of the brain. There are areas concerned with color, others deal with contrast, still others with depth perception. These areas all get stimulated at the same time, and then send their information to the occipital cortex before anything is actually "seen." This is where it's almost like David Bohm's holographic universe, where you've got the implicate and explicate order. There's this implicate order in the brain which spreads information everywhere, and suddenly it comes together as meaning.

Q: *You really are creating reality.*
READER: It's a phenomenal mechanism. I really must say that I believe the brain evolved along these lines specifically because that's what the Universal Spirit wanted.

Q: *In fact, if evolution and logic had a say in matters, the old model would still hold true.*
READER: As far as integrating all these remembered images into the life flash (during the NDE), we still haven't put all that together. I feel that it corresponds to the escape mechanism that is present in lower animals. If you have an animal that

The best description I could give you is that they are almost like "fractal chaotic fields" in the brain. They're organized through thoughts rather than dedicated "passageways."

> I think that evolution has kept these memories in our brain so that when we get into a state of extreme emergency, our brain attempts to dump all of our life experience into consciousness so we can look for an escape mechanism.

is being predated upon, and is caught, the animal will either fight or try to run away. But if it can't escape, what it does is go immediately into a "sham death." This is called the "dying reflex" as I mentioned in my article. At that point either you'll look like you're dead, or at least act like you're dead, and the predator will leave you alone. I think that evolution has kept these memories in our brain so that when we get into a state of extreme emergency, our brain attempts to dump all of our life experience into consciousness so we can look for an escape mechanism.

Q: *If we're bombarded with everything we've got, there might be a chance...*
READER: It makes sense. This is the "last ditch attempt" to get everything into consciousness as quickly as possible. If you can dump all your "hard disk data" into as short a span of time as possible, and it is interpretable, it is well worth it.

Q: *But your body can't do anything about it at that point.*
READER: Theoretically, that's true, but I think that it is more of an intuitive sense on my part as to what it's all about, rather than any scientific sense.

Q: *Perhaps the purpose is simply to smooth the path out of an inevitably traumatic experience.*
READER: There is another aspect of that life flash; and that is the reassurance that it is O.K. to die. With that flash is the assurance that everything that happened in your life was meant to be, you have no regrets in dying, and you couldn't have chosen it anyway. You couldn't have changed anything about your life, so you might as well accept it as it was. With that is a profound sense of peace and connectedness to the universe. Perhaps that is the sole purpose of the life flash-that this is the way it is supposed to be and not to fear. That came to me now as a result of your comment.

Q: *How have your peers in the medical and scientific community reacted to your researches into NDEs?*
READER: I wrote an article for the staff newsletter of Cedars-Sinai where I described a little of what had happened in my NDE, and some of the alternative therapies I have gotten into. I actually was very surprised at the amount of positive comments I received—"Hey, I saw your article. It was really fascinating—let's talk." I have been enthusiastically pleased that it touched a lot of people. A lot more than I had ever expected.

Q: *In the Internal Mystery Plays article you were very careful to perhaps protect yourself with a highly academic and scientific description of the physiology of the NDE.*
READER: I am very well respected within the scientific community. It's almost like I have a multiple personality, but I'm very happy with it. I'm able to move in both worlds simultaneously at all times. I giggle a lot about it. There are so many unusual paradoxes happening around me daily, that it becomes a childlike awe.

Q: *Do you see a lot of coming together of people from the scientific community with those in the spiritual community?*
READER: Yes, and it's growing, and I'm so glad that it is. This last weekend at the

Transpersonal Psychology meeting I felt a solidifying of this situation. We had more physicians there than at any other conference in the past. In the past, I was actually one of the first non-psychiatric physicians to show up, but this year we had obstetricians, general practitioners, pediatricians, internists-people from all walks of medicine coming to hear the lectures. I met a radiologist in his sixties who was quite enlightened in all the stuff-I'm delighted that these people exist. I see myself as a bridge. I'm trying to bridge the spiritual and medical. In the future, I hope to convince more of my medical colleagues this stuff is valid and real. That's going to be tough.

Q: What do you recommend for individuals who have had an NDE and are having trouble reintegrating into society?
READER: One thing I would recommend is the Spiritual Emergence Network (SEN). The whole idea of this group is when someone has one of these transcendent experiences to be able to call and talk to someone who can tell them that they're not crazy. I think that's a much better way to handle it than waiting for these people to wander around...

Q:...and the first thing they happen to run into...
READER: The first thing they hit is what they attach themselves to because there's a lot of charlatans out there who will take advantage of these troubled people. They are troubled-they have these images, they have these feelings they don't know how to deal with-I was there myself for a solid year. I thought I was crazy, I knew I wasn't, but I couldn't tell anybody about it. No one else knew about my experience for a year, I kept it to myself because I didn't know how it would be taken. The Spiritual Emergence Network wasn't in existence at the time, but I think that it's the best thing in these situations right now. If people can at least get into some kind of meditative practice, and I won't put any label on what kind-whether it's T.M. or Zen or Vipasana or Tantric, or whatever-or for that matter Catholic or Christian or Jewish. All meditation practices in every culture have at the foundation closing your eyes, relaxing the body, and controlling your breath. Most people, if they're intelligent or strong enough, can find the answers on their own. A lot of people do need help though; the really troubled people do need assistance from organizations like SEN.

Most people, if they're intelligent or strong enough, can find the answers on their own.

Q: Perhaps UFO abductees would be better off with something like that. (Both besides and including Budd Hopkins Intruders Foundation.)
READER: Budd has got a lot of bad press recently both because he's not really a therapist, and any information he gets out of them is more to his advantage than theirs. There's a psychiatrist who's really into this named Rima Laibow. I know her very well, she does the TREAT [TReatment for Experienced Anomalous Trauma] conferences. She's been inviting me to come to them since TREAT 1, but I've always been too busy. The other reason is that my data wasn't developed enough at the time to present anything, but right now I think I'm ready-I wouldn't get laughed out of the room.

Tracks In The Desert

George Hunt Williamson and the Genesis of the Contactee Movement

Alec Hiddell

George Hunt Williamson

And there came a voice from heaven, saying, Thou are my beloved Son, in whom I am well pleased.

—Mark 1:11 (King James Version)

The 1950s threw up any number of space-age mystics and messiahs, each more dotty than the one before. Among the earliest and most influential of these was American channeller Dr. George Hunt Williamson, who died in 1986 at the relatively early age of 60. Williamson was a prolific writer on the theme of contact with extraterrestrials. It would however, be a capital error to classify him solely as a UFO researcher. He was above all an occultist whose activities helped to usher in a new magical aeon—the aeon of the Flying Saucer. No attempt can be made to understand him or his work unless this fact is first taken into account.

Little is known of Williamson's early life. Jacques Vallee states in *Messengers Of Deception* that his real name was Michel d'Obrenovic. This canard has been repeated in several articles on the early days of UFO research. I have on file a photocopied bibliography of the contactee movement (source unknown) in which it is stated that "Williamson [frequently] used his Yugoslavian family name of Michael d'Obrenovic although most of his writing was done under the Anglicized name." In actual fact, Williamson was born in Chicago, Cook County, Illinois, the son of George and Bernice (Hunt) Williamson. Inquiries to the Yugoslav government have revealed that although there was at one time a royal family named d'Obrenovic, it ceased to exist as long ago as 1903, when the head of the line was assassinated by revolutionaries. Williamson's use of the title appears to have been entirely spurious, dating from an occasion in 1961 when he attended a wedding posing as "H.R.H. Prince Michael d'Obrenovic van Lazar, Duke of Sumadya." Like some latter-day Dr. Mabuse, he routinely used disguises and aliases to further his own ends.

Williamson's academic qualifications were equally bogus. In the late 1950s he was listed in *Who's Who In America* and *American Men of Science* as a leading anthropologist and authority on the Hopi and Zuni Indians. It later transpired that his various degrees and qualifications were either self-conferred or, in one notable case, acquired from an institution known as the Great Western University of San Francisco, which researcher John J. Robinson was

moved to describe in *Saucer News* as "a massage parlour." Williamson's formal education actually came to an end in February, 1951, when the University of Arizona disqualified him for further study on the grounds of poor scholarship. Disdaining to re-register, he instead moved temporarily to Noblesville, Indiana, and there took up an editorial position with *Valor*, the in-house journal of William Dudley Pelley's Soulcraft organization.

Pelley was at the time enjoying a new lease on life, having recently been released from prison after serving an eight-year sentence for his wartime opposition to Roosevelt. A former fascist and leader of the Silver Shirts, he also had an abiding interest in occult matters and compiled 32 volumes of automatic writing on contact with higher intelligences. In addition to Williamson, his post-war circle is believed to have included seminal contactee George Adamski and others of the same kidney. Some authorities suggest that Pelley and Adamski first became acquainted as a result of their mutual interest in Guy Ballard's I AM cult. There is also evidence to suggest that Pelley may have introduced Williamson to Adamski.

Like many a UFO buff before and since, Williamson later gravitated to the southwestern state of Arizona, settling in Prescott and attempting to contact the space people by radio telegraphy and direct-voice channeling. According to investigator Sean Devney, quoting from eyewitness accounts, "When Williamson started to channel, it was something truly inexplicable. [he] would begin speaking in several different voices, one right after the other."

On November 20, 1952, Williamson and his wife Betty were among the witnesses to George Adamski's historic first meeting with Orthon the Venusian in the desert near Mt. Palomar, California. This event more than any other seems to have catalyzed his activities. From then on, he switched into high gear, publishing *The Saucers Speak* in 1954 and following it up with a series of the most remarkable UFO documents ever conceived.

Another little-known but influential saucer cultist was Dr. Charles Laughead, who with his wife Lillian published Williamson's *Book of Transcripts* in 1957. (Lillian Laughead was among the dedicated to Williamson's *Other Tongues, Other Flesh*, "for her contribution to the Lemurian interpretation of the **tracks in the desert**." (emphasis added) Laughead is though to have emerged from the same pseudo-occult background as George Adamski, et al. In 1949-1950 he gave up a position at Michigan State University to help the famous Marion Dorothy Martin, aka "Mrs. Keech", who had lately been told by spacemen that the end of the world was imminent. The full story of what happened next is told in *When Prophecy Fails* (Festinger, Reicken and Schacter, University of Minnesota, 1956.) Laughead's role in that affair was basically that of *agent provocateur*. Without him, it is doubtful whether events would have turned out as they did. He is referred to throughout *When Prophecy Fails* as "Dr. Armstrong." His efforts on behalf of Mrs. Keech were rather akin to those of Thurber's Get-Ready Man, who "used to go about shouting at people through a megaphone to prepare for the end of the world." When the appointed hour came and went, and the world continued much as before, Laughead moved on to other things, and chanced to meet Dr. Andreja Puharich in a hotel in Acambaro, Mexico.

George Adamski

George A., George W. and those "tracks on the desert"

Greg Bishop

Although many contactees eventually made their "tracks" (and tracts) in or near deserts (with the notable exception of Howard Menger), George Adamski did it first and did it best. Whatever did happen was well documented by the participants (see illustrations) but strangely, no detailed photos Adamski said he took showing spacecraft on that fateful day have come to light, with the exception of one showing some mountains with what Adamski claimed was the top half of a saucer peeking over the crest of a ridge. To most critics it appears to be just part of the rocky peaks.

As described in *The Flying Saucers Have Landed* (1953), Adamski left his Palomar, CA mountain retreat at 1:00 AM on Thursday November 20, 1952 along with his lifetime secretary Lucy McGinnis and Alice Wells-the owner of the property where Adamski gave lectures on Universal Law and the cafe where he flipped burgers to pay the rent. Shortly after passing appropriately enough near the town of Ripley, at about 8:00 AM they met with Al Bailey and his wife Betty, and George Hunt Williamson and his wife (strangely enough also called Betty) in Blythe, CA just west of the Arizona/California border.

Turning back on a "hunch" the group

retraced their drive back to Desert Center and took a small highway 11 miles northeast towards the town of Parker, Arizona and stopped. After a meal, the group aimlessly scanned the skies for saucers. Passing motorists slowed to rubberneck at this small band staring into the sky in the middle of a barren desert. Shortly after 12 noon, a plane passed overhead, causing momentary excitement. The real drama began moments later, when "riding high and without sound, there was a gigantic cigar-shaped silvery ship." Williamson understatedly asked "Is that a space ship?", as Betty Bailey tried to set up a movie camera, but couldn't beacuse "she was so excited." According to Adamski, they were anxious not to attract attention to the object, so they didn't point at it and alert other passing cars to this event.

"Someone take me down the road-quick! That ship has come looking for me and I don't want to keep them waiting!" Adamski yelled, and jumped into the car with Mc Ginnis and Mr. Bailey. About a half-mile down the road, with the craft shadowing them, Adamski told Mc Ginnis to turn off the road. He then instructed the two to "go back to the others as quickly as possible...and watch for anything that might take place" -from the safe viewing distance of half a mile or more away. After this first craft was chased away by interceptor jets, another "beautiful small craft" arrived and landed behind the crest of a mountain about 1/2 mile away. Soon, he saw a figure waving to him and walked towards it. Suddenly Adamski "fully realized I was in the presence of a man from space-A HUMAN BEING FROM ANOTHER WORLD!" Adamski learned he was from Venus and that his name was Orthon. (It's strange how space brother names often sounded like synthetic fabrics.) After some warnings about atomic weapons and wars, (Adamski taught Orthon to say "boom boom") and a refusal to be photographed, he returned to his ship and sailed away.

Adamski waved to his companions to approach, which they did soon after. Conveniently enough (or through psychic premonition-if you are a supporter) Williamson had brought along some plaster of paris and proceeded to make casts of the footprints the Venusian had left in the desert floor. According to Williamson, writing in *Other Tounges, Other Flesh* (1954) he was "the first to arrive at the footprints after the contact had been made. I could see where the space being had scraped away the topsoil in order to get to a more moist sand that would take the impressions from the

Puharich records his impressions of Laughead and his wife in *Uri* , referring to them as "charming but naive people." Laughead, for his part, was delighted at meeting a fellow M.D. in such unlikely surroundings and immediately launched into an account of his work with George Hunt Williamson: "Through the assistance of a young man who is a very fine voice channel or medium, we have been in frequent communication for over a year with one of the ancient Mystery Schools in South America. These sessions covered a wide range of subjects, from ancient history and life origins on this planet, to science and religion. This Brotherhood also serves as a communication center for contacts with intelligences on other planets and star systems, and on spacecraft. Some of these intelligences are obviously not human...Their knowledge and wisdom far exceed our comprehension. For simplicity we referred to them as Space Beings or Space Brothers..."

Puharich was initially dismissive of all this, no doubt viewing it as a flight of fantasy. Later, on returning to continue his research at the Round Table Foundation in Maine, he received a letter from Laughead containing two space messages, "each from a different channel." These, together with a paranormal experience involving a self-renewing piece of carbon paper, went some way toward changing his mind, laying the groundwork for the Spectra/Hoova affair described in the latter half of *Uri*.

Puharich's pursuit of Spectra (a hawk-headed entity said to communicate through Uri Geller) effectively placed him beyond the pale of orthodox science. Few people during the 1970s were prepared to substantiate his more extravagant claims. One who did was Ray Stanford, himself a contactee of many years' standing. In the autumn of 1973, Stanford was allegedly teleported a distance of some 30 miles, car and all, while en route to a meeting with Geller. This happened on two separate occasions and was reported to Saul-Paul Sirag with all due sobriety. For more on the Geller-Stanford connection, see *Cosmic Trigger* by Robert Anton Wilson.

Perhaps significantly, Stanford was a product of the same milieu as Laughead and Williamson. Throughout the early '50s he and his twin brother Rex were involved in a long-running UFO case involving telepathic communication and channeling. One of their fellow contactees at the time was John McCoy, who in 1958 co-authored *UFOs Confidential* with Williamson. McCoy wove many strange new skeins into the tapestry of UFO research, notably the theory that a cartel of "International Bankers" lay behind many 1950s sightings. ("International Bankers" is of course a favorite synonym among far rightists for people of the Hebrew persuasion.) For better or worse he and Williamson continue to influence the sensibilities of UFO researchers worldwide.

The Stanford brothers subsequently went their separate ways, each distinguishing himself in his chosen field. Rex worked extensively as a parapsychologist, first at St. John's University in New York, and later for the Texas based Center For Parapsychological Research, while Ray formed the Association for the Understanding of Man (AUM), a fairly typical Great White Brotherhood setup.

Others of the original Adamski/Williamson circle weren't so lucky. Channelers Wilbur Wilkinson and Karl Hunrath, who collaborated with

Williamson during the latter half of 1953, disappeared in November of that year after setting off from the Gardena Airport in Los Angeles county to make contact with a grounded UFO. No trace of their rented plane was ever found. D.J. Detwiler of Carlsbad, California, the man responsible for processing Adamski's earliest flying saucer photographs, died shortly afterwards. Hal Nelson, an associate of Hunrath and Williamson, was drowned, and Lyman Streeter, the ham radio operator whose contactee experiences are described in *The Saucers Speak*, succumbed to a heart seizure.

The disappearance of Wilkinson and Hunrath has since become a classic in the annals of UFOlogy. Williamson later ventured the opinion that Hunrath "was working as an agent for the Blacks of six solar systems of the Orion Nebula." His own researches continued in an unbroken trajectory, encompassing hermetics, ancient tribal lore, and Theosophical literature. There can be no doubt that, by accident or design, he and his various collaborators played an enormous part in shaping New Age thought in all its manifestations. Together they constituted the single most important occult group of the post-war era. Their influence is made all the more remarkable by the fact that it has seldom been acknowledged, or even perceived, by other researchers in the field.

As the 50s drew to a close, Williamson ceased to play an active role in UFO research, and instead founded a monastery in the Andes mountains, This occupied his time for several years. Later he returned to Santa Barbara, California, and was ordained into the Nestorian Church. Always an enigmatic figure, he died in 1986, having retained his secrets to the end. Many details of his involvement with the Soulcraft group and its offshoots are now lost to us. Others of the circle are either dead or widely dispersed. Pelley and Adamski...Hunrath and Laughead...John McCoy and the Stanford brothers...It was from the tangled lives of these men that the contemporary UFO mythos first grew and took shape.

carvings on the bottom of his shoes...The carvings on the shoes must have been finely done for the impressions left in the sand were clear cut..." Either Orthon had a weight problem on Earth, or someone had taken extra care in making the impressions. He goes on to state his interpretation of what meaning the symbols hold for those who "fail to obey the laws of the Infinite Father." Williamson also stresses that the designs are not "alien" since the Earth is "part of the Great Totality" and ancient symbols of Earth are the symbols of the space beings as well.

The plaster casting and drawing of the symbols by Betty Bailey is well-documented in photographs, which seemed to have escaped the "Oz factor" (a term coined by Jenny Randles to describe the strangeness experienced during encounters with anomalous phenomena and the attendant failure of photographic equipment) of the spaceship pictures. Perhaps it was just the will of Orthon to keep the meeting under wraps. In any case, after this event Williamson seemed to have found his calling, and concentrated on turning out his own brand of contactee literature-most of it "channeled"-leaving clear the nuts-and bolts domain (at least for the moment) to his friend and inspiration, the other George-Adamski.

Orthon's footprints as rendered by Williamson

In Memoriam
Sun Ra: May 23, 1914 – May 30, 1993

Peter Stenshoel and Jerry Modjeski

It could really change the planet if people could only visit some other planets. I'm trying to get them to feel other planets. And people are ready for something different, they've had enough trouble on this planet to know they've got to find an outlet. I have been outa space [sic], I've had experiences going out there, I know it's possible. There are people who think that's crazy, but it's real. Dreams are real. They tell you something.

Sun Ra (née Herman P. Blount) was, as far as I can tell, living out a life of allegory. A band leader, showman, composer, key boardist, and mystic, Sun Ra made claims which sent my head spinning He was a member of the angel race, he came from Saturn, he traveled the spaceways, he visited Venus, he was "about 5,000 years old." Back when I was consciously setting myself up as a young artistic iconoclast, Sun Ra's outsider mystique proved heady stuff. One part of me really wanted his claims to be true. So does Sun Ra's death of May 30th, 1993, betray his mythos as nothing more than tongue-in-cheek hoodwinkum? Well, not exactly. Just as many are reappraising the flying saucer tales of Orfeo Angelucci, Truman Bethurum, George Adamski, et. al., admitting that there might have been a kernel of truth presented with improbable baroque embellishment, Sun Ra's claims and philosophical constructs, not to mention his magical, odd music, strongly suggest a mind grappling with a genuine encounter with the weirder, wider universe (or omniverse, as Ra would call it).

As was pointed out in Jerry Goldsmith's excellent *Goldmine* article, Ra was decidedly not pursuing the fast track to capitalistic glory. His communal life with his musicians and his tireless rehearsing and recording express a fierce dedication to his muse, not to the mammon of popular recognition. Back when his Arkestra's five and dime space costumes were the height of uncool, he made no attempt to ditch them to appease the fashion-conscious, trendy "jazz scene." His live shows included space ritual dancing, chanting, and theater, all in flashy "outer space" clothing.

Sun Ra's music itself is as uncompromising as it can be, reflecting the intuitive twists and turns of Sun Ra's cosmic delight. Sometimes swinging, sometimes meandering, never pandering, the music shows the inner workings of genius, and if only for that Sun Ra should have been declared a living national treasure. But now it's too late. Or is it?

Jerry Modjeski, Radio Producer (The Musical Transportation Spree, Little City in Space, The Mechanical Spider Clinic, UFO Update etc.) and amateur flying saucer authority, says:

"My radio programming isn't made more accessible or popular if I play Sun Ra. He doesn't fill an "easy" niche in music. I'd liken Ra's place in music to director Ed Wood's place in film. Laugh if you'd like at *Plan 9 From Outer Space*, but behind the shower curtains and cardboard sets is heart, mixed with messages most people ignore or ridicule. Just as there is more to *Plan 9* than flying hubcaps, there's more to Sun Ra than his 50's sci-fi tunics. Not only is his jazz way "out there," but any seasoned eye will spot something truly unearthly looking at the original album artwork (now seen on the Saturn reissues): Cryptic designs look like a cross between an old Marvel Doctor Strange comic book and contactee religioso. Sun Ra leaves behind a residue of mystery and entertainment that is unforgettable. And speaking as one who enjoys music history AND excluded middles, I cheer Sun Ra for hooking up a flying saucer caboose on the mythic A-Train of jazz."

Conversation from a tribute to Sun Ra on The Musical Transportation Spree, KFAI-FM, Minneapolis-St. Paul, July 6, 1993.

BLANCHE FUBAR: I always thought that his shows were creating a zone of protection. I hate to sound too cosmic here.

CHUCK ISLE: Like you felt safe there–at home?

BLANCHE: Yes, I did, and I remember that especially in the Fall of 1990 when it seemed like there was a storm gathering all around us (well there was; it even had a trademark, and logos on CNN), but I felt that when we were in that space, that it was safe.

STUART MATHEWS: He always did these wonderful hand movements, too, when he was not playing or singing and he was directing the band or just dancing, and these movements seemed to be sort of like he was moving energy around...

BLANCHE: Exactly. Sometimes it seemed like he had a concentrated ball of fire that he'd throw out into his Arkestra, and then he'd take it back.

PETER STENSHOEL: Throwing fire. Throwing fire. Yeah.

CHUCK ISLE: He played the Arkestra like a theremin. [Leo Theremin, the inventor of the theremin, died a few months after Ra.]

Interview with Sun Ra from the Chicago Jazz Festival, August 3, 1988

SUN RA: "I used to be a man, but I got promoted by the Creator to be an angel. And then I got promoted to be an archangel, so then, I'm here to help the planet....I went out of space several times...I met other kind of beings, they taught some other kind of things about the future. And I feel that, and I'm trying to convey that message to people that they can go to outer space. I've been. They could go, too, but they have to be pure in heart, because if they're mixed up, then they might get out there and want to become a satellite or something. They won't go straight to the place they're supposed to. So they can't deal with freedom. They have to be dealing with precision and discipline. And so, I'm in a country that's always talking about freedom. So the change came when I began to realize the value of discipline and precision. And that's what this band is. It's not a freedom band. They go through a lot of disciplines. They go through a lot of what we call the 'Ra Fire.' Well, I don't say anything to them when they do something I don't like. I throw some 'Ra Fire' on them. Which might be silence. It might be cursing them out in Earth language which

they can understand. Therefore it's a different type of band. But the thing about it is it gives people a message of happiness, merriment, something different from the sadness and destruction they always face every day. This is something else. And people are beginning to feel that there is something else all over the planet. They don't know what it is; neither do I, but I just know it's real."

From Destination Unknown album liner notes:

"It could really change the planet if people could only visit some other planets. I'm trying to get them to feel other planets. And people are ready for something different, they've had enough trouble on this planet to know they've got to find an outlet. I have been outa space [sic], I've had experiences going out there, I know it's possible. There are people who think that's crazy, but it's real. Dreams are real. They tell you something. "

Sun Ra

Tales from the Shelf: Our Hero is the Butt of a UFO Practical Joke

Peter Stenshoel

Part 1:

Fear of Laughter

No one likes to be the butt of a practical joke. That's why cases of good photographic evidence for UFOs, fairies, ghosts, etcetera, incite such controversy. A positive statement in regard to a photograph, reduced to worst-case scenario, means you're falling for some prankster's hoax. One wonders how much good scholarship has been scuttled by this overarching fear. Its roots are hopelessly deep in the human psyche. At some point in our childhood, most of us had names thrown at us which left the tops of our ears burning with deepest shame: "Sucker!", "Fooled you!", "Can you believe he fell for it !? Ha ha ha ha!"

Poor old Bruce Maccabee, whether or not he was correct in his initial positive judgment of the authenticity of "Mr. Ed's" Gulf Breeze polaroid photographs, must have felt a burning in the tips of his ears. For some odd reason, it is deemed more honorable to believe that a given artifact is a hoax, than to render an informed positive opinion, or even simply reserve judgment. According to such bandwagon thinking, we must be living in a nation of pranksters, all hiding just out of sight, barely able to contain themselves, waiting for that peak moment when they can walk out guffawing, slap their victims on the back, and grin ear to ear, saying, "Whassamatta? Cantcha' take a joke?"

In my years of careful wandering through the forest of phenomena, perhaps I have taken a wrong path or two, but I have developed a kind of deep woods smarts by which I can always navigate back on to the best pathways. Living with ambiguity is a way of life for me. To switch metaphors, I'm happy to be off the "either/or" merry-go-round. Although life is more satisfying this way, it is anything but easy, and it does have its price. For example, in the summer of 1974 I was the recipient of an elaborate hoax. Because of my known interest in UFOs, a couple schoolmates thought they'd have a bit of fun. The ironic twist of fate here is that a third friend tipped me off ahead of time, so I was already in on the prank. Here's what happened:

I was living in my parents' house at the time, which enjoyed a secluded lot with a walk-in basement. My room's oversized window looked out onto dense

> **To a very large degree, memory no longer agrees with reality.**
> **Philip K Dick, from his Exegesis**

woods. A friend, Mark Freeman, informed me that friends Jim Wilson and Jeff Pike were going to dress "like spacemen" and provide me with a close encounter. I was miffed at this, more because such behavior clutters up real investigation than that I was the butt of a joke, although it did reduce the chances of my ever confiding with these two again. I filed it away and forgot about it. Then, one sultry Minnesota summer evening my brother David and I were in my room listening to Weather Report's *Mysterious Traveler* album. The music was at it's height of mystery and suspense. A tap came on the big window. David and I turned to see, in perfect blue twilight, two beings head-to-toe in silvery garb, prancing on the turf in what looked like slow motion, waving at us with Interplanetary Wisdom. Then, still in that incomprehensible slow motion, they retreated, presumably to their waiting saucer. Of course I knew at once they were really Jim and Jeff, but I must admit it was an awesome performance. They instinctively chose the best time to arrive musically, and David and I, knowing full well this was a prank, were left feeling elated and alive.

Mark Freeman wrought revenge on the two by cooking up a cock-and-bull story that my parents called the cops on two trespassers that evening, and the police were in the process of investigating! As for me, I was left wondering what I would have thought had I not been forewarned. Would I have taken their apparent slow-motion movement, which could have been a subjective slowing down of time for me to appreciate the moment, as proof of non-human status? Most probably I would have stuck with "I don't know what I saw; I know that I saw it." Such, alas, is the best most UFO reports can claim. Should we give it up? Nope. You see, it's like school. We're struggling through life's dull algebra workbooks right now, but there could well be an application for all this knowledge when we're more grown up. As for the occasional prankster, just consider him or her the Lyceum attraction on Friday afternoon: even if it's corny, you get to stop being serious long enough to relax.

Part 2: The Autonomy of Memory

> "To a very large degree, memory no longer agrees with reality."
> — Philip K Dick, from his *Exegesis*

Now we get a little weirder: What if memory is itself a creator? Imagination is already credited with creating our future. For example, an inventor conceives a design, and the design overtakes the environment. What if this worked backwards as well? Cutting-edge therapists have been telling us to rework our memories in order to transcend bad behavior patterns, or even neurosis or traumatic events. If stress is seen as a tangible unhealthy substance in our systems, then apparently bringing our memory to a moment of peak happiness (or peak distress) works to clean out the gunk. In turn this technique could be a catalyst for achievement: to remember the energy from your best moments, to feel your body's physiological and neurological response to those memories, and to adopt the proper ones for any project at hand.

How would backward-creating memory work? Well, it wouldn't automatically rewrite all the history books on library shelves. Rather, it would create an alternate history tracking right alongside ours, existing, as the time-

honored phrase goes, "in another dimension." This alternate history would eventually break into our reality as a collective vision come to us in dreams. It could change humanity's future because it could influence our collective imagination. This could be how the gods in power constantly change. That is, those who are remembered the most at any one moment exert the most power.

What does this have to do with hoaxers and pranksters? Well, it could mean that, without knowing it, what they're really doing is engineering the future by causing memory mutation. Doug and Dave, the crop circle hoaxers, by having a lark and a laugh, might be inadvertently ushering a paradigm of Gaia worship like we've never seen. Ye gods! Maybe there's a flying saucer circling the globe with a couple aliens dressed in silver named Jim Wilson and Jeff Pike!

NEED HELP, SUMMON ASHTAR

PHIL KLASS IS A FINK.

No. 4

Editorial

I have come to see the process of editing and publishing a magazine seems very much like putting out record albums. First, there is a concept or just a few tidbits of information, like the beginnings of a song. The collaborators pool their ideas under some theme (or none) and a producer shapes and shuffles them around to create what he hopes is a coherent whole. *The Excluded Middle* now has two co-producers: Robert Larson and myself. Alas, Peter Stenshoel has elected to leave the fold and pursue his real career. He will continue to contribute *Tales from the Shelf*, and other welcome bits in every issue.

Year after year, I try to get away from the UFO subject, and diversify my interests. Every time, I get sucked right back into it. It has been pointed out that the enigma is so intricate that it may never be "solved." UFOs and related matters are the ultimate fashionable trend in that they can never be held down in one comfortable place. Once we think we have it figured out, theories squirt out from the clenching tendrils of our thoughts and ego before we realize what's happened. In this way, it is a perfect lesson in emotional and intellectual rigor. Panicked struggling will only sink the victim to the bottom of the pool. The individual who ultimately survives is the one who allows an open (but good-naturedly skeptical) mind and sense of humor to buoy them up. Those who can't or won't tune into the and/or brainwave will be left in uneasy confusion not just on anomalies, but also the unsure path humanity seems to be hurtling down faster every year. Informed confusion is fun and vastly educational!

Although I must remind our readers that we are NOT a "UFO magazine," the bulk of submissions this time 'round were saucer-related. Dr. Karla Turner asks us to consider the anomalous details in abductions as a path to true learning. Banging our heads on the Budd Hopkins wall certainly hasn't brought any concrete answers... Maven of Kookology Donna Kossy weighs in with a story about Oregon's one-man saucer religion named Leo Bartsch, and his miraculous story of healing and salvation under the power of our Space Brothers. The (intentionally) funniest man in the field is Jim Moseley, publisher of *Saucer Smear*-the longest-lived UFO zine in existence. Richard Sarradet has needled his deep-throat sources for a shiver-provoking overview of black-budget shenanigans, and presents us a tale with the theme of caveat emptor. Puerto Rico has always been a hornet's nest of strange activity, and now Scott Corrales twists the legend with further revelations of U.S. military interests on the island. You may have seen the recent press coverage of the "official" Air Force explanation of the Roswell incident, but what do we know about the man who wrote it?

There are no "answers"! Get hip to the saucers!

—Greg Bishop

PRIVACY ACT AND FREEDOM OF INFORMATION ACT REQUEST

_____ _____
 (date)

(requestor's address)

Federal Bureau of Investigation
Records Management Division - FOIA/PA Office
9th & Pennsylvania Ave. N.W.
Washington, DC 20535

To Whom It May Concern:

This is a request for records under the provisions of both the Privacy Act (5 USC 552b) and the Freedom Of Information Act (5 USC 522).

I hereby request of any and all records about me or referencing me maintained at the FBI. This includes (but is not limited to) documents, reports, memoranda, letters, electronic files, database references, "do not file" files, photographs, audiotapes, videotapes, electronic or photographic surveillance, "junk mail", mail covers, other miscellaneous files, FBI requests for infromation from other agencies or individuals, and index citations relating to me or referencing me in other files.

My full name: _____ Date of birth:_____

Place of birth: _____ Social Security #: _____

I have lived in these places: _____

Other names, places, events, organizations, or references under which you may find applicable records: _____

FOIA/PA regulations provide that even if some requested material is properly exempt from mandatory disclosure, all segregable portions must be released. If the requested material is released with deletions, I ask that each deletion be marked to indicate the exemption(s) being claimed to authorize each particular witholding. In addition, I ask that your agency exercise its discretion to release any records which may be technically exempt, but where witholding serves no important public interest.

I hereby agree to pay reasonable costs associated with this request up to a maximum of $25 without additional approval. However, I strongly request a fee waiver because, this is in part, a Privacy Act Request.

This letter and my signature have been certified by a notary public as marked below.

Sincerely,

(signature)

_____ _____
(printed name) *(notary stamp and signature)*

National Insecurity: A51/AFOSI/DOD/CIA etc...

Richard Sarradet

Here it is fall 1994, and World War III hasn't started yet, nor have flying saucers flattened the lawn in front of Bill and Hillary's house. Their backyard, however, appears to tell quite a different story. A couple of thousand miles west in the bombed-out, radiation-soaked desert of Nevada, these two subjects have merged into a sensational new mythology about cutting edge craft influenced by alleged alien technology. This article is a brief exploration of how this scenario came into being.

It was in the late 1980's that Area-51 at Groom Lake, or S-4, as it is allegedly called, came to the public's attention. We now know it to be a highly classified, black-budget, research, development and operation center. During WWII, it was known as Camp Murphy. After the war, the Atomic Energy Commission, under the direction of the newly formed Department of Energy, took control. The DOE eventually annexed millions acres of Bureau of Land Management (BLM) land for above and below ground nuclear testing. In the early 'fifties, the CIA discovered a vast track in the shadow of the 8,000 foot Groom mountains to he ideal for developing and operating its high-altitude, long-range reconnaissance craft, the A-12, and its infamous successor, the U-2. Since then, it has continued to grow as the military-industrial complex's black-budget baby nursery. The SR 71, the F-117A, the B-2, and the as yet unacknowledged Aurora class aircraft were all weaned within its sun-baked borders. These are only a few of the more or less "known" projects located there. Needless to say, security has grown apace. Air space above the Nellis range is totally restricted. Groom Lake (only a lake after desert cloud bursts) no longer appears on U.S.G.S. maps. Perimeter security includes electronic heat sensors, video surveillance, armed patrols and reaction teams provided by the Wackenhut Corporation. It is but one of many security contracts given to Wackenhut by the Dept. of Energy. According to the company's recent annual report, it operates in over 50 countries, including Russia. Internal security is provided by elite military troops from the Navy and Air Force. For many years, aerial recon photos were scarce. Today, however, such photos can be purchased from Russia in a new spirit of capitalist glasnost. See the March 1994 issue of Popular Science (p. 55) for an example.

In the early '50s, the CIA discovered a vast track in the shadow of the 8,000 foot Groom mountains to he ideal for developing and operating its high-altitude, long-range reconnaissance craft, the A-12, and its infamous successor, the U-2. Since then, it has continued to grow as the military-industrial complex's black-budget baby nursery.

If Moore's 1989 statement wasn't part of an orchestration by his Aviary friends, it might as well have been. The who can-you-trust list got shorter.

That is a thumbnail sketch of some of what's known about Area 51 and environs. Now where does this intersect with UFOs? The sequence might look something like the following. In 1980, Paul Bennewitz was the president of his own company, Thunder Scientific Laboratory. It was situated just outside Kirtland Air Force Base in Albuquerque, New Mexico and had contracts with the military. Already interested in UFOs, Mr. Bennewitz allegedly photographed and filmed them over the air base. He also claimed to be intercepting alien communications and decided to share his findings with the Air Force Office of Special Investigations (AFOSI).

His information coincided with official reports of sightings during August of 1980, reported by base personnel. In November of the same year, special agent Richard C. Doty, reported to Bennewitz and U.S. Senator Harrison Schmidt that AFOSI was not investigating these reports. However, Doty continued meeting with Bennewitz and with UFO author and researcher Bill Moore, who was the first to publish an in depth investigation in the 1947 Roswell crash of a supposed alien disk. He claimed to have developed a number of intelligence contacts with code names like "Condor" and "Falcon" etc. (the Aviary) that supplied him with inside information regarding UFOs and our government .

Then in July, 1989 at the annual MUFON Convention in Las Vegas, researcher Bill Moore acknowledged that he had been used by the AFOSI to monitor the activities of Paul Bennewitz, pass disinformation to him and report how well it "took." [See *Roswell Redux* in this chapter for more on this connection.] Bennewitz wound ever deeper into an extraordinary saga of little grey bug-eyed aliens, underground bases and secret treaties. This was at the same time that Budd Hopkins, Ray Fowler and others were publishing accounts of alien abduction by similarly described beings. Eventually, Mr. Bennewitz required psychiatric help. Moore defends his involvement because it allowed him to glimpse and reveal the extent of the governments counterintelligence operation against Bennewitz, and by extension the entire UFO community. Of course, whatever evidence, if any, Bennewitz might have had was thoroughly tainted, and the UFO community was all the more frustrated and fractured as a result. If Moore's 1989 statement wasn't part of an orchestration by his Aviary friends, it might as well have been. The who can-you-trust list got shorter. But it did reinforce that something mighty important must be going on for the government to have gone to such lengths to discredit Bennewitz. While nothing new may have been learned about UFOs, a great deal was learned about the power and extent of intelligence operations. In addition, it deepened suspicion and cynicism between and among UFO investigators. So one could say it was successful .

Another high-profile figure emerged on the UFO scene in the 1980s. He lived outside of Las Vegas and is the son of the famous aircraft developer William Lear. Theatrically surrounded by bodyguards, ex-CIA pilot John Lear also spoke at UFO conferences about underground bases, little grey aliens, secret treaties and UFOs at Area .51. Lear spun a tale of CIA conspiracy going back to the assassination of John F. Kennedy who Lear said wanted to talk openly about UFOs. All of this he worked into a New World Order scenario

with an extreme right-wing slant. Call it "H.G. Wells via Orson Welles meets Oliver Stone's JFK and Henry Kissinger of the Bilderburgers" with special guests Bill Moore and the Bluebirds.

Then came Milton William Cooper. UFO, ONI, CIA, JFK, NWO, J&B, Revelation 6:3. Enough said there.

Bob Lazar was next. On November 6, 1989, CBS-affiliate KLAS, Channel 8 in Las Vegas, broadcast a week-long investigative series called "UFO's - The Best Evidence," produced and narrated by George Knapp. One of the segments presented a man who called himself Bob Lazar. He claimed to be a physicist who had been hired on the recommendation of Edward Teller (father of the hydrogen bomb) to work at Area-51. His job? To back engineer the propulsion system of an alien craft. In the course of many interviews, he described seeing nine different craft parked in giant hangars, and to have had experience inside one. He called it the "sports model" for its relative smallness and child-sized seats. He tried to explain its anti-gravity reactor fueled by an unearthly substance designated Element 115. Aside from the technology, he described the intimidating and oppressive security treatment that accompanied working at the base. He recounted "gun to the head" threats and drugged interrogations by security which so annoyed him that he opted to quit and go public to protect himself. He felt that something was happening in Area 51 which the public ought to know about. In addition, he thought there were better minds to address the challenges of the technology than had been recruited by the government through its contract with E.G.& G. There are many more wrinkles to this chronology than are being covered here, not the least of which deal with the credibility of his story and identity.

Since psychological intimidation and drugs were allegedly used, was he telling the truth, or was he used to disseminate a certain scenario for intelligence purposes? Perhaps his independent personality simply rebelled against the system. Do we actually know any more about UFOs because of Bob Lazar? The government denied everything and supporting proof was hard to find. Lazar's story crystallized the connection between Area-51, and hence the military-industrial black-budget agenda, with aliens.

In the 90's, little grey aliens, Groom Lake and UFOs entered pop culture with the vigor of a Michael Jackson tour. Television shows, beer commercials, the entire Madison Avenue selling machinery were blasting us with the "alien" theme. Today one cannot open a magazine or watch TV without confronting a bug-eyed reptoid or two. UFO conferences continue to multiply and draw crowds and Area-51 is today fast approaching "I'm going to Disneyland" status.

In September of this year, TV talk show host Montel Williams conducted a follow up to a previous segment on UFOs. He showed footage of his own recent trip to Area-51, where he spent one afternoon, guided by Glenn Campbell, who has become the "A-list" guide to the spot. Campbell says he retired from his own computer company in Boston to move into a mobile home next to the little Ale'Inn in Rachel, Nevada, just over the hills from the Nellis range. He says one goes where the UFO stories are, so he went. He developed detailed maps of the region, noted the remote control cameras,

Campbell says that since he established himself on the scene less than two years ago, he hasn't seen anything that couldn't be explained by conventional military technology. He's also commented that "If aliens are real, so what? One still has to get up and go to work the next day."

highway vehicle counters, good viewing areas, Wackenhut and Lincoln County sheriff's radio frequencies, and compiled a handy booklet called "An Unofficial Guide To Area-51". He was Dennis Stacy's guide for an article in the October, 1994 issue of *Omni* magazine. He guided Stuart F. Brown, James Goodall, John Andrews and others on an excursion for *Popular Science* March '94. He was also interviewed by Larry King on the October 1 [1994] TNT special entitled, *UFO Coverup Live From Area 51*. Campbell says that since he established himself on the scene less than two years ago, he hasn't seen anything that couldn't be explained by conventional military technology. He's also commented that "If aliens are real, so what? One still has to get up and go to work the next day." A unique outlook for any serious UFO researcher.

The fact is, Campbell wasn't around in the late eighties and early nineties when some exotic lights were bobbing and streaking over the Groom Mountains in the wee hours and being captured on videotape by Norio Hayakawa and various other persistent investigators. If anything strange was flying back then, it seems all this attention has some what changed all that. Now Campbell, a day late and a dollar richer, offers us a cool, well-wrapped voice of reason. In fact, with the Larry King and Montel Williams shows over, and having already done the magazine circuit, we may have seen the crest of Mr. Campbell's popularity. So where does one go now to follow the UFO story, other than to wait for the little bug-eyed fellows to come hovering over the barbecue and give us their version of events? Inquiring minds want to know. Or maybe, since the whole question now about aliens is a "so what" for Campbell, he'll go back to Boston. But what about all the detailed research information that Mr. Campbell has generated? Does this put the issue to rest?

Let's take a step back and try to get a view from the "Top of the World", as one of the command posts has been overheard to call itself. What would you do if you were in charge of security at the United States' most secret testing facility, during the Lazar incident? What would be going through your head as you waited outside your boss' office? Would you wonder how much your weekly unemployment check was going to be? Or perhaps you might be practicing your response to the effusive praise you anticipated for the overwhelming success of the ultimate security operation.

That the Department of Defense has a very big set of challenges, even in the post Cold War era, goes without saying. But for this inquiry we'll focus on three:

1. To continue to develop cutting edge weaponry to preserve our nation state.
2. To protect the development of this weaponry safe and secure against foreign interests.
3. To continue to deal with all of the ramifications inherent in the presence of unidentified flying objects.

The first two are so obvious that they need no explanation. The third would fill, and has filled, volumes, not to mention classified briefing documents. UFOs, as we all know, are a very sticky subject for the Dept. of Defense. By now, everyone who has followed the search for government documents, especially through FOIA, has seen the trail of deception on this subject. It is, to put it succinctly, a labyrinth with no end in sight. The wall behind what is known remains unknown and is built on the impenetrable, legally self-justifying issue of

national security. Therefore, one thing we can deduce from this is that UFO secrecy some how serves national security, or at least the motives of those claiming to protect it. What are other possibilities? Let us enumerate a few.

If there are technologically superior, intelligently controlled craft "invading" this nation's (or any nation's) airspace, for which there is no effective protective response, to make this fact public might be socially destabilizing to say the least. And if at the same time, these craft do not appear to be actively attacking, perhaps it is better to maintain plausible denial, until events prove otherwise. Meanwhile, we'll all keep watching and learning and see what develops. Simultaneously, perhaps this unknown presence can be explained away in various "known" scientific terms: ball-lightning, swamp gas, temperature inversions, misidentified aircraft, hysteria, etc. If nothing else, it might assuage interest for the moment and buy time. Yet as time goes by, and the world remains a scary place with ever new and more sophisticated weaponry cropping up, it may serve as a useful decoy for one's own cutting-edge craft. Something like, "It's not ours, Mr. Chairman. It must be one of them damn UFOs."

As more time goes by, and even more exotic propulsion systems begin to become practical, perhaps these craft could go with impunity any where, and no one would assume that they were anything but "those UFOs". Another brand of stealth technology.

All this technology gets incredibly expensive, and harder to hide, even in the blackest budget. That's assuming, of course, that all of the funding comes from Congress. Somewhere during the Reagan/Bush years, permission was granted to the CIA to create legitimate businesses, use them and not have to tell anyone about it. What if they owned Kemper Mutual Funds, or some such company which might generate funding. How about the antics of Iran/Contra or BCCI? A declassified memo, signed by Robert Gates, on "Greater CIA Openness," states that the CIA can "manage" the media. Should we say: "Well done, Mr. Gates?" With the collapse of the "Evil Empire" threat, the providers of funding-the public-could also be influenced by an even more sinister threat: the one that everyone sees on *Sightings* and *Unsolved Mysteries*, etc. And the funding continues.

One of the problems that would face the government, if UFOs were real, and interacting with certain elements of it, is a confrontation with the learning curve. Buried in Cold War secrecy, at what point and how does the government reveal what it has learned? How does it manage the information leaks, and control the results of this situation? Everything in this article could have been generated by such a management effort. Reality is not perception, but if one can control the perception, one can control the reality. In the case of UFOs, spin control would be the order of the day. Spin control is generally a "soft" technology; what might there be in "hard" technology to control perception? Technologies that interface directly with the brain would usher in a whole new battle field. New weapons, new insecurities. National security begins to look like national insecurity, a new wrapper put on the old cold war.

In such a rapidly shifting agenda, all possibilities could be exploited to keep the public, whom the government is foresworn to protect, from being

As more time goes by, and even more exotic propulsion systems begin to become practical, perhaps these craft could go with impunity any where, and no one would assume that they were anything but "those UFOs". Another brand of stealth technology.

overwhelmed by the learning curve, thus widening the gap between the soldier and those he would serve. Time must be continually bought while perhaps well-meaning, but increasingly challenged techno-bureaucrats figure out how to proceed. Any avenues, as well as laws, regardless of their constitutionality are in play behind the principle of "National Security." The once expedient caveats of the need for secrecy may have led our unseen, unelected servants deeper and deeper into a game of unending isolation and deception. In the end, one is finally left pondering an observation: Namely that secrecy inevitably leads to mistrust; mistrust leads to insecurity and loss of faith, a very REAL, threat to national security.

Interview with Karla Turner: Don't Exclude the Anomalous

Greg Bishop and Wes Nations

Karla Turner, Ph.D. has authored two books on the abduction phenomenon. *Into The Fringe*, published in 1992, chronicled the Turner family's experiences over a one-year period and described their journey from ignorance and fear to an unflinching truce with the intrusions plaguing their lives. The effects of unnameable forces spread to include other relatives and friends, who discovered their connection with the phenomenon while examining earlier anomalous events beginning in childhood. Turner chose to call the agencies she and others encountered "aliens," but as a professor of English, Dr. Turner uses this label in a literal, dictionary-definition sense to distinguish the entities from any familiar personalization. She refuses to define a literal originating source for her encounters. Sorry, Zeta-Reticuli fans.

Self-published this year(1994), her second book *Taken: Inside the Human-Alien Abduction Agenda*, examines the stories of six women who wrote to her in the wake of the release of her first work. Discounting nothing in their confessions, Turner weaves the history of ever-increasing weirdness with which her subjects have lived from birth, as well as their families before them. She avoids the pitfalls of earlier abduction research and its disposition towards rejecting the "stuff that doesn't fit." Turner urges the abductees, and the researchers and therapists who work with them to consider all details, no matter how trivial, horrifying, or strange they may seem. It is only in this way, she feels, that we can begin to understand the purpose behind the illogic and "fright theater" of much of the abductee experience. The research community is working with information and recollections that are basically controlled by the agencies responsible for the abductions, she maintains, and must therefore sort through vast amounts of hay to find the needle that carries the thread of "purpose."

In person, Karla Turner is what used to be called a "little spitfire." Feisty and opinionated, she doesn't particularly care if you believe her or not. She has no patience for fools or dogmatists, but will readily deal with any intelligent questions. Her effervescence is contagious, and coupled with her disdain for "new-age" trappery and the slightest hint of the "politically correct," she engages in

Karla Turner

A lot of people have tried to push me towards the idea that this is totally human mind control. The evidence I have gathered and experienced just doesn't support that idea. There is so much in their (human agencies') programs of trying to play catch-up with the alien technology and what we're having done to us.

interesting and enjoyably challenging conversation on any topic. Her current favorite subject is her new grandson.

We chose to speak of course about the abduction scenario, and the effects it has had on her life, her family and friends, and the women she contacted for the research in *Taken*. Wes Nations of *Crash Collusion* magazine joined us for lunch and a smoke outside later. Take heed and enjoy.

Karla Turner died in early 1996 of cancer.

Q: Many researchers / writers / abductees have described the "end of the world" scenario, and its imminence as presented or described by their abductors. How do you deal with this aspect of your experiences?

TURNER: I've never had anything personally told or shown to me, although other people in my family have. What happened to me was that I woke up on August 4th, 1989 with no memory of anything happening, but programmed to "get the hell out of Dodge City" as soon as possible. We were living in the Dallas-Ft. Worth area. The compulsion was very specific, and extremely urgent and over-whelming. I made plans with my whole family to have a place where we could meet within fifteen minutes from our various locations during the day at a certain point to get out. I loaded the trunk of the car with every single item I could for starting over in a new place. The only way I could sleep at night was knowing that we had a plan to get out. It took two years to get up the money to actually make the move and fulfill the requirements for our new place: it had to be at least twenty acres, it had to have its own water supply, its own fuel supply, it had to be in a very sparsely populated area.

When I got there I ran into thirty different abductees from around the country who were "programmed" as well to get out of New York, Oregon, Arizona, Iowa, etc. and move to Arkansas. I know it was not my own desire to do this; I never wanted to live in the woods, I'm a girl from a town. It's not something that suddenly I woke up and said "I want to do this." It was "YOU need to do this NOW." So we built a house on 23 acres and moved in.

This is how I was personally treated by this thing. For instance if you read in *Taken*, where I was shown the "Jacob and Esau scenario," you know I'm highly skeptical anyway, and I'm told that this is all a manipulation. [In the incident referred to, Dr. Turner was shown a live dramatic presentation of a biblical story to illustrate the deceptive nature of the aliens' manipulations, coupled with a warning that giving in to apocalyptic fear was unwarranted. It is all a lie, she was told, to frighten humanity into acceptance of alien control.] I received a very different treatment from whoever I dealt with that time. It confirmed the fear I'd had ever since I'd heard the term "new age." There are people being taken for such a ride-being placed on a spiritual sled of their own delusions.

Q: I have been told that the technology is available for a truck to park on the street in front of your house and without coming anywhere near you, to "run" an entire abduction experience through your mind. Much like the "virtual reality" scenarios you say have been given to abductees.

TURNER: A lot of people have tried to push me towards the idea that this is

If I were them [aliens], I would have helped humans along to a point where they could pretty much run the farm for themselves, and all I would have to do was periodic harvesting. The theory that I'm hoping to get evidence for is that they upgraded the intelligence level of the herd to be self-maintaining, but this has proved to be a double-edged sword.

totally human mind control. The evidence I have gathered and experienced just doesn't support that idea. There is so much in their (human agencies') programs of trying to play catch-up with the alien technology and what we're having done to us. I am confident of cases going back to 1905, when we didn't have this technology. My husband had an episode on Labor Day in 1947 when he was 11 months old driving with his father in the Sierra foothills, which was independently supported by his father. I really don't think the technology was there then. Today, who knows what they're doing. The history of this scenario is longer than our technology in this area. So, I'm not convinced about the solely human-controlled theory.

Q: Do you think it may go back before 1905, as in the fairy lore stories, and their many similarities to abductions?
TURNER: I'm talking hypothetically here, and there's only one thing I'm convinced of, and that's that these things lie—they lie like dogs about their motives—and they say they own us. In a book called *The Way Of The Shaman*, a man goes to South America to study with a shaman. He had taken this strong psychedelic and described these reptoid "things" coming in from space who say they own the earth and humanity. And he goes back to tell the Shaman, and he's told "Well, they lie." I think that they well may have been messing with us for a long time. My sense is more "Keel-ish" than "Valée-ish"; we are a highly valued resource that is husbanded as a farmer cares for a dairy cow. This would explain so much as to why this is trans-generational, and why the genetic study is done. Give a farmer a choice to get a sick kid to the doctor, or a sick cow to the vet, and that cow's going to the vet! The cow may well be thinking, "Wow. That farmer takes such good care of us, and performs these miraculous healings, and protects and loves me so much." And you don't "invade" cows, you use them. There's a difference.

If I were them, I would have helped humans along to a point where they could pretty much run the farm for themselves, and all I would have to do was periodic harvesting. The theory that I'm hoping to get evidence for is that they upgraded the intelligence level of the herd to be self-maintaining, but this has proved to be a double-edged sword. Perhaps the cows have gotten wise enough that they're getting uppity and they're not going to do it anymore.

Q: Just discussing the matter forces people to think in different ways, that is if they don't just reject everything outright. I can't seem to get any concrete position or opinion out of you on the subject…
TURNER: But I don't have one. I'm so reluctant to be taken in by a false scenario that I will reject what may well be the truth for as long as possible until it is irrevocable. When I pray, I ask for the "God Of Truth And Love, if you exist, because I don't want the rest of you guys." I do say "if." You're talking to probably the most skeptical person in this thing, and if I could say anything for certain, I would. I wish I had something concrete I could hold on to. It's gotta be right or I don't want it, but they design it so that the rules always change. You get a handle on one thing, and immediately they change where the handle is. They're certainly not studying us to

> As much as I admire Budd Hopkins, he's one of the worst in saying, "I throw out all the anomalous details until I've got 20, 30, or even 200 anomalous cases that I'm not going to pay attention to." Well sure—they're running the same damn "movie" over and over for everyone. The truth to me more likely is going to lie in the anomalous details.

learn more about the race; they know us better than we know ourselves. They can manipulate us far better than we can manipulate each other. I think "cross-breeding" is one of the biggest scams they're pulling on us.

Q: It seems from what you're saying that the "facts" from which conclusions are drawn are designed to promote faulty correlations and paths of reasoning.

TURNER: This is why [the interbreeding scenario] is such a wonderful propaganda tool to make us think that we share offspring, and they're doing it to "save" us, on top of that. Of course they tell us they're doing it to save them...

Q: So they really are "space brothers."

TURNER: (Laughs) Yes, that's right. "We must have some commonality — we can breed" — yeah right. Yet, when I see the hybrid nursery, I tend to think that they have some favorite "movies" that they run for almost everybody. I'm talking about in a "virtual reality scenario." As much as I admire Budd Hopkins, he's one of the worst in saying, "I throw out all the anomalous details until I've got 20, 30, or even 200 anomalous cases that I'm not going to pay attention to." Well sure-they're running the same damn "movie" over and over for everyone. The truth to me more likely is going to lie in the anomalous details. I've come at this from a completely different approach, and he's very reluctant to pay attention to anything I've had to say. I always paid attention to what he's saying though, I've learned a lot. We couldn't be doing anything the rest of us are doing without his work.

> I use [the term] 'abductee' because as a teacher, I understand the definitions of words. We are abducted. We were 'experienced' with Jimi Hendrix! I think words are important. I also think some people are just scared shitless.

Q: Well, it's a logic of illogic in a way. The scenario you are depicting is very non-linear. What I find confusing is that Hopkins is a non-representational artist, but he doesn't let that kind of thinking into his UFO research.

TURNER: This is what blows my mind too. Hey, they're all telling the same story because they all went to the same movie. I wish he would consider that.

Q: Has anyone criticized you for "telling"? That is, have any other researchers complained that you are "contaminating the data base," as it were?

TURNER: Budd has said that about his own research, but he's never said to me "Don't tell people your stuff." He chooses to be paternalistic and protective towards abductees and the audience, and he has explained in public that he's trying to reach a mainstream group, and you don't give them everything at once, because they'd run off and wouldn't listen. That's just not my approach. I think people are adults, and have a right to the facts. One time I was giving a lecture and a woman started moaning and left the room in tears. I found out later that something I had said triggered a memory, but I talked to her later and it was allright. Later however, I was told that another researcher had heard about this (he wasn't there) and said that I was dangerous and shouldn't be allowed to speak in public.

Q: Another book-burner...

TURNER: I was told he said that I was talking about human mutilations and so forth, which wasn't even close to the truth. That's the only time I've heard

that I was targeted for criticism. Perhaps there have been many others, but that's the only instance I've heard about it.

Q: *Why do you use the loaded term "aliens" to describe what you have encountered when you say you won't assign a specific origin for them?*
TURNER: It's a shorthand term. I'm an English teacher, and we get stupidly picky on things like definitions, and "alien" means "other." I don't have a better term than that.

Q: *A certain segment of the research community is starting to use the term "experiencer" instead of "abductee." I find this too politically correct for my tastes, and also because of the fact that everything is an "experience"...*
TURNER: I use "abductee" because as a teacher, I understand the definitions of words. We are abducted. We were "experienced" with Jimi Hendrix! I think words are important. I also think some people are just scared shitless. I got over that a long time ago. Don't bother threatening me. I know we're all going to die. That's no threat — I'm not afraid. If I could get my hands on them, I'd do some things myself!

Q: *Have you heard of any abduction accounts from other countries that correlate with the details of American cases? Are we just culturally bound to our standard version because of a self-imposed information blackout?*
TURNER: Lots of accounts have come in. They are similar. You get some physical differences and some identical things. You also get people like Michael Hesseman who have the absolute inanity to suggest that only Americans have bad abduction experiences by greys or reptoids; it's not true. It's like the guy who says that we're being abducted because of guilt over what was done to the Native Americans. If you start looking at what really comes in, you see it's going on in South Africa, Russia, France, South America...everywhere's got it.

Q: *The same scenario?*
TURNER: In many cases, somewhat the same, in others a whole lot worse. There are some cases in South America where I say 'please don't let that happen here.'

Q: *Well, the UFO cases from South America have always been a little more "intense" than here. Do you think that's a culturally-specific thing?*
TURNER: It may be cultural bias. It may be communication differences or problems. It may be that people in ufology consciously or unconsciously do their own sort of censoring of what happens...I don't really know. I'm not on the "inside" of any of ufological research. I'm a member of nothing, I have no backers or endorsers. For the most part, the "big names" either try to avoid me or ignore it, so I'm not really in a position to tell you what's going on around the world, except through people I know who manage to have contact with these information sources.

These are not things that are hypothetical in my life. They're there. They're real. I can't help it if it's not in somebody else's life and I can't argue about it. My job is not to convince anyone of anything. My job is to work with people who already know this is in their lives. That's all I see in my work. I'm not out there to change anybody's mind, and I don't blame them for asking every skeptical question they can.

Q: There was an instant in Into The Fringe *where you met for the second time with a therapist who said that he "wouldn't react that way now, believe me" when you confronted him again with your abduction experiences. Did you ever find out what changed his mind about taking you seriously?*

TURNER: I tried to get him to tell me why, actually. He said, "Well, I was just so unprofessional..." He would not go into it with me. Not long after that, I sent him an announcement about TREAT [society for the TReatment of Experienced Anomalous Trauma.] I told him that "Well, here are some people in your field who seem to think there is something to this." Basically he said that he had learned enough at that point so that he should not have dismissed it out of hand. Other than that the guy was an academic-he wouldn't go any further. He was young and was trying to get a career going.

The worst moment I have had with that man was when I met with him the first time. I described my experiences and he said it was all psychological, yet he wouldn't touch the subject. Then I asked him, "Well then, what are we supposed to do about all these" and I showed him some puncture marks on my skin. He reached out and held my hand and said, "I wouldn't be showing those scars to people, they'll know you've been abusing yourself." That was the lowest point emotionally that I had felt through all this.

Q: Perhaps this next question will offend you...

TURNER: Hey, after that nothing could offend me, I don't think.

Q: When I heard about the mysterious marks on abductees' bodies, I was immediately reminded of the stigmata phenomenon, and I wonder how much stake you would place in that sort of explanation.

TURNER: I have tried to consider that as an explanation. The sheer weight of what I've been through and in case after case that I've examined doesn't support it very well. That would be on my "list of facts" as far as I'm concerned-its not stigmata. When I moved to Arkansas, I promised myself that I would get a sympathetic doctor. I found one with a family member who had had a UFO sighting, and she knew the relative was telling the truth. So I asked her if she would be willing to document anything that appeared on me besides the normal punctures and bruises. I wanted her to document them and give me the best medical explanation she could as to where they'd come from. At one point she had to document a slice of skin which had been cut open in my genital area. I had gotten up at 3:15 AM to go to the bathroom, and it wasn't there. Believe me, you'd feel that kind of thing. At 7:00, when I got up, it was there, and the doctor told me, "I don't believe that anyone other than a completely psychotic person could have done this to themselves." The scar is still there.

Q: Have you or anyone you know ever been hypnotically regressed and found nothing out of the ordinary actually happened, or even something that was completely prosaic?

TURNER: I normally don't do any regression, except in an emergency situation. Barbara [Bartholic, a therapist from Oklahoma] who I generally refer people to has worked with people who have had a dream, or something that

Have you heard of something called 'emotional vampires?' I would put at least some of these beings in that category. A lot of these (what I call) Virtual Reality Scenarios [VRS] are designed to elicit emotions that are literally 'harvested'-energy of a certain sort.

they want to explore and came up with nothing unusual. Other than my husband's initial abduction memory from 1947 which was confirmed circumstantially by his parents, we have not looked at anything under hypnosis, or at least anything of which we didn't have at least a partial memory.

Q: Many people would have a problem with your reliance on so-called "dreams" as reliable sources for information. Has anyone mentioned this to you?
TURNER: Not that I have heard. And it wouldn't change my mind anyway. These are not things that are hypothetical in my life. They're there. They're real. I can't help it if it's not in somebody else's life and I can't argue about it. My job is not to convince anyone of anything. My job is to work with people who already know this is in their lives. That's all I see in my work. I'm not out there to change anybody's mind, and I don't blame them for asking every skeptical question they can. Once it's happening, they can come talk to me and we'll go from there.

Q: There is a comparative chart in the appendix of Taken *that lists the women subjects and compares background, psychic abilities, poltergeist phenomena, ancestry, and so forth. I found this a helpful tool for getting thoughts flowing. Why did you include it?*
TURNER: I put some of those subjects on the questionnaire that went out to the women because some people in the field have raised certain points. Some say [abduction experiences are] a result of Celtic ancestry, Native American Ancestry, people who have members of the family in the military, child abuse, psychic experiences, etc. For example, I personally have every reason to believe that everyone has a psychic gift.

Q: Just not developed in most cases.
TURNER: Yes, and some things are so irrelevant that people want to hold on to as relevant, that I thought the chart would make it clear that there is no one contributing factor. It's also not surprising that most of the women have Celtic ancestry if you look at the population and history of this country. In China they don't, and in South Africa they don't. We forget that we're living in a place that has a certain cultural heritage.

Q: Do you think we can ever "catch" whatever is causing these experiences?
TURNER: Yes. I think they're physical and finite and fallible. I know this from firsthand experience. There is hope. I think one of the biggest fallacies they perpetrate on us is that we can't do anything about it. If we couldn't do anything about it, we wouldn't even be talking right now. In the last few pages of *Taken*, I do present an optimistic theory. In the last year or so, I've felt a growing sense of certainty and joy and something inside that makes me feel that we're not warring in vain. People just say I'm getting "religious." You know me, I'm not that way. It's just a stronger feeling. I have started to listen to my gut a lot more, and it's helped me to survive better with this thing. Maybe we'll have to start listening to our intuition, and controlling any psychic gifts that we may have. It may well be that it will take the kind of intense stress we're seeing to kick it into gear.

Personally, I don't believe God screwed up and gave us the wrong existence. It's blasphemous to suggest that we're not physically put here for a purpose. I'm one of those stupid people that have never seen the Earth as a "school" a "trial" a "prison" or a "test." I think it is a worthwhile thing that we're here.

Q: You said they were coming to control people and keep them in line...

TURNER: That's that double-edged sword I was talking about. They came in to make the farm self-sustaining and keep it from going any further and it's still a-going. I see this as a highly ironic possibility.

Q: Perhaps it's some sort of "tough-parenting" scenario.

TURNER: I think that's really stretching it. It's a desperate desire on the part of people who don't want there to be devils. I'm not saying these things are "devils," of course-that's the only real criticism I have of Vallee's thinking. He will go all over the map to avoid a straight line that logic and evidence points to because he's afraid of what's on the other side. He will go to absurd leaps to get around something that he finds personally repelling.

Q: I've heard John Keel sometimes does that.

TURNER: I spent a lot of time checking out one story that was easily obvious to look into. Keel talked about this guy named Bruce Berkin from Asbury Park, New Jersey. I'm a Bruce Springsteen fan. I've gone to that area many times. Keel said this guy was abducted off the shore right there not two blocks from the Stone Pony bar. He was missing for two months. They put out flyers, there was a massive search, and they finally held a memorial service. Suddenly, two months later Keel says the guy shows up with no idea of where he's been. He described him physically and gave the dates. This did not happen, okay? I checked everything from the police records to the papers, to...everything. There wasn't even a record for this happening to someone under another name. That sort of bothered me. I like Keel's work, but as something to base your life on I'd be careful.

Q: You and a lot of your study subjects have described what you call the "night of lights" dream of many UFOs arriving on Earth. What do you find unique about this? I've had those dreams. Many friends of mine have had them...

TURNER: I don't know what's behind that. It may be part of the mass-programming scenario, it may be the "trailer" to the movie, the "cartoon" or something. Either we're generating it as a natural human response to something anticipated, or it's part of getting us to the point of thinking that there is nothing we can do, and to accept anything that looks like help.

I'll tell you this: I don't have any fear of them. People say that I'm too angry or defensive, but anyone breaking into my house, I'm not going to be nice to.

Q: One of the men in your family had an experience in which he was called outside by a beautiful woman and while they were in an embrace, the woman appeared to change into a hideous creature. What do you think was the purpose of that?

TURNER: Have you heard of something called "emotional vampires?" I would put at least some of these beings in that category. A lot of these (what I call) Virtual Reality Scenarios [VRS] are designed to elicit emotions that are literally "harvested"-energy of a certain sort. When I put out my next book [*Masquerade Of Angels,*] it's going to blow the lid off the "new age", if people will be open-minded enough to respond to it.

Q: Has anyone actually ever retrieved an "implant" from an abductee's body?
TURNER: Sure. I've seen them on X-rays, MRIs; a friend of mine, Derrel Sims has some right now. There are also some like a little metallic thing with wires coming out the end that a man's chiropractor found. The test results on these things are inconclusive. Perhaps we don't have the technology yet to examine them properly.

Q: If there were so many abductions 40-50 years ago, why are they only being discussed now?
TURNER: As a child, my husband's grandmother had an abduction and missing time in the middle of the day. She was six- or seven years-old and they were living in east Texas. There was a swampy area near the house that the kids knew they were not supposed to go into, and a beautiful, mysterious little butterfly led her off into the swamp one day, where she had a couple of hours of missing time before this beautiful, nice lady let her back out. This was reported as a child in the early 1900s. What did they think about it at the time? Angels perhaps?

I think the reason that this was never reported was for the same reason a lot of us who have had this in our lives since childhood never remember this until a certain point. There's either a timing mechanism that goes off at a certain point, or we're in a changing state as a species where we slowly beginning to get the perceptions to see these things. You and I can't see X-rays, but perhaps if we developed a new ocular perception, we could. That's my hypothetical answer to that question, and it's all I can give you.

Q: Do all your anomalous experiences involve "aliens?"
TURNER: I'll tell you a story about what happened when I was 22 years old. I was getting ready to leave for India to meet up with my first husband, and at 4:00 in the morning one night before I was going to go, a man came to the door and told me he was there to take me to India. This was a 3-4 day trip, and we went: flew there and got in a Jeep and drove across this weird landscape to a big village. He took me to this house and showed me how everything worked to cook, to get water, etc. Then we went back: got in the jeep, went to the airport, flew back to Texas, and went back to my house. The next thing I knew, I was sitting on my bed and it was two hours later than when I left. I thought: what a weird dream! I didn't actually leave until the next month to fly to India. I got there and my future husband wasn't there. He didn't get the message that I was arriving two weeks early. I found another American who knew him and who offered to let me stay at his place, so I got in the jeep with him and drove about an hour until we came to a village. "Turn off here" I told him, we drove through this place until I saw the house from my "dream." I told everyone, "This is my house. Break the lock." We finally got someone to do this and went inside. This house was the one I'd been shown. There were pictures of me on the walls, the kitchen was exactly as I'd remembered it, and everything was in place. My fiancée did not show up for five days. I was there with my four year-old kid for five days alone. If I had not been taken there before, I don't know how we would have made it. Abductees often have other stories besides the alien ones.

Q: What happens to abductees' spiritual orientation during the course of their experiences?
TURNER: They get more non-dogmatic, and the aliens train them not to be so attached to their bodies. "It's just a container." Of course this is to their advantage, because they can then do anything with the abductees' bodies. The "just a container" idea seems to be the thrust of a lot of the "spiritual" dogmas that are pushed. It moves toward devaluating us from our physical existence. Personally, I don't believe God screwed up and gave us the wrong existence. It's blasphemous to suggest that we're not physically put here for a purpose. I'm one of those stupid people that have never seen the Earth as a "school" a "trial" a "prison" or a "test." I think it is a worthwhile thing that we're here.

Q: Trying to assault the abduction field with logic doesn't seem to help. Once you nail down one or two aspects of it, much more is left unaddressed. Have you been able to form any kind of scenario that would put your experiences into some kind of coherent form?
TURNER: My husband and I sat up late one night and said, "Let's throw out all the things we'd like it to be. Let's throw out all the theories we know have holes in them. What could we come up with that would unify everything?" It would have to do with these creatures being strictly of Earth origin. If you take the history of the planet as far back as we can with our limited perception, the first life forms to arise into any dominance were probably insectoid, and if they survived long enough to develop into an insectoid race, and there was a cataclysmic change as the Earth goes through every so often, perhaps they could have gotten themselves off the planet or dimension-jumped or something like that. They would come back and re-establish themselves. The next group to come to dominance is reptilian, and perhaps we get intelligent reptoid life. The cataclysm happens again, and the reptilians see the mammalians come to dominance. These could very well be creatures of the Earth, who have developed their own technologies through eons of time, and look upon us as a resource, in the way we look upon some animals as our resource. That's the only theory we could come up with that explained things to our satisfaction. No one ever talks about it, it's just something we came up with to help us deal with things. I'm still very open to other theories.

One of the letters I received from Karla after we discussed the fact that nearly all of her correspondence had been obviously opened and resealed. She took to writing "sealed by sender" on the envelope flap and then putting her own tape over it.

UFOs Are God's Angels: Leo Bartsch and His One-Man Crusade

Donna Kossy

Leo Bartsch, "the one and only most outspoken UFO researcher in all southwestern Oregon since 1959" doesn't get along very well with preachers; they wish he'd just stop talking about UFOs. Nor does he get along with UFO enthusiasts; they wish he'd just stop talking about the Bible. Neither preachers nor the UFO crowd will accept, as Bartsch keeps telling them, that the Bible is "the best book on UFO," and that UFOs are angels sent by God to expose "false religion."

Bartsch, a resident of Coos Bay, Oregon since the forties, began his devotion to UFO research in 1959, but the story of his one man crusade begins three years earlier, at the death bed of his first wife. "When she died, I was holding her head in my left arm," Bartsch recounts. And it felt like something just crawled in that arm. Afterwards, I had to go to the doctor. The hand had the shakes and it was like the blood didn't want to go into that arm." Part of his arm became numb, and its movements were out of his control; despite doctors' attempts to heal it, the arm only got worse.

During the next few years, with his sick arm in tow, Bartsch remarried and continued his career as a real estate agent. But on September 27, 1959, Bartsch suddenly became a man with a mission. At 3AM on that day, Bartsch awoke. Though he saw nothing and heard nothing, he somehow "just knew" that a UFO was near, and told his second wife that "something out of the universe just went low over this roof." Though his wife felt nothing, Bartsch "became weightless for almost a minute," and his "arm became normal almost instantly." Bartsch realized that his wife thought he was drinking or having a nightmare, so he told her to be sure to look at the clock and remember the time; he knew somehow that his story would be backed up with a report in the next day's newspaper.

Sure enough, the next morning a Coos Bay newspaper reported that a woman and her two young sons in nearby Empire had reported seeing a brightly colored object passing low over the ground; they saw their object at exactly the same time that Bartsch became weightless. There was another report in Redmond, Oregon shortly before which also fit the description of

Leo Bartsch in 1960

Neither preachers nor the UFO crowd will accept, as Bartsch keeps telling them, that the Bible is "the best book on UFO," and that UFOs are angels sent by God to expose "false religion."

the Empire sighting.

Before this incident, Bartsch had been busy with his career, and hadn't paid the slightest attention to flying saucers. But now, after being "exorcised by a UFO," Bartsch began gathering information and attending UFO research meetings. But his most burning questions weren't answered until 1962, when he began to "look for spiritual help":

> For some unknown reason I looked up and silently said, "Oh, God, who are thou?" Then suddenly, my entire left arm that had been healed back in 1959 felt like a sparkling electric contact, yet wonderful! Then suddenly I heard these words, "How did you like your answer?"

Though he saw nothing and heard nothing, he somehow "just knew" that a UFO was near, and told his second wife that "something out of the universe just went low over this roof."

Bartsch began studying the Bible, which convinced him that UFOs are electric living creatures sent by God to fulfill prophecy. Assuming that the clergy would be interested in such information, he wrote letters to over 100 churches, but received only three replies: one minister told Bartsch that he had a warped mind, another telephoned to ask what UFOs were, and the third arrived in person, expecting to meet "the most demon-possessed man on earth." Bartsch continued to entertain the representatives of organized religion at his home, but soon realized that they were incapable of understanding the truth about UFOs:

> I had a Baptist minister and a Pentecostal in my home to talk to me about my UFO stuff. They got to arguing so much they weren't even talking to me. Then there was a knock on the door and it was a Seventh-day Adventist. Pretty soon all of them got into one big hell of an argument. I never had such a wonderful time as I did listening to the three of them cut each other up.

Besides a good laugh, the clergy provided Bartsch with the last piece to his UFO puzzle: The reason God was sending UFOs to earth was to expose organized religion as "false religion," in preparation for the Last Days. Bartsch was now ready to go public with his earth-shattering message.

Bartsch began a letter writing campaign which included newspapers, government officials, celebrities and his fellow UFO researchers; He corresponded with J. Allen Hynek for years; he also received a very positive, personal reply from Shirley MacLaine. But the response from the mainstream UFO crowd was disappointing:

> I kept saying, 'Let's start with the word 'supernatural' and everything would fall into place.' Figure it out. You can't shoot them down. You can't capture 'em. They've got to be supernatural. But all those other people wanted to talk about our space brothers. They wanted to talk about ships from Mars and Venus—cigar-shaped ones and round ones and small ones and big ones. They'd talk about everything but the supernatural. They want 'em to be made out of nuts and bolts and iron. If that was true, the junkyards would be full of 'em by now.

Bartsch continued to hold court in a special room he'd set aside for UFO discussions, which doubled as world headquarters of UFO NEWS." When the flying saucer fans arrived he'd show them a UFO episode of the TV program "You Asked For It," to break the ice. But inevitably, they would try to explain UFOs scientifically. As soon as Bartsch would bring out his Bible, they'd leave.

But Bartsch held his ground, and continued to search for converts elsewhere. During the '70s, be blanketed the U.S. with letters and flyers, one state

at a time. He also began placing large ads in the Coos Bay World, with such headings as, "UFO FROM GOD OR SATAN?":

> My UFO encounter back in 1959 did reveal the answer to this. Yet as a business man, the last thing I wanted was a confrontation with conflicting religions. But when some religions teach that UFO are satanic - this caused me to become very outspoken about the real mission of the UFO, and soon found myself judged and condemned, right from the pulpit, where you cannot speak in your own defence, where brain-washing is legal and this mass hypnosis has become billion dollar business, that will not allow reproof for correction. So let us find out why all the religious leaders ordered Jesus put to death (Matt. 27:1) and why a religion (NOT UFO) deceives the whole world (Rev. 18:23).
>
> We know a serpent has a forked tongue, and satan was called "that old serpent which deceiveth the whole world" (Rev. 12:9). ...And now, these serpents and devils transform into ministers of righteousness and false apostles of Christ (2 Cor. 11:13-15). ...
>
> But this will be exposed by a flying object 15x30 feet (Zech. 5:1-4) and the flying objects of God are many. So to cover this up, these blind guides try to hypnotize their captive audience into BELIEVING only the occult world contact UFO, or that satan has a counterfeit everything God has, to have you believe that UFO are satanic. But the "ONLY" satanic UFO comes out of the mouth of those who speaketh with the forked tongue, because they hope and pray they are not from God.
>
> — *Inspired by a UFO encounter that revealed the inner man (2 Cor. 4:16-18). Leo Bartsch (non-sectarian)*

Only recently, after Whitley Streiber and others suggested that their experiences with alien creatures belong to the supernatural, rather than the physical realm, has the UFO community even considered the possibility that UFOs could be something other than "brothers from another planet." Bartsch, it seems, is ahead of his time, despite his reliance on the Bible for information. His insistence that UFOs are "Electric Living Creatures" is at least as plausible as the standard idea that UFOs are little ETs in spaceships, who just happen to defy all known laws of physical reality:

> The UFO can disappear right before your eyes; and they do pulsate and glow in all colors of the rainbow, and are consistent in causing electro magnetic effects all over the world. But first let us compare the electric eel, which scientists now call "Living Lightning," and can recharge itself instantly. So these UFO could be supernatural living creatures which can recharge themselves instantly. But where do they come from? When we know where our mysterious eternal energy, called electricity, comes from, we will know where these UFO come from.
>
> Lightning proceeded from the throne (Rev. 4:5), and lightning is electric; and God's throne is like wheels of fire that issue a fiery stream (Dan. 7:9-10); And the face of angels have the appearance of lightning (Matt. 28:3), and they ascend in a flame of fire (Judges 13:20).
>
> Perhaps we could understand this all better if we knew more about certain living creatures whose body is like beryl, and his face is as the appearance of lightning, and his eyes as lamps of fire (Dan. 10:6); or a living creature which comes with a rainbow on his head and his face as it were the sun and his feet as pillars of fire (Rev. 10:1). Yes, a living creature which may look like a fireball, rocket, meteorite, or a UFO glowing in all colors of the rainbow. ...
>
> ...And now electricity is like an angel to man when man transformed electricity into man's messengers to send, or teleport, his words and image almost instantly all over the world by radio or T.V. Even man was transported from one place to another instantly in Biblical times (Acts 8:39-40). Angels did act in various capacities as

When the flying saucer fans arrived he'd show them a UFO episode of the TV program "You Asked For It," to break the ice. But inevitably, they would try to explain UFOs scientifically. As soon as Bartsch would bring out his Bible, they'd leave.

guardians, messengers, and did transport.

Now UFOs seem to travel the same way, as does electricity send or receive; and electricity is a visible fire or invisible things as are angels. We may entertain angels unaware, (Heb. 13:2). ...

The Great Northeast Blackout of Nov. 9, 1965 that could not happen (but did) which took even the government electrical commission a week to decide the whole Northeast of USA and 30 million people were blacked out by one little relay switch. Well, they had to give some answer or admit UFO. ...If God should remove all electricity from this earth even man's brain cells would black out as it is known they also register electricity. ...

Ezekiel's wheel sounds like a living dynamo which he called the wheel with-in a wheel a living creature that did light up like lightning and was like a whirlwind. Ezekiel spoke with the Spirit of God in him, or God spoke through him as man does through radio or TV except God's way is perfect and limitless; so when Ezekiel said it was a living creature, that is just what it was! So is live electricity; so are UFO; and if you are earthbound or grounded don't touch a live wire to find out unless you are positive.

It's been over 35 years since Bartsch's UFO encounter, and still, nobody has produced a crashed saucer or an extraterrestrial, alive or dead. UFO researchers may finally begin to look at alternatives to the "ET hypothesis," but they will probably never give any credit to Leo Bartsch for saying that UFOs are supernatural before anyone else did.

References

"Are U.F.O.s Supernatural?" by Malcolm L. Koch, *WEEKLY*, Bandon, OR, 2/18/77
Flying Saucers, Electricity, and the Bible by Leo Bartsch
"I Was Excorcised By A UFO" by Beauregard Briggs, *National News Extra*, 9/15/74
"UFO Crusader Flies High On His Theories: Leo Bartsch On A Mission" by Mike Thoele, *The Register-Guard*, Eugene, OR, 4/18/88.
UFO Electric Living Creatures By Leo Bartsch

The Secret of Hart Canyon: White Vans and Desert Car Chases

Dean Genesee

In the summer of 1987 I obtained a copy of William Steinman's *UFO Crash At Aztec.* In an impressionable mode, I read with fascination about the crash-retrieval of a 100-foot diameter disc which had allegedly made an emergency landing in the desert 12 miles from the northern New Mexico town of Aztec.

On the personal pretext of a rendezvous with two friends in Las Cruces, I flew into New Mexico three days early, rented a car, and pointed it north towards the Four Corners area to take a leisurely drive through the mountains of the northern part of the state. Stopping briefly at the famed secret saucer base at Dulce (which couldn't be seen, as it was underground) for a few pictures of the lovely countryside, I continued to my destination. It still puzzles me as to why Wilhelm Reich identified desert regions as the result of the effects unhealthy DOR, (Deadly Orgone Radiation) and a source of physical and emotional desolation. Deserts (especially those of the southwestern US) have always given me the feeling of "charging up my batteries," and in general clearing out the muck of civilization. Perhaps it's just the result of uncluttered stimulation and the useful introspection this encourages.

Aztec, New Mexico lies almost at the southern border of Colorado and to the west and northwest respectively, Arizona and Utah. The land in this area of the state is high desert, with thick underbrush unbroken by any significant landmarks. Stopping at the local cafe for a lunch, I asked a local the way to Hart Canyon road. I was too embarrassed to tell the kindly man why, and made some excuse about looking for a piece of property my family used to own. "All BLM [Bureau of Land Management] and oil company land out there now" he said. I thanked him, belched heartily and paid my bill.

With some difficulty, I found and followed the dirt road exit for about 6 miles to the site clearly delineated by Steinman as where the space vehicle had come to rest. With the car safely parked out of sight from the road, I began to explore the plateau for any signs of past activity that the book had mentioned. All I could find were a recently poured concrete slab and a few cattle bones, bleached white in the sun. After taking a few pictures and wandering about on the mesa, I

After driving for a few hundred feet, I passed a fork in the road which branched off to the rear of the direction I was traveling. A plain white pickup truck with no discernible markings shot from this entrance and assumed a position nearly touching my bumper.

began to get the very uneasy sense that I was being observed. The exact feeling was like running around naked and unprotected while someone watched.

I ventured to the edge of a steep drop-off that overlooked the road I had come up on. Too far away to see any detail, but enough so that I could see someone in it, was a white late-model American car sitting beside the road. The car was not stopped at any obvious landmark, although it may have been an oil company vehicle out to check the natural gas pipelines that run throughout the area. The figure in the car seemed to be looking in my direction, and never looked down as if to fill out a report or anything of the like. Although I remained hidden behind some low bushes, and was fairly certain that I couldn't be seen, I decided that my time was up, snapped a quick picture of myself, and went back to the car.

After driving for a few hundred feet, I passed a fork in the road which branched off to the rear of the direction I was traveling. A plain white pickup truck with no discernible markings shot from this entrance and assumed a position nearly touching my bumper. It appeared to be a late model Ford, and emerged from the desert as if it had just come from a car wash or the showroom floor. The driver was the only person in the vehicle and seemed to have on a suit, or at least a white, long-sleeved shirt with a tie. Sunglasses obscured his eyes from view. He made no effort to communicate with me, and when I slowed down and planned to let him pass, he retreated further away in the dust cloud I was kicking up. The white sedan I had glimpsed earlier apparently had moved on from its parking spot.

As I resumed speed, I looked in the rearview to see another truck, exactly the same as the first, with another white-shirted driver pull in behind and add to the entourage. A few minutes of cat-and-mouse ensued, with speed changes that the trucks matched as they continued to pace me. If I was adventurous, I could have stopped the car and asked if my two persuers had anything to say, or indeed if they were even chasing me at all. As it was, I decided to test the car's handling at high speed on a dirt road, and found it quite adequate. After rounding a few curves, I could no longer see the trucks, and very soon thereafter, I reached the safety of the blacktop highway. A few hours later I checked into my favorite hotel- the Laughing Horse Inn in Taos-and retired in front of the fireplace to ponder my adventure/ misconception.

Were these people government agents chasing me off or oil company personnel or what? If anyone else has had a similar experience at Aztec, or in other places with these new white trucks and their persistent drivers, please write in care of this magazine and let me know.

Interview: James Moseley
Saucer Smear "Commander" and Publisher

Greg Bishop

Jim Moseley don't take no guff. That is, he won't take it if it's not interesting or at the very least, entertaining. The publisher of *Saucer Smear* has been in the UFO field (by his own admission) since 1948. Although he would be embarassd to admit it, this makes him one of the few "grand gentlemen" of Ufology (or You-fool-ogy as he might call it.) *Saucer Smear* is mailed out gratis on an irregular basis to a couple hundred of the ufological hard-core, and comprises the only record of the evolving personality of the saucer-smitten. Within its eight typewritten pages, researchers lash out at each other in vitriolic rants full of personal insults and very often, four letter expletives, some directed at the editor. Presiding over this fray with a bemused eye, Moseley praises friends, points a good-natured but sharp and sarcastic pen at attackers, and referees intense insider squabbles with alacrity and an eye for raking the muck when needed. I caught up with Jim at one of Tim Green Beckley's conventions in San Diego. It was pitifully attended, but this gave me a chance to corner him in his room for a very enjoyable conversation and historical view of the social side of UFO history.

Jim Moseley
(It took me two hours to convince him to wear the Groucho glasses and nose –G.B.)

Q: What first interested you in the UFO field?
MOSELEY: It was in the early '50s. The first thing I paid any attention to was the Mantell case in 1948-a military fellow who allegedly got blown out of the sky by a UFO. It was a popular subject suddenly, and became an emerging field of research. I had this intellectual curiosity about something which seemed to be real and interesting. I met a writer who wrote for True and Argosy and he said that if I would take the time and travel across the country and interview these people who had had UFO experiences, then I would get a co-author credit. And I was young and eager, so in late 1953, I took my car and drove from New York out to the southwest and California and interviewed maybe a hundred people. And I talked to everybody; the contactees, the scientists etc., but the book was never made. The notes I had for that book were later fictionalized by Gray Barker and eventually turned into the horrible book *Crash*

It was the biggest "flap" of its sort as far as public interest was concerned, and because of that, my circulation shot up literally overnight. I had this little one-room office in downtown New York where I worked all by myself hacking out this magazine, and was listed in the Manhattan phone book under "Saucer News."

Secrets At Wright-Patterson Air Force Base. I had found out by then that there was actually a UFO field, and I met Gray Barker and others who were in it at the time. So the next thing I did was to start my own 'zine, which was called Nexus, which was a stupid name, it means "a connecting link," but nobody knows that. Two other guys started that with me who were also living in New York at the time; Dominic Luchesi and August Roberts. August died last month, and Luchesi died several years ago. We started this and kept it going for a year, and then they dropped out and I changed the name to *Saucer News* and it stayed on a very small scale until 1954 when the "marsh gas" thing happened. That marsh gas thing did more for me than anything else – (J. Allen)Hynek's marsh gas – he went to Michigan where there had been a few sightings of things. The most prominent ones were by some college co-eds. One thing was seen diving at a police car, and another was seen floating over some woods near a college dormitory. There were no marshes in that whole area. There was a premature press conference and Hynek was forced to do it. He didn't have an answer and didn't claim to have and answer. The Air Force put him on the spot rather unfairly. I ended up being very friendly with Hynek, and I liked him. So he was pushed to the wall and said that it might or could have been marsh gas. And then there were the T-shirts and cartoons, etc. just ridiculing him. The whole country was excited about it then, and then Michagan Representative Gerald Ford got on it and promised a congresional investigation, which of course never happened, but it was a hot time for the topic. It was the biggest "flap" of its sort as far as public interest was concerned, and because of that, my circulation shot up literally overnight. I had this little one-room office in downtown New York where I worked all by myself hacking out this magazine, and was listed in the Manhattan phone book under "Saucer News." So when they wanted to talk to a local "authority", they called me, and I didn't know any more about the subject than the day before. But I was hot. I was on every news program in New York, since there were not a lot of other rivals around like there is now.

Q: What year was all this?
MOSELEY: 1964. At this time there was a man in Boston with a radio and T.V. show named Bob Kennedy (not THE Bob Kennedy of course.) I appeared on his show a few times, and they were also working with a speaker's bureau who booked Donald Keyhoe to speak about the saucer stuff. They also booked the college lecture circuit and Keyhoe was starting to charge too much. This is where I really stepped in some shit. Bob Kennedy gave my name to this bureau and since I hated Keyhoe anyway, this was the best luck of all. He was charging too much, so I started getting his gigs. I would have gone for free just to knock Keyhoe off the lecture circuit. (Stanton) Friedman hadn't come along yet, and he didn't push me off the circuit 'till years later. I did over a hundred colleges and got well paid for it for the time. Saucer News circulation shot up to about 10,000 for awhile, and I got on all kinds of shows, etc. I finally had to hire a staff to keep up, including Tim Beckley, who worked there for a couple of years. This was all because of the marsh gas! The first lecture I did for this bureau was

for a engineering society in Detroit. I was not experienced with speaking to large groups at that time, of course now I'm on tranquilizers and high blood pressure medicine and everything else. I was kind of terrified of life, not the sane, wonderful person you see here before you today. I was ready to bolt off the stage when I got up there with my eight slides and eleven photographs. Perhaps if I could use these as an opener I thought I could calm down, but the assistant ended up putting in most of them upside down. All of these engineers started laughing before I had even done anything, and then the light in the projector went out. At that point of desparation I realized that these engineers were there for entertainment and not for a scientific lecture. Most of them were drunk anyway, so I made it humorus and entertaining and you know they loved it. I got a glowing review back to the bureau. After that I never had to audition for another speaking date. - nobody remembered who I was or exactly what I said, but luckily, the topic was hot and it filled the room. That era was real fun. Then in the early '70s, Friedman came along and did to me what I had done to Keyhoe. Actually, he was vicious about it. He would find out which colleges I was lecturing at and call them up and try to get them to knock me off and book him. He had the degree and the beard and I didn't. The colleges kept calling me to inform me what he had been doing - sometimes more than once to the same places.

Q: What do you remember as the most unique experience when you were on the college lecture circuit?
MOSELEY: I once did a lecture over the phone because the people were too cheap to pay my fare out to the college. It was through a bureau, and I was in this fleabag hotel in New York. I didn't even bother to get dressed. All I did was just pick up the phone and heard this voice saying "Mr. Moseley will address you now." So I talked for an hour and hung up the phone. I got a hundred bucks for that. To me, it was eerie - I was just talking to myself. I didn't know how many people were there or whether they were naked, or anything.

Q: What did you say about hating Keyhoe?
MOSELEY: Keyhoe and I were rivals, because when I was first trying to write a book and Keyhoe had written one, the publisher took his second book and turned down mine. I was also not intellectually happy with his focus on Air Force secrecy, and I'm still not a fan of that subject. I mean, if they can't find out what this is, there must be something strange about the phenomena itself that prevents us from finding out what it is. So I don't see how over a period of many years how the goverment can keep us from finding out what it is, all other things being equal. Keyhoe's big schtick was always that angle and along with many other people I think he really overdid that one focus.

Q: It seems as if you wanted to sound off a bit more about Stanton Friedman...
MOSELEY: He was big time for a long time, but he really took a dive recently - and I was secretly happy to see this - was he hitched his star to Gerald Anderson and the Roswell thing. And then Anderson turned out to be a dreadful fraud, I

This is where I really stepped in some shit. ...since I hated Keyhoe anyway, this was the best luck of all. He was charging too much, so I started getting his gigs. I would have gone for free just to knock Keyhoe off the lecture circuit. [Stanton] Friedman hadn't come along yet, and he didn't push me off the circuit 'till years later...He had the degree and the beard and I didn't.

mean, how could anybody miss it when his "diary" was simply recollection and not even written at the time. [Gerald Anderson claimed to have come upon a crashed saucer and alien bodies in New Mexico around the time of the Roswell incident.] He also got caught faking a phone bill among other things, and to this day, Friedman sticks up for him. So now, the parade has passed him by and it's Kevin Randle and Don Schmitt's turn, except that now they're going to get it because their book has more gook in it than anybody else's.

Q: Bill Moore is ready to crucify them.

MOSELEY: Oh Moore! He's ready to hang them because he was eclipsed even further back. Anyway Schmitt and Randle are going to get it from the (UFO) field because this new book of theirs is not going over among the people I've talked to.

Q: What do think of Erik Beckjord?

MOSELEY: The most memorable (or weird) time I saw him was when I was out in Los Angeles. We had arranged to met at the Queen Mary, and he was late. He called and left a new time that he'd be there and he missed that as well. I was getting hungry, so I left a message for him at the desk. Well, 10:30 P.M. rolled around and after I had finished eating, he arrived at the bar on the front of the ship. We hadn't seen each other in a long time and we had both gone to the trouble of getting there. He walked in and gave me one of those "if looks could kill"-type faces. And he said, "Where the fuck were you?" I said, "Where the fuck were you? I had to go eat...etc." and he was going to pick apart that whole topic for the rest of our time together. So finally, I said, "Look, we did the best we could, and now we're here, and if you want to argue about it the rest of the night, you can go fuck yourself." And he got up and went out the door and went home – he had to be like a little boy and have his tantrum and waste the whole thing. He's a character. A couple of years ago at a convention, Bill Cooper and Beckjord almost got into a fist fight. They were both drunk out of their minds. Erik holds it in, but Cooper went nuts. After Erik had left, Cooper yelled at everyone: "The whole fucking bunch of you are a bunch of assholes. You don't know the goddamn truth about saucers, and you never will. He cursed out everybody at the party just on general principles, and then he left. The next day, I saw him leaning against a wall and I said "Hi, Bill," and real cheery, he said "Hi, Jim." "I guess you were a little drunk last night?" I said. And he said, "Naah, I would have said the same stuff whether I was drunk or not. I don't give a shit." Cooper's hot shit, and I don't know why, I guess it's chemistry. It's like Gary Schultz...I don't know why Cooper gets the bigger crowds...

Q: Schultz isn't as vocal - you don't always know what he's thinking. You always know where you stand with Cooper. Strangely (or frighteningly) enough he seems to attract a lot of the younger crowd...

MOSELEY: He tells it straight from the hip. I've spent a lot of time in bars at conventions with Cooper and I enjoy it. A lot of people think he's a fascist or something, but he isn't exactly, he's in his own category.

If they can't find out what this is, there must be something strange about the phenomena itself that prevents us from finding out what it is. So I don't see how over a period of many years how the goverment can keep us from finding out what it is, all other things being equal.

Q: What are some differences between the UFO scene now and how it was in the "early days?"

MOSELEY: Well, in the '50s you had your classic contactees who met creatures who looked almost like us, if not better, and who were giving messages of sweetness and light, and save the environment and ban the bomb, and all this good stuff. But nobody sees anyone like that anymore in the last 20 years or so. Another thing was that they used to see little men getting out of the saucers, smaller than us, but sort of normal-looking. They were not described in the same way that these "greys" are – the height is the same, but the face is different. So, how come nobody sees these classic "little men" anymore?

Q: Or even the "hairy little dwarves" like the ones in South America in the '50s...

MOSELEY: Exactly. And how come nobody got abducted until the '60s? Betty and Barney Hill's experience wasn't even like the "classic" ones we get today. Now, everybody's being abducted – according to some researchers, millions of people – all this is going on now, but none of that earlier stuff. What do you gather from that? Sounds like fads coming and going to me. Think about that for a minute: no abductions then, no sweetness and light guys now – except through channeling, etc. It sounds so much like a trend. One guy has an experience and what does he do? Does he subconsciously make it like the others that people are having, or is it imposed upon him by the hypnotist or therapist who doesn't know what they're doing? It's like a pattern, and your case has to fit the mold of your particular generation. You don't get much of a feeling of objective reality.

Q: I've just read Karla Turner's new book Taken, *and I noticed that she really doesn't hold anything back – she discusses dream imagery, government involvement, strange sexual encounters, and other subjects that seem to be taboo in other abduction studies. I'm sure that she's getting a lot of heat from the UFO community for this.*

MOSELEY: What these guys like John Mack and Budd Hopkins seem to do is if your case isn't the kind of case they're looking for, they either reject you, or fit your story into their mold.

Q: Perhaps what goes on to some extent is that if you are in their program, and you say something that "fits in" they may give you some subtle hint like nodding or probing further if there is something that they recognize. And conversely, if you say something that doesn't fit, they won't react at all, at the very least. And perhaps they're not even aware of this, since we all do this to some degree.

MOSELEY: What if I said to you that I met some aliens yesterday, and I said "Well, what did their spaceship look like?" But I didn't mention a ship, I just saw them on the street. You brought it up. I think that's kind of what they do. And Mack, unfortunately turned out to be a disappointment. In a way I feel sorry for him, and I like him, but at the same time, I feel he's intellectually out of it. There was a story in Time magazine about him, and how this woman named Donna Bassett surreptitiously posed as an abductee and fooled him completely.

> **What these guys like John Mack and Budd Hopkins seem to do is if your case isn't the kind of case they're looking for, they either reject you, or fit your story into their mold.**

*Q: How do you see Budd Hopkins now as opposed to when he came out with his first book (*Missing Time *- 1981)?*
MOSELEY: I never really got on his case until the Linda Napolitano (or "Cortile") thing came up.

Q: Why not?
MOSELEY: Well, it's so patently absurd. First the United Nations Secretary General was supposed to have seen her floated out her apartment window in midtown Manhattan, then these two government agents start harassing her, and one of them tried to drown her and the other saved her... But the best part was, she had the chance to rummage through their drawers and found CIA stationery, which is how she found out who they were. I mean, what CIA agent would have stationery in his home? Pure drivel, all of this. One of them, "Dan" I think it was, ended up in a nut house or said he was, and he was in love with her and wanted to take her away to Europe, or something. She's not a bad looking woman; I've had the chance to meet her a few times. The other agent was named "Rich" I think. This is just what *Smear* was made for. If a leading investigator is going to come out with something as patently absurd as that, it's his fault, not mine. I was hoping that the abduction phenomenon would go away. Because it's very complicated and confusing, but there could really be something to it. I thought that the fad wouldn't last this long, but it's taken over the whole field.

Q: You perpetrated one of the most famous hoaxes in UFO history at the expense of George Adamski. How did that come about?
MOSELEY: Gray Barker had a friend who's still alive now and begged me never to reveal his name, but at the time was a kid of 18 or 20, and who's father was rather high in the State Department. He wandered into his father's office and stole some official State Department stationery, about six or seven different kinds. So, one night Barker and I got together at his place in Clarksburg, West Virginia and wrote six or seven different letters to people in the field. And the Straith letter was so-called because it was signed by R.E. Straith of the "Cultural Affairs Committee" of the State Department, and we deliberately made that part up because it didn't exist. There was a committee with a similar name, but Straith did not exist. We opened the letter "Dear Professor Adamski," which was flattering him because he wasn't a professor at all, he just made that up. And it said in essence that "there are some of us here that know of your contacts and we are behind you all the way, but we cannot come out publicly to support you at this time. But rest assured that we are behind you in spirit" etc. That was the gist of the letter, and whether Adamski thought it was a hoax or not didn't really matter, since it was just what he wanted to hear. So he publicized it and after a few months the FBI came to him and told him to stop it. They told him it was a hoax and to stop saying that it was genuine. This was just what he needed, and he started crowing that the FBI had harassed him, and so that meant it had to be genuine. There were then two investigations by the FBI and the State Department. They went down and talked to Barker, since someone noticed that

> Gray Barker had a friend...who's father was rather high in the State Department. He wandered into his father's office and stole some official State Department stationery, about six or seven different kinds. So, one night Barker and I got together at his place in Clarksburg, West Virginia and wrote six or seven different letters to people in the [UFO] field.

the typing on this letter was just like the ones he sent to all kinds of people. Barker got very paranoid after this and took the typewriter and broke it into many little pieces. Then he found where they were building a wall somewhere in Clarksburg, and dumped the pieces in. So, to this day that typewriter is buried in a wall somewhere in that town. Then Barker died in 1984, and I had warned him that if I outlasted him, I was going to confess, so I wouldn't embarass him anymore. So, after he died I put it in the next issue of *Saucer Smear*

Q: Could you talk about your friendship with Gray Barker?
MOSELEY: I think he was probably my best friend and used me as a sort of psychiatrist really. What's not generally known was that he was gay and died of AIDS. But in 1984 in Clarksburg, West Virginia, they didn't know that much about it, and they didn't cover it up, they just didn't recognize the symptoms. I've lived in Key West for ten years and I know a number of people who have died of AIDS and so I suspected at the time that's what he had died of. He had wonderful sense of humor, and a sense of wonderment (which is a good word for him) about the UFO subject. He stopped being a "believer" very early on, but kept the sense of wonderment. What he got out of it was entertainment for himself, and the audience he wrote for. He thought of himself as an entertainer, not as a scientist or a person dealing in facts. There were "New Age" types long before there was a UFO field, and he knew this audience and what they wanted to hear, so he wrote books and published them as a book business. He also had a theater that he owned and operated, and he started out as a booking agent for films at theaters in the area. So, he was always in the entertainment field and thought of himself as an entertainer. He thought I was too serious, because I believed some of it, and still do, but he didn't believe any of it. He wrote a poem that I have here with me, which is entitled "UFO Is A Bucket Of Shit," and I think that really summed up his feeling about the whole thing. He also wrote serious poetry. I would go down there a few times a year from New York, and we'd drink and bullshit and do hoaxes or whatever. He drank quite a lot, and didn't like to travel, because he would get very disoriented. I went to the Giant Rock convention in 1970 with him and a girlfriend of mine. There were a lot of psychedelic drugs floating around the Rock that year... Here's "UFO Is A Bucket Of Shit":

> UFO is a bucket of shit
>
> Its followers: perverts, monomaniacs, dipsomaniacs
> Artists of the fast buck
> True believers, objective believers, new age believers
> Keyhoe believers
> Shushed by the three men
> Or masturbated by space men
>
> UFO is a bucket of shit
>
> The A.F. investigated UFOs And issued a report
> Couched in polite language Which translated, means:
> "UFO is a bucket of shit"

Barker got very paranoid after this and took the typewriter and broke it into many little pieces. Then he found where they were building a wall somewhere in Clarksburg, and dumped the pieces in. So, to this day that typewriter is buried in a wall somewhere in that town.

> Meade Layne is a bucket of shit
> Lex Mebane is a bucket of shit
> James W. Moseley is a bucket of shit
> Richard Ogden is a bucket of shit
> Ray Palmer is a bucket of shit
>
> And I sit here writing
> While the shit drips down my face
> In great rivulets.

Yes, they don't write poems like that anymore, do they? Thank God! So there you have it, a little sample of Gray Barker's poetry.

Q: Who was Lex Mebane?
MOSELEY: He was the founder of a group in New York in the 1950s called Civilian Saucer Intelligence. He dropped out of sight in the late 1950s. Just about three months ago I was reading a skeptical newsletter by a man named Gary Posner. He's a very close friend of Phil Klass'; he worships the man. In fact I think there's something a little…ahem.. I think there's a little touch of something - the **very strong feelings**…

Q: He loves Klass more than one man should love another…
MOSELEY: Yes. And he's not married. And I saw Mebane's name mentioned in this newsletter, so I called Posner and got in touch with Mebane 35 years since I last saw him, just the other day. Which really has nothing to do with anything.

Q: Did you have any recollections about the Giant Rock conventions?
MOSELEY: Well, what killed it by 1970 was that there were a lot of hard-ass bikers showing up, raising hell and it wasn't the sort of gentle, new age crowd that he [George Van Tassel] was catering to, and he sort of got tired of it. I've heard that he kept doing it until 1975, but I can't confirm it. California bikers you don't mess with. But while it was going, it was a wonderful circus. Thousands of people, each on their own wavelength, would come out there and camp. He wouldn't charge them, either, except if they ate food at the diner he had out there. He really didn't make a lot of money on it, he was just a nice guy, and I really liked him. I met all those early contactees out there. The one I liked the most was Orfeo Angelucci. He only died a couple years ago. He was originally from New Jersey, and I think that's where he's buried. He was a colorful character - of Italian extraction and quite "fond of the grape" you might say. I spent a couple of evenings with him. There was an unwritten rule among the contactees that was "Never knock the other guy's story" because he might knock yours. They just pretended to believe each other. The field was much more gentle then.

Q: Now you're only safe if you stay in Switzerland like Billy Meier - it's a neutral country! What do you think the contactees were really thinking and experiencing?
MOSELEY: I haven't got the faintest idea. With Angelucci, though, his original encounter was when he was driving alone - this was in his first book, *The Secret Of The Saucers* - and under a bridge or something, he saw this thing land and he

There was an unwritten rule among the contactees that was "Never knock the other guy's story" because he might knock yours. They just pretended to believe each other. The field was much more gentle then.

went into his story. Well, he could have hallucinated some of that. He had a background of some nervous disorder or something, although I have no documentation of this. But he believed his story - he didn't make it up.

Q: I have a documentary at home where they went and talked to Angelucci, and he said that he had had an hallucination or something, and it "came back through his subconscious to his consciousness as visions."
MOSELEY: Really? That's very interesting. He never said anything of the type at the time. If I'd known he was still alive a few years ago, I would have interviewed him about this new take he had on his experiences. To a degree, Howard Menger reevaluated his story as well. He talks out of both sides of his mouth, it seems to me. He said that some of the space people he met looked so much like humans that they could have been CIA agents or something. But now, he has repudiated his repudiation, and says it pretty much like he did in the 1950s. He's very hard to pin down, and it's not worth trying. He contradicts himself and uses scientific terms of which he has no idea of the real meaning. He's a pleasant guy, though. A couple of years ago, he drove with his wife Connie all the way from Florida to Phoenix to do one of Beckley's conventions, and he had all his inventions with him. He set it all up, and got only about 30 people come to see him, which was pitiful. Somehow he blew the circuit in the hotel with his machines, and it was just kind of sad.

Q: You're obviously more interested in the people surrounding the UFO phenomenon, than in the UFOs themselves. Can you explain why?
MOSELEY: There's no hope of solving the question. There's endless confusion and contradictory theories, so certainly the UFO field is real, whether the saucers are or not, and the people are real, and some of them are very interesting. I have more fun with the people, so I talk about personalities in my magazine. I don't print sightings, because everybody else does, or could, and you can find that anywhere. I just try to do something more interesting and more to my own personal taste.

Q: Did Al Bender have a contactee experience before he became infamous for his Men In Black experience?
MOSELEY: Albert K. Bender started a thing called the International Flying Saucers Bureau in 1952. He had a quarterly magazine, and he only put out about four or five issues. In the last issue, he had that famous letter he wrote to the subscribers that he had been visited by three men in black outfits who said that he had gotten too close tothe truth and to cease and desist his operation, and he did. He wouldn't tell anybody why. Barker came all the way up from Clarksburg to ask him about it, and Luchesi and Augie Roberts came, but he wouldn't say anything about it. I got into the field about that time and I went up to talk to him, but of course he didn't tell me anything either. Years later, he wrote a silly manuscript called *Flying Saucers And The Three Men*. This book told the story of a race who were mining rare minerals from Antarctica and taking them back to their home planet. It wasn't well received, and I think he just

> To a degree, Howard Menger reevaluated his story as well. He talks out of both sides of his mouth, it seems to me. He said that some of the space people he met looked so much like humans that they could have been CIA agents or something.

wrote it to get people off his back. After that, he went back into hiding again. He moved out to California, and nobody knows where he is. Augie Roberts, who I mentioned just died recently, stayed in touch with Bender. He had his address, but I never asked him for it - he wouldn't have given it to me anyway. He said that Bender would talk about other things, never UFOs. I didn't believe the hush-up story anyway, but Barker was impressed, even though I tried to convince him it wasn't what he thought it was. He eventually did lose faith in the Bender tale, and that's when I think he lost faith in the whole UFO field.

Q: How much does the government pay you to keep all the UFO nuts fighting with each other?
MOSELEY: They pay me exactly as much as they pay Phil Klass.

Q: Have you ever been approached by anyone who claimed to be from the government and offered information?
MOSELEY: No, but I will tell you funny story about how I was accused of threatening the president. During the 1980 election, I sent letters to Carter and Reagan asking what their opinions on the UFO thing was. I got a reply from some third-string presidential assistant that didn't answer anything - a form letter. So, I reproduced it on the back page of my magazine, and simply because it also fit on the page, I had a little pornographic line drawing - just stick figures that I picked up from some office supply store - totally innocuous. Some of my enemies in the field had written to the White House and sent this page from the magazine. So someone on the staff wondered if I was a threat to the president and informed the Post Office. Some guy from my local p.o. came out to investigate, and I said, "Are you out of your mind?" I went and got a few other issues and showed him that the only one that mentioned Carter was the one he was worried about. I finally got the guy to laugh at himself, and gave him a bunch of free issues, so he crossed me off the threat list.

Q: Have you ever actually seen anything that you would qualify as unidentified?
MOSELEY: In the course of 40 years I have seen a few things that I could not identify. The last one was in Gulf Breeze, in 1992. It was a light in the sky that was there for about four minutes. It might have been a flare, but I'm still not sure. Yeah, I've seen stuff that I couldn't identify, but so what? (laughs)

Q: What does the "J.S." mean after your name on the cover of some Saucer Smears?
MOSELEY: That's "journal subscriber", and it's my status in MUFON. It's the lowest rank possible. I was made state section director for Monroe County, since they didn't have anyone else who would do it. I did absolutely nothing with it for years, and the state director for Florida, Charles Flanagan and I just didn't have the right chemistry, and we clashed on Gulf Breeze. So he let a few years go by and demoted me to assistant section director, even though that left no one as the director! Then after another year, he wrote me a letter and said I would be known as a "journal subscriber," so I printed that one in *Smear.* It's the only degree I have, so I'll make the most of it.

Yeah, I've seen stuff that I couldn't identify, but so what?

Q: How have your views of the UFO phenomenon changed over the years?
MOSELEY: I went off on different tangents: first the secret weapon theory, then little men, then I got hung up on Mars for awhile - it seemed reasonable - what got me was the lines on the surface of the planet. But the camera can see what the eye can see, and it doesn't make it any more real. When you get enough resolution of course, that stuff disappears. Then Vallee and Keel came along, as well as J. Allen Hynek, and put forward the 4-D idea, and that's where I'm generally at now. The interplanetary idea is the least likely. If there is something going on along those lines, it's beyond our present understanding. I'm not totally agnostic, I do think there's something going on, but it defies scientific examination. You have to be able to repeat results experimentally, and how the hell do we investigate something that changes continuously? When we can summon a demon or poltergeist or spaceman at will, then we'll be much further along. We can't expect to solve everything overnight. People need answers right away, and if we don't have answers, they're invented. MUFON has invented the interplanetary theory, and that satisfies them.

Q: Will you keep Saucer Smear *going for as long as you can?*
MOSELEY: As long as I'm alive and reasonably healthy, sure. My business takes hardly any of my time, and I really enjoy it.

The Grey Neighbors: Budd Hopkins and the Unconscious

Viewpoint by Dean James

The abduction syndrome is of course a complex subject touching many aspects of human behavior. For Hopkins, it rapidly became a sort of idee fixe.

By vocation an artist and sculptor, Budd Hopkins began writing on UFO-related themes in the late 1970s and rapidly became a major name in the field. He first secured a following among proponents of the Extraterrestrial Hypothesis (ETH) with *Missing Time* (1981), a study of the phenomenon indicated by its title. This was followed in 1987 by *Intruders*, which cemented his reputation and is now regarded as one of the cornerstone books of abduction research. Hopkins' interest in otherworldly phenomena was first stimulated by a daylight disc sighting in 1964. Thereafter he studied all aspects of nuts and bolts ufology and became well versed in it's lore. The pivotal point in his early research came circa mid-1966 when publication of *The Interrupted Journey* by John Fuller alerted him to Betty and Barney Hill's alleged ordeal at the hands of medical examiners from the wild blue yonder. Although initially skeptical of the Hill case, he nevertheless kept it in mind, and after much deliberation found himself forced to concede that "abductions might literally be occurring as described."

The abduction syndrome is of course a complex subject touching many aspects of human behavior. For Hopkins, it rapidly became a sort of *idee fixe*. He began studying individual cases at every opportunity, using hypnotic regression to elicit accounts of strange medical procedures carried out on board craft from outer space. "Hypnosis cannot guarantee accuracy [of recall]," he admits in an appendix to *Intruders*; but it has nevertheless "proved useful in the majority of abduction cases to help the subjects overcome what appears to be an externally imposed amnesia."

Hopkins would further have his readers believe that the humanoid activity detailed in *Intruders* "has yielded more new information...about the nature and purpose of UFOs than any case yet investigated." This extravagant claim is unsubstantiated by anything in the text. *Intruders* actually chronicles phenomena of a type well known to psychic researchers. The bulk of these occur in a semi-rural area of Indiana dubbed the Copley Woods, where divorcee Kathie Davis (AKA Debbie Tomey) lives together with her parents and two

children. Kathie's experiences figure prominently in Intruders. Hopkins seems to suggest at one point that she isn't terribly bright, but softens the blow somewhat by referring to her as "a true *Menschenkenner*," a "knower of men." He describes the Davis home and its environs in terms more appropriate to a pulp horror story than anything else. The house itself, while outwardly "neutral and prosaic," hides a terrible secret. The surrounding maple trees isolate it from the outside world and allow nonhuman forces to carry out their depredations unobserved. Even the very soil feels "unnaturally charged," though in what way isn't made clear. Hopkins' chief concern at this stage is to establish the proper mood for what is to follow. He has no time for trifling details.

It is against this backdrop that the *Intruders* of the title pursue their inscrutable ends, subjecting Kathie Davis to all manner of indignities in the process. Her reported experiences include repeated abduction from an early age, impregnation by saucer men, and various gynecological disorders. She also dreams of being shown her own hybrid child (significantly described as looking "like an elf") by "a whole bunch of...little grey guys" who seem "very pleased with[her]."

Hopkins has vast reserves of sympathy for Kathie Davis and others like her, but evinces very little understanding of their plight. Time and again an ignorance of folklore vitiates his argument. At one juncture he hypnotizes a dancer known only as "Pam" and draws from her a confused account of being taken to "an unfamiliar setting" by a grey humanoid, and there shown a baby resembling "a little lamb...sort of half-human, half whatever it was before." Pam first of all describes her alien captor in detail, stressing its "creepy head and shiny skin." Then, in what is presented in the text as a bombshell revelation, she adds: "It wants me to nurse the baby. It seems to want to watch, to see what I do with it...They [the Intruders] don't understand that you can't have milk unless you let the baby grow inside you. They seem to think you have endless amounts of milk. That's sort of stupid." Hopkins describes Pam's recollections as "a shock, even in this bizarre context." He is seemingly unaware that similar motifs are commonplace in folklore. As Gillian Trindall has it in her *Handbook On Witches*: "Women were particularly liable to visits from fairies when they were in childbed, and were sometimes carried off to fairyland to suckle fairy children."

Hopkins speculates that the Intruders' ultimate purpose may be "to enrich their stock and...then depart, having achieved their goal and revivified their own species." This theme is later taken up by "Ed," a Wisconsin mechanic who first of all describes being taken aboard a UFO and made to impregnate a female entity, then suggests that his captors were somehow "trying to upgrade their own species." In actual fact, such beliefs have come down from remote times. Gillian Edwards explains in *Hobgoblin And Sweet Puck* that the denizens of Elfhane "need now and then to enrich their own stock by grafting onto it the more robust blood of humankind." Katharine Briggs advances a similar view in her *Dictionary Of Fairies*, remarking that in olden times human children were often spirited away "to reinforce the fairy stock." Significantly, the (Scottish) Highland tradition ascribes such depredations to a race known as the "Grey Neighbours." A folk-tale recorded by Jessie Saxby asks fatalistically, "What can a body do when a bairn [baby] has had the grey man's web about it?"

Hopkins has vast reserves of sympathy for Kathie Davis and others like her, but evinces very little understanding of their plight. Time and again an ignorance of folklore vitiates his argument.

Significantly, the (Scottish) Highland tradition ascribes such depredations to a race known as the "Grey Neighbours." A folk-tale recorded by Jessie Saxby asks fatalistically, "What can a body do when a bairn [baby] has had the grey man's web about it?"

Toward the end of Intruders, Hopkins remarks that several female abductees in his files "have dreamlike memories of being shown tiny infants which they were made to feel were their own." He goes on to cite a number of examples, notably that of psychotherapist Susan Williams, whose "Wise Baby Dreams" are described at length in chapter nine. Susan is the ideal witness from Hopkins' point of view. Her professional status adds weight to what would otherwise be a fairly unremarkable range of experiences. She describes her "wise baby" as "small and precious [with the] quality of a tiny bird," but ends by stressing its "funny greyish pallor" and vacant expression — incongruous elements in what would otherwise be a straightforward wish-fulfillment fanstsy. A dancer referred to only as "Andrea" reports much the same type of thing, adding an archetypal fairy midwife encounter for good measure, while Kathie Davis weighs in with recollection of a baby resembling "an old man...more wise than anybody in the world."

Hopkins presents all this in sober fashion, evidently taking it at face value. "It is crucial to know if extraterrestrials exist and are, as the reports indicate, experiementing with humankind," he writes; "or if the reports represent some profoundly new mental aberration." Here again the implications of his own subject matter seemingly elude him. There is nothing in the least "radical" or "new" about Susan Williams' dreams. They are in fact identical with changeling accounts first set down as long ago as the 13th century by Gervase of Tilbury and other chroniclers of the period. According to Spence, changelings can be recognized by their "wan and wrinkled appearance [and] slight, bony development." Wirt Sikes likewise refers to them as "shriveled of face [and] ugly of form, ill-tempered, wailing and generally frightful." The parallel with Hopkins' material need hardly be stressed. Even Kathie Davis' remark that her wise baby "looked dead" is not without significance. Gillian Tindall explicitly identifies fairies with the realm of the dead in her *Handbook on Witches*.

Virtually all the indignities heaped on Kathie Davis have to do with what she terms her "female stuff." Genital examination is a frequent feature of Intruders, albeit readers are assured that "in none of these cases, involving either men or women, do we have what can be called a basically erotic experience." Psychological profiling is also used to establish that despite their outward normality, Hopkins' subjects "[aren't] fully at ease physically, at home in their bodies or comfortable with their sexuality." In other words, they are unable to enjoy sensuality for it's own sake, and therefore represent easy prey for elemental forces known since time immemorial to delight in manipulating the human libido. As doyen of para-ufologists John Keel puts it: "In Celtic countries the little people have been credited with bizarre sexual activities often accompanied by hallucinations just as intriguing as the modern stories of hanky-panky aboard flying saucers." (Interested readers should also locate selected texts by Stan Gooch, who argues convincingly that in terms of unconscious motivation, "sexuality is a major force, probably the major force, in paranormal physical phenomena.")

It is not the purpose of this article to disparage Kathie Davis, Susan Williams, et al, or to make light of what they have been through. There can be

no doubt that UFO abductions are in some sense "real" and pose a tremendous challenge to the research community at large. By shoehorning them unceremoniously into an a priori theoretical model, Hopkins does a grave disservice to the very people whose interests he purports to represent. Far from throwing new light on the origin and purpose of UFOs, *Intruders* actually obfuscates matters still further with a lot of nonsense about nasal implants, laparoscopy, and the like. Readers searching for a balanced, coherent, well-informed treatment of the subject must look elsewhere.

Roswell Redux: The Air Force's *First* Roswell Explanation

Dean Genesee

It is not generally known that Col. Weaver has been employed by the Air Force Office of Special Investigations (AFOSI) in the past to concoct stories for eager UFO researchers. While stationed at Bolling AFB in Virginia in 1978, he was assistant to Col. Barry Hennessy to plan and implement a project that has become known publicly as the "Bennewitz Affair."

Roswell has become another conspiratorial Rorschach blot. "I want to believe it, but the author's name makes me wonder" was one source's comment on the so-called "Weaver Report"—the newest official explanation of the "Roswell Incident." On September 8, 1994, the Air Force Office of Special Projects released a 23 page paper detailing its research into the event we have all come to love as "conclusive proof" that an extraterrestrial craft crashed on a remote ranch in central New Mexico. The event was met with the expected crowing of the skeptics and renewed cries of "coverup" from saucer proponents. There are indications that New Mexico congressman Steven Schiff and the General Accounting Office (GAO), who are due to release their own report after the first of the year, are more than a little pissed off with the Air Force's "preemptive strike."

Last year, in response to complaints from constituents, Schiff queried the Air Force to answer the UFO allegations in connection with Roswell in an attempt to lay to rest the rumors and speculation. Schiff was stonewalled, so trying another tack, he asked the GAO to look into its records for a paper trail which would lend credence to any of the stories which kept sprouting up like tenacious weeds. While the GAO took it's sweet time, it seems that Colonel Richard Weaver whipped his office into attention to interview witnesses and scour Air Force records for their own version of events. It is not generally known that Col. Weaver has been employed by the Air Force Office of Special Investigations (AFOSI) in the past to concoct stories for eager UFO researchers. While stationed at Bolling AFB in Virginia in 1978, he was assistant to Col. Barry Hennessy to plan and implement a project that has become known publicly as the "Bennewitz Affair."

Paul Bennewitz is generally believed to have been "driven crazy" by elements of the AFOSI, assisted by various researchers and informants in the UFO community. Although he was basically feeding off his own delusions to begin with, Hennessy, Weaver, et.al., saw in his plight a chance to obfuscate the issues surrounding secret developments which ultimately had nothing whatso-

ever to do with UFOs. When the intelligence community decides to move in a given direction, it does so when its actions will kill many birds with one stone (rhetorical pun intended). By discrediting Bennewitz and filling him with ever-increasing paranoia, they hoped to keep prying eyes away from the Sandia-Manzano (New Mexico) research and development complex. Bennewitz said he had filmed UFOs over the base and intercepted their radio transmissions, which indicated imminent takeover by more than one race of extraterrestrials, who were "harvesting" humans for their own inscrutable ends. These and other myths have become commonplace in the saucer literature, and keep Ufologists (and ratings conscious Hollywood producers) fighting with each other over the "real" story. It's the old bait and switch, and it still works quite well.

REPORT OF AIR FORCE RESEARCH
REGARDING THE
"ROSWELL INCIDENT"

July 1994

Now in 1994, Col. Weaver takes authorship responsibilities for the explanation that the Roswell debris was the result of a project to detect nuclear testing from the upper atmosphere. Progressing through the report, it is very easy at times to accept that what many of the Roswell witnesses reported can be explained as debris from a giant metallized rubber balloon or balloon train with attached instrumentation. It can also be assumed that rancher W. W. "Mac" Brazel (who originally found the debris on his land northwest of town and brought it into Roswell) was kept under wraps by the Air Force for at least a week for the purpose of convincing him that it really was the wreckage of a flying saucer—thus covering up the super-secret nature of what was called Project Mogul. Such an operation did exist, and one of the men involved in its development was Jesse Marcel.

Yes, this is the same Major Jesse Marcel who began to talk with researchers and reporters in the late 1980s about his experiences at the Roswell RAAF base in July, 1947. He was involved with Mogul to the extent that he authored and presented a report on the results to President Truman. If he was so intimately involved with the project, Weaver never answers the question as to why Marcel would mistake the Roswell wreckage for anything that wasn't man-made. He blames many of the myths that have grown around Roswell on "persons who...may have, in good faith but in the 'fog of time,' misinterpreted past events" and statements taken out of context or simply made up by UFO researchers.

While we all know that Ufologists would NEVER do this, it is interesting to note some outright contradictions between the Air Force report and some of the events that all Roswell researchers appear to agree upon. According to the Weaver report, Brazel's daughter Bessie (now Schreiber) Brazel never recalled "seeing gouges in the ground or any other signs that anything may have hit the ground hard." While there is contention among researchers as to whether Bessie Brazel ever visited the site during the wreckage retrieval period, it stretches credulity to believe that she never saw the area. The furrow left in the field is one detail brought up in all Roswell books and papers. The report goes on to quote Loretta Proctor, who lived on the adjoining ranch, recalling that Mac Brazel had told her the material he found "wouldn't crush or burn." Weaver's report never deals with this aspect of the story, which all (UFO) researchers seem to agree on. Rubber burns or melts, even "metallized" rubber. Weaver's team contacted original Mogul

project consultant, Charles Moore, who described the balloons and their payloads: "Some of the early developmental radar targets were manufactured by a toy or novelty company. These targets were made up of aluminum 'foil' or foil backed paper, balsa wood beams that were coated in an 'Elmer's-type glue to enhance their durability...Some of these targets were also assembled with a purplish-pink tape with symbols on it." From this description, Weaver opines, "It is very probable that this TOP SECRET project balloon train...made up of unclassified components; came to rest some miles northeast of Roswell, NM, became shredded in the surface winds and was ultimately found by the rancher, Brazel, some days later." This claim is on par with the most ridiculous claims of our Ufologist friends.

Just as there is much to prove in the case for the story that an alien craft crashed in the desert in July, 1947, there is an equal onus on anyone who cares to refute the claims of many researchers. Throughout the report, reference is made to "attachments" (there are about 300 pages of them) that were not released. It may be assumed that there is a prosaic explanation for the Roswell event, but Col. Weaver's report is as guilty in its vagueness on salient points as the UFO writers in many of their unqualified statements and quotes taken out of context. It is also strange that Weaver, as " Director Of Security And Special Program Oversight" suddenly decides to release a report which would normally be handled by the Air Force's public relations office. Once again we must choose our reality, friends

RICHARD L. WEAVER, COL, USAF
DIRECTOR, SECURITY AND SPECIAL
PROGRAM OVERSIGHT

Weaver's signature on Roswell Report. "Security" secures sensitive Air Force program information, and "SpecialProgram" usually involve intelligence and counter-intelligence work. Weaver is well-versed in both.

No. 5

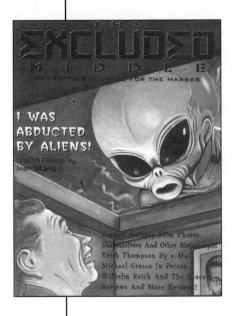

Editorial

Welcome to issue number five where we still have **NO ANSWERS** — at least not to the big questions about life and existence. But we do keep asking. It's strange: Why have we accepted this seemingly futile task? Are we, like Sisyphus, to find meaning in the situation even though ultimate solution seems guaranteed against? Find out what Keith Thompson has to say about this in his interview.

Maybe we need to talk to a professor of philosophy. So we did. It's Dr. Michael Grosso's job to wrestle with the enigma of life. He discusses - among other things - why it may be that most of his colleagues shy away from what could not be more relevant to philosophy: the paranormal. Another notion Grosso puts forward: Certain components of life will probably always be a mystery. That doesn't mean we can't probe those mysteries and find purpose in the search. Uh-oh, there seems to be a theme developing here and it's Zen-flavored and dripping with paradox. (How coincidental that the just-released book, *Zen in the Art of Close Encounters* weaves just this theme. Editor David Pursglove features bits by the above-mentioned thinkers as well as an excerpt from an interview with Robert Anton Wilson that appeared in *Excluded Middle* # 1. This book is a definite tEM companion. Check it out.)

We're also proud to present an exclusive from The Reverend Ivan Stang— Sacred Scribe of the Church of the SubGenius. Is he joking or serious? Beware of either/or thinking.

Some more Roswell tidbits are sprinkled herein as well. Is that damned little episode / non episode the ultimate in the mystery that is perpetually almost solved and then not? I don't know.

I do know you'll be inspired by these folks who inspired us to do what we do. (Thank you Michael, Keith, Reverend...) That, some impressive contributions from newcomers, hip artwork and much more will, I trust, keep you enjoying the game.

— Robert Larson

I Was Abducted By Aliens!

The Reverend Ivan Stang,
Sacred Scribe of the Church of the SubGenius

Some lucky people can laugh at so-called "Abduction Phenomena." I used to. I'm a skeptic and, aside from holding a Church of the SubGenius philosophy, I'm probably what the average religious nut would call an atheist. I believe only in science and "Bob," and while both are admittedly damned fickle, at least there's SOME sense to 'em. The SubGenius teachings may sound unscientific at first, but an authentic paid scientist, Rudy Rucker, has assured me that he can justify ANYTHING "Bob" says on a scientific basis.

Since "Bob" hadn't said much about alien abductions, I pretty much shrugged off those stories just like I shrug off "repressed memories" of Satanic Ritual Abuse on the part of my fellow white trash trailer park denizens. I wrote both off as combinations of wishful thinking, paranoia and unforgivable, almost willful ignorance of common human dream states.

Then it happened to me.

I didn't start remembering childhood Satanic abuse on which I could blame my inability to hold down a job, no... but I did get abducted by aliens. Greys, to be specific. It was an ABSOLUTELY TERRIFYING ORDEAL, and I no longer titter at those who have suffered unexplainable forced intrusion into their lives and brains. I would not wish it on my worst enemy.

What makes this confession particularly awkward is the fact that I'm a professional preacher/satirist who has specialized in the "high weirdness" arena. I make my living spinning wild yarns about UFOs, when I'm not researching "REAL" UFO lore or badmouthing UFO aficionados that I consider to be deluded. So I'm now stuck in the tricky position in which L. Ron Hubbard must have found himself when he had to start explaining, "Well, sure, I WAS an unsuccessful science fiction writer, and this Scientology religion I've founded probably SOUNDS like science fiction, but I swear to Zenu that it's FOR REAL, THIS time ! " Likewise, I now know how Whitley Streiber must have felt while writing that nonfiction book about his own abduction experiences,

I pretty much shrugged off those stories just like I shrug off "repressed memories" of Satanic Ritual Abuse on the part of my fellow white trash trailer park denizens. I wrote both off as combinations of wishful thinking, paranoia and unforgivable, almost willful ignorance of common human dream states. Then it happened to me.

Communion. He'd been writing horror and fantasy for many years, "crying wolf" so to speak, and now he was expecting people to believe that, THIS time. he WASN'T FAKING.

I still think Hubbard was full of crap, and while I never thought Streiber was lying exactly, I did think he was kinda nutty.

Now here I am in the same boat, hollering about a very real wolf; and nobody with half a brain will believe me, just because I happened to have been BULL SHITTING about wolves on all previous occasions.

But I swear to God that I really experienced all that I'm about to describe. I have a wife and two teenaged kids. In 1993 we were living in a large but very old and very rickety inner city house in Dallas. My daughter Sivet (not her real name) was 11 at the time, her brother a year older. He doesn't figure in this, I HOPE; as far as we know, he slept right through it.

It was a normal night. The kids were in their separate rooms sleeping, and my wife and I were in bed reading. Then...

PAUL MAVRIDES

...LOST TIME...

I have the feeling that it was very much later in the night, but I can't know for sure. It might have been mere SECONDS. Maybe I just fell asleep.

But SOMETHING is missing from my memory. I dunno what happened in the interim, but all of a sudden I definitely wasn't just lying in bed reading. I was lying in bed with TWO STRUGGLING BRAINS inside my head. One brain knew that a terrible, unjust thing was being done to us, particularly to my little girl in the next room, and the other brain was saying, "EVERYTHING'S OKAY. NOTHING BAD IS HAPPENING. YOU ARE HAPPY AND WILL STAY IN BED SLEEPING." And THAT was the brain that was in control of the body. The terrified brain knew there was something unspeakably dreadful happening, BECAUSE it was being made to stand by helplessly and "watch" while SOME THING KEPT ME FROM RUNNING INTO THE OTHER ROOM TO SAVE MY DAUGHTER.

There is no way I can impart even the slightest inkling of what this felt like. Lots of scary things have happened to me-getting chased and beaten by rednecks, almost drowning, bad acid trips, seeing my children injured or thinking they were lost, etc.-but nothing can compare to the horror of being paralyzed, of having something else take control of your body and PREVENT YOU FROM TAKING DESPERATELY NEEDED ACTION. Well, I shouldn't say that. I've never been raped. Rape might well be the only comparison. The overriding emotion throughout this whole experience was one of revulsion at being violated. I hate to admit it, but that feeling of personal revulsion even overshadowed my parenting instincts-at first, anyway.

My wife was awake too. The bedside lights were still on. There was a book in her hand. She looked at me and smiled. I smiled back. Nothing was more obvious to my Scared Brain than that these smiles were HIDEOUSLY FALSE. BOTH of us knew that THERE WERE "ALIENS" IN MY DAUGHTER'S ROOM AND THEY WERE DOING SOME THING TO HER AND OVER POWERING OUR MINDS SO THAT WE COULDN'T FIGHT BACK. And yet we were both being held in stasis,

Nothing was more obvious to my Scared Brain than that these smiles were HIDEOUSLY FALSE. BOTH of us knew that THERE WERE "ALIENS" IN MY DAUGHTER'S ROOM AND THEY WERE DOING SOMETHING TO HER AND OVERPOWERING OUR MINDS SO THAT WE COULDN'T FIGHT BACK.

smiling at each other, as if the demons that had taken over our bodies thought that making the bodies smile at each other would help placate them. We were PUPPETS.

Being a puppet makes you want to puke. But you can't, because the strings aren't making you puke. You can only dangle there with bile slapping against the back of your throat.

When I say we knew there were aliens in my daughter's room, I'm not saying we thought there were creatures from outer space in there. I use the term "aliens" strictly as a pop culture reference. I knew only, but intuitively, that the things in Sivet's room were the same beings that all those abduction accounts describe. I didn't know or care what they were, or how they got there, but I knew they were "the Greys." There was a "sense" of that. (At this point I hadn't actually SEEN a damned thing.) There was also a sense, probably implanted along with the paralysis, that this was somehow NORMAL, and had been happening to other people for hundreds of years. Something was making me feel like it was all part of some TRADITION, like I was SUPPOSED to lay there while "THEY" did "THINGS" to my daughter... because that was how it had always been done.

So my wife and I sat there in bed smiling at each other, and pretending to read, while our, uh, "souls" were struggling to MAKE OURSELVES JUMP OUT OF BED AND GO HELP OUR DAUGHTER.

Apparently I have more will power than my wife does. I'm definitely a whole lot CRAZIER than she is. And I have a very brief history of not being able to see UFOs when everybody else could. In 1975, when we lived way out, in the South Dakota boonies of the Rosebud Sioux Indian Reservation, a classic UFO hovered one night over the pond near our trailer court, visible to everybody who lived there EXCEPT ME. Perhaps my hard-core, psychically insensitive, troglodytic atheism/skepticism, or possibly just incipient schizophrenia, make me "blind" to these things! At any rate, somehow, laying in that bed with that false rictus grin plastered on my face against my will, I was able to break the paralysis.

Let me try to describe what this was like. Maybe it could be compared to parachuting out of an air plane. Every nerve and brain cell in your body is telling you not to do it; your very TENDONS are trying to hold back; but somehow you make yourself leap out into the strong arms of gravity, anyway. An entire OTHER BRAIN was making every step away from my bed and toward my daughter's room feel like walking into a burning house. EVERY FIBER OF MY BEING except the essential core was screaming, "TO STAY IN BED READING IS GOOD AND NORMAL AND SAFE! ! ! TO DO OTHERWISE IS CERTAIN DEATH, AND YOU'RE INSANE! !" Every single step required a gigantic effort of will. It wasn't that it hurt to move, it was that it felt hideously WRONG. It went against every instinct except one, the one that (praise evolution) took precedence: the parenting instinct. HOW COULD I LIE THERE LETTING THIS FAKE BRAIN PRETEND EVERYTHING WAS OKAY WHILE MONSTROUS THNGS WERE BEING DONE TO MY LITTLE GIRL? ? ? The fact that I had already been

paralyzed so LONG added EXTRA HORROR and a sort of shame as well.

Somehow I fought what my interpretive mind remembers as a "paralysis ray." Funny how we have been trained by movies to think of such things in terms of "rays." In the movies, aliens use "rays" to do their dirty work, and that's how I still think of this paralysis. But I'm sure that the idea of a "ray" - and, for that matter, the idea of "creatures from space' - result from living at this partic-ular level technological civilization. In another time, I would have been visual-izing devils and curses.

Step by step. I was soaked in sweat and trembling violently. A kind of white light seemed to interfere with my vision, threatening to replace every-thing. It was like the nightmare in which you're trying to slog your way through waist-deep syrup or up an impossibly muddy, slippery road to reach some goal, but the monsters are closing in behind you. I mean this was BAD BAD BAD. That fake brain was yanking me back towards my bed with all its might, but I was some how progressing, step by clunking, halting step, like Frankenstein's monster, to the hallway outside Sivet's closed bedroom door. I put my hand on her doorknob. The light was getting brighter and brighter. I was in utter, full-fledged panic at this point, my heart slamming away like a jackhammer and my knees wobbling all jelly-like. But I yanked that door open. It was like cutting off my own hand. There was nothing in the room. My daughter was gone. But there was light pouring from the closet.

(I know, I know, I saw *Poltergeist* too.)

GRANTED:

My daughter's closet provided the only access to the attic. A crude trapdoor in the ceiling, reached by climbing a ladder of boards nailed onto the closet wall, led up there. And I knew that Sivet was in the attic . With the THINGS.

I could barely see at all. I was running on madness and Daddy instinct alone. But I yanked the closet door open. I tried to look up towards the trap-door. Getting my neck to tilt my head up, and my eyes to focus upwards, was the hardest thing I have ever done. The light coming through the trapdoor opening wasn't really so bright as it was somehow INTOLERABLE to the NERVOUS SYSTEM. I lost my mind and started scrambling at the board-ladder that led up to the open trapdoor. I can't describe the face except to say that I think it was the lace of a Grey or the servant of a Grey. There was some sense of machinery and more faces and the next thing I knew I was tangled up in bedsheets in the dark, soaking wet with sweat, shaking like a whipped dog, whimpering, crying... my wife hugged me and comforted me AS IF IT HAD BEEN NOTHING MORE THAN A BAD DREAM. I stopped shaking and ran into my daughter's room, and she was sleeping safely, tucked in, snug as a bug in a rug.

Okay.

GRANTED:

I had seen the MOVIE of *Communion* for the SECOND TIME, on VIDEO-TAPE, only THREE DAYS PRIOR TO THIS EXPERIENCE, and had read

> It was like the nightmare in which you're trying to slog your way through waist-deep syrup or up an impossibly muddy, slippery road to reach some goal, but the monsters are closing in behind you. I mean this was BAD BAD BAD.

the book a few months earlier. Granted, I had also read probably three or four dozen cheesy paperback books on UFOs, from Keel to Cooper. (I've met both writers and I consider Keel a cool dude with a carny barker background, and Cooper a humorless, self-deluded creep. No offense, Bill.)

GRANTED

I had been working long hours for days, hardly sleeping, and

GRANTED

I had run out of my favorite recreational dream suppressant .

So why do I have the NERVE, to think it wasn't a just a dream? The same way all UFO abductees know their abductions weren't dreams. The aliens ALWAYS make you THINK it was just a dream. THAT's how you know it was REAL. EVERYBODY KNOWS THAT. The Collective Conscious, from the *Weekly World News* to the *X Files* says so. The bug-eyed Greys ALWAYS use the "dream" trick. That's why you only remember the SPECIAL, details under hypnosis.

WHAT MORE PROOF DO I NEED?

Heck, I can go on the talk show circuit now.

I'm well aware that STUPID NEW AGE IDIOTS routinely convince themselves that their daydreams are past life visions, or prophecies, using EXACTLY THIS SAME LINE OF REASONING. But I'm not like that. I'm SPECIAL. I've been SINGLED OUT by SUPERIOR INTELLIGENCES who recognized ME as one of the Mud Dwellers sufficiently sensitive to be OPEN to their HIGHER WAYS. BUT IT GETS WORSE! ! ! Those poor crazy contactees and abductees don't know the HALF of it.

Did you ever see any of those *Nightmare On Elm Street* movies? The slasher films that you always get mixed up with the *Friday the 13th* series? With the evil murderous ghost, Freddy Krueger, the Boogeyman, the burn victim mass murderer who lives only on the dream plane, but he can KILL YOU HORRIBLY if he gets into your dream? It's actually a fairly imaginative series. The plot device of mixing up dreams and reality allows the filmmaker to pull off the occasional TRULY STARTLING and SURREALISTIC scene. It's coloring-book surrealism for junior high kids, and they're inconsistent films, rife with dopey teenager stereotypes, but I've enjoyed them. They never SCARED me; I used to be a film special effects technician.

But.

FREDDY KRUEGER IS REAL.

I know. he attacked me in a dream. He almost killed me. I woke up screaming. I rolled over in bed and hugged my dear wifey, sobbing with relief. She turned toward me and it wasn't my wife, IT WAS FREDDY, AND HE WAS CLAWING MY EYES OUT WITH HIS RAZOR HANDS!

Needless to say—sorry for the corny gimmick—that was a dream too. But it was REALLY NASTY, so scary that I had to get up and go to the bathroom and

dash water in my face to clear it from my head before I could go back to sleep. And when I looked up at the bathroom mirror, FREDDY WAS STARING BACK AT ME AND LUNGED OUT WITH HIS CLAWED HANDS AND STARTED TEARING MY THROAT OUT WITH A THOUSAND TIMES MORE CRUELTY THAN ANY MONSTER MOVIE COULD EVER IMPART!. until I woke up sweating and wrapped in sheets.

After that series of Freddy Krueger dreams, I tried to write up a little essay about them, and about how close the dream world is to the waking world, at least for lunatics like me, and how in some cosmic way, "You never can tell." I was sitting at my Mac, typing away at this essay, when FREDDY SUDDENLY LUNGED FROM THE SCREEN AND GUTTED ME FROM GROIN TO STERNUM!!

Then I woke up. And I have been "awake" since then, at least to the extent that Freddy hasn't returned. But YOU NEVER KNOW. This whole last year since Freddy was here might turn out to have been PART OF THE DREAM TOO!

Bummer.

Freddy was a lot meaner, and a whole hell of a lot more realistic, in the dreams than he is in the movies. But even in the movies, HE ONLY WORKS THROUGH DREAMS. So... you see the dilemma?? THERE IS NO WAY TO PROVE THAT FREDDY KRUEGER ISN'T REAL.

None.

The self-validating logic is circular and perfect.

There's no escaping from it. Freddy Krueger, as well as the Greys, cannot NOT be real... according to the definition they set up for themselves. Just when you THINK they're not real, THAT'S JUST WHEN THEY'RE MOST REAL. The lack of any empirical proof IS ITSELF THE PROOF.

Let's not dwell on how this logic might apply to any and all religions, political beliefs, philosophies, etc. In fact, let's JUST NOT THINK ABOUT ANY OF THESE DEVILS AT ALL. Again by definition, that's the only way to make 'em go away and leave us alone.

One time an acquaintance of mine was dozing on her couch in the middle of the afternoon when a HUGE, SWEATY, SEXUALLY AROUSED INVISIBLE PRESENCE, suddenly woke her up with its disgusting vibes, held her in paralysis and attempted to rape her, until she woke up.

"Since I was the only preacher she knew, the young lady asked me to come to her house and perform some kind of exorcism to banish the raping demon. I told her that I thought she had probably experienced nothing more than a "night hag" dream, that archetypal "helplessness" dream that everybody has sooner or later. I had had one just the week before. I didn't tell her that thought she was PRETTY DURNED IGNORANT not to know that such dreams have accounted for all manner of superstition since humans started sleeping.

For that reason, I was pretty sure that I could banish this evil thing. My plan was to go to her house and stride around cussing at the ghost. My understanding of ghosts is that they're more scared of us than we are of them. I also

believe that they don't exist in the first place.

Unfortunately, my friend could tell that I didn't take her demon rapist ghost attacker seriously enough to be able to exorcise it properly; she called another mutual friend, who did a much better job than I would have done. This more serious exorcist placed candles in all four corners of every room of the house, waved incense around, and muttered polite incantations and requests for the raping devil ghosts to skeedaddle.

And by God, what do you know? It worked.

Case closed.

The Moral

Don't ever believe anything a SubGenius says when he swears "to God" on it.

Oh, my alien abduction happened, all right. It just happened while I was SOUND ASLEEP.

And there are people who will STILL say, "Stang, you UTTER FOOL! That's just what the aliens WANT you to think!"

Interview: Keith Thompson
Angels And Aliens and In Between

The Editors

Nineteen ninety-two was a watershed year for the UFO community. Not due to any revelations from the ranks of the saucer-smitten, but for the publication of *Angels And Aliens: UFOs and the Mythic Imagination*. For the first time in recent memory, an author with a fresh perspective wrestled with a modern history of the subject, and more importantly, the people who study or are at least affected by the phenomenon. Keith Thompson chose to look at the 20th century evolution of the UFO phenomenon as a developing system of mythology, complete with heroes, villains, power struggles, battles, and innocent bystanders. If you caught the first issue of this magazine, Thompson's name was in evidence throughout, reflecting our collective fascination with his novel point of view. Through a series of electronic pulses delivered through the hydra of the internet, we managed to gain a more coherent picture of the man over the course of a few weeks. Thompson is currently "Editor At Large" for the Institute of Noetic Sciences journal.

Keith Thompson

It seemed clear [to me] that at least some of the "whatevers" called UFOs didn't fit Big Science's view of reality.

Q: Angels and Aliens is, to me, one of the most important books dealing with the subject of UFOs. I'm curious about the process that inspired the book. Was there a specific series of events or circumstances that led you to feel a book of this type was necessary?
THOMPSON: I came to the UFO phenomenon, or it came to me, by a circuitous route. One evening Walter Cronkite opened *The CBS Evening News* with a dramatic rendition of a UFO sighting in Michigan. Dozens of witnesses reported a football-shaped object the size of a car performing gyrations in the sky, before maneuvering out to a nearby swamp. J. Allen Hynek, the tragic hero of the Air Force's ill-fated Project Blue Book, arrived on the scene only to be quoted—misquoted, actually—as saying the witnesses had seen "swamp gas." This in turn was taken as proof that the military had no intention of dealing sensibly or honestly with the UFO phenomenon and its ramifications.

My twelve year old psyche was captivated by this case, with its cast of confounded witnesses, befuddled military experts, know-it-all debunkers, and

The debate immediately polarized between those who were sure UFOs "had" to be real and those who were equally certain UFOs "couldn't" be real. It was my first exposure to the "mythic electricity" that surrounds the UFO domain.

of course the media circus surrounding it all. I grew up in rural northern Ohio, not far from where the sightings took place. The debate immediately polarized between those who were sure UFOs "had" to be real and those who were equally certain UFOs "couldn't" be real. It was my first exposure to the "mythic electricity" that surrounds the UFO domain. Soon the Swamp Gas Case was infamous, and the media forgot about it, and I did too. I didn't pay much attention to the UFO phenomenon until quite a few years later.

Q: What prompted you to return to the subject?
THOMPSON: In the early 1980s I was associated with Esalen Institute in Big Sur, California. I coordinated a series of annual think tank-style conferences on subjects such as altered states of consciousness, shamanism, mysticism, quantum physics, and parapsychology. One day I came across an *Omni* magazine interview with J. Allen Hynek, the dean of UFO studies, and was impressed by his perspective. Michael Murphy, Esalen's founder and my longtime comrade in various adventures of the spirit, suggested that we invite leading UFO researchers to Esalen for a free-wheeling discussion.

I thought it was a great idea. Mike and I felt the UFO phenomenon was a cultural goldmine waiting to be tapped. The first thing I did was fly out to Arizona to meet with Allen Hynek, who had long since retired from the phony Air Force investigation and had concluded, incidentally, that UFOs were real but probably not "extraterrestrial" in the usual sense of the word. Hynek agreed to captain the Esalen UFO conference, but destiny had other ideas. Soon he fell ill with a fatal brain tumor, leaving the Esalen conference in my hands.

There I was, about to receive a symposium of experts on a phenomenon I knew very little about. I spent two months reading everything I could get my hands on, including the works of Whitley Strieber, Budd Hopkins, Jacques Vallee, and the classic books of John Keel. It seemed clear that at least some of the "whatevers" called UFOs didn't fit Big Science's view of reality. I ended up spending five days with leading researchers, getting steeped in UFO evidence, a world brimming with surrealism. This was a phenomenon I could get along with just fine—I felt sure of that much.

Q: You talk about the personality of this thing we call UFO and how it wears different masks: Hermes, who revels in ambiguity, and two mythic shape-shifters, Proteus and Trickster. When you became fully engrossed in producing the book, did you feel that it (UFO) responded to you personally? I guess what I'm getting at is, did anything weird or peculiar happen to you while you were writing or researching the book? Strange synchronicities; unusual dreams; anything?
THOMPSON: I went into my research wondering whether I was in for something weird, especially since Whitley Strieber's highly strange case was still on everyone's mind. The woman I was dating at the time made me promise not to get abducted. I gave her my word, but neither of us was sure I had much say in the matter. I knew Vallee's research had found a consistent paranormal dimension—Men in Black, telephone disturbances, ESP, psychokinesis, that sort of thing. But in retrospect, the period that I spent writing *Angels and Aliens* was

remarkably stable and focused. I think the researchers who have the hardest time with the logic of UFOs are those who have bought the idea of the universe as a rationalistic straightjacket. The UFO universe is a strange place, but then again so is ordinary reality-Latin American magical realism shows us that.

Q: Before your book Angels and Aliens, *you were involved in a public symposium called "Angels, Aliens and Archetypes." This was held, I believe, in San Francisco in the mid-1980s and featured, besides yourself, Jacques Vallee, Whitley Streiber, Terence McKenna, Michael Grosso and others. What struck me about that even was that even though each of you had your own ideas about UFOs, you all seemed, for the most part, to represent a "post-modern" or "new paradigm" or "excluded middle" school of thought—something rare in prior UFO conferences. Do you view that gathering as significant in terms of increasing dialogue about new ways of looking at this phenomenon?*

THOMPSON: A theme that emerged throughout the two days of that conference, among practically every speaker, was best phrased by Jacques Vallee, who emphasized three points: one, the UFO phenomenon is real; two, it has been with us throughout history; three, it is physical in nature yet it represents a form of consciousness that is able to manipulate dimensions beyond time and space as we know them. Vallee's friend and mentor Allen Hynek had arrived at a similar conclusion as early as 1976, when he began expressing his doubts that UFOs are nuts-and-bolts spacecraft from other worlds. He found it ridiculous to suppose that super intelligence would travel enormous distances to do relatively stupid things like stop cars, collect soil samples, perform repetitive "medical exams" on abducted clients, and generally go around frightening people.

Hynek decided it was time to "begin looking closer to home." A key idea at the conference was that UFOs may operate in a multi-dimensional reality of which space-time is a subset-an idea that doesn't require the reality of UFOs to stand or fall with the extraterrestrial hypothesis. I like to think the San Francisco conference may have helped encourage new ways to think about the phenomenon. For instance, Vallee's idea that the intelligence the phenomenon represents could coexist with us on earth just as easily as it could originate on another planet, or in a parallel universe.

Q: One of the themes we found most intriguing in your book was the idea of ufology viewed as an evolving mythology. What inspired you to take this approach?

THOMPSON: There were a couple of departure points. First, as I began to immerse myself in the literature and attend various UFO conferences, I was struck that many of the personalities in the field of ufology spent much of their time doing to each other what the personalities of Greek mythology are famous for: quarreling, settling scores, jockeying for position, seeking revenge, and so forth. I wanted to find out which of the gods and goddesses, which actors from the timeless annals of mythology might have slipped into the UFO cosmos, like thieves in the night.

Hermes, Greek mythology's swift-footed messenger between heaven and earth, is all over the place. Communication under the sign of Hermes borrows from twisted pathways, shortcuts and parallel routes. Hermes loves to

> Vallee's friend and mentor Allen Hynek...began expressing his doubts that UFOs are nuts-and-bolts spacecraft from other worlds. He found it ridiculous to suppose that super intelligence would travel enormous distances to do relatively stupid things like stop cars, collect soil samples, perform repetitive "medical exams" on abducted clients, and generally go around frightening people.

straddle the fence between the explicit and implicit and never tires of inventing nuances to place his message in the "right" context, which involves deliberate ambivalence and strategically partial disclosure. This is a good description of the UFO's style of display. Another Greek divinity who shows up is Dionysus, with his characteristic ways of upsetting our notions about secrecy and true identity—two key themes in the debate about UFOs. The thing to remember about Dionysus is that he wears masks not to disguise himself but rather to reveal himself. Maybe the UFO's behavior, which fits our fantasy of secrecy, constitutes its own style of self-disclosure. That's a Dionysian way of thinking.

But the idea that ufology involves "mythology" doesn't mean I dismiss the reality of UFOs, although some readers thought that was what I was saying. All of life has a mythological dimension, and the UFO phenomenon is no exception. Myth offers a background of images that allow life to show up with greater richness and depth. The assumption that UFO events must be either real or symbolic—but not both—is fundamentalist thinking at its worst. Try as we might, life refuses to be reduced to any flat singular interpretation. Interesting, that the word "symbolism" is derived from the Greek *symballein*, which means "to throw together." The word denotes the drawing together of two worlds. Hermes is a spanner of boundaries, a mediator between realms, an ambassador between domains which seem separate but are connected by subtle thresholds.

In *Angels and Aliens* I was trying to show that UFO reality is complex, multidimensional, remarkably nuanced and textured—and not cooperative with the mental categories to which the Western mind has become so attached.

Q: Mythic realities imply much more than can be precisely defined or explained.
THOMPSON: Yes, but that shouldn't be seen as reducing the significance of the search for answers. UFOs beckon the human psyche in the same way a bobber entices a fish toward the surface, where one element, water, meets others, air and dry land. Efforts to understand the UFO in conventional human ways have the effect of locking the phenomenon from perception. UFOs span the chasm between conscious and unconscious, surface and depth–and this drives us crazy. The UFO's message is that we, too, must learn to move back and forth among separate and diverse worlds. The individuals who report the experience called "alien abduction" may be unwitting pioneers in that quest.

Q: So, would you say that the conventional scientific procedures to ascertain the nature of things ultimately lead to the wrong answer, necessarily?
THOMPSON: Normal science works well enough for normal scientific problems. I think the UFO research field needs a multidisciplinary approach—physicists and chemists to measure alleged physical traces, along with biologists, sociologists, psychologists, philosophers, information specialists, all attending to particular aspects of this baffling phenomenon. Ufology also needs more top-notch field workers like Jacques Vallee, who continues to travel the world interviewing witnesses and comparing patterns, rather than appearing on "Geraldo" to make extravagant claims.

Of course, a major problem with UFOs is they can't be replicated by

I was struck that many of the personalities in the field of ufology spent much of their time doing to each other what the personalities of Greek mythology are famous for: quarreling, settling scores, jockeying for position, seeking revenge, and so forth. I wanted to find out which of the gods and goddesses, which actors from the timeless annals of mythology might have slipped into the UFO cosmos, like thieves in the night.

researchers; UFOs come and go on terms other than our own. That's why Carl Sagan and his high-tech colleagues have put so much stock in Project SETI. It's quite reassuring to the conventional scientific mind, the thought that extraterrestrial intelligence will become apparent to us as a result of our listening for signals from them on frequencies of our choosing. But after more than 20 years of listening, nada, not a single peep. Meanwhile, ordinary people from all walks of life are reporting close encounters with UFOs—yet these don't count as "extraterrestrials" because Big Science isn't able to control the terms of the exchange.

While he was in the process of writing his book *Abduction*, Harvard psychiatrist John Mack paid a visit to his old friend Thomas Kuhn, author of the groundbreaking book *The Structure of Scientific Revolutions*. Mack said Kuhn insisted that the Western scientific paradigm has come to assume the rigidity of a theology, with a belief system held in place by the structures, categories and polarities of language, such as real/unreal, exists/does not exist, objective/ subjective, intrapsychic/external world, and happened/did not happen. Kuhn urged Mack to continue his UFO research by simply trying to collect as much raw data as possible, without worrying about fitting the evidence into any particular worldview. Only later, Kuhn advised, should Mack look to find a coherent theoretical formulation to make sense of his data.

That's good advice. Sadly, the mainstream of UFO research seems more concerned with pressing its baroque theories about aliens intent on forced interbreeding with the human species, and elaborating details about crashed flying saucers and the supposed all-encompassing government coverup. I think science researcher Dennis Stillings was close to the mark when he described that wing of UFO research as "a playground for the bungled and the botched."

Q: Do you see any likely change in the "rorshach blot" status of the UFO/human interaction? Is it proper or even possible to extrapolate any coherent prediction based on a mythological viewpoint?

THOMPSON: Human beings are wired to hold expectations about their environment which influence what they perceive. Some years ago psychologist Jerome Bruner did an experiment in which he showed subjects two sets of playing cards, one with colors reversed and one normal, at speeds of a fraction of a second. Not surprisingly, subjects had greater difficulty identifying the color reversed cards. But what specifically interested Bruner were the lengths to which subjects went to reinterpret and "regularize" their perceptions to fit with their prior expectations about the nature of playing cards.

One subject reported that the red six of clubs was indeed a six of clubs, but there was a pinkish illumination inside the instrument that presented the cards to view. But there wasn't, in reality, any such coloring inside the device. Bruner drew the conclusion that perception is always to some degree an instrument of the world as we structure it by expectation. We try to assimilate what we see and hear to what is expected. G. Spencer Brown observed that if two observers habitually look for different kinds of pattern, they are sure to disagree about the category they call "random."

I agree with Thomas Kuhn about the importance of collecting raw infor-

> Carl Sagan and his high-tech colleagues have put so much stock in Project SETI. It's quite reassuring to the conventional scientific mind, the thought that extraterrestrial intelligence will become apparent to us as a result of our listening for signals from them on frequencies of our choosing.

mation and keeping theories in the background. Still, ultimately there's no way around the necessity of interpreting the patterns that emerge. It's wise to remember Einstein's warning: "The theory decides what we can observe." We need perspectives that aren't wedded to the rigid mental categories of the Western mind. The UFO meets us at a threshold, and in Greek mythology thresholds and passages belong to Hermes, the notorious character who spans boundaries and who, like quicksilver, is hard to track down. Quicksilver turns into little beads and runs all over the place.

Q: *It sounds like you're betting on more of the same.*
THOMPSON: I can live with that. If UFOs were planning to invade, they would have done so by now. If UFOs are waiting for the right time to make formal contact with the earth community, they must be smart enough to see that humanity as a whole is still very much of a tribal species that doesn't take well to foreigners. If UFOs are essentially monitoring us, I would bet my money on the idea that they will continue, seeing whether we can learn to grow up. And, finally, if UFOs are merely cosmic tricksters, they must be having a marvelous time.

> **If UFOs are essentially monitoring us, I would bet my money on the idea that they will continue, seeing whether we can learn to grow up. And, finally, if UFOs are merely cosmic tricksters, they must be having a marvelous time.**

It seems the phenomenon is forcing us through a long-term learning curve-enticing us with bizarre images that lead some to suppose aliens are traveling millions of light-years to gather human embryos and implant tracking devices in the noses of people in Nebraska driving home from bowling. Of course, that's an idea that can easily be mocked by the intellectual class of the target society, even as the idea is absorbed, over time, into the popular culture where it shapes beliefs, hopes, fears, and dreams. The UFO functions like an allegory-telling us different things at different levels.

Q: In Angels and Aliens, *you invoke the Myth of Sisyphus as a tale of futility that could give us a wise place to stand.*
THOMPSON: Yes, that's how I ended the book. You know the story. Sisyphus is sentenced by the gods to roll a rock to the top of the hill, knowing full well that it will roll back down to the bottom. He must do this for eternity—no reprieve. He defies the gods by saying yes to his task, even though this amounts to affirming endless labor intended as torture. The task of making sense of UFOs is Sisyphean. Each attempt to explain these hovering shapes manages to get the rock to the top—and then each theory falls, inevitably, like his rolling rock. On it goes.

I find this strangely heartening. The human spirit always agrees to make the climb to the top, not knowing why. For me it comes down to an article of faith that, in the entangling of human and divine fates, to be human is not to be at a loss. I want to keep asking questions. Keep pushing the rock.

Controlling the Conversation: Are We Having Fun Yet?

UFOs, Secrecy, and National Security

Viewpoint by Richard Sarradet

Face it. Short of a private audience with HRH Ashtar, or the alien technical adviser on *Close Encounters*, discovering the truth about UFOs rests in the hands of our government. The government controls what is essentially a *conversation*. We're having that conversation right now, right here. The ability to control the conversation is no mean feat, but has obviously been and remains successful. This would imply a very strong Command and Control hierarchy, directing the gathering of technical and human intelligence, debriefing, compartmentalizing elements for analysis, assigning security classifications, need to know, and SCI (Special Compartmentalized Information) status. Also feeding into this structure would be black budget R&D updates, and new or revised operational protocols.

In order to keep oversight and control of all of this, the information must collate at various levels on its way "up" the hierarchy. Repeat this procedure for each project, each branch of service, each with competing budgets and agendas. It is a formidable task, requiring a giant bureaucracy to service it. And then of course, there must be executive and legislative oversight.

At each step up the chain of command and control, someone, or some elite group, must be monitoring the *significance* and value of the information. They would have the "big picture." That would ultimately be the most powerful and autonomous position to be in. The rotating doors of politicians would only have the information supplied to them on which to base their decisions and policies.

It is startling to ponder the immense power it takes to hold a truth and construct a myth to obscure it at first, then to exploit it in various ways. When it comes to UFOs, the boys assigned to retrieve exotic hardware may feel quite differently about it than the boys who, say want to land a contract to apply the technology any way the military sees fit. And the military might feel differently about it than the boys who are assigned to inconspicuously monitor and perhaps prepare the public in various creative ways. A dysfunctional petri dish, more toxic perhaps, than tonic these days. For a current example of the government's apparent confusion, witness the spectacle of Congressman Steven Schiff of New Mexico trying to

> The government controls what is essentially a conversation. We're having that conversation right now, right here.

get answers on the 1947 Roswell incident. The Department of Defense "don't know nuthin' about it" and the Government Accounting Office (who uncovered the dirty details of Iran-Contra) reports back to Schiff that it can't find anything, but there are some missing documents.

It is interesting to note that it was the U.S. Government that first acknowledged the existence of UFOs. On July 7, 1947, Walter Haut, Public Information Officer for Roswell Army Air Base, issued a press release to the effect that the Army had finally recovered a crashed "flying disc." Within 72 hours another press release, issued from Fort Worth, recanted the story, claiming it was nothing more than a weather balloon gone rogue. General Roger Ramey even staged what we would now cynically call a "photo op" for the assembled press: "See, here's the debris—a perfectly ordinary weather balloon, MISidentified by our Major Jesse Marcel, SOMEHOW." For quite awhile, it worked, but the genie would not go completely back in the bottle. Reports of UFOs continued. In fact, stories abounded. The public's imagination was kindled.

So, from this point, one secret, one lie, generates a policy that continues to this day-almost a half-century later. The Manhattan Project had already created and codified the genesis for this structure of secrecy. In matters of "national security" lies are elevated to operational tools. Once the lie is accepted, there is no ground, no ceiling, no limits. That is the natural course of lies. Lies create elaborate conversations (like the one we're having right now) instead of clear, direct communication.

In making movies, writing poetry or drama, we call it "the willful suspension of disbelief" when we mimic reality in order to recreate actual feelings, to "walk in someone else's moccasins." The audience is not deceived however, in fact, we applaud the actor for taking us on the journey. We applaud him for his talent and skill.

There is obviously a lot of talent and skill on the U.S. Government payroll, managing the public's perception and understanding of *anything* connected to UFOs.

Anyone care to disagree? Please— entertain and enlighten us with a new conversation. Perhaps the always sincere and reasonable Carl Sagan, or NASA's Jim Oberg could bring us down to earth on this. Or perhaps in executing their new "greater openness" policy, one of the highly talented and rigorously skilled spin artists at Langley, or some hot Pentagon talent would care to respond. Why not? A chance to follow orders, exercise skills, get paid, and serve your country. After all, we're all in this together AREN'T WE?

The parent who puts off telling his kid the facts of life is a cliché. Generally speaking, the kid already knows a lot about it. Of course a lot of what he's heard is baloney, (no pun intended) so one better make sure that the kid at least has the basics straight. It's kind of a cat and mouse game when it come to what to tell and when. When will what he doesn't know yet fit in to his understanding? If you first told the kid that the stork dropped off his little sister, you're already standing in a hole, but the kid will get past that. After all, it was for his own good, but somewhere he will file away the fact that he was lied to. He just got his first lesson: Don't trust your parents; they lie sometimes and tell you it's for your own good. Although he may not realize it then, it has subtly shaped his

perception. Conversations can do that.

In the real world, is there a Santa Claus? To me, there is—because even at three, when I peeked and saw my dad and Uncle Hubert playing with the windup train that Santa Claus would leave me in the morning, it didn't occur to me that there wasn't a Santa Claus. I didn't understand it, and I just didn't make any connections. Later, when I did, I still pretended to believe, maybe because my little sister and brother still did—and I wanted them to. It was fun to believe. My son is almost eight now, and he's struggling with these same issues. I've told him I believe in Santa Claus, because "Santa Claus is the 'spirit of giving for the joy it brings' personified." Hey, it works for us right now.

Whoever is in control of managing our understanding of UFOs is I think in a similar position. I say this not because I'm privy to any "inside information," but because it's the only one I can reconcile with our country's constitutionally-defined powers of government. National Security must provide a legal antidote to each constitutional issue which lies in its path.

However, there is to me some evidence of disagreement on how and when to retire the deaf, dumb, and blind monkey show that passes for official denial. These days, unofficial sources abound. Retired Sergeant Major Robert O. Dean speaks with impunity about the highly classified UFO assessment he saw while assigned to SHAPE (Supreme Headquarters Allied Powers Europe) in 1963 and '64. Looking quite the prophet figure these days, he speaks at length about what he read, and forsees an exciting, glamorous new future arriving. A retired Major Jesse Marcel, spoke out in 1977 about what he saw in Roswell in 1947—it was *not* a weather balloon. Or ask George Knapp about how many "off the record" sources he has that support the Lazar scenario. Pick up any of the late Leonard Stringfield's *Status Reports* on crash retrieval. Then ask yourself: What does this mean? Are those trusted with management (and you know who you are) losing control of the conversation, or are they getting better at it? Is it a different stage of the parent-child charade? If one saw the inevitable breakdown of strict control of the subject, one could plan ahead to distort, confuse, evaluate, educate, refine, and redirect the conversation in order to keep the game going a bit longer.

Parents learn to be quite creative at times like this.

Just consider how dysfunctional the stories could be if the parents disagree on how best to handle the situation. It is good I think for parents to do their disagreeing in private, and spare the children the more raucous moments. The best course is to find a way to agree—most likely a compromise—and to do it quickly. The children are depending on you. "Ask not what your country can do for you.."

Otherwise, the children get a lot of double messages. Most kids take it in stride with resigned cynicism, but some get very upset and act out their distrust and disillusionment. That's the price of the mission, these loose ends—dysfunctional households produce dysfunctional children. I guess that's why there are concrete barriers in front of the White House gates, and grieving in Oklahoma. That's not paranoia, it's just a "big picture" observation. Lies—even well intended—have their price.

Perhaps dysfunctional children could serve an agenda, too.

The Last Sin of Wilhelm Reich: The Arizona UFO Battles

Gregory Bishop

"On March 20, 1956, 10 p.m., a thought of a very remote possibility entered my mind, which, I fear, will never leave me again: am I a spaceman? Do I belong to a new race on earth, bred by men from outer space in embraces with earth women? Are my children offspring of the first inter-planetary race? Has the melting-pot of interplanetary society already been created on our planet, as the melting pot of all nations was established in the U.S.A. 190 years ago? Or does this thought relate to things to come in the future? I request my right and privilege to have such thoughts and ask such questions without being threatened to be jailed by any administrative agency of society."

— **WILHELM REICH,**
 CONTACT WITH SPACE-1957.

Wilhelm Reich was jailed and tried for his refusal to appear in court on interstate commerce and fraud charges, and by court injunction many of his books were burned in an inciner-ator in lower Manhattan in 1956. Mid-20th century paradigms being what they were (and still are to some extent) this is hardly surprising. As Lenny Bruce died for the sins of our present media culture, it can be said that Reich was nailed up on the cross of scientific fundamentalism for his alternative medicinal practices and forays into UFO research, many aspects of which are now taken for granted. In the last ten years of his life, Reich became increas-ingly isolated in his thinking, and obstinate in his refusal to submit to peer and public review. This was the final straw for the scientific establishment, who ulti-mately sought his arrest for breaking the laws of consensus believability.

Presently, Dr. Steven Greer appears to be the chief proponent of initiated extraterrestrial contact, but Reich claimed hostile involvement of which he surmised only himself and the United States government were aware. Many of the details of his work in the 1950s reads like a dream or science fiction novel, and it is amazing to realize that unless Reich and all of his associates were purely fabricating these events, they point to a significantly revised view of the Universe, and "reality" as it is popularly defined.

While George Adamski, George Hunt Williamson, Orfeo Angelucci, Truman Bethurum, Daniel Fry and others were taking joyrides in flying saucers with jovial space brothers, Wilhelm Reich was engaged in an "inter-planetary war" with what he called "$\varepsilon\alpha$" or "energy alpha." He surmised that the craft traveled by exploitation of the "orgone," Reich's term for his discovery of a primordial energy permeating all living things and indeed the whole universe: "The same energy that guides the movements of animals and the growth of all living substances also guides the stars." The spaceships were powered according to the laws of orgonomy and so for Reich represented a practical application of this basic form of energy. Striving for recognition of this theory and others, as well as attempts to support his research by renting out

therapeutic orgone devices branded Reich as a crackpot and sealed his fate at the hands of the FDA, AMA, and many medical doctors as well as the press. He died of a heart attack in Lewisburg Federal Prison on November 3, 1957.

In 1920 at age 23, Reich had become part of Freud's inner circle of students and associates, but later broke with his mentor when the two disagreed on (among other things) the therapeutic value of the psychologist involving himself in a direct way with the emotions of the patient. In much the same manner as a traditional eastern doctor will examine the patient for "emotional blockages" and areas of tension to begin treatment, Reich would "relax, sit down, look at the patient, chat with him and get 'the feel' of him"[1] before moving on to any direct analysis.

Through the 1940s, Reich concluded after a lengthy series of experiments and observation of patients that most if not all physical and psychological ailments could be traced to an imbalance of "orgonomic charge" (more reference to eastern medical treatments.) This mass free energy, he postulated, permeates all of space and forms into living units (like animals and plants) and non-living units (like clouds) and are negatively entropic, i.e. drawing energy from the environment. He also observed that the orgone energy charge in living substances was increased through confinement in metal-lined boxes. This led to the development of the "orgone accumulator," a passive device which would charge and redirect the orgone streams of unhealthy individuals, with therapeutic results. Testimony to the effectiveness of the "orgone box" was demonstrated during Reich's life, and survives as his legacy with numerous documented replications of his findings, including the testimony of William S. Burroughs, who attributes his longevity in part to his daily accumulator sessions. (Considering Burroughs' life and drug use, this may not be too far off the mark.) Of course, the legion of individuals who swear by the device could all be laboring under the placebo effect of popular hypnosis. Of course.

One of the last projects that Reich directed involved weather control. In the early 1950s, he theorized that the vast orgone envelope which surrounds the earth was no less easily affected than the human organism. With the advent of the atomic age, he searched for a way in which the life-positive effect of orgone could be directed to nullify atmospheric radioactivity that would increase with atomic testing. 1951 marked the start of the first ORANUR (ORgonomic Anti-NUcleaR) experiment at Orgonon, the laboratory and research facility on 280 acres in southwestern Maine that was established in 1942. In early January, at Reich's request, the Atomic Energy Commission forwarded three milligrams of radium in the form of radioactive needles. With two milligrams enclosed in an orgone accumulator, the radioactive count tripled. (The other needle was kept in a lead box as a control.) A general sickness suddenly overcame all who lived at the facility. Headaches, feelings of nausea, feelings of weakness and loss of appetite, mottled skin, sensations of pressure, and conjunctivitis"[2] affected the researchers. Experimental mice that were in another building in the area all died, and the orgone-treated radium, now dubbed "ORUR," was buried in a lead box some 15 miles southwest of the laboratory for the next 3 1/2 years. Reich and his compatriots also noticed

Illustration by J. T. Steiny

Testimony to the effectiveness of the "orgone box" was demonstrated during Reich's life, and survives as his legacy with numerous documented replications of his findings, including the testimony of William S. Burroughs, who attributes his longevity in part to his daily accumulator sessions.

U. S. AIR FORCE TECHNICAL INFORMATION SHEET

(SUMMARY DATA)

In order that your information may be filed and coded as accurately as possible, please use the following space to write out a short description of the event that you observed. You may repeat information that you have already given in the questionnaire, and add any further comments, statements, or sketches that you believe are important. Try to present the details of the observation in the order in which they occurred. Additional pages of the same size paper may be attached if they are needed.

NAME ___WILHELM REICH, M.D.___
(Please Print)

SIGNATURE ___Wilhelm Reich___

DATE ___March 18, 1954___

(Do Not Write in This Space)

CODE:

see attached Survey; further information available upon request

"Ea" is my code word for "Unidentified objects"
Please confirm receipt of Ea-survey
and photostatic copy (Ea)-formulae
in writing.
This communication will be published at some
future date, if no objection will be raised
by responsible AAF official

WR

Enclosures:
1 sketch
1 map
1 manuscript copy "Survey"
1 Photostatic copy

Wilhelm Reich's UFO report to the Air Force Technical Intelligence Command in Dayton Ohio, dated March 18, 1954—at the height of the 1950s saucer craze. After repeated inquiries from Reich, Air Force offficers and a curious coterie of civilian "consultants" agreed to a meeting with one of Reich's associates to discuss the report and his theory that flying saucers were responsible for air pollution and the spread of deserts. Handwritten note by Reich says "Ea is my code-word for "unidentified objects." He called UFOs "Engergy Alpha." He attached his formulae and notes on this for the Air Force.

39. Do you think you can estimate the *speed of the object?*

(Circle One) Yes (No)

IF you answered YES, then what speed would you estimate? _____ m.p.h.

40. Do you think you can estimate how far away from you the object was?

(Circle One) (Yes) No

IF you answered YES, then how far away would you say it was? ___1'98 ki off 1___

41. Please give the following information about yourself:

NAME ___REICH M.D.___ ___Wilhelm___ _____
 Last Name First Name Middle Name

ADDRESS ___Orgonon___ ___Rangeley___ ___ ___Maine___
 Street City Zone State

TELEPHONE NUMBER ___99___

What is your present job? ___Basic Research, Natural Science___ ___Orgonomy___

Age ___57___ Sex ___male___

Please indicate any special educational training that you have had.

a. Grade school ___4 years___ e. e. Technical school ___18 years Research Laborat.___
b. High school ___8 years___ (Type) ___Orgone Energy Research___
c. College ___5 years___ f. Other special training ___Medicine, Psychiatry___
d. Post graduate ___8 years___ ___Physics, Bioenergetics___
Medical Faculty Vienna, Austria,1922 **see attached list of publications**

42. Date you completed this questionnaire: _____ _____ _____
 Day Month Year

Has Maine Scientist Answer To Rain-Making?

by Anthony F. Shannon

A solution to drought, a word that has meant disaster to farmers for hundreds of years, may have been found by a Maine scientist. And the day when growers may confidently turn to "rain makers" to save their crops could now be on the brink of reality. At least, that's what two Hancock County blueberry growers would like to believe. The two men on the verge of losing their crops to the whims of nature took a chance when a scientist told them: "I think I can give you some rain within twelve to twenty-four hours." And the chance paid off. They got their rain and said they were satisfied with both the quality and amount.

Here's their story:

On Friday, 3 July, when the drought in Northern and Eastern Maine was at its worst, the two men were approached by William Moise, a resident at Hancock, who said he knew of a scientist who might be able to solve their problem by giving them rain. Moise said the scientist was Dr. Wilhelm Reich, head of the Orgone Institute at Rangeley, Maine, and discoverer of "Orgone energy, the cosmic-like energy of the atmosphere".

Admittedly doubtful at the prospect of rain-making, but anxious to save their crops, the two men made a contract with the Rangeley Institute on a "produce and pay" basis.

The understanding was this: if the scientist produced rain, a given sum would be paid; if he failed, no money would be forth coming. One of the two growers - both

that the granite rocks and stonework around the complex began to blacken and disintegrate in a process that was measured on a daily basis.

Reich attributed the sickness and other effects to a stagnant life negating atmospheric phenomenon he called Deadly Orgone or DOR for short. (Reich had a fondness in his later years for acronyms-another good one was "HIGS" or "Hoodlums In Government") While DOR is now recognized as something called (or akin to) air pollution, Reich attributed the change to a loss of the pulsatory function of atmospheric orgone. Theorizing (and experimentally confirming to his satisfaction) that orgone held an affinity for water, Reich developed a device he called the "cloudbuster." In spite of the name, the device was used to create clouds and rain as well as to disperse them. In one instance, the efficacy of the cloudbuster was documented in the *Bangor Daily News* of July 24, 1953. (See sidebar.) Reich eventually retrieved the ORUR, and almost by accident brought the lead-shielded needles in close proximity of the cloudbuster. The effectiveness was increased exponentially. A wind began to blow, and the sky cleared. Results which normally took hours were reduced to 30 minutes or so. Reich's son Peter, nine years old at the time, wrote about this period in *A Book Of Dreams*. (Incidentally, this is the book that rock singer Kate Bush credited as the inspiration for her song "Cloudbusting.") Visiting Rangely (the closest town to Orgonon) many years after his father's death, he spoke to Vernon Collins, longtime area resident:

> Yessir, it was really something to see. I remember one day I was drivin' up around near Orgonon with some friends and they seen the cloudbuster sitting there by the lab and they said 'What's that?' and I told them about it and they just laughed, so I said 'Well, lets go up and see if the doctor is there and he can show you.' And by gosh he come down and went on the other one up by the laboratory and he said, 'Do you see that cloud right over there?' and pointed to a cloud up in the sky. Then he said, 'and do you see that one over there?' and pointed to another one. And then he started working, and by gosh didn't those two clouds come right together into a big one. Yessir. And they just looked at it for a minute, and the doctor said, 'Now watch' and he started workin' with the cloudbuster again and in a couple minutes that cloud opened up like a big doughnut. [3]

As he engineered the weather patterns of the northeastern US Reich began to notice other aerial phenomena in the skies around Rangeley "Drawing" the atmosphere around Orgonon the evening of the 12th of May, 1954, he noticed that a star appeared to fade out as he worked the array in its direction. As the developing experiment progressed, Reich began to notice more pesky lights hovering about his property Clouds seemed to disperse in their presence and the observation that the cloudbuster would disrupt their movements and luminosity was confirmed repeatedly Reich began to think that a real "Battle of the universe" was taking place "with Orgonon in the role of a Planetary Valley Forge"[4] Given the rough treatment he suffered at the hands of other government agencies it seems incredible that Reich contacted the U. S. Air Force to report his sightings Filling out the standard Air Force Technical Intelligence form for UFOs (see reproduction of part of this report in the photo section) he attached page after page of vital information about orgonomy and its relation to the $\varepsilon\alpha$. Intrepid research remains to discover what if any reaction was engendered within the USAF ranks. Air Force consultants who saw the data and theories probably had a

good laugh before throwing it away and informing their superiors that there was nothing to worry about in the ravings of a "mad scientist" (Reich also forwarded equations and notes to the CIA in 1956, just before his trial, in the hope that it would mitigate the outcome in his favor.)

Undaunted by the deafening silence from the flyboys, Reich forged on with his newest project: bringing vegetation to the desert. This endeavor was inescapably linked with the εα which were manned by "CORE men" (Cosmic ORgone Engineers.) The changing colors of the floating light UFOs were familiar to Reich from his experiments with charged orgone in sealed vacuum tubes. The rotating disc movement in other sightings (he had read Donald Keyhoe's *Flying Saucers From Outer Space* and Edward Ruppelt's *Report On UFOs*) fit neatly with his theory concerning *Kreiswellen* or "spinning waves," one of the primary forms in which orgone energy propagates. (Reich's evidence for this was the phenomenon of "floaters" that the human eye perceives when looking into a clear blue sky. The effect is increased when flying above the DOR envelope which he said hung over large cities and deserts.) He also came to believe that the εα were actually accelerating the buildup of DOR on Earth and inexorably sucking the life out of the planet." Perhaps the preponderance of UFOs in the desert is why contactees generally met their space brothers there.

In 1954, the gang from Orgonon went to Arizona in the world's first attempt to green the desert through cosmic orgone engineering of weather patterns. Reich now referred to the cloudbuster as the "spacegun" when it was used to disable or snuff out the εα. He explained the choice of Tucson for the "OROP (ORgone OPeration) Desert εα": 1: It was situated in the southwestern corner of the U.S.A...at the southwestern entrance of the Galactic Stream onto the continent. 2: The Tucson region was open in three directions: Toward the southwest, (the Pacific Ocean), north (Great Basin) and northeast (Great Plains). Moisture drawn from the Pacific toward the Tucson Basin would move freely in all these directions." [5]

One of the most problematic issues facing the expedition was transportation of the ORUR material from Maine to southern Arizona. Reich had an assistant, William Moise, (who was married to his daughter Eva) leave Maine with a cloudbuster in tow on October 7, 1954. He was instructed to stop off at the Air Force Technical Intelligence Center (ATIC) in Dayton, Ohio to report on the "battle" with the εα, and to ask for help from the Air Force.

Moise called ahead to the ATIC and after a few false starts and phone tag, a meeting was set up on October 15, 1954 with Dr. W.H Byers, a physicist with the Air Force. Also present at the meeting were a Colonel Wertenbaker, Captain D.M. Hill, and curiously, one "Mr. Harry Haberer, civilian, working with the Air Force in regard to the *history of UFOs*." [6] (italics in original.) (It must be questioned under which authority civilians were hired to decipher the UFO question for the Air Force. Perhaps Haberer was in the employ of *another* government agency.) Owing to the influence of Reich, Moise carefully observed and reported on the appearance and reactions of all present, noting that Byers was "...a man with a flabby hand shake and eyes that don't look at you." [7] Moise proceeded to give a complete report on all that had transpired at

of whom prefer to remain anonymous-claims the Boston Weather Bureau predicted there would be no moisture in the area for the next thirty-six hours or at a time the experiment would be conducted. Dr. Reich and three assistants set up their "rain-making" device off the shore of Grand Lake, near the Bangor hydro-electric dam, at 10.30 on Monday morning, 6 July. The device, a set of hollow tubes, suspended over a small cylinder, connected by a cable, conducted a "drawing" operation for about an hour and ten minutes.

The scientist and a small group of spectators then left the lake to await results. They were soon forthcoming. According to a reliable source in Ellsworth the following climatic changes took place in that city on the night of 6 July and the early morning of 7 July: Rain began to fall shortly after ten o'clock Monday evening, first as a drizzle and then by midnight as a gentle, steady rain. Rain continued throughout the night, and a rainfall of .24 inches was recorded in Ellsworth the following morning.

A puzzled witness to the "rain-making" process said: "The queerest-looking clouds you ever saw began to form soon after they got the thing rolling." And later the same witness said the scientists were able to change the course of the wind by manipulation of the device.

The growers who contacted the Rangeley Institute claim that they were perfectly satisfied with the results of the operation, and one man said that if drought were to strike again he would call the "rain-makers" a second time.

From the *Bangor* [Maine] *Daily News* — July 24, 1953.

Orgonon in the last few months. Echoing his boss' concerns, Moise asked that the Air Force "share the responsibility for the $\varepsilon\alpha$ battle, and in another questionable move, offered Reich's notes and equations for safekeeping. Wertenbaker seemed particularly to impress Moise as the only one who paid attention throughout the entire presentation, asking intelligent questions and affirming the Air Force's willingness to safeguard Reich's notes. The meeting lasted just under an hour. The forthcoming reply from Washington was that the Air Force would not assist the Institute in any way, however Reich said he had observed Air Force planes towing monitoring equipment in the vicinity of Orgonon throughout the first cloudbusting experiments.

On October 18, 1954, Reich and his daughter left Orgonon bound for Tucson—a distance of 3200 miles. Strangely enough, while in Washington D.C. for two days, he was convinced that someone was cloudbusting in the area. Continuing southward, he noted the terrain and foliage along the route. Clearly delineated areas were noted where DOR was heavy and affecting each region. Thirty miles from Oak Ridge Tennessee, (site of the first uranium mining and refining operations for atomic weapons) Reich wrote about the particularly "DORish" nature of the landscape with dead trees, blackened soil and rocks, and dusty earth characterizing the area. He also noted the increase in temperature upon his approach to Roswell, New Mexico. Upon arrival in Arizona, his diary reads that he stayed at the Spanish Trail Motel, Tucson.

Issue #12 of *Flatland* magazine contains a detailed examination of Reich's activities while in the Tucson Area. Author Jim Martin uncovers the establishment of a weather modification study at the University of Arizona which was inaugurated on January 23, 1954 with a grant of $150,000 from the Alfred P. Sloan Foundation. These funds gave birth to the "Institute Of Atmospheric Physics." The man who secured the funds to establish this study group was a wealthy Arizonan by the name of Lewis (Lew) Douglas. Martin points out that Douglas (apart from stints as a congressman and FDR's Director of Budget) served as the Director of the Council on Foreign Relations from 1940 to 1964. It was this man who helped Reich to secure a residence just north of Tucson for his experiments. Reich received no monetary assistance in his research, but the fact that he was under investigation and harassment by the government probably made Douglas a bit skittish about outright support.

The group now established at "Little Orgonon," experiments were undertaken to facilitate "greening of the desert." Within a month, Reich observed what he called "proto vegetation" growing on the lower slopes of mountains in the area around the cloudbusting operations. The cattle in the area were content to call it food, and descended on the rapidly growing patches in herds. "The green spread toward Mt. Catalina, climbed during the following weeks up the mountain slopes...and by December it stood several inches to a foot deep over a territory of about 40 to 80 miles from Tucson... *Grass grew knee deep on a territory where no grass had been before*, where only barren sand had been as far back as people remembered."[8] (Italics in original) Reich emphasized this phenomenon occurred without any rainfall-the moisture drawn in from the west seemed sufficient for this miraculous growth. The rains came later in January.

And again the $\varepsilon\alpha$ returned. Reich and his associates watched them flit around the periphery of the mountain ranges which surrounded Little Orgonon. As tensions and stress would "armor" the body, blocking the free flow of orgone and making a person unable to show emotion, Reich figured the $\varepsilon\alpha$ were doing the same to the atmosphere over deserts. All the crew noted sickness and uneasiness when the $\varepsilon\alpha$ appeared—which began to happen with alarming frequency. Peter Reich described one experience with the pesky UFOs: "I figured that if the cloudbuster could sort of take the energy away or weaken it, I could make the $\varepsilon\alpha$ sort of fall by drawing underneath it and to either side of it, weakening the energy around it...I let the cloudbuster orurize on either side...the $\varepsilon\alpha$ [became] a faint glimmer and seemed to be getting smaller and smaller as if it was being sucked up by the sky." [9] Reich surmised that they were "under attack" again. Strangely enough, when the Orur radium needles arrived in Tucson, Dr. Michael Silvert, who had brought them by air from Orgonon, noticed many aerial flares dropping from the sky, and Air Force jets criss-crossing the sky.

The Orur needles were transported by private airplane to Tucson. Flying from an airfield at Lewiston, Maine on December 12 across the country in short hops to facilitate fuel refills and meals for the crew, the radioactive material was carried in a specially designed container. This was necessary to keep the Orur as far away as possible from any metal, which seemed to carry the radioactive count up to dangerous levels. A towing device was designed to reel the package out from the plane when in flight to a distance of about 100 feet. The Orur was encased in two individual plastic boxes packed in cotton inside a "container of wood, looking some what like a football...hollow inside, with an opening to insert the Orur material." [10] The material and its escort arrived safely in Tucson at 1:00 AM on December 14.

By 4:30 that afternoon, Reich writes that a "full scale planetary battle came off; a battle which would have appeared incredible as well as incomprehensible to anyone who knew nothing about the $\varepsilon\alpha$ problems or who adhered to the illusion that neither $\varepsilon\alpha$ or cosmic energy existed." [11] A black cloud spread out over Tucson, and Reich noted that the radioactive background count moved to a dangerous 100,000 CPM. (This would suggest atmospheric nuclear testing, but Reich was convinced that the trouble was from unseen Eas in the area.) The "Cosmic Engineers" (as Peter Reich refers to the Orgonon crew) sprang into action and began waving the cloudbusters from horizon to horizon. Air Force jets passed low overhead and Reich got the impression that "they saluted our base." By 8:00 P.M. the radiation count had returned to normal and the assembled company all had some stiff drinks to calm down.

In March, the group traveled to California, where at a farm near Jacumba, some 40 miles west of El Centro, a second base was established. From March 6th through 12th, more OROP activity seemed to break a "barrier" and brought rains to the Imperial Valley desert region, and eventually all of southern California. The little group started home for Orgonon at the end of April.

This story was drawn almost entirely from one of Reich's last books. By 1957, he was in prison on contempt of court charges, where he died two days before a parole hearing. It is easy to take Reich to task for his lack of peer review

Reich aims a cloubuster.

in any of the disciplines to which he applied himself. It is also easy to find other explanations for the results he claimed with the cloud buster apparatus, i.e. opportunism, observation within a carefully controlled set of parameters (his own), and simple self-delusion. What is forgotten in this rush to judgment is that most of us are tutored in the Aristotelian, duality-minded approach to science. Reich came from this school as well, but was finally unable to tread the straight and narrow path as prescribed by the scientific community. He continually stressed the need to understand his work on its own terms, and by joining microcosm and macrocosm, be believed he had stumbled upon a "unified field theory" of natural science-Orgonomics. In this regard, he felt privileged to study everything from psychology to chronic disease to meteorology with equal zeal and little regard for any authoritarian judgment of his work.

Perhaps Reich will be seen as a pioneer when, as stipulated in his will, most of his papers and lost publications are unsealed and available to the public for the first time in 2007. He believed that it would take 50 years from the time of his death for the world to come to grips with his discoveries. The Reichian community is alive and well, and several journals carry on his work. The UFO community has steadfastly refused to examine any of his $\epsilon\alpha$ findings, but this is not surprising considering the infantile wish to be accepted by the scientific establishment. Perhaps today's Ufologists and other interested parties would do well to take a cue from Reich and disregard 20th century science as a road to the understanding of UFOs and related phenomena. One advantage of our wacky times is that many of the most seemingly outrageous ideas are accepted by the public at large, and are just beginning to merit serious study by both the serious scientist as well as the interested amateur. Perhaps this is what Reich dreamed of.

More Information

- For Info on ordering reprints of Reich's work, contact: The Wilhelm Reich Museum Box 687 Rangeley, Maine 04970

- A very good series of articles on Reich are contained in issue #12 of *Flatland* magazine — $16.00 for 4 issues from: Flatland, P.O. Box 2420, Fort Bragg, CA 95437 www.flatlandbooks.com. Editor Jim Martin has also completed a definitive biography of Reich entitled *Wilhelm Reich and the Cold War*, which can be purchased through the website or from the P.O. address.

Footnotes:

1. Reich, Wilhelm. *Contact With Space*. 1957, Core Pilot Press, Rangeley Maine. p. 11.
2. Boadella, David. *Wilhelm Reich: The Evolution Of His Work*. 1985, Arkana, London. Pg. 263
3. Reich, Peter. *A Book Of Dreams*. 1989, E.P. Dutton, New York. Pg. 128
4. W. Reich, Pg. 46.
5. ibid. Pg. 132.
6. William Moise, Quoted in *Contact With Space*.
7. ibid, Pg. 81.
8. W. Reich, Pg. 158.
9. P. Reich, Pg. 26-27.
10. W. Reich, Pg. 185.
11. ibid, Pg. 199

Interview: Michael Grosso Planetary Near Death Experience

Interviewed by Robert Larson

There are several books on UFOs and the paranormal that are often mentioned as classics. Often overlooked is Michael Grosso's *The Final Choice* (Stillpoint Publishing, 1985.) It is essential for an understanding of different schools of thought regarding interpretations and philosophical implications of "all of this stuff." Grosso, as a professor of philosophy and humanities at Jersey State College, is professionally trained to "look at the big picture." His look, however, doesn't exclude those things that don't fit neatly into the established scientific worldview. This is not always popular in the scientific arena. A couple of unusual personal experiences made it impossible for him to bow to the peer pressure and still maintain his integrity.

Grosso goes back through history to look at reported miracles of saints, mystics, and shamans, and compares them with modern accounts of UFOs, near death experiences, and psychokinesis. He sees the cults of the Virgin Mary, and people like Sai Baba and Padre Pio as especially relevant to human evolutionary potential. He uses the lenses of different philosophical minds throughout history to look deeper into possible meanings. He finds C.G. Jung's model particularly useful in piecing it together. His ultimate vision is an affirmative and hopeful look at humanity on the verge of transformation into something nearly divine.

Michael Grosso

These ideas were developed further in his later books *Soulmaker, Frontiers of the Soul,* and *The Millennium Myth.* All have established him as one of the leaders in the proclamation and recognition of the paradigm shift necessary to incorporate the anomalous into our lives and thoughts. The fact that these concepts— revolutionary when *The Final Choice* was published—are now almost the norm amongst people involved in the world of anomalies and spirit, suggests the degree of success Grosso has achieved in ushering in a new paradigm.

Q: You've made frequent use of a term the Archetype of Death and Enlightenment (ADE). *Could you explain that a bit: What it is and how you came to develop the concept?*
GROSSO: I think I arrived at the idea of an archetype, by which I mean a universal and recurrent pattern of images, through the study of the near-death

experience. What struck me was the recurrence. The typical near death encounter had certain features which repeated themselves. Not everyone experienced every feature. It seemed to be an archetypal or primordial or prototypical pattern.

You know, archetypes have certain characteristics: They are numinous in the sense that they are fascinating; they are compelling; they have a sense of overwhelming depth and meaningfulness-and so do near death experiences. They usually have powerful after effects. They're deeply memorable. And they are supposed to be—at least the way Jung uses the notion of archetypes—deeply embedded in the experience of the species. Death being such a basic part of the human experience, perhaps these NDEs were giving us, in a coherent and consistent way, evidence for a particular archetype that was built into our deep psyche—there to somehow assist us in this universal transition that all human beings go through. I just use that term as kind of a label to suggest the existence of a deeply embedded set of images with these particular properties that I'm describing. Then I extended the concept: I concluded that the ADE turns up in a variety of mystical experiences where you don't have to be literally near death. There might be an ego death. There are stories of individuals who were not near death but who were really going through major changes in their lives; all sorts of people have spontaneous manifestations of similar types of imagery with similar types of aftereffects.

> **Death being such a basic part of the human experience, perhaps these NDEs were giving us, in a coherent and consistent way, evidence for a particular archetype that was built into our deep psyche—there to somehow assist us in this universal transition that all human beings go through.**

Q: *I think of individuals who may not be physically near death, but believe they are, in a certain type of psychedelic drug experience or UFO experience…*
GROSSO: That's right. I extended the idea to suggest—and it's only a suggestion because it's not the kind of thing that you can put in a laboratory and test—that in a variety of other types of transformative encounter, you have a similar type of phenomenon of coming close to the edge of death, whether it be literal death or ego death. Any shock to one's sense of reality may trigger this sequence of experiences.

Light is a profoundly recurrent feature of the ADE. The Marian visions struck me as a variation on the theme of the ADE. But the difference there is, first of all, the light assumes the form of a goddess—and, here, what's dying or threatened with death is not necessarily individuals but a cultural group, in other words, Christians. It's sort of a cultural death—a cultural near death experience. And if you look at the Marian visions, they're frequently associated with actual threats to the survival of the Christian community in a particular locale or at a particular historical point.

Q: *In* The Final Choice *you talked about the imminent possibility of nuclear destruction putting us as a species in a near death state and thus activating the ADE on a global scale. How do you feel the easing of the Cold War, this sort of turning back of the 'doomsday clock', will effect these urgings from 'mind-at-large'?*
GROSSO: That's a good question. It doesn't seem to me that the nuclear threat has been eliminated. Moreover, now the focus seems to be the sense of what's threatening us as a species still exists—perhaps less focalized in the threat of nuclear calamity—but in eco-catastrophe. You know there was a TV program

recently about prophecy. It struck me as quite exploitative, but nevertheless, it ran through all of the, as it were, fears that are *still* very strong apparently in the collective mind-the sense of imminent threat to the species as a whole, whether it be through massive economic collapse or population explosion or environmental disintegration or meteors hitting us from outer space. But I also have the feeling, and this I learned after research on my more recent book on the millennium, that this sense of archetypal death and rebirth is more like a recurrent internal part of our collective psychology. Whether there are external threats mounted against us or not, it seems to me that this is just part of our cyclic collective psychic rebirth process. It may have something to do with an evolutionary trend of consciousness. It seems to me that, whether or not you have an impending nuclear threat, the sense of growing danger and the need for breakthrough into new levels of consciousness is pretty much a permanent part of our mentality.

Q: Even though the nuclear threat is still there, the trigger fingers aren't so itchy at this point. When it was the pre-eminent threat, do you think the images we were seeing, the experiences people were having were somewhat different because of the nature of that-or do you think they're always about the same? There are apocalyptic visions...

GROSSO: Whether the trigger is going to be a nuclear trigger or an environmental trigger, they're basically images of chaos. You still hear the channelers talking about earth changes. The UFO abductees are still talking about earth changes. I think the image of earth change, though at one level might be construed as literal, could also be viewed as symbolic. They certainly are that in *The Book of Revelations*. Images of disorder. For example, in Greek tragedy, images of natural disorder reflect moral disorder. I suspect that there are basic constants here. My sense is that the same imagery seems to be surfacing—and these are basically images of chaos. Massive terrestrial moral disorder. Looking, for example, at John Mack's apocalyptic prophecies and images in the 1990s, it doesn't seem very different. The content of those images don't seem very different from the images that were coming from the UFO contactees of the 1950s where clearly the nuclear threat was the conscious fear at any rate.

Q: That brings me to another question. In the 1950s, we had UFO contactees *and now UFO* abductees *are the big thing. Is this a shift in the ADE and, if so, why?*

GROSSO: One possible thing that might be happening is: In the images of the 50s, the aliens, the higher beings, tended to be more benign. They were more like friendly saviors that were here to warn us against our own self destruction. Though that's part of the imagery now, the image of the abductor is more sinister. It's more violent. We're literally being raptured away by these beings; placed on operation tables or examination tables—all of which I think is fraught with symbolism. You know, I find it difficult to take that whole story literally. Although it's not pure fantasy. There's something else going on. So I would say there's a shift toward a darker imagery. Definitely a shift toward a more blatantly apocalyptic imagery in that I see alien abductions as a variation on the Christian apocalyptic idea of the rapture. The same idea: rapture; abduction. They literally mean the same thing. We're being carried away almost

> this sense of archetypal death and rebirth is more like a recurrent internal part of our collective psychology. Whether there are external threats mounted against us or not, it seems to me that this is just part of our cyclic collective psychic rebirth process.

against our wills. The difference, of course, is there's somewhat more of an ambiguity in the alien abductions. In the Christian rapture it's the chosen who will be enraptured and taken away and saved. It's not quite that simple in the contemporary UFO/alien abduction scenes. These are not necessarily the chosen, but rather the victims. And they're being carried off, not necessarily to be saved but to be used for some unknown purpose. But for whom: for the aliens? For us? You see, it's not clear.

Q: You had mentioned in The Final Choice, *in talking about NDEs, that they are bipolar. We hear mostly about these heavenly, joyous experiences, but there are also these dark, hellish NDEs. They aren't talked about as much but they are there. It may be that the contactee/abductee polarity is the same thing? There is a light and a dark side. Maybe it has shifted because the old way didn't have any effect on us. We didn't change our ways so, well, now okay, let's try it from the dark side. Have you thought about that?*
GROSSO: The messengers are knocking harder on the doors of our psyche; trying to spook us out, so to speak, more dramatically. As I said, if you read about those early contactees-there's a much more benign view that they have. And as you suggest, that as we come to the close of the century-and as tensions grow in the collective unconscious and there's a deepening sense of despair— that there is a darkening more dramatic emphasis on the urgency of these encounters. That is a plausible interpretation.

Q: In Frontiers of the Soul, *you have a quote from the French philosopher [Henri] Bergson, where he puts forward that "The essential function of the universe is a machine for making gods." How do you see it: That we* **are** *divine and that life and existence is our way (as God) of forgetting who we are for the joyful experience of rediscovering it? Or, that we are "just" human but evolving technologically and psychically into something that will be indistinguishable from God?*
GROSSO: More the latter. I tried to suggest that the basis of our evolving toward something divine—like has something to do with our latent psycho-spiritual powers. Figures like Jesus, and more recently Padre Pio and Sai Baba, seemed to literally in their own persons embody some of the features that we traditionally associate with God. God is supposed to be omniscient. So what we see are the great saints, gurus and occult masters possess extended powers of telepathy and clairvoyance and precognition. I see these psychic faculties, in a certain sense, a working out in human evolution of these images of divinity. Likewise, God is supposed to be, in traditional religions, omnipotent. So we see extensions of our physical powers through psychokinesis: For example, the ability of a Padre Pio or a Sai Baba to materialize objects. This certainly seems to be, on a small but nevertheless suggestive scale, indicative of perhaps emerging or evolving god-like powers. My own feeling is that religious mythologies might be seen as blueprints of latent human evolutionary potentials. That is the reason why I was so taken by that quote by Bergson.

Q: Do you think human evolution will be so complete at one point that time will be transcended? If so, some of these paranormal events throughout history could be seen as

The messengers are knocking harder on the doors of our psyche; trying to spook us out, so to speak, more dramatically.

the result of our future selves-wtih the possession of some sort of time travel capability-going back in time to spur history or evolution in a certain way?

GROSSO: I'm not sure how I see that. Part of what emboldens me to speculate on these matters is: First of all, I'm convinced the paranormal is a fact of nature. By extrapolating, for example, precognition and retrocognition seem to suggest that there is some point of contact in the human mind where we somehow enter into a timeless realm; where we're not conditioned by time; where somehow the past and future are co-present. So that suggests to me that there may be an end point in our evolution as a species when we depart from time and we enter into what Boethius, the Latin philosopher of the fifth century, talked about when he used the expression the "nux stan", the now standing of eternity: That there is a fullness of life that awaits us in which the realities of the past and the future are somehow all bound together in the plenitude of the present. We do have some model experiences: (I always come back to the empirical as the starting point for my wild speculations.) For example, the panoramic memory feature of the NDE where individuals report somehow being simultaneously present to their whole past as well as glimpsing their future. So that's one model. Also, there are mystical experiences and sometimes some drug induced experiences in which the sense of time is obliterated. Rather analogous to synesthesia in which colors and sounds mingle; likewise there are moments in mystical and psychedelic epiphanies in which past and present and future are somehow all blended into a fullness of eternity. I think that happens, you see, in works of art. I also believe that's why we're fascinated by movies. Movies, in a way, take us out of time. They give us a kind of mechanistic projection out of our sense of being tied down to a single moment in time. Great works of art synthesize the opposites and give us glimpses of a world that somehow brings the past, present and future into a wholeness; into a simultaneity.

Q: Do you feel that is the natural state of things; this timelessness? And this linear time that we normally perceive ourselves in is just something that we've somehow fallen into?

GROSSO: Linear time is physical time. The time in which our bodies are moving and are subject to entropy and the laws of physics and gravity and the forces of nature. Human beings are what I call 'metaphysical amphibians.' We dwell simultaneously in a physical world in our bodies but at the same time we inhabit a mental world. It's the mental world in which we connect with other minds; connect with the past; reach out toward the future; summon forth visions of beauty, harmony, perfection, bliss. We're simultaneously shifting in and out of those two worlds. We catch glimpses of these higher dimensions and moments of glory; mystical epiphanies and possible intrusions of entities from other worlds. They come to us via the mental. What is natural, to go to back to your question? I don't know. From an empirical point of view, we're both.

Q: We're amphibians, we exist in both-as opposed to being something larval on our way from one to the other?

GROSSO: Well, I *do* think we have a powerful need and an attraction toward this plenitude of existence. So I speculate that we may in fact be evolving toward a fuller mental existence. Jung said each individual has an internal impetus toward individua-

tion; toward wholeness. The whole process of living our lives is a process of gradually coming to realize our need for completeness. It may be something similar to that is at work in the species. It may account for the reason we're attracted to certain things. For example, the current fascination with virtual reality, which almost everybody agrees is now very crude and unsatisfying. But the **idea** of virtual reality is thoroughly fascinating. Why? It gives us a techno-analog to the spiritual. That's why there's so much excitement about the prospect of somehow getting out of our physical bodies and entering into a kind of electronic mind-at-large. But I don't consider that to be the last word. On the contrary, I think the electronic mind-at-large is a way station toward the ultimate freedom that we desire. Again, I see these images of the apocalypse from religious mythology as, in a sense, presentiment of what we are consciously or unconsciously striving to achieve on the historical and meta-historical plane. I think technology plays a very crucial role here. I invented a word in my new book which I call technocalypse. The suggestion is that technology is really driven by our apocalyptic aspirations and fantasies. VR is an illustration of that.

Q: You suggested that psi may be an unanalyzable fact of nature just as life and the existence of mind may be. How do you feel about the notion that psi and mind are God— or at least that part of the divine that impinges into the mundane?

GROSSO: Well—*precisely*. I would say something like this, you see. I've just written a paper with the rather immodest title, *The Parapsychology of God* for the next issue of *ReVision*. I argue that the human conception of deity, which at first was construed naively by early peoples and then dismissed by materialists—both approaches are incorrect. In other words, the literal minded religionists or theists and the scientific materialists are both wrong. I believe that there is a psi-mediated potential of the human mind that enables us to extend ourselves beyond our bodies; possibly survive bodily death and enter into a world I call Mind-at-Large. On the basis of those powers, which I believe are completely natural, we can construct a new parapsychological theology. They simply emerge out of nature. They're facts. They're primitive facts of our reality. Our perception of God, of angels, of the other world: These are human fabrications—as I see it, at any rate-of these fundamental facts of reality which we label psi or paranormal. So I see the history of religion, in a sense, as a fabrication, as it were, and a projection based upon these realities which interpenetrate our human existence. If someone wants to call it God—fine. If someone wants to call it *super*natural, that's fine too. Because in a sense it is. It's *super*natural in the sense that psi is *super* or beyond the nature that current physics understands. That may change. We may yet come to a firmer understanding of, let's say, the physics of the paranormal and hence the physics of God. Although, I'm a little on the skeptical side about that. I suspect that psi, as I said, is simply irreducible. A given. Just as mind and consciousness are irreducibles.

Q: They're just there and we'll never be able to explain them.

GROSSO: Exactly. We know that in logic and mathematics and in nature, sooner or later you come up against axioms; underivables; things that are just logically primitive. I don't have any difficulty at all in simply accepting

> **The idea of virtual reality is thoroughly fascinating. Why? It gives us a techno-analog to the spiritual.**

consciousness, mind and certain paranormal functions as logically primitive. On the other hand, if someone comes up with an explanation in terms of something else—fine, I'm all ears. So far, I haven't seen anything that's persuasive.

Q: *So, you're keeping your mind open and not going out on any limb.*
GROSSO: No. That would be inconsistent with the empiricism that I espouse.

Q: *We were talking about the bipolarity of these archetypes. In arguing for the archetypal nature of NDEs, you said that they must exhibit this bipolar quality. These negative horrifying NDEs, though less frequently reported, do occur. Are you familiar with the new book,* Beyond the Light *by P.M.H. Atwater?*
GROSSO: No. I know some of her earlier work. But I have not seen this new book. Does she talk about negative NDEs?

Q: *Yes. In fact, that's the focus of the book. She's saying that these occur much more frequently than anybody had earlier suggested. Experiencers as well as researchers didn't really want to look at this. She, having had this experience herself, just decided she couldn't ignore it any longer. Basically, I thought it was supporting what you were talking about: that these things* **are** *bipolar and that the negative experiences occur just about as frequently.*
GROSSO: Right. Well, I don't know if that is true. But I am convinced that they do occur and I've interviewed a few people who've had them. I can also imagine a good reason why they are not reported as frequently. They might simply be repressed. People might have negative NDEs but then they'd be so horrible that they'd just be shut out of their minds—literally repressed. So I wouldn't be surprised. But I would add that the fact that they're negative does not imply that they are not in the long run just as creative in terms of transformative potential.

Q: *Well, that's the conclusion she comes to in her book. What determines whether it'll be a positive or negative experience is what the person evolutionarily needs at that point in his or her life.*
GROSSO: I would add to that and say this: All experiences, whether they are mundane experiences or extraordinary experiences, of themselves carry no guarantee of growth or evolutionary significance. Everything depends on how we interpret; how we handle them; what we do with them; what they lead to... I like to talk about the co-creative process of evolution. People have all kinds of experiences and they close themselves off—or they don't have the mental framework, or the courage, or the imagination to face them; to work with them; to work through them; to do something with them. In the end, it's the creative power of the individual that makes an experience truly significant. I think some of us need to be bopped over the head with these powerful experiences to wake us up. Others can be transformed by a casual stimulus; a common event.

Many people have striking experiences and they don't make anything of them because of the culture; because the paradigm does not permit them to. They go to a priest or they go to a psychiatrist or they tell their family, "I've had this amazing experience." And they say, "Oh, you're just crazy or hallucinating." So I think what Phyllis is doing, our colleagues, what you're doing, and

I think some of us need to be bopped over the head with these powerful experiences to wake us up. Others can be transformed by a casual stimulus; a common event.

what we're all trying to do here is simply bring this stuff out and make it available and put it in a useful frame of reference.

Q: Education being a big key. People can have the experience but you're saying they need the courage and imagination to make sense of it. I take it then that you'd be in support of groups like The International Association of Near Death Studies, The Institute of Noetic Sciences...
GROSSO: Of course. Sure. All of them. The odd thing is: Most of these institutions are outside of the academy. By and large it seems to me that within the academy you have forces that seem to be antithetical and destructive of the creative potential of all these unusual experiences that we're talking about. That's just where it's at right now. So thank goodness that we have the extra-academic institutions, writers, researchers and individuals trying to shed some light on this stuff.

Q: What do you think of the Grofs' Spiritual Emergence Network?
GROSSO: It's great that Stan's and other groups are out there to help people. I would like to make a point about Stan's work. I'm working on a project on survival research. Researchers are looking for new ways to access what I call Mind-at-Large. So, for example, we know that psychedelics dramatically open you up to the archetypal regions of consciousness; the nether worlds; the higher worlds; the multi-dimensions of the human mind. But we also know that there are some risks and, unfortunately, legal and political obstacles. So what's great about what Stan is doing now with the Holotropic Breathing is that the trigger is just breathing. Some of his work is similar to what was done in the 1950s by a fellow by the name of Meduna. Basically, you hyperventilate and flood the brain with carbon dioxide. It produces effects that are very similar to the NDE, I think. Also, August Reader has a similar approach.

Q: Yes, Reader [interviewed in issue #3] *mentions that those things are just right there in the brain—the triggers. You just have to activate them.*
GROSSO: That's right. Now Raymond Moody is trying to reproduce parts of the NDE, using a technique he calls "mirror gazing". It's essentially like crystal gazing. He has developed a system for taking subjects through a kind of orientation toward opening themselves up to the creative powers of the unconscious mind; or the revealing powers of the unconscious mind. He's been getting some pretty striking results. In other words, instead of waiting for these things to happen spontaneously, the model I'm stressing is active, neo-shamanic. You even see this in UFO research. There're some people out there like Steven Greer. Rather than wait for contact, they are creating what I would call seances in attempt to elicit responses from the alien intelligences.

Q: Well, I guess that goes back even to the contactees in the 50's. Van Tassel and a couple others were involved in that kind of thing.
GROSSO: That's true. That's true but they were *initially* contacted.
Q: Okay, I see the difference.

Basically, you hyperventilate and flood the brain with carbon dioxide. It produces effects that are very similar to the NDE.

GROSSO: The new thrust and new phase—and I think this is in line with the way science has evolved—is a greater awareness that we need to actively enter and explore and manipulate-whether it be our brains, our breathing mechanisms, our sensory perception-whatever. We need to enter into this extended world of consciousness which may be the scene of our evolution as a species. At any rate, that, I feel, is the next step for research.

Q: Do you know of any groups of artists who are consciously and actively using these techniques you mention?
GROSSO: No, this is my thing but it's not totally original to me. I'm basing it on...

Q: The surrealists?
GROSSO: Well, yeah, the surrealists and the 'pataphysicians. They're partly my inspiration. You see, it's not commonly known that modern art is deeply indebted to the occult. Guys like Kandinsky, for example, were steeped in Theosophy. One of the things I'm interested in doing right now is recreating or re-establishing a connection between art and psychical research. Ufology, in many respects, has all kinds of interesting overlaps with surrealism.

Q: Definitely.
GROSSO: Jacques Vallee talked about a metalogical feature of the whole UFO phenomenon. I would use the term surrealism.

Q: So many things associated with the whole UFO experience—even the study of it-seem like things out of dreams.
GROSSO: That's right.

Q: Even the way people talk about it. Dennis Stillings has brought this idea up: When people talk about UFO experiences, they have the logic of dreams. The way things sort of jump around...
GROSSO: Have you ever stayed up for several days on end? You know, sleep deprivation? I don't do it any more. But I used to when I was a student. I'd stay up all night and on several occasions I remember starting to dream, more or less, while I was awake. Things started shifting a little bit like an LSD experience. Similar things happen with fasting. This is a time-honored technique of the vision quester to access the world of spirits and the world of beings—just through fasting. It seems to me that almost anything that we do that disrupts the normal sensory motor rhythm or reflex is liable to open us up.

Q: It seems that there are all these different triggers: In the NDE, Reader has talked about those actual physiological triggers. In meditation and shamanic practices, we know about these physiological changes that are keys to these experiences. But there doesn't seem to be a consistent trigger for the UFO experience that we are aware of. They just seem to happen spontaneously to certain individuals. I'm wondering if some people are just somehow genetically or otherwise predisposed?
GROSSO: If we look at the work of Greer... I've heard some accounts of his

efforts to induce contact. Quite honestly, they sound to me like seances. The seance, you might say, is an attempt to induce a contact with the dead. Visions, apparitions of the dead occur spontaneously. They intrude upon you. The seance is an attempt to make that happen. I wonder if we just don't know enough about it in the case of the UFOs. It may be if we try to induce these experiences, we'll come to a better understanding. It's an area that needs to be looked into.

Q: *If UFOs turn out to be physical objects from another planet, how would that effect their archetypal and mythic nature? Would those qualities just fade away? Or, do you feel that it's not possible for UFOs to be mere mundane objects?*
GROSSO: Oh no! I'm not dogmatic at all! I'm completely open. You see, that's why I like the expression Mind-at-Large. I'm convinced there are intelligences out there. When I say "at-Large", this is sort of non-committal. I don't know where the hell they're coming from! Could be vehicles or beings from other planets; could be from an extended human mind or collective mind.

Q: *So if that mystery were taken away; if somehow they came out in the open and it was determined that they were actual physical beings from another planet, do you think the archetypal nature would mutate into something else?*
GROSSO: We could be dealing with beings from other planetary systems and still be projecting archetypes on them. We do that all the time. I was once with a person in a psychedelic episode which I report in my book *Soulmaker*. In the course of this experience that we had, this young woman alternately projected upon me the archetype of Satan and Christ. This was not fun. It was a hazardous afternoon, let me tell you. But it was fascinating because I could see by her expression and by her words that I was no longer perceived as the man she knew. I was alternately Christ and Satan. Completely fascinating but entirely as I say... a little risky...

Q: *A hairy experience...*
GROSSO: Really. So we project archetypes on things all the time. I mean, Hitler was the Christ archetype for many Germans and hence his uncanny power over people. But the reason why, of course, we're more likely to project archetypal images on UFOs is because they **are** unknown. The more unknown something is, the more we project upon it. Certainly if it were clarified once and for all that the UFOs were specific beings from outer space, there'd be less temptation to project on them. But the tendency would still be there. To the degree that they remain unknown and inscrutable forces in our lives. we would tend to endow them with archetypal significance.

Q: *What is meant by a veridical out-of-body-experience (OBE) and why is that so important?*
GROSSO: There are two kinds of OBEs. You can have an experience of being out of your body-and it might be an interesting and pleasant experience. But it doesn't carry the same wallop as a veridical (or verifiable) OBE in which someone reports being out of their body and seeing or observing something

> **In the course of this experience that we had, this young woman alternately projected upon me the archetype of Satan and Christ. This was not fun. It was a hazardous afternoon, let me tell you.**

that they could not have otherwise seen or observed while in their body. Let's say during a NDE your body is inanimate and you float out of it, go to the end of the hall and observe who's there and what they're saying—things that you could not possibly know while in your physical body. If you're able to demonstrate this later on and have it confirmed by external facts, that shows this experience was objectively real. Your consciousness was external to your body.

Q: So scientific materialists have to go to some rather strange extremes to explain those away.
GROSSO: That's right. That's why these 'skeptics' who try to dismiss or undermine the importance of the NDE will rarely own up to the reality of the veridical OBE component of the experience. Because that's very difficult to explain away as mere hallucination. Clearly something objective is going on. Now, it's true that it's harder to come up with verifiable veridical OBEs than the non-veridical.

Q: In Frontiers of the Soul *you were talking about scientific materialists and their dogmatism; their denial of these things. One of the things you mentioned was fear—not of death; but fear of life after death. I kind of resonated with that, having grown up Catholic. Many people I knew in that community later went through this hard core atheist phase. That, of course, being preferable to this belief system where everybody seemed to have a high probability of damnation. I feel that this "fear of life after death" is a valid factor. You think that plays a major role?*
GROSSO: I think it does. I'm convinced that it does. What I think is so interesting is that you normally only hear about the will to believe in a life after death. You don't hear about the will to disbelieve. As I think I pointed out in that chapter, the ancient Romans hailed Epicurus as a virtual savior because his materialism promised extinction of consciousness. Extinction was so infinitely preferable to the gloomy, horrifying picture of the afterworld that reigned in ancient Roman myth. That was just an interesting historical example. There is, for sure, the will to believe. But, to balance things out, there is this will to disbelieve. There are these reasons that people prefer not to believe. One is the fear of hell. Another is the fear of the unknown; fear of loss of control. It's a spooky thought that we're going to survive in a dimension that we can't describe or anticipate how we're going to handle ourselves. For many, it may be more comforting to think, "Okay this is it. One trip here and we're gone. Let it go at that. I don't wanna worry about what I'm gonna have to do in this next world."

Socrates says in the *Phaedo*, "If there is no life after death, it's a boon for the wicked." They don't have to worry about the consequences of their lives.

Q: I've often considered that extinction or non-existence, for all practical purposes, isn't really possible because you can't experience it. If you can't experience it, it's not real. It you don't exist, you have no experiences. You can only experience existence.
GROSSO: That's right. By the way, that's exactly what Epicurus said. He said, 'When you're alive, death doesn't exist. When you're dead, you don't exist.' So, in effect, there's no such thing as death. There's only life and your awareness of life.
Q: You talked a little bit about Michael Murphy in Frontiers of the Soul. *Are you in*

touch with him?

GROSSO: I know Michael. I think his book [*The Future of the Body*] is a marvelous kind of a blueprint for the potential evolution of the body. What especially intrigues me is some of the things Michael says about the extraordinary abilities of the body shading off to the point where it becomes increasingly plausible to imagine extending oneself beyond death.

There are two models of survival: one is platonic—that is to say the soul separates from the body. Murphy gives another that I also touch on in my book. I call this the Resurrection Model. Here it is not so much the soul separating from the body but the body acquiring through evolution or technology a capacity to continue and even develop on a new plane. That's the Christian model: Our souls don't separate from our bodies but our bodies are reconstituted in a higher state. This is the spiritual body that St. Paul speaks of—which is a body but free of the limitations of an ordinary physical body. So Michael's book is an encyclopedic review of these extended powers of the human body that point in that direction—toward an evolutionary omega point. A resurrection body. A spiritual body.

Q: What are some specific scientific experiments you'd like to see carried out to examine psi and/or the Survival Hypothesis?

GROSSO: I have this image that if there's another world, it's not an "afterworld;" it's a very close world. The way I conceptualize death is: If it is a doorway into another world then it must be an altered state of consciousness. Therefore, if we wish to explore the next world now, the way into that world is by altering our consciousness. So, the kinds of experiments that intrigue me are experiments that would come under the heading of a kind of neo-scientific shamanism. That would include sensory deprivation, psychedelics, fasting-whatever we need to do to break down the barrier between our consciousness of the world as we see it mediated by our senses and the world which surrounds and interpenetrates us which I believe is this next or higher or alternate reality.

I'm interested in this concept of "conscious dreaming". I haven't really written about this or gotten into it in any great detail but it's an idea that's burgeoning in my mind. One thing I've done-and I've tried this with other people-is used active imagination as a technique for inducing an encounter with a "being of light". Now, you know, the being of light is a feature of, not only the NDE, but of all mystical and transcendent experiences. There are a number of ways you can do this. One way is to try to induce this experience in dreams. I have found that if you persist you will get some response. You may not experience the being of light in its purity but some "light dimension" will intrude itself into your dream experience. I have some records of these things. I have done this with a few people—not many—and it's surprising: the results that one gets. Basically, I have a rule of thumb and it's this: The psychic universe is a mirror universe. If you pay attention to it and you think about it, things happen. It's just a question of focusing attention. So, for example, if you start focusing on synchronicity, you'll start experiencing synchronicity. I do this all the time. I mean, my life is an endless chain of synchronicities. Partly because I'm very interested in a lot of different things and whatever interests me seems to invoke a response.

So, the kinds of experiments that I'm interested in would come under this model of what I would call neo-shamanism. It's shamanic in the sense that it

> **What I think is so interesting is that you normally only hear about the will to believe in a life after death. You don't hear about the will to disbelieve...the ancient Romans hailed Epicurus as a virtual savior because his materialism promised extinction of consciousness.**

attempts to directly plunge into those altered states of consciousness. I believe that's the only way that as individuals we will ever achieve any kind of conviction as to the reality of "another" world.

Q: *The experiential...*
GROSSO: Yes. Exactly.

Q: *So, if let's say, a university was going to fund a study, you would like it to be something where several individuals would be involved and there would be an induction of some kind of altered state and the data would be collected and...*
GROSSO: That's right. And we could make comparisons and we could learn a lot. Eventually, you see, we could begin to create a new consensus. Let me draw an analogy: If you are in a roomful of people who have all experimented with mushrooms or LSD, you have a consensus there. You can negotiate the world of that discourse with those people in a way that is convincing and meaningful because you've all had the experience. If someone were to walk in and say, "Oh, taking one of these psychedelics just makes you into a crazy degenerate," you would all laugh. Right? We'd all laugh. Because in our consensual paradigm, this person would just be an obvious fool. He has not had the experience.

Q: *Well, McKenna has mentioned that back in the early days of psychedelic research, scientists were studying psychedelics and talking and writing about them, but they themselves had never had a psychedelic experience. He felt this was kind of crazy. I mean, how could you really talk about it...*
GROSSO: Absolutely crazy. Especially when you could induce the experience. You know, I could understand someone writing about ESP, who's never had ESP, because you just can't invoke it at will. But there's no excuse for that sort of shallow approach to psychedelics, when anyone can enter the door...

Q: *One last thing I'd like to ask you about: You teach at a university. What kinds of reactions do you get from your peers about all your interests in these things?*
GROSSO: Ohhhh... They tolerate me. For one thing, I publish things, I give talks- so I give a little more cache to the school. However, I did have one student who loved my courses and he said to me, "You know, my advisor told me not to take your course in psychic phenomena. It would ruin my life." And I've heard things like that a few times. I just laugh. I just find that crazy and amusing. It's just part of the deep resistance. That's a whole fascinating topic: the fear of the paranormal; the fear of the unusual.

Q: *They pretty much let you do your thing, though?*
GROSSO: They let me do my thing. Exactly. And my students really enjoy it. That's even more important.

Q: *Well, they sound like some great classes you're offering.*
GROSSO: I consider myself a fortunate man. Being a teacher; having a lot of time to myself to write and do the things I want to do. It's a lucky situation.

> **The psychic universe is a mirror universe. If you pay attention to it and you think about it, things happen. It's just a question of focusing attention.**

Only the Maimed: Giving up on Anomalies

Viewpoint by Bennett Theissen

1. **The universe is a defect in the purity of non-being.** I want to write publicly, with eloquence and passion, because that is how I have privately dealt with the "intrusions."[1] But I can't. I find that I really can't. I have reached a conclusion[2] that the intrusions are not worth the energy. I hardly want to justify their "existence" by giving them names, and that would then deny any communication at all — wouldn't it?

Recent studies[3] in precisely what consciousness is[4] seem to validate to me the thrusts of psychoanalyst Jacques Lacan[5] that the "I" is a construction, that is, that individuality is an illusion which has evolved as a survival mechanism in the human organism.[6] That the brain contains a belief machine of perpetual motion that moves in a relentless forward stream, and that we mistake that machine for what we are. I don't feel that I'm here in this body just to waste myself on belief systems.

At the very least one "learns" merely by observing, but passively taking in and then accepting conclusions drawn only from belief, in other words not using the capacity for critical thinking, changes and challenges nothing, creating entropy. This is ultimately often masked by passion, and it quickly turns to anger when confronted with something contrary to the belief.[7]

Just as the only way one can study the non-conscious aspect of the mind (the "sub-conscious") is through language,[8] that is also the approach to intrusions. The intrusions are, finally, ineffable and indescribable,[9] because they are personal. For instance, there is no "objective" way to examine "UFO abductions" as a form of reality, because they only "exist" when talked about. See, there are stories, and there are those people who stand outside and explicate the terms of those stories through a belief-defined code. The believers[10] and the symbol-seekers maintain that their ideology is separate from their beliefs, but in fact they can be read as highly conservative with a repressive either/or way of thinking.[11]

2. I always speak the truth.

People are apparently conditioned to believe, through religion and sentiment and fantasy, that there is more to life than living. There are so many other consciousnesses out there and "anything is possible." But, as it is possible for something to be impossible, yes, the intrusions are just in the head. There aren't any intrusions, in other words. There are just heads which think there are.

And it appears that it will never go away. The study of intrusions has a history, and that which is already-said-by-others has in its favor existence and solidity. So the discourse has existed, is going on now, and will always be. Facts and reality have nothing to do with it, just as surely as George Bush is convinced he did the right thing in the Gulf War. The machine is driving forward.

Why? Or rather, what's the point? In the barrage of information experienced daily I both feel and know that I am being lied to at all sides constantly, and it's hard enough as it is to live life fully. The world of the intrusions seems propped up on so little rational thought and substance, and the paths are so convoluted and obfuscated, I no longer feel it's worth investigation at all. I am completely open to the possibilities, but the Sisyphean drudgery has worn me out, and I ask again of all believers and skeptics and in-betweens, what's the point? What is being accomplished?

Notes:

1. I refer to what Hilary Evans, whom the *Fortean Times* calls a skeptic, wrote about in *Intrusions: Society and the Paranormal* (London: Routledge & Kegan Paul, 1982), which, on at least one level, attempts to integrate the various conflicting paranormal claims from ghosts and levitation to UFOs and spontaneous combustion. I find the term conveniently imprecise.

2. For now.

3. The Fall 1994 "In Praise of Prometheus" issue of *Free Inquiry* contains a good summation.

4. Which is, after all, what this is all about.

5. The epigrams in this essay are from Lacan. Of course Francophobes and anti-intellectuals will recoil in horror at my reference to this great thinker.

6. Now Lacan never said any such thing. This is an extrapolation, a sort of vamping on his initial theme. Lacan himself said things like "the signified object of desire is the square root of the negative 'I'."

7. Charles Fort: "To our crippled intellects, only the maimed is what we call understandable."

8. By talking about it, you know?

9. A "phenomenon" is something discerned through the senses, not rational thought.

10. And here I would also include the skeptics.

11. I want to make some point about the ufologists and the anti government *Soldier of Fortune* fringe, but that's so obvious.

Roswell Grab Bag

The Autopsy Film, and the Disinfo Authors of the New AFOSI Report

Dean Genesee

The Roswell crash is here to stay

It will never Die

It was meant to be that way

Though I don't know why.

I don't care what the people say

The Roswell crash is here to stay.

[Apologies to Danny & the Juniors]

Relevant groups on the internet have been abuzz for the last few months with the latest in ready made puzzles to show up on the UFO scene. The concern is over the bizarre film stills on these pages. Most seemed concerned about the who, what, where, and when, but not the why of these mysterious and disturbing images. It is beginning to appear that we are left with only the debate. "It's all over by the shouting" as the popular phrase goes, and it should have been coined to describe the endless discussion propagated by the purported "Roswell Autopsy Film," first foisted upon the public at the beginning of 1995 by one Raymond Santilli, British TV commercial and music video producer.

It should seem strange that someone of this magnitude should come into possession of such an historic artifact. The story as Santilli tells it is that the film was uncovered—literally—from under an old Army Air Force cameraman's bed in the course of Santilli's search for old Elvis Presley Footage. (Can anyone think of a good *Weekly World News* article here?) The old timer (whose name changes with each telling, but "Jack Barnett" seems to stick in many of them) had been present at an autopsy of "aliens that were found in a saucer crash" as the military cameraman, and had the good foresight to obtain a copy for posterity. It sat unmolested under his bed in the intervening years until a producer came searching for deteriorating footage of a deteriorating Elvis.

Hardly daring to believe his luck, Santilli rushed the footage home and sometime afterward sent a press release out to every UFO related media outlet he could think of, along with a few stills (probably these here) and an admonition that for fifty dollars US, the inquisitive could "decide for themselves" with a copy of the film mailed on home video-format tapes. No specific claims were made as to the authenticity of the subject matter, but the alien angle was really

This piece was published before the first public showing of the now mostly debunked "Alien Autopsy Film."

all that was suggested.

Then came the pitches to the major TV companies. Six- and seven-figure sums were bandied about, and it appears that a few conglomerates went for it, including Fox Television. The sale price was probably vectored down quite a bit due to a "public" showing in London on May 5, 1995 to selected members of the press and UFO organizations, including representatives of the British UFO Association, BBC and NBC. In all, approximately 100 people attended. With no introduction the lights were dimmed and the show began. An excerpt from an eyewitness report follows. (This was downloaded from alt.paranet.ufo internet newsgroup and was apparently written as witnessed by one John Holman, from the anti-government secrecy group Operation Right To Know):

At a table in a well-equipped [operating] theatre, two people in white outfits and hoods and visors over eyes (all in-one suits) were inspecting the being...One of the surgeons looked closely at the body and was gesturing where he/she would be cutting and pulling the legs apart inspecting the vagina. The female being had no breasts. It had five fingers and a thumb [6 digits]...The ears were smaller than ours and located lower on the head than ours, level with the mouth. The head was larger (especially behind) and the eyes were larger, at least as big as golf balls. It had a small nose and small mouth, which was open. The body was very muscle-bound with very short, stocky legs and larger human-looking feet. The belly was very large and looked eight months pregnant, which it was not. The ears had the same major spiral trough as ours but was smooth and featureless above, more simple and basic than ours. The chest and stomach were exposed and the heart removed and placed into a tray with other substances from around that immediate area...The camera was hand held, and would on occasion move in close, losing focus in so doing. The flesh and attachments to the organs being removed were moving and responding to those actions in a very convincing manner—as if real. There were small amounts of fluids running down the side of the body when the body was opened and organs removed. The colour of the liquid was dark and blood like...the surgeon removed a black lens layer from each eye, revealing white eyes just like ours under it...A wall mounted telephone was visible, as were glass bottles and medical instruments.

The body and procedures looked very authentic and in my opinion would have been hard to fake, but perhaps not impossible with current techniques.

If this sounds like an autopsy on an (albeit horribly deformed) human, the consensus among those who have actually viewed the film points in that direction. Fox asked Jaime Shandera, 20-year veteran producer and creator of special effects for television for his opinion, which not surprisingly is not favorable. If this name is familiar, it is because Shandera, along with William Moore and later Stanton Friedman was the original recipient of the still-debated MJ-12 documents. His expertise has also been called to task in a court case involving evidence tampering on audio tape. (The defendant was acquitted based on Shandera's testimony.) He also collaborated in bringing the first information on the suspected Roswell crash to public attention for the first time

Fox gave him 25 minutes of footage to examine on-site at the interview.

[Jaime] Shandera cites evidence that the film was transferred to videotape, artificially aged with video effects, and then placed on film again. There are two plaster of paris blocks of some sort visible with hand prints of six-fingered appendages impressed into them, and I-beams from the supposed spacecraft . "They look like rain gutters with the welds visible"

"It's one of the worst things I've ever seen in my life" says Shandera. It begins with an autopsy scene in a smallish sterile-looking room, complete with the requisite beakers, jars, and other medical paraphernalia. "To begin with, this is not a military record" Shandera comments. "If the military was involved, they would have had two cameras running in overlap so they didn't miss anything, and this film cuts out every three minutes or so as the guy changes the film reel, then starts back up again after missing a few minutes of the action." Shandera also mentioned that any zoom-in for closeups are so out of focus as to make the action unrecognizable. No tripods were used for this segment, which would seem a requirement for such an important event-not to mention the tight security which would never have allowed the type of lapse in security that would allow Mr. Barnett to make off with a copy.)

This is not the work of a professional, of which there were many in the Army Air Corps—especially at the Roswell base. "Those guys (the military photographers) told us they knew something was going on out there, and were frustrated that they were not called upon to document any of it." Barnett (the photographer) claims the autopsy took place in Dallas, Texas in late June of 1947. There is nothing in any of the literature or any timelines of the Roswell event worked out by researchers to indicate that this time frame is valid. No extraordinary measures were taken in the action or the camera work to ensure quality documentation of what would be one of the most important events in the history of the U.S. military, and the world. A wall-mounted clock occasionally visible in the footage indicates the passage of about two hours. Shandera mentions that some surgeons he has spoken with comment that this sort of autopsy "would take at least two weeks." Shandera also says that the autopsy table itself shows no evidence of a lip or trough—a standard feature to catch any fluids and drain them away.

The second portion of the film purports to be shots of the debris field during recovery operations. Shandera cites evidence that the film was transferred to videotape, artificially aged with video effects, and then placed on film again. There are two plaster of paris blocks of some sort visible with hand prints of six-fingered appendages impressed into them, and I-beams from the supposed spacecraft . "They look like rain gutters with the welds visible" is Shandera's assessment.

An interesting point was bought up by Mr. Shandera concerning the possible origin of this footage. It is suspected that Uri Geller researcher Andija Puharich was in Brazil in 1973 investigating the case of one Dr. Arigo, called the "Surgeon of the Rusty Knife" for his ability to effect amazing operations with the most primitive of medical instruments. One of Arigo's assistants obtained a copy of what he claimed was the Brazilian military performing an autopsy on an alien. After viewing this footage, Puharich pronounced it a fake, partially because one of the figure's hands was severed at the wrist with what appeared to be less than surgical precision—an unprecedented and uncalled-for procedure in an autopsy. This same footage may have shown up later in a low-budget Brazilian sci-fi film. Some physicians and pathologists with whom Shandera has spoken have commented on the appearance of the bodies,

claiming the dead things are very much human, albeit horribly deformed. An entry for the genetic disorder known as "Turner's Syndrome" from the reference book *Current Medical Diagnosis and Treatment* from 1993 lists as symptoms: "Low-set ears, short stature, sexual infantilism, " and "lenticular or corneal cataracts" among others. The disorder affects 1 in 10,000 female births. These and other symptoms seem to fit the appearance of the cadavers in the film. Shandera also commented that the organs appeared no different than one would expect in a human, although somewhat distended by the rigors of decomposition and disease.

For supporters of the authenticity of this film the evidence just doesn't hold. Coupled with the extreme unlikelihood that this film could have ever been brought to public light when so many others may exist depicting much less important, though certainly just as paradigm-shattering events, we must conclude that it may only hold interest for physicians and geneticists.

Air Force Roswell Report Composed by Disinformation Veterans

In issue #4 of this magazine, we reported on the Air Force Roswell report, released for public consumption by the agency's "Director of Security and Special Program Oversight." In a move that would normally be handled by the Air Force's public relations office, Col. Richard Weaver performed some preemptive damage control before the (Government Accounting Office (GAO) could finish their report and make the findings public. (As it turned out, the GAO found no real evidence that an alien craft crashed to the ground in Roswell in 1947. As always, there were documents either destroyed or held for national security purposes which still leaves the door frustratingly open.)

In a classic example of Air Force psy-ops (psychological operations) full-time independent electronics contractor and part time UFO investigator Paul Bennewitz was manipulated into a paranoid delusion that aliens were hanging around the Sandia/Manzano research and development complex near Albuquerque. After it was determined that he was monitoring transmissions from the area, spurious messages about (among other things) aliens eating human body parts and an imminent extraterrestrial takeover were broadcast for his benefit. The deception worked, and drove him clinically insane. This episode stands as a cryptic warning for anyone accepting or offering this kind of information. Either some of this information is true, it can all be traced back to this 1978-79 incident, or it was just starting to be released at that time. You decide.

In the Roswell article in Issue #4, it was revealed that Weaver worked with Major Barry Hennessey of the AFOSI (Air Force Office of Special Investigations) at the time of the Bennewitz incident. Researcher Bill Moore (who was in a position to know this fact) offered this information, and says Weaver took his orders from Hennessey at that time (Maj. Hennessey is now retired.) Other researchers have pounced on the fact that Moore knew what was happening to Bennewitz., did nothing to stop it, and that since Moore was willing to keep these facts from Bennewitz, there is no reason why he should be truthful in any statements. If a lie or deception is evidence of blanket lies and deception, then no one should believe anything they ever hear. While all this

An entry for the genetic disorder known as "Turner's Syndrome" from the reference book Current Medical Diagnosis and Treatment from 1993 lists as symptoms: "Low-set ears, short stature, sexual infantilism, " and "lenticular or corneal cataracts" among others. The disorder affects 1 in 10,000 female births. These and other symptoms seem to fit the appearance of the cadavers in the film.

Richard Weaver's phone number at AFOSI, Bolling Air Force Base, Building #626, in early 1983.

Major Barry Hennesey's location in the same building, three phone numbers away.

Both numbers and their locations in the next-door offices of Criminal Investigations / Special Techniques.

Note: These phone numbers require a special Defense Department code to access them, and are most likely obsolete.

might be considered hearsay, *The Excluded Middle* has obtained a copy of the Defense Department phone directory for the period directly after the Paul Bennewitz incident occurred. The listings place Weaver and Hennessey in the same office (actually three phone numbers away from each other) in the AFOSI office, building #626, at Bolling Air Force Base in Virginia in at least 1983.

The office in question is listed as "Special Techniques." Anything with the term "special" should immediately cue the reader to its status. In concert with the word "techniques" the insightful seeker will immediately sit up and start to wonder. "Special Techniques" (among other activities) is a watered-down Air Force double speak term for getting information out of or into an individual without his or her knowledge that the information has been passed. This was Weaver's assigned office. Hennessey's number is the last in the sequence for the office of "Criminal Investigations," which would fit nicely with the fact that the A.F. was investigating Bennewitz to find out if national security had or would be compromised.

According to Moore, Hennessey directed the operation against Bennewitz, while Weaver served as his assistant. As was stated in the previous article, if this is taken into account, the Air Force Roswell Report may be a case of Col. Weaver simply continuing his work in the way he (and his bosses) know best. More truth and deception thrown together and frapped for public consumption.

Book Review

Whitley Strieber's
Breakthrough: The Next Step

Reviewed by Greg Bishop

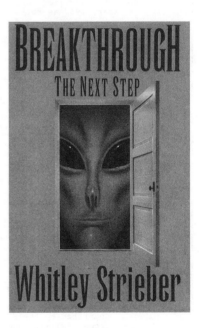

Whatever you may say about Strieber's "visitor" books, this is the one to get. It confirms everything I suspected about the man from Communion on. If you read "Aleister Crowley and the Lam Statement" in Issue #2 you will know what I'm talking about. It seems that Strieber has delved into the realms of western occultism to the tune of invoking entities from wherever—and he wasn't really prepared to deal with the consequences. Until now. He's come to the realization that it is possible to live and even cooperate with his tormentors. A correspondent of mine wrote in a letter a while ago that the invocation of LAM was not for the faint-hearted, according to a friend of his who had tried the ritual. (LAM was a bubble-headed entity that Crowley said he had contacted in 1917. His sketch of same looks very like some of the drawings that show up in abductee accounts.) Strieber's account is so full of solitary meditations in the forest (and elsewhere) that it's hard NOT to believe he is treading the path of the neural explorer/ shaman/ magickian and bringing us his report on what was found there. In this light, it is easier (at least for myself) to take the work more seriously and understand it on a deeper level. The publisher's hype on the dust cover states "What has happened to Whitley Strieber is completely without precedent." I don't think so, but describing it in the understandable terms he has, is. In this sense, it is indeed a Breakthrough.

297 pp. Hardcover Harper Collins $23.00

Church of Scientology® Western United States
Continental Liaison Office
Western United States

30 November, 1996

To the Editor:

 Re: JACK PARSONS - The Magikal Scientist and His Circle
 (The Excluded Middle, Issue 6)

 I must take issue with the depiction of L. Ron Hubbard in the aforementioned article regarding Jack Parsons, Alastair Crowley, et al. It was taken from a book, "Jack Parsons and the Fall of Babalon", which data has long ago been debunked. The author missed a few details that your readers might find of interest.

 In October, 1969, the now defunct London Times printed an article covering the same events. After learning of the true facts, however, the Times reprinted a retracting article on Sunday, 28 December, 1969 as follows:

 "SCIENTOLOGY: NEW LIGHT ON CROWLEY"

 "On 5 October, 1969, Spectrum [a page of the Times] published an article 'The Odd Beginning of L. Ron Hubbard's Career.' The Church of Scientology has sent us the following information.

 "Hubbard broke up black magic in America: Dr. Jack Parsons of Pasadena, California, was America's Number One solid fuel rocket expert. He was involved with the infamous English black magician Alastair Crowley who called himself 'The Beast 666.' Crowley ran an organization called the Order of Templars Orientalis over the world which had savage and bestial rites. Dr. Parsons was head of the American branch located at 100 N. Orange Grove Avenue, Pasadena, California. This was a huge house which had paying guests who were the USA nuclear physicists working at CA1 Tech. Certain agencies objected to nuclear physicists being housed under the same roof.

 "L. Ron Hubbard was still an officer of the U.S. Navy because he was well known as a writer and a philosopher and had friends amongst the physicists, he was sent in to handle the situation. He went to live at the house and investigated the black magic rites and the general situation and found them very bad.

 "Parsons wrote to Crowley in England about Hubbard. Crowley 'The Beast 666' evidently detected an enemy and warned Parsons. This is all proven by the correspondence unearthed by the Sunday Times. Hubbard's mission was successful far beyond anyone's expectations. The house was torn down. Hubbard rescued a girl they were using. The black magic group was dispersed and destroyed and has never recovered. The physicists included many of the 64 top U.S. scientists who were later declared insecure and dismissed from government service with so much publicity."

 I trust that clears up this matter completely.

Sincerely yours,

Glenn Barton

Glenn Barton
Community Relations Director

After publishing an article about Jack Parsons and L. Ron Hubbard, Scientology sent letters like this for months. We finally printed an excerpt. The note from "Community Relations Director" Glenn Barton points out that the London Times (actually it was the London Sunday Times) printed a "retracting article." This was simply a dissenting letter from Scientology with their version of events, which doesn't really qualify as a "retraction."

No. 6

Editorial

The worst thing that the UFO and anomalies research communities can do is to ask for "respect" from the mainstream of academia. The game of western science has been developed over the last couple of thousand years, and it is a good one. It allows, even encourages us to seek out error in attempts to find the most reliable models to describe and predict aspects of the physical world.

Attempts to apply the scientific method to something like the subjects discussed in this magazine is, on the whole, a losing battle. As many now think that the human race is at a developmental precipice, it is possible that we are at least on the verge of the popular acceptance of differing models of reality and better ways of examining and discussing them.

It is understandable that the scientific and academic communities demand objective, quantifiable, and repeatable evidence for flying saucers, abductions, elusive monsters, ghosts and the like, but we are in error if we think that what has been observed constitutes "scientific evidence." And scientific evidence is what most civilized societies demand as a prerequisite to "respectability."

I suggest that those of us who are interested in these subjects begin to seek acceptance for the existence of strange phenomena in the realm of human interaction with them. All we are left with are recollections from witnesses, and it seems in many cases that "reality" is the result of the thing experienced combined with perception.

Individuals must have a personality built over years of maturation and experience and then begin to bend and break the rules to gain real insight and grow. This is far from a new or original idea, but it seems to have been forgotten by those interested in the mysterious. Perhaps we must begin to realize that growing beyond our training / programming is the only way the human mind will be able to move forward towards an intellectual and spiritual peace with the anomalous.

—Greg Bishop

Gargoyles At Night: Puerto Rico's Baffling "Goatsucker"

Scott Corrales

Clearly, all that we have to go by in these amazing cases is the amassed testimony of frightened witnesses, many of whom have suffered irreparable losses resulting from the slaughter of their livestock by a creature that allegedly "does not exist."

For decades, Puerto Rico has experienced paranormal phenomena beyond the amount usually felt elsewhere in the world. Major documentaries like *Ovnis Sobre Puerto Rico — Documento Confidencial* alerted the world to a situation in which bizarre creatures, UFOs and their occupants, and religious phenomena played out on the same stage, or in different rings under the same tent. Animal mutilations presided over the weirdness of the early 1970s, mirroring the Stateside UFO wave of 1972-73, while at the same time people disappeared at the rainforest known as El Yunque, Men in Black walked into business offices, and presumably alien craft crossed the skies with impunity — one of them even pausing to be picked up on a TV commercial for a rum distillery while the camera was left running all night in order to capture a perfect sunrise from the top of a building in the heart of San Juan.

Since a still-unexplained subterranean explosion in the Cabo Rojo area during 1987 opened the door to the ongoing wave of bizarre phenomena, the entire spectrum of UFO/paranormal related phenomena has played out to a greater or lesser degree. The latest permutation to surface in Puerto Rico's long line of weird happenings has been the appearance of an odd creature known only as "El Chupacabras" (literally, "The Goatsucker") on account of its penchant for drawing the blood not only out of goats, but also rabbits, chickens and household pets, through small circular orifices in the animal's body. More often than not, the most important of these wounds is located on the hapless animal's head, where the creature's sucking organ pierces deep into the cerebellum, slaying its victim painlessly before consuming its vital fluids. The Goatsucker has been described as around four feet tall, weighing in at about seventy pounds, with powerful taloned hind legs and painfully thin clawed arms. Its pointed face has a lipless fanged mouth and enormous red eyes. Drawings of this unknown entity are reminiscent of the fusion of an alien "Grey" with a terrestrial animal.

Clearly, all that we have to go by in these amazing cases is the amassed testimony of frightened witnesses, many of whom have suffered irreparable

losses resulting from the slaughter of their livestock by a creature that allegedly "does not exist."

There are no hard and fast rules for monster hunting. Certainly, crypto-zoologists can indicate the most suitable equipment to take on an expedition, but every researcher, has his or her own method. Some might opt for a "photo safari" approach, hoping to capture photos of the elusive critter. Others might consider carrying firearms in case there should be a replay of the Goatman incident, where a cornered entity began hurling tires against his pursuers with the ease of a frisbee thrower. Certainly Mayor Soto and his unarmed cadres, using a cage built from welded iron fencing and with a goat as bait, constitute another option.

Jorge Martín, like Salvador Freixedo before him, would not be considered a monster-hunter by these standards. They have gone for documenting the eyewitness testimony with a vengeance, realizing that the human component of the phenomenon is the only facet over which we can truly say to exercise any control, or claim any knowledge. It is also better than returning home empty-handed after outfitting a massive hunt.

Some of the Goatsucker cases are fascinating: the industrial complex that

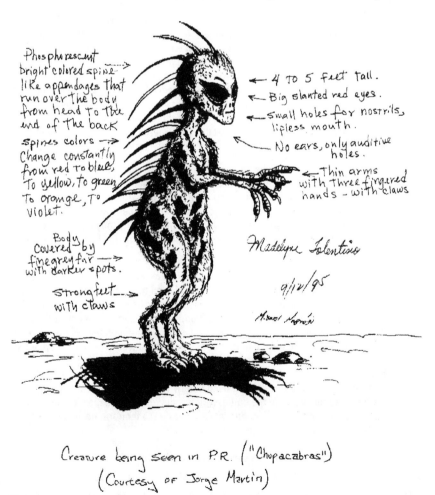

Witness sketch of a Puerto Rican Goatsucker.

couldn't find any security guards to work the graveyard shift, because three "Goatsucker"-like creatures had been seen at the same time; the people waiting for the bus in broad daylight who saw the Chupacabras walking down the street they were on; the driver waiting at a stoplight who thought "a dog" was crossing the street in front of him, only to realize that it was a creature he had never seen before; the woman who looked out the window in the midst of Hurricane Luis only to see the Chupacabras standing at a distance, impervious to the rain, wind, and lightning; the man with the machine gun who fired a hail of hot lead against the creature, but was too scared to report his case on account of his illegal firepower...The Martins' files are filled with accounts that will make a fantastic, absorbing book when it is finally published.

Flashback: The Moca Vampire

During the 1975 wave, Freixedo observed that the smallness of Puerto Rico allowed any investigator to hop into a car and drive to the scene of the events in an hour or two—something that would be difficult to do in his native Spain, much less in the United States. It was this closeness that enabled him to be one of the first people on the scene at Moca.

> "During an evening in which UFOs were sighted over the town of Moca," Freixedo says, "two ducks, three goats, a pair of geese, and a large hog were found slain the following morning on a small farm. The owner was going insane, wondering who in the world could have visited this ruin upon him. The animals betrayed the wounds that have become typical of this kind of attack, and of course, they were all done with incredible precision. I did not doubt for one moment who could have been responsible for the crime...I got in my car and visited the area immediately, and realized what was filling the animals' owner with wonder and fear: there wasn't a trace of blood in any of the animals, and in spite of the fact that the dead geese had snow-white feathers, upon which the slightest speck of blood would have shown up immediately.

> "Over the next few days, the newspapers continued reporting on the growing number of dead animals found in the region. No explanation could be found for these mysterious deaths. I visited the rural areas on various occasions to investigate the events firsthand and found that the farmers were as intrigued by their animals' deaths as they were by the enigmatic lights they could see in the nocturnal skies. One of them told me that the lights reminded him of the revolving lights on top of a police cruiser.

> "During one of my forays, I was able to see a black and white cow spread out in the middle of the field. I got out of the car and tried to reach the cow, which wasn't easy. The dead beast had characteristic wounds on its neck and on its head. Skin had been pulled back on one side of its head, as if by using a scalpel, and the opening to one of its nasal orifices was missing, although there was no indication of rending. In spite of the whiteness of its head, there wasn't a single drop of blood to be seen. The farmer who escorted me could not stop wondering what had caused his cow's death. He related how that very same night he had heard his dogs barking furiously, and that a blind elderly woman who lived on the edge of the field had told him that the cattle, which ordinarily spends the night outdoors, had kept her from getting a good night's sleep due to their frantic, maddened running from one end of the field to another."

The benefit of twenty years hasn't added much to the investigator's arsenal. Researchers of the paranormal still stand over the carcasses of bloodless, mutilated animals wondering what explanation might satisfy the pleading look on the rancher's face. Can the ufologist, cryptozoologist, Fortean investigator or

paranormalist really "level" with the animal's owner, who has just lost a valuable investment or a beloved pet, and start spouting wisdom about EBEs, killer UFOs, interdimensional beings that need blood for their sustenance, and other standards of the occult? On the other hand, can the skeptic tell the same distressed farmer that an "archetype" or figment of the popular imagination just put a finger-sized hole through an animal's throat?

The early months of 1995 brought sporadic sightings and reports of the Goatsucker, while UFO activity remained constant. The situation did not pick up again until the focus of activity had shifted from the town of Orocovis, deep in the mountains of the island, to the coastal town of Canóvanas.

Canóvanas is a prosperous community that benefits from its location on Route 3, which handles the heavy traffic between San Juan on one end and Fajardo on the other. The majestic, mist-enshrouded peaks of El Yunque are only a stone's throw away, and the excellent beaches of Luquillo attract thousands of local and foreign tourists. Canóvanas also boasts the spectacular El Comandante, one of the finest race tracks in the entire world. It was this fortunate piece of real estate that the gargoylesque creature called the Chupacabras would select as its own.

Residents of Canovanas' Lomas del Viento neighborhood were treated one evening to a rather spectacular UFO sighting. One of them, Victor Rodríguez, told Jorge Martín that around 11:45 p.m. on the night of the event, he became aware of the scintillating object that descended upon a group of trees. The light, described as "round and brilliant," took off from the area as if it had been spotted.

Lucy Batista, residing in the Alturas de Campo Rico neighborhood, commented on the curious noises associated with the Chupacabras—inhuman screams resembling the combined sounds of a cat yowling and a goat's braying. Not only did it cause her to feel fear, it also caused all of her animals to panic. One night, she heard the sound of an animal running behind her house. At first, she thought it was a horse until the terrifying cackle filled the air, causing her to fear for the safety children in her household.

During her interview with Jorge Martin, Mrs. Batista expressed her belief that a link existed between the creature or creatures known as the Goatsucker and the lights seen entering and leaving El Yunque, facing her development. Her husband and her son had also witnessed the brightly-colored lights that maneuvered above the mountain rainforest.

Believing at first the lights belonged to National Guard helicopters on nocturnal maneuvers, she soon realized that the lights were executing a number of senseless maneuvers every single night—standing still, ducking, flying in circles—that no helicopter is able to do. Motivated by curiosity, her husband and son drove up the tortuous mountain road to El Yunque, proceeding on foot to avoid detection by patrols. An encounter with Forestry Service workers put their expedition to an end, and both were turned back. She now believes that the lights correspond to what are commonly called flying saucers. "The creature being seen everywhere in Canóvanas must be an extraterrestrial," she told Martín during the course of the interview. "The

drawings that are going around show a combination of extraterrestrial and terrestrial animal. This is the conclusion that we've reached, and the conclusion of the people who've seen it." Other residents of her area refer to the creature jokingly as "The Rabbit" on account of the shape of its hind legs, or "The Kangaroo," for its ability to take prodigious leaps with its powerful legs.

In the light of all the commotion the creature's antics caused in Canóvanas, many of the locals were surprised that no agencies aside from elements of the Civil Defense had chosen to look into the matter. "The Department of Natural Resources was called, but no one was sent to investigate. Perhaps they thought this situation was something cooked up by the townsfolk." One local grumbled.

The fact of the matter is that the witnesses were subjected not to the negative influence of MIBs or hostile government agents, but to the scorn of their own peers. A young woman named Mariane, interviewed by Martín, indicated that her husband's co-workers had taken to teasing him by calling him Goatsucker all the time. Other members of their family, who had also expressed their belief in the existence of this creature, or had seen it with their own eyes, had also been subjected to ridicule. "This creature isn't a joke," she said angrily. "I didn't make it up, either. It's real."

Canóvanas' Mayor, the Hon. José "Chemo" Soto, could not have agreed more with the young woman's assessment of the situation, and decided to take measures aimed at capturing the Goatsucker: together with his band of cammo-clad hunters, a 200-man unarmed militia, the mayor patrolled his municipality at night in hopes of reducing whatever had been slaughtering the area's livestock.

Mayor Soto was clearly pleased at the response elicited by his nocturnal patrols in search of the winged intruder: news of the Chupacabras and its nefarious deeds had made worldwide headlines. According to the mayor, one of his constituents had described the beast as a creature some three feet tall, which could increase its height suddenly, and was endowed with either a crest or horns on its head. It also had large hind legs resembling those of a kangaroo. This matter, stressed Mayor Soto, was a very serious one, and that his patrols served the added purpose of calming the citizens of Canóvanas. His political opponent, Melba Rivera, hoping to unseat Soto in the 1996 elections, went on record saying that the incumbent mayor was doing his level best to discredit the city by his ridiculous antics.

Meanwhile, the Chupacabras' attacks were increasing exponentially. While its' regular "beat" still remained Canóvanas and the surrounding municipalities, the trail of bloodless animals led to sites on the other side of the island. It was then that people expressed the belief that there surely must be more than a single Goatsucker at work. By November 1995, the situation had reached a fever pitch - not a day went by without the elusive predator making its presence felt.

The senseless slaughter of animals of all sizes prompted certain politicians—against the wishes of party leaders and the government currently in office—to call for decisive action to be taken against whatever animal or entity was responsible for the mutilated carcasses. On November 9, 1995, congressmen José Núñez González and Juan "Kike" López presented a resolution in the Commonwealth of

Puerto Rico's House of Representatives calling for an official investigation into the matter. RC 5012 requested "an in-depth and thorough investigation of the unknown phenomenon and an accounting of the damages visited upon the country's farmers by the so-called chupacabras." Congressman López voiced his dissatisfaction with the apathy evinced by his colleagues on Jorge Martín's *Ovnis Confidencial* radio program: "We're dealing with a situation in which hundreds of animals are turning up mutilated, dead, slaughtered...which is highly uncommon. If we all know that something unusual is going on, why isn't anybody doing anything about it? The government does nothing, the legislature does nothing, federal and local agencies do nothing. The Department of Agriculture has done nothing, the Department of Natural Resources has done nothing, yet this situation has already affected enough farmers who've experienced losses which may be considerable in the end...This cannot be. What are we waiting for?"

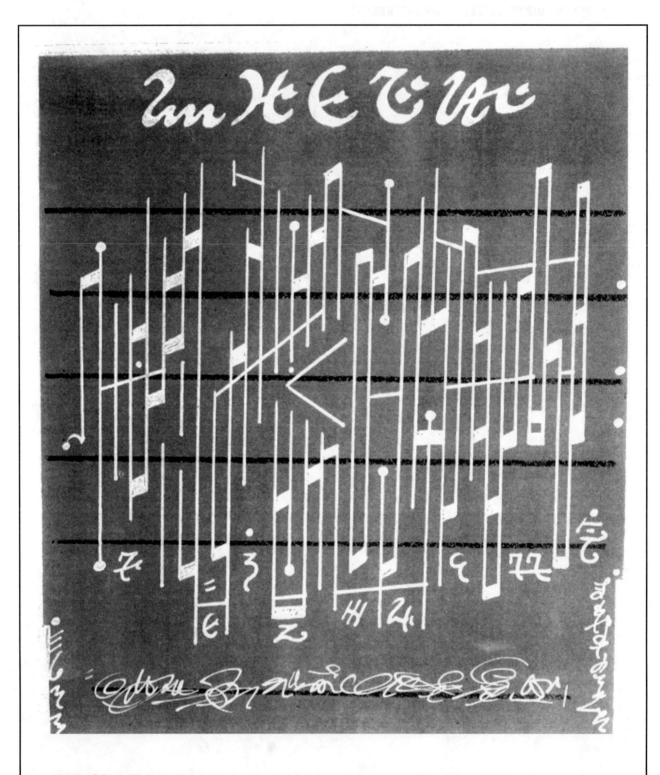

Sample of alien writing

Alien Writing And Received Scripts
An Interview With Dr. Mario Pazzaglini

Greg Bishop

A review of the first *Anomalist* series of fortean anthologies appeared in Issue #4 of *The Excluded Middle*, along with an illustration from a curious self-published book bearing the cryptic title: *Symbolic Messages*. As intriguing as this was, while we tried to get in touch with its author, clinical psychologist Dr. Mario Pazzaglini, a package arrived with a Delaware return address. Pazzaglini had seen the review and sent a copy because in his words, "I knew you needed to see it."

He was right. This singular study is one of those rare documents that defines a completely original phenomenon. Specifically, the text discusses "received scripts"—any form of written communication that the human percipient alleges to have originated with a non-human source. Methods of reception range from channeled writings, to symbols that were seen on or in extraterrestrial craft, to simple, inexplicable desires to communicate something that seem to come from outside of the receiver's frame of reference. "I just have to do it. It's not by my own choice" is a typical phrase.

Taking a cue from Galileo, Dr. Timothy Leary, and Dr. John Mack, Dr. Pazzaglini is careful to separate his professional life from his interest in alien writing. As direct witness to the persecution of Mack at the hands of the Harvard administration after the release of his book *Abduction*, there is ample reason for his trepidation. There is however, an inescapable intersection between the bipolar parts of his life, as the first few responses will reveal...

(Note: When Dr. Pazzaglini refers to a "stateside" frame of mind, he's talking about how "sane" people operate for most of their waking hours.)

Q: What's your professional training and background?
PAZZAGLINI: I'm a clinical psychologist, and my background is in clinical psychology and neurophysiology, and in particular, sensory physiology. I treat

Mario Pazzaglini

"If You Want To Make Light Solid, Show It To The Moon"
—TRANSLATED ALIEN SCRIPT

(Note: Dr. Pazzaglini died of cancer on November 25, 1998)

mental patients and specialize in the severely mentally ill. I deal with people with some brain damage, and I also deal with a lot of people with severe addictions. I have done research on street drugs for about 30 years. This is ethnographic research on drug use, going out on the street interviewing people. In the late '60s, I was doing research on the visual system, and realized that people were doing experiments on themselves that I couldn't get funding for. The cheapest way to do this was to talk to people directly while they were doing it. That not only gave me the information I was looking for, but I ended up having some expertise in hallucinogens and their effects.

I got asked to go to Woodstock to run the "bad trip" tent and ended up treating 5000 people. We had two classes of assistants: one was people whom we had guided through their bad trips, and got them stabilized. They understood what we were doing and caught on. Then I brought in some Tibetan monks who were very good at this. We had sort of an "intense" tent and a "cool-down" tent. The system worked fairly well. We had a psychiatrist and a heli-copter, and we had to medicate a few people, and we only flew out about five people who had gone violently crazy.

Sensory physiology is the study of neuro-sensory mechanisms. I'm mainly interested in the visual system.

Q: Did you see the interview we did with opthamologist Dr. August Reader (issue #3) on the near death experience?
PAZZAGLINI: I think so. There are certain disciplines in meditation where you can get your whole visual system to flood with light in a totally dark room. What we had in the '60s was what is called an anacoustic chamber. This is a chamber where you're totally isolated from sound, but because of that, you're also totally isolated from light as well. What we found was that with very little prodding, if you don't stay compulsively "stateside" is that you drift kind of nicely away into all sorts of hallucinatory activity.

Q: What year was that?
PAZZAGLINI: 1966 I believe.

Q: Was that before John Lilly was putting people in flotation tanks?
PAZZAGLINI: Probably about the same time. I studied with him from 1970 to 1973. We would meet in Berkeley as part of the Esalen Institute. That's when I met him. A lot of us doing that kind of research stayed pretty isolated from each other. I probably stayed more isolated than anyone else. This is because when you came out of this state, there weren't many people who knew what you were talking about, or who would even **care**, or knew what you were talking about. What we were finding was that the brain would download infor-mation. Then the question came, was it downloading stuff that was already in there, or was it reorganizing stuff and then downloading it? Then a third possi-bility began to appear, and that was; is it downloading stuff that **wasn't** in there? Perhaps acting as some sort of receiver.

> **What we were finding was that the brain would download information. Then the question came, was it downloading stuff that was already in there, or was it reorganizing stuff and then downloading it? Then a third possibility began to appear, and that was; is it downloading stuff that wasn't in there? Perhaps acting as some sort of receiver.**

Q: How did this theory begin to take shape?

PAZZAGLINI: Because I had a patient who was an Amish boy. He went psychotic, but in the midst of that, he did a couple of weird things: he began writing symbols that he didn't know. I happened to know what they were because I was fairly well-versed even at that point in "weird stuff" and I could watch him doing this. I knew that he hadn't gone past the eighth grade because Amish people just don't, and he hadn't read that kind of stuff. Then he began talking sporadically (but not well) in Old High German. I could get individual words and look them up and actually find meaning. I asked the family if they knew that language, and it's a tricky piece because they're of German stock. But they didn't. It would be like me speaking in Chaucer's English. Somehow he had that information.

When people go out if their head, to us [psychologists] it's like a cyclotron or a nuclear explosion is for a physicist, you can see how the thing works.

I had another kid who went out of his head who was about 15. I ran a hospital for adolescents for awhile in the early '70s. He was interesting since to say that he came from the backwoods area of our state [Delaware] was an understatement. He had never had shoes on before. He was really primitive. As he went psychotic, he spoke better and better, until when the psychosis was the most advanced, he was able to dictate hours of what sounded like a conversation between Schopenhauer and Alfred North Whitehead. It was the most complex cosmology I've ever heard come babbling out of an adolescent's mouth. He used to tell me "Please don't give me any medication, because this will all break, and I'll be gone forever."

Q: So you didn't do it?

PAZZAGLINI: At that time I had enough power that I talked everyone into allowing me to work with him. What I was able to do was to get him stateside again, but still preserve the ability. I went on vacation, and these idiots who were left in charge with him, who I told what and what not to do, I think they were just waiting for me to leave to pump him full of thorazine. They turned him into a chronic patient, and he's still in the hospital today. They basically killed him, but I still talk to him and once in a while I can get him back on the thread. The circuits are damaged, and he begins to falter and tumbles out of the library into some kind of "dump" in his head. There were numerous instances like that which made me think that "something else is happening."

Q: How have you come to the conclusion that the messages and phenomena you've just described comes from outside the mind of the percipient?

PAZZAGLINI: If you look at the brain, it's clearly "hardware" and "software." Except it's different than a computer, because in the brain the software changes the hardware. It's constantly doing that. What that system does I think, is it either generates or connects with what's loosely called the "soul." (Pardon me if I start to sound really crackers!)

We could think of consciousness as a quasi-material that is organized by whatever this neural system is doing, and that the nervous system begins to act as both a container and a vehicle and organizer of something. And the point here is

> **If you look at the brain, it's clearly "hardware" and "software." Except it's different than a computer, because in the brain the software changes the hardware. It's constantly doing that. What that system does I think, is it either generates or connects with what's loosely called the "soul."**

that "something" is not bound by space-time as we understand it, and it's just in contact with everything, just as your radio is in contact with "everything" but you have to have it on and tune it. Something like that is happening, and that's as simple as I can put it into words. This is not a new idea, but that's what it looks like is happening. The information exists, and I'm quite sure that the contact exists, but I'm not quite sure that the material is always or even mostly "worth" anything. I talk in the book about how things are distorted as they pass through the nervous system. I think that's a huge source of distortion as that information comes through, and it has to get wrapped around our metaphors. It sounds like watered down Christian Science! I've heard hundreds of people channel, and what always struck me about it is; "OK, we're sitting here listening to the center of the universe talk, and people are dozing off."

Q: How do you reconcile that to the point where it's meaningful?
PAZZAGLINI: I have seen a handful of instances where the information is pretty interesting. One of them is Betty Andreasson. [Andreasson has had a continuing series of what she sees as contact with extraterrestrial visitors, as documented in Raymond Fowler's *The Andreasson Affair*] I've talked to her quite a bit, and what strikes me about her is that she's dead honest and earnest, and believes what's happening. I think it is happening to her, whatever "it" is, and my hunch is that if someone was there watching it, there wouldn't be much to see, because it's happening in that other medium which we loosely label as "consciousness." Real contact is being made. It's a very reliable channel: she can tune into it over and over again, as can her daughter and her husband— the same writing, the same symbols, the same kinds of frequencies of symbols, so it's a very consistent phenomena—whatever it is. I think at times it has some validity, but it's barely understandable.

Q: Could you give me an example of something meaningful?
PAZZAGLINI: One sentence that we were sort of able to squeeze out was "If you want to make light solid, show it to the moon." That's one of the greatest sentences that has ever plopped out of anything I've done.

Q: How did you figure that one out?
PAZZAGLINI: I'm embarrassed to tell you what I did! First I bowed down to the god of "I Have Absolutely No Idea Of What I'm Doing Here." And I must add a footnote here: I know how to teach people to channel (whatever "channeling" is) it's an easy thing to do, and I can teach anyone how to do it within 20 minutes to half an hour. Then they can follow the phenomena and let it get as complex as they'd like it to.

I did this to myself, and sort of made a mental "machine." I asked her connect to her alien, and she did. Then, with my "machine", I connected into that too, and asked them what to do. They said "make a few assumptions" as a first piece of advice. That's exactly what you need to do if you were translating Etruscan for example.
Q: Like breaking codes.

Young Mario Pazzaglini

PAZZAGLINI: Yes, find a pattern. So they said, what does it [the alien writing] look like to you?" and I said "Gregg shorthand and alchemical symbols." And the reply was "Where do you think the gold lies?" So I said "With the Alchemical symbols, I would guess. Thank you." I have a library of volumes on symbols and languages, so I have a dictionary of alchemical symbols, and there's hundreds of symbols in it. I could weed out one factor, and that was that these [Andreasson's scripts] are not archetypal symbols-circles, diamonds, etc. So they're not automatically generated by the nervous system. These are complex symbols. I just picked a sentence that I thought was a sentence, and made the assumption that this was some whacked combination of alchemical symbols strung together. As I looked through the glossary for the right symbols, that was the sentence that came out. Now, scientifically that's worth nothing.

Q: It's entirely subjective.
PAZZAGLINI: I reinvented the mirror! And it was amazing because it just translated so easily.

Q: Is that the only instance of that in the text?
PAZZAGLINI: Well, I can do it with the whole text. That was the only one where it didn't say, for instance "rat dog bird bathtub." This one said something.

Q: So the rest of it was gibberish?
PAZZAGLINI: The gibberish level was about 90 per cent. I translated all the words and read through them. You can sort of get a feel for what they might be saying, and what that reminded me was of many people who channel. If they get what is sort of an "ascended being"—they don't have some sort of shrew mouse level of being—the message comes through as a sort of incomprehensible growling, which then begins to organize into words.

Q: Like tuning in.
PAZZAGLINI: Yeah. And it felt like I had gotten just past the "growling stage" symbolically.

Q: What drew you to start your study of received writing?
PAZZAGLINI: The basic question that I started with in the late '50s was "What is an internal representation?" or "What is an idea or internal picture, and where does it reside and what does it do, and how does it get there?" That's the basic core interest, and it's always been my interest. How do we form pictures and metaphors for things, and what is the relationship between that, and whatever it is out there?

Q: Whose work and thought affected you at that time?
PAZZAGLINI: Probably Einstein, if I had to think back. Plus, we were knee-deep in UFO activity. Where we lived, everyone saw them. This was in upstate New York.
Q: That area seems to be a real hotbed.

One sentence that we were sort of able to squeeze out was "If you want to make light solid, show it to the moon." That's one of the greatest sentences that has ever plopped out of anything I've done.

PAZZAGLINI: It's almost never stopped up there. I knew that there was a lot that science couldn't explain, although my main identity was as a scientist, and I thought if I'm going to walk a path, I'd better walk a fairly standard path before I try unstandard things, but I'm certainly going to give myself the luxury of immersing myself in this other stuff as I'm doing it. I thought that would be a fairly valuable way to track thoughout and keep my hands busy. Also, I draw and paint, so the whole display piece of human existence was very important to me.

The second part of the start of my interest (in fact I'm writing a book on this now with my mother) [now published as *Aradia: Gospel of the Witches*] was that we come from an area of Italy where we are taught two religions: Catholicism, and something called the "Old Religion." What this is a whole system of communication with otherworldly beings-but in the in the most deadpan, ordinary way you could imagine. It's hard to explain to anyone how ordinary this was to us, until I stepped out of my house into an ordinary school in the '40s. Other people didn't do this. For instance, if you were doing something in the garden, and you disturbed a piece of earth, you would always ask the elemental "Is it OK if I'm doing this? And if it's not OK, I don't care, but I'll build this little house off to the side, and that's where you can stay for the summer." There was an ongoing dialogue.

Q: That sounds very similar to the Celtic fairy faith, and even somewhat like the Native American trickster.
PAZZAGLINI: It has little goblins, the entire...in fact, it has so many similarities with the fairy faith in the fact that the Celts inhabited that part of Italy for quite a while. Whether that's the reason for it or not, I don't know. What happens is, the people who believe in this almost take a vow of silence, which you don't realize you've taken, and you don't really talk about it.

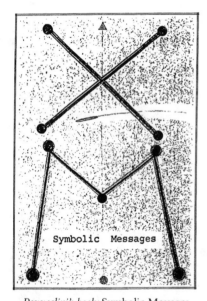

Pazzaglini's book: Symbolic Messages

Q: Like the "silence is power" edict in many occult and religious practices.
PAZZAGLINI: It seems the more you talk about this, the less power you will have over it in the long run. The idea of another world was something I grew up with and assumed to be true. So, those are sort of the three pieces: that family piece, trying to understand what imagery was all about, and trying to keep a very solid foot in hard science. I've tried to keep a very solid foot in hard science as a sort of reference point to come back to.

I've noticed that the people who don't keep that scientific, skeptical edge tend to go spinning off into the irrational void. In another way, it recalls the "banishing" rituals performed before occult work that is said to be necessary to keep the magician from being "possessed" by the forces he wants to work with.

Q: What made you choose the alien messages, in particular?
PAZZAGLINI: I've been interested in UFOs from the get-go. If I was going to do this, I figured that I should choose one small area where I could contribute something in a concrete way, and I thought that I was probably best equipped to do this particular piece.

Q: Did that come about gradually?
PAZZAGLINI: Yes. Well, I had been collecting writing-related stuff for years. Every time I would see a book on symbols, or someone would show me some symbols they had had in a dream, I'd get it and put it in the file. So I ended up with a fair amount of stuff.

Then I was lucky through Arcturus books to begin to get files of the early contactees. I have Adamski and George Hunt Williamson's files—that whole group.

Q: Why did you collect these kinds of documents?
PAZZAGLINI: One thing that struck me in Adamski's personal letters is that he doesn't sound like the crackpot that he appears to be when he's written about. After reading through all this stuff, my hunch is that he actually had some experiences that he sort of hyper-verified or over exaggerated them.

Q: There was a quote I read somewhere once where I believe an acquaintance of his said that he'd had some experiences, and in his mind that made it OK to extrapolate in public.
PAZZAGLINI: I came away with a picture of the early contactees as not just crackpots, but a group who over-clarified and over-represented to get the point across. And then they got more involved, got followers, etc. and then it sort of becomes just masturbation.

They were going down to Peru...I have a tape of Williamson from 1953 which is just great. It sounds remarkably like a channeler I've been listening to here in the last couple of years—I guess they have the same channel!

Q: Ashtar also seems to have been a dominant broadcaster on the astral hit parade.
PAZZAGLINI: Also buried in their papers are a lot their own symbols. Williamson had a whole thing he called the "Solex Mal." I have the originals documents with two color plates, all hand drawn, and then this dictionary with fairly complex symbols that look like sigils. They also look like Churchward did in the "Symbols of Mu"—and they looked vaguely (and I must use the word strongly) *vaguely* Mayan. He ran all over Mexico and Peru looking at things.

I also have the files of his friend Thelma Dunlap. She's one of those behind-the-scenes people who ran around these circles, and she actually connected him up with Howard Hughes. He actually worked for Hughes for awhile, and Hughes hid out with them for awhile. That's another thing that spun off from all this: I began to make a list of who knew who.

Q: A little "tree?"
PAZZAGLINI: A huge tree. It's on a big piece of paper now. It turns out that all sorts of communities knew each other. For instance the astronomer George Everett Hale, who designed Mount Palomar [telescope] lived right near Adamski. What they don't tell you, which he reports in his own notes, is that he was plagued by what he called "imps" which would come into his room at night and fiddle with his designs—telling him how to alter them. What the hell's happening there? This is the government funding a man who set up Yerkes [Research Institute], Mt. Wilson, and Mt. Palomar, and he's getting extraterrestrial messages.

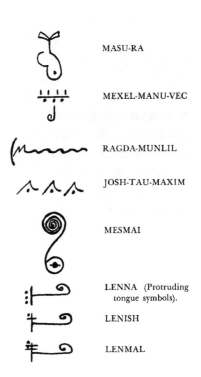

MASU-RA

MEXEL-MANU-VEC

RAGDA-MUNLIL

JOSH-TAU-MAXIM

MESMAI

LENNA (Protruding tongue symbols).

LENISH

LENMAL

Sample of the Solex Mal

I came away with a picture of the early contactees as not just crackpots, but a group who over-clarified and over-represented to get the point across. And then they got more involved, got followers, etc. and then it sort of becomes just masturbation.

Q: *How did you find this information?*

PAZZAGLINI: I just put a "call" out, and say "I want this particular piece of information" and it'll just come in the mail, or I'll look something up at the library, or whatever. In this case, I just decided to go to the library and pulled down a book which mentioned the autobiography of George Everett Hale. So I went and got it and that was that. Anyone can do this and it works.

Q: *Who do you find is most interested in your work?*

PAZZAGLINI: Well, the UFO community in general with the small subgroup of people who actually read books. (Laughter) It's a bit of an esoteric issue amongst them. If there is a response it's usually accompanied by a personal experience. And then, the occult community got very interested in it because of all the sigil stuff. [A Sigil is an abstract diagram or symbol in magick used to invoke a wish or set of events and/ or circumstances. Personal and standard designs are used.]

Several occult groups have contacted me to buy my book. The other group who contacted me were the Mormons. The first line Mormons do not know about this, and you have to go to the "second line" Mormons. I went to Los Angeles to visit my kid, and they have a beautiful Mormon temple there. I was really dressed inappropriately. While I was standing there looking at the pictures, one of the "elders" as it were came down to the desk and he told the receptionist to send me over. He asked what I was interested in. So I replied outright about the symbols. He said "Oh, good" I said "Aren't you showing me stuff you shouldn't be showing me?" He said, "for you it's OK."

He showed me the church and all the symbols, and said "This will be very interesting to you." I don't want to make more out of this than there really was, but the upshot was that I was able to come home and locate a sample of the script from the Joseph Smith tablets. [Joseph Smith claimed to have found engraved metal tablets in upstate New York which instructed him in the founding of the Mormon church.] Now the Mormons are interested in my help to help them find more scripts to compare.

Q: *What paths has that led you down?*

PAZZAGLINI: I've become interested in if other people were here in America before us. For me, that's clearly true because I have some archaeological projects. What I have found over the years is that there are structures all over the east coast that are on the original deeds to the properties. In other words, they were there when the settlers got there. They are complex. There are chambers, there are stone-lined wells that go down and then off at a right angle. New York state and Pennsylvania are absolutely riddled with them. There's a whole school of people coming out of the Epigraphic Society who've worked on that for years. There are stones with script on them all over the United States. In some areas there are huge caches of script-covered stones which have remained unpublished. So, either some hoaxers spent many years of their lives carving tablets by the tens of thousands, or there is a whole area of history we don't really know about. American archaeology is just as dead as can be, and

they do horrible, nasty things to people who try to study this kind of thing-ruining careers and other things. This is under the guise of being scientific and protecting the field from "infiltration."

Q: Which of course happened to Wilhelm Reich.
PAZZAGLINI: Yeah, that's a good case. So the ancient American script is another whole pool of material. I'm not sure these are people that came here, or that something weirder is happening. All the American writing has a funny "cracked" feel to it. It looks like what people do when they have their eyes closed and they try to draw. It's some sort of "slushy" execution of the symbols themselves which makes me think that the people are in some kind of altered state when they're doing it.

Q: These are the carvings you're talking about?
PAZZAGLINI: Yes. If you look at what I think is called the "Devon Stone" it supposedly shows a column with three rings around it and people dancing around it. It looks like a fifth-grader did it. It's purported to be sort of like...lost Egyptians. But Egyptians were a pretty tight crew.

Q: Even in their graffiti...
PAZZAGLINI: Yeah. There's a tremendous pool of information that I had on hand when I decided to do the UFO stuff. I had all these ancient alphabets, I had non-traditional ancient alphabets, channeled stuff, now I wanted to see what the UFO stuff looked like.

Q: What are the similarities?

Mormon script

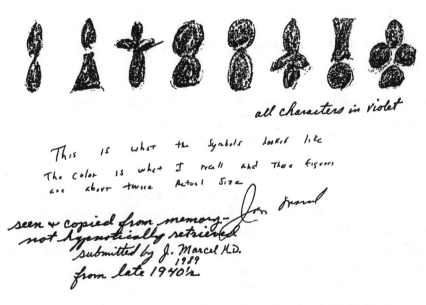

all characters in violet

This is what the symbols looked like The color is what I recall and These figures are about twice Actual size

seen & copied from memory — not hypnotically retrieved submitted by J. Marcel M.D. 1989 from late 1940's

Jon Marcel

Jesse Marcel, Jr.'s depiction of the symbols he saw on Roswell wreckage in 1947. Drawn at Pazzaglini's request.

PAZZAGLINI: Nothing looked Egyptian, except for the Mormon script, which looks like Hieratic.

Q: Is that the informal written language?
PAZZAGLINI: There's three Egyptian scripts: There's the Hieroglyphics, which everyone's familiar with, there's Hieratic, which is a more cursive form of the hieroglyphics, and there's Demotic, which is a late form that is even more cursive. And out of that group, parts of Arabic developed, as well as Coptic. A couple of symbols in our alphabet are remnant—like the "N." That is still a remnant of the Egyptian "N" which was just a wavy line. So one thing I can say clearly is that I see no Egyptian hieroglyphs, except for maybe one or two samples. Absolutely nothing like cuneiform—Sumerian or Babylonian. I've not seen any of that.

The writing comes in three forms mainly: The dot-and-line, the geometric, and the cursive. The only script that stands out as not fitting into any category is Jesse Marcel's. [Jesse Marcel M.D. is the son of Major Jesse Marcel—the first person involved with the Roswell incident to come forward to tell his story. The junior Marcel claims his father showed him parts of the wreckage that were embossed with a strange set of symbols.] I just talked to him again a couple of weeks ago. Now what they're trying to tell him was that what he was handling was this Scotch tape with designs on it.

Now, I know about that tape, because I used it when I was small. It's not that. It makes me crazy when people make these stupid comparisons and then close out the whole thing because of it. I'm old enough to have handled that tape, and it didn't look like that. And it came out around Christmas, so that violet [which Marcel claims was predominant in the symbols] was not a prominent color in the scheme. It had holly, or green or red flowers and berries.

Q: It would seem something like that would be easier to remember!
PAZZAGLINI: He would recognize that. I even saw the Easter tape, which was yellow and purple, but it was Easter lilies. He's a doctor-(laughs) he would recognize that for what it was.

Q: Does he remain convinced that the symbols were not referential to anything he'd seen?
PAZZAGLINI: He just says "There were I-beams, and there were these symbols on them, and they were nothing like I've seen before or since, nor did they feel like anything else."

Q: Paul Davids, who wrote and produced the Roswell *Showtime movie confirmed for me that the original beams were about as thin as his pinkie finger, and that the beams shown in that "Roswell autopsy" footage were completely different.*
PAZZAGLINI: Well, the symbols on the beams in that film are bigger than his, and the material is different, and the symbols look nothing like what he recalls. They're also not colored, it looks like they're just embossed into the metal.

I copied them all down, because they seemed very familiar to me, and this was because they were all Greek letters! Although some people have now

... astronomer George Everett Hale, who designed Mount Palomar [telescope] lived right near Adamski. What they don't tell you, which he reports in his own notes, is that he was plagued by what he called "imps" which would come into his room at night and fiddle with his designs-telling him how to alter them.

decided that the Greeks were extraterrestrials, a lot of Greek letters as they exist now are reduced to very geometricized form. So it could be because the forms are archetypal, it could be that the person who made the film had a science background, and they thought it would be great to use the letters as alien writing, or it's a spurious coincidence that the writing looks like Greek.

Q: Slightly modified, or older versions?
PAZZAGLINI: Slightly changed, and what they've done is mixed upper and lower case. Only one other person in the world has put that up, and that's Linda Moulton Howe. We met a couple of weeks ago, and she said, "What do those letters look like to you?" and I said "Well, you say it first." She said "Greek" and I agreed.

Q: How do you separate the "true" scripts from anything derived from human sources?
PAZZAGLINI: There's a definition problem first, but I did an experiment: I took a roomful of people, and taught them how to channel. And I asked them to tune into whatever that channel was, and produce a new alphabet. This is all in my book. What they did, because human minds are fairly rigid actually, was they tended to carry formal aspects of one symbol to the other as they do them. So you'll see a zig-zag for an "f" and then a zig-zag with a line through it for a "g." Every example made an English alphabet. No one in the crowd thought of making a syllabic alphabet, or an ideographic alphabet.

Q: What sort of "crowd" was this?
PAZZAGLINI: Uh...these were all therapists! (Laughs) I really did a horrible thing. I was giving a workshop on neurophysiology and unconscious processes.

Q: You were being selfish and sneaky!
PAZZAGLINI: Yes and no—I told them what I was doing. They said it was OK for me to do this to them. They were just pigs for experience, so we went ahead and did it. So that gave me some handle on the made-up alphabets. When I see a script where that's happening, I become suspect that it's a stateside phenomenon.

There's a problem here though, because the aliens could be writing for **us**. Or they'd have to do that since it's the only way we could understand. So then the question becomes "Why are they sending this gibberish anyhow? Why don't they send us nice decent English?"

Q: Perhaps it's spillover, and we're egotistical enough to think it's meant for us.
PAZZAGLINI: That's right. We're just catching it on the way to someplace else. (Laughs) How awful! Also, when there's this exact one-to-one correlation between the English alphabet and a script I just have to wonder what's happening. It doesn't mean I throw it away, I just keep it in a different compartment.

*Q: What about someone consciously trying **not** to match the alphabet?*
PAZZAGLINI: It's quite possible, but I still find that people have a hard time trying to think up a lot of different symbols, and they tend to begin making

A good way to start authenticating a script is if there is anything that looks real foreign to me. [Jesse] Marcel's [Jr.] does, actually. It just looks real wacko.

symbols that look a lot like each other. One person made a circle with a line coming down from it. They must have thought "Gee, that's really good" because then they made a circle with two lines coming down from it, and a line across the bottom. One was supposed to be the number "2" and the other was the letter "B." So you can see how they would fall into the same place in the series–both the second element. So here the probability meter begins to go off the scale again.

A good way to start authenticating a script is if there is anything that looks real foreign to me. Marcel's does, actually. It just looks real wacko.

Q: But there's just that little sample, right?
PAZZAGLINI: Well, over the years I've collected a fair amount of it, because every once in a while he'll remember some more. What's interesting is the hypnotic regression pieces are not as good as the consciously remembered piece. He may just be a lousy hypnotic subject—which he thinks he is, after talking to him. He's a very solid person. I hope he doesn't put on a crown tomorrow—that would blow that theory right out of the water! (Laughter.) He is incredibly tolerant. I called out of the blue one time and I could have been anyone, but he was very patient. He listened to what I had to say, and then responded and made all the drawings for me in color, and sent them. I have a number of other script examples in color now and I'd like to publish them since they're quite pretty if nothing else. Actually, I'd like to publish [Flying Saucer Contactee] George Hunt Williamson's *Solex Mal*, because I think it's a really important historical piece and there are a couple of plates in color in it.

Q: Why do you think it's important?
PAZZAGLINI: It's historical. These are the first examples of channeled alien writing. I have original copies of Adamski's footprints too. [These are drawings of what contactees George Adamski and Williamson said were footprints left in the sand when a spaceman landed and talked to Adamski. See Issue #3.] Those footprints exist in Brazil as a petroglyph. Not in the same form, but similar. I don't think Adamski knew about this, but these people were much better readers than we give them credit for.

Q: What do you mean?
PAZZAGLINI: I saw what George Hunt Williamson had in his library. It was huge. He had books on writing, philosophy...tons of them. He was very well-read. He wasn't just babbling. So these people, although they have a bit of a show-biz quality, were actually doing a lot of what they called "research."

Q: Perhaps it was one of the only ways they could get an audience.
PAZZAGLINI: We have a California audience responding to them at that point, and also, it's very hard to turn your head away from fame. So that was part of the phenomenon too—that was everyone was getting a little theatrical.

Q: What sort of people send you these things, and what kinds receive these scripts?
PAZZAGLINI: I've gotten a couple that look like they've some straight out of

> I saw what George Hunt Williamson had in his library. It was huge. He had books on writing, philosophy ...tons of them. He was very well-read. He wasn't just babbling.

the back woods, but most of them are coming from white collar people. I'm surprised at the number of them that come from professionals, or are like junior executives. I have one woman who writes to me, and won't give me permission to use her name or her writings. And that's another piece here: People will give me permission to write anything about them, but they won't give me permission to reprint their symbols. I don't know why they hold them so close to their chest, it seems to be very important to them.

This woman who writes to me is the vice-president of a very well-known company, but she will only give me her first name, and won't allow me to talk about her, but keeps sending me this stuff, and it keeps getting better and better. This has been going on for about three years. This was happening to her in isolation, and it wasn't necessarily UFO-related. She just realized that she had to sit down and begin writing, and this stuff would come out. And when she was done, she would stop and just get up-it was as if someone had turned on a teletype. She was very upset by it.

Q: She must have come to some kind of peace with it, since it's still going on.
PAZZAGLINI: She feels compelled to do it. It's like if she doesn't do it, she will be betraying something. But she is still upset about it.

Q: Do you have anything to do with her continuing this?
PAZZAGLINI: Well, I tried to make her feel more comfortable about doing it. I told her she either has to do it, or not do it, not to think about being halfway. Since I've dealt with a lot of people, and helped them through this, and I told her to get a bound book to keep it all in one place. And if it wasn't interfering with her life, just to continue. She seems OK with that system, although she hopes it not Satanic.

I said "Stamp some Christian symbols all over the inside of the book. So if it's Satanic, that will dilute it" and she bought that.

Q: Whatever helps…
PAZZAGLINI: She feels protected, and is willing to do it. But I think they're talking to her now.

Q: Who?
PAZZAGLINI: Whoever "they" are. A channel piece has started. They're talking to her directly. It used to be just the writing, which she couldn't understand. Now these ideas just pop into her head.

Q: I tried some automatic writing, (or whatever you call it) a few years back, and all I could get were obvious answers and some gibberish.
PAZZAGLINI: There's a funny quality here and that is that it's very tricky—it loves to play tricks.

Q: That happens with Ouija boards as well.
PAZZAGLINI: What you need to do is say "OK. I'm done playing games if you are. But you choose the topic, you say what you want to say." After a while,

Well, in religions, there are the path of knowledge, the path of belief, and the path of experience. This is the path of experience because the other two are not working.

the channel settles down and it begins dictating.

Q: What other attitudes do people have when this crops up in their lives?
PAZZAGLINI: There's another group that feel that it's a very important part of themselves, and they've made contact with…Well, in religions, there are the path of knowledge, the path of belief, and the path of experience. This is the path of experience because the other two are not working. Our religious constructs are cracking, and as people try to find the historical Jesus and the temple of Solomon, and so forth, when you concretize religion like that, for a lot of people it destroys the belief. Also, as Chritianity gets watered down and fundamentalized, people begin to lose that awe that kept them entranced and in contact. So what they do is slip into other experiences. They personally experience something that feels bigger than them, and like it knows more than them, and that's very important. So they really hang on to it.

Q: Do you find that this is inherent in a lot of points in your research?
PAZZAGLINI: Yes.
Q: Is this from a Christian perspective?
PAZZAGLINI: Mostly these are Christians.

Q: Overtly, or just brought up in the tradition?
PAZZAGLINI: Both. These are Christians with a lot of slippage. You see some of the other cultures would not see this as separate. If this happens to a Tibetan, this is not separate, they have a thing called *termas*, and it's expected that certain people in the culture will get messages, and they will be in foreign languages, and will be in foreign symbols. What they're supposed to do is turn them in. They just report to headquarters. There is no "headquarters" for us to report to.

Q: Except you, now.
PAZZAGLINI: Yeah. (Laughs) I have that.

Q: Do you see any connection between the UFO-human interaction, your research, and occult practices (West and East)?
PAZZAGLINI: For the western, the answer is definitely yes. Elizabeth I had a court astrologer called John Dee. He, along with Edward Kelly was in contact with some sort of spirit being—I have a copy of the manuscript, actually—and this being did a number of things: it dictated an alphabet to them…

Q: Enochian?
PAZZAGLINI: Enochian…and then it dictated some chants, and then an entire system in this language. That system flourished while Elizabeth the First was ruler, and in fact, a lot of English history was probably influenced by this since he was using this channel to not only get information, but to control events.

Q: How do you mean?
PAZZAGLINI: Well, for instance she could say "John, the Spanish Armada blah,

> Some tapes of the hypnotic regressions I've heard are done so badly. This stuff would not just be thrown out of court, some of these people would be fired for this. It's like "Do you see the small grey people?" These people have no respect for how big the unconscious is.

blah, blah... and what do you think? Can you help? Can we arrange the forces in such a way that we have an advantage?" and he would do that—it was his job. So he'd tell her what days to do it, but not using only astrology, but these "tablets" as well that the "angel" dictated. So this goes into the Ashmolean museum in England and is used by a series of occult societies, until it really surfaces again in about 1870 with MacGregor Mathers and Wynn Wescott, and they develop the Golden Dawn using this system. Aleister Crowley then takes this system and uses it for a series of things he calls "workings" beginning in 1911. Along the way, he contacts Aiwass and another entity called Lam.

Q: Did you see our coverage of that in issue #2?
PAZZAGLINI: Yeah. He looks just like one of the alien "greys" with an eye disorder. Smaller eyes. Crowley continues these working until the last one in 1946, which was done by Jack Parsons. [See John Carter's excellent book *Sex And Rockets: The Occult World Of Jack Parsons* for the full story.] It's funny, because the OTO [Aleister Crowley's Ordo Templi Orientis organization] and other groups keep popping up all over the place. The private lives of these people would make *Dynasty* look like Mickey Mouse! Parsons is working at the Jet Propulsion Laboratory, and the government has hired an arch magician to do ultra-sensitive work.

Q: And they checked up on his background and didn't find it bad enough to bother with.
PAZZAGLINI: And they knew he was Crowley's "chosen kid." It is weird all the people who knew each other, and sometimes I think "Gee, I'll just throw away all my history books!"

Q: "Everything You Know Is Wrong" There's a thrill in the discovery of these things. Uh oh...now I'm starting to sound like one of those conspiracy people.
PAZZAGLINI: And there's a thread of that running through the Hollywood community. Because [filmmaker] Kenneth Anger knows Jacques Vallee. They've known each other for a long time.

Q: What's that connection all about?
PAZZAGLINI: I don't really know. Vallee mentions in his latest book that he knows the man. People I know who have asked him about Anger say that he says nothing and won't talk about it. A magical magazine called *Green Egg* dedicated a recent issue to Vallee. I talked to Whitley Streiber once and asked him what was going on about all this, and he said "If you really want to know, read my book *Cat Magic*. That's where I tell the whole story. [Streiber has apparently denied this.]

Q: So what did you find?
PAZZAGLINI: Well *Cat Magic* is about evocational magic. It's some sort of a war between magicians. So that information seems to point to the theory of UFOs that some gate has been opened and this is basically a "leak." It's sort of the space-time ripping theory. In other words, there's this hole in space-time and these things are getting through.

> **Some tapes of the hypnotic regressions I've heard are done so badly. This stuff would not just be thrown out of court, some of these people would be fired for this. It's like "Do you see the small grey people?" These people have no respect for how big the unconscious is.**

Q: Vallee actually hints at this over and over in his books-he just couches it in scientific language.
PAZZAGLINI: He's being very careful, but he's saying the same thing. Actually, a lot of people are saying it. John Keel does this.

Q: I think this idea just sank into my subconscious being and has been suggested for many years in many forms.
PAZZAGLINI: Well, you see the phenomena is bad because it doesn't just violate one or two physical laws, it violates the whole deal. So you know it's just bad. Something's really off. It's either very bogus—a lot of neural noise, or it's just so far beyond our understanding that we have no concepts to wrap around it to get a handle on it. If that were true, then the space-time holes idea might just be what it would look like. In fact, that's just what my great-grandmother told me. "These things are not from here. They come through here, and you have to be careful. You can use them, but just be careful." The things we were taught about were called "foletti." The root of that word is the Latin word "folis," which means "whirlwind." They speak of little creatures about two to three feet high that inhabit this "other world." And they do things: they abduct people, they play tricks, they're very sexual-they like to fiddle with people sexually, and this begins to sound like Jacques Vallee.

Q: And Keel, and Mack, and more recently Gregory Little. [Author of Grand Illusions.]
PAZZAGLINI: Some tapes of the hypnotic regressions I've heard are done so badly. This stuff would not just be thrown out of court, some of these people would be fired for this. It's like "Do you see the small grey people?" These people have no respect for how big the unconscious is. They have no respect at all. Actually, the some of the best stuff I've heard is from [Budd] Hopkins. His stuff isn't great, but it's actually better than some of the therapists. He actually has a huge pile of alien writing, but he won't send it to me, even though he says he will.

So, with western magick, there are just connections everywhere. Remember I was talking about the three or four year old who was writing out this angelic music, and that alphabet is straight out of the early Renaissance. It's an actual alphabet called the "Celestial Alphabet." And it's just for ritual purposes, not day-to-day work, so the letters won't get contaminated.

Q: Did you tell him this?
PAZZAGLINI: Yes.

Q: What was his reaction?
PAZZAGLINI: "Oh."

Q: That was it? He didn't care otherwise?
PAZZAGLINI: No. One of the things they used to tell him was "You're not home." And he used to tell me "I'm just waiting to go home."

Q: Did this cause him any kind of consternation?
PAZZAGLINI: It only caused an intense nostalgia.

Q: One of the criteria for suggesting alien abduction scenarios in your life is supposed to be that very thing.
PAZZAGLINI: The idea is that "this is just real temporary here, and if you just thought about it a bit, you would remember that you came from some place else." [Pazzaglini later privately revealed that he was talking about himself at this point.—G.B.]

Q: How is the script received or encountered for the most part?
PAZZAGLINI: There are people who get it telepathically—straight out. There are people who see a sample of alien writing. They see an alien book—like Betty Adreasson—it's left with her, and that experience enables her then to receive more of it. And then there are people who just see the stuff and copy it down from memory. Jesse Marcel is a good example of that. Those are the three categories. Actually there's one more, and that's the people who find them written on something—like the Tibetan *termas*—and they actually have the stuff.

Q: An artifact. Like Joseph Smith's tablets.
PAZZAGLINI: Yes, or a flying saucer takes off and a couple pieces of tissue paper come floating down with symbols on them.

Q: You were at the MIT-hosted abduction study conference. What was the reaction of the researchers there to your work?
PAZZAGLINI: There was a small interest. I got asked a lot of private questions. Publicly there was not too much response. Most people were focusing on the abduction experiences and the hideous body intrusions stuff.

Q: The stuff that gets you in the paper and on TV.
PAZZAGLINI: My stuff is perhaps a bit dry for them. I had some people coming up and handing me pieces of paper with things on them and saying "What does this mean?"

Q: Things they'd gotten from people who they were dealing with. Anything interesting on them?
PAZZAGLINI: Not right there. An "R"-type symbol kept appearing at that conference over and over again. A backwards "R."

Q: The space people watch the Little Rascals *too much.*
PAZZAGLINI: Dyslexic aliens! (Laughs)

Q: What do you make of that?
PAZZAGLINI: I don't know. Unless it was just being traded telepathically amongst the crowd like some sort of candy. (laughs) It's just one symbol and you can't really do much with it. It's not an archetypal symbol, it's just part of our alphabet. It was really nothing.

Q: Why did you think you were invited?
PAZZAGLINI: Because they thought it was a piece no one else had.

Q: Was that correct?
PAZZAGLINI: No one I know is doing this. I think Bob Hieronimus [UFO radio show host in Maryland] has a few examples.

Q: What do your professional colleagues think about your work with the alien scripts?
PAZZAGLINI: The only colleagues I have that know about this are lifelong friends actually. The other people I work with don't really know, unless they know me fairly well, and then they might guess it. I don't have many friends locally within the field. They're really boring! (Laughs) Also it's the whole professional thing. It's really a gag. There's insurance companies and managed care, that are really killing this field [mental health] and are killing patients...

Q: Why did you start your studies with Tibetan lamas?
PAZZAGLINI: I started that in the late sixties. After I'd studied a fair amount of ancient history, it sort of boiled down to a handful of cultures that did two things: I sort of resonated with them, and I thought that these cultures really knew something, and Tibetan culture turned out to be one of them.

Q: What do you mean by "know something?"
PAZZAGLINI: Knew something about the way that reality was put together that wasn't being represented well by the science I knew. So I started studying with them not from a religious standpoint, but because I wanted to see how they conceptualized the world. And I learned a lot. I still am.

Q: How has it affected your outlook on UFOs and your research?
PAZZAGLINI: I guess it's sort of part of that whole belief thing. I don't really need to "believe" much. I practice a lot, but it's not like a belief that obscures other possibilities.

 Now I am sounding like a new age pamphlet to myself, but it's true—it leaves me more open—I'm able to see more. It's opened my perception more and more so I can see more. And I don't have to believe anything because it's stuff I just see. So it goes from experience, and then I have to figure out whether or not I want to share the experience, and I'm not always pressed to do that.

Q: How does the Tibetan viewpoint specifically do that for you?
PAZZAGLINI: If something works, you don't have to believe in it, it just works and the "belief" becomes superfluous. It's like, "My lamp works, so I don't need to believe in it." So those practices just work. They produce some specific kinds of experiences that are very valuable, and they are consistent.

Q: That's almost the definition of the scientific method-consistency of results.
PAZZAGLINI: And when it's not consistent, there's at least some consistency to the logic that things go through, so there's a connectedness, so even when it's changing, it feels connected. All I need to do is participate, and that takes the place of just believing.

Q: Is there a trend that you can see in the scripts?

PAZZAGLINI: It almost feels like it will peter out and get replaced by more direct kinds of communication.

Q: Is that an intuitive assessment?

PAZZAGLINI: Yes. There's not much more to it then that! (Laughs) I think the symbols do something that the direct channeling doesn't, and that is they seem to carry…it's the difference between linear, verbal kind of reasoning and spatial reasoning. They're so spatial that they transmit tremendous amounts of information at one blast. And you may not always be able to relay that information back as a reported word, but as an internal experience, it's pretty rich. So if the symbols continue in that vein, they'll be very valuable. We are well built for that, because biologically we have this system called "entrainment." If you and I are talking, we just look at each other and there's tremendous amounts of information passed besides what's passed verbally. So you have some feelings about me, I may have some about you, and you may at some point visualize what you think I am, which will encode information about me (not necessarily what I look like) and all that stuff is going on. So that's what might be the value of these symbols—that they're not trying to communicate to us (if that's what they are doing) the particular thing that the symbol is supposed to be saying, but there's a whole downloading of experience and possibility that is going on that we're not even aware of yet. Certainly the culture is different for this phenomena existing.

Q: In what overt ways?

PAZZAGLINI: Probably at least two. One is more specific. That is, if you look at John Dee and that kind of stuff, is that this information, put in the right place and at the right time, has a great influence on the flow of human history. The second piece is that I think gradually everyone's waking up, and it has an effect at that level.

Q: Waking up to what? Meaning there's more to life?

PAZZAGLINI: Every day there's more space in my head. I'm aware of more, and I see more, I feel more, and I'm more connected. That goes through stages of being frightening, overwhelming, etc., but then it will be resolved into this incredible connectedness. And then that will disintegrate and go through more changes and then I'll wake up even more connected. Now I don't know what I'm getting plugged into here, but that process is definitely happening. It's interesting because in my research, I talk to a lot of street kids, and I can see that happening. It's interesting to see a street kid come into my library and start reading for hours through what are basically medieval texts, because ultimately it's connected to them.

Q: They're being taught the wrong things. No wonder they're bored.

PAZZAGLINI: They'll look up and say, "Why isn't school like this?" And so I've used this material in my consulting work for adolescent treatment centers. Or I'll talk to a kid on the street and see if I can get them off the street and interested in their own heads. This is what the material does. In doing that, they begin to learn how to use themselves, and that tuns them around a whole corner.

> **Every day there's more space in my head. I'm aware of more, and I see more, I feel more, and I'm more connected. That goes through stages of being frightening, overwhelming, etc., but then it will be resolved into this incredible connectedness.**

I made a wise decision at a young age that I'm thankful for, and I'm not going to let them take that away from me. It's too valuable. So I will do everything to bring them to their knees, and I will do nothing to join them. This is happening to more and more people, and I think more and more people are going to drop out again.

Q: Self-awareness.

PAZZAGLINI: Yes, so what happens is that their drug use becomes superfluous. They realize that it's just static, and they're just going to have to stop doing it.

Q: "D.A.R.E. to get kids interested in something."

PAZZAGLINI: What they were trying to do with the drugs was figure out what their dumb parents couldn't or wouldn't tell them because one thing I'm finding is that when I ask fourteen or fifteen-year-olds "When was the last time you really had a connected conversation with your parents?" you're not going to get much. This set of parents left, and sort of checked out at around age eight. So they're left with school, which is sort of like lukewarm bath water. There's just nothing to hang on to. So there's just a richness to their culture that they can finally connect to and to themselves, and so they understand that they're not just like "Game Boy." So there's that kind of waking up that I see happening. I'm not sure the culture will last through all that, if something really horrible happens.

Q: Israel Regardie said something like that for a few years before he died-"It's going to get worse before it gets better."

PAZZAGLINI: What's interesting is that in the business world, which I am occasionally exposed to is that those people are so screwed up that you couldn't even put it down on paper. They're tense, they're anxious, they have chronic illnesses—they are in the middle of a war and they don't even know it.

Q: I have a sister working in the business world and a lot of what she is exposed to on a daily basis either scares me or bores me.

PAZZAGLINI: It seems to run in those two areas. I bet she's in the process of getting out of it.

Q: You know you're right. She has actually taken control of her situation quite a bit more recently.

PAZZAGLINI: This happened to many people in my field. My partner and I looked at each other and said "Do we realize that we're doing one day's worth of paperwork and phone calls to keep ourselves working for the other four days?" And something snapped in me and I said "I can't do this anymore or I'll slaughter myself." I'm not going to let these people turn my life into a business nightmare. And I made a wise decision at a young age that I'm thankful for, and I'm not going to let them take that away from me. It's too valuable. So I will do everything to bring them to their knees, and I will do nothing to join them. This is happening to more and more people, and I think more and more people are going to drop out again.

Q: I noticed all this happened in the last year with both you and with things in my life.

PAZZAGLINI: I am not me without that.

Q: Sounds like the patient you mentioned in the beginning with the thorazine—"Don't let them medicate me or this will all go away." What keeps your interest going in studying the received scripts?

PAZZAGLINI: I sort of had a crisis a few months ago, "What am I doing?" So

I decided that I'm going to continue doing the script stuff because it's a good thread, and it's sort of like some kind of umbilical cord. In other words, it's drawing me through larger and larger experiences, and I'm just going to let it do that. It's teaching me a lot of things. So, I'm going to participate in the particular, because I think it's valuable for me to do. It also does something for me personally, and that is it drags me through incredible amounts of experience.

Q: *It's the same reason most people do anything they really love.*
PAZZAGLINI: You could do bricklaying. These are people's vehicles, and the vehicle has to be tuned to you personally, and I'm so invested in symbols, that there is no way I could pop out of that and still keep my life.

Q: *It's a spiritual quest.*
PAZZAGLINI: We'll see if that turns out to be true! (Laughter) I'm betting on that.

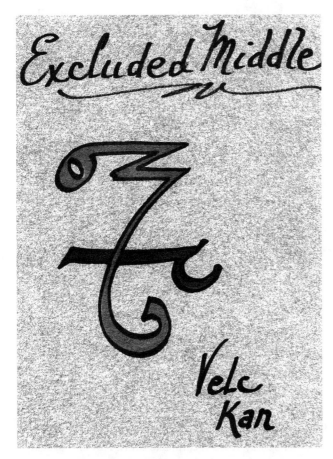

Soon after Dr. Pazzaglini revealed to me that he was a longtime recipient of alien writing, he said that his "companion" sent this symbol through him and that it was the meaning and representation of "The Excluded Middle."

Green Eggs and So'Ham

A Qabalistic Interpretation of Dr. Seuss'
Green Eggs And Ham

Darren McGovern

This essay was inspired by a conversation with Greg Bishop about Aleister Crowley. In his <u>Book</u> <u>4</u> Crowley gives a brief interpertation of several random nursery rhymes and this is the obvious source of the idea to extrapolate from the Great Work of Theodore Seuss Geisel.

Unlocking the (imaginary?) hidden meanings within nonsense can automatically set one to thinking of the mysteries. This, done with discipline, can lead to deep contemplation of Holy things and God Himself and that is the true path to illumination. This can be done with any seemingly nonsensical text you may choose; *Grimms Fairy Tales*, ancient Egyptian papyri, the Bible, the morning news etc. The source is unimportant, however, the method is difficult without the aid of the Holy Qabalah. For example, let's take the seemingly innocuous modern children's book, *Green Eggs And Ham*. By deciphering the meaning between the lines, the roots of words, the correspondence on the Tree of Life, and connections to myths, we can invoke the truth that lies hidden. As written in Hermes Emerald tablet and the Mag Hamadi Scriptures, "AS ABOVE, SO BELOW." Distilling the information to extract the "gold" from the original matter is an alchemical transformation operation. The book begins with the innocent sentence,

"I am Sam."

This simple phrase is perhaps the most sublime. Sam can be seen as an abbreviation of the sacred Sanskrit mantra from Vedic literature, *So'Ham*, which means "I am that." Thus we have the Hebrew God name Eheieh or I Am That I Am. Sam can also be seen as one of the the root words of Samadhi, which means "together with," *sam*, "the Lord," *Adhi*. Thus we have *together with, I Am*. Either way this is certainly Kether; complete unity. This blissful state is secretly betrayed by the repeating of it. Here also, we have the appearance of a new character. He is the witness to the statement repeated,

"I Am Sam."

Dualism has been evoked and heaven will never be the same. The negative veils of existence have been shattered. Kether has given way to Chokmah and Binah, the Yin And Yang of creation. There is nothing left but to look to where this new consciousness emanated and to speak what now appears in reverse.

"Sam I Am !"

Like an inverted pentagram, the truth is seen improperly due to the faulty perspective of the viewer. Immediately, we see the second character resist. He states,

"That Sam-I-Am! That Sam-I-Am! I do not like that Sam-I-Am!

Here we have it! The *Ego* separates from the now *Higher-Self* (Sam-I-Am) and begins to resent it, not realizing he is it! This resentment is the root of all human error as Nietzsche so exactly examines in *Will to Power.*"Yes, the original sin is committed. The observer posits himself separate from the observed. But the *Higher-Self* is ready with a solution, an offering, an Holy Eucharist,

"Do you like green eggs and ham?"

He offers. Again, the Ego resists,

"I do not like them Sam-I-Am."

In an act of compassion or perhaps some sort of Zen joke the *Higher-Self* asks,

"Would you like them here or there?"

But it is to late. The Fall from Grace has begun. Adam is banished from the Garden by his inevitable refusal to cooperate. But the Higher-Self follows and asks,

"Would you like them in a house? Would you like them with a mouse?"

Here the Ego has descended to Malkuth and is presented to himself, the mouse or *mus*, which means ego, in its small pathetic symbolic form. Yea! And the Ego resisteth.

"Would you like them in a box? Would you like them with a fox?"

Now the house has turned into a box and the *Ego,* a fox. In typical reverse meaning like the Chinese finger torture toy that would tighten the harder you would pull, the further the *Ego* separates from the *Higher-Self* the more confined it becomes, as represented by the box, and the more wily the ego becomes, as it is represented by the fox. Yea! And the Ego resisteth.

"Would you? Could you? In a car? Eat them! Eat them! Here they are."

Here, they have found themselves in a car. A car, symbolic of the body, has four wheels, like the four elements. It is in motion, like the swastika, which is a cross in motion. And Yea! the Ego resisteth.

"You may like them. You will see. You may like them in a tree!"

The car now drives up a tree, obviously the Tree of Life itself. And Yea! the Ego resisteth.

"A train! A train! A train! A train! Could you, would you on a train?"

They rapidly fall down from the tree to the train. Trains have forever been associated with the sex act and verily they are sped off into a tunnel.

"Say! In the dark? Here in the dark! Would you, could you, in the dark?"

The chakra roller-coaster ride continues. This descent into darkness by means of the sexual act is familiar to all and would be an insult to the reader for me to comment further. And Yea! The Ego resisteth.

"Would you, could you, in the rain?"

In a moment of Grace they are freed from the tunnel and are exposed to the rain. Ah! the sweet, sad, beautiful rain. But even this blessing is spat upon by the now lost *Ego* who begins to believe he is master in his separation. And Yea! The Ego resisteth.

"Could you, would you, with a goat?"

Now of all characters, of all possibilities, who would he now meet at the near end of his travels, but the old goat himself, Satan, King of the Fallen, Lord of this World, Master of Illusion and Separation.

"Would you, could you on a boat?"

And finally the boat, the blessed ark, or perhaps the Eygptian Henu boat, is sent as an another act of grace for his return but Yea! the Ego resisteth. Finally, the *Higher-Self* makes one last plea.

"You do not like them. So you say. Try them! Try them! And you may. Try them and you may, I say."

Then, not because of faith, not because of wisdom, not because of divine revelation, but because of a long slow evolutionary process he accepts the Eucharist just so he will no longer be tormented and Lo! And Behold! He is awakened by the divine sacrament.

"Say! I like green eggs and ham! I do! I like them, Sam-I-am! And I would eat them in a boat. And I would eat them with a goat, etc. etc."

The *Ego* realizes fighting his divine will is not only futile but that *giving in* IS *bliss!*

For his tormenter was himself, his Higher-Self, his *Holy Gaurdian Angel*.

The torment came from the Ego's perception of being separate from The All.

But what are the Green Eggs and Ham? Are they symbolic of the fear of the unknown? Are they the delicious rewards of selflessness? Or is the ham the forbidden fruit of bodily existence and the two eggs the symbol of rebirth? Are they green for fertility and growth? After all, Gods creation *is* creation and is meant to perpetuate itself by its own nature. Maybe it is a koan, not meant to have one answer, but meant to inspire the seeker on his path.

Yea! Verily there is nothing left but to rejoice with a prayer. For all *is* one. I *am* Sam! *We all are Sam!*

"I do so like green eggs and ham!
Thank you!
Thank you!
Sam-I-Am!"

Abducting Aliens: Turning the Tables on the Little Grey Bastards

Reverend John Shirley, CoS

It was ten p.m. on a deserted mountain road and the Reverend Deathmonkey was taking the curves at 60 miles an hour and up. ¶ First thing you got to understand is that Reverend DEATHMONKEY is not like other people, SubGenius mutants, happy mutants, or devos: he's got a level of COSMIC RAUNCH, of Interdisciplinary Sleaze that most of us can only dream about. ¶ Me and the Reverend Deathmonkey, if I'm not lyin', were up in the mostly-logged-off state of Oregon; the place where the trees rise mightily and green alongside the road, a screen to cover the clear-cut areas just beyond. We were drivin' his slowly dying '73 Buick station wagon in a valley up in the Cascade mountains, on the way to the ocean, and Deathmonkey was flying high. This figure of SubGenius Myth - the Paul Bunyon, the Pecos Bill of Misfit Weirdos Everywhere - was sucking on Church Air (namely, Nitrous Oxide) from a tank while driving. Not wanting to be a wet blanket I was trying to persuade him to stop the Buick allegedly so I could pee, but really because I wanted to take over driving so we didn't get killed before we got to his Alleged Abduction Site.

"Not a fuckin chance in hell I know what you're up to motherfucker," he said between sucks at the oxygen mask connected to the steel bottle wedged between the seats. "I can drive this piece of crap in a tornado with both my eyes gouged out by a rabid lobster; I can steer a space shuttle through the eye of a needle while mainlining pure LSD and methedrine and getting my dick sucked and my ass felched by a pair of hairy titted yeti bitches! Praise G'BROAGH!

AIIIIIIIIIEEEEEEEEEEEEE!"

Reverend Deathmonkey, he weighs about 300 lbs, he's got a big black beard matted with hamburger juice and twined with razor wire; when he's REALLY partying he calls on Blackbeard, his ancient piratical ancestor, calls him for guidance the way an Injun calls on the Bear Spirit, and he puts thirteen little birthday cake candles in his beard and lights em up and his black eyes burn right through his shades. He's got most of his teeth but a lot of them got the crowns busted off

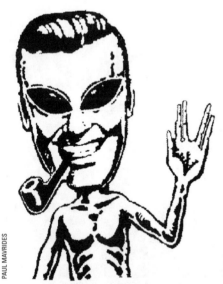

"Just trying to steal a moment...in this ZOMBIE BIRDHOUSE."
—IGGY POP

PAUL MAVRIDES

when he did that "I can eat a whole damn Harley Davidson piece by piece" act that landed him in the hospital.

Today he's wearing overalls festooned with the butts torn from Barbie dolls, hung from safety pins. He's wearing snakeskin cowboy boots; he's wearing lipstick under his black mustache. He's missing three fingers, I should mention, from his left hand, something to do with "me and Survival Research getting too ambitious with them explosives one Saturday".

He smells like...I veered my senses away from it. Some things man was not meant to know. Hell, he's Deathmonkey, and even "Bob" is in awe of the size of his willie.

Reverend Deathmonkey spotted the fire road through the Nitrous haze at the last moment and wrenched the vehicle hard to the right...

The Fugs first album – thirty some years old – was raving offkey on the tape deck; he switched it off. And he cut the lights, rumbled the Buick through startlight and shadow between the mighty first and acres of stumps, till we got to "Area Zero" – a cow pasture.

He stopped the car, killed the engine, we clambered out and stood shivering in the October mountain air. I was shivering anyway – Deathmonkey didn't seem to feel it. I mentioned three hundred pounds, did I mention that they're stacked up six foot five? And when, like now, he puts on his high crown ten gallon hat, brought from back home in Dallas Texas, he's a living edifice close to seven feet vertical. Towering over me, he led the way through the brush along the edge of the cow pasture, outside the fence, muttering to himself as he went. Only thing I could make out was, "I'll make their succotash suffer..."

Then he vanished; three hundred pounds – gone. Or he seemed to. I'd looked away, at the cattle milling in a sleeping group in this high mountain pasture (gov land provided free to a cattle outfit of course), the animals should've been in a barn, at this hour, I'd have thought, but some were awake, and even grazing, and I started to ask Deathmonkey about it and...he was gone.

Then I heard his voice coming from the ground. "Getcher ass in here you wantem to seeya, Harry Dickinbutt?" I've tried to persuade him for years no to call me Harry Dickinbutt, but he won't quit, damn his eyes.

I looked around and saw the hole in the hummock of earth to the right; glimpsed a bearsized figure moving around in there. "DM?"

"I said gitcher ass IN HERE." This is not an expression a bear would use, so I deduced it was Deathmonkey. I entered the bunker, as he called it. It was actually a sort of duck blind of mud and sticks and shrubbery cuttings, something he'd erected a week before. The smell...

He was firing up a 'frop; he offered me a hit. "No thanks, man, you know I don't do any mind altering –"

"Your neurons cain't stand up to it. they are limpdick neurons."

"Too true."

"My neurons and brain cells, they are quivering hard and drugs is just like the lubricants in the deep black vagina of Being."

"How long we got to be in this hole in the ground?"

He looked at the luminous dial of his pocket watch. "Six point seven

minutes longer."

"You're full of it. How can you know –"

"Chaos theory calculus, Dickinbutt. Combined with Salient Event Orientation: every seven days they come to this pasture; tonight's the last night they'll come."

"You are so full of shit."

That's when the saucers came.

They were just bright stars at first, like satellites skating the ionosphere; then they got brighter, and closer, and took on shape. Two of them...they were classic ET frisbees, maybe fifty feet in diameter, metallic, rims throbbing with a dull inner light.

"Oh shit..."

"Quiet, Dickinbutt. Complete quiet."

The saucers danced like fireflies, for no damn reason I can imagine, and then...merged. They sucked into one another, like two blobs of mercury becoming one; yet the process looked as mechanical as it was fluid. And when they were combined they'd become a silvery hockey-puck shaped object, not glowing but somehow quite visible...hovering about sixty feet over the cattle.

The cattle had stopped moving – completely. They were like statues frozen into the field.

I watched. Not a tail twitched.

Rev Deathmonkey was puttering with some equipment I couldn't clearly make out. cursing under his breath when he clanked a piece of metal.

The Greys...

They rode a shaft of light down like humanoid snowflakes, drifting to the edge of the clutch of cattle...

There were shiny instruments in their hands. I couldn't make them out.

"Shouldn't we be videotaping this?" I whispered.

"Fuzzes out on videotape. I did manage to get a few seconds of one of these little visits to come out," he said, barely audible, as he moved out the hole of the bunker. "Tried to sell it to Santilli. He got scared. Said the real stuff gave him the willies. Schnabel might report him to the Company. Asked me if I couldn't fake up one for him instead..."

The night air outside the bunker was poignantly sweet, pregnant with electricity. We crept along through the brush, on hands and knees, to a place where a ditch ran under the wire. Icy water trickled through the ditch; I know it was icy because I followed Deathmonkey into it, crawling like a couple of scared GIs on our bellies, elbows and knees, fingers sluicing the creek slime as we slipped under the wire into the field, the smell of cowpies, and another smell, burnt ozone, and that acrid, otherly scent of...greys?

One of them just up ahead, I could see his outsized head and scrawny shoulders just above the edge of the ditch. I thought of that movie I'd seen as a kid, teenagers killed by little men with big heads and cat eyes from outer space, the little men with alcohol injecting claws...The Greys weren't cat-eyed. They were the Roswell aliens; they were Streiber's aliens. They were the very creatures whose like-

ness giddy saucerettes wear around their necks at Psychic Fairs – creatures now using an impossibly prehensile dull gray metal instrument to ream out the ass of a paralyzed bovine.

DeathMonkey could move with astonishing quietude for a dude his size and stonedness. He slipped a little closer, a little closer to the nearest Grey...who stood at a good distance from the others...As DM went he took a net out of his duffel, and his own metallic instruments: handcuffs. He handed me a ballgag.

I looked up at the slowly rotating hocky puck overhead; surely it must be aware of me? But perhaps it discounted me, I was just one more "cow", on an interstellar scale, and not to be taken seriously. Or perhaps our being in the ditch, below the level of the surface dirt, with the distracting vibes of the cattle around us, confused its surveillance. There was no sense of being watched; we were, I thought with a jolt of exhilaration, the watchers. WE were the researchers; WE were the experimenters; WE had turned the tables, like Lab Rats escaped from their cages to gnaw the faces of their white-coated tormenters.

And as this thought rippled through me The Reverend DM positioned his net, whipped a hand out like a bear slapping a fish from a river, and jerked the Grey by the ankles – both of em – off his feet, and backwards into the ditch...and into the net. It made ONE squeaking sound before I jammed the ballgag into the little fucker's mouth. The alien cattle mutilating instrument fell into the creek and spat a few sparks and then lay still; Deathmonkey shoved the instrument into the duffel, slung that over one shoulder, the struggling Grey over the other, and ran, hunched over, back along the ditch to the wire. He slipped through the wire; I passed him, the squirming alien, and followed, back to the bunker.

We kept it tied up good...until the saucer left. "They'll be back for it," I said.

"Not for awhile. They're strange, socially. The ones we abducted in Arizona—"

"You did this before, in Arizona? Oh sure, me and Stang and sterno and Philo and Dr Howl...We did some of that toad squeezin stuff, and went'n hung out at cattle mutilation sites...took us three or four tries but we caught some of the little bastards...took em awhile to come lookin' for em...We let em go. But not before. It's better'n cowtipping. Better'n putting gerbils up a Bobbie's ass. It's BIG fun, son. Watch this...Peel off that tacky silver suit he's got on there..."

"What if he sends a telepathic message?"

"He can't — cause you got me here. 'America takes drugs in psychic defense'. The stuff I took creates a sort of psychic backwash - it's like white noise to them. They can't get their signals through for a good five yards around me..."

"Do they bite?"

"No, they're wimps once you take away their damn gizmos...Lordy this one's got some fine piece of rump there...You see that? They put on their interstellar ruling class airs, but they got butt-holes just like the rest of us...Mostly atrophied though because they don't eat solid food no more..."

The gag popped out of the creature's mouth while I was stripping it. It spoke...with MY VOICE. Then with DM's. "You please can tell: what you do with me, is?"

"Got my voice but not my diction."

I jammed the ball back in and duct-taped it in place.

It's skin was so slick, almost like balloon stuff...under the silver suit I found no navel, and something that might be atrophied female genitals, and might not have been. Its four fingers had little pads on the end, sort of like tiny little blisters. Its eye coverings pulled off easy; its eyes rolled with fear. I almost felt pity, but then I remembered all those cored out animals, all those hybrid human babies, all those abductees; poor Whitley getting things shoved up his butt...

Remembering that, I found the nearest appropriate instrument, which happened to be a crescent wrench, and shoved that up the creature's butt. It squeaked through the gag and writhed. But it seemed intrigued somehow.

Well we did what SubG's do when they abduct aliens. We shoved things up their butts, we took samples of skin and Deathmonkey, who had experience with this, used a syringe to suck some kind of fluid from the little fold at the creature's crotch. He squirted this into a rubber-plugged test tube. We pretended to do all kinds of things to the critter, with Dustbusters, electric toothbrushes, blowdryers, and rubber bands, but we didn't actually hurt the grey physically.

I figure it got the point.

Then we released it...it wandered off, dazedly. One last touch: DM gave it his ten gallon cowboy hat, kind of funny watching this alien wander off with that hat on its head...

After a hard night of abducting aliens, it was Miller Time. Went to a mountain bar, and I don't drink alkystuff so I had Clausthaler nonalcohol brewskies, DM drank boilermakers, and we didn't talk about it much, but every so often we'd take turns chuckling and remembering and chuckling. "Little fuckers...little bastards..." DM would mutter.

That was the only time I went abducting aliens. I heard DM is taking parties of SubGs out regularly, for a fee, sort of like taking tourists sport fishing. He's still got that mutilation instrument; told me recently on the phone to watch the papers and "Just see if Jessie helms don't turn up with his butt cored out."

And that fluid he extracted from the Grey? I'm not sure. But you should see this puppy DM's got, progeny of his dog and...I don't know. I only know the dog's got an oversized head, eyes like dark glasses, furless skin like a balloon, and it tells him it's dinner time telepathically.

Interview:
Richard Boylan, PhD.

Positive Experiences with Mysterious Visitors

Gregory Bishop

Close *Extraterrestrial Encounters* is Dr. Richard Boylan's second major documentation of his work with "experiencers" (he prefers the neutral term) he is a clinical, research, and consulting psychologist who maintains a private practice in Sacramento, California. For the last five years, he has worked with an expanding group of people who have come to realize positive effects on their lives from repeated contacts with extrahuman "visitors." The California Board of Psychology revoked Dr. Boylan's license due to allegations of improper misconduct. Boylan characterizes the charges as "groundless" and due to a smear campaign conducted, as he says in an open letter, by elements of the military. If this is true, it would certainly not be the first time that this has occurred in the recent history of this country, and considering some of the subjects he discusses, it wouldn't be surprising.

Richard Boylan, Ph.D.

Q: What's your background and how did you get interested in the subject of abductions?
BOYLAN: Basically I would divide my interest between ETs and UFOs. UFOs I have been interested in since 1947. I became more interested since having a sighting of my own. The ET thing came looking for me. I actually had very little use for the 1950s contactee story genre. In 1989 I had four people who I'd been counseling, and after we got along to the problems they had come in for, admit to me that they had had contacts and I realized that I would have to look into this if I wanted to be a well-informed counselor, so I did. So I started my own research and found that there was almost nothing of scientific value published in this area. At the end of 1991 I set up my own project, and put out the word that I would be happy to talk to people who had experienced contact. I learned a lot and I'm still working at it.

Q: The impression I got from your book was that you took the abduction scenario at face value, and would expect it to be experienced basically the same way by anyone. This seems to me to be constricting, given the nebulous nature of the phenomenon.
BOYLAN: Well, I do my research according to the scientific method, and there are

very few people doing that in the UFO field, particularly in ET research. What may not be obvious is that I pre-screened my data samples to weed out the crazies, the delusionals, the hoaxers, and any others who for various reasons could not be taken as truthful. So what's left is sort of a pure distillate. That's not to say that anyone who comes through the door is taken seriously, but what I've been doing all along in my career in counseling is determining what people believe, and what they believe they believe...

Q: I'd like to ask what criteria you propose for such an uncommon occurrence as an abduction, when the most ordinary events in life can be perceived so differently by various witnesses.

BOYLAN: I have dealt with cases where there are multiple witnesses, but you have to understand the way that behavioral science works: If you get replication over time and over a series of reports by credible witnesses, you begin to have something there that you have to take seriously. Any one person can make a mistake in perception, and indeed as I cite in the book, sometimes somebody thinks they've seen something, but it turns out they have some mental influencing from the ETs and see something a little differently than it actually is. So I'm sifting all the time, using my critical faculties to sort out if this is real or is it just a result of perception.

> **I think that one of the things that the UFO experience does is assault the commonly received social reality so that people start to demand extraordinary truth-finding mechanisms to establish reality. That's a response to the threat to existing perceptions that people have; it's not the nature of the phenomenon that it requires such extraordinary proof.**

I think that one of the things that the UFO experience does is assault the commonly received social reality so that people start to demand extraordinary truth-finding mechanisms to establish reality. That's a response to the threat to existing perceptions that people have; it's not the nature of the phenomenon that it requires such extraordinary proof. You can investigate the ETs in just the same way you can look at psychic surgery in the Philippines or any other topic. It doesn't require some brand-new way of finding the truth in order to establish it as truth. People get confused about that.

Q: But you aren't standing in a lab studying these things, you're only dealing with human perception...
BOYLAN: You speak of that in a diminutive fashion...

Q: Here's the crux of my argument: I spoke recently with a researcher who had just taken a trip to an undisclosed location and seen something which established for him the reality of the UFO/alien presence on this planet. I asked if he had actually seen anything physical, and he said he had not. This made me wonder how he could convince me in the same way he had been when he hadn't even witnessed something that would constitute proof of a reality for most people. To me, that would prove the existence of God, if extrapolated far enough.
BOYLAN: Corroborating minute details from people who have no way of communicating this to each other. That's one way.

Q: Do you have any examples?
BOYLAN: Facial descriptions, symbols...in one case two people who were totally disconnected from each other, coming independently to me, and

depicting the same symbol. It's not something you come up with at random. I might call another researcher to corroborate a report, and get the same settings, behavior, procedures, and so forth from people who have no way of communicating this to each other and compare stories. You have to remember that multiple witness corroborative testimony is enough to send a person to the electric chair, and if you say that's a problem with ETs, then people just don't understand epistemology—they're confusing their fright that this might be true with the way in which we gather evidence in this society. After awhile, you get statistical averaging over time, and you have to accept the scenario.

Q: What about the writings of people like Michael Persinger, Jacques Vallée, John Keel, Gregory Little, and others who posit other explanations for human/alien interaction?
BOYLAN: Well, you're talking about a hopeless melange of people there, none of whom I agree with. You have to remember that I'm a psychologist. I've taken cognitive psychology and I understand about perceptions and the way people process their environment. There's a well-established scientific understanding of this, and [Persinger's] magnetic fields and their effects on the brain is very interesting as a laboratory study, but it's not an explanation for people's encounters with ETs.

Q: So what is your "laboratory" for coalescing research?
BOYLAN: Laboratory science is not the only kind of science. This is field science.

Q: So your statement that people repeat things over time and without any communication with each other is your evidence for repeatability?
BOYLAN: Well, it's more than that. Solid people who have everything to lose and nothing to gain report this, and they have no motivation to fabricate, and many with a scientific background. In social scientific research, these are classic ways of gathering information.

Q: Why is there this dichotomy between the "positive" and "negative" views and aspects of the abduction phenomenon?
BOYLAN: Well what's the obvious answer?

Q: People have some sort of need to get on one side or another of an issue and defend it.
BOYLAN: Not with this kind of ferocity. The subject involves preternatural position-taking for some people. It's very metaphysical. It's tends to impugn humankind sitting at the top of the evolutionary ladder, and there are a lot of loaded elements to it.

Q: Why do you think the abduction phenomena has only existed in its present form in the last 10 years or so?
BOYLAN: Well, we had accounts from the 1970s of encounters with ETs. (Notice that I avoid the [Budd] Hopkins vocabulary of "abductions" which is semantically loaded.) I think it was phenomenologically rare in the past, and it

> The subject involves preternatural position-taking for some people. It's very metaphysical. It's tends to impugn humankind sitting at the top of the evolutionary ladder, and there are a lot of loaded elements to it.

has picked up over time. Unless there is an absolute increase in the number of contacts made, I think it's in the ETs game plan to increase publicity and gradual accustomization to their presence. There were many contacts in earlier decades, but people were induced to forget them until a later time, that time being now. Now we have an avalanche of reports which is the sum of increased contacts and delayed memories brought forward now.

Q: *Why* ***now***?
BOYLAN: I think it's so the person would remember it when the situation was better for remembering.

Q: *So you ascribe this phenomenon to an extra-human inducement, and not a cultural shift in this direction?*
BOYLAN: I wouldn't say it's all that. Some of this is the way that a repressed memory pops to the surface when certain triggers are present, and when external signals are similar enough to the buried incident, and there's more of that around now. Many people were triggered off by the face on the cover of Communion.

Q: *Just about everyone in your book* (Close Extraterrestrial Encounters) *mentioned that.*
BOYLAN: Accurate depictions of actual extraterrestrials were extremely rare until that cover came along. Even that picture is not real accurate, but it's close enough. With this high degree of accuracy, then the triggering effect can occur. I don't know the ETs method of specific hypnotic suggestion—whether they have specific cues to trigger the memories, or they have a more generalized suggestion that if the environment is right, people will remember. Whatever it is empirically, people seem to be remembering now. It's just an avalanche. Not all of it is cued by the environment either. Some of it is ET time-capsule type of situation, and also we have a lot more talking about this going on.

Q: *You, Hopkins, and other researchers mention that non-participants are "switched off" during an encounter, couldn't this be based solely on the perceptions of the experiencer?*
BOYLAN: We have to be careful that every episode of missing time is not due to an ET encounter. There are a lot of other human explanations that would apply to an explanation of missing time that have to be looked at.

Q: *Such as...?*
BOYLAN: Inattention, falling asleep, a petit mal seizure (rarely), temporary hypnosis (like when you're driving if you're not careful.)

Q: *I used to drive between L.A. and San Diego at night and not remember anything but leaving and arriving. How would you find out if I had experienced anything out of the ordinary?*
BOYLAN: I would want more circumstantial evidence to find out if anything of an ET nature had possibly gone on. I wouldn't waste my time with anyone who had nothing else to go on than that.

Q: *What could someone say that would indicate that you should probe further?*

BOYLAN: I would want very affirmative specialized cues. Like a strange light came down out of the sky and paced their car for awhile, and they didn't think too much about it, but when arriving at their destination found themselves arriving an hour too late. Also, if there were any strange scoop marks on their bodies. Any nightmares about ETs and they normally don't have content like that in their dreams.

Q: When reading some abduction literature, I have those sorts of dreams. This happened when I was reading Karla Turner's book.
BOYLAN: Well she writes very traumatic stuff. David Jacobs is like that too. But you can also get that way from reading Stephen King.

Q: Yes. True.
BOYLAN: I'm talking about people who haven't been reading anything about it. I screen for whether people have been contaminated by reading. I do a lot of screening-believe me.

Q: How do you determine this? It's very difficult to avoid it nowadays.
BOYLAN: To show you how far this has come; it was very possible to find "virgins" even three years ago. People who came from all walks of life. They weren't reading books on the subject, they hadn't seen anything on TV. That's why now the cases I work on are mostly filling in backlogs of memories. I think the truth is going to be out very soon anyway, through governmental or private research.

Q: My opinion is that when you get a person in to talk about this, that their memory is going to be colored by what is discussed. How do you reconcile the fact that other researchers like Hopkins and David Jacobs always have their subjects recalling traumatic experiences, but when people come to you, it invariably turns out to be generally positive?
BOYLAN: It's impossible in behavioral social science to find those kinds of homogenous results at random.

Q: You mentioned that you sometimes have to bring up events in a contact before people would start remembering. In what way is this not leading the subject?
BOYLAN: It's not leading in the context of the person already being aboard a craft and having the sense of other people and not being alone. They will say "Well I sense another person over there" and I'll ask, "What kind of person?" In some cases it might be an ET and other times, a fellow human being. They say that. I don't ask it.

Q: Is there a standard set of questions you ask?
BOYLAN: There's no standard incident. It's the art of how of listening to someone to find out what they've been through to keep it from being contaminated. It's a skill. Therapists know how to do that.

Q: What about any subconscious cues you may give, such as reacting to what is expected,

and ignoring what is not?

BOYLAN: Well, you have to develop a "poker face." We can go into the whole art of how you would do a professional interview without imposing your views...

Q: I don't think many abduction researchers let that guide them.

BOYLAN: Well, in terms of behavioral science, almost no one in the field of ufology is careful about it. John Carpenter, John Mack, Edith Fiore (I guess), myself, and that's about it.

Q: You're saying people with the proper training who do research in this area seem to find positive experiences to be the norm in encounters.

BOYLAN: I'm talking about enduringly traumatic as opposed to any initial anxiety or fright. The therapists I've mentioned do eventually come up with a positive experience. The others who are the fright-mongers have no background in psychology. These people think the initial fright is the whole experience and carry that out based on their own prejudices. They lack the professional tools to interview people and counsel them accordingly. In this field, that's a recipe for mischief.

Q: When you talk to your subjects, you say that if your training is in the field of psychology, the alien encounter experience is always positive.

BOYLAN: It's not a question of making the best out of a bad situation. We're just clarifying what's gone on.

Q: If a Zen monk smacks you on the head 200 times, you may think he's doing it for a good reason, because you know that's what they do in training. However, someone can pose as that monk and hit you on the head because he likes it, but you think he's doing it for your own good because that's your background and maybe he's told you that.

BOYLAN: What's the point you're making?

Q: The intention of the source of these encounters may not be what people think it is.

BOYLAN: You're being hypothetical here. I've talked to people who are aware of the motives, emotions, and communications of the ETs they're dealing with. In fact, I find that this is what moves people to a more settled place—when they find out despite how unsettling it is to be woken in the middle of the night to find yourself on board a saucer—they finally understand there's an interpersonal communication going on and there's a point to this and concern for their feelings, they settle down and see it as a pioneer experience in interspecies contact rather than an unremitting horror show.

Q: Some segments of society used to think that the rape of women was because they were asking for it. Now it's a terrifying, traumatic experience, but nevertheless, some people thought this at one time.

BOYLAN: I don't see that this has anything to do with ETs. Investigators can influence how the experience is processed. We have some clearly prejudiced investigators going out and dealing with impressionable people in shock, and lo

and behold, these people walk away sharing the negative view of the experience.

Q: *The same thing could be happening with your work, though.*
BOYLAN: I don't know what you're saying.

Q: *It seems to me that there are equal reasons on both sides of this issue for...*
BOYLAN: But there isn't. Budd Hopkins and I are not the same thing pushing opposite agendas. For one thing, I'm not pushing an agenda, and for another, I am qualified. So I don't think it's two sides of the same coin.

Q: *Your book deals only with positive growth experiences and Hopkins, David Jacobs, and Yvonne Smith (for example) never deal with this sort of thing.*
BOYLAN: Well, they're into the horror stories.

Q: *They can just as easily claim that you and Mack seem to be into the positive side.*
BOYLAN: Well, here's the difference: When I started out, my operative hypothesis was that people that had experienced extraterrestrial contact were like people who had experienced post traumatic stress disorder from childhood sexual molestation. I thought it was a fairly good comparison, and there were points of similarity. I had to get rid of that hypothesis because the data would just not support it. Using just as much of my anthropology background as the psychological skills I found that as people got over the initial shock, that I could make them understand that they were the pioneers in an interspecies contact experience. Once they have a context within which to look at their experiences, there's nothing intrinsically evil about it. It's just darned unsettling. If given a chance though, people will find confirmation of their fears.

Q: *Why do you think it is that the only cases of abduction are reported from individuals who have a reasonable amount of stability in their lives (economically speaking anyway)- why don't we get any aliens coming into slums and dodging bullets and drug dealers?*
BOYLAN: Well, we do. One reason is that we hear very little from these people about the quality of their lives, or anything else. Most researchers don't talk to them. They're very different, they're elusive, and are not interested in talking. We hear from the kind of people that the Gallup poll talks to. White folks out in the suburbs are easy to find and you don't have to worry about your tires being on your car when you get back from an interview. It's a reporting artifact, not an incidence artifact.

There's situational reason as well. The ETs seem to want to work with people who have a potential for some kind of consciousness change. Somebody that's on drugs all day is not a real good candidate. However, I've had a number of people on welfare that I've talked to.

Q: *And their experience is essentially the same?*
BOYLAN: Yes. So, where consciousness is impaired, there's a rough time, and it's a screenout. Where there's no evidence for change, I don't see ETs waste their time with such folk. They love skeptics, though—if there's a chance that

you will change your mind and grow from the exposure. So you have to be potentially educable. I haven't seen any hardened criminals.

Q: You attended the "When Cosmic Cultures Meet" conference that was organized by (human potential movement founder) C.B. Scott Jones. Who attended and what happened there?
BOYLAN: Next to the M.I.T. abduction study conference, it was probably the most significant thing that has happened in [this subject area] this year. We had 25 national, world-class scientists from a variety of disciplines that were gathered, along with some military and journalists to discuss very seriously what should be the reaction when it comes out in the open that we are being visited. Scott Jones deliberately put the hypothesis as a future conditional, though so that people would not be afraid to come if they had university tenures on the line. In point of fact, however, most of the presentations dealt with it as a current reality.

Q: How did the attendees feel about that?
BOYLAN: I think the audience was self-selected to agree with that view. There was certainly a warm reception. The proceedings should be out fairly soon. The important thing is that in a seat of world power, this conference did take place, and a substantial cross-section of disciplines from many universities thought it was worth their time to devote careful thought to the subject.

This was not lost on the people behind the scenes in Washington, which is what Scott Jones intended. Tapes of this were made available to the Congress and White House and elsewhere, so these people could hear what went on in the privacy of their offices.

Q: Has there been any reaction?
BOYLAN: Scott Jones would know that. He characterized the meeting as an exercise in consciousness raising, and moving toward open disclosure. I know from independent sources that the CIA is worried about the reaction. This is one more piece of proof—that the fears of the fear-oriented people that we can't disclose this fact are ungrounded. A significant cross-section of professionals were treating this in a matter-of-fact way, and forming a framework for dealing with this as it becomes more public.

Q: It seems that every few years, the UFO community and other interested parties make the claim that the revelation of "alien contact" is "just around the bend." There were supposed to be open disclosures every year for the past few years, but nothing of the sort has happened. What makes you think this time is different?
BOYLAN: You'll find all sorts of claims, but for any serious researcher, "definitely" is not very reliable.

Q: I guess that depends on who you think is a "serious researcher."
BOYLAN: I guess it does. I've got some basis for this though. For example, Bob Dean has formed a coalition to gather people together who have dealt with saucer [crash] retrievals—knowledgeable national security-type people

who are ready to testify. This will come out in the next eight months, and if the government doesn't cooperate, they will make a public disclosure. Dean has called for congressional hearings and asked people to contact their congress person and insist on this.

Q: How seriously do you think he's being taken?
BOYLAN: He's trying to get the word out, but the press is controlled and hostile to the topic. That's the problem. In spite of this, networks are being formed. This has just started in the last month or less. (November, 1995.) We can't discount the impact of the alien autopsy film as well.

Q: What's your impression of that?
BOYLAN: I don't know about the actual film itself—I just saw the Fox program—but I'd like to know more about the source of it. I tend to agree with one person I've talked to that it came from an intelligence source, because two years ago some Chinese ufologists saw the same film, which was shown to them by the CIA. Richard Doty (ex-Air Force Intelligence) says he saw it at Los Alamos. Supposedly Santilli [the producer who now owns the rights] has the only copy of it, and it's been floating around in intelligence circles for years. Based on partial data, and I'm still on the fence, I'd have to say that it's a hybrid, not an ET or a human. It's not from Roswell, and it's a positive disinformation ploy by shadowy sources to accustomize the population to ET reality while allowing for a large measure of deniability. It has the possibility of being the film of another recovery while being billed as Roswell. So, possibly this is a partial disclosure and partial disinformation.

Q: To what ends?
BOYLAN: As negative disinformation, it would be to distract and hoax Roswell so that the very actual information that is continuing to accumulate will be neutralized by a film that can later be established as a solid hoax. Therefore by inference, it can be claimed that all the evidence for Roswell is a hoax and keep the coverup going. If the agenda is positive disinformation, it is a way to get out the truth, but keep a plausible deniability. This is what appears to be going on. It gives everybody what they want: the true believers can cite this as the evidence they've been howling for, and the debunkers and fearful folks can have a piece of film that they can punch holes in as having nothing to with Roswell, and therefore satisfies them that there are no such things as UFOs. Everybody's happy.

Q: You mentioned that some of the abduction scenarios may be the result of PSYOPS, [psychological operations against humans by the intelligence and military community] and I was wondering how you could convince anyone of this idea.
BOYLAN: Multiple independent accounts from people who are abducted by the military and have no reason to be making that up. Plus, circumstantial corroboration from others who have witnessed armed aggression against UFOs. There was also the example of the video from STS-48. [Videotape

You can't examine the UFO issue very thoroughly and not run up against the coverup. A comprehensive understanding of UFOs is tied right into the fact that there's a coverup going on, and the implications of that are useful to understand, since it helps you understand why you can't get at certain bits of information, and why public perception is at variance with certain data.

taken aboard space shuttle Discovery in September, 1991 that shows objects streaking about in artificial-looking ways behind the shuttle.]

Q: I hadn't heard that theory about it.
BOYLAN: Even Don Ecker had to say that it looked like someone was taking potshots at UFOs, and as we know, Mr. Ecker is not a wild protagonist of UFO reality.

Q: How do the people who've experienced these supposed PSYOPS know that this is what has happened to them?
BOYLAN: They don't come in saying that they're the victims of this. They say "I was taken by military, or military and some aliens" Either this or they were made to believe it was aliens. They are dragged off, interrogated, and mishandled—in some cases rather brutally. They're told to shut up about it, and then dumped back where they were taken from. The questioning has to do in some cases with their genuine ET encounters—but sometimes this part is not remembered.

Q: What is the purpose of this?
BOYLAN: My conclusion, from my own and other researchers' data is that it is a disinformation and coverup operation to create a coterie of badly-handled victims of alien abduction and a cluster of people who go around saying that "you don't want to be taken by them. Those aliens are bad and do terrible things to you if you are taken. So, if you see a UFO coming, stay far away." In almost all instances the military presence is not something they're supposed to remember—it's something they've retrieved, or popped into memory despite the drugs and hypnosis [that they are subjected to during the experience.]

I also infer that when the military requests permission to shoot on them, the citizenry will be aroused (of course we know that they don't wait for permission-shootdowns have occurred and are continuing.) I have this from other sources. Steven Greer has it from two separate CIA informants, and I've interviewed people who have been aboard craft when they're shot down...

Q: How do you trust the information from a government source—how can it be corroborated?
BOYLAN: Two independent sources helps. To be sure, one always has to be careful of information that the CIA puts out—there are both friendly and hostile elements—it's not a uniform organization. If you want to ask what's the point of revealing this explosive bit of information, it's that it certainly doesn't help the coverup stay in place.

Q: Is there a uniform reaction and /or agenda amongst the world's governments about these subjects?
BOYLAN: Do you mean the formal, elected governments?

Q: They seem to be silent about it.

BOYLAN: No. That's just the U.S. and U.K. You get in other parts of the world, like Africa and Latin America, Belgium, Scandinavia, Russia (Gorbachev talked about it) and the governments and particularly the press discuss it openly. We live in one of the most controlled of media environments in the world. We tend to think it's covered up with equal vigorousness all over the world, but elsewhere it's more out in the realm of the possible or just "clearly so."

Q: Well, other countries have little to lose in the discussion of this subject.
BOYLAN: That assumes the formal, elected [US] government is in charge of the UFO coverup. I don't believe that.

Q: Why do you think the elected government is ignoring this subject?
BOYLAN: It isn't any more. Dick D'Amato from the National Security Council told Jesse Marcel Jr. [son of Roswell debris recovery participant Col. Jesse Marcel] and Stanton Friedman that the NSC is desperately trying to find out who these people are, who they're getting their funding from, and why they're trying to keep this a secret. The NSC (according to him) doesn't know where the Roswell saucer is, or who the coverup people are, and would like very much to find out. So, it's not because of indifference. We have a situation where an elected government finds a powerful element is controlling the information about a massive phenomena with huge budgetary and personnel resources, and they haven't a fig about who it is or what exactly they're doing. To have to admit that you're impotent inside your own country against a force that's extremely large and treasonous, as well as influential, is explosive.

Q: Well, it seems like it's just not UFO information that's being hidden. Wouldn't you think that it would be easier to reveal some nefarious activity that is very terrestrial in nature to "open the door" as it were-like the case with MKULTRA or PAPERCLIP?
BOYLAN: Those are documented CIA atrocities which have been the subject of congressional hearings, and they were not conducted by the UFO coverup group. The CIA has since admitted to these things under duress, so that's a whole other kettle of fish. The CIA is ostensibly part of the elected government in that the president appoints the director. So this is not a "rogue" entity.

Q: Well, then who is?
BOYLAN: That's the $64,000.00 question.

Q: You mentioned in your book that the ONI (Office Of Naval Intelligence) and the NSA (National Security Administration)—among others—were involved in part in the UFO coverup, and they're certainly not "rogue" organizations either.
BOYLAN: Well, that's old data and I've since revised that. I did a piece for Perceptions magazine on this which ran over two issues. I named names, but it's not just the UFO coverup, it's the whole apparatus that keeps things like Iran-Contra and so forth under wraps.

Q: Why did you get interested in this aspect of things?

BOYLAN: You can't examine the UFO issue very thoroughly and not run up against the coverup. A comprehensive understanding of UFOs is tied right into the fact that there's a coverup going on, and the implications of that are useful to understand, since it helps you understand why you can't get at certain bits of information, and why public perception is at variance with certain data. There's a massive program of propaganda and psy-war being perpetrated on the domestic population.

Q: For the benefit of those who have not read your book, could you give a few bits of evidence supporting the reality of alien encounters?

BOYLAN: One has to look at the science—the data recorded by scientifically trained, professional researchers who have the background to investigate this phenomenon. One has to respect what the data represents. As John Mack has said, if these phenomena aren't real, then we're in the midst of the greatest psychological phenomenon in the history of humankind. We're having a mass hallucination with extreme detail with no possible psychiatric explanation. The data for UFOs is overwhelming. Just read Timothy Good's book *Above Top Secret*. Government documents tell you they're real. Then you have to ask yourself the question: "Is somebody piloting them?" Probably so. I think most people would concede they're being piloted. "Do the pilots ever land?" Most people would say that's a possibility. "Do they come out and walk up to somebody?" Again, most would say that it's a possibility.

Now, we've got people with scientific training talking to and reporting on many thousands of cases of this nature. There is corroborative data that this is actually going on, including independent circumstantial evidence: burns in the field, neighbors seeing a UFO, people taken independently and seeing each other aboard craft. If that isn't good enough, than you should throw out a lot of the jury verdicts in this country that are based on a couple of witnesses saying "Yeah, he did it." If you take the position that you "weren't there and didn't pull the trigger, we're gonna let this man go free" then a lot of murderers would be walking free in this country.

The UFO phenomena and ET visitation is the greatest epistemological challenge to modern man, because it engenders a radical paradigm shift (to use an overworked phrase) and so people demand bizarre, absurd, and unreasonable levels of proof. When you realize that it's about your fear that this reality might be true, rather than about inadequacy of data, then I think the proper focus becomes what people have to master. I think this is what the Cosmic Culture Conference was about, it's what the CIA's fear is about, and it's really the task that a number of us see ourselves as having to deal with when we get past this phenomenon coming out in the open. The big issue is what we make out of it as a people and as a culture—not whether it's true or not.

> **The UFO phenomena and ET visitation is the greatest epistemological challenge to modern man, because it engenders a radical paradigm shift (to use an overworked phrase) and so people demand bizarre, absurd, and unreasonable levels of proof.**

The Trickster of Truths: Carlos Castaneda and Scholarly Opportunism

Adam Gorightly

Part I: Did He Make It All Up?

Probably one of the more interesting chapters in Timothy Leary's *Flashbacks* (aside from the one dealing with Mary Pinchot-Meyer, and how she allegedly turned on JFK to LSD) deals with the period Leary spent—after getting kicked out of Harvard— in Mexico at the isolated Hotel La Catalina in Cuernavaca where he continued his LSD research project, recruiting intrepid explorers there to sample his wares in the positive set and setting of tropical sand and foam. Most of the trips taken there were positive and pleasant, though one funny session is recalled where some guy flipped his wig thinking himself an ape álà *Altered States*, running around the island berserking ape-like and terrorizing the native populace.

Another interesting episode from this chapter was a visit from Carlos Castaneda, a few years before Carlos penned his classic chronicles of Don Juan's shamanic teachings. It seems that Castaneda even at this time had begun his role as cosmic prankster, doing all kinds of flaky stuff and circulating false rumors about Leary as he tried—albeit unsuccessfully—to gain admission into Leary's psychedelic hotel, and get into his head. But Dr. Tim was having no part of this young conservative-looking Hispanic flake, whom he figured correctly was up to some sort of mysterious mental mischief. Upon first meeting Leary, Castaneda presented himself as a Peruvian Journalist named Arana, at the time confusing Leary for Richard Alpert. Leary, smelling a rat, politely informed Arana/Castaneda that they entertained a policy of "no visitors" at the hotel. He shook Carlos' hand and bade him farewell, sending Castaneda back with the hotel station wagon that was making a run into the village. The next day an employee of the hotel, Raphael, met Leary with a solemn expression. Raphael informed Dr. Leary that his aunt, who was a medicine woman, had imparted to him on ominous story. Seems she had been visited the previous night by Arana aka Castaneda who was now claiming to be a professor from a big University in California. The 'professor' claimed that he was a 'warrior of the soul' and needed the medicine women's assistance. He said his powers were being attacked by an American (Leary) who possessed great

magic that had been stolen from the Mexican Indians. Castaneda—now claiming to be an Hispanic-wanted the medicine woman to help him steal these powers back, so that he could protect the Mexican people. When all was said and done, the medicine woman was having no part of the ruse. Little did Carlos know when he approached her, that many of the medicine woman's family members worked at the hotel La Catalina. Carlos told her this was also the name of a bad witch-woman who was his enemy. In response, she informed Castaneda that Leary was a good man under her protection, and sent Carlos on his way. (The character of 'La Catalina' appears in Castaneda's first book, *The Teachings of don Juan*.)

The next day Castaneda showed up again at the La Catalina, using as before the alias of Arana. This time Castaneda apologized for having earlier mistaken Leary for Alpert, and offered him a gift, said to have come directly from Gordon Wasson's personal shaman, Maria Sabina. When Leary caught Castaneda in a lie concerning this so-called gift, he once again politely asked Carlos' to leave, and —after much spirited protestation—the 'young sorcerer' reluctantly acquiesced. (Arana was, in fact, Carlos' paternal name, with his maternal last name, Castaneda tacked on the end. Quite fittingly, Arana, when translated in English means: trap, snare, fib, lie, deceit, fraud, swindle or trick. So, in his native Peruvian tongue, Carlito's Arana=Charlie Trick.)

In a recent *SteamShovel Press* article, noted psychedelic researcher Tom Lyttle addressed the Holy Trinity Of Sixties Psychedelia: Leary, Castaneda, and R. Gordon Wasson, reflecting upon how these three seminal forces influenced & gave rise to the psychedelic anthropology that came into fashion during that era. Wasson, a much respected NY banker, left the environs of business to devote his latter years to the pursuit of the mysteries of the magic mushroom, traveling to Mexico where he was introduced to its wonders by the healer-shaman Maria Sabina, who-according to Merilyn Tunneshendes-was also an intimate of don Juan. Lyttle notes the interesting and mercurial relationships these three wanderers upon the path of hallucinogenic illumination shared, often coming into conflict over their varied views of the psychedelic experience. Wasson felt that Leary at times was naive and reckless in his grandiose proselytizations. Conversely, Leary must have felt that Wasson was a bit of a scholarly stuffed shirt, lacking in mental flexibility. What's funny is that this is much the same way The Merry Pranksters viewed Leary once upon a trip, when the Kesey clan attempted to raid his research center at Millbrook, and the good doctor refused to party with the Pranksters since he was too busy with some sort of scholarly psychedelic experiment. Perhaps this is the same apprehension of Leary's that turned him off to Castaneda; the fear that he was in the company of a trickster who was cleverly involved in some sort of role playing mind game. As for Castaneda and Wasson, the two met on a couple of occasions, and afterwards exchanged several letters over the years. Throughout it all, Wasson remained highly skeptical of Castaneda's claims. After his initial reading of *The Teachings of don Juan*, Wasson stated that he "smelled a hoax."

Wasson and Castaneda biographer, Richard De Mille, though both admirers of Castaneda's work, were equally critical of its veracity, particularly in

Maria Sabina

regards to the inconsistent use of language throughout. Where the first book had don Juan speaking formal English, in the later books he frequently used English slang. The problem here is that don Juan did not speak English, and that Carlos conversations with him were transcribed from Spanish. In Castaneda's second offering, *A Separate Reality*, there are several examples of this, as there are in the third of the series, *A Journey to Ixtlan*. In that *A Journey to Ixtlan* was a recapitulation of the events that transpired at the time of the first book, these inconsistencies collectively raised the respective eyebrows of both Wasson and De Mille. Such phrases as "off your rocker" "cut the guff" "lose your marbles" "shenanigans" & "the real McCoy" were liberally peppered throughout; English slang words with no Spanish counterparts. One reason for this may have been the editorial constraints Castaneda was under with the University Press, who published his first book, as opposed to the freedom he exercised afterwards with Simon & Schuster, who basically gave Castaneda carte blanche control over subsequent manuscripts. Castaneda apparently used this leverage thereafter by refusing to have his work scrutinized by any of the S&S editors. De Mille, in *Castaneda's Journey*, noted these aforementioned linguistic problems, and went even further into examining the chronologies of the books, once again discovering conflicts within the time frames and chain of events.

In the end, Wasson who upon first meeting Castaneda described him as "an obviously honest and serious young man," later found him to be just "a poor pilgrim lost on his way to his own Ixtlan."

A series of books by one T. Lobsang Rampa came out in the late fifties, chronicling the psychic adventures of Rampa, a Tibetan Yogi adept. I read the first of this series, *The Third Eye*, back in the mid-seventies around the same time I first discovered Castaneda, and was effected similarly to the tales of Rampa as I was to those of don Juan. Later, as I read other books in the *Rampa* series—and their claims became increasingly fantastic and far out—I began to smell a rat behind the humble trappings and simple dress of the high mountain monk. It wasn't until the later Castaneda offerings, *Tales of Power* onward, that I likewise grew skeptical of little Carlos and his extravagant and ever broadening paranormal claims. In *The Third Eye*, Rampa detailed his initiations into the mystical world of the Tibetan Monks, and the eventual and dramatic opening of his Third Eye, accomplished not only through secret initiations, but also by way of physical means which consisted of boring a hole into his forehead with a steel instrument. Then a sliver of wood was inserted into his head, and "there was a blinding flash." Immediately afterwards, Lobsang was able to see auras. "You are now one of us, Lobsang," one of his mystical masters instructed this young lad of eight. "For the rest of your life you will see people as they are and not as they pretend to be." Thus began T. Lobsang's strange adventures into the merry land of the occult. Other phenomena imparted to the readers of *The Third Eye* consisted of a whole grab bag of various paranormal phenomena such as astral projection, clairvoyance, levitation, invisibility and past life regression. One scene which I found particularly fascinating recalled a group of monks, who—according to T. Lobsang—periodically gathered together in group mediation to converse telepathically with aliens from another planet. At

Carlos Castaneda died of liver cancer on April 27, 1998 at his home in Los Angeles. His age was given as 72. The death certificate lists him as a teacher for the Beverly Hills School District, although official school records list no such person. It also said Castaneda was "never married," even though Margaret Runyan Castaneda was his wife from 1960 to 1973, and they had a son, who is now 36. Castaneda remains an enigma even in death...

In the first few books (which were better than the latter) it appears at times that Castaneda's prose is clumsy and amateurish; the prose stylings of a novice. But possibly this is exactly what he was trying to approximate; to deliver the impression of your average naive Joe in the street who had been propelled suddenly into the paradigm shattering domain of don Juan Matus.

one point in *The Third Eye*, the abominable snowman even made an appearance. Eventually, these books were exposed as a hoax, written by an Englishman, Cyril Henry Hoskin. Hoskin maintained this hoax through at least eighteen sequels. At best, perhaps, the Lobsang books could be called an unsophisticated precursor to the Castaneda chronicles.

Even if the books of Castaneda and Rampa álà Hoskins are purely fictional, to label them all a hoax might be missing the bigger picture. Perhaps these literary constructs were used as vehicles to express higher truths discovered by their authors. There are several other literary corollaries I could draw, one recent example being Victor Noble's *R. Marcus: The Making of an Avatar*. Though the enigmatic Mr. Noble has recently admitted that his alleged guru cum avatar, R. Marcus Christianson, is a fictional model, this in no way detracts from Noble's main purpose, which in essence is an attempt to lay down on paper—for all who care to see—his strongly felt self realized religious discoveries.

Other questionable literary offerings as these have come from such renowned scribes as Phillip K. Dick and Kerry Thornley. But where Dick's claims fall more in line with the sublime theological and metaphysical musings of a Noble, Rampa or Castaneda; Thornley's assertions cast himself in the realm of a grand conspiracy, playing the role of a central character cast in a web of vast plots that he has little or no control over; like a leaf in a windstorm tossed hither and yon.

Earlier in Thornley's often colorful career he co-wrote *Principia Discordia*, the definitive precursor to such loathsome offsprings as *The Church of the SubGenius*, Ivan Stang's idiot child/beast. In that Thornley (aka Omar Khayam Ravenhurst) was at first a merry prankster in his role as author of this tongue-in-cheek classic theological put-on, some consider his later autobio-graphical/conspiratorial rantings as woven fantasies, crafted to confound and confuse, while at the same time teaching us fundamental lessons about paranoia, conspiracy politics, and the apparent nature of reality. Maybe this is what all these authors share in common; an ability and need to express higher truths and personal convictions through literary constructs that blur the lines between fiction/non-fiction. Perhaps the holy scribes of our information overloaded technological age need to be tricksters to express these hidden truths.

What makes Castaneda's accomplishments all the more impressive is the skill in which he delivers his narratives, and their believability to the reader. This believability is due either to Castaneda's sincerity, or—on the other hand—his skill as a storyteller. In the first few books (which were better than the latter) it appears at times that Castaneda's prose is clumsy and amateurish; the prose stylings of a novice. But possibly this is exactly what he was trying to approximate; to deliver the impression of your average naive Joe in the street who had been propelled suddenly into the paradigm shattering domain of don Juan Matus. Harlan Ellison, a true master of Science Fiction and fantasy, and one of its finer critics, once placed Castaneda's books among the preeminent in the genre, no small statement coming from the likes of Ellison, who is notorious for slamming anything that appears to be even slightly hackneyed or

unoriginal. But that's what good writers do; they make the difficult seem simple. The unbelievable; believable.

Although the authenticity of Castenada's books are open to question, one—after reading them—cannot deny there's something more to them than just a fantasy spun for personal profit. Even if the books contain what appear to be seemingly apparent inconsistencies, they are told with such a tilted zen-like spin and a sense of the mysteriousness of life encountered on the road to knowledge, that it really isn't important if the events depicted therein actually transpired; it's the trip that Castaneda sends us on that counts; and what we bring back from it that really matters. A friend of mine at UCLA who once saw Castaneda there said he had the look of someone who'd seen beyond the veils of normal human perception; its unstated wisdom speaking volumes from his eyes as he momentarily glanced at my friend as they passed each other on campus one day.

But who really knows what lurks behind the jester's mask?

What makes this subject all the more confusing are the recent condemnations of Castaneda made by Merilyn Tunneshendes, who reaffirms many of Carlos' claims, but also testifies that he has in recent years gone astray, and in fact has himself been tricked by the master trickster of them all, don Juan. Tunneshendes claims that she herself is a sorceress from the same school and lineage as Castaneda, apprenticed in the Yaqui ways of knowledge by don Juan and his loco partner in crime, don Genaro. According to Tunneshendes, Castaneda was banished from don Juan's world in 1980, which corresponds with the same time frame when Castaneda's work began to be called into question. Since then, asserts Tunneshendes, the old Nagual (don Juan?) "has blasted Carlos into a very unpleasant energetic space, and as anyone can plainly see the quality of his books deteriorated drastically afterward." Tunneshendes says she has even heard rumors that Carlos had a nervous breakdown or psychotic split as a result of being excommunicated by his former teachers, and was afterwards treated with Lithium. (At this time he was also reprimanded by UCLA for supporting the work of Florinda Donner, allegedly a member of Castaneda's witch's circle. I have spoken to others who believe that Florinda Donner is a pen name of Castaneda.) What caused this parting of ways between Carlos and his mystical mentors resulted from the way that Carlos wanted to use energy, a way that the old Nagual "found totally abhorrent." Apparently, at this time, Carlos fell under the spell of a dark sorceress named Silvio Manuel. In all fairness to Castaneda, he refuses to acknowledge these controversial claims, or even the very existence of Ms. Tunneshendes, although Tunneshendes alleges that she "can describe to perfection features of Carlos that I would have no way of knowing, unless I had very "CLOSE" contact with him." So go figure.

The gist of Tunneshendes' allegations are that Castaneda and his associates-who are involved in the Tensegrity workshops—are nothing less than psychic vampires, draining massive quantities of energy from the naive participants enrolled in their seminars. Carlos is now a slave of the aforementioned Silvio Manuel, as are all the innocents he attracts to the workshops, from whom he draws power. Their stolen power is then fed to the Spider, Silvio. Says Tunneshendes: "She finishes the draining and enslaving process. She also keeps

Eventually, [the Rampa] books were exposed as a hoax, written by an Englishman, Cyril Henry Hoskin. Hoskin maintained this hoax through at least eighteen sequels. At best, perhaps, the Lobsang books could be called an unsophisticated precursor to the Castaneda chronicles.

Carlos weak enough to control, energetically speaking." In the literature I've seen advertising the Tensegrity workshops, its promoters come across more like new age entrepreneurs than psychic parasites, with Castaneda fronting the act, instructing the paid participants—at $250-plus a pop, no less(!)—in a series of T'ai chi-like movements supposedly developed by prehistoric hunter/gatherers. Apparently there is also a video soon to hit the market, of Carlos performing these very movements.

So who knows really what goes on behind the scenes of this ever widening web of mystery? This apparent literary/psychic feud between Tunneshendes and Castaneda may be just so much mushroom smoke blown from the respective medicine pipes of don Carlos and Merilyn, who—for all we know—might be working in cahoots to further muddy the waters of their Folly's Pool.

My personal take on Castaneda's work is comprised of an equal measure of awe and guarded skepticism. In *Carlos Castaneda, Academic Opportunism in the Psychedelic Sixties*, Jay Fikes' presents the case that Castaneda—with literary license firm in hand—borrowed his conceptual framework from the experiences of former UCLA grad students Peter Furst, Diego Delgado, and Barbara Meyeroff, then embellished upon their already somewhat imaginative and spurious fieldnotes. In the early sixties, Furst, Delgado and Meyeroff were observers of Huichol Indian peyote-eating rituals in Mexico. Fikes claims that the field notes taken from these rites were subsequently fictionalized to accommodate the growing psychedelic cargo counterculture which, at that time, was just starting to bud like young cannabis tops, waiting to be sifted and inhaled by a new generation of vision/thrill seekers. Some bought into this line of academic bullshit that had been laid down—like so many tantalizing turds—by these three anthropology students; while more seasoned and critically astute researchers were able immediately to cut through the crap. (What better place to concoct fanciful stories about exotic mushrooms than in the paddies of cow pies?) If, in fact Carlos did borrow his early ideas from these three bullshit artists, then—as Jim DeKorne suggests—he took it to another, higher level. A level convincing enough to fool casual readers, vision seekers and seasoned academics alike. For awhile, at least.

Or perhaps Carlos did meet, during his early field research, certain medicine men and shaman women who shared with the young anthropology student their magic mushrooms and sacred visions. From these supposed encounters—some suggest—Castaneda drew the composite figure of don Juan Matus, based on persons real and imagined; borrowed from true life experiences, as well as the biographies of mystics and other holy mad men. The early books seem to have more of a foundation based in traditional Native American culture, specifically in regards to the ritual use of peyote, and such paranormal phenomena as shapeshifting, than the later books do, which come across more like acid-addled Science Fiction. In his shadowy travels to South American and other unnamed environs, I'm sure that Carlos must have done his best to ingratiate himself with as many shamans and curanderos as he could shake a magic stick at. Carlos has claimed that prior to his meeting don Juan, he had no interest whatsoever in areas metaphysical and philosophical, though his former wife

Margaret says that this is all they ever talked about during their short-lived marriage, which ended several years before don Juan supposedly entered Carlos' life. Contrary to Castaneda's apparent self-made legend, his pre-don Juan days resemble someone more in search of answers and meanings to the eternal mysteries, than they do the obtuse and skeptical young anthropologist of the time as he has portrayed himself; a very staid and conservative young fella who knew nothing of such matters, and claimed to have no interest in them at all until exposed to the teachings of don Juan. This conflicts with Margaret Castaneda's portrait of a young Carlos, who spent many an idle hour attending metaphysical lectures and reading books on philosophy and the paranormal.

From a personal standpoint, certain scenes in *The Teachings of don Juan* reverberate with a ring of truth, in that they closely parallel and echo the stories of ritual peyote use and evil shapeshifters of which other Native Americans have spoken. As an example, a Native American acquaintance spoke to me with great fear and reverence about a medicine man of his tribe who was known to turn himself into a half man/half wolf-a lycanthropic werewolf, if you may-to spy upon those with whom he was enemies, much like the character of "La Catalina" in *The Teachings of don Juan*, who could change her appearance at will. Likewise, the peyote visions my acquaintance shared were as equally riveting, conjuring up such deeply ingrained archetypes as demons and angels, or-as don Juan called them-'foes and allies.' The most important aspect of these visions were that they taught their users a lesson; a special gift one had to earn; an experience that one did not enter into lightly, because of the inherent dangers-but whose rewards were incalculable, often lasting a lifetime. It must have been just these types of stories-and perhaps personal experiences-from which Carlos drew his ideas and fabricated his characters; either out of whole cloth, or as partial renderings of events or persons he encountered on his own 'path of heart.'

Part II: Bullshit As Fertilizer In The Garden of Truth

Nonetheless, there is no concrete documentation that Carlos ever actually entered into the non-ordinary world of don Juan, or any other curing-shamans or *curanderos*, for that matter. In fact, contrary evidence exists suggesting Castaneda borrowed his ideas from a variety of sources; not only from the aforementioned Meyeroff, Delgado and Furst, but from the likes of Gordon Wasson, Andrija Puharich and Antonin Artaud, to name but a few. As the legend goes, Castaneda first met don Juan in the Summer of 1960. According to Margaret Castaneda, in 1959, "Carlos and I had read Puharich's book (*The Sacred Mushroom*) and somehow it changed us." She noted that afterwards Carlos "seemed withdrawn." Margaret asserts that at this time Carlos took a trip to "Mexico" where he was "digging for bones." It's biographer Richard De Mille's contention that the rare "bones" Castaneda spent time "digging up" was the actual fieldwork that Gordon and Valentina Wasson had compiled in their researches into mushroomic shamanism. In *The Sacred Mushroom*, Puharich had heaped lavish praise on Wasson's seminal *Mushrooms, Russia and History*, a rare two volume edition published in 1957, limited to a sparse 512 copies. This two volume set would have been accessible to Carlos in the special collection

What better place to concoct fanciful stories about exotic mushrooms than in the paddies of cow pies?

section of the UCLA Library, and this is exactly where author De Mille theoretically places our young "warrior" in early 1960; sitting unobtrusively in a corner, ingesting the words and images of R. Gordon Wasson like so many honey dipped mushrooms, planting the spores of don Juan there in his mind. During this period, according to his former wife, Castaneda was also taking creative writing courses. (Tom Lyttle reports even more Castaneda revelations courtesy of ex-wife Margaret to hit the market soon in a tell-all book.)

In an article from *Entheogen Review* entitled "Bullshit As Fertilizer In The Garden of Truth," Jim DeKorne suggests that much of Castaneda's work is actually bullshit piled upon bullshit. DeKorne speculates that in some instances the likes of Meyeroff, Furst and Delgado, were perhaps unknowingly slung a certain amount of BS themselves by the Huichol Indians; bullshit, which later, was further embellished upon. By the time Castaneda got his tricky latin hands upon these stories, yet another layer of colored coated candy had been dumped into the mixture, leaving us with three generations of delectable doo-doo. In Furst's H*allucinogens and Culture,* he makes reference to "peyote enemas" which is now regarded as so anomalous by enthographers that it is suspected Furst was having his leg pulled by his Huichol hosts: "These gringos will believe anything!" This is akin to Carlos smoking don Juan's mixture of mushrooms, The Little Smoke. When smoked, psilocybin is rendered inert, thus inactive. This reminds me of the urban legend that evolved during the sixties drug counterculture involving the use of banana peels, that allegedly when dried and smoked would cop its users an hallucinogenic buzz. Rock crooner Donovan sang of this in *Mellow Yellow*: "Electrical banana/Gonna be a sudden craze/Electrical banana/Gonna be the very next phase!" Of course the mellow yellow banana peel craze had little more than its customary fifteen minutes of Warholian fame; whereas Castaneda has now enjoyed close to thirty years of success, and is probably now more popular than ever.

Puharich's *The Sacred Mushroom* comes across equally as fanciful as anything in the Castaneda pantheon. *The Sacred Mushroom* revolves around the bizarre experiences of Puharich, psychic Perter Hurkos and small group of other psychics and researchers who happened to stumble upon the mysterious mushroom known as *Amanita Muscaria* (believed by many to be the fly agaric/Soma of The Temple of Eleusis) in the late fifties at their research facilities in the eastern US. Its premise seemed to suggest that it was by no mere coincidence (read: Synchronicity) that these mystical mushrooms seemed to pop up every where this band of intrepid explorers turned, beckoning them to come taste of its forbidden fruit, thereby inducing them into the secret rites of the ancient mystery religions. Upon succumbing to the beguiling charm of this strange toadstool elixir, the group was propelled backward into ancient Egypt and other previous incarnations, not to mention being subject to various forms of paranormal high weirdness. In a nutshell, Puharich's book theorized that Amanita Muscaria had sought out his research group (shades of McKenna's alien spores) to bring these select souls together who had lived and loved in Greece and ancient Egypt past, as a means to continue their higher education, the wise and mischievous mushroom guiding these adventurous souls through

In Furst's Hallucinogens and Culture, he makes reference to "peyote enemas" which is now regarded as so anomalous by enthographers that it is suspected Furst was having his leg pulled by his Huichol hosts: "These gringos will believe anything!" This is akin to Carlos smoking don Juan's mixture of mushrooms, The Little Smoke. When smoked, psilocybin is rendered inert, thus inactive.

their respective ascensions on the spokes of the karmic wheel.

For those who don't remember, Peter Hurkos was a legendary psychic, famous for his presumed ability to telekinetically "think" pictures onto camera film. I've always thought if this were a trick—by the always animated Mr. Hurkos—it was indeed a nifty one. I don't recall any debunker ever duplicating this photographic feat, or exposing it for a fraud; not even James "The Amusing" Randi, who a decade later exposed one of Puharich's later protégés, Uri Geller, as a fake before a national TV audience on *The Johnny Carson Show*. Which leads us to one of three possibilities concerning Puharich and his kooky claims: 1) He was duped by the likes of Hurkos and Geller into believing all this high weirdness that transpired in their respective companies: Hurkos with the mushrooms; Geller with his aliens. 2) Puharich himself was behind these hoaxes, orchestrating all this supernatural flim-flam with the aide of his illustrious psychic sidekicks, or 3) all this cosmic craziness actually happened on one level of reality, or another. Just like the unanswered questions concerning Kerry Thornley's Nazi brain implants, the ever-continuing Castaneda Controversies, or the Dick/VALIS affair; we'll probably never get to the absolute bottom of the otherworldly endeavors of Puharich and his mushroom munching minions. Especially since Puharich has now shed his mortal coil, and Mr. Geller has (mostly) removed himself from public view.

Another possible instance of bulldada that Castaneda has elaborated upon, can be found in a passage from *A Separate Reality* in which don Juan describes how warriors see the human aura:

> "A man looks like an egg of circulating fibers. And his arms and legs are like luminous bristles bursting out in all directions."

Compares this to a passage from a book written in 1903:

> "The Human Aura is seen by the psychic observer as a luminous cloud, egg-shaped, streaked by fine lines like stiff bristles standing out in all directions."

The above quotation comes from Yogi Ramacharaka, who-as fickle fate would have it-was a pseudonymous American hack writer of bogus eastern mysticism. Is this but one of many examples, where Castaneda has borrowed his ideas from the popular psychic literature of the time? Once during a lecture at UC Irvine in the late sixties, a student brought up these apparent similarities, and Castaneda—ever fast on his warrior-like feet—stated his belief that this was because those who later passed on the Yaqui ways of shamanism, had originally migrated from Asia when once the two land masses of the eastern and western hemispheres had been connected. According to Richard DeMille, this was just another of Castaneda's many talents, along with earning a Ph.D. in Advanced Sorcery and writing best selling novels: The ability to conjure fanciful explanations-and opportunistic embellishments-when poised with a delicate question.

Another oft cited example of supposed Castaneda chicanery, comes from the aforementioned Dr.'s Meyeroff and Furst, who have since gone on to become much respected in their fields, both now heads of university anthropology departments. Dr. Meyeroff was an early acquaintance of Castaneda, when both were undergraduates at UCLA, together going through the various trials and tribulations associated with writing their doctoral dissertations and attempting to make their marks upon the academic world. Meyeroff, like Castaneda, was one of a staggering five hundred anthropology students who at

Ramon Medina Silva

the time were struggling to earn advanced degrees. This shared experience—and their mutual interests in Native American Shamanism and hallucinogenic drugs—created a bond between the two which existed for many years after their initial meeting in the spring of 1966. At this time, Carlos had been writing about don Juan for many years. Dressed always in a conservative dark suit, Castaneda-'the impeccable warrior'-worked rigorously, normally eight hours a day, five days a week, stationed religiously at one of the many cubicles at the UCLA Library, writing what later become known as *The Teachings of don Juan*.

Mutual friends of both Meyeroff and Castaneda had been suggesting for over a year that the two should get together, hinting that they would have much to talk about. When finally they did, Meyeroff felt as if she had met a long lost blood brother, who was walking down the same path of knowledge as herself; not only in regards to their academic struggles, but as well with their mutual interest and first hand knowledge of Native American Shamanism: Carlos with his stories of don Juan, and Meyeroff's experiences with her own personal shaman, Rincon, whom she had met in the course of her field work in Mexico. During Meyeroff's and Castaneda's first meeting, the two talked for over ten hours, as Carlos amazed and delighted Meyeroff with his tales of don Juan, the mysterious Yaqui Indian sorcerer. At last she had found not only a friend with whom she could converse with on such weighty subjects, but also someone who would be able to collaborate and validate her own field data.

Later that summer, Barbara Meyeroff traveled to Guadalajara with fellow grad student Peter Furst, where they spent several days with the Huichol Indians, tape recording peyote chants and songs, and listening to allegorical stories and explanations of ritual and myth given to her by Ramon Medina. One afternoon Medina—who at the time was preparing himself to be a Huichol shaman-priest—interrupted their daily routine with an unplanned outing into the country. As Meyeroff was later to tell it:

> "Ramon led us to a steep barranca, cut by a rapid waterfall cascading perhaps a thousand feet over jagged, slippery rocks. At the edge of the fall Ramon removed his sandals and told us that this was a special place for shamans. We watched in astonishment as he proceeded to leap across the waterfall, from rock to rock, pausing frequently, his body bent forward, his arms spread out, his head thrown back, entirely birdlike, poised motionlessly on one foot. He disappeared, reemerged, leaped about, and finally achieved the other side. We outsiders were terrified and puzzled but none of the Huichols seemed all that worried."

In late August, when Meyeroff returned to UCLA, she told Carlos about Ramon Medina's amazing waterfall acrobatics. "Oh," replied a surprised Carlos. "That's just like don Genaro!" Castaneda then went on to describe don Genaro's now legendary *Separate Reality* waterfall levitations, which were strikingly similar to Ramon's own acrobatics, though with a couple of extra added paranormal feats thrown in for effect. Don Genaro's descent of the waterfall included not only the great physical prowess exhibited by shaman-to-be, Ramon Medina, but at times it also appeared as if he were walking on water, as it rushed across the slippery rocks below. As a finale, the ever entertaining don Genaro executed a backward somersault and disappeared from the view of don Juan, Carlos and the rest of captivated Yaqui audience who had gathered at the

base of the waterfall to witness his phenomenal feat. After Carlos had shared his tale of don Genaro and the waterfall, Meyeroff felt instant validation for her own research. It was a much needed confirmation of the observations and interpretations that she had observed when Ramon traversed the magical waterfall in Guadalajara; and very much in synch with Castaneda's own interpretation of don Genaro's 'Dance of the Waterfall': as a rite of—and initiation into—the secret world of shamanism.

In the spring of 1970 Castaneda was invited to speak at a lecture series on the ritual use of hallucinogens at the behest of Dr. Peter Furst, who had put the event together. Each shared their own recollections of shamans manifesting agility or magic on Mexican waterfalls. Furst who had witnessed Ramon Medina's demonstration along with Barbara Meyeroff in Guadalajara, shared his account, followed later by Castaneda's own description of don Genaro's acrobatic levitations. Furst found Castaneda's rendition "strikingly similar" to his own, but didn't press the issue. By this time Castaneda had become the golden boy of New Age Shamanism, so many of his claims went unchallenged. In later years, Meyeroff suspected that Castaneda had made up this version of don Genaro and the waterfall, as related—in a mid seventies interview—to Richard DeMille:

> DeMille: Even though his part of it was made up on the spot, the feeling of mutual understanding and significance remains.
>
> Meyeroff: Yes.
>
> DeMille: He must have a remarkable ability to resonate to things people tell him.
>
> Meyeroff: Oh, he does.
>
> DeMille: The stories he makes up exactly fit the person he is talking to.
>
> Meyeroff: They're mirrors. it's happened over and over. So many people describe their conversations with Carlos, saying, "I know just what he's talking about." But each one tells you something different, something that is part of his or her own world, which Carlos has reflected. "it's all really sexual," they say, or "it's all psychological," or "mystical" or "shamanic" or whatever they're into. His allegories, the stories he tells, seem to validate everybody.
>
> DeMille: In *Castaneda's Journey*, I called Carlos a Rorschach Man, a man on whom people project their inner worlds.
>
> Meyeroff: That's right, and the first day we met he did that with me. I was telling him about the sprinklers on the VA-hospital lawn near UCLA. They're the old-fashioned kind that send sprays whipping around, sparkling in the sun. I told him about driving down the freeway and being dazzled by the beauty of the sunlight on the whirling water, and almost feeling I was being drawn into it, and then he described it to me from above the way he had seen it as a crow, when he was flying over it.
>
> DeMille: Right after you had said it.
>
> Meyeroff: Yes. (Laughing)...

Though DeMille wasn't fooled by the Castaneda Canon, he was perhaps taken in a bit by Meyeroff and associates, whose own fraudulent exploits nearly rivaled those of the master trickster himself, though lacking Castaneda's deft and sleight of hand. Among the assorted acts of ethnographical and shamanic fraudulence that later came to light under academic scrutiny (remember mushrooms grow best in the dark when fed bullshit) consisted of the following:

1. A photograph claiming to depict an Indian sorcerer "flying". The sorcerer in question later turned out to Ramon Medina in a staged photo.

2. Furst and crowd represented Ramon Medina as a sacred Huichol "singer" though such was not the case. Whereas don Juan was a literary celebrity, they attempted to market Medina—in the flesh—much the same way .

3. Meyeroff recounted many tales of Medina's sexual feats and prowess with members of the opposite sex. In reality, a true Huichol shaman-healer must live a totally monogamous life.

The above are only a few of the misrepresentations and outright lies unleashed on the academic community by Meyeroff and Associates, according to Fikes. Fikes book proved so provocative and scandalous, that at one point Dr. Furst threatened to file a lawsuit for slander.

Part III: "Now," said don Adam, "I will tell you of the Two Winds, and how Carlos tried to get blown!"

During Castaneda's short stint at UC Irvine in the early seventies, he came into contact with Ramona DuVent—a Plains Indian and apprentice shaman—and her friend and fellow grad student, Marjory Dill. DuVent and Dill were going through an occult phase, and were both fascinated by Castaneda and his purported knowledge of magic and shamanic lore. At this time Dill was receiving special instructions from Castaneda, who had selected her to be one of his "winds." As the legend goes, a sorcerer has four wind-women, who must come to him of their own accord. In *Tales Of Power*, Carlos had found one of his "winds," but don Juan felt that alone, she was not strong enough to help Castaneda "tackle his ally." Eventually, Carlos acquired his second "wind," so to speak. Biographer Richard DeMille considered this just one in a long line of Castaneda's literary inventions, until he received a letter one day from one of these so-called "winds," namely Ramona DuVent, and this is the story she told.

One day Dill introduced DuVent to Castaneda, and the three went out for lunch. DuVent immediately impressed Carlos as a prime candidate for his sorcerial intent. He invited her to a followup luncheon date later that week to further discuss the matter; but true to the ways of the trickster, Carlos broke their engagement at the last moment, for reasons unknown. Dill informed a confused DuVent that Carlos had more important matters to tend to, than meeting a sub-apprentice for lunch. Actually, it was probably just a technique used to confuse and gain the upper hand on DuVent, in an attempt to keep her off balance, much in the same as he was dealing with 'wind' number one, Ms. Dill. Such was the way of Carlos' pseudo zen-like Yaqui teachings; keep forever tossing his apprentices curve balls, and questions without answers without questions. Before long, Dill informed DuVent that she had been ceremoniously chosen to be Carlos' second 'wind'. DuVent was thrilled with the prospect, realizing that such a step into the realms of sorcery could help advance her greatly upon her perspective path toward shamanism and esoteric knowledge. Besides, graduate school had been rather dull up to that point, and something as mysterious and intriguing as an apprenticeship with Mr. Carlos Castaneda was an opportunity a budding shamaness just couldn't pass up.

In any case, she'd find out if Carlos was a legitimate sorcerer, or merely blowing mushroom smoke from his posterior. In the meantime, Dill had been preparing for her initiation. Carlos' had given her a strict regimen to follow, which consisted of living in a twig hut he had built over her, and situated in a 'place of power' in the Malibu hills. Dill was further instructed that she must cut herself off from all her friends; that they were a drain of her witchly energy, of which she would need in abundance to pass her apprenticeship under Carlos. He also told Dill to get rid of her dog, on which she spent to much attention, and to refrain from sex unless it was with a sorcerer, or a sorcerer's apprentice. Casual sex, he warned her, disperses a sorcerer's power. When DuVent heard these curious demands, she immediately grew suspicious, unfamiliar with them as any rite she'd ever heard of among the Native American tradition. The deal with the dog especially concerned DuVent. She had three of her own, and was damned if she was going to give them up unless she saw a directive from Carlos' fieldnotes that spoke directly to the subject of dog abatement. Carlos brushed off her request by saying that he was living out of his van, and that his fieldnotes were in L.A. When Dill inquired as to when her own initiation would take place, Carlos said he would get back to her. First he had to travel to Mexico to consult further with don Juan.

Upon his return, Carlos summoned DuVent and Dill together to inform them what'd transpired during his trip. While in Mexico with don Juan, Carlos and he had consulted with the sacred mushroom as to the acceptably of Dill and DuVent for his "winds." With the aid of the Little Smoke, don Juan saw that Carlos had chosen wisely, wind-wise. It didn't hurt either, that they both were stone foxes—to use the vernacular of the time. This being the case, Carlos awaited further instructions from don Juan as to the nature of the initiations. After some time had passed, Carlos' two perspective winds approached him, as they had both grown impatient waiting. Carlos seemed agitated when the matter of initiation was brought up, and explained that he had just conferred with don Juan, who had instructed him as to the exact nature of the ritual that Carlos must perform with his 'winds'. He explained that these rites of passage consisted of ritual intercourse. DuVent and Dill-free-swingin' liberated 'seventies chicks that they were—didn't bat a figurative eyelash at this suggestion, proffering a 'let's get it on, then!' attitude to Carlos, who—just the opposite— seemed terrified at the prospect of performing ritual sex Magick with his two would-be apprentices. When Dill asked if it was group sex in which they were to be engaged, Carlos responded in the negative, explaining that their "initiations" would come in the order of their acquaintance, with Dill being the first to let her wild wind blow; then next in line to spread her wings, DuVent. When at last the day of reckoning came, Carlos called Marjory Dill to let her know he was on his way over. With this, Dill hid her dog in the back room, then mentally prepared herself for the coming of Carlos.

When Castaneda arrived he seemed wary of the situation. Dill tried to put him at ease, though he insisted that something felt terribly wrong. That's when the dog barked, and Carlos glared at Dill reproachfully, informing her that she could never be initiated into the lofty world of sorcery if she was not even able to follow

Carlos seemed agitated when the matter of initiation was brought up, and explained that he had just conferred with don Juan, who had instructed him as to the exact nature of the ritual that Carlos must perform with his "winds." He explained that these rites of passage consisted of ritual intercourse.

the simplest instructions. As fate would have it, neither of Carlos' two perspective "winds" were ever initiated into the sorcerer's world. In the end, they felt Carlos' had been simply blowing them gusts of particularly hot air throughout the whole ridiculous affair.

Nowadays, Carlos surrounds himself with attractive young ladies; members and participants of his STARFIRE/Tensegrity Workshops. For this he has received a certain amount of flack from some sectors, but I guess that comes with the territory. Just like an old rock star who can still hit the high notes or play a mean riff, Carlos is apparently drawing large crowds these days to his classes; the young and old alike—not to mention a certain amount of groupie types— all hoping that some of his luminous charisma might rub off on them. Though Merilyn Tunneshendes makes these workshops sound like some sort of mass vampiric ritual (with Vlad Carlos' sucking the psychic energy from the auras of his unwitting victim/participants) in actuality, Tensegrity—from what I under-stand—is a discipline similar to t'ai chi or yoga, but with more of an emphasis on developing shamanic powers in a transformative-like process. Carlos described Tensegrity in a 1995 interview as a series of "...magical passes to keep the body at an optimum...The movements force the awareness of man to focus on the idea that we are spheres of luminosity, a conglomerate of energy fields held together by special glue." Unfortunately the interviewer failed to elicit any further explanation as to the meaning of the proceeding statement, so you're guess is as good as mine. Whatever the case may be, these workshops are bringing in mucho babes and bucks, and if in the process they're helping a few people find their 'path of heart', then more power to Carlos, and his teachings.

When one strips aside the specific semantics of Yaqui sorcery, what don Juan's teachings boil down to (in his bubbling brujo's cauldron) are a handful of applied techniques similar in nature to elements of various religious disciplines, such as TM, Hatha Yoga, Zen Buddhism and other current popular transforma-tive practices, including Lucid Dreaming and don Juan's own peculiar brand of confrontational psychotherapy. Added to these more traditional religious and transformative techniques, various psi phenomena occur with frequent regu-larity throughout. Telepathy, astral projection, alternate dimensions, shapeshifting, psychokinesis and levitation are just a handful of the paranormal doings witnessed by Carlos while in the company of his Yaqui and Mazatec mentors, dons Juan and Genaro.

A recurrent theme don Juan constantly harped on, was that Carlos—in order to become a true "man of knowledge"—had to stop the internal dialogue of his mind. Only then could he view the world as it truly exists. When don Juan spoke of such matters—based partially on TM-like methods—his way of explaining them, and his selection of descriptive words bring to mind those of the Indian philosopher, and renegade Theosophist, J. Krishnamurti. Whether Castaneda lifted certain ideas and phrases directly from Krishnamurti, we can only venture to speculate, although one can be all but certain that Castaneda was quite familiar with Krishnamurti's writings, and very well may have attended some of his lectures during the late sixties and early seventies. Stopping

this internal dialogue was vital to the success of don Juan's teachings, as was the necessity of "stopping the world" (as don Juan articulated it) which is the key to seeing. Once one had 'stopped the world', another reality emerged, one that could be expressed as non-ordinary, though no less real than ordinary reality. In order to instruct his apprentice to "stop the world" and see, don Juan enlisted the aid of various psychotropic plants, such as psilocybin, peyote and jimson weed. As don Juan explained, drugs were not always an essential component to facilitate seeing; but in Carlos' case they were used as almost a last resort-like a reality blasting sledgehammer—to bash a hole through the protective psychological armoring in which he had subconsciously insulated himself. In the case of other apprentices, hallucinogens were not generally needed, but Castaneda had been so conditioned to view the world in a conventional manner, he needed something to shake him up and rock his world; something to deconstruct the wall of consensus reality erected around him.

After *Journey To Ixtlan*, Carlos had reached a point where the psychotropic drugs were no longer a necessity. Carlos' graduation from these sacraments just conveniently coincided with the New Age/Mysticism deluge of the seventies, which had replaced—to a large degree—the 'sixties psychedelic drug experimentation, as starry-eyed initiates sought out new and less dangerous ways to expand their craniums. To meet the needs of a changing mass metaphysical market, Carlos books now delved into areas of growing popularity with New Age consumers, such as astral projection and Lucid Dreaming. Whether Carlos teachings were an amalgam of concepts gleaned from others sources—with his own personal brujo brush strokes applied to the canvas for added color—he'd nonetheless discovered a wide audience ready and willing to employ these techniques, in one manner or another. During the period I had read *Tales of Power*—which deals in part with the phenomenon of astral projection—I experienced out of body experiences not unlike those described by Carlos in his book, though I don't remember which came first: *El pollo*, or the luminous *huevos*? Were my own OBE's simply subconscious suggestions I'd planted in my mind after reading *Tales of Power*? Or conversely, were they a validation of the phenomena as described by don Carlos?

I've known a wide range of people who've used the teachings of don Juan in their own lives, though normally under no formal system or set of rules. Usually it was an interpretation of Castaneda's writings translated into whatever form best suited the user/experimenter. Many were the heads I knew who did such stuff as smoke mushrooms mixed with pot then look sideways at moonshadows in their somewhat misguided attempts at 'stopping the world'. Of course, what works for one urban apprentice might be a total waste of time to another. But that's the magic of Castaneda; he is—as DeMille called him—the true Rorschach Man; his words speak on many levels, and when put into effect offer a wide spectrum of results.

Lucid dream researcher Paul Rydeen told me of his own experiments using Castaneda's methods, with often inconclusive results. One of the Lucid Dreaming/"Dreaming Awake" techniques that Castaneda advocates, is the act of looking at one's hands to preserve lucidity. When Paul attempted this

When one strips aside the specific semantics of Yaqui sorcery, what don Juan's teachings boil down to (in his bubbling brujo's cauldron) are a handful of applied techniques similar in nature to elements of various religious disciplines, such as TM, Hatha Yoga, Zen Buddhism and other current popular transformative practices, including Lucid Dreaming and don Juan's own peculiar brand of confrontational psychotherapy.

method, he usually discovered ten to twenty fingers on each hand, and immediately woke up. Another of Castaneda's methods for preserving the "dreaming awake" state, consists of extending one's arms and spinning like an ice skater when the lucid dream begins to fade. Once again this technique produced ineffectual results in Rydeen's case, often spinning him right out of the dream and into a dark space, or into another non-lucid dream.

Whatever the truth may be, Castaneda's impact upon the last few generations can not be underestimated. Many people have been forever transformed in one way or another by his many books. A close friend—who's normal gait in life is one of good humor and constant rib-poking—became absolutely dead pan serious and reverential when I brought up Castaneda books, of which he had read several years earlier, but who's influence he still felt resonating deeply through his life. In relating a dream, my friend recalled traveling to the huge green dome where don Juan and don Genaro journeyed, after biding farewell to Carlos' world. They he stayed for a brief period, a visitor—in this vivid dream—to the afterlife of Sorcerers. Upon leaving the huge green dome, he traveled through a colorless wasteland of the dead and bleak, making his way through a purgatory like setting, at last to return to the realm of the living. To this day, the memory of this dream invokes in my friend a feeling that there is more to life, than what is simply at hand: Namely that death is his ally, and He will be waiting when this world ends, to show my friend what waits beyond.

The picture of Castaneda at UCLA in the mid-sixties is that of a frightened and insecure young man, who—as mentioned before—was searching for his way in the world, struggling with the obvious pressures of trying to earn an advanced degree. Thus his writings of don Juan, at this time, might have helped him to achieve a two-pronged purpose: 1) as a means of elevating himself eventually into the realm of advanced academics and earning his doctoral degree, and 2) as an effective means of getting in touch with his higher(truer) self, don Juan; i.e.: the eternal wisdom in us all. Was this daily act of entering into his separate reality/library cubicle and shutting himself off from the world, a means Castaneda employed for coping with the academic stress? And who better to help him through these trying times, than the imaginary child-like playmate and father/figure of don Juan Matus? Was this Carlos' way of growing up and

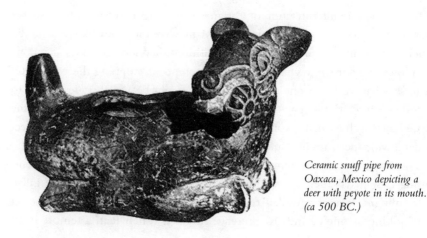

Ceramic snuff pipe from Oaxaca, Mexico depicting a deer with peyote in its mouth. (ca 500 BC.)

coming to terms with himself? I detest Freudian analysis as much as the next neurotic, but I think in this instance my evaluation might hold some water.

It recently came out—this according to *Time* magazine—that Carlos first began writing about don Juan as far back as 1956, eleven years before his first book was published, and four years before allegedly meeting his Yaqui mentor. This first unpublished manuscript was called "The Whole World Sounds Strange, Don't You Think...?" and was co-authored by someone named Alberta Greenfield. So if in reality Carlos ever did in fact meet don Juan, then it was several years earlier than first reported. I'm sure Carlos would argue that by dating his first encounter with don Juan in 1960, he was just protecting his teacher's identity by further obscuring the actual dates.

Don Juan—though he often shook his Yaqui head and laughed like a child at his apprentices' incessant note-taking on more than one occasion—told Carlos' that this ritual of writing he so studiously performed was part of his "path"; a means that would aid him in becoming a "man of knowledge." Does Carlos, in this instance, once again speak metaphorically through the wise old mouth of his Yaqui sage? I think first and foremost Castaneda's mission in life was to become a successful writer; a storyteller and creator of myths. And this is just what don Juan says to him, in so many words, upon occasion: "This deliberate act of notetaking (writing) will help you grow, Carlitos; like The Little Smoke, it will teach you many things." At the end of *Tales of Power*, Don Juan and Carlos meet on a barren Mexican plateau. Carlos at last has been fully initiated into the mysteries of sorcery, and it is here that he bids a final farewell to don Juan, and leaps into the Abyss, metaphorical though it may be. From *Tales of Power* onward, Carlos has now become a Sorcerer, though clearly still with many miles yet to travel on his own personal journey to Ixtlan; the sorcerers land of no return. Running parallel to Carlos' fictional, or allegorical, life—in the transition between *Journey to Ixtlan* and *Tales of Power*—he earned his Doctoral Degree. In the concrete terms of academia-and ordinary reality, Carlos had at last become a full-fledged "man of knowledge." Now he held true power with this credential in hand; his figurative magical staff.

From this point forward Carlos was a certified Sorcerer (read: New Age Guru) weaving larger and more mind boggling tales with each new book-of-the-month-club selection. In one of his later literary offerings, Carlos at last openly declared his Sorcerer's status, which was perhaps the first such instance in the history of modern literature: A self-made multimillionaire New Age Guru, living out his own allegorical myth in public, and in paperback; a precursor to Shirley Maclaine's own brand of New Age nonsense. Of course, this is just one way of viewing reality, as I'm sure don Juan would be apt to point out. And even though this is still the direction I'm leaning—vis-a-vis don Juan as Myth—I still consider myself a bit of a fence straddler in regards to the Castaneda Controversies: On the one hand, wanting to believe the myth; though on the other, skeptical of being had by someone, who over the years has shown himself to be, as Jim DeKorne describes him, "a consummate trickster with subtle truths to tell." Or perhaps he is the consummate con-man, who is so good, in fact, that he has conned himself into believing his own legend,

transforming his life into an allegory.

Don Juan—like other pop cultural icons—refuses to die, in the imagination of Castaneda and his readers. At one point in the saga it appears that don Juan and don Genaro have slipped through the crack between worlds, journeying to the Yaqui Sorcerer afterlife; an afterlife that just happens to exist inside a huge green dome—or something to that effect. But this is the age of the sequel, and like Spock or Superman, don Juan is resurrected in later books (in one guise or another) enabling Carlos to further expound upon the myth—and don Juan to continue with his teachings. Like Freddie Krueger, don Juan's memory is tenacious and refuses to die, so Carlos breaths life into him again and again—or hot Sonoran desert air, as the case may be. The problem many readers have with the later books (present company included) is that they pushed the limits of credulity far beyond what most of us could take seriously. As DeKorne suggests, Carlos is "analogous to the homicidal maniac who scrawls graffiti messages: 'Please stop me before I kill again'" on washroom walls; Castaneda's ensuing literary output seemed to be begging us to please stop taking him so seriously.

In the Spirit of Ambrose Bierce
A Devil's Dictionary of UFOs

Dean Genesee

Abasement, n. A decent and customary mental attitude in the presence of wealth or power. Peculiarly appropriate in an employee when addressing an employer." So begins 19th century writer and journalist Ambrose Bierce's *Devil's Dictionary*. For the next 100 pages, Bierce skewers convention and public sensibility with one of the most cynical collection of syllogisms ever to see the printed page. Weird phenomena maven Charles Fort would probably have been (and perhaps was) a great fan of Bierce, given his penchant for rib-jabbing in the side of establishment science in the early part of this century.

A is for ADAMSKI, George

Prominent flying saucer contactee of the 1950s. George did it first and did it best. We will never know for certain what he and his buddy George Hunt Williamson encountered in the California desert in November, 1952, be it extraterrestrial or straight out of their heads, but it makes a great mythology. It is rumored that in a wine-stoned moment, Adamski once declared that he was sorry that prohibition was repealed, since it paid much better than "this saucer crap."

B is for BOAS, Antonio Villas

First earthman (in 1957) to specifically claim he bedded a saucer maiden, and didn't feel the need to start a religion. "She was beautiful, though of a different type of beauty compared with that of the women I have known. Her hair was blond, nearly white...and she had big blue eyes. Her body was much more beautiful than any I have ever seen before. It was slim, and her breasts stood up high and well-separated." While there is no real evidence for or against this occurrence, the episode has provided fantasy material for male (i.e. the vast majority of) UFO fans ever since.

C is for CAUS (Citizens Against UFO Secrecy)

Formed in 1978, the CAUSers stated objective is to end the secrecy surrounding the UFO subject within the U.S. government. While many of us may admire Todd Zechel and his group for their continuing efforts in federal court to release even more blacked-out documents that point to SOMETHING, the marches and sign waving out in front of government buildings looks very silly to most of the public. Who is this supposed to impress? What is being accomplished?

D is for DISINFORMATION

A funny game played by many government representatives and UFO researchers. A good example of this is the false lead planted to give the originator an idea of information flow based on who eventually leaks the selected tidbit out. Kind of like putting dye in a pipe and waiting to see which drain spews the same color. The difference between the government employees and the saucer crowd is that the UFOlogists are blissfully unaware of it most of the time. Hint: Don't tell what you know for MANY YEARS, if you can really do that.

E is for EXTRATERRESTRIAL HYPOTHESIS

States that UFOs and their reported occupants come from far away star systems. A strange belief construction that seems to affect many MUFON members and others over the age of 40 or so. Symptoms include denial of the psychological/spiritual/transcendental nature of the UFO phenomenon and attacks on those who espouse any of these dimensions. Kook reductionism in "respectable" Aristotelian clothing.

F is for FREEDOM OF INFORMATION ACT

The Holy Grail of the UFO community seems to rest with the repetition of this mantra (or tantra—for those obsessed with proper usage of eastern terms) Skillful application of this exercise nets researchers the coveted "blacked-out page"—useful for parading in front of cameras for years on end. Apparently this proves something with evidence of nothing.

G is for GEORGE

Seemingly favorite name for the space brothers in the 1950s. Examples: George Adamski, George Hunt Williamson, George Van Tassel, George King, to name but a few. The UFO field seems to be contaminated by "Bills" now. Think about it.

H is for HOAX

Next time you and your friends are out in the middle of nowhere, try to smuggle along a small helium tank, a couple of those "light sticks" and a fairly large (black rubber) balloon. On some pretext, leave the group after dark and fill the balloon, attach the activated lightsticks a few feet below the balloon, and tie to fairly heavy

gauge fishing line. Let 'er rip and tie the line down to a stationary object. Get back as soon as possible and feign amazement. Don't point it out if no one else has noticed! This works rather well with a decent breeze going.

I is for IDIOT

One who doesn't share your views of the UFO phenomenon.

J is for JEALOUSY

What you feel when one who either does or doesn't share your theories gets on TV first.

K is for KEECH, MRS.

Woman who was the subject of the excellent book *When Prophecy Fails*— recounting the actions and group dynamics of a contactee sect that grew around her revelations through automatic writing. After predicting a flood which did not happen as scheduled, the group only redoubled the strength of its belief since they could take credit for having averted the disaster. When the saucers did not come as predicted to pick them up the group for the most part disbanded, but one member summed up the feelings of many: "I've cut every tie. I've burned every bridge. I've turned my back on the world. I can't afford to doubt. I have to believe."

L is for LITTLE GREEN MEN

Convenient term used by the media and people who just don't understand that they're GREY fer crissake.

M is for MISSING TIME

Another example of evidence of nothing passing as evidence for something when applied by the proper authorities. A convenient catch-all that ignores the history of anomalous experience and shows little respect for the subconscious.

N is for NATIONAL SECURITY

Yet *another* example of evidence of nothing passing as evidence for something when applied by the ufologist (government document-collecting type.) "The request came back negative for my FOIA request, and they said it was for reasons of national security. This has got to mean that anything to do with UFOs is so big that they can't tell anyone!" Stop patting yourself on the back and look under "D is for DISINFORMATION." Or look at your request, and see if you mentioned anything else besides UFOs—names? places? dates? that could be interpreted in any number of ways, or have involved any number of people whose jobs and lives may depend on the "security" of the information. On the other hand, perhaps you're just being "carrot and stick"ed to draw attention away from the REAL information. Maybe.

O is for ODDBALL

How much of the public looks on UFO fans, enthusiasts, and -ologists.

P is for PALMER, Ray

Shameless huckster of science fiction and fantasy magazines from the 1930s to 1950s. Promoted the Shaver mystery which rocketed sales to stratospheric heights by promoting tales of the evil Dero (DEtrimental RObots) living in the hollow Earth. Strangely enough, Palmer's early science fiction stories of aliens and their mysterious flying machines were in a way confirmed and enlarged on after Kenneth Arnold's famous 1947 sighting touched it all off. This fortuitous event finally catapulted Palmer to into superstardom on the flying saucer scene. He started *Fate* magazine the next year, and it has since featured something on UFOs in every issue since (even most recently, where the biggest word on the cover was "SEX".)

Q is for Major QUINTANILLA, Hector

Headed Project Blue Book starting in July, 1963. In March, 1966, Blue Book was called out to Ann Arbor, Michigan to investigate a series of reports concerning the ubiquitous flying whatsits. In the face of overwhelming testimony to the contrary, Quintanilla forced Air Force consultant Dr. Josef Allen Hynek to explain to the assembled press that the sightings of huge, rapid, darting nocturnal lights might have been due to luminous swamp gas—in an area devoid of swamps. Even the skeptical reporters had to laugh, and poor Hynek became "Professor Swamp Gas" for a few embarrassing months.

R is for RORSCHACH BLOT

Classic psychoanalytic test, wherein the participant is asked to assign meaning to amorphous blots of ink, thereby giving the therapist insight into his personality and any neuroses that may be present. Curiously enough, the UFO phenomenon/field is *just like this*! R is also for ROSWELL, which has become *the* Rorschach blot of the last 10 years.

S is for SCHIRMER, Herbert

On December 3, 1967, patrolman Schirmer was on his rounds when he observed what he first thought to be a disabled truck in the road ahead. When he turned his brights on the object, he was stunned to see a classic saucer glinting in his headlamps. As he approached, it took off quickly—or so he thought. Gathering his wits, he returned to his HQ and entered in the logbook: "Saw a flying saucer at the junction of Highway 6 and 63. Believe it or not!"

After a series of nightmarish headaches and a buzzing noise in his head, accompanied by a rectangular red bruise on the back of his neck, Schirmer underwent hypnosis to discover any connection to his encounter. As you would expect, even at this early date in the abduction lore, Schirmer recalled going inside the object with a few short, wiry, human-appearing figures. After showing him around the place (unfortunately without any introductions to red-haired, horny breeding

vixens) they took him back to his car, leaving him with the best mantra ever related by any contactee: *"We want you to believe in us, but not too much."*

T is for TRUTH

...with a capital "T." There seem to be more of these floating around every year. To rip off Robert Anton Wilson, "Truth is what you can get away with."

U is for UMMO

A series of documents mailed to Spanish and French researchers over many years in the 1960s and 1970s. Purported to originate with beings from the planet UMMO who revealed sophisticated philosophical meanings to us lowly earthlings. Unfortunately, many of these ideas had already been thought up by humans, and indeed in the late 1980s one of the participants admitted on his deathbed to his involvement in the fraud. Of course he could have been a government plant, coerced into this confession for the purpose of...uh oh.

V is for VENUS

Brightest object in the night sky after the moon. In the early days of debunking it was used as an explanation and excuse (sometimes correctly) to the overeager saucer searcher. (I have actually witnessed this phenomenon, so don't give me all that.)

W is for WRIGHT-PATTERSON AIR FORCE BASE

Near Dayton, Ohio. Site of recent Bosnia peace talks. Wonder why they went so well? There are no pickled aliens or busted-up spaceman contraptions stored here, at least that's what they told Senator Barry Goldwater when **he** asked.

X is for

...the unknown, and perhaps describes all this stuff better than the tired term "UFO."

Y is for YARN

Meetings among the saucer-smitten feature lots of these. Not much delving into the origins of or reasons for same, though. That would spoil the fun, and that's what scientists are for.

Z is for ZETA RETICULI

Star group that first gained prominence when early abductee Betty Hill remembered a "star map" shown to her by her visitors, which was subsequently reviewed by many researchers, including schoolteacher Marjorie Fish. Fish concluded that the groups of dots and lines connecting them represented the star system of Zeta 1 and 2 Reticuli, viewed from a different angle than is available to Earth-bound viewers. Unfortunately, Fish first assumed that the star system this supposedly represented should be within 55 light years of Earth.

Why this should be any criteria is anyone's guess. This could be done to count-less other configurations of stars with similar results, but the Zeta-Reticuli legend took hold, and we are now asked to believe in an invasion of reptoids and greys and who knows what else from this portion of the firmament.

Z is also for Zilch,

which seems to be what your left with when trying to nail all these phenomena down to ONE THING. Whatever happened to synergistics? YOU and your effects aren't the result of one thing or event, so why should UFOs be?

Bugs Bunny, Space Brother

Book Review:
George Hunt Williamson's
Other Visions, Other Lives

Reviewed by Dean James

Posterity has yet to acknowledge the achievements of pioneer contactee George Hunt Williamson, who died in 1986 at the relatively early age of 60. Always a mercurial figure, he shunned the limelight and in John Keel's words, "spent a lot of time probing around the ancient ruins of South America." His books were utterly unique, reflecting a sensibility steeped in Theosophy and the occult. Unfortunately, their sheer dottiness denied them a wide audience, and although UFOlogy owes Williamson himself a sizeable dowry, his work is in danger of being forgotten.

At first glance, Abelard Productions' *Other Visions, Other Lives* with its glossy cover illustration and intriguing title, may seem to offer hardcore Williamson collectors the promise of something new; a hitherto unpublished treasure trove of vintage saucer lore. Sadly, this impression isn't borne out by the contents, which prove on closer inspection to comprise the text of Williamson's first book, *The Saucers Speak,* padded out with some 30 pages of new material by Timothy Green Beckley. *The Saucers Speak* was written in collaboration with failed chiropractor Alfred C. Bailey, who was at the time working as a railway conductor. First published in 1954, it purported to be "a documentary record of interstellar communication by radiotelegraphy."

The new Abelard edition is full of details which, in the light of current scientific knowledge, are demonstrably false, and must have caused considerable bemusement even in the 1950s. "The Sun is not a hot, flaming body," readers are assured at one point; "it is a COLD body...You think the Sun gives off great heat because you can 'feel' it. [But] certain forces come from the Sun, and when they enter the earth's magnetic field, this resonating field causes friction. And from friction you get heat." And again: "Pluto is not the cold, dreary world astronomers picture it to be, [and] Mercury is not a hot, dry world...All planets have almost the same temperature, regardless of distance from the Sun." Some of the saucer-men's pronouncements are garbled and incoherent; others frankly beggar belief.

Wiliamson with Incan mummy—Peru, July 1957.

Other Voices, Abelard Productions, Inc. Wilmington, DE (No price given)

Events reach a kind of burlesque nadir when Zo of Neptune solemnly informs Williamson and his colleagues that a Bugs Bunny cartoon titled "Hasty Hare" contains information vital to their research. "We mentioned Bugs Bunny to you several times before, but you thought it foolish and didn't enter it in your records," he chides, adding that while his instructions may occasionally seem ridiculous, "[that] is the way we do things at times." (On the other hand, Zo also dismisses American soap operas as "Pooh," so his critical faculties appear basically sound.) It should be obvious even from this brief summary that *Other Voices* is no ordinary channelled book. The narrative is chiefly remarkable for its occult subtext, which hints at the true origin and meaning of flying saucers. Like Tennyson's Lady of Shallot, Williamson himself saw life always through a magic mirror. Everything he wrote had a firm basis in personal experience. His books were trademarked by a kind of mystic strangeness, and *Other Voices* is a prime example. Thronged with echoes of the cryptic Enochian language, and cipher references to Earth's second, 'dark' moon, it deserves a place on any serious UFOlogist's bookshelf.

"yeah…I seen 'em, too"

Video Review:
Klark Kent: "UFO Expert" on Andy and Pat's Groovy Cosmic Love Hour

Edward James

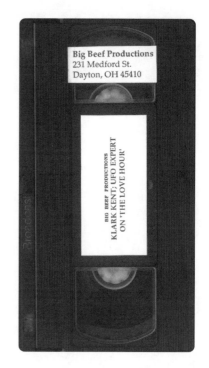

S ent with no comment or accompanying literature, the tape itself is a 3M broadcast quality tape, with the program title photocopied onto a strip of paper which partially covers up a "Fuji" home video cassette label underneath. In the company of two friends, and having procured a generous supply of opium poppy heads and homegrown sinsemilla, we readied our psyches for the Klark Kent Experience. A thoughtful girlfriend supplied the poppy seed pods from her job at a flower shop. After pulverizing the mess in a coffee grinder and boiling it, we strained it through a clean-smelling "Metallica" tee shirt and drank. It is the most disgusting taste imaginable. I survived by holding my breath while drinking. The taste still makes my stomach well up just writing about it.

After firing up the bong, the tape was popped into the VCR. The logo comes up on screen in the most garish, blurry fashion that a struggling cable company can afford. Apparently, the program recurs on some sort of schedule on local cable in Ohio. Public access is the savior of the bandwidth for folks like us. The low-level dose opium was starting to make me dreamy, but I snapped to attention when the guest of honor (the only guest) was introduced. Mr. Kent (who claims this is his real name) presented the requisite slide show and rambling, confused UFO history lesson. He's obviously read a lot of UFO books, and in fact uses this as one of his criteria for the claim of UFO "expert." I actually saw him at the MUFON convention in Las Vegas in 1989, walking around in a dark suit and crisp white shirt, holding a small box with blinking colored lights on it. He didn't talk to anyone that I saw.

At one point in the program, he compares the plight of the Ufologist to any number of pioneering heroes like Thomas Edison and a pair he refers to as the "Apple Brothers." As we did double takes on this thought, I suddenly realized that Mr. Kent was referring to Steve Jobs and Steve Wozniak, founders of

VHS tape About 2 hrs. Big Beef Productions . 231 Medford St. Dayton, OH 45410
The copy I have in my hands is labeled "Love Hour," but the actual title of the show is "Andy And Pat's Groovy Cosmic Love Hour"

Apple computer. We laughed so hard I think that we passed out.

Returning to consciousness rewarded us with the "call in" segment of the program. After a few minutes of rambling question and commentary, ("yeah, I seen 'em too") a woman calls, asking to see Kent's ID. He refuses, then hems and haws his way through an explanation of his "qualifications," which seem to rest on the premise that any facts he gleans from reading are to be taken for granted as facts, and that the respectability that has so long been denied UFOs can be redeemed in the forum of "American Business." What we gathered between guffaws was that Kent believes (he HAS to) is basically that money talks, and if he's able to dupe a few people into buying products from his "Super Science" catalog, the bullshit of academia and peer review can and will walk. Another caller asks right off the bat what Kent's credentials are, commenting that he explains no more than "a lot of crap." While he tries patiently to explain that his extensive interest and study is enough (which it IS unfortunately) the elderly-sounding woman cuts in and yells "You're an expert on CRAP!" and slams the phone down. This was really too much and we finally shut the machine down to go in the bathroom to puke. This was because the opium was really starting to kick in, but mostly because our sides hurt from laughing so much.

The next day I spent either throwing up or feeling like it, but the *Groovy Cosmic Love Hour* has since provided many more gut-splitting guffaws. Write to Big Beef and request this tape NOW before the government bans this sort of quality entertainment, or the company disappears. The price is no more than $15-20.00, I believe, but don't quote me on it.

No. 7

TESLA'S EARTHQUAKE MACHINE • UFOS AND BLACKOUTS
JOHN SHIRLEY'S MEDIA / INTERNET VIVISECTION

NUMBER 7 $4.50

T H E
EXCLUDED
M I D D L E
WEIRDNESS DISSECTED AND DECODED

THE ETHICS OF
EXTRATERRESTRIAL
BELIEF

By Martin Kottmeyer

ALSO:
THE ACADEMIC OPPORTUNISM OF CARLOS CASTANEDA
TOURETTE'S SYNDROME OF THE GODS
THE UMMO CONTACTS: FACT AND FICTION
NEW PSYCHEDELIC PLANT DISCOVERED
COMET HALE-BOPP CRAZE
AUTHENTIC – LOOKING ALIEN PHOTO

Editorial

Seven is perhaps the most symbolic of numbers, and *Excluded Middle* #7 promises to fire up your symbolic imagination with a set of the pithiest articles we've yet published. Paul Rydeen always weighs in heavily on the symbolism scale, and his not-to-be-missed contribution here should cast Diogenes' hermet light within the temple of your subconscious. The day ID4 premiered, light was lost in a major portion of the U.S., and according to FATE magazine, HAARP (questionable atmospheric research project sponsored by your tax dollars) was fired up for the first time. Scott Corrales provides historical overview of light and dark and UFOs, and a separate history of the pernicious UMMO hoax. Our favorite skeptic cyberpunk writer grouses aplenty about that bloody information super-dupe-highway hitting a panoply of nails upon the head, and Martin Kottmeyer twists us all up in Laingian knots concerning extraterrestrial ethics; you'll be surprised by his conclusions.

Symbolic allusions continue in the form of inexplicable poetry I unearthed for *Tales from the Shelf* (not about placid English lakes!) and the pyramidic grid Jeremy Bate proposes in his defense of pure science against the onslaught of irrational debunkers. Oscillations causing earthquakes are investigated by Greg Bishop.

Whither the state of anomalous studies? Consider a slate of spiritist communications in the first decade of this century by several psychics worldwide whose output only made sense by *cross-referencing* the whole*, and I think you'll see where we are. Sure, we all get what we want and are ready for: Debunkers get stories they can easily trash, conspiracy buffs and anti-government types get ammunition for their tirades, dream researchers get symbols, and hardware fans get fancy propulsion theories. The cross-referencer who holds up culture firmly in the middle gets all of the above and far more: All the excluded bits without which none of it makes sense.

— Peter Stenshoel

**Life Without Death? by Nils O. Jacobson, M.D. (tr. Sheila La Farge, Delacorte Press, 1974) pp. 149-151.*

No. 7 *continued*

Another Editorial

The anomalies community appears to be at a pinnacle that hasn't been seen since the late 1950s. Movies about UFOs or other weirdness grossed more than ever last year, and TV shows like *The X-files* and *Paranormal Borderline* are among the most popular. This has thrown the "skeptic" community into a froth of activity. The readers of this magazine (and the editors) however, are comfortable enough with our critical faculties, and do not appear to require any "saving." As last issue's editorial pointed out, many aspects of reportage in our pages may not be cognent with present scientific methods.

How strange, then that a posthumously published book by an aeronautical physicist has more relevance than ever before. *Unconventional Flying Objects* by NASA scientist Paul Hill is the attempt of one classically trained intellect to reconcile his own UFO sightings with 20th (and 21st) century science. Taking flying object reports at face value, Hill undertakes to explain observed movements and characteristics of unidentified flying whatsits in terms of known physics. For example, since observers often lost sight of rockets at launch due to almost instantaneous acceleration, Hill posits that the reported "dematerialization" of UFOs may be due to the same circumstance. He concludes with the painfully humble statement: "The world of UFO students has been literally and openly crying for scientific assistance and explanations. This book is my answer." Completed in 1975, it was not published until 1995 by Hill's daughter.

Other aspects of the anomalous and numinous still remain outside the purveyance of classical science. That doesn't mean that this will always be the case, but as in politics, perhaps the stagnated state of true scientific inquiry may have to wait for the passing of a generation to resume its forward path. I trust you will find this theme running through this issue.

—Gregory Bishop

Thanks due to those individuals who have increased my general knowledge, vigilance, and even paranoia. The first steps through the veil are the most difficult.

News: Spring 1997

HALE-BOPP COMET STIRS UP
ART BELL LISTENERS, REMOTE VIEWERS, SCIENTISTS

Comet Hale-Bopp has turned out to be quite a spectacular sight in the pre-dawn sky as of mid-March, surpassing many expectations, and engendering many of the predictions co-disoverer Alan Hale (not the actor) made last year regarding the "comet madness" that seems to infect societies whenever these spectacular objects make their brief appearances.

The best chance for optimum viewing will occur in early April, when Hale-Bopp is at its closest approach to Earth. At that time, it will be visible in the first few hours after dusk about 25-30 degrees above the west-northwest horizon.

Curiously, last year's appearance of the comet Hyakutake elicited none of the apocalyptic excitement that was building to a fever pitch as of late December, 1996.

No less than three straight weeks of the nationally syndicated Art Bell radio program were devoted to predictions associated with a so-called "companion" object accompanying the comet. This "companion" appeared not only in photos and CCD images taken from observatories around the globe, but also in the prognostications of Dr. Courtney Brown's remote-viewing Far Sight Institute. It was reported to be three times the size of Earth and possibly hollow. Short wave radio signals were also rumored to be eminating from the object.

While a guest on the Bell show, Brown announced photos in his possession which seemed to bear out the "companion" hypothesis. He would not reveal the source for the images, except to say that the mystery man was a university astronomer who would hold a press conference to bear out the images' authenticity. They were later found to have been faked, and in a tense exchange with Bell and Whitley Strieber (who had also received copies,) Brown refused to honor his earlier promise to "out" the scientist if and when he did not reveal his identity and vouch for the pictures.

Hale identified the object as a ninth magnitude star that was in the field of view when the original picture/discovery (by Houston amateur astronomer Chuck Shramek) was announced in late November. Without exception, all professional astronomers interviewed by reseacher/reporter Linda Moulton Howe have expressed the opinion that the alleged anomaly can be explained as a normal celestial object.

Without exception, all professional astronomers interviewed by reseacher/reporter Linda Moulton Howe have expressed the opinion that the alleged anomaly can be explained as a normal celestial object.

Streiber was at first a vocal supporter of the "companion"'s non-natural origins. "I don't think that there is much real doubt that Hale-Bopp has a companion..." He writes at his web site. "I have known this for certain ever since I saw [an] image posted by the Japanese National Observatory." In spite of this, Public Information Officer Juinichi Watanabe has stated that "we have an anomalous object in 1996 Hale-Bopp photo, but it is just the artificial one we often have, where the saturated star caused the electronic trick when the electrons were transfered from the CCD [imaging device]... we can say that it is definitely a star."

The Rorshach principle is alive and well, and it seems the alleged companion will either change the world or become forgotten like so many other failed "end is nigh" auguries.

WHITLEY STRIEBER CALLS ALIEN PHOTO "MOST ACCURATE"

Famed author Whitley Strieber received this photo anonymously and first described it as a composite of images posted on a Usenet internet newsgroup for a short time. Until the originator identifies him (or her) self, Strieber has taken copyright control in the name of his Communion Foundation. At a recent booksigning in Torrance, CA, he emphasized that the image was put up on his web page as a "challenge to the community to figure out how it was done."

He describes it as the most authentic-looking photograph of an apparent alien that I have ever seen" and adds: "...it seems to reveal anatomical structures around the black eye covers that I have observed, but intentionally never reported anywhere. In addition, the high level of reflectivity in the eyes that appears here is among the most startling things about face-to-face contact with these people...In the flesh, this extremely bizarre effect takes a lot of getting used to."

GOLDIGGER TARGET ROBERT BIGELOW BUYS UTAH RANCH FOR RESEARCH

For many years, Las Vegas magnate Robert Bigelow has been a source of financial succor for the UFO and anomalies community. In 1995, MUFON, FUFOR and CUFOS were vying for a large chunk of research funds that Bigelow had offered to the organization that showed the most promise (and presented the best premise) to "solve" the UFO mystery. Ultimately, and not suprisingly, the conflict between Mr. Bigelow's quest for "results" and the mercurical nature of the phenomena remained at odds, and the offer was withdrawn.

With the money saved, Bigelow has purchased a ranch (reportedly for $200,000) in the Utah wilds to serve as a "laboratory" and paranormal clearinghouse of sorts. The ranch belonged to the Terry Sherman family of the Uintah Basin.

Like a story out of *Scooby Doo*, the Shermans were forced to sell their property below the market price due to alleged anomalous events that appear to occur with disturbing regularity on the property, and have a history reaching back to the

1950s. Other families in the area have also reported strange goings-on.

Classic cattle mutilations and "lights emerging from circular doorways" as well as craft with humanoid figures skulking about have been seen by the Shermans and others.

Bigelow's National Institute for Discovery Science was formed in October of 1995 to put financial muscle behind research into the paranormal, and it appears that consultant John Alexander (formerly of the Non-Lethal Weapons lab at Los Alamos) and institute grant awardee Linda Moulton Howe will have their hands full along with a hired team who live at the ranch. When availible, the curious can get the sanitized results from the institute's website: at http://www.accessnv.com/nids/.

Mystery Earthquake Rattles Southern Australia; Seismic Warfare Suspected

The *New York Times* of January 21, 1997 reported a mysterious seismic disturbance in the Australian outback. Truck drivers, camping gold prospectors, and area residents reported bright flashes, rumbling and ground movement on the night of May 28, 1993. The seismic signature, picked up by sensors in the area, did not appear to correspond to any naturally occurring event (such as an earthquake) leading local authorities and later the US Senate to request an inquiry.

The Japanese Aum Shinrikyo "cult" had bought a ranch in the area and stocked it with mining and laboratory equipment. Records show that a representative, Kiyohide Hayakawa, had been looking for a site with uranium ore deposits. The fear was that the group had built or purchased an atomic device and had detonated it. There has been no residual radiation or other evidence found to support this.

Surprisingly, the group had sent representatives to the former Yugoslavia to study the work of Nikola Tesla. They contacted and visited the Tesla museum in Belgrade and appear to have studied research papers relating to seismic oscillators. The *Times* article states "Many geophysicists view seismic warfare as a fantasy that is highly unlikely to ever materialize. Even so, the subject has been quietly studied for decades by governments worldwide, including the Soviet Union and the United States during the cold war." (For more, see "Tesla's Earthquake Machine" in this chapter.)

ETH*ics
Is Belief in Extraterrestrials an Oxymoron?

Martin Kottmeyer

Is the existence of UFOs a question that should be asked? Is it moral to search after aliens who wish their activities to be secret and who do not seek open relations? Is the search for truth an absolutist enterprise which demands no exceptions whatever the ultimate consequences might be?

*** Extraterrestrial Hyposthesis: You know...the theory that ALL UFO phenomena are the results of space visitors.**

Premise:

Earth is being visited by extraterrestrials that have chosen to conceal their presence by a programme of furtive operations and deliberate deception and chosen not to communicate their reasons. Is it ethical for a UFOlogist to attempt to subvert such a program?

We may infer interstellar travellers necessarily possess some form of intelligence and cooperative skills or they would not have developed the extensive body of scientific knowledge and technological know-how necessary to construct space vessels. Their concealment is probably not capricious, but reasoned and guided by principles acceptable to a population of beings bound by mutual interests. What is their logic likely to be? We will consider three possibilities.

1. It is done for our own good. They are sparing us the trauma of knowing superior beings exist, knowing we are powerless before them, knowing we are inferior in so profound a sense that concourse with them would only result in our collective humiliation. Interaction with their culture might prove harmful to us for a variety of reasons. One that any reasoning exo-sociologist of earthling mass behavior might predict is that politicians would use the existence of aliens as a scapegoat for this or that problem, foment a collective delusion about their their relative immorality, and lead humanity into a futile war. They understand too well to get involved with us.

If this correct, where is the ethics in Ufologists trying to prove they exist? A knowledge of their existence would only cause needless suffering. If their reality were accepted and politicians behaved as predicted, resources would be drained into building up military weaponry. If war happened, the destruction of much humanity would be obliged in their self-defense. As Aime Michel once warned, our inferior ethic might lead them to cause our total extinction to

prevent us from being a menace to the peace of the rest of the galaxy.

> 2. It is done because they are studying us and interaction or excessive belief might ruin the value of the investigation. Results would be dismissed as experimenter effects. Belief would yield cults which would change our history in undesirable ways.

If this is correct, then the attempt of Ufologists to make all or most of us believe in the existence of aliens would be a crime against universal science. They are diminishing our value to the rest of life in the universe as an uncontaminated sample.

Additionally, there is a risk that if belief levels get too high it may become evident the experiment has become useless and they will have to start over again. What will happen to us? They might, so to speak, sterilize the planet or chuck us down the lab drain. Where is the ethics of promoting UFO belief if this scenario has even a remote chance of being correct?

> 3. It is done because they are malicious and evil. Perhaps they are collectively self-interested and are exploiting the planet or humanity for nefarious purposes. They require our bodily essences, organs, memories, emotions, our capacity to live and experience joy or ecstasy. They conceal themselves because they don't want the hassle of our preaching against them, saying bad things about them, resisting them, or fighting them with weapons.

What is gained if UFOlogists prove them real? We would inevitably resist. Inevitably, because they have an immense technological advantage, we would be destroyed. Or, if we are too valuable to them alive, we would be put under a greater degree of control. The truth of their reality would be gained at the cost of a vast curtailment of freedom.

A pleasant corollary to this argument is that debunkers are in a no-lose situation here. If UFOs are real, they are heroes to humanity because they are contributing to our survival and well-being or increasing knowledge for the larger good of universal science. If UFOs are not real, they are heroes by helping free mankind of error and collective delusion.

Premise:

There are no extraterrestrials and the beliefs of Ufologists are false. Such beliefs exist because they serve some purpose. Is it ethical for debunkers to subvert this program? Consider two possibilities:

> 1. UFO beliefs are a form of paranoia. If true, it serves the individual by being an ego defence. It allows a degree of moral piety and superiority to an individual otherwise prone to a sense of shame and inferiority. He knows a transcendental power exists greater than not just himself, but others more powerful than him. When others agree, all are equally inferior. When others disagree, they are inferior because of their stupidity or cupidity.

When paranoia is successfully combatted, depression is the standard outcome. There is an increased risk of suicide. To fight the self-loathing, new defenses are sought. The individual will probably latch onto a new delusion and this one may potentially, even likely, be more political and harmful than UFO belief ever is. Think here of various extremist beliefs having paranoid slants, intense religious fanaticisms, and medical crankery. UFO belief has low risk

consequences to society as a whole compared to these behaviors. If UFO beliefs divert just one megalomaniac from the reigns of power, its value to the course of freedom and the common good would be immense.

> 2. UFO beliefs are theatre. There is clear evidence such beliefs amuse some people and provide escapism. Like all art, it lifts people out of periods of banal existence and helps them waste time in less destructive ways than violent sports, getting drunk, or interfering in other people's lives.

The debunker might try to justify his efforts by saying he might be steering occasional gullible non-paranoids away into more useful venues for their talents thus providing a useful service for society as a whole, but how can we weigh these meager benefits against the potentially greater costs of disbelief? Where is the ethics in fighting against human happiness and steering people into more dangerous pursuits? It would probably be wise not to debunk rather than to risk success.

CONCLUSION:

If UFOs exist, we should not believe in them. If UFOs do not exist, we should believe in them.

The UMMO Experience: The Hoax Exposed (mostly)

Scott Corrales

UMMO—a name to bewilder researchers, yet one that delights the true believers. The full panoply of Ummite madness was never unleashed upon the United States, nor indeed the English-speaking world. The putative race of space-farers from the star Wolf 424 was partial to France and Spain, and its network of informants directed the bulk of its reports to recipients in these countries. One researcher has gone as far as to describe the whole UMMO experience as "Star Trek made flesh," a phrase which elegantly summarizes the legacy of millions of words left to us by visitors from another star system. Before we get too excited, it is necessary to observe that like Star Trek, UMMO was merely a work of fiction (a much kinder description than merely branding it a hoax). The incredible mythos spun out by Spanish psychologist José Luis Jordán Peña had consequences that went far beyond any hoaxer's expectations.

An Exercise Out of Control

In the mid 1950's, José Luis Jordán Peña was elaborating the theory that paranoia was much more widespread among the population than psychiatrists of the time were willing to admit. Jordán Peña believed that no less than 79% of the population was afflicted, and proceeded to demonstrate the validity of his theory by concocting the UMMO affair-the story of tall, blond and friendly aliens who had landed near the French town of Digne. The belief in superstitions such as astrology, flying saucers, spiritism, shamanism, etc., was considered as proof of this paranoia by the Spanish psychiatrist.

The perpetrator of this hoax of the century penned his own confession in an article entitled "UMMO: Otro Mito Que Hace Crash" for *La Alternativa Racional*, the Iberian equivalent of *The Skeptical Enquirer*. A believer in the concept of "systematical paranoia," Jordán Peña put forth beliefs which, in his own words, were imbued with a certain logic. He didn't limit himself to the theoretical framework, but actually took steps (by his own admission) to create a false landing in the

BRIEFING

UMMO and associated documents refer to a series of communications received by Spanish and French UFO researchers and some scientists. Beginning with two alleged sightings of unidentified craft in 1966, one of which bore the)+(symbol on its underside, the phenomenon steadily gained momentum over the next few years, largely due to letters postmarked from various countries bearing information about a group of aliens who claimed to be from the star system "UMMO" and instructing earthlings on how to save themselves. The letter-writer's first language seemed to be Spanish, so most recipients of this wisdom were from Spanish-speaking countries.

Madrid suburb of Aluche, leaving bogus landing marks behind, and adding to the confusion by availing himself of a few sheets of polyvinyl fluoride which were unknown in Spain at the time (a material known as TEDLAR, manufactured by E. duPont de Nemours for the U.S. space program).

History of A Phantom Planet

The physical forgeries, never too impressive to begin with, occupied the backseat to the scientific material dictated by the Ummite-reams of paper filled with information concerning their society, organization, and beliefs in the form of learned reports aimed at familiarizing humans with their culture, as well as acquainting humans with their perspective on our affairs, such as war, inequality, etc. These reports were allegedly transmitted by means of dictation to a human typist (who was strictly ordered never to attempt contact with the addresses), and then sent to scientists, philosophers, and broad-minded individuals who in the Ummites' criteria, would be able to understand them and put them to good use.

A considerable amount of the UMMO doctrine was put forward by Fernando Sesma Manzano, a teacher and journalist who directed the "Association of Friends of Space Visitors" a loose affiliation of occultists, writers and saucer buffs who met every Tuesday in the basement of a Madrid cafe for lengthy conversations on the subject. Sesma allegedly had the very first and only telephone conversation with one of the Ummites, during which he was given the now-classic introduction to UMMO and its lore:

> "It is our wish to inform the planet Earth of our origin and the intentions which have led us to visit you. We come from UMMO, a planet which orbits the star IUMMA, recorded in the astronomical maps of your planet as Wolf 424...the difficulties of comparing and checking the identifications of your system of astronomical references against our own is quite indescribable."

Sesma's contact, DEI 98, son of DEI 97, proceeded to explain that UMMO had undergone our own world's bloody turmoil in distant ages, when it was exploited by brutal tyrants like NA 456, daughter of NA 312. A child "renowned from birth for her intelligence," NA 456 espoused the belief that breakneck scientific development was critical to UMMO's survival. The entire concept of God (or WOA, in the Ummite's language) was reinterpreted to mean the collected mass of Ummites, with NA 456 as the "brain." The youthful dictator imposed her belief system on billions of Ummites, declaring emphatically that all those unwilling to make the ultimate sacrifice for science would be destroyed. UMMO underwent a reign of terror until NA 456 died under mysterious circumstances, to be succeeded by her daughter WIE 1, a vain matriarch who put four million Ummites to death.

As DEI 98 informed Sesma, this rule of terror caused an anti-scientific backlash which culminated in the destruction of everything from libraries to nuclear powerplants. An interest in philosophy and telepathy replaced the lust for science. But perhaps the most important event of this horrific age on a world many light-years from earth was the rise of UMMOWOA.

UMMOWOA (the "Redeemer of UMMO") spread the belief in the One True God among his fellows. Scientists, jurists, technicians and workers flocked to hear the teachings of this simple Ummite, a worker in the solar

KEN DE VRIES

An UMMO Glossary

One of the most distinctive aspects of the UMMO mythos must be, of course, the strange sounding names and concepts written entirely in uppercase letters. A concise glossary of 400 Ummite words was compiled in the late '70s by Antonio Moya and Ignacio Darnaude, the latter of whom submitted it to the attention of linguists at a major university in Seville. The academics were unable to say if the Ummite words constituted a real language or not — a fact which heartened believers in the veracity of UMMO. Here are a few examples of the Ummite language.

BUUAWAA: soul, spirit
DOROO: magnetic recording
GEE: man
OIWI: year
OEMMII: body
OEMMOYUAGAA: terrans
OEMIIA BII: humanization
ONAWO: college of mathematics
UAA: code of ethics
UUMOALEWE: geneal assembly of UMMO
UUMOTAEEDA: university
WAAM: cosmos
WAAM TOA: cosmology
WOA: God

power factories on the SIUU Plateau. UMMOWOA's teachings, compiled in the form of a thousand TAUU (paragraphs), were distributed around the planet in recorded form. But the authorities had no truck with UMMOWOA's message of harmony and understanding: he was arrested, tormented and sentenced to death, only to "disappear" before the eyes of his captors.

In spite of the strong similarities with Christianity, all that the humans were interested in learning from DEI 98 was how they had first become aware of our "small blue marble" light years away. The Ummite was only too pleased to elaborate.

An Expedition to Earth

In the 1930's, a Norwegian vessel on the high seas had conducted an experiment in the upper reaches of the radio frequency (400 megacycles). These signals were received on UMMO, and although they were short in duration, they sufficed to help Ummite astronomers to pinpoint our location in space.

After much arguing about whether the signals were intelligent or not, the Ummites decided to outfit their first expedition to Earth, arriving on our world in March 1950. One of the earliest problems, according to the Ummites, in establishing contact with humans is that their race is almost completely telepathic, since the vocal cords atrophy and are useless beyond a certain age. Thence the importance of establishing written communication. A large number of the Ummites chosen for the expedition to Earth belonged to a minuscule segment of their society that actually had use of their vocal cords.

The Ummites were not at all hesitant in providing descriptions of their homeworld. The planet UMMO was similar to our own in most respects, with oceans, a single continental landmass, and with considerable volcanic activity- some of the Ummite volcanoes spew clouds of incandescent gas for many miles into the atmosphere, adding a glow to the evening skies that the Ummites consider highly attractive. The physical conditions of their world cause Ummites to be tormented by a number of afflictions, most distressing among them a sort of madness that causes the telepathic collapse of an otherwise rational member of society. Ummites have extremely delicate fingertips, and the simple act of holding a cold glass is excruciatingly painful to them.

Hard Science

While the Ummites neo-Catholic version of theology may have been all the proof some followers needed, the hard, cold formality of Ummite science was constituted pay dirt to others.

Recipients of the UMMO reports dealing with the secrets contained within the propulsion systems of their OAWOLEA UWEA OEM (spacecraft) were fascinated by the presentation of the concepts. UMMO's physics bore no relation to terrestrial physics, and their scientists considered Earth's view of space simplistic, since it didn't factor in a veritable legion of algebraic and geometrical concepts. Space, they explained, consisted of an indefinite number of dimensions, ten of which had been mastered by Ummite technology. Perhaps most distressing to the human recipients was the statement that subatomic particles were merely "the various orientations obtainable in space by the IBOOO UU (dimensional

José Luis Jordán Peña

axises)"—according to the manner in which the axises were aligned, the space-ships could become mass, matter, energy or any form of radiation. A series of dimensional shifts enabled the Ummite saucers to take shortcuts in space that deviated "from the standard mode of diffusion of light." This ability allowed the Ummites to make the trip between UMMO and our own world in eight or nine months, crossing an interstellar gulf of 14.6 light years.

Scientists like Juan Dominguez in Spain and Jean-Pierre Petit in France were riveted by these concepts and were counted among UMMO's staunchest defenders in the scientific community. Petit, in particular, was captivated by the Ummite concept of WAAM-WAAM, the "pluricosmos" or "multiverse" that was the cornerstone of Ummite philosophy.

The Snowball Effect

The attractive belief in benign, human-like aliens from a kindred world some-where in the cosmos could have not found more fertile ground, and the UMMO mythology went from being a clever trick played by a psychologist to a social phenomenon spread like a contagion from researcher to researcher and onto the public.

Jordán Peña insisted that he had at first tried pouring the proverbial cold water on the entire subject, but that the snowball effect had wrenched any control he may have imagined that he had over his creation. The reports allegedly dictated by the Ummites were mimeographed and photocopies to researchers all over Spain and overseas by zealous "spreaders of the word." A religion had been born. Even more distressing to the creator was the fact that clandestine "UMMO reports" were mushrooming everywhere, discussing a range of subjects that went far beyond the original ones, such as the veracity of the Shroud of Turin.

The diffusion of the so-called UMMO message, ironic though it may now seem, contravened the rules that the experimenter had lain down for the project. In a letter to fellow researchers written in the 1990s, Jordán Peña stressed the "code of ethics": to limit the diffusion of the myth (made impossible by the publication of books on the subject); the repeated admonition "do not believe us" that characterized the UMMO documents; the avoidance of any financial contamination of the experiment; avoidance of any possible identification with a cult; to culturally enrich the reader by means of the allegedly extraterrestrial reports. In the letter, the psychiatrist bemoans the fact that French scientist Jean Pierre Petit's reputation was "burned" by his steadfast defense of the reality of UMMO. But despite the good doctor's protestations, a dark side to his involve-ment in the UMMO affair was beginning to take shape.

El Ojo Crítico, a serious newsletter published by a diligent and resourceful group of young Spanish UFO researchers, collectively referred to as "the third generation of ufologists" shocked believers in the UMMO mythos and scandalized their elders with the accusing headline "A SEXUAL ORIGIN TO THE UMMO FRAUD"

The article, penned by journalist and television personality Manuel Carballal, stated succinctly that "after 25 years of continuing mystery, it has

> The attractive belief in benign, human-like aliens from a kindred world somewhere in the cosmos could have not found more fertile ground, and the UMMO mythology went from being a clever trick played by a psychologist to a social phenomenon spread like a contagion from researcher to researcher and onto the public.

been the 'new wave' of UFO researchers who has shed light upon one of the greatest hoaxes ever perpetrated in ufology on an international level—the UMMO affair."

Carballal went on to describe how researchers Carles Berché, José J. Montejo and Javier Sierra, among others, were the first to discover that noted parapsychologist José Luis Jordán Peña was in fact the intellectual mastermind of the hoax. This allegation would have remained pure speculation had José Luis Jordán Peña himself not chosen to step forward and admit his role in the hoax, using the pretext that it had all been a "scientific experiment" aiming at gauging the level of gullibility among Spanish researchers of the 1960s and '70s. Further research into the matter uncovered far less sanguine motives.

Trinidad Pastrana, an occultist from Madrid, revealed herself as having played the role of the mysterious "Marisol," who served as a mediator between the aliens from the supposed planet UMMO and their human contacts. According to Pastrana, she had made use of the telephone to transmit many of the alleged alien communications, and took advantage of trips abroad by friends or relatives to deposit letters with Ummite messages in the postal services of foreign countries, leading UMMO followers to believe that there was indeed a worldwide network (conveniently headquartered in remote Australia) of alien "visitors" combing our planet as part of their reconnaissance activities. But most shocking of all was Pastrana's admission that the messages had all been dictated to her by none other than José Luis Jordán Peña, whom she had met during a radio program on paranormal phenomena and who had later hypnotized her, subjecting her to sexual abuse.

Mercedes Carasco, the second "UMMO messenger," claimed to have met Jordán Peña in the early seventies at a meeting of the Center for Paranormal Studies and agreed to undergo hypnosis, first in the presence of witnesses and later alone. She alleged that the parapsychologist later took to writing her letters "masquerading as an Indian guru" and telling her that "in another lifetime" Jordán had been an abusive military man who was guilty of committing excesses, and that she had been a domineering woman who had kept him enslaved. In order to balance the "karmic debt," she would have to endure a sadomasochistic relationship with him.

The Loose Ends
It would be easy enough to stop at this point and considered the UMMO affair "solved." Too many loose ends persist, and some of them are significant enough to explain why the public hasn't fully accepted the explanation of UMMO as a hoax.

First and foremost are the questions surrounding the landing of the Ummite spaceship (with the ")H("logo on its undercarriage) at San José de Valderas in 1967. While the spaceship photographs have been proven fake by computer analysis, where did Jordán Peña obtain access to the strips of TEDLAR, a material for highly sensitive military use? Where did the psychiatrist secure the 99% pure nickel tubes containing the TEDLAR strips? Wouldn't it be more logical to suppose that somebody gave him these items?

The possibility that the entire UMMO experience may have been a sort

She alleged that the parapsychologist later took to writing her letters "masquerading as an Indian guru" and telling her that "in another lifetime" Jordán had been an abusive military man who was guilty of committing excesses, and that she had been a domineering woman who had kept him enslaved. In order to balance the "karmic debt," she would have to endure a sadomasochistic relationship with him.

of secret war or battle of nerves between warring intelligence agencies has been approached by a number of researchers, most notably Jacques Vallee. It is also possible that "Project UMMO," for want of a better name, came to an end when the intelligence agencies in question achieved their goal. Those who swallowed the myth hook, line and sinker, unable to bring the magnificent little universe to an end, continued it with their own "reports" and "letters." When they ran out of scientific material, the gravitated toward a far simpler doctrine of harmony and love whose comprehension did not require an advanced degree. This is evidenced by the frequent UMMO conventions held in major Spanish cities and which are sponsored by prestigious individuals who no longer talk long into the night about interstellar propulsion systems but about UMMO's doctrines of peace and love.

Veteran UFO researcher Raymond Fowler observed in his book *UFOs: Interplanetary Visitors* that in the event of massive open contact with a benevolent advanced alien civilization, many elements of the civilian population would actually "transfer their allegiance" to the newcomers on account of their advanced wisdom and power. If the arrival of a fleet of disc-shaped vehicles from UMMO were imminent, would their terrestrial followers obey their elected officials, or would they unhesitatingly run to meet their "elder brothers"? Could this be the reaction UMMO was meant to gauge?

The Song Remains the Same: Weird Lyrics and Altered States

Paul Rydeen

Late science fiction writer Philip K. Dick once received a psychic message in an unusual way. He was listening to the Beatles "Strawberry Fields Forever" when the familiar words changed to tell him his young son had a hernia which needed immediate medical attention. A trip to the family doctor confirmed the otherworldly diagnosis, and an operation was scheduled for the next morning. I've never received medical advice from Beyond, but I have had song lyrics change on me for no apparent reason. All three instances occurred while driving, so perhaps some sort of highway hypnosis is responsible.

One day about 15 years ago, I was riding with a friend to a golf course out in the Minnesota countryside. The Eurythmics' "Sweet Dreams" was playing on the radio. I was staring out the Duster window at the passing cornfields when I realized the words were not anything like I remembered them. The music had become very thick and layered, and the words had changed to short looped phrases. In full multi-track style, the chorus played in the background while Annie Lenox sang "Fuck me" over and over on one track, and "Kill me" on another.

I wondered if this was a remix of the original, or just a part I had never paid attention to. I was surprised that the radio would allow vulgarities to be played, but rock songs are difficult to understand and several other bands had snuck the F-word onto the air. I asked my friend if he had heard the correct lyrics, but he said he hadn't been paying attention. I thought little else of it for a long time.

A decade later, I was driving to a work-related training session in another state. The only station my little car radio could pick up was an oldies station. At one point they played Frank Sinatra's "That's Life," in which he lampoons the rumors about his Mafia connections. At the very end of the song, Sinatra said something to the effect that if you don't like his lifestyle, he'll have his mob buddies come and "shoot your ass and you'll die." I was again surprised

> **I have had song lyrics change on me for no apparent reason. All three instances occurred while driving, so perhaps some sort of highway hypnosis is responsible.**

by the public vulgarity. Had an old tape of an alternate take been discovered and released on CD? Surely this sentiment wouldn't have been released on LP way back then.

I commented on this humorous song to my wife when I returned. She fully denied that those words were in the song. She said it went, "I'll curl up in a little ball and I'll die." I acquired a tape of the song from an older friend at work. My wife had been right. So what had I heard? Tourette's Syndrome of the Gods?

A year or so later I was commuting to work early one morning. I had just discovered Nina Hagen, and was playing her *NunSexMonkRock* for the first time. Nina uses multi-track effects to overdub her own voice saying many different things. Her song, "Mr. Art is Dead" is one such effort. I repeatedly heard her say "I am the chosen one," which I can still hear every time I play it. I also heard her say "Nina is chosen," which is not anywhere in the song, or in the printed lyrics that came with the LP. I know I heard it because it seemed especially remarkable when "I am the chosen one" in one track and "Nina Hagen" in another subtly merged into "Nina is chosen." But it's not anywhere on that tape!

Around the same time, I was playing a Sleep Chamber tape on the way to work. It was an ambient "industrial" recording, very repetitive, even "spacey," designed for sexual rites of ceremonial magic. No lyrics were recorded, only music. I left home on time, encountered the usual number of red lights and traffic delays, drove my usual speed. I was surprised when I realized I had arrived at my exit because I didn't feel I had been driving all that long. I had kind of "zoned out" listening to the music - highway hypnosis again. I checked my watch. I was a full ten minutes early for work. I had gained ten minutes in a 45-minute drive. It only took me 35 minutes to get there. I've heard of missing time, but this was gained time. I can't explain.

There is one other time I received an unexplained transmission of sorts, this time visual rather than audio. I was working a summer job during college as a member of a survey crew. We were unable to work one afternoon because my crew leader was attacked by bees. The other two crews continued surveying unaware of his plight, while he and I returned to the hotel room to rest. He dozed off while I sat on the other bed watching a game show. Right in mid-sentence the show was interrupted by a series of sepia-tone football plays from the 1930s, run over and over several times each. This lasted nearly five minutes before the game show came back on as if nothing unusual had ever happened. The football plays I saw were not even complete plays, as one would expect of someone studying the game. They were simply excerpts from an old, old game, repeated several time each before the next excerpt was shown. No soundtrack accompanied the transmission from the past, only silence.

In *Disneyland of the Gods*, John Keel writes of the Black Knight satellite. The Black Knight was found by astronomers decades before any earth-launched satellites orbited the globe. Several strange radio transmissions were detected, then it disappeared. Other "alien" objects have also come and gone, before human satellites appeared on the scene. Other weird transmissions—both radio and TV—have been reported.

It's as if, Keel says, some strange satellite in space receives an earth signal,

> **At one point they played Frank Sinatra's "That's Life," in which he lampoons the rumors about his Mafia connections. At the very end of the song, Sinatra said something to the effect that if you don't like his lifestyle, he'll have his mob buddies come and "shoot your ass and you'll die."**

records it, and plays it back some period of time later—even years in some cases, including my own. Some of the transmissions were positively identified as to date and location of original transmission. There's no way they could have bounced around in the atmosphere, across continents, for several years, to be picked up by one TV in one home. What happened?

Philip K. Dick thought his medical prophecy originated with an ancient extra-terrestrial satellite he called VALIS, or sometimes Zebra. Beside the above-mentioned modification of Beatles lyrics, VALIS transmitted much other information to Phil over a period of years-in dreams, while high, at other times. Is VALIS the Black Knight? Was John Keel right in assigning it an extra-solar origin? I don't know.

I can explain the three instances where song lyrics changed for me as some sort of auto-hypnosis (no pun intended), especially since I received no valuable medical diagnoses—only nonsense. It's possible the "Fuck me/Kill me" message I heard Annie Lenox sing was subliminally embedded within the song, but the transformation of the Frank Sinatra and Nina Hagen lyrics seems to have originated outside the framework of the actual recording.

The "gained time" incident was not done under rigid controls, so it could be argued that I was wrong about when I left, traffic conditions, etc. No "Control" Paul Rydeen left home with a stopwatch to double-check my results. I know what I experienced, but I can't prove it.

The football delayed-transmission is definitely exterior to myself in origin, and I cannot see why anybody would have done this accidentally or as a prank. Readers with possible theories or similar experiences are invited to write the author c/o this publication.

Chalk it up to VALIS, to the Black Knight, I guess.

I sat on the bed watching a game show. Right in mid-sentence the show was interrupted by a series of sepia-tone football plays from the 1930s, run over and over several times each. This lasted nearly five minutes before the game show came back on as if nothing unusual had ever happened. The football plays I saw were not even complete plays, as one would expect of someone studying the game.

Ken De Vries

(No Model.)

N. TESLA.
RECIPROCATING ENGINE.

No. 514,169.

Patented Feb. 6, 1894.

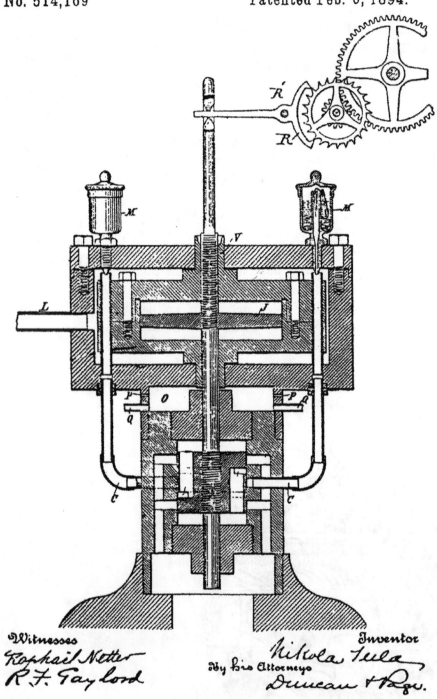

Witnesses

Raphael Netter

R. F. Gaylord

Inventor

Nikola Tesla

By his Attorneys

Duncan & Page.

Tesla's patent for the basic piston assembly used in the resonance generator

Nikola Tesla's Earthquake Machine

Greg Bishop

A few years ago, a friend mentioned that he had noticed a peculiar pattern of the earthquake frequency in Southern California. In all recent instances except the 1994 Northridge blockbuster, the space shuttle had been aloft at the time. (Conspiracy researcher and radio show host Dave "I Read It In A Book So It Must Be True" Emory has commented on this as well.) There are obvious implications for anyone who could control this final frontier of the natural world. Perhaps this has already been accomplished. In the waning years of the 19th century, technological alchemist Nikola Tesla may have harnessed this principle to similar effect.

Tesla has been called everything from a genius to a quack. The fact remains that the alternating current electrical system now used worldwide was his conception, and among other inventions he perfected a remote controlled boat in 1897—only a few years after the discovery of radio waves. This device was publicly demonstrated at Madison Square Garden the next year to capacity crowds. In 1896, Tesla had been in the United States for 11 years after emigrating from his native Croatia. After a disastrous fire in his former laboratory, he moved to more amenable quarters at 46 Houston St. in Manhattan. For the past few years, he had pondered the sigificance of waves and resonance, thinking that along with the AC system, there were other untapped sources of power waiting to be exploited. The oscillators he designed and built were originally designed to provide a stable source for the frequencies of alternating current-accurate enough to "set your watch by."

He constructed a simple device consisting of a piston suspended in a cylinder, which bypassed the necessity of a camshaft driven by a rotating power source, such as a gasoline or steam engine. In this way, he hoped to overcome loss of power through friction produced by the old system. This small device also enabled Tesla to try out his experiments in resonance. Every substance has a resonant frequency which is demonstrated by the principle of sympathetic vibration—the most obvious example is the wine glass shattered by an opera singer. If this frequency is matched and amplified, any material may be literally shaken to pieces.

Neighborhood Threat

A vibrating assembly with an adjustable frequency was finally perfected, and by 1897, Tesla was causing trouble with it in and near the neighborhood around his loft laboratory. Reporter A.L. Benson wrote about this device in late 1911 for the Hearst tabloid *The World Today*. After fastening the resonator ("no larger than an alarm clock") to a steel bar (or "link") two feet long and two inches thick:

> He set the vibrator in "tune" with the link. For a long time nothing happened-vibrations of machine and link did not seem to coincide, but at last they did and the great steel began to tremble, increased its trembling until it dialated and contracted like a beating heart-and finally broke. Sledge hammers could not have done it; crowbars could not have done it, but a fusillade of taps, no one of which would have harmed a baby, did it. Tesla was pleased.

But not pleased enough it seems:

> He put his little vibrator in his coat-pocket and went out to hunt a half-erected steel building. Down in the Wall Street district, he found one-ten stories of steel framework without a brick or a stone laid around it. He clamped the vibrator to one of the beams, and fussed with the adjustment until he got it.

> Tesla said finally the structure began to creak and weave and the steel-workers came to the ground panic-stricken, believing that there had been an earthquake. Police were called out. Tesla put the vibrator in his pocket and went away. Ten minutes more and he could have laid the building in the street. And, with the same vibrator he could have dropped the Brooklyn Bridge into the East River in less than an hour.

Tesla claimed the device, properly modified, could be used to map underground deposits of oil. A vibration sent through the earth returns an "echo signature" using the same principle as sonar. This idea was actually adapted for use by the petroleum industry, and is used today in a modified form with devices used to locate objects at archaelogical digs.

Even before he had mentioned the invention to anyone he was already scaring the local populace around his loft laboratory. Although this story may be apocryphal, it has been cited in more than one biography: Tesla happened to attach the device to an exposed steel girder in his brownstone, thinking the foundations were built on strudy granite. As he disovered later, the subtrata in the area consisted of sand-an excellent conductor and propogator of ground vibrations.

After setting the little machine up, he proceeded to putter about the lab on other projects that needed attention. Meanwhile, for blocks around, chaos reigned as objects fell off shelves, furniture moved across floors, windows shattered, and pipes broke. The pandemonium didn't go unnoticed in the local precinct house where prisoners panicked and police officers fought to keep coffee and donuts from flying off desks. Used as they were to the frequent calls about diabolical noises and flashes from Mr. Tesla's block, they hightailed it over. Racing up the stairs and into the lab, they found the inventor smashing the vibrator to bits with a sledgehammer. Turning to them with accustomed old-world aplomb, he apoligized calmly: " Gentlemen, I am sorry. You are just a trifle too late to witness my experiment. I found it necessary to stop it suddenly and unexpectedly in an unusual way. However, If you will come around this evening, I will have another oscillator attached to a platform and each of you can stand on it. You will, I am sure, find it a most interesting and pleasurable

Contemporary magazine illustration from 1911

experience. Now, you must leave, for I have many things to do. Good day."
(Another story is related of Tesla's good friend Mark Twain, a regular visitor to
the laboratory, standing on the vibrating platform to his great surprise and
pleasure, extoling its theraputic effects while repeatedly ignoring the inventor's
warnings to get down. Before long, he was made aware of its laxative effects
and ran stiffly to the water closet.)

One source has it that the device "bonded to the metal on an atomic level"
and Tesla was unable to get at the controls, but it seems more likely that the wild
movements of the girder, combined with the panic that he might bring the neig-
borhood down, moved Tesla to this unsubtle action. He later mused to reporters
that the very earth could be split in two given the right conditions. The detona-
tion of a ton of dynamite at intervals of one hour and 49 minutes would step up
the natural standing wave that would be produced until the earth's crust could no
longer contain the interior. He called his new science "tele-geodynamics."
Newspaper artists of the time went nuts with all manner of fanciful illustrations of
this theory. Tesla's fertile imagination posited a series of oscillators attached to the
earth at strategic points that would be used to transmit vibrations to be picked up
at any point on the globe and turned back in to usable power. Since no practical
application of this idea could be found at the time that would make money for big
investors or other philanthropic souls, (one can't effectively meter and charge for
power derived in this way) the oscillators fell into disuse. In the 1930s, Tesla

revived the idea of tele-geodynamics and proposed devices designed to effect small, realtively harmless temblors to relieve underground stress, rather than having to wait in fear for nature to take it's course.

Government Interest

Unanswered questions surround the handling of Tesla's possessions at the time of his death in 1943. Since no will or other statement was left as to the disposition of literally tons of papers and effects scattered in storage facilities and hotels, diverse elements such as the FBI, the Office of the Vice President,, and the Office of Naval Intelligence competed to gain possession, or at least to get a good look.

Many of Tesla's notes and abstracts were removed to the Manhattan Storage Company immediately following his death and subsequently catalogued and possibly microfilmed by employees of Naval Intelligence and Dr. John Trump, an electrical engineer working for the National Defense Research Commitee. Tesla had chosen to pass away right in the middle of WWII and interested parties were naturally looking for anything that would increase the "war effort." Research by Tesla examined and abstracted by Dr. Trump included *The Art Of Telegeodynamics or The Art of Producing Terrestrial Motions At A Distance*. Trump commented that "the proposed scheme appears to be completely visionary and unworkable."

Perhaps so, but between 1945 and 1947 the Air Technical Service Command at Wright Field in Ohio (location of the famous "Hangar 18" rumor/legend and epicenter of many UFO-related matters) requested copies of some of Tesla's writings on "beam weaponry" and other subjects from the Office Of Alien Property, which retained possession. Wright Field denied having any of these papers, although photostatic copies were documented as sent by registered mail from the base in late 1945. They were never returned despite repeated requests by the OAP.

The disposition of Tesla's remaining notes remain a matter of contention, at least to the extent of who saw them and to what purpose, if any, the principles were used in later research and development. Perhaps we can speculate that some theories delineated by Tesla did not remain the idle musings of a scientist whose star had never been on the ascendant since the turn of the century, and that we may occasionally experience the devious machinations of invisible "earthquake merchants" at the behest of unseen hands who wish to experiment with nature and the dynamics of our civilization.

A Barometer for the Cultural Climate

Video Review:
Ralph Coon's *Whispers From Space*

Reviewed by Paul Rydeen

I had a chance recently to watch the most important UFO film since the Discovery Channel's *Farewell, Good Brothers*. *Whispers from Space* is a series of eulogies for one of ufology's early masters—Gray Barker (1925–1984). Though he's a decade gone, *Whispers* is as timely as ever. I'm glad somebody's documenting these things before it's too late. Mainstream history overlooks the fringe areas. To me they act as barometers for the cultural climate. Who could have predicted the huge interest in UFOs that exists today? Yet there was Gray, writing his books and newsletters in the 1950s and 1960s when the field was full of teenagers and hobbyists. Gray stood apart from his peers in one important way. He openly professed his disbelief in the UFO phenomenon. A portable tape player runs in one early scene. It sits atop Gray's headstone. We hear Gray's own voice tell us "if you look deep inside yourself" you'll find the UFOs. In other words, he postulated a psychological approach to the phenomenon, foreshadowing trends not popular until 30 years later. Gray saved every letter he received. Jim Moseley (*Saucer Smear*) says Gray made a study of "crackpottery." His files would make good fodder today for those who profess to follow "kooks." They are available for viewing in the Clarksburg, West Virginia Public Library, along with his many other publications (The *Saucerian* newsletters, *They Knew Too Much About Flying Saucers, Men In Black, The Silver Bridge*, etc). Gray's early fame came in 1952 with his study of a local sighting known as the Flatwoods Monster, the Braxton County Monster, or the Green Monster. He visited the site, interviewed the witnesses, and wrote up the results. It stands today as a classic of urban legendry. From that day on, Gray never left home without his Super 8 camera. Though most of those interviewed in *Whispers* are relatives, some of the more interesting footage features James Moseley. At one point Moseley confesses to hoaxing a letter on government letterhead which he and Gray sent to George Adamski. Moseley says

Gray Barker from a 1950s kinescope.

VHS, approx. 120 minutes Available from Videoactive Releasing (800) 666-2627 $20.00

Adamski recognized the forgery but used the letter for his own benefit. This is the famous "Straith" letter. [ED. See Moseley's interview in chapter 5 for more on this.] Moseley and Gray perpetrated other hoaxes as well, including flying disk photos. A classic scene shows Moseley holding a fishing rod, hubcap-and-ball-bearing UFO hanging on the end. Gray is also to be credited with publicizing the notorious *Men In Black* with *They Knew Too Much*. Begun when he had his own visit in 1953, the book came out in 1956 and sparked a whole new round of paranoia. It stands alone in the annals of American mythology. Perhaps Gray's most famous effort was *The Silver Bridge*. Many have read John Keel's *The Mothman Prophecies*, but *Bridge* covers the whole Point Pleasant incident as viewed by a local. Keel points to an "ultraterrestrial" as the cause, but Gray uncovered an Indian curse. (The main bridge collapsed there on Christmas Eve, 1964–at the busiest traffic hour. Numerous lives were lost. It made national news during the President's Christmas Eve address to the nation.) *Whispers from Space* has its faults. It wanders off on several lengthy tangents at times. A more experienced editor could have removed another 20 minutes of irrelevant material from this movie, and focused solely on Barker. That was the reason for the film. Discussions of local murders, urban legends, horror movies, *Dark Shadows* [TV series], and intricately detailed conspiracies don't belong here. Save them for another film. If *Whispers from Space* comes to your town, don't miss it. Until then, in the words of Gray Barker, "UFO is a bucket of shit."

No. 8

REMOTE VIEWING CONTEST • CIA "OPENNESS" MEMO REVEALED
AL BENDER AND THE M.I.B. • JOHN SHIRLEY'S MEDIA CASTIGATION CONCLUDES
8 $4.50
THE EXCLUDED MIDDLE

Not Your
Grandpa's
ESP cards...
**Parapsychologist Dean
Radin, Ph.D.
Interviewed**

Steamshovel Press' Kenn
Thomas Speaks

Flying Saucers vs. Airplanes

Fringe Folk Encyclopedia

Castaneda Expose Pt. III

6th Grader's UFO term paper

"I thought that
science involved the
investigation of the
unexplained, not the
explanation of the
uninvestigated"

—GEORGE KNAPP-
KLAS TV, LAS VEGAS

Editorial

Take a look at these quotes:

1. Magick is the science and art of causing change to occur in conformity with will.

2. There is a rapidly growing body of impressive scientific research which is more clearly indicating that human consciousness, merely by intention alone, can have a measurable effect on everything around us. Imagine being able to insert and extract information and thereby alter random events through the exclusive powers of your intentions.

The first line was written by occultist Aleister Crowley in 1929. The second is from the Princeton Engineering Anomlaies Research (commercial division) website at http://www.pearinc.com. A clarion call that was enunciated in our last issue, although not unique in its scope, has been answered. Over the last few years, a growing body of researchers and scientists have been quietly investigating the next frontier of human existence, and have begun to announce their findings to the public. As you can see from these two quotes, this information and latent human talent was noticed and harnessed nearly seventy years ago, as well as hundreds (if not thousands) of years previous to our generation. The methods of 20th century science are indeed ready to make this leap, and the baby steps in that direction are clearly beginning.

This July, I was extremely disappointed to have missed the Society For Scientific Exploration's annual meeting in Las Vegas hosted by UNLV professor Dean Radin, PHd. Radin has recently written a book entitled *The Conscious Universe*, which contains the notes for the opening trumpet call of new science. Although other specialists like Fred Alan Wolf and Charles Tart have covered some of the same ground and put their brains to the grindstone to propose the acceptance of the human mind's integral relationship to reality, they have unfortunately gone unnoticed by the vast majority of the "thinking" population.

Radin gathered together the best and brightest in the fields of consciousness and psi research to present papers on such diverse concepts as "Anomalous Cognition in the Brain," "Operator Influence On A Mobile Random Robot," "Knowledge Beyond Reason and Emotion," and "UFOs, A Debate On Proof." In *The Conscious Universe,*, he even reports that in his final book, Carl Sagan had admitted compelling evidence for reincarnation and remote viewing. Personally, I think that there is little question left of the interaction between the human mind and the "external" world. Indeed, they actually "depend" on each other. If a tree fell in the forest and there was no one there to hear it, it wouldn't make a sound after all because it wouldn't make any difference!

Reared on the public school and PBS-inspired worldview, the mainstream intelligensia (who incidentally comprise the mindset of the major media) are loath to accept anything that isn't stamped with the imprimatur of scientism. It's a safe attitude, after all, and doesn't involve any intellectual WORK. Face it—if "everything you know is wrong," there is WORK involved to create a new basis on which to balance your concepts of reality and the precepts that it engenders. Never mind the horrors of government/military/industrial secrecy and abuses and the eroding of constitutional rights, etc. If you haven't accepted any of this, you're either old or dumb or both.

Wake up dammit. The future is here and kicking you out of bed. If you've read to this point, you've already gotten up and had your coffee. Oh well. I hope the choir enjoyed the sermon.

—Greg Bishop

By the way, science is not the problem. *Scientism* is what I'm on about.

News: Summer 1998

When the national security establishment or their cohorts in the private sector decide to move in a certain direction, they will most likely do so when their actions accomplish many things at once.

NO UFO CONNECTION TO CATTLE MUTILATIONS SAY JOURNALISTS, RANCHERS, REMOTE VIEWERS

Peter Jordan began investigating cattle mutilation cases in 1979. Concentrating on the Dulce, New Mexico area, Jordan first talked with Manuel Gomez, owner and operator of the largest private ranch in the area. Soon before any disturbances began, Gomez reported receiving calls late at night from a man with a thick German accent threatening that "they" would get his land no matter what he did. Soon after this, Gomez' cattle began showing up dead in his fields, some lying a few feet from his bedroom window. "He said the voice sounded like it was reading from a script" says Jordan. The calls continued after the deaths as well, reinforcing the previous threats.

Jordan received little or no cooperation from official sources in a search for the culprits, so as law enforcement officials have been doing for decades, he enlisted the talents of psychics. To ensure consistency, four individuals were consulted. Sealed envelopes containing pictures and slides of the land and dead cattle were given to the sensitives. Their comments, published in issue #38 of *Fortean Times* showed great similarity in theme if not detail. All agreed that the phenomenon was human-based, pointing to some government or quasi-government agency using the isolated location to perform a number of operations connected to the cattle operation.

When the national security establishment or their cohorts in the private sector decide to move in a certain direction, they will most likely do so when their actions accomplish many things at once. This being the case, the cattle mutilation scenario could be useful in the following ways:

1: Psychological warfare techniques in remotely populated areas.
2: Training/ testing of covert operations personnel and techniques.
3: Testing of stealth technology and aircraft under cover of darkness.
4: Study of the spread of rumor and disinformation flow.
5: Adding another layer to the UFO mythos.
6: Land acquisition without the hassle of negotiation or revealing the motivating interest, i.e. mineral deposits, underground facility access/ construction.
7: Genetic experimentation.
8: Testing of medication and/or pathogens.
9: Testing of field medical procedures.

Jordan has suggested some of these reasons. Others were extrapolated from information provided by his psychics and the historic record of covert operations

in the US as well as abroad, as well as the observations of local residents.

The psychics also saw underground facilities, helicopters with "feathered blades to change the sound," lighter-than-air craft, men in shiny black jumpsuits, and ex-military personnel. An experiment was performed on an affected herd in which cattle were exposed to varying wavelengths of UV light. Fluorescent blotches showed up on the backs of individuals with similar lineage and in the same general age group. Some of the marked cattle later turned up dead and cut up in classic mutilation fashion.

Resercher and journalist Ted Oliphant has published an article on his website entitled A Fresh Look at the Cattle Mutilation Mystery, detailing his ongoing investigations into the subject. Serving as a police officer in Fyffe, Alabama, he was able to examine over 40 suspicious cattle deaths firsthand. Oliphant's source and contact, "Phil" suggested that he look into the history of Bovine Spongiform Encephalopathy (BSE), otherwise known as "mad cow disease." Oliphant points out that this may answer the question of why the mutilators don't have their own herds. In his scenario, helipcopters fly low over pastures at night looking for diseased animals that can be spotted by their heat signature on an infrared camera. Citing two overt and one covert group that is studying BSE, Oliphant speculates that the black budget-funded group may be the culprits in the mutilaitons. The examination of bodily fluids is important in diagnosis, and the exsanguination of affected cows lends further credence to this theory.

MORE DEAD HEROES

In 1997, the final remaining triumvirate of the Beat and 1960s generations went to their great reward. Allen Ginsberg, poet, buddhist, and Beat iconoclast died on April 5th, followed by Dr. Timothy Leary on the 31st of May, and saddeningly, William Burroughs on August 2nd. Ginsberg was 70, Leary was 75, and Burroughs lived to a remarkable 83.

Each of these men were sought out by their admirers and Excluded Middle writers and editors retain recollections of personal contacts with these most quintissential of American personalities.

Contributing Editor Peter Stenshoel remembers a small gathering of poets and writers in Minnesota, where Ginsberg asked him to read one of his (Stenshoel's) works to the group. Ginsberg proceeded to dress him down for the work, and didn't pull any punches.

Editor Greg Bishop saw Leary at a book signing and lecture in Los Angeles, three months before his death. The ailing but ever-smiling doctor was asked by the assembled media to show off a shirt with his name printed across the back. He waited for the cameras to start clicking and tapes to begin rolling and flipped the bird with both arms raised high.

Contributing writer Dean James carried on a limited correspondence with Burroughs and received this letter a few months before the author's death.

Also passing into the hands of the Ascended Masters was George King, founder and Spiritual leader of the Aetherius Society. He died early in the morning of July 12, 1997 aged 78, at his Santa Barbara, California residence.

While washing dishes at his London flat in March, 1954, King was star-

tled to hear a voice in his head declare "Prepare yourself! You are to become the voice of Interplanetary Parliament!" The former cab driver founded the Society in 1956 and served as its grand poobah up to the end. King communicated with a Venusian named Aetherius, a Cosmic Master who represented the Planetary Parliament on Saturn. In 1960, King moved the headquarters of the Society to the heart of Hollywood. He instituted the practice of "Spiritual Battery charging" and used these devices to provide "healing energy" to trouble spots around the globe. We can only hope the Society refrains from infighting and continues this practice.

JAMES EARL RAY DIES; "RAOUL" SCOT FREE
by Kenn Thomas

James Earl Ray

James Earl Ray, accused assassin of Martin Luther King who plead guilty and then recanted died recently due to complications of cihrosis of the liver from a long-term hepatitis infection. A new liver would have given researchers more time to work on James Earl Ray's account of his involvement in Martin Luther King's assassination, but he was too much of a flight risk to allow travel for that purpose. The only way they were going to let him out of that Atlanta prison was in a pine box. Ray died on April 23, 1998, sticking to his story that he served only as patsy to the mysterious Raoul. Author Gerald Posner says Ray held fast to this story to protect his brothers, who formed a small "kitchen" conspiracy against King in St. Louis. At a recent book-signing in Memphis, one of those brothers, Jerry Ray, confronted Posner, charging that the author had many distortions about the Ray brothers in his new book, *Killing The Dream.*

Back in 1992 the FBI picked up the other brother, John, on a two year old arrest warrant. John could never escape the FBI as he had both feet amputated because of diabetes. The FBI only enforced the warrant after James Earl accused them of involvement in the MLK hit on the old Phil Donahue show. James Earl knew that such harassment could result as fallout from his TV comments but apparently was not in a protective mood that day. In any event, James Earl's version of events has convinced the King family and Prez Clinton that a new investigation should be forthcoming. What dupes, says Posner.

Meanwhile, Lee Oswald's brother Robert recently told MSNBC's *Dateline,* "If there was a conspiracy to kill the president, it was separate and apart from what Lee did." *Dateline*'s Josh Mankiewicz then made the observation that "I'd expect the guy's family to be telling me just the opposite. I'd expect the accused assassin's brother to say, 'Hey, look. You know, he was never tried. He never admitted it. It was never proven. They got the wrong guy." Of course, MSNBC had no shortage of appearances by Posner crying foul when Martin Luther King's family followed similar logic.

PHONE NUMBER FOR THE MEN IN BLACK

Issue #2 of the *New Phenomenon Monitor* (PO 436, New Philadelphia, OH, 44663) featured a visit to Mothman's home town of Point Pleasant, West Virginia. Among the oddities remaining in the area is a "truly bizzare phone number with a recorded 'message' which changes from minute to minute, along with its strange background

beeps." We called from the *Excluded Middle* offices and heard a long tone which is usually associated with fax or modem transmissions, and then a robotlike voice: "TIME: 034600... ENTER... COMMAND." The thing waits until a number is entered and then reads off another six digit series of numbers followed by the "enter command" message again. The number seems to correspond to hours, minutes, and seconds, but other numbers read off did not follow in sequence of clock time. Drop us a line if you can figure it out. This mind control number is (304) 675-5352. According to the *Phenomenon Monitor*, the number "has been circulating in the area since the days of the Men In Black."

UFOLOGIST WHO FIRST WROTE ABOUT MEN IN BLACK STILL REFUSING INTERVIEWS, CONTACT WITH RESEARCHERS

Albert K. Bender, now living in obscurity somewhere in Los Angeles, left the UFO research business in the early 1960s, having come under the influence of the Men In Black. The release of last year's film of the same name should have conceivably brought Bender out of retirement—at least to comment on the phenomenon of the MIB, a term he coined to describe the menacing figures who dogged him with their presence and threats after he founded the International Flying Saucer Bureau, one of the first and largest of the early saucer groups.

Bender's 1954 book *Flying Saucers and the Three Men* was written after a long self-imposed silence and the closure of the IFSB due to repeated visits by MIB, asking him to discontinue his investigations. Bender was told that he was "too close" to a solution to the UFO enigma and that this would upset some delicate balance. Despite repeated entreaties by his friends and associates (such as Gray Barker, Jim Moseley, and Dominic Lucchesi) Bender would not reveal the nature of the warnings he received from his dark and sulfur-scented visitors.

In a speech delivered at an East-coast UFO convention in the mid-1960s, Bender admitted that he had "witches and warlocks" in his family tree, and felt that he may have inherited some of their talents for calling upon the dark forces. He gave examples of those he had harmed or killed by merely visualizing their demise. This may sound like further evidence of an elaborate wish-fulfillment fantasy, but soon afterwards, Bender dropped out of the UFO scene completely.

Founding the Max Steiner Film Society (for film composer Steiner) Bender let his UFO interests lapse and moved to Bakersfield to manage a hotel, finally settling in Los Angeles in the early 1970s. Since about 1977, Bender has refused interviews and contact with any UFO-related people. He must now be approaching the age of 80, and a few researchers are still trying to get in touch for that one last interview.

PHILIP CORSO'S BACKGROUND, MOTIVATIONS QUESTIONED

Col. Philip Corso, info source for last year's book *The Day After Roswell*, and temporary darling of Ufology, has brought attention to himself with the revelation of a history in spin control and association with right wing extremist

Philip Corso

elements in the military as well as his former ties to a semi-secret society called the "Shickshinny Knights Of Malta."

Before *The Day After Roswell* was a gleam in the eye of someone at Simon & Schuster, Peter Dale Scott wrote about Corso in *Deep Politics and the Death Of JFK*. In light of the fact that he is working on another book with Roswell co-author William Birnes (to be entitled *The Day After Dallas*) it is worth noting that Corso was an investigator involved with the Warren Commission who according to Scott, "built on...anti CIA paranoia by telling his friend and fellow Senate staffer [for segregationist Strom Thurmond] Julien Sourwine, who made sure it was relayed to the FBI, that Oswald was tied to a communist ring inside the CIA, and was doubling as an informant for the FBI." Corso may soon build on his "insider status" to push the theory that Oswald was a knowing accomplice in a CIA-communist conspiracy to kill JFK.

He makes little secret of his opinion that the CIA of the late 1950s and early '60s was rife with communist infiltrators. Actually supporting this is the fact that James Jesus Angleton, the man charged with keeping KGB spooks away from "The Company" (CIA) was in fact so deeply paranoid about the success of his job that Russian assets (including unknowing ones like Anatoly Gulitzen) and double agents (like the legendary Kim Philby) were able to wrench the CIAs best kept secrets from him through skillful manipulation of this fear. Why this should equal a communist plot to assassinate Kennedy will have to wait for possible exposition in *The Day After Dallas*.

The Shickshinny Knights of Malta was apparently founded by old-guard White Russians who emigrated to the US after the revolution, eventually settling in Shickshinny, Pennsylvania. By the end of the Second World War, the organization had evolved into a haven for mothballed right wing military intelligence personnel. When Corso became involved with the Knights, (circa 1963-64) the organization seemed to operate as an undergound think tank and spin factory, using its contacts as leverage in an effort to affect lawmakers and others in power, and to coerce them with "inside information" from supposedly authoritative sources. Scott points out that their claims were generally "distorted to the point of absurdity." Corso disavows any association with the group.

Perhaps this has little to do with Corso's present activities, however a few people in the UFO community have expressed the feeling that his claims in Roswell may be the result of a few verifyable facts diluted with much more mis- or disinformation. If this is true, Corso himself may not be aware of it. In light of the man's history, this may not be far off the mark, and there is reason to suspect that he may have been called out of retirement to play the role of publicist one last time.

Interview with Parapsychologist Dean Radin

Greg Bishop

Dean Radin

Dean Radin has recently joined the ranks of Giardano Bruno, Galileo, and Timothy Leary as the latest sacrifice on the altar of academic freedom. Bucking convention in a conscious effort to effect far-reaching change comes naturally to this soft-spoken man with a penetrating mind and manner. Radin is in a sense an excluded middle personality, fusing the scientific mindset with the intuition and lateral thinking of an artist. He stresses the fact that he comes from an artistic family, and that this is probably what drew him into leading edge research. His first book, *The Conscious Universe*, released last year, was the catalyst which finally burned his ties with the University of Las Vegas, where he worked for four years perfecting the newest techniques for studying psi (modern shorthand for mind-over-matter) effects in the laboratory and it's etheric footprints in the realm of statistics. Radin has found compelling evidence for both. As one reviewer has stated, *The Conscious Universe* is both a solid introduction to the newest developments in the field of parapsychology, and a well-written primer on the scientific method.

Radin makes us aware of the severe linguistic and conceptual handicap we face in attempting to discuss the nature of reality. As the interview progressed, it became obvious that the language we have evolved to discuss these subjects is like using a "sledgehammer to kill a flea." The effects that parapsychologists study are only slight and ephemeral because we are not equipped to examine them on their own turf. Perhaps Radin and others in his field are moving us from the point-and-grunt stage to the tool-using age.

This severely truncated version of an interview was conducted over a four-hour marathon session in a small cafe near Radin's home in east Las Vegas. It is a credit to his gracious and patient manner that what was originally planned as a lunchtime conversation finally ended just as the place was setting up for dinner.

Q: What led you to be interested in the field?
RADIN: Well, everyone's interested in the subject, but I what I usually do is

turn it around and say, "Well, why are all *you* people here?" Perhaps people are asking the question of themselves. In many cases it's a religious motivation, or "I come from a family that had a million psychic experiences," or "I'm psychic" or something like that. I turn the question around to emphasize that we're talking about a common human experience that most people are interested in for curiosity's sake, or from their own experience, or the family's experience, or something. And it's compelling. It's not just a weird thing that happens, it's compelling as well, which means that there's something important underlying it, and we don't know what it is exactly.

So, why did I pursue it as a profession is more close to a question I can answer. Why did I decide to pursue it given the controversy and the risk? The answer is that I've done enough conventional research and R&D to realize that it gets boring after awhile. Even in the midst of working at Bell labs with lots of resources and very bright people and interesting projects, I think I was born in an existential crisis. I was wondering "What in the world am I doing? How am I spending my time with what's worth doing?" For some people, working in a lab on technical projects is fulfilling, but I felt that it wasn't pushing me beyond what I knew. So here is a realm where you are pushed because of our ignorance to be the most creative, hardest working scientist that you can possibly be because you're working right on the edge. You don't have the comfort of falling back on methods, tools and techniques (well we do have some) but they're not sufficient to advance it quickly. So, you take the idea of someone who's a creative scientist, which I am since I come from an artistic family, and I have that creative gene, and in addition, to be willing to take the risk. There are a number of revolutionaries and union organizers in my family background, so I guess there's a revolutionary gene as well that recognizes that nothing really great is created without some risk. Is the purpose to live a life that's safe and conventional? For one thing that's an illusion because it doesn't exist, and what do you do when you get to the end of your life? What have you done? So I don't want any regrets.

> **Here is a realm where you are pushed because of our ignorance to be the most creative, hardest working scientist that you can possibly be because you're working right on the edge. You don't have the comfort of falling back on methods, tools and techniques (well we do have some) but they're not sufficient to advance it quickly.**

Q: *And you had to go and write that silly book, and now everyone wants to talk to you. Why did you leave the school?*
RADIN: I left because they failed to renew my contract. It wasn't my choice: "You should probably go somewhere else now."

Q: *How long were you there?*
RADIN: Four years. I don't think it was a coincidence that one month after the book was published and I started to get a lot of media attention that suddenly they started to feel very uncomfortable about it.

Q: *They didn't like that sort of attention.*
RADIN: Yeah. I can imagine what it must be like to be an administrator. His job is to uphold the status quo.

Q: *Does Princeton care about Robert Jahn and PEAR (Princeton Engineering Anomalies Research?)*

RADIN: Yes. Sure they do. For political reasons his research cost him his dean-ship, but they can't get rid of him because he has tenure. Whereas people like myself and other colleagues who are going through the same thing are let go. I didn't go into academia because I wanted an academic career, but because it was the appropriate place to do this kind of research. It not short-term project-oriented like industry.

Q: It's the difference between a merchant and a scholar.
RADIN: You would think that academic freedom issues developed precisely to protect people from this sort of persecution, but the history of ideas is full of it. It's distressing to see that it's still prevalent, but again, you must imagine what it's like to be an administrator whose job it is to maintain things in a conserva-tive way. If I was in that position, I would handle it in a very different way than they did. I would advise people who are getting publicity for controversial topics to be very quiet. One of the reasons that I've been talking to a lot of media is precisely because the perception has to come from there. After Rhine [JB Rhine-parapsychology researcher from Harvard who began his studies in the late 1920s with the famous ESP cards] died, no one took up the mantle again. It's been to everyone's disadvantage for the last 30 years that there is no recognizable authority (with the credentials or whatever) to counter what CSICOP has done.

Q: Hey, speaking of CSICOP, your friends Penn and Teller are in town at Bally's.
RADIN: Well, they live here now. I think I just understand things a little too well. I can put myself into other people's positions too easily. So, in the case of Penn & Teller and a lot of other magicians, they see a lot of deception and fraud, and it angers them. It angers me too, but that doesn't mean that I automatically snap shut and reject everything. Clearly a lot of the people that are making claims are doing so because the public is gullible and they're taking advantage of them. So I applaud CSICOP for that. If people are perpetrating bunk, then debunk them, but it doesn't mean that everything else is illegitimate.

Q: Yeah, they do cross that line indiscriminately.
RADIN: It's proselytizing one way of viewing the world, which will automat-ically exclude other things. As I try to point out in the book, even the skeptics who have paid attention to this realize that there is quite a difference between the Penn & Teller view of the psychic world, and all the nonsense that goes along with it versus what scientists have tried to do. It's been an uphill battle, and I realize that the way to change people's minds in this era is through the media, because that's all that people ever see. CSICOP performs a certain service, which is valid, and I guess I do too, but it puts me at risk. It got me thrown out of the University. But if I were risk-adversive I would never have done it in the first place. I figure it's worth it.

Q: Have you had anything "anomalous" happen since you started this research?
RADIN: The most amazing experiences I've had have been in the laboratory.

I would advise people who are getting publicity for controversial topics to be very quiet.

"Separateness" science
BASIC ASSUMPTIONS:

- The universe is made up of fundamental particles and quanta that are separate from one another except for certain connections made through fields.

- Nonnormal states of consciousness, dissociation, and so on, are to be studied in the context of the pathological. Consciousness is a by-product of material evolution and is an epiphenomenon with no intrinsic meaning or purpose.

- There is no evidence for "drives" or "purposes" in evolution. What appears as a survival instinct is merely the result of natural selection; any organisms that did not have such a drive were selected out. There is no scientific evidence for any thing in the universe resembling "purpose" or "design." The biological sciences use the term "teleology" for convenience, but what it really means is that those structures and behaviors were ones that contributed to survival.

- A scientific explanation of a phenomenon consists in relating the phenomenon to increasingly general, fundamental, and invariant scientific laws. Ultimate scientific explanations are in terms of the motions and interactions of fundamental particles and forces.

- The truest information about objective reality is obtained through the observer being as detached as possible. A clear separation can be maintained between subjective and objective knowledge.

- All scientific knowledge is ultimately based on data obtained through the physical senses. Such information is ultimately quantifiable.

I'm enough of a psychologist to realize that there are a number of coincidences and synchronicities that occur in the lab that are personally meaningful, but we don't know what to make of it. I mean, I've had the experience of picking up the telephone with the intention of calling someone and having them on the line. What do I do with that? I just check it off to personal experience. But what really gets me excited is setting up something in the lab where you know under controlled circumstances what you wish to occur, and then you see it happen, which is much, much more meaningful-for me.

Q: What is meta-analysis and why is it important to parapsychological research?
RADIN: Meta-analysis is conceptually the same as running an experiment. The reason you do multiple trials in any given experiment is that you're not dealing with phenomena that are 100% reliable, so if you have to rely on a statistical likelihood of something, you have to do it repeatedly. As soon as you realize that you're working with something with degrees of existence, you must also realize that an experiment will have a probabalistic outcome. I mentioned eight different reasons why experiments are not so easy to do. The most important one here is the issue of statistical power. You're dealing with a small or variable effect. If you do too few trials, you don't have a very high confidence that your effect is real or excludes chance. As the graphs [in *The Conscious Universe*] show, a lot of the experiments that have been done do not exclude chance. The error bars include chance, but they're called non-replicative and that's what has sustained this mythology that none of it is real.

Q: Are you talking about selective attention on the part of skeptics?
RADIN: They look at an experiment without considering at the body of experimental evidence, and say "Well, this is a non-significant study" which is equated in their mind to "doesn't exist," as opposed to measuring what actually occurred in the study, which is quite different. This is just an evolution in the behavioral sciences and medicine, which are in the same boat. Working with highly variable living systems, we don't really know what's going on in many cases, so we need to run a single study with an enormous amount of data. A case in point is Princeton, which is a single laboratory with the same experiments and an enormous amount of data, but nobody believes them. Why is that? Well, it's one lab. The criticism is: Do other labs get the same result? So other people replicate the same thing, and the question becomes "What has the entire group found?" If they are simply not able to replicate the effect at all, and you're looking at all the data, then you're justified in concluding that there's nothing happening. The fact is in all the large classes of psi phenomena, the effect *is* there. On an individual basis, some of the experiments, they don't work, but in the concatenation of them, they do. So the value of meta-analysis for parapsychology is the same as it is in psychology and medicine. That is, to show that these highly variable things that we call human beings translate into these multiple experiments, and it's only by combining them and looking at it as a body of data, does the effect suddenly become real.

Everything I've just said is geared toward the idea of proof. The very

next question that people come up with, and I've been criticized for in this book is "Well, how does it work?" It's frustrating because getting to the point of proof of principle is so difficult. We've spent a century on this stuff, and to make this cavalier statement of "Maybe it's real, but so what?" as I point out in the book is going from stage 1 to stage 2 [see sidebar] everything else is forgotten. It's as though there never was a stage 1. It will be the same when we get to stage 3. There is also something called "hindsight bias" where all of the previous argument just vanishes, and for somebody who has been pushing to get to that point is very frustrating, because the history of it just vanishes. I wrote a chapter which the editor took out that showed this effect over and over. It's such a predictable part of human nature, in the way that people react to things that are not quite on the plate yet, and I wanted to illustrate we are dealing with the same thing.

Q: What is the saturation point at which the ideas and technological use of psi will be in common usage and parlance?
RADIN: I've talked to a lot of people about this, and my sense is that it won't be that much longer, partially because of other theoretical developments in other areas. It's also a sociological change, which is reflected by things like the enormous popularity of alternative medicine.

Q: There's a readiness.
RADIN: This is true among the general population, but also among scientists and technicians as well. People are more willing to make it public. If you have just graduated from college, and you're not yet "solidified," and you're around senior people who are talking about it without that kind of hate or taboo, it allows the topic to be thought of and treated in a way that it hasn't before. I have great sympathy for scientists who were trying to work in the Dark Ages-during the Crusades and the Inquisition. You simply could not talk about certain things. That doesn't mean that it didn't go on, it just went on secretly, and at great risk. This never went away, but we're at the point now where the Inquisition is not dying out, but putting its attention on other things, and allowing it to develop a little bit.

Q: Like alternative medicine.
RADIN: Right. Hospitals and insurance companies are allowing people to use these things, and if it works, why are we suppressing it?

Q: If the economics show efficacy, perhaps that's the quickest acceptance. It wouldn't matter what the reason is.
RADIN: That's why Silicon Valley is interested. It also valuable for scientists who are interested in this to talk about it more and more openly because of the danger that as the taboo starts to break down, everyone who would take advantage of it for fraudulent means will do it even more so, "Since science has proven it, I can charge $5000 a head instead of $1000." The only way to counter this is to have a voice of caution and authority around to talk about

"Wholeness" science BASIC ASSUMPTIONS:

- The universe is a single whole within which every part is intimately connected to every other part.

- The entire spectrum of states of consciousness, including religious experiences and mystical states, has been at the heart of all cultures. These states of consciousness may be an important investigative tool, a "window" to other dimensions of reality.

- Human beings are part of the whole and there is no justification for assuming that "drives" such as survival, belongingness, achievement, and self-actualization are not also characteristics of the whole. Similarly, since we experience "purpose" and "values," there is no justification for assuming these are not also characteristics of the whole. The universe may be genuinely, and not just apparently, purposeful and goal-oriented.

- There is no reason to assume that scientific laws are invariant; it seems more plausible that they too evolve. Hence, extrapolation to the big bang may be suspect. Evidence points to consciousness either evolving along with, or being prior to, the material world.

- There is an ultimate limit to objectivity, in that some "observer effect" is inevitable in any observation. Understanding comes not from detachment, objectivity, and analysis but from identifying with the observed, becoming one with it.

- Reality is contacted through physical sense data and through inner, deep, intuitive knowing. Our encounter with reality is not limited to being aware of messages from our physical senses, but includes aesthetic, spiritual, and mystical senses.

what we think we know at this point, and hope that people listen. This is as opposed to the approach which has been taken before, which was to say that "None of this is real and it deserves ridicule, and it should just stop." That doesn't serve anybody.

Q: You make reference to Jung's "psychoid forms" - that is a physical object that is brought into existence by a critical mass of intention. Have you encountered this phenomenon, or been exposed to any evidence for this effect?
RADIN: A case can be made that an experiment, no matter how rigorously designed it is, is a manifestation of a psychoid form in the Jungian sense. You put a lot of intention and design and thinking into a project, by yourself or with other people, and wish to see something. There is this mythology that scientists are completely neutral about their topic, but this is ridiculous, since if you were neutral you wouldn't study anything! Scientists are always polarized in one direction or the other for or against something they wish or wish not to see, depending on their predilection, or who the funding agency is. The hope is that methodology like randomized trials and counterbalanced designs are sufficient to overcome the natural human bias that we have. What some studies suggest is that they're not sufficient. You can design the most rigorous, double-blind, randomized trial, and it will still show differences depending on the expectations of the experimenter. Some of the reasons can be described as psychological reasons, but not all. It's important to realize that any methodology has limitations. Among other things this is not as strictly a subjective world as we thought it was. That makes people very upset.

Q: How could you get past that?
RADIN: We don't know yet, and that's a topic of contention amongst researchers right now. It's extremely important to figure out what the next methodological steps are, and there are some ways of doing it. For example: It's too bad that deception is not as easy to work with as it used to be. For ethical reasons it's very difficult to use deception in experiments, but you can do the equivalent of it by selecting subjects and experimenters based on their prior belief. It would be very nice to run an experiment at a psychic fair, where the dimension of belief is known very well. So is a CSICOP convention, where you have belief on the other end of the scale. And you can make predictions, because we know very well that belief modulates what people can see. The second level is that you want to select your experimenters on that basis as well, so we've done a selection of the population for experiments. We haven't done a selection of the experimenters, but there was an experiment reported last summer where a long-term successful psi researcher and a long-term skeptic (but an interested skeptic) did an experiment on the feeling of being stared at from a distance. They used the same laboratory, the same experiment, the same population pool, and they interweaved the sessions so that there wasn't a time-sequence problem. The proponent got significant results in the predicted direction, and the skeptic did not. This is a strong confirmation of the idea that whatever the experimenters are doing in these studies is not magic, but they are conveying something to the subjects involved (and maybe

Scientists are always polarized in one direction or the other for or against something they wish or wish not to see, depending on their predilection, or who the funding agency is.

in their own methodology) which makes a different experiment. A psychologist who has studied expectation effects would say "Duh! This has been known for 30 years. The experimenter invariably affects the nature of the experiment."

Q: What does that say about the effect that was being studied? You have a conundrum where it exists and it doesn't exist at the same time.
RADIN: Well, it's not in the realm of "No hypothesis exists, but nothing is going on." That's where the "Duh" stops. If you're doing a conventional study on perception or cognition or something that everybody agrees is real, then the experimenter effect is easy to show, but it shouldn't show up in something where convention would say that there is no effect to begin with. So we're able to modulate through belief and expectation even something as subtle as psi. Well, actually the effect is not subtle, but our methods for detecting it are like trying to hit a fly with a sledgehammer. That's closer I think to what's going on here rather than that we're dealing with a fragile phenomenon. It's the nature of the methods that are developed or were developed for other reasons. Methodology evolves as well.

Q: How have you been able to "shrink your sledgehammer?"
RADIN: Physiological detectors, which get you out of the game of having to consciously report reactions. That makes a big difference.

Q: That's like a lie detector?
RADIN: GSR [Galvanic Skin Response] yeah. The effects seen in those studies are comparable to some of the remote viewing studies, but they're one or two orders of magnitude larger than using a random number generator. It's partially because it's a biological target. You're not asking anybody to do anything. It's all happening below the level of awareness, in which case you have a chance of bypassing expectation effects.

Q: So, you wouldn't even tell the subject what's going on, what's being studied?
RADIN: For ethical reasons you have to tell them what the experiment is like, but they don't know anything about it, and don't have to do anything about it.

Q: I heard that Sony and Nintendo were at the Society For Scientific Exploration's meeting that you hosted this last August. Do you know how far they've gotten integrating psi effects into their technology?
RADIN: It's very difficult to tell. I don't think anyone's near commercializing anything yet.

Q: I know that PEAR has that "box" that they want to market that supposedly closes a circuit by intention.
RADIN: Yes, but these are just games.

Q: But don't you think that this sort of exposure to the public at large could break the final barrier of resistance to psi concepts and effects?

> **We're able to modulate through belief and expectation even something as subtle as psi. Well, actually the effect is not subtle, but our methods for detecting it are like trying to hit a fly with a sledgehammer.**

RADIN: A lot of people have reported good feedback, but the effects are coarse.

Q: Well, so was laughing gas when that was discovered.
RADIN: It could create something like a grass-roots change of opinion, since people can do something for themselves. It's not clear that this is any different than the ESP cards that were a fad in the 1950s. Someone doing something in their house for their own amusement doesn't necessarily bubble up and change things. People are not the ones who decide what culture accepts. If the editor of the *New York Times* is personally convinced that there's something interesting going on and started writing editorials about it, then that would make a change (if he didn't get fired.) So there is a strata of media and technical power elite that pretty much determine what is sociologically correct to talk about.

Q: Do you have the feeling that younger people would not accept that as easily? Perhaps it's just because they're not enculturated yet...
RADIN: Partially that, but the media supports the idea that there should be a certain amount of rebelliousness among the youth, therefore they should be cynical of blah blah blah.

Q: Maybe the inquisitiveness is what is lacking.
RADIN: Well, the great promise of democracy is the free flow of information, in which case it becomes more and more difficult to create an image of the way things ought to be. The national media are very powerful in presenting the way things ought to be. It's nice to see more magazine-type shows in primetime, because even though they're extremely conservative, they are presenting opinions and people stories. You figure if the average person is watching TV for 4-6 hours a day, holy smokes-what a brainwashing tool. The media has the same fears about ridicule and credibility that everybody does, and so it takes an enormous amount of courage and maybe stupidity to challenge it in any significant way.

Q: This brings to mind Gary Webb's CIA-crack story and the San Jose Mercury News' *initial support. After a few months of ridicule by other papers, they demoted and reassigned him.*
RADIN: "You shall not say this, and you need to go away now." We live in a society where information is mediated socially, and it almost doesn't matter if it's true or not. What matters is how you and I react to it, in which case it's a very tough nut to crack. In this particular case it might be cracked from the bottom up, and games and toys might do it, or it might happen from the top down, and it's already happening top-down. I'm not at liberty to discuss who I'm talking with, and what positions they're in, but there are a lot of people.

Q: Can you talk about what they're talking about?
RADIN: There's a recognition in some quarters of the national media that previous taboos concerning psychic phenomena and spirituality have been too conservative. There's an unstated agreement that some ideas shall not be considered mainstream. You see an example of this in the story about Hillary Clinton

> **The media has the same fears about ridicule and credibility that everybody does, and so it takes an enormous amount of courage and maybe stupidity to challenge it in any significant way.**

using Jean Huston to communicate with Elanor Roosevelt, and this was a perfect tool for ridicule. This was used widely with almost no defense for it, and of course it was completely absurd, because the nature of what was going on was distorted beyond recognition. Well, where does that come from? Partially from the personality of reporters who are taught to be skeptical and cynical.

Q: I heard from a friend recently that some pundit on a Meet The Press–*type program was lamenting the fact that with the world wide web everybody can look like* Time magazine. *My reaction was, "So what? Now people will have an opportunity to look for their news and make their own minds up."*

RADIN: Most people don't have the time or the inclination though to figure out what they want to believe. There's great value in professionalism. A good journalist can convey information in a way in which other people can't, and I respect that talent, but there's an enormous amount of power in it. Most people in media know this. They can make you love or hate someone very quickly. I'm most sensitive to this in areas of science. Science that begins to challenge core concepts about who we are and what we can do, and things of that sort.

I think one of the taboos that is slowly breaking down is the one that separates science from religion. Religion is a touchy subject, and obviously people have strong beliefs in that area, so it probably won't be cast in those terms, because nobody's going to come out and say "this church is right, and the others are wrong." It will probably move in the direction of recognizing that the world is a unified whole, and separations made by the "fracturing" of the universe by science is a completely artificial way of carving things up. What's worse is that it carves up the world and leaves out very important things. Some of those things are handed over to religion: Issues of meaning, faith, values, and ethics and philosophy formalized by law to some extent. There's an assumption that these things are outside of the realm of science, which is *ridiculous*. That comes from the point of the view of science saying "All we deal with is the physical world and understanding how things work, and making models of it." Well, meaning and ethics and values are part of it too, or you start having to postulate a non-physical world, and scientists don't like to do that, so they say everything is physical. When you need to understand what it means, then that spawns the idea of studying consciousness and the nature of the mind. One view says that it's all hard-wired brain stuff–it's a big illusion and it doesn't matter except for personal and humanistic reasons.

Q: An article I was handed by a skeptical friend from a CSICOP *magazine* (Free Inquiry) *discussed the idea that consciousness was "simply" the interaction between memory and current sensory input.*

RADIN: That's a prevailing view, and he's probably right, except that's not all it is. The "nothing but" school of thought tends to be pretty heavy in the skeptic community. It is mentally uncomfortable to entertain opposing hypotheses or uncertain hypotheses. Some people just can't do it. My experience is that people who are artists or do some kind of creative work live for that — they love it. I love it. I don't like to prematurely collapse into one position, because

> **There's an assumption that these things are outside of the realm of science, which is ridiculous. That comes from the point of the view of science saying "All we deal with is the physical world and understanding how things work, and making models of it."**

I immediately start worrying "Is this right?" It's an uncomfortable position to be in, so you have to be willing to live with that.

There are people at large institutions I've talked to, directors, etc. who will privately admit that they are really interested in this stuff. They know that there is something very important underneath it that ought to be looked at, not just for the spirituality thing, because nobody really knows what that means, but because society is kind of at a turning point now that it was at a hundred years ago. A the end of the 19th century scientists and businessmen were very proud of themselves and the very rapid accomplishments that had taken place up to that point. It started to look more and more that the world was like a giant clockwork–in which case there is no room for all this other stuff, which we personally find meaningful. That was one of the reasons that Spiritualism became so popular practically overnight was because of the recognition that maybe there was something left to learn.

The other day I was talking to a bunch of folks about this, and I asked whether scientists of one hundred years ago had a sense that this was about to occur, not just in relativity and quantum mechanics, but in molecular biology, and other realms that were about to explode. Was there a sense in people who watched these things, and the equivalent of sociologists, could they feel that something was changing? And the consensus was that we don't know, really. I suppose that you would have to talk to a social historian, but I suspect that the answer is "yes." Some people would have felt that they knew everything, and "Yes, we can make this all from the ground up" but that's not all there is. There's something more. This is of course built into the process of science, but it's easy to forget. So the evidence for psychic phenomena is saying that right now we're at another turning point. A lot of people recognize that, and they did even before they'd seen my book. One of the reasons that people pick it up and go away with a little more of a sense of solidity about it, is that it's confirming what they already know.

> I don't like to prematurely collapse into one position, because I immediately start worrying "Is this right?" It's an uncomfortable position to be in, so you have to be willing to live with that.

Q: *That's just how I felt.*
RADIN: It remains invisible until it becomes OK to look at it. That's why I put that chapter in the book about "Seeing Psi." The effect of psychological blinders are not just individual, they're societal as well. It really does prevent us from seeing things that are every bit "there" as anything else, but they go away because we're not allowed to see it. So here we have this rising tide of opinion (of course I don't talk to everyone, just people who are interested.) What we have at least is a slice of humanity who are interested, but the reason I think it's important is that among that slice are business leaders, media leaders, and other people who are in a position where you'd think that they could do something about it. So things are slowly changing. If all goes well, Sony will no longer be the only outfit that's looking at this in a major, serious way.

Q: *What are some of the implications of psi concepts and principles for classical and quantum physics?*
RADIN: Classical physics is still what most people use as their model of the world, since it's what we see, and it's challenged mainly by the concept that

information somehow passes unbounded by space and time. From a classical perspective, we don't know how that could happen. Sometimes when a skeptic says that "This can't exist because it violates natural law," or "the laws of science" they almost always mean that. They mean a naïve, classical view of science, mainly of physics, but of science in general. That view is one which is highly reductionistic and in which things only occur because you have the equivalent of billiard balls and sticks, and if you can't explain anything by that level of causality, then it doesn't exist! It turns out that that model is very powerful, and that's why we learned a lot very quickly. The reductionistic model is very good.

Q: It plays off our senses and is reinforced by them.
RADIN: It's still the basic driving mechanism for neuroscience and a lot of other realms as well. The problem is that after the realization that there are emergent processes that occur, where you can't predict what will emerge from something even if you know it at this basic level, then that reductionistic model is the only one that gets blown out of the water.

Q: I guess that happened in the 1920s and '30s.
RADIN: Well, things take awhile to infiltrate the rest of the world.

Q: Perhaps the nails of nonlocality take awhile to get pounded in one by one.
RADIN: It's clear now, especially since the 1930s, when relativity was tested and confirmed. Suddenly the classical view was shattered, but it was so far out of the realm of ordinary existence, that people didn't pay any attention to it, and most people still don't pay attention to it. I mean, how many physicists or other scientists are concerned about these issues? It's a small percentage. So when you come down to the actual number of people who would really be disturbed by this, it's really not that many. Most people couldn't care less. It just happens that the few who do care, tend to be vocal, so they write books and they do talks. It's very easy to take the position of (and this was done in the late 19th century as well) "anybody can just see from their own experience that if you do such-and-such, this is how the world works." That's what I call naïve physics. But we've learned through other instruments that the world also exists in other ways. It's becoming easier to find books that talk about modern physics and quantum mechanics and "post-modern physics," whatever that is.

It's unpopular in academia to write popular books, which is just mind-boggling. There's a prejudice against writing popular books. The prejudice is "keep the science for the scientists. Don't democratize this information because people might misuse it or..." what in the world. "They will misuse it by using nonlocality to sell things and take advantage of people. And you know what? It happens! There are ads in magazines that sell these "tachyon particles," faster than light particles somehow embedded in beads and fabric and stuff. They have tachyons in them and they're supposed to give you additional energy, and etc. I'm not a physicist, but when I look at this stuff I don't get angry, I get amused that someone would look at this [picking up a french fry] and say "This is a

tachyon french fry, and it has special particles in it that are invisible, that only we know how to put in it, and if you eat it, you'll feel much better."

Q: ...and science has proven they exist.
RADIN: And if you believe it, the placebo effect alone will make a difference, but as far as a scientific basis, this is ridiculous. I'm not threatened by it, because I see it as entertainment, but I could see how it would be. If my job was studying tachyons and someone claimed they were in my french fry, I would be kind of upset about it. But personally, I only start becoming concerned if somebody is spending their life's savings on it.

　　You won't see psychic phenomena if you don't think that you should. I don't think many quantum physicists have been pushed to believe in telepathy as a result of the verification of nonlocality. In reality, we don't really under-stand what "nonlocality" means either. There's a lot of talk now about "entan-glement," where particles interact with each other and entangled with each other's history in some weird way.

Q: But that's almost like "balls and sticks" though.
RADIN: We have to talk in terms of balls and sticks, but we're actually talking about probabilities. Entanglement discussions are central to the development of optical computing and quantum computers, which will be amazing things when they occur, since there are actually people working on this stuff. It's like a leap between sequential programming and parallel programming, where these computers will work off of superimposition of states-this is a quantum idea.

Q: It seems that this is the way that an artificial intelligence would have to work-emulating natural thought.
RADIN: It's not quite going in the direction of the way the brain works, but maybe this is something that will transcend it. Who knows?

Q: Then it sounds like what you're getting at is that consciousness works in a way that's not stuck all in your head.
RADIN: Yes, and that's the point. We are always limited by what we can imagine. Science Fiction writers are not limited by what they can imagine, because that's their job. In this case, I don't know where the future of nanotechnology and quantum computing are going, but in discussions I've read from newsgroups the idea of psychic phenomena comes up. Some of the descriptions of what these things seem to be capable of would be called "psychic" in our world. "What would the experience of that device be like to us if we could have that experience?" The answer is that if we could, it would be something like telepathy or clairvoyance, just by virtue of the physics of the system. Post-Classical physics could be that the taboo against the possibility of what we call psychic experience is the realization that this is actually our perception of the actual nature of the physical world. "Telepathy" is our expe-rience of nonlocality, and clairvoyance probably is too.

> **You won't see psychic phenomena if you don't think that you should. I don't think many quantum physicists have been pushed to believe in telepathy as a result of the verification of nonlocality.**

Q: *It would seem that when you get to these levels that dualism breaks down.*
RADIN: I think that dualism started because it was just mentally easier to think about the world being separate. It's conceptual baggage that will take a long time to go away. I can imagine a world where kids are brought up (and this happened in the cultural revolution in China) where in one generation you can completely change everything. Overnight, all the books are gone, and you have new books and they're trained in a new way. They don't know any better. That's not going to happen here, but something like that may happen over time. The view of what we think is possible will change in terms of what is taught to kids. I don't know at which age kids are taught about relativity, but it's an astounding shift in the way that the world can exist. So, something like that may happen and psychic phenomena will be recast in another name. See, the world is everything, and we carve it up and give it a name, and we claim it, and suddenly it's acceptable. The same thing is going to happen to these kinds of phenomena.

Q: *In reference to UFO and related phenomena, do you think that mind could conceivably affect "ephemeral matter" to conform to societal or just expected forms? Is it a "downward causation" effect?*
RADIN: Yes... We don't know the limits, especially given the more recent evidence on field consciousness. We really don't know what the limits of that are. Events like the Marian visions at Fatima that 20- or 30,000 saw, people saw different things, and even skeptics saw weird stuff. It's possible that there was some strange natural phenomena, and yet it was predicted on a certain day at a certain time, and it becomes less likely that the girls knew [in advance] that there was some one-month repeated cycle. In this case it becomes more likely that the expectations or wishes of all the people there caused something to occur, and it was interpreted in a way that persists to this day. So you'd think something like that, certainly in a country that had bizarre geophysical things going on would push people a little bit. You could imagine a plot for a story: You have some sort of secret military thing beaming who knows what into the air. All the local people don't know about it, and the military denies it.

Q: *Kind of like HAARP. [High Altitude Auroral Research Project]*
RADIN: Yeah. And people start seeing UFOs, or having psychic experiences, or whatever. Meanwhile, all the neuroscientists involved in the project are saying, "Yeah, we know what's going on: they're getting their brains scrambled, and they're reporting everything we'd expect them to report." Except that this begins to have a precipitating effect. This is when you initiate something artificially which is false through manipulation of belief, but people don't know that, and as a result their belief changes and it allows new things to occur.

Q: *Meaning that someone who was not subject to the effects could look at it with a telescope from 30 miles away and see weird things going on as well..*
RADIN: Yeah. Their brain is not being influenced in the same way, and yet these folks whose brains have been altered in some way begin to believe something, and that belief begins to become recursive with the local environment

> **"Telepathy" is our experience of nonlocality, and clairvoyance probably is too.**

and changes it in some way, which becomes strong enough to push it into the realm of objectivity where people know that something is going on. They may not get a sense of craft or lights, or anything, but they may get a sense that *something* weird is going on.

Q: Have you talked with Jacques Vallee since he wrote Messengers Of Deception?
RADIN: Yeah.

Q: That's based directly on that idea, and then he released Fastwalker *[in English translation] a couple of years ago, which carried that concept to an extreme. He's not willing to say what's based on fact, and what isn't.*
RADIN: I know Jacques pretty well. He's into all kinds of weird stuff, and he's very knowledgeable about it.

Q: He doesn't talk about it too much.
RADIN: He's not at liberty to do that, and I don't know what I'm at liberty to repeat, but I guess if he told me something and didn't say to keep it private... I'll just say that in general, there's a lot about exotic military hardware- experimental gizmos–most of which is mistaken for UFOs. Some of which can indirectly (not intentionally) cause people to perceive things. You can imagine that having this gigantic electromagnetic thing hovering in the air, it changes the local environment in ways that makes people's brains go funny. That sort of stuff apparently really does go on. It's no coincidence that many of the sightings occur near military bases. It's no coincidence that the military bases also deny it. It's been known since the beginning of Bluebook that sightings cluster around bases more than anywhere else. It raises the likelihood that when you have a climate that has to deny what is going on, combined with exotic hardware and unlimited funding (so you can make really strange devices) this virtually creates UFOs. If they weren't around, they would be created anyway, because things are seen all the time. What's more interesting is not the brain scrambling, since this is reasonably well understood, but what the consequences are of creating those changes in perception. The unethical part of this is allowing people to sustain what in many cases is an illusion. Sustaining that illusion, and building your life around it, I mean people go nuts with this stuff.

Q: That sounds like the Paul Bennewitz case from 1980-81. Instead of jailing him for failing to cease and desist from picking up coded transmissions from the Sandia-Manzano complex outside of Albuquerque, the AFOSI decided to let him persist in his folly and build on it. He went literally crazy.
RADIN: The human psyche is very fragile. It is not difficult to drive somebody nuts. You can make somebody paranoid in *minutes*.

Q: I know.
RADIN: I wouldn't be surprised that in the work you're involved in, that you have had what you consider to be a "men in black" experience, because it's so common.

When you have a climate that has to deny what is going on, combined with exotic hardware and unlimited funding (so you can make really strange devices) this virtually creates UFOs.

Q: I haven't.
RADIN: Well then, you will.

Q: I had a glass break in my hand in August. I was going through a tough time at home and I was holding a glass in my right hand. I heard a very distinct "pop" and felt a small concussion of an explosion. The glass pieces went flying in every direction, and some landed ten or more feet away on the kitchen floor. It didn't really startle me until about five minutes later.
RADIN: That's because in context, that's precisely what should have happened. Anything that threatens the core "sense" can externalize and cause physical effects.

Q: That sounds like the "pop in the bookcase" story with Freud and Jung.
RADIN: Yes. My friends that tell me stories like that all the time-really strange externalizations of internal anxieties and anger. In fact there's a story in the book about "Gail and Dan." I was "Dan." I saw these things happen, and I know very well that high anxiety (which is really just Murphy's Law pushed to the edge) spills out into the world and causes bad things to happen, especially with electrical things, which are unstable. I would love to find some way of doing that in the lab.

Q: You'd have to get people upset! "Feeling down? Suicidal? Come to our lab!"
RADIN: *Really* upset. Right up the edge. Psychotic break types. I wanted to do a study here in town with disturbed youths who were in prison. It would be very interesting to put some of these random number generators and other stuff in a place where there are already a lot of nerves on the raw edge of explosion, and see what happens in that environment. I went as far as investigating what would be required for consent, etc. and we discovered that we could probably do the experiment, because the kids were bored to tears, and they'd love to do it, and the people who run the place would like it too. We were afraid, though that the kids might literally destroy the equipment, and we couldn't afford that. So, it's a nice idea, but...

Q: I was interested in the concept of "downward causation" as you discussed in the book. What was the origin of that idea?
RADIN: It comes out of pure psychological theorizing. What accounts for teleological effects - purpose and goals? The mechanistic and reductionistic universe doesn't have purpose and goals. It's an abstract thing that we develop that's racked up to ideas like free will, and that sort of thing. The skeptical neuroscientist will say that it's an illusion. It's driven by the same sort of stimulus/response mechanism as an amoeba. The amoeba's goal or teleology might be to go towards light. This is a purely mechanical process. "I feel that I really want to see *Seinfeld* tonight": that's the goal, the teleological drive. The skeptic would say that you are conditioned as an organism would be. You gain a certain pleasure out of that, and that's why you feel that goal.

Q: Then I guess scientists do experiments purely for pleasure!
RADIN: I've been to conferences where someone will forcefully argue that

"none of this matters, because we're talking about illusion."

Q: *"Well then, what do you care?"*
RADIN: Yeah. "Why are you so excited?" It's always an argument, and many people accept this, that "There's nothing going on up there." It's sort of a grand "stimulus-response-machine-illusion" sort of thing. That may be true, but my passion is an organismic-mechanistic driving sort of force. I don't really care if it's true. It really doesn't have an impact on whether psychic phenomena are real. I don't really care if they're real either. It would be nice if this was real. I kind of believe in the science aspects of it where you start questioning the methodology, you start asking "what is consciousness?" what are the bounds of it, etc.

After a while, you start wanting to make "muffins or salad." That's about it. You start getting into the realm where I'm not sure whether we have the cognitive apparatus to understand things at this level of detail. It's on that basis that these books about "the end of science" are based. It's not so much that we've discovered everything, but maybe we're reaching a limitation on what we can understand. An individual can no longer absorb enough to understand things much more in depth. I'm enough of an optimist that to think that we're clever enough to figure out ways of expanding what we know, because I suspect that a hundred years ago, people had the same problem. It takes someone like Einstein (and others) to come along and say "Well, what if we do *this*?" That was an artistic or intuitive act, and not one of science. Science as usual will continue to plod along in an evolutionary way, and get closer and closer to an asymptote of what's possible on its boundary horizon. It keeps expanding until people start writing books about how we've reached the end. What they mean is that we've reached under the current set of assumptions, and it takes an artist to pound through that.

Look at how people responded to the wave theory of light and to quantum theory and really all new theories, even Maxwell's equation. A conventional view says that "this is completely absurd, and it will set us back a hundred years. No one will ever pay attention to us again, and it will be the most horrible thing that we could do." You see this over and over again. It's the same response. It's almost like somebody's assigned the role to say this, and defend tradition.

Q: *The "big theater."*
RADIN: There's a drama going on, and people unknowingly have to adopt certain roles. I had a very strong intuitive sense that in the midst of the problems with the university, that we were playing out a drama that has been repeated from Galileo onward.

Q: *And Socrates and Giardano Bruno…*
RADIN: It's something about ideas, and clashing with institutional authority. I was being objective and dispassionate as much as I could. I kept using my boss as sort of a reality check on it: "Am I crazy or…?" We kept getting these documents coming in, and at each stage he'd shake his head. We didn't know what

> **There's a drama going on, and people unknowingly have to adopt certain roles. I had a very strong intuitive sense that in the midst of the problems with the university, that we were playing out a drama that has been repeated from Galileo onward.**

was going on here, because it was so irrational, but it was almost as if someone was scripting it to make an interesting story. It started me thinking that this story seems to have to play out every so often.

Q: *I always thought that on a clinical level, the psychologist would have to treat every case on it's own parameters, and change the "stories" to suit the situation.*
RADIN: There are always little things that are different, but the basic stories are the same.

Q: *I guess it becomes easier for them to write self-help books with these basic scenarios in mind.*
RADIN: The scenarios are so well known that books like *Men Are From Mars/Women Are From Venus* are so popular: because people recognize their behavior, and those of their spouses, etc. It's all very predictable stuff. And the question becomes: When you get to the end of all that, where's free will?

Q: *That was my next question.*
RADIN: I think there's very little of it. Free will is expressed most often in creative work, and one of the ways of seeing it perhaps is in the kind of creative work that drives people nuts-in music, art, film, and even science. If you're extremely lucky you get a reaction like "Wow, that's great. We like that." I remember for example when I saw Robert Palmer's video for "Addicted to Love." The first time I saw that, I thought "This is going to be a major hit" -those women dancing in the background and everything. It was just a perfect distillation of differentness, of creative effort. And of course it was a giant hit. Then you get something like Stravinsky's *Rite of Spring*: the first time that was played, the audience went into a riot. This suggests that we have a limited way of responding to things in the world, and most of the time, we know how to deal with it.

In a roundabout way now, given what happened with the university, there's kind of a confirmation (even though it's not something that I particularly liked) that it mattered.

Q: *I wanted to know if you think that there is a propagating medium for psychic effects?*
RADIN: In a word, no. I think that we're dealing with something that's closer to the eastern philosophical viewpoint.

Q: *Like "chi."*
RADIN: Well, that's a western name for an eastern concept.

Q: *I guess it makes things easier to understand in terms of a "force."*
RADIN: A force that has power and direction, and that may very well be true for the short term, or close-term effects like hands-on healing, etc. I'm sure that there are ways that we can change the electrolytes in the body and create huge fields. We know that experimentally, fields of a couple hundred volts are possible. If you can create fields of that magnitude around your body, you can create palpable effects.

Free will is expressed most often in creative work, and one of the ways of seeing it perhaps is in the kind of creative work that drives people nuts-in music, art, film, and even science.

Q: I suppose if the patient believes in the efficacy of the healing, that would help too.
RADIN: If both believe, it's better. There's a creation and a receptance. So I believe that some of that stuff is real, physical, electromagnetic stuff. Especially when people say they feel that something is happening like during massage and so forth. It's much too real and "touchable" somehow, to not be electromagnetic.

Q: Like Stanislov Grof's holotropic breathing that you said was used in one experiment.
RADIN: For distant healing though, there's something else going on. The field drops off too quickly with distance. Here's an analogy: Somebody who goes into a field and dowses for water can be looked at as someone who's sensitive to electromagnetic fields created by underground water. But somebody who does map dowsing can't be working on the same basis anymore. The goal is the same. So, close-up healing and remote healing may seem the same, because the words are there, but I don't think it's the same mechanism. Sending and receiving is probably an illusion. There is no separation between the person and the object. That separation is probably a dualistic concept. It's a persistent illusion.

The problem is that this raises the specter of solipsism. Not to say that it is a solipsistic effect, but there really is a real world that is unified in a way that we don't understand very well yet. Given that mentality and the pervasiveness of it, the eastern idea of everything all being in one may literally be true. The internal sense in a case like clairvoyance is that you're *there*. In healing, you identify with that person and when you become that person, that's when the healing takes place. There are all these anecdotal-level stories that fit in with eastern assumptions and even with one of the easier ways of interpreting what's going on here. In a strange way it's most parsimonious to get rid of "message passing." We don't really need any of that stuff if we simply decide that the creation of these two different people is real at some level, but at another it's a kind of illusion. There is no separation.

So how do you account for the fact of not being overwhelmed with information all the time? The answer is that the human organism has evolved to exclude it, because otherwise you'd be paralyzed-you couldn't do anything. You'd get eaten by the tiger who's right near you. It's sort of a dualistic way of looking at things which says that there are real separate, objective and isolated events, but at another level of perception, it really is all connected, just as the mystics say. At that level, which is almost diametrically opposed to the ordinary waking state, but more readily available in other states of consciousness, you can get anything you imagine. You're only limited by your language.

This is why I have a section in the book where I explain that I'm very suspicious of people who say they're using remote viewing to access aliens and other civilizations, etc., because the only way that they can come back with an explanation is in terms of something that they will already understand.

Q: In regard to your casino studies that related slot machine payoff to the geomagnetic field and lunar cycles, I wondered if you (or anyone else) considered any other, possibly more mundane factors that might have come into play.

> **I'm very suspicious of people who say they're using remote viewing to access aliens and other civilizations, etc., because the only way that they can come back with an explanation is in terms of something that they will already understand.**

RADIN: The only thing that someone has suggested with regard to that database was fraud. Or at least a sort of collusion. The suggestion was that if the casino knew what the nature of the analysis was in advance, that they could arrange the data in such a way that the data could show up the way that it did. It would provide an interesting thing that could be talked about in the newspaper and would fill the casino up around the time of the full moon. The way the data was received was in copies of printed daily sheets of payout levels over a period of four years.

Q: I guess it might be quite a job to rearrange that data.
RADIN: Well they'd have to get ahold of the sheets at the right time and do their number shuffling in the right way. The fact of the matter is that they did not know in advance what the analysis was. There was no way of cooking it because they wouldn't know what to cook.

Q: Anything else? A Circadian rhythm or something?
RADIN: The problem with what are called "secular variations" is that there is a 27 day solar cycle. So maybe we're dealing with something like that-a solar effect. I have looked at other geophysical parameters, but the only one that really shows up is the moon. Even stronger than the moon though (and I don't know if I talked about this in the book) are tidal effects. The strongest data in this study was tidal correlations. This of course links back to the lunar effects.

The main reason I thought about the moon was that for one thing you can't do an analysis in an ordinary way by looking at what's happening on a daily basis because we don't know anything about the people involved. So you're limited to looking for environmental effects, and we only knew of two at the time. There was even a suggestion that the moon and the geomagnetic effects were linked in certain ways.

Q: I noticed that the effect was not robust enough that you would really have that much of a better chance around the full moon anyway.
RADIN: You'd have to gamble for a long, long time, over many moons, and you might see a statistical effect. It doesn't mean that it's not real, and it doesn't mean that it's not interesting, but things that appear to modulate psi also appear in the real world. You can't get much more real than in a casino.

Q: I noticed that in your book a lot of subjects that are considered "native" or folkloric knowledge came in for testing. I liked that this sort of information was considered valid enough for study.
RADIN: Any folklore which persists for a long time means something. It either means that it's a really good story, or that observation is spawned and sustained by something. The word "folk" has a disparaging connotation. Like "folk physics" or folk-psychology...

Q: Or medicine...
RADIN: Yes...are used as disparaging terms. It's an arrogant way of dealing

with observations, because for thousands of years the only way knowledge was passed along was through observation and stories.

Q: I think that the scientific establishment's posture on this is being resisted more now than before.

RADIN: This is a kind of anti-elitism stance. On the other hand, I have a very strong recognition that professionals do know a lot more than other people. You can be a professional about something where you recognize that you know a lot more without being arrogant. I'm willing to listen to anyone and talk about anything, because I recognize that at least in the psi realm that we are profoundly ignorant. Unfortunately, the more I study this stuff, the more I realize how little we actually know about it. That is the paradox of course. It's like around the time of high school or college, when you're really deep into books, and that's all you know, but you think you're really something, especially if you get good grades and good feedback. Then you get into graduate school, and this could be sustained even more. So it's not surprising that you get out of college and suddenly when you start encountering things that aren't the way the textbooks said it would be, most people ignore it. Who wants to have their illusion shattered?

Q: And such an expensive illusion.

RADIN: In terms of money, and it's more costly to get rid of the illusion at that point. It's a lot cheaper emotionally to sustain it.

Q: There was a scenario for psi applications in your book that posited passenger aircraft crews in the future who could be somehow hooked up to sensors that registered the minute changes in physiology that occur just before a stressful event (like severe turbulence or a crash) and would warn some automated system to correct for the event. What I was wondering was if this creates a paradox, since if the event didn't eventually occur, why would it need action to prevent it?

RADIN: That's a causal paradox. It's unresolved, with one exception: This feeds into this idea of multiple worlds, etc., probabilistic futures versus fixed futures, and so on. In one sense, there's just one world and one universe, but the future is not fixed: it's probabilistic, and there are events that are *likely* to occur. In the case of hitting turbulence in the aircraft, that's a probable event, but it doesn't *have* to occur, and if you change something because of the result of it, you could avoid that future. You have reacted to something that was no longer going to happen. As soon as you recognize that and start reacting to it, the nature of that future changes. You could almost detect when that recognition would occur, because it will change at that point. That's one approach. The other is that you're detecting something that really *does* happen. As soon as respond to it, you spin off a new world line, so that world line no longer has that future.

Q: So you would be using your subconscious awareness to change something that…well I can't express it properly because I can't tear myself away from a linear time sequence way of thinking.

RADIN: There's nothing linear about this. You're along some sort of a fixed track in time, about to come to some sort of future, but you don't like that

It's not surprising that you get out of college and suddenly when you start encountering things that aren't the way the textbooks said it would be, most people ignore it. Who wants to have their illusion shattered?

future, so at this point you essentially make some sort of a decision, and you go onto a new "rail." On this "rail" that future doesn't exist anymore.

Q: I think I'm starting to get this: Subliminally, your physiology will react the same to a nonlinear probability as it would to a linear probability.
RADIN: Sure. In a sense, you're not responding to an event, but to a superposition of probable events. So all if all of those possible futures are out there, then some are more prominent because they're more likely to occur, but they're all out there–all possible events. If the prominent one attracts your attention because it's more likely to occur, then you can do something to keep from diving into that future and change the probability of it. So, there is a causal paradox, but it's not wound that tightly. It's a loose thread that can be disconnected.

I like the idea of the "probabilistic mush" because you don't need to start thinking about spinning out other worlds, etc., and it feels a little better in terms of the ideas free will and destiny being wrapped into one. We're talking about changes in probability instead of a predetermined scenario.

Q: It also brings to mind your idea about the stock market and the theory that if people used presentiment as a forecasting tool, that they could conceivably "crash the future." Based on the "out" we have of free will, that likelihood becomes less determined.
RADIN: Right. It creates a mush though. But if people are messing about with their own futures, it could create a "churn." The law of unintended consequences is very strong, because we don't know exactly what we're doing. There's no way of really knowing what we're doing until we actually start playing with it. It's like Madame Curie, you start playing with a thing and you don't know that twenty years from now the entire universe will end as a result of it! There is a way to do the presentiment experiment–to do what I think of in terms of a "Navajo rug experiment." I don't know what the result would be, but a [Navajo] rug is woven with a thread hanging from it, partially to suggest that it's unfinished–it's in the process of "becoming." Well, if you have something like a fabric with a thread hanging, you're tempted to pull on the piece of string. Well, if you pull on it in a certain way, you'll unravel the whole thing. It's not sticking out of nowhere, it's actually part of the entire fabric–you pull on that, you unravel it all. Once you have a probe into your own future, you can create an experimental context where you are physiologically detecting when a certain future arises, so let's say you're involved in an experiment, and a picture is about to come up that you're going to respond to emotionally. You can detect that reaction physiologically before it occurs. By the very fact of the detection, you can change the future. If you do that, and you are now reacting to something which will no longer occur, it raises the possibility that there is a weak causal loop that you've created that is abducted somewhere. Where does it go? You've changed the future based on your knowledge of the future, directly. You're no longer changing a future event, you're changing the *probability* of events. So you can change the probability of a probability.

Q: This brings to mind the old idea of "man is not meant to fly" where in this case you

may destroy yourself with this knowledge.

RADIN: You can keep spinning it backwards until you bring the "mush" closer and closer to you until you're in the "mush." When I think about that, it almost discourages me from even trying it. Almost in the same breath as "we are not meant to know certain things." You can imagine that someone has an atomic bomb, and realizes that "if you do such and such, the thing will go into fission and explode. Nobody has ever done it before, and maybe it won't work, maybe it will. Let's try it."

Q: If you're dealing with probability there's no way to step back from it.

RADIN: Nor would there be with an atomic bomb if you set it off in your face. There is a very strong consequence of accidentally doing something that you probably shouldn't have done. But in any case there are sometimes unintended consequences because of our ignorance. I haven't tried that [future prediction] experiment yet, mainly because I haven't had the time.

Q: How would you go about something like that?

RADIN: You get somebody who can do the task well, so you know you're dealing with someone who can really get future information. Then you devise some physiological monitoring system, so that when the physiology begins to rise over baseline, you have a pretty good probability that there is about to be a known future. You in a sense have pulled a little piece from the future and back into the present. With the knowledge of that, you cause a computer [almost instantaneously] to change the likelihood of that future event. It's no longer an emotional target, it's a real one. Well then, what were you responding to? You've had a response and then made the stimulus go away. You've changed the probability of that future event. As soon as that happens, you change it again. You can keep changing this...

Q: Until you catch the "wave."

RADIN: Yes. When you catch it, you can keep moving what the unconscious precognition is attracted to. You see, it's a sequential experiment, and you have all these targets lined up in the future, and what I'm taking about is just changing the nature of one of them. There may be a way of cascading the events. [Radin lines up objects on the table.] This target is dependent on the next one in the future. You can link it up as far into to future as you want. You can start the experiment and have the events fixed, and you come up on the first target where you actually know that you can detect it, and the whole thing can be cascaded for 10 or 20 minutes into the future. They're all dependent on each other. In that case, you can start extending the length of time that this thing will go. We're sort of locked into time like this [points at the linear progression of objects] but these things [the objects representing events in the experiment] are now getting pulled in different directions.

Q: Now I think I can understand what you're trying to accomplish with this idea. The thing is, when I finally understood the concept of your goal, I sort of got scared! You essentially want to start a chain reaction to change probabilities of one event stream, and who knows if that can also escape the confines of the experiment?

RADIN: It bothered me too, but I'm more intrigued than frightened. You only know what happens when you do the activity. The usual reaction is fear. How can you constrain that [possible effect?] I haven't thought about the consequences of limiting the effects in this [lateral or probabilistic "direction"] but if you don't limit it in this [linear time] direction, then all bets are off.

Q: The effects in the lateral direction are what is disturbing...
RADIN: But the linear one is disturbing too.

Q: How ?
RADIN: Limiting in this [linear time] direction I think can be known because you can confine the experiment in that way, but if you don't limit for this one [lateral/ probabilistic] it almost suggests that for the individual involved in that experiment, their whole universe starts to look very strange.

Q: What if they got frightened and stopped the experiment?
RADIN: I suppose that they could, but if they continued it, things might start disappearing in their world. You've now gone down a low probability version of your future which is very unlikely to occur. We know from thermodynamics and stochastic methods that [in the course of an experiment like this] the likelihood is that all the water molecules in the air will suddenly go into a cup and fill it up. That's possible...it's not likely, but possible. The experimental subject might suddenly enter a world where magical, weird things are happening all the time because you've steered it accidentally.

Q: "Magical" in the sense of where you came from before beginning the experiment, because you haven't "collapsed the probability wave" at that point.
RADIN: Right. Once you've steered off the course of this great inertia where things kind of work statistically, then you enter a realm where almost literally anything can happen, because almost anything can happen anyway-it's just that it doesn't happen very often. So, maybe you set up the experiment so that you go into a casino, because the unlikely events are going to occur: every single machine you play is going to pay off, or something like that.

Q: How would you (as the person running the experiment) see this?
RADIN: Perhaps everyone involved in it would see this. Anyone who observes the result is pulled in too. Maybe. I don't know.

Q: That's enough to make it far more interesting than frightening.
RADIN: I think the world is pretty robust. Maybe people appear and disappear every so often, but it doesn't happen very much, and it probably doesn't make that much difference one way or the other. Part of the risk of exploring things we don't know is that things can happen.

Q: This is like the first test of the atomic bomb. They didn't know if the explosion would set off a chain reaction and ignite the atmosphere...
RADIN: But it didn't. I guess we're OK.

I think the world is pretty robust. Maybe people appear and disappear every so often, but it doesn't happen very much, and it probably doesn't make that much difference one way or the other. Part of the risk of exploring things we don't know is that things can happen.

Q: You talked about Joseph Mc Moneagle and some work you'd done with him. I had just finished his book Mind Trek *and your book actually put some things into context that Mc Moneagle had discussed in relation to his remote viewing experiences.*

RADIN: I met Joe when I was at SRI [Stanford Research Institute] in 1985. I think that was when he was leaving the military. I've been in contact with him off and on since then, and it occurred to me when I was working on the psychic switch idea it would make a lot of sense to take advantage of a remote viewer who could forecast or see what's about to happen to help design it. I knew that Joe's remote viewing results looked like draftsman's drawings: they were very precise. I targeted him on a bunch of technical aspects of this stuff, and I ended up with a large sheaf of papers. I think we did ten or fifteen trials on this, and every time that I would get one back, I'd make a new question for him based on it. He had no idea what my ideas were, he only knew it was some sort of technology, but not any of the specifics. I don't think I want to say what the details are like, but we came up with about half a dozen ideas, all of which I think are viable. The part which Joe and I both puzzled about was that what he was describing in each case was very close to what I was thinking about. So then I didn't know if Joe was really good at knowing what I was thinking about, or whether I was on the right track. He didn't know either. So I have this sheaf of documents that I'm sort of keeping, and maybe someday I'll do something with it. Maybe in Silicon Valley. At some point there will be technological gizmos which are to the mind what transistors are to electronics. Sort of a "transistor for the mind."

But there's a consequence of having it. One of consequences is in the act of doing these experiments and making these devices, is that it limits and starts extinguishing itself. The theoretical reasons have to do with entanglement of quantum states: there's this weird incursion that goes on. There's quantum observational problems, there's psychological problems...there are all kinds of reasons why creating something can over the long term extinguish it.

Q: We were talking earlier at your home about this idea and how it relates to human goals and experience: If you accomplish a goal, you eliminate it.

RADIN: There's something about creating certain kinds of things that will make the thing itself go away after awhile. This is the opposite of the way we normally think about it. You would think that if you create something, it becomes easier to create something new.

Q: But that's at this cause-and-effect level.

RADIN: Yeah. At a psychological level, or whatever this other level is, we're dealing with something very different-something quasi-objective. It's a puzzle because if somebody comes up with a really neat paradigm to study something, if we do what is normally done in science, which is to beat it to death, we will beat this out of existence. It's a very strange idea because if I do this presentiment thing a thousand more times, will I make it go away? I don't think so, I think that particular version of it may go away. At least part of me thinks so.

Q: Do you mean "go away" for you, or for others, or for everybody?

RADIN: It goes away for everybody.

Q: How would that work? Has this already happened in something you
RADIN: Not in anything I've done, but it has been observed in telepa[.]
iments. Some people have noticed that if you do a long-term chronol[.]
analysis of the effect sizes in different experiments-whether it's for telepathy [.]
clairvoyance or whatever-it starts to become constricted, and in some cases it
starts to decline. In fact the decline effect was noticed by Rhine and others for a
long time now. It was presumed that it was for psychological reasons: basically
you get bored. Much of that is probably true. Now we're talking about some-
thing involved with the systems of observation this particular style of looking at
the universe. Once you've made a little rip in the universe, cracked the egg so to
speak, it will seal itself up again. So that particular way of cracking the egg is more
difficult to do. It gets progressively more difficult until you can't do it anymore.

Q: What do you think causes that effect?
RADIN: Maybe it's a built-in protection mechanism.

Q: Then can't you do those presentiment experiments without too much worry?
RADIN: Well, not the first time. The first time you do something there is a
novelty effect which has a low probability of occurring in the first place, and
you could blow the "egg" apart. Now, if you're lucky, the egg will be able to
repair itself because there's this conservation mechanism built in, and it will fix
itself, but not if you blow it up too much.

Q: How far does that go? It's just human experience, isn't it?
RADIN: Maybe physical too. Maybe it's like a physical conservation principle.
The thing tends to be self-repairing.

Q: Maybe that's the answer to the big bang.
RADIN: Maybe, yeah. Maybe it's the result of some kid playing in a garage
with some experiment he shouldn't have done, and it accidentally worked too
well, and it "blew up" everything!

Q: God as a kid with a probability experiment.
RADIN: I like this Gary Larson cartoon with a kid with his face all black and his
hair blown straight back holding something, and there are feathers in the air and
the caption is "God as a kid tries to make a chicken." What a thought, you know:
we're God as a kid trying to make something that could blow up in our face.

Q: I couldn't begin to imagine what the news would be like that day...
RADIN: There wouldn't be any. And there wouldn't be any news anymore. Or
it would be: "A large portion of Las Vegas disappeared today, and there is no
evidence that it ever existed. There is a large circle of desert centered around
this particular part of town. No explanation has been offered."

Q: And it doesn't show up on any maps, etc.
RADIN: Well, the world would repair itself. Actually, I was thinking about the nature of medical miracles, and when you think about this sort of "miracle," like a tumor disappearing overnight, the thing that makes it a "miracle" is the discontinuity in our memory: "One day it was that way, and today it's this way." Well, you can't get from one state to the other that quickly.

Q: I see what you're getting at, since you just made the analogy of the piece of real estate not being there suddenly.
RADIN: Right. If the real estate can disappear overnight and the tumor can disappear overnight, then it's that discontinuity that makes it "unknown." So in the healing arena there's a potential there of understanding what's happening by experiment. The problem in this is... [Radin arranges objects on table] Let's say this is a time scale. Here, you have a tumor, and here, there's no tumor anymore. Something happened between these that was a "miracle." The healer's job is to cause this to occur. If the healer is trying to focus on you at this point [where you have the tumor] it's a very difficult job, because the body can't get rid of it quickly enough. You have to start violating entrenched laws of conservation and so forth.

Q: Would he in a sense have to collapse the probability of it not being there in the first place?
RADIN: Yes. But how do you do that? You don't do it here [where the tumor exists] you do it back here, back in time where the tumor doesn't exist at all, or it's a little tiny thing. At that point, it's much easier to start mucking about with it. I've investigated this, and some healers actually do this: They envision you when you're healthy. They don't envision you when you *will* be healthy, they see you when you were healthy. This means that there is the possibility of affecting someone in the past. There have been some experiments looking at these retro-effects. If you were successful in something of this sort, and you prevented it from occurring, then what you would start seeing at this point [in the present]...

Q: It's probability is going backwards, except we're still going forwards.
RADIN: This [the tumor] would disappear. If you could see it, it would actually melt away very quickly. It's previous history has been altered, making it less and less likely to exist.

Q: Perhaps at some point perhaps that "transistor for the mind" may allow almost anyone to do it.
RADIN: But that would be more likely used as a diagnostic tool.

Q: I'm thinking in linear terms again.
RADIN: This all suggests that the placebo effect may not be limited to real time. It also suggests that the doctor's bedside manner is not limited to the bedside. So I did an experiment like this: (Well, I know what I did, but I've never thought of it in terms of linear time) OK, let's say that this is blood pressure measured in the lab right now. At some point in the future (two months) a healer comes along and his job is to focus on you back then. We're not measuring anything about you at that point, all the measuring was done two

months ago, so if anything is going to happen to you, it happened back then. We recorded you at that time, but we don't know what the conditions are yet.

Q: You just recorded it blindly.

RADIN: Twenty minutes of recording. Now, [two months in the future] the healer is given instructions to make the blood pressure go up then make it go down randomly. We record this data too. At this point [the original recording] it still has no meaning yet. Then, months after the healer does his thing, we take the raw data from the blood pressure readings, we have the instructions to the healer, and I'm in the process now of analyzing all this to see if there is any evidence that this person modulated the blood pressure of that person at that point in the past. The analysis program is looking at 31 people who did this for 20 minutes apiece, and the evidence so far suggests that in at least one of six physiological measurements (heart rate actually) that these people's heart rate actually increased according to what these people [the healers] were doing two months later.

The healers were actually healers from Brazil. I had colleagues in Brazil working with these folks. The way that they were targeting these people [the blood pressure people] were as digital pictures that I had them sign their names to. They were told to "focus on this person in the picture at this time." What they would see was an image of the person, which was their signal to send their healing energies backwards in time. In one minute segments, the picture would remain, or change into a landscape, which was their signal to stop doing it. The computer picked this fixed random sequence at the beginning of the experiment, and kept a record of it.

Right now, the analysis suggests that these healers made a difference in lock step. You shift everything back two months in time, and for 20 minutes it somehow worked. The only thing that is fixed in this experiment is the meaning. It's no longer space and it's no longer time. It's the meaning: agreement among the people in the experiment. Well, what I just said is the essence of magic, because it means that we can transcend space and time. The only thing that is left to stand on is *meaning*, which is a dimension that doesn't exist as far as conventional science is concerned. It's an abstract. That's the reason why the methodologies used to test this stuff is like the "sledgehammer and the flea." It kind of works-we can get a result from it - but when you start thinking about the consequences, it makes your brain hurt. So what's to prevent me (and I know of some colleagues who are doing this) from just imagining this whole experiment? I don't have to go through all this stuff. I'll just collect a bunch of data, and imagine that somebody did such-and-such, and you know what? This experiment has already been done, and it worked!

Q: Except in our society this would be subjected cries of "fraud!"

RADIN: Well, that's the easy explanation.

Q: In the context of what we've been discussing, it's not an explanation at all.

RADIN: It's not outside the concept of pure magic, but it is certainly outside the context of science. And yet, I think that it's a possibility that you need to acknowledge: Once you step outside a purely objective realm (and that may not even exist...) there's some kind of a spectrum perhaps, where there's a very

Well, what I just said is the essence of magic, because it means that we can transcend space and time. The only thing that is left to stand on is meaning, which is a dimension that doesn't exist as far as conventional science is concerned.

"Can meaning be a cause?" Well, conventionally the answer is "no," but unconventionally, the answer is "yes."

strong objectivism on one side, and there's a very strong subjectivism on the other, and we're talking about something in the middle. Well, that's wrong, because you could subjectively inject meaning and context into it and change the nature of that objective world. That's the *tertium quid* that Jung talked about, that third world, had one foot in either side of a dualistic spectrum. That's where synchronicities occur. That's probably where some UFO events occur as well.

Q: You said in the book that things are not acausal in this sense because people are there.
RADIN: The acausal thing about synchronicity is that we don't see the cause. Which is quite different than there is a cause, but we just don't know it. So I kind of suspect that some of those synchronicities are causal, but the nature of the cause is in a dimension that we don't pay attention to. The reason that I say that is that what makes a synchronicity in the first place is *meaning*. So the next thing we say is, "Can meaning be a cause?" Well, conventionally the answer is "no," but unconventionally, the answer is "yes." Here's meaning defined as an experiment which gives a result suggesting that there is some kind of retroactive thing assigned. We don't know that there really was or not.

Q: Has this been tried with an inanimate thing?
RADIN: Yes. We've tried it with random number generators, and it worked just as well.

Q: What does a "psi device" consist of, other than opening garage doors or turning on appliances by intention?
RADIN: Well, the humane application is (and this was said by Don Hill) is the reanimation of Superman. And the application is a prosthetic device which responds to thought. So Christopher Reeve would actually use this as a quadriplegic. He has the need, and he has the symbolic archetype underlying that of the "crippled Superman." He could be reanimated through the use of some semi-magical method. It's technology, but it looks like magic.

Q: It's that old Arthur C. Clarke idea about any sufficiently advanced technology being indistinguishable from magic.
RADIN: So I think that something like that is viable, because it's in the right context–socially and personally.

Q: What about inhumane applications?
RADIN: There's all kinds of those, because basically we're talking about psychically controlled robots. A humane way is to have a robotic exoskeleton to reanimate yourself, but a bad one might be robots running around out there that are doing the beck and call of someone.

Q: Have you ever been asked to work on or theorize about something that you thought was morally repugnant? In any case, a concept that might be used for something unethical?
RADIN: The answer to the first question is no. The answer to the second is that anything can be used that way. I wouldn't want to work an anything that was morally repugnant.

Q: Do you think that anybody in your field would?

RADIN: Morality is relativistic, so under the right conditions, somebody could be convinced to do something that under normal terms they wouldn't do. So under a terrorist attack or something like that, some of these things could be used for not-so-nice applications, like harming or killing people at a distance.

Q: Could you give an example?

RADIN: Well, Larry Dossey just wrote a book on this topic, which was originally titled *Toxic Prayer*. I think the title got changed to *Be Careful What You Pray For.*

Q: Sounds like a good name for a band.

RADIN: That's what I thought too, but they [publishers] changed it. I think they thought it was too frightening. If you harbor bad thoughts about someone because you don't like them, is there any evidence that this has an effect? And the answer is "yes." There is empirical and experimental evidence that what you think about someone at a distance causes an effect. All you need to do is push that scenario out to it's extreme and where does it end? Well, it ends with in death. I don't know of any studies in the US against human subjects, but there are others involving everything from bacteria to animals which suggest that this works.

Q: "Empowered intention?" As in something like voodoo dolls?

RADIN: Well, yes-malevolent use of intention. The evidence suggests that it works-not just making the evil intender feel good-it actually does something. It's expressed in some way. Fortunately, we're not surrounded by psychic "Michael Jordans." In fact Joe Mc Moneagle And Ed May and I were talking the other day about the likely percentage of natural talents in this realm, and we came out with something like a half of a percent. That's true in basketball and other things like that-you have something less than one half of one percent where you have really good natural talent, and the personality traits and whatever else that go together that allow someone to use it. So among that group, you figure about 300 million or so in the United States: that's a lot of psychic talent! And you don't need that many people to do some really serious disruption. So maybe we're talking about a lot less than that-maybe it's far fewer than that number. Maybe a lot of people in that realm are taking medication because they've been declared schizophrenic.

Q: Mario Pazzaglini told me something like that. This one patient of his was getting all sorts of advanced philosophical "dictation" channeled through him, or coming from somewhere in his head, and he begged not to be put on medication because he was starting to integrate it into his life (with Pazzaglini's help.) Pazzaglini had to go on a trip and left the guy in care of the workers at the institution where he lived, and he gave instructions to keep him off medication. But as soon as he left, they pumped him full of pills and he lost his "gift." He got worse, but he's still trying to get the "messages" back.

RADIN: Some medication is designed to suppress your awareness of the outside world, so if you did have a connection to gain some kind of skill that you otherwise wouldn't have, (and channel is kind of a good word, it is pushed through you

somehow) you could medicate someone up the wazoo and basically turn it off.

The people who have this may not know what to do with it, because it's not supported by society. In another context, they would be trained as shamans, and they wouldn't have to be concerned about everyday problems, because that's not their job.

Q: Their job is to be out there for other people.
RADIN: Right. They're supposed to have one foot in that other reality where the buffalo are going to be, or do some kind of strange healing and change something in the past. Of course people will say that the whole shamanistic thing is an interesting idea, but "what about the ghost dancers?" Well, a shaman can make mistakes too and wipe out a whole tribe. It's not clear that a tribe *must* have shaman. We sort of need our own versions of this, but it really is rare to have an individual who is both stable and out there at the same time, in which case maybe there's a thousand in the entire country. Those thousand people probably would probably never let anybody know about sit. They're certainly not going to become the gurus. They won't flaunt what they do.

Q: Maybe they'd turn out like Joe Mc Moneagle.
RADIN: Joe's one expression of it. I suspect that there are many different kinds of talents, and they're expressed in different ways. Do you know that movie *Resurrection*? With Ellen Burstyn I think?

Q: Nope. Sorry.
RADIN: This lady has a near death experience and comes back being an exceptionally good healer. She just touches people and they get better. She learns very quickly that if you let people know that, it ruins everything.

Q: Didn't that sort of happen to Edgar Cayce?
RADIN: Cayce actually did quite well after awhile. He had a staff. So, if you discover that you have a talent, the best bet is to disappear. At the end of the movie, the lady owns a gas station in the middle of the desert somewhere. That's all you can do. She can heal people as they kind of pass through the gas station, but that's about it. So the last scene is a family with a child who is dying of cancer, and the family is taking him to Disneyland and she knows this of course, because she can sense it, and she heals him. Of course she can't say anything about it to anybody. You know that the cancer is going to go into remission and mysteriously disappear, and nobody will ever know why. I suspect that there are a lot of folks out there who can do things like that, just from a purely statistical standpoint. We've seen quite good people do things repeatedly in the lab.

Q: Do you think that this will ever progress to the point where these people are that good all of the time, or even most of the time?
RADIN: It depends on the nature of the talent and something about the ability to detect when the world is right for new ideas, and what should be done. Most of the time it is probably *not* right. Regardless of anything horrible

that might be going on sociologically, it just cannot sustain ideas of that sort-especially individuals because they're idolized instantly. They're put into a celebrity status. I can imagine scenarios where people move into politics and media and other realms where they can do things that don't act as a giant disruption for all of society.

Q: And they would go about this as quietly as possible.
RADIN: You'd have to, because the ones who are not are the ones we look at as false prophets and basically crazy people, and all too often, they're wrong.

Q: Do you think that an inflated ego would get in the way of a talent in the same way as the prescribed drugs that we talked about earlier?
RADIN: The most dangerous person in the world would be an ordinary person with extraordinary psychic ability. This is why I hope that the constellation of factors that it takes to make a really high talent in this area is not an ordinary person. I'd rather believe that there is a conservation between ego and this ability. If you really have a large amount of ability in this area you don't come at it from an egotistical point of view, because if it's not true...

> The most dangerous person in the world would be an ordinary person with extraordinary psychic ability.

Q: Well, up to now, it seems like a self-correcting system.
RADIN: Maybe that's true, because if you can live with one or both feet in a realm that is truly interconnected and in a wholistic state, that's incompatible with the idea of an encapsulated ego. Because the ego is designed to pull everything in with a barrier in between, and in that realm, a barrier doesn't exist.

Q: It's actually a hindrance in that case.
RADIN: Sure. I'm hoping that the way the system is constructed that this is the case, because if it isn't, we're in serious trouble.

Q: But wouldn't we have been in serious trouble to begin with if that was the case? Perhaps we already are, from some points of view.
RADIN: There is folklore about the 12 magicians who control the world from somewhere in the Himalayas, and others like that that go way back.

Q: The Count de Saint Germain, etc.
RADIN: Yeah. And Merlin and all this stuff about a secret order of controlling magicians... You could make a case though that if these people existed, they would know of the existence of the other people. Like *Highlander*, where you would recognize your enemy from...

Q: This is of course the basis of lots of comic books and movies.
RADIN: Yeah, well in mythological stories I would go along with Joseph Campbell, where they reflect something about the human psyche. Not literally true, but something which is a repeating motif, which is important in some way.

The limited data that we have now suggests that people like that ought to exist. Some surveys and experiments that have been done suggest that they in fact do exist, like in a normal curve, and that they're out there.

Q; I guess that you would have to move to that area of shrinking ego for it to be of any use to you or others, though.

RADIN: That's what the gurus say. You always wonder about somebody like David Koresh, or other charismatic leaders who are nutty, if they might have some ability like that that they can use, but are seduced quickly by that power. To begin with, they can do anything, and their followers might have witnessed some miraculous thing (from their point of view.) It may also have something to do with powerful personalities attract weaker personalities and they feed off each other or something like that. I see that as a pathological expression of this though.

Q: It eats itself up.

RADIN: It flames out after awhile. It's just too bad that there are innocent people in the way. One of the things I'd like to look at in the second book is to do an actual survey and find out what the folklore and history actually says to see if people at that level of performance were likely to have existed, because they are likely to have made a mark. You see, at that level, and with the healing talent available to them, they probably wouldn't ever need to die. There are legends about such things.

Q: Why wouldn't they need to die?

RADIN: We're dealing with something where we're changing the probabilities of events. Most events will kind of march along on their way according to a sort of mindless physical ordering-things will just spin out in a certain way. Perhaps we have the probability of some of those future events, either by retroactive activity or even just forecasting future directions to go, you can steer yourself a better course. You could probably reverse aging, or prevent it, or stop it. You could be able to do things which run counter to the way that we ordinarily think that time spins out, because you're no longer bound to it. Even now, we're beginning to understand the nature of cell division. Most of it works according to clocklike, fixed rules, but it's also very flexible, so almost anything you could imagine would be possible for someone who has the talent of manipulation (even to a very slight degree) over elements of space and time. I suspect that's one of the reasons that there is fear associated with this, because as soon as you allow someone to start mucking about with the basic structure and fabric of space-time intentionally, you better have good control over your intentions. "Be careful what you wish for." You'd also better hope that that person likes you a lot. You can't too concerned about your own privacy or anything.

> Almost anything you could imagine would be possible for someone who has the talent of manipulation (even to a very slight degree) over elements of space and time.

We think of musical talent as a strange and not easily definable set of skills that somebody has to do stuff. And maybe one in a hundred people has the skills it takes to be a musician, but how many Mozarts are there? We're talking here about what would look like a violation of "natural law." The effects of what would be able to be done at that level would multiply, and we just wouldn't be able to understand it.

Q: So maybe when I go to watch the Aetherians charge the spiritual battery, they might not be too far off the mark!

RADIN: Well remember, we're talking about very, very small percentages of people here.

Q: *Perhaps if everybody in L.A. did it, that might make a difference.*
RADIN: There's the issue of a social fabric here as well. The social context can change what's real, but not in a strong physical sense. The small percentage of people who can really do stuff might spin this out to...

Q: *Then you might* really *have pieces of real estate disappearing.*
RADIN: But you'd never know it. Because you could arrange things to have walls disappearing and appearing, and you would have no way of knowing it. You see this in movies sometimes where the character will face a guard saying "You can't go in there" and he looks at the guard for a second and he lets them in. The convention has changed to something like he convinces the guard, or they're invisible, but I don't see any reason why that couldn't happen [the mind control scenario.] These are all projections from where we stand. I don't have proof that there are psi people doing this...

Q: *What you're saying is that hypnotism might be convenient metaphor for what could be going on?*
RADIN: Yes, but I don't know what it is.

Q: *I'd like to ask about the "Oz factor" phenomenon. For instance, when a group of people undergo an anomalous experience like a UFO sighting or seeing an unexplained animal, the experience is usually not talked about until years later, and even then it's in an offhanded way.*
RADIN: We don't know what to do with it. We're not equipped very well for accommodating and absorbing things which are too different-partially for memory reasons: If you don't have a place to stick a memory, it's just doesn't stick at all. There's no schema to hang it on. You can both agree that something just happened, but you can't agree on what it was, and feeling uncomfortable with that experience after awhile, most people will forget it, and may never remember it. This happens with eyewitness testimony all the time. Even descriptions of accidents are recalled by people with totally different scenarios.

Q: *Do you think that an emotionally laden moment could effect the physical world in any way in this type of case?*
RADIN: I have done an occasional experiment, and my colleagues and I talk about this on occasion: What happens in an experiment where you don't set anything up, you only record data? The hypothesis is that it's really the analysis of the data that does an experiment. It's called a "checker effect." It's the checking of the data that causes the effect. Well, what if you check the data in day one, and get a certain result? Well, you go back on day two, after seeing it once: what you wish to see, what you saw, etc. Check it again. It may not be the same. You go back on the third day and check it again: And it's *still* not the same. So you get a very destabilized view of what it means to record stuff, and the stability of things that shouldn't change. I've experienced that myself a few times...

Q: *I was about to ask...*
RADIN: I have noticed that. The first instinct is to say, "Well, I changed it in

> We're not equipped very well for accommodating and absorbing things which are too different-partially for memory reasons: If you don't have a place to stick a memory, it's just doesn't stick at all.

some way. I saved the wrong file on the computer" or whatever. But this happened enough with other colleagues as well, that we sort of suspect that we really don't understand the limits (and this is a methodological issue) we don't understand where the experiment ends. Because if it's not ending on the basis of one observer collapsing the whole system which then cannot be changed, or it is changed depending on future observers as well, then the nature of the present and the past become more malleable.

Q: You mean like a stream of numbers on a printout? Those change?
RADIN: Yes! You see the problems in methodology that we encounter. We're pushing science right up to the edge, and it's beginning to fall off. So, many of us are interested finding a way to bridge further and further into that realm using the methodology, because if we use something that's too different, no one will pay any attention to it. So we're trying to find these new methods, and in fact I'm going to a conference at Harvard in about three months to discuss this very issue in the context of healing research, and it's because of effects like this retroactive stuff. We don't know what to do with that.

Q: You'll find out, and then it will become institutionalized if it can save money.
RADIN: God! What a prospect! It's the ultimate in preventative medicine.

Q: "Never get sick."
RADIN: That's right. It wouldn't matter if you did or not, you just fix it before it happens. Perhaps we could come up with some sort of cure for jet lag, to begin with.

Q: I think I've heard of ideas in this direction.
RADIN: Well, of course one of the ways to do it is to reset your clock in the plane to the time at your destination. You start living in the other time, but maybe you could do it some literal way. You convince yourself that you are in that other time. You adjust yourself instantaneously. Actually, I'm flying to Germany next week, so I'll try that. I'll just make an agreement with myself that as soon as the plane leaves the ground, at that point, I'm in the other time zone, and see what happens. I've got nothing to lose other than jet lag.

Open-Minded or Just Indecisive?

Donna Kossy

Is it a character flaw or is it a rare virtue? Moodiness or spinelessness? True to the pattern, I can't decide which. On my robust, healthy and confident days, I think of my open-mindedness as a virtue, something to cultivate and brag about. In darker moods, I'm convinced that my indecisiveness robs me of the energy, courage and conviction to become an heroic activist, crusading for freedom, fairness, the earth, or just plain decency. If I'm not going to be just another parasite on the planet I must act, and act soon. I envision feverish letter-writing campaigns, defiant challenges to authority, chaining myself to a tree, public protests, triumphant debates. Then I remind myself that the last time I was up close to an activist I broke out in hives. Organizations and meetings put me to sleep. Action itself implies physical challenges that would likely give me vertigo. And sooner or later I would tire of the strident activist personalities, see through the rhetoric, and take the opposing viewpoint.

Could it be that I'm just as suggestible as the proverbial couch potato? Though I've ripped out the mass media feeder tubes, I continue to imbibe the heady concoctions offered by the more intellectually minded press and gulp down large quantities of scholarly and pop social science and cultural criticism. My husband can almost guess which book I've just read by what topic I begin to harp on ceaselessly. After I'd read *Brain Sex*—a book which details the results of scientific studies on the differences between men's and women's brains, I was convinced that most of the gender-linked behavior paraded in front of me was due to chemical and physical characteristics of brains. All the mysteries of the personalities of my friends and family were instantly solved by the new information. But some months later, I read *The Beauty Myth*, a brilliant feminist polemic by Naomi Wolf. After that, I was ready to attribute all typically "female" behavior as totally a result of backlash propaganda administered by TV and glamor magazines. There might be physical differences, but they were irrelevant.

Similarly, I find myself smack dab in the middle between believers—

> On my robust, healthy and confident days, I think of my open-mindedness as a virtue, something to cultivate and brag about. In darker moods, I'm convinced that my indecisiveness robs me of the energy, courage and conviction to become an heroic activist, crusading for freedom, fairness, the earth, or just plain decency.

New Agers, UFOlogists, Forteans, occultists—and the hard-core skeptics. Every time I read a story about another unexplainable cattle mutilation or spontaneous human combustion episode, UFO sighting, or crop circle, I get that uneasy sense that I'm only dimly aware of what "reality" is, and that there are probably a host of strange spirit forces that are constantly "playing tricks" on us heavy-laden physical entities. Or maybe they aren't spirits at all, just something we are too far behind to begin to comprehend. And then I'll pick up an old *Skeptical Inquirer* and find out that the report was just a rumor or a hoax, was all easily explained, or was based on statistical misinterpretation, and poof!—away go the spirits, if only for the afternoon.

And then there's the matter of capital punishment. While talking to my enlightened friends, of course I'm against that barbaric practice which is a miserable failure as a deterrent, costs taxpayers millions, is unfairly meted out to the underclasses, and most importantly ignores the real causes and breeding-grounds of crime. Yes, I remain an enlightened humanist with such views until I pick up a book which details the grisly exploits of hopeless sadists like Charles Ng or Ted Bundy at which time I say, "Sure! Fry the bastards!" becoming instantly transformed into a bloodthirsty, vengeful would-be vigilante.

I don't think I'm the only one. It's a psychological (and legal) common-place that viewpoint is linked to one's mood, one's experiences, as well as what one has been reading. Jury selection is based on this. Thus, it seems somewhat dishonest that people place themselves (and each other) in rigid ideological categories such as "left," and "right," "liberal" and "conservative" and take rigid stances on issues, rather than confronting their natural tendency to vacillate. Journalists regularly castigate politicians for "flip-flopping" on issues. But might this not be the result of an open mind? And then again... maybe it's just spinelessness.

The Black Knight From Space

Was Philip K. Dick's VALIS A Space Satellite?

Paul Rydeen

In *Disneyland of the Gods*, John Keel writes of the Black Knight satellite. Never mind the almanac. You won't find it listed with Sputnik or Explorer. Black Knight is the name given to a radar blip discovered in 1960. This mystery satellite was found in a polar orbit, something neither the US nor the Soviets had accomplished. It was several times larger and several times heavier than anything capable of being launched with 1960 rockets. It shouldn't have been there, but it was. If that weren't enough, ham operators began receiving odd messages from the Black Knight. One operator decoded a series of these messages as a star map. The map centered on Epsilon Boötes as seen from the earth 13,000 years ago. Remember, stars don't move very far even after 13,000 years, and Epsilon Boötes is moving towards us. Only the neighboring stars appear different after that amount of time. Was the Black Knight an alien calling card?

Perhaps the strangest effect associated with the Black Knight is the Long Delay Echo (LDE). The effect observed is that radio or television signals sent into space bounce back seconds (or even days) later, as if recorded and retransmitted by a satellite. They didn't begin with the Black Knight, but they were part of its mystery. Keel places the earliest LDEs in the 1920s. It's not in Keel's book, but in 1974 another mystery entered earth's orbit. No radar saw it. No ham operator listened to it. One man contacted it—or rather, was contacted by it. That man was science fiction author Philip K. Dick (1928-1982). Dick is probably best known to the public for writing the stories on which the movies *Blade Runner* (1982), *Total Recall* (1990), and *Screamers* (1996) were based. Before the movies, there were the books. That's where we'll find Dick's own encounter with a Black Knight.

Beginning in February of 1974, Dick had a series of "mystic" experiences (substitute "paranormal" or "fortean" or "psychotic" if you like). When he died eight years later, he was still unsure of their origin or their meaning. Left behind was what he called the *Exegesis*, an 8000 page, one-million-word continuing dialogue with himself written late, late at night. This is where we go to find the Black Knight's return.

> **Black Knight is the name given to a radar blip discovered in 1960. This mystery satellite was found in a polar orbit, something neither the US nor the Soviets had accomplished. It was several times larger and several times heavier than anything capable of being launched with 1960 rockets. It shouldn't have been there, but it was.**

Very little of Dick's *Exegesis* has been published. The Black Knight material formed the core of four novels—*Radio Free Albemuth, VALIS, The Divine Invasion, and The Transmigration of Timothy Archer*. They remain in print. All four read as autobiography. The pivotal element in each is Dick's own contact with the Black Knight, which he called the Vast Active Living Intelligence System, VALIS for short. In a series of visions and coincidences, VALIS revealed itself to Dick as an ancient satellite from another world. It was sent here long ago by three-eyed, crab-clawed beings from a planet orbiting Fomalhaut. They built our civilization, taught us writing and science, then returned to their own world. VALIS was left behind to prod certain individuals when civilization needed a boost. If it sounds like Von Däniken meets Scientology, read on.

Albemuth is the name Dick gave Fomalhaut in *Radio Free Albemuth*. I believe he derived it from the Arabic Al-Behemoth, which he took to mean "whale." Fomalhaut is the fish's mouth in the constellation of Piscis Australis, the Southern Fish. In VALIS he moved its origin to Sirius, probably after reading Robert K.G. Temple's *The Sirius Mystery*. He also offered an alternate name for the satellite: Zebra. He called it Zebra because of its ability to mimic its surroundings. We'll discuss that in a moment, when we return to LDEs.

Dick's contact began with a vision of St. Elmo's Fire filling his apartment. It was a strange pink flame which burned but did not consume. He says his cat saw it too. It was strongest at night. Dick would lie in bed unable to sleep, watching the light show. He compared it to a rapid-fire succession of modern paintings by the likes of Klee and Kandinsky. At one point he wondered if Soviet scientists were working with the aliens on psychotronics experiments. He thought they might be beaming images at him from a Moscow Museum. His dreams during this period took on a whole new nature, so much so that he began referring to them as tutelary dreams because of their information-rich content. He experienced numerous waking visions as well.

In some of his visions, Dick saw Soviet scientists rushing around behind the scenes to keep the alien satellite functioning. Strange texts which appeared to be Russian operating manuals were held up for him to see. The Builders, as he came to call the aliens, were sometimes seen floating in large vats of water, observing the operation. The whole complex system was apparently set up solely for his benefit!

Dick saw VALIS as a benign entity. He saw its position as teacher, sometimes protectress. (I say "protectress" rather than "protector" because VALIS reminded Dick of his twin sister Jane, who died in infancy.) He credited VALIS with taking charge of his life, recovering a lot of income due from unpaid royalties, and even re-margining his typewriter.

While listening to the radio one day, Dick heard the words of the Beatles' "Strawberry Fields Forever" change to a warning from VALIS: "Your son has an undiagnosed right inguinal hernia. The hydrocele has burst, and it has descended into the scrotal sac. He requires immediate attention, or will soon die." Dick rushed him to the hospital and found every word to be true. The doctor scheduled the operation for the same day.

Dick occasionally heard other, less positive messages from his radio at night, even when it was turned off. Admittedly, hearing voices and claiming harassment

At one point he wondered if Soviet scientists were working with the aliens on psychotronics experiments. He thought they might be beaming images at him from a Moscow Museum. His dreams during this period took on a whole new nature, so much so that he began referring to them as tutelary dreams because of their information-rich content. He experienced numerous waking visions as well.

from an energy beam are symptoms of mental illness, but there seems to be something more at work here. Anybody can claim crazy, incredible things, but only Philip K. Dick produced works of art because of it. In the end, though, he may have overexposed himself to it. As he hinted in *VALIS*, too much of a good thing can kill you.

Dick had another vision. He saw the pink St. Elmo's fire coalesce into a door perfectly proportioned to the Golden Mean. Through the door he saw ancient Greece, or some other Mediterranean land. He later regretted never stepping through it. This brings us full circle to the subject of Long Delay Echoes. As Dick sat staring at the Y in an ICHTHYS sticker in his window one afternoon, he pondered these strange occurrences. As he did, he saw first-century Rome fade in and remain superimposed on top of 1974 California. The experience lasted through February and March. He still knew which was the vision and which was real, but when he looked away and then looked back, Rome was still there.

The message he decided VALIS was sending him is that we still live in Roman times. Nothing has changed, we still live under the rule of a cruelly corrupt empire, and the Christian apocalypse is near. VALIS predicted the downfall of a King. Nixon left office soon after. As Dick said in *VALIS*, "The Empire Never Ended." This catch-phrase was made known to him in one of his tutelary dreams.

If this concept of one "reality" superimposed onto another is difficult to conceptualize, let's consider a parallel from more orthodox (!) sources. Without trying to establish or deny its validity, the field of psychic archeology tries to do exactly what Dick had happen to him. This is akin to remote viewing with a time element involved, rather than one of space. This author is in possession of a small number of unpublished correspondence describing others' experiences of this phenomenon. One called the satellite "Max." Dick was not the only one.

Though Dick's vision of Rome faded, his tutelary dreams continued for six more years. So did the AI voice (Artificial Intelligence), a soft feminine voice he heard in times of stress and during hypnagogic revery. This was the aspect of VALIS which reminded him of his late twin sister Jane. He claimed to have first heard it during a high school physics exam (it gave him the answers) 25 years earlier. During the VALIS days it told him, "The Head Apollo is about to return. St. Sophia is going to be born again; she was not acceptable before. The Buddha is in the park. Siddhartha sleeps (but is going to awaken). The time you have waited for has come." It's in *The Exegesis*. Dick quoted it in *VALIS*.

It all appeared to end November 17, 1980. Dick claimed to have had a theophany that day, though witnesses noticed nothing unusual. Dick suddenly comprehended God as infinite, by nature incomprehensible. In other words, the *Exegesis* would never solve anything because there was no answer to be had. Dick actually stopped writing for a time because of this, but was at it again before too long. It was the search that was important to him, after all. He wrote *The Divine Invasion* around this time, which was when the voice finally stopped.

Dick persisted in speculating for the remaining year of his life, and managed to produce one more novel before the end—the posthumously published *The Transmigration of Timothy Archer*. Dick suffered the first of several strokes in February 1982 and died a few days later in the hospital, on March 2. He was 53.

Ken De Vries

Tales from the Shelf: Caveat Hypnotherapy

Peter Stenshoel

**Part I: "Everything's Wrong at the Same Time it's Right"
— Don Van Vliet, from <u>Tropical Hot Dog Night</u>**

> The spirit falls into sordid foxholes, unable to climb out, stand, and gradually awake to a higher order, infinitely more complex than any curriculum can ever teach, more divine than any religion can convey, and more integrally associated with ourselves and our true and universal natures than we are able to grasp with just our temporary physical apparatus.

We as a species seem perpetually affected with the disease of simple ideas. How else could ufologists be reduced to vicious little aides-de-camp dedicated to snapping at the throats of rivals? How else could such a noble ideal as science be so compliantly dumbed-down by a pair of smart-aleck illusionists, so that radio medical doctors give advice based on the "Penn and Teller Effect"? How is it we allow such insane separations of "the natural world" from "divine order," or "government" as somehow separate from "individual liberty"? Smatterings of syllables are glommed onto and fiefdoms set up prematurely, as memes fiercely battle for primacy. But the victories are hollow, and the spirit falls into sordid foxholes, unable to climb out, stand, and gradually awaken to a higher order, infinitely more complex than any curriculum can ever teach, more divine than any religion can convey, and more integrally associated with ourselves and our true and universal natures than we are able to grasp with just our temporary physical apparatus.

Delusion is not simply the provenance of contactees picking up messages from Jupiter. Delusion is the air we breath, the molecules we use. It is part and parcel of our everyday world. We all fall prey to it. That is the lesson of maya. Both Buddha and Krishna referred to it. In Christianity it is called "sin," a broken-ness and a word to the wise that this ain't it; this hegemony of picnic ants and crustacean hubris is a sham, what the Gnostics were anxious to exit. Yahoo scientism and immature anomaly scholarship both mistake material reality with the ultimate, and premature theories flow like Philip K. Dick's policeman's tears.

When we remember that illusion is the currency we use to sustain the physical, then we can approach anomalies with a calm focus. When the Grays stare down at you from the foot of your bed, ask, "Which part of the universal illusion are you from?" Then tell them which part of the universal illusion you come from. And have a good laugh. None of us are immune from the effect of ever-larger templates, impinging consciousness into our cherished corners of presumed solitude.

Part II: "Stepping Out of a Triangle into Striped Light"- Don Van Vliet

My own cherished solitude was busted up at a young age. Rather than hide behind the usual false security humans conjure, it became more important for me to find the faces hiding behind the masks of the night. They had revealed themselves to me under the duress of high fever, also in dreams and certainly they spoke through music, pictures and poetry, whispering aspirations which left me chronically unsatisfied with the ordinary, but easily fascinated with the complexity of all of human interaction.

Previously, "The Shelf" has related my UFO encounter and the follow-up hypnosis which suggested your typical abduction scenario. In that case, presumably hypnosis was a tool to aid recovery of interactive patterns and emotions: true to psyche even if not necessarily "physically real." My second hypnosis, at the hands of a licensed hypnotherapist, was not a tool but a weapon. I relay it now as a warning to all hypno-wannabes to KNOW YOUR HYPNOTIST.

In exchange for writing background music for a hypnosis tape, I was offered a free hypnosis session, to further explore hidden "alien encounters." The hypnotherapist, whom I shall call Cheryl, was a regular in the new age crowd, and split her time between her house in St. Paul, Minnesota and Sedona, Arizona. She was very friendly. In one grand and sweeping gesture she confessed a love of John Lennon and a pride of having been a member of the "hippie generation." She then informed me that she was "working on a book about abductees." That should have been my cue to run for the hills! But I stayed there as she grilled me about "any and all strange memories from your entire life." This part took several hours, because as I have previously written, my life has an embarrassment of rich anomalies (even if, as our skeptical friends might believe, it all boils down to the anomaly of a rich imagination which internalizes itself into spurious memories).

I had forgotten to eat lunch, which didn't help any, but I nevertheless went through a long list of events, knowing that some of them were simply psychic flags in my mind of a more vivid-than-usual accompanying emotion; certainly no anomalous experience, but, I felt, something which in the interest of objectivity should be related.

Little did I know how literally Cheryl would take the stuff. She proceeded to put me in a hypnotic trance and go down the line, skipping nothing on the list. Whenever I drew a blank, she refused to take "No" for an answer. She would use tactics to make my trance "deeper," but for all the world I felt like I was being bullied; bullied to dredge up information, spurious or not. Because I was weak, hungry, and hypnotized, I believe that my mind cooked up stories to satisfy Cheryl and get me off the hook quickly. Oddly, I didn't "just make it all up," but I nevertheless didn't believe a word of what I said. This included:

A terrarium garden of my own soul; creatures with heads like horizontal footballs; being offered the red drink of forgetfulness "for my own protection," seeing some chipmunk-faced, tunic-wearing, migratory aliens. They suspiciously resembled hobbits, wore sandals, and were into music. They told me Louis Armstrong was a highly evolved individual (no argument there) and that

My second hypnosis, at the hands of a licensed hypnotherapist, was not a tool but a weapon. I relay it now as a warning to all hypno-wannabes to KNOW YOUR HYPNOTIST.

they as a race were working behind the scenes with composers of various types of music. When I was 8 years old and got lost in a Colorado campground, that I came upon "some kind of very metallic, shiny substance but it looks like an inverted rocket ship crashed into the ground and it looks like it's dented. I'm the only one there looking at it and all of a sudden now I'm on the inside of it. I see a ring going this way and a ring going this way and it's sort of dark inside there. I see something about a big tree... Um I am twirling around. It looks like I see the earth from below me. It's twirling around. I may be aboard the craft looking outside going for a ride in it and wondering if I'm ever going to get back and I still don't see any being."

Well you get the idea. Sounds like the fantasy life of an 8-year old kid. Unless I was enrolled in my own "secret school," that incident of getting lost in Rocky Mountain National Forest, which my parents say was just for 20 minutes or so, was just that; a traumatic walk back from the outhouse; losing my way and getting frightened. I inwardly resented this needless addition of juvenile science fiction added on to what already was a legitimate experience.

The session continued for around two hours, with my unconscious bringing forth various races and ideas, which, of course, the hypnotherapist was recording for inclusion in her book!

As I lay in trance, I was also aware of what was happening, and was I pissed! I was aware of how hungry, thirsty and weak I was. I had a headache, and whenever I told her I had no strange experience to relate (tied to our earlier interview points) she refused to believe me, and would literally lead me "deeper" until I satisfied her. No doubt about it, here was the kind of hypnotherapist with an agenda that skeptics and debunkers consider the rule in all alien abduction episodes. I'm not going so far as to assume that all sessions are like mine. After all, my first session by a disinterested non-professional hypnotist was completely untainted by such mental violence. Violence is not too strong a word, because when I came out of the trance I felt as if my brain had been raped; I was seething; and did my best to remain civil.

A few days later, I received one of those weird universal question marks in relation to this hypnotherapist. "Cheryl" had made it quite clear her totem animal was a deer. One morning, about 6:00, at my house in South Minneapolis, a solidly residential area just 20 blocks away from downtown, I was astonished to see a beautiful deer prancing in our sunlit front yard. I had my wife look, and she verified what I was seeing. Needless to say, this was singular, and we immediately set about calling animal rescue professionals. Meanwhile, the deer ran off somewhere else. When I told "Cheryl" about this a few days later, she appeared elated but just as surprised as me. Could the deer have been a sign that I was actually well-served by this hypnotic encounter?

Black Stigmata

Albert K. Bender: The Man Who "Discovered" The Men In Black

Dean James

It is doubtful whether any name could be more synonymous with the so-called Men in Black than that of American researcher Albert K. Bender. His 1962 potboiler *Flying Saucers and the Three Men* ranks as a classic of the genre indicated by its title. The text is full of bizarre departures from logic, but nevertheless rewards careful study. As an example of folklore in the making it is invaluable. ¶ Bender himself exhibited a degree of paranoia unmatched by his contemporaries. Preoccupied with the occult, he spent the early 1950s brooding on strange phenomena in a specially appointed "chamber of horror," and eventually fell prey to some form of psychic attack (albeit many latter-day readers are likely to find his symptoms indicative of nothing more exotic or mysterious than migraine.) *Flying Saucers and the Three Men* relates how he discovered an unspecified 'secret' relating to the origin and purpose of flying saucers, and was later visited by three men in black (MIB) who whisked him off to Antarctica for further astounding revelations. It concludes by pointing out that since 1960, "flying saucer reports have decreased [as] the visitors from space left our planet." On the face of it this may seem a wildly inaccurate summation of actual events, but in fact it contains a strong element of truth. Flying saucers did indeed begin to disappear from the Earth's skies circa 1960, withdrawing to make way for their linear successors- UFOs. The distinction here is not merely one of terminology alone. Flying saucers were called into being by the psychic demands of the immediate post-war era; UFOs reflect an entirely different set of millennial concerns.

According to American author Allen H. Greenfield, "it would not be too much to say that Albert K. Bender conjured up the Men in Black through a magic ritual, pure and simple." Here again, this seemingly implausible statement contains a strong element of truth, even though it doesn't really tell the whole story. It is important to bear in mind that Bender's MIB weren't the saturnine agents of terror portrayed so vividly by other writers on the subject. Neither good nor evil, they functioned as neutral characters in some larger heirachical design. At one point in his account Bender even refers to them as

Bender's depiction of an MIB

"my friends," a term more redolent of terribly loneliness than anything else.

This in turn hints at the true nature of Bender's experiences, which appear to have been elaborate wish-fulfilment fastasies projected onto external reality by sheer effort of will. The psychic landscape delineated in *Flying Saucers...* is fraught with fear and wonder in more or less equal measures. Among other things Bender meets a nine-foot tall bisexual who insists on being addressed as "exalted one," and has the living daylights scared out of him by a monster "more horrifying than any depicted in the work of science fiction or fantasy artists." He is also stripped naked by three glamorous space-babes and given an intimate all-over massage to prevent him from contracting "a dreaded disease...feared by all persons (presumably cancer, which seems to have preyed on his mind a good deal). "It was the most magnificent feeling I have ever experienced," he records soberly.

In 1954 Bender began corresponding with an English airline hostess, and later met her in person. They were married in October of the same year, at which point his other-worldly friends gracefully bowed out of the picture, their purpose fulfilled. It was the end of an era.

By his own admission, Bender's youthful ambition was "to rent an old house, fix it up with spooky devices, label it 'haunted house' and charge admission." With hindsight it is clear that *Flying Saucers and the Three Men* was written in much the same spirit. The narrative is full of lurid descriptive passages and imagery more appropriate to the pages of pulp fiction. Above all it resembles an allegorical tale with the moral: "Don't dabble in the unknown." Perhaps that is the best way to view it.

Footnote:

Bender's putative experiences were first brought to public attention by the influential author and publisher Gray Barker, who dealt with them at length in his 1956 book *They Knew Too Much About Flying Saucers*. Barker, a homosexual, died of AIDS in the mid-1980s. Unkind readers might suspect that he had an ulterior motive for his initial interest in Bender, a bachelor who devoted himself to contacting "strange men."

Bait and Switch:
A CIA "Openness" Memo

Greg Bishop

Dated "20 December, 1991" an internal memo from the "Task Force on Greater CIA Openness" was apparently leaked by accident soon after its completion. The report was in response to a request by then CIA Director Robert Gates. Copies have been floating around on the fringes of the research community for about four or five years. One of the humorous (?) aspects of this document is that a memo on "greater openness" was classified and clamped down upon by CIA censors when it was realized what had happened. Maybe the memo was leaked intentionally, or an employee at the Public Affairs Office was canned for it, or handed a transfer to Tierra del Fuego. The text reveals both a self-congratulatory smugness and a paradoxical desire to evolve the image of the CIA as a "visible and understandable" organization. There is obviously a sense that the American public has just about had it with an agency that seems to serve no important purpose in a post-Cold War world. This is coupled with the fact that many informed citizens believe that the CIA routinely covers up its mistakes and dirtier dealings with documented false-hoods and bait-and-switch techniques. Amongst those who have come of age in the last ten years, this attitude of distrust is pervasive enough to have become accepted in the mainstream.

Reacting to this in an early attempt at spin control, rather than outright stonewalling or lying, the task force recommended some changes in the methods that the Public Affairs Office (PAO) utilizes to deal with their information conduits (news media, academia, and private sector business.)

Throughout the document, the Task Force members reveal that they seem to want it both ways, as evidenced by this statement: "there was substantial agreement that we generally need to make the institution and the process more visible and understandable rather than strive for openness on specific substantive issues." Viewed in this light, the study seems to recommend no real change in attitude, only in the way that the agency presents itself to a hostile or at least an indifferent public.

Particularly revealing is the passage that describes the "contacts with

> One of the humorous (?) aspects of this document is that a memo on "greater openness" was classified and clamped down upon by CIA censors

Formal acceptance of this statement by the Agency, or one similar to it, will provide a necessary and well-understood framework for taking the steps to achieve greater CIA openness.

7. We have an important story to tell, a story that bears repeating. We are the most open intelligence agency in the world which is proper in our form of democracy. (In fact, several foreign intelligence organizations have sought advice from PAO on how to establish a mechanism for dealing with the public.) That said, many Americans do not understand the intelligence process and the role of intelligence in national security policymaking. Many still operate with a romanticized or erroneous view of intelligence from the movies, TV, books and newspapers. These views often damage our reputation and make it harder for us to fulfill our mission. There are steps we can take which will benefit us and the American people.

Throughout the document, the authors of the CIA "Openness Memo" congratulate themselves on being "the most open intelligence agency in the world"

MEDIA

1) Current Program:

a) PAO now has relationships with reporters from *every* major wire service, newspaper, news weekly, and television network in the nation. This has helped us turn some "intelligence failure" stories into "intelligence success" stories, and it has contributed to the accuracy of countless others. In many instances, we have persuaded reporters to postpone, change, hold, or even scrap stories that could have adversely affected national security interests or jeopardized sources and methods.

b. PAO spokespersons build and maintain these professional relationships with reporters by responding to daily inquiries from them over the telephone (3369 in 1991), by providing unclassified background briefings to them at Headquarters (174 in 1991), and by arranging for them to interview the DCI, DDCI and other senior Agency officials (164 in 1991).

After the remark about the "most open intelligence agency in the world," the PAO (Public Affairs Office) boasts of its contacts with "every" media outlet and its ability to completely control all public information about the Agency.

6. In most of our discussions with outsiders as well as within the task force there was substantial agreement that we generally need to make the institution and the process more visible and understandable rather than strive for openness on specific substantive issues. To do this, we need to develop a strategic vision of what we want to be open about, why we want to be more open and to whom we want to be more open. Our suggestion for such a vision statement is:

CIA, the most open intelligence agency in the world, wants to be recognized as an organization of high caliber and culturally diverse people who achieve technical and analytic excellence and operational effectiveness in fulfilling their mission with integrity and the trust of the American people. We believe that it is important for

Later, the authors further contradict their open-door policy, stating that the PAO should strive to make the CIA more "understandable" rather than honest on any important issues.

every major wire service, newspaper, news weekly, and television network in the nation." The writers go on to boast that the PAO has been able to change or even scrap stories that were not to the Agency's liking. This appears to indicate that the CIA really does control a portion of the news media through a "carrot-and-stick" sort of relationship with reporters who boast of their "secret sources" and secretly fear the loss of same if they happen to piss off "Mr. Deep Throat."

The best way to affect opinion is to make the public and policymakers believe that their conclusions were reached by a fair and balanced judgment of facts. If the "facts" are controlled, the hamhanded coercion practiced in other areas of the world that is feared in a free society never rears its head. Based on the ideas and recommendations in this memo, a certain percentage of the news media becomes a CIA mouthpiece simply through the illusion that any Agency source is a valuable source. When a reporter treats information from the Agency as unimpeachable, the public discourse suffers. While this basic intelligence principle was set forth over 2000 years ago by Chinese General Sun Tzu in *The Art Of War*, it seems that many journalists may need a refresher course.

(Another interesting note: The document mentions Oliver Stone's *JFK* by name and reveals that the CIA knew "for some time" that this film was in the works.)

The text reveals both a self-congratulatory smugness and a paradoxical desire to evolve the image of the CIA as a "visible and understandable" organization. There is obviously a sense that the American public has just about had it with an agency that seems to serve no important purpose in a post-Cold War world.

Interview: *Steamshovel Press'* Kenn Thomas

Introducing the Ispissimus of Parapolitics

Dean Genesee

The "summer session" UFO conference in Laughlin, Nevada took a conspiratorial turn this last August [1998], proving that there is a definite connection between genetically engineered viruses, the JFK assassination, and flying saucers. Conference organizers showed rare insight when they invited *Steamshovel Press* editor/publisher Kenn Thomas to present his latest research and writing. *Steamshovel* is arguably the conspiracy research journal of record, and has for the past few years kept interested citizens abreast of the latest revelations about the power elite and its Machiavelliean machinations. Thomas has written six books (*The Octopus, Popular Alienation, The Torbitt Document, Oswald Mind Control and JFK, Flying Saucers Over Los Angeles,* and *Maury Island UFO.*) Goaded by sleep deprivation and hunger, Thomas and the interviewer ranted late into the night, with giant bats fluttering by the hotel window and retirees slamming the slot machines downstairs.

Kenn Thomas

To the mainstream culture all of this is "kooky stuff" and it's not true. That point of view can be superimposed over the entire body politic of the country, save for a handful of people. As a result of all of this, I felt it was important to do the conspiracy stuff.

Q: How and why did you start Steamshovel Press?
THOMAS: It had to do with an interview I conducted with Ram Dass [Richard Alpert.] We got along famously. I had an agreement with one of the local [St. Louis] newspapers that they would publish the interview. They reneged on the agreement, and I didn't know what to do, since I don't do anything unless it's already "pre-sold." I billed the accounts payable department anyway and took the interview and made it the first issue of *Steamshovel Press.*

Q: Is that available, or did you hide them like many zine publishers do?
THOMAS: They're gone. It was tremendously embarrassing. The *Steamshovel* anthology [*Popular Alienation*] begins with issue #4. People ask me all the time where the first three are, and I'd really rather forget about them because they really are crappy looking.

Q: What was the genesis of your interest in conspiracies?
THOMAS: It goes back really far. I had a great interest in Lenny Bruce in high

school. Paul Krassner had written Lenny's autobiography. Krassner was always connected with Mae Brussel and so I had read Mae Brussel's stuff as early as high school. I was mainly a reader and consumer of the information.

After I did the Ram Dass thing, I did another issue on Wilhelm Reich, and this was all done on the office photocopier after hours. Then I started to send them around to publishers to get free books to review. If you can convince publishers that you are a viable magazine, you can get review copies and save lots of money. I've got about a 90% success rate with getting publishers to send books for review. That was it's sole function until the third issue, when at that time Bob Banner was doing *Critique*—the quintessential conspiracy zine. But the conspiracy stuff depressed him so much that he joined a self-help cult—Robert Le Masters' group —and he changed the name of the zine to *Sacred Fire*, and published the homilies of his guru. It was a disaster in terms of those of us who liked the conspiracy stuff. Then Mae Brussel died, and John Judge and Dave Emory started their competition. [Fighting over her files]

Q: Whatever happened to all of her material?
THOMAS: A woman named Virginia McCullough has control, and offers it to others for study. It's now out of the hands of either Emory or Judge. So *Critique* was down, Mae Brussel was dead, and some of the bozos who were coming in their wake weren't building on the material. Well, not so much John [Judge], he's a good guy, takes himself a little too seriously at times, but has a good sense of humor. One way or another, though they both mismanged everything that Mae Brussel had left behind. Judge didn't get steam up and going again until Oliver Stone's movie [*JFK*] came out. Now he has the Coalition On Political Assassinations, but all that is the outgrowth of the movie, just as the Assassination Materials Review Board is. [Official review of records in the National Archives pertaining to JFK's death.]

There is always a great deal of pressure to homogenize history and political culture. People like Mae Brussel hold onto our history, and when they die, they aren't transmitting any more. That vacuum could be filled and that information can be erased within a matter of months. To the mainstream culture all of this is "kooky stuff" and it's not true. That point of view can be superimposed over the entire body politic of the country, save for a handful of people. As a result of all of this, I felt it was important to do the conspiracy stuff.

Q: So it grew out of a need to keep the information flowing, and was basically a selfish impulse?
THOMAS: That's what it was. I'm a reader, a consumer of this material and to feed that need, I felt I had to do more with *Steamshovel* instead of the literary zine it was until the third issue. At the end of that issue, I called for papers, and we got some conspiracy stuff. Issue #4 was a donated print job. This was actually done on photocopy equipment at Monsanto Chemical.

Q: That sort of situation is sweet.
THOMAS: We were able to manage it right, and sold enough copies of that issue to do the newsprint thing with the wraparound cover. And that's how I

> **There is always a great deal of pressure to homogenize history and political culture. People like Mae Brussel hold onto our history, and when they die, they aren't transmitting any more.**

moved from just being a consumer of this material to becoming some kind of an activist or player.

Q: *How did the name "Steamshovel Press" come about? Wasn't it from a Bob Dylan song?*
THOMAS: How did you know that? It was supposed to be a secret!

Q: *You printed it, or I read it somewhere.*
THOMAS: I never printed that or told anyone who wrote about it.

A lot of the conspiracy culture is driven by right-wing extremism and militia movements and other groups that don't really connect with that creative underworld.

Q: *Well, maybe I remote viewed it.*
THOMAS: Maybe so. There's a line from the song "From A Buick 6" from *Highway 61 Revisited*: "It takes a steamshovel, baby to unload my head/Takes a dumptruck to keep away the dead" something like that. It's an absurd thing—people think the magazine is about industrial farm equipment. And it's not even absurd in a good way, like *Dharma Combat*. It's just dumb. I've been thinking about calling the enterprise Steamshovel Press, and calling the magazine *Popular Alienation*, but everyone knows it by that name, and I might not even do another issue! [Due to Fine Print Distributors bankruptcy.]

I hate to say "this means that" and be so linear. It's like John Lennon trying to explain "Beatles." Even the word "beat" came out of the beats and the beatniks, and that came from the Commie smear using "Sputnik" and appropriating it in phrases like "no-goodniks." In the '50s, everything was a "-nik." Allen Ginsberg said "Isn't it beatific?" It also had to do with music and beats and rhythms. Kerouac said that it meant "be-attitude." So it's not just one thing.

Q: *It was a return to what "freedom" means in America. People were horrified by WWII and the soldiers came back and wondered what was going on in the world.*
THOMAS: One of the unique things about *Steamshovel Press* is that it has that perspective of the Beat movement. A lot of the conspiracy culture is driven by right-wing extremism and militia movements and other groups that don't really connect with that creative underworld.

Q: *It seems the Beat aesthetic drives your perspective in that the reason for the discussion of these subjects is not out of a selfish motivation. It's more altruistic.*
THOMAS: All these things are connected. What does the Kennedy assassination have do with the Beats? Some of the things that were responsible for the assassination from the "straight" world were referred to as "Moloch" in Ginsberg's *Howl*.

Q: *Like Phil Dick said; "The empire never died" meaning the Roman empire, but also that that imperialistic, materialistic, and controlling impulse survives to this day.*
THOMAS: *Popular Alienation* has that quote right at the beginning from Ginsberg: "Recent history is the record of a vast conspiracy to impose one level of mechanical consciousness on mankind." I'm sure that to many people involved in conspiracy zines and the community, the mention of Allen Ginsburg would make them retch. In fact, when he died, half of the discussion

in the *Konformist* newsletter was that he was a member of NAMBLA [North American Man-Boy Love Association] and that he was a pedophile.

Q: So was Burroughs, and no one mentions that either. (Not that he was in NAMBLA, because I don't think that he was.)
THOMAS: Frank Sinatra has mafia connections, but what does that have to do with his being Frank Sinatra? When Ginsberg dies, our only job (and I'm talking about the conspiracy research community) is to honor our venerated dead. We shouldn't sit around splitting hairs and say "He was a great poet, but goddammit, he was a pedophile."

Q: No one seems to care that Kennedy was sleeping with who knows how many women when they want to lionize him, either.
THOMAS: So that is part of the mission of *Steamshovel Press*: getting people to realize who their allies should be.

Q: And, for all we know, Hitler was nice to babies! Who else would you say contributed to this aesthetic?
THOMAS: Well, all those people died in the last year: Leary, Burroughs, Ginsberg–it was their time. They were very old. I guess I'm trying to emphasize the fact that we're out here alone. These guys were like our "uncles." I'm trying to think about how I can raise children in a world that doesn't have these people. The "dropout" message is going to be around forever now, and you can't do with these people what you might have done with a previous generation of writers and enshrine them and make sure all the high school students read them.

Q: Not for about 100 years, anyway.
THOMAS: It will mean something totally different for the people who are forced to do it. Really the only hope I think that young people have is that the beat and the dropout ethic is not going to go away. Being involved in conspiracy analysis is like working backwards—letting people know that no matter what's happening, there is something wrong with the way things are.

Q: It's the antithesis of that "Love it or leave it" ethic.
THOMAS: What the conspiracy culture is a big spectacle: The military-industrial-entertainment complex spectacle. What we're doing is pointing out that not everybody here is the happy little consumer that the spectacle wants us to be.

Q: One symptom is illustrated by this story I was told. One of my friends was talking to a colleague at work about the Kennedy assassination, and this person finally asked if he was "some sort of conspiracy nut," and my friend shot back, "Well, maybe, but are you some sort of coincidence nut?"
THOMAS: Well, being called a "conspiracy theorist" to me is like calling a black person a "nigger." What people are seeing right now with that movie *Conspiracy Theory* is a caricature of someone who is a stereotype. It's as bad as Stepin' Fechit or the Yellow Kid.

> Really the only hope I think that young people have is that the beat and the dropout ethic is not going to go away. Being involved in conspiracy analysis is like working backwards-letting people know that no matter what's happening, there is something wrong with the way things are.

Being called a "conspiracy theorist" to me is like calling a black person a "nigger."

Q: It puts the person in a box so he can be categorized and no one has to deal with it. That would involve thinking and work. Although something like that kind of conspiracy wacko does exist.

THOMAS: People need to laugh at it because they just can't handle it. Not that it isn't true, not that you're insane because you're into it, but that it IS true, and it's a rational thing to be concerned about the kinds of things we're concerned about.

One of the things about the monolithic mainstream culture is that it's always right. I would be the first person to tell you that half of what I say is wrong. It's as much as I understand it. This is what I think distinguishes what we do from what the militias or other such groups publishing this material are doing.

Q: They're a consumer culture, but also a fringe culture which is spitting their cherished view back out without checking for any supporting evidence. It seems like many of the personalities and events of the conspiracy culture are connected at some level, and if you're in it long enough, you become a part of this web. For instance, you had a personal connection to the Heaven's Gate group, right?

THOMAS: I never solicit advertising for *Steamshovel*. Except once. (Laughter) I was quoted in *USA Today* and the Heaven's Gate ad was on the opposite page. So I looked at the ad and I thought "Well, this is pretty far out. My readers would probably be interested in this." It looked like they had a lot of money, so I wrote to them and I got a typed and signed letter back from [Marshall] Applewhite saying "Oh sure, we'd love to take an ad! We always get an enthusiastic response from people in Missouri!" Kind of makes you wonder, doesn't it?

It didn't click with me right away when they all killed themselves that it was the same people. I asked a friend to look through some old issues I had lying around the house for the ad, because I was curious that it might be the same people. Then [*Conspiracies, Coverups, and Crimes* author] Jonathan Vankin was on *Crossfire* just before I contacted him by e-mail, and he had done an article on biowarfare for me in the same issue as the Heaven's Gate ad appeared.

Q: Those people [Crossfire hosts John Sinunu and Geraldine Ferraro] were just on during the Roswell event and they generally sneered at the whole thing while looking at it in such a cursory manner. No substance and all emotion, essentially.

THOMAS: Yeah, they always have an agenda there. He wrote me back and he asked me why I didn't contact him earlier with the info because he wouldn't have looked like such a fool on the air. He was identified as an "internet researcher" because they were trying to blame it as a product of the internet. The internet is of course a threat to entities like *Crossfire* and CNN, since it allows people to access information on their own.

Q: Oh no! Now people have to work to find their own truth if they choose! Can't have that! Their hypocrisy was contained in the statement that was made on one of these news analysis shows about "How can we trust anything when anyone can look like Time *magazine?"*

THOMAS: They always have a bunch of "facts" and package it and make it look pretty, and the complaint is that anyone can now take a bunch of crap and make

it look pretty, but they've been able to get away with it forever.

Q: What do you think the major news services are doing to co-opt this new access technology, and possibly circumvent it?
THOMAS: I think in addition to PROMIS software and things like it, that the powers that be are trying to make everyone alarmed about the power and the freedom to be able to communicate in that way, and also to use it to spy on people in various ways.

Q: You have mentioned that in earlier versions of Windows 95, the program would read your hard drive and send it back to Microsoft to check for example for any stolen software. The company issued subsequent versions with a warning asking the user if this was OK!
THOMAS: Bill Gates just doubled his fortune this year. We don't know a lot about the PROMIS software—information keeps coming in occasionally— but we do know that bits of it have been mimicked on Windows 95, and the Netscape browser had that same "backdoor" spying feature that they of course called a "bug" when it was discovered.

Q: That's frightening, since most people have either one or the other of those browsers on their computers. So the conspiracy reaches into your office or living room! Actually, since hearing Leonard Horowitz today speaking about deadly viruses riding on vaccinations, it conceivably reaches into your body as well. We have to watch ourselves though, because it becomes quite disconcerting to just believe all these researchers without checking into the facts yourself. You can drive yourself nuts.
THOMAS: A lot of these retirees and other people have come to UFO conferences for years, and yet they all still seem to be shocked about what is said.

Q: Do you have problems in your public appearances with people who are unfamiliar with the material? In other words, how much backgrounding do people need?
THOMAS: At times, I think that an audience should know a lot more than it does. This morning at my presentation I brought up the Maury Island case, which is my next book, and I was surprised that many people in this UFO audience seemed to draw a blank. This book has to come out this year because it's the 50th anniversary of the case.

The other book is *Oswald, Mind Control and JFK*, or the "Were We Controlled?" book. *Were We Controlled?* was a book by Lincoln Lawrence which is a classic in JFK assassination literature, which came out in 1968. The thesis of the book was that the perceptions of the public were controlled because of a few people who were mind controlled. This also has to do with the "Great Salad Oil Swindle."

Q: The what?
THOMAS: In 1963, a man named Tony De Angelis had these receipts for warehouses full of thousands of gallons of salad oil. He was then going around to banks and getting thousands of dollars in loans based on this as collateral. After awhile, he started getting exposed as a fraud, and this caused a panic on the stock market. This

> We don't know a lot about the PROMIS software—information keeps coming in occasionally—but we do know that bits of it have been mimicked on Windows 95, and the Netscape browser had that same "backdoor" spying feature that they of course called a "bug" when it was discovered.

was a major news story on the morning of November 22, 1963, before Kennedy was shot, and of course when he was shot, the panic was exacerbated. Because of the short-selling this caused, many people were profiteering on it. One of these people was Warren Buffet. [CEO of American Express.] This part about Buffet isn't in the book, but I have found out through my own research that he is a cousin of Art Bell, and since I'm circulating this information, this is probably why I haven't been invited on his radio show!

> **Ruby and Oswald and De Angelis were all mind controlled in their actions for the sake of making money on the stock market that day. One of the other groups that made money that day was called the Bunge Corporation out of Argentina which was of course where all the exiled Nazis went.**

Q: Who was mind controlled in this scenario according to Lawrence?
THOMAS: The point of the book was that Ruby and Oswald and De Angelis were all mind controlled in their actions for the sake of making money on the stock market that day. One of the other groups that made money that day was called the Bunge Corporation out of Argentina which was of course where all the exiled Nazis went.

Q: I think it was Len Horowitz who said that Bormann hid all his assets in corporations before the war ended, like in I.G. Farben and other big companies?
THOMAS: Yeah, I think that's right. At the time, the Bunge Corporation was called "The Octopus." This might have been the origin of Casolaro coming up with the same term when he was investigating the PROMIS case.

The other book is *Maury Island UFO*. I'm still working on it. I just got the Freedom Of Information Act documents on Fred Crisman.

Q: Anything interesting in that pile of stuff?
THOMAS: There is a substitute teacher's log for the Oregon high school where Crisman was teaching in November, 1963. There is no substitute teacher listed for him, so supposedly this proves that he couldn't have been one of the tramps picked up in Dealey Plaza. But this all happens on a Thanksgiving weekend, and there is every possibility that the school wasn't even open on November 22nd.

Maury Island is of course one of the first UFO incidents in modern lore. It predates Kenneth Arnold by three days. It also odd that Guy Bannister was in the area when someone found a 30-inch "flying disc" and Bannister was involved with it. I have a couple of articles from *The East Oregonian* and the Tacoma newspaper. It's clear that there is some kind of a coverup going on. Bannister is only mentioned in the Tacoma report.

Q: Wait. What was Guy Bannister doing in Oregon? What year?
THOMAS: This was in 1947. Nothing had ever put Bannister in the northwest until this original research by this man Halbritter. Bannister was based in New Orleans. Then Gordon Winslow—this archivist in Miami, came up with the HUAC testimony of Guy Bannister where Bannister said that racial tensions were all caused by communist agitation. This guy also uncovered the fact that he was the Special Agent in Charge in Butte, Montana and also working in Idaho.

But Bannister was involved in recovering this metallic disc in Washington state in 1947 as well. The first news article from Tacoma says that this thing was

recovered by the police and the FBI told them to shut up about it, then a couple of days later they reported that some boys had taken their phonograph and radio apart and put them together and made the disc, and that's what it really was.

Q: Sounds like Roswell.
THOMAS: Yeah, kind of the same thing. But getting back to Bannister, he was the Louisiana coordinator for the Minutemen, which was a militia group in the 1960s that was actually investigated by the Warren Commission. The California coordinator for the Minutemen was William Gayle, who was also part of Charles Willoughby's spy network. Willoughby was always referred to as Douglas MacArthur's "little fascist" and ran this spy network for MacArthur. All these guys were part of a group called the "Shickshinny Knights of Malta." Another person in that network was Philip Corso, who has of course released this Roswell book recently.

Q: What network was that? What did they do?
THOMAS: Corso was one of Willoughby's spies. So was Gayle.

Q: So this was a private group under MacArthur who did "spying" for him?
THOMAS: Yes. All under Charles Willoughby.

Q: Is that normal in the armed forces?
THOMAS: Well, it was standard operating procedure with Douglas MacArthur. There's a whole line of interesting questions that need to be asked of Corso with regards to that history. His book ends with the Kennedy assassination. He doesn't really talk about how the aliens might have been involved there. Corso also worked for CD Jackson who worked as an aide for Eisenhower, and wrote the "Atoms For Peace" speech with Robert Cutler, who is of course famous for the "Cutler-Twining Memo" [concerning a meeting of MJ-12.] Wilhelm Reich always said that the "Atoms For Peace" thing was stolen from him, and Corso would be a good person to ask if he had ever heard of Reich. We know of course that Reich went to Roswell as well. [passed through on his way to Tucson]

So there's a whole world of questions that need to be asked of Corso that really don't have anything to do with what he said directly in the book. I'll take his word about the back-engineering of alien technology, etc., but tell us more about being a member of the Shickshinny Knights of Malta...

Q: What was that group about? Were they a self-conferred spin off of the Knights of Malta?
THOMAS: It was some kind of sub-order or branch. I really don't know a lot about them past that. Phil Corso was a known spy personality way before this Roswell book. Dick Russell wrote this tremendous book called *The Man Who Knew Too Much*, and Corso's in it. He's got a whole page on Corso in there. He outlines his whole history. When I get all the documentation lined up, it's going to make a good story.

That's the shame about what goes on at a lot of these UFO conferences:

> There's a whole world of questions that need to be asked of [Col. Philip] Corso that really don't have anything to do with what he said directly in the book. I'll take his word about the back-engineering of alien technology, etc., but tell us more about being a member of the Shickshinny Knights of Malta...

There are certain parts of [the Maury Island UFO incident] that are hoaxed, and all of this has to do with Fred Crisman, who was a notorious liar.

You have some real figures here like Corso who were involved in some real aspects of espionage history, and if you're prepared you can ask him some very good questions. If he was here, I'd corner him away from the crowd.

Fred Crisman was supposedly holing William Gayle up at his ranch for awhile, and Corso knew Gayle, or had contact with him. Corso was investigating the Minutemen for the Warren Commission, so if he did know Gayle, it was like the Fox investigating the henhouse.

Q: Why was Jim Garrison interested in a subpoena on Fred Crisman?
THOMAS: Because of this fact that he was harboring Gayle or a number of other Minutemen at his ranch in Oregon. Anthony Chimering, who did the article for *UFO* said that Crisman was connected directly to Clay Shaw, and thereby connected to operation Paperclip. Shaw was part of the Permindex Centro Mondiale Commerciale group in Italy which helped with Paperclip.

In this Maury Island book I'm doing right now there's going to be a whole section that focuses on Crisman. It appears very probable that some kind of strange event happened at Maury Island, and that Harold Dahl actually saw these six doughnut-shaped saucers.

Q: Why is this probable after so many UFO researchers have concluded that the "Maury Island Incident" was a hoax?
THOMAS: There are certain parts of it that are hoaxed, and all of this has to do with Fred Crisman, who was a notorious liar. He involved himself in the episode after Dahl had come and reported his experience. Then Crisman said he went out there by himself and saw a saucer too, and then he's the one who's holding on to all the "metal slag" that he says fell from the object.

Before all that happened he had letters published in Ray Palmer's magazine [*Fate*] about how he was fighting the Deros in Burma as part of that Shaver mystery. And later, Palmer hired Kenneth Arnold to go out and investigate Crisman and Dahl and paid him 200 bucks to go out and talk to them, saying he'd never heard of either of them. He knew all along that Crisman had written him letters about the Dero and a wound he'd suffered to his arm that was a very prescient description of a laser wound, before the laser was invented. So Palmer knew who Crisman was, and here he is asking Arnold to go out and check him out. Then there's a whole element of intrigue here as well with pseudonym that Shaver used which was "Robert Webster," which was the name of one of the Oswald doubles!

Q: Why is this significant?
THOMAS: Maybe I'm making more out of it than I should, but it's just that Crisman has so many different connections to the Kennedy assassination. Also that brings in the whole idea of the Oswald doubles in the first place. This guy Robert Webster was one of several, and he went over to Soviet Union and defected and came back. And he's the spitting image of Oswald.

Q: "Food for thought and grounds for further research" as our friend Dave Emory says.

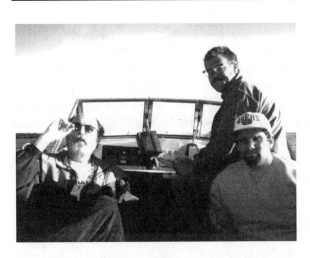

Sink this boat and wipe out half the conspiracy research community. Thomas, Jim Martin of Flatland, *and Robert Sterling of the Konformist.com.*

THOMAS: I should also make it clear that Crisman was also a business partner to Marshal Riconosciuto, who was Michael Riconosciuto's father. So this connects back to the Danny Casolaro case, and underscores the pattern of financial abuse. The idea of presenting bogus receipts in order to get collateral for loans is the exact thing that Earl Brien was convicted on last October. He was the guy who was given the PROMIS software in exchange for his role in paying off the Ayatollah Khomeni in the October Surprise. He was convicted of fraud because he had holdings in the Financial News Network and United Press International, and he exaggerated those holdings to get loans. Earl Brien was a brain surgeon in the first place, and the argument is that the Salad Oil Swindle had something to do with mind control that had to do with brain surgery because they were talking about electronic implants. All this stuff is based on the work of José Delgado: "the man who stopped a charging bull with the press of a button."

Q: How does someone draw the conclusion that someone would be able to control someone remotely well enough that they would do what DeAngelis or even Oswald or Ruby did?
THOMAS: The kind of technology for this had existed for many years. The book [*Oswald, Mind Control and JFK*] traces the history of it to Germany going back before the 1930s. The Maury Island manuscript is about 700 pages right now, and I haven't written the chapter on Fred Crisman yet! Part of the problem with that is that there is a long appendix because I want to present as many documents as are available.

Q: Unlike Philip Corso...
THOMAS: Hey, he has the project Horizon stuff in there. [Laughter]

Q: So what, right? Plans for an army moon base to mine minerals and incidentally as an outpost to "guard against alien attack." Of course the documents he provides don't mention this alien stuff.
THOMAS: Well the absence of evidence is not evidence of absence. They wouldn't put that in the [Horizon] report. Did he request those through the FOIA?

Q: Well, you know people like Corso don't need to go through the channels that the rest

I believe UFO stands for "U Figure it Out."

of us do. I've actually seen documentation of some stuff he has in there that he doesn't provide. The thing really sounds like a setup, whether Corso is aware of it or not.

THOMAS: Let's assume for a minute that everything that Corso said is a total lie, or maybe it' stuff he believes? Then how is it that all sorts of people (like Ronald Reagan) believe in extraterrestrials that don't exist? Corso, being some sort of military bureaucrat all his life believes that he's in charge of the "Roswell File" and maybe higher-ups are pulling his leg and having some kind of joke.

Q: You could assume that, but I think that as far as the totality of the book goes, it's probably 80-90 percent disinformation. That's my personal gut feeling. If this is true, I don't know if Corso even knows that though. Of course, this means that the other 10-20 percent has a core of truth to it. I can't even begin to guess what it is, though.

THOMAS: It is a discipline to separate the wheat from the chaff, or even trying to imagine an alternative scenario. I'm so used to thinking that there are extraterrestrials that the government is dealing with. I presume it. I've lived with that so long that it's hard for me to get in touch with what *would* be real if that isn't real at all.

Q: I guess our thinking is alike in that we have sort of a mental bulletin board where we are constantly examining things.

THOMAS: That's part of the *Steamshovel* metaphor, actually. The "bulletin board" model becomes a "desk" model after awhile: there's piles and piles of research, none of which you can reach any real conclusions on. That's why I did the magazine, and why a lot of it is so scattered. The "Things Are Gonna Slide" section is just because I can't deal with it anymore. I have to create the steamshovel to push it all out there for everybody. I believe UFO stands for "U Figure it Out."

So what if there is no such thing as extraterrestrials? I am satisfied that there was such a thing as MJ-12 because of the Lou Douglas memo. The Lew Douglas memo supports the Cutler-Twining memo. Jim Martin won't let me say much about it. To me it's the smoking gun to prove there was an MJ-12. If there was an MJ-12 and there were no aliens, does this mean that there was a secret group of geeks who believed that there were aliens when there weren't any?

Q: Maybe this is the sort of thing that Jaime Shandera is talking about: This scenario with aliens is for him supported by a web of evidence that includes documents that are time-specific and person-specific, and unaltered. There are as many as he could possibly find, and then there's one that might be the key, like your Lou Douglas memo.

THOMAS: The one that convinces you that there is no way it could have been altered or even made up.

Q: They aren't hoaxing themselves, and if that's true, who's doing it to them? How paranoid can you get?

THOMAS: I don't believe in "Occam's Razor," the argument that the simplest explanation is probably the right one, because it hardly ever is. Most things happen because of a complex web of events. After a while, it defies your common sense

more to say that there's no extraterrestrial stuff going on here at all. Of course, that's the reverse of what most people who consider themselves common-sense types would think.

Q: *It's not worth most people's time to look into this stuff, but what follows immediately is that that type of person should shut up with the ad hominem attacks.*
THOMAS: Or don't marginalize me because I'm trying to use my common sense to look into these things. You know, it's kind of weird that anyone *wouldn't* be interested in this stuff, I mean, it's really intriguing. It's common sense to ask these questions, once you look at the evidence.

Q: *I look at your experiences, and from what you've told me, it seems eerie that many of the subjects you look into become quite close to home, like the Heaven's Gate thing. How many degrees of separation do you see between yourself and some of the people involved in the stories you cover?*
THOMAS: Well, there's a tremendous amount of satisfaction when you're working on a story and then somebody you meet fills in something that makes you go "aha!"

Q: *Well, what I'm interested in primarily is something like the weird coincidence that Marilyn Monroe could be seeing RFK, and him telling her about Area 51.*
THOMAS: Well, there is a document that Marilyn talked to JFK about this in a transcript of a conversation between Dorothy Kilgallen and a friend of hers named Howard Feinstein discussing another transcript they were looking at of RFK and Marilyn Monroe where she's saying that JFK took her to Area 51. You know there's a movie called *Seven Days In May* that was actually written by Rod Serling with script approval by JFK himself about a right-wing takeover of the government being run out of a desert base in the southwest. The movie came out in 1964 after the assassination. JFK worked with Rod Serling to write that. He had an awareness of a secret base out in that area—Area 51.

You get into very interesting philosophical discussions about reality after awhile. Once you remove that need to have linear cause and effect, and instead see everything as a web of data points that intersect, and that you can skate around in, you come to an understanding that everything is real—that all these relationships have some kind of meaning and purpose—even things that aren't real are real. Everything reverberates with meaning that we basically try to ignore by forcing our minds into a linear pathway.

Q: *After awhile you realize that everything is connected to everything else, and it's just our minds that want to categorize and separate.*
THOMAS: Yeah, like just after my speech this morning someone came up to me and asked "Can you tell me what cover stories the Air Force put out after the Roswell incident, and in what order?" That wasn't connected to anything I was talking about.

Q: *But it could be.*

There's a movie called \that was actually written by Rod Serling with script approval by JFK himself about a right-wing takeover of the government being run out of a desert base in the southwest. The movie came out in 1964 after the assassination. JFK worked with Rod Serling to write that. He had an awareness of a secret base out in that area—Area 51.

The information is just all out there and that's why they hide it out in the open, because there's so much of it. People involved with it just fall over from thinking too much. They're paralyzed to ever do anything about it.

THOMAS: Yeah, it could. My answer wasn't related to his question *or* what I was talking about in my speech. That had to do with Carl Spatz, who was the first Chief of the Air Force, and who had dispatched Brown and Davidson out to investigate Crisman and Dahl, and who subsequently died in the B-29 crash which Crisman may have sabotaged. Carl Spatz' previous intelligence work in the Mediterranean was doing for the Italians and the Germans what MAGIC had done for the Japanese, that is breaking encryption codes. The program to break the Italian and German codes was called ULTRA, as in MKULTRA. Now, there are prosaic reasons for this, and any military historian will not argue that there was a secret military program called MAGIC, and it had to do with Japanese codes. People will argue that there was ever an MKULTRA or there was an alien program called MAJIC-those are arguable, debatable things. However, both of them have to do with encryption technology, which is a form of back-engineering.

The reason people get upset by things like that is it's just too fucking much. The idea is this overload phenomenon, which is part of what Jacques Vallee talks about as the UFO experience. He said he would be extremely disappointed if they turned out to be just metal ships from another planet. I think what he's describing is the information overload experience. The way that they get away with a lot of conspiracies is that they hide them out in the open. People say "Oh, they couldn't have covered up the Kennedy assassination, because too many people would have talked." So everybody knows about it and there wasn't a conspiracy. So everybody knows that there are UFOs and there's an international coverup, but it's all out in the open.

Q: So there's an attitude of "We know it exists, and it's fun to think about" and people put it in that box.
THOMAS: You know what that's called in psychology is "denial." It's a psychological phenomenon that you can't deal with it because it's just too much. The information is just all out there and that's why they hide it out in the open, because there's so much of it. People involved with it just fall over from thinking too much. They're paralyzed to ever do anything about it. In our culture we don't have anyone who is seriously criticizing or changing things, what we have instead are UFO conferences. Retirees and alienated people are coming together not being able to deal with the mess of it all. This is what we have instead of a serious political movement.

Q: It's a thrill ride for a lot of people. They thrive on the mystery of it. Maybe they think it makes them comfortably different because they think it's real. And because they think they have to choose between what's "real" and what's "not real," and don't realize that they do have the freedom to consider and even believe both, it will drive them nuts.
THOMAS: That's what I'm trying to get at. This was Carl Sagan's argument against UFOs and new age stuff, as if there wasn't enough room in the mind for the mainstream scientific model and another one. You either believe that or you believe this other stuff. These other beliefs would get in the way. Now, I don't believe that's true. I've read all this stuff and it hasn't pushed me over the edge—

can still perform high school science experiments and talk about physics and chemistry and so forth with no problem or contradiction. Even if everything that comes out of the new age pipeline is utter bullshit, it's not going to kick what you know about science out your ear. It can all exist simultaneously.

Q: I was forwarded an e-mail in which Kevin Randle said " I like Jacques Vallee, but I think he delves a little too much into the supernatural for my taste." and my response was:"WUSS!"
THOMAS: [Laughter] "You can't handle it!"

Q:Yeah, Vallee saw it thirty years ago while everyone was circle jerking around the science campfire.
THOMAS: Well William Burroughs said this, that "People believe that the Scientific paradigm came along and all human evolution came to a reverent halt." The one way you can't go, biologically speaking anyway, is back. There's still more changes to come, and still more paradigm shifting that people will need to go through.

Q: That's why this remote viewing thing excites me, because it has been just about conclusively proven that people can do things that most scientists say is bullshit. So what was put to rest by the scientific revolution might be coming back to give science a kick in the ass. So do you want to keep Steamshovel *going, or go into writing books, or anything else? What do you see for the future?*
THOMAS: Well, I really want to keep the magazine going because I enjoy it, but I've been really frustrated by this Fine Print distributor problem. I should be making enough money off of it, at least enough to produce the next issue. I can't do what *Gnosis* magazine did and send out all these notices asking for money to people who have already paid their subscription price. I don't really know what the future for *Steamshovel* is. Probably the next issue will be more like a tabloid with more editorial space.

Doing a book, you really get the opportunity to get into something for awhile. There's all kinds of things that I don't want to do that with-all kinds of interesting information-that other people can pick up on and do something with, so I want to keep the zine as an outlet for that.

Denial of Instinct, or Man: The Most Stupid Species

Viewpoint by Jeremy Bate

In nearly every case where an animal attacks a human, at least in the context of this documentary, the human is either WAY out of his element, like in the ocean, or doing something...utterly stupid.

Picture it if you can. A guy drenches himself in deer piss and goes wandering out into the woods with his reluctant, handycam-toting wife, thinking he'll somehow "attract" a friendly deer to come over and maybe lick his face, while his wife gets it all on tape for the entertainment of his hunting buddies, failing to take into account that male deer are in the habit of beating the crap out of each other on a daily basis during rutting season. The "timid" woodland creature eventually approaches, and, smelling a rival perhaps, rears up on his hind legs and proceeds to pummel the Helpless Hominid with his front hooves. We can only watch as Man's "dominion" over the fauna of the Earth is mocked, while his dutiful wife keeps the camera running. Perhaps she was thinking, "Well HE thought of this. I told him it was a bad idea. But if HE wanted a video of himself playin' with a deer to amuse his pals, that's exactly what he's gonna get!" So she stands and videotapes her husband's near-death experience, holding the camera on the action as he pleads for help.

This was on television. It was on one of those "reality" shows that the Fox Network runs during sweeps week. The ones where people are killed in horribly stupid car stunts or airshow disasters; tragic and senseless deaths of hundreds of people made all the more lurid and intensely real by the low resolution home videos of the events. I like to tape them. This particular show was called *When Animals Attack*, and of all of the reality-based-amateur-video shows I have ever seen, it is unquestionably the best. There have since been two sequels. It should be called, *When People Are Dumbshits*. It is a testament to the pervasive and unrelenting arrogance and stupidity of man, and an hysterically cathartic orgy of vengeance by Nature upon those who deserve it most- those sad, large-brained primates who, with all of their intellect and worldwide telecommunications, have lost the common sense that the Great Spirit gave to an earwig.

In nearly every case where an animal attacks a human, at least in the context of this documentary, the human is either WAY out of his element, like in the ocean, or doing something so utterly stupid that we would be disappointed if the animal DIDN'T attack. A guy tries to feed a mountain lion. An

Australian macho-man sticks his arm in the mouth of a crocodile. A girl climbs the railing around the polar bear habitat and leans against the bars so that her friend can take a picture. When the polar bear reaches through the bars and grabs her, the look of astonishment on her face is priceless. The tragedy is, even after the girl was rescued alive, the polar bear was probably killed, as if the animal was somehow more wild and dangerous after the attack than it was before. Through the stupidity of one tourist, a great beast is now destroyed, for the crime of doing what it does naturally.

Even in the cases where the animals seem to attack unprovoked, the hand of man is ubiquitous. There is the black bear with a ring in his nose who mauls a taunting talk-show host. And there is the rogue circus elephant, his tusks removed, but no-less a behemoth, who yet still attacks his handler and trainer, to the exclusion of all others. It is clear that the elephant has a specific score to settle. It is a tragedy not only for the trainer that his ignorance and abuse should come back to haunt him with such violence, and certainly for the elephant who could take confinement and enslavement no longer, and who is destined for destruction, but also for the hapless children whose day at the circus has turned into a bloodbath, and who will grow up with the unshakable belief that elephants are vicious monsters.

These creatures simply respond to their environment in a way their instincts deem appropriate. In nature it seems, things like this don't happen without a reason, and the prevailing motivation is usually survival.

There is a logic and a sense to the survivalism which characterizes the behavior of the "lower" classes of life on this planet. A logic which frequently seems lost on humans. A desert rat knows, when confronted by the rattlesnake which has crawled into its burrow, that if it stays very very still, the snake, unable to see it clearly until it moves, will eventually slither away. A human is the only creature who would say, "Sheeooot, Vern, lookie there, a rattler. Let's go git it!" and get bitten and killed by a creature better left alone. The rat knew what to do when confronted by the snake. He didn't have to go and watch some nature documentary or need a degree in herpetology to know to keep still. But it seems like most people do, even those who you would think would know better. Until fairly recently in fact, most of our best minds believed that the reason the rat stood still was because the snake hypnotized it. Many still do. You can't very well talk to the rat, can you?

Many still cling to the image provided by Genesis of the evil serpent. For that matter many believe animals in general are denizens of Satan's domain. Even more level-headed biblical types still take literally the decree that Man has dominion over the Earth. This premise is so far reaching that even many of our modern scientists, while on the one hand presenting their craft as a "rational" alternative to religion, behave as if to further the self-same concept of dominion as a thoroughly modern and acceptable assumption. This hidden variable rears its ugly head when the discussion of animal experimentation comes up. It's as if the primary concepts of Judeo-Christianity are so imprinted upon our collective psyches that the most ardent debunkers of religion arise as Elmer Gantry in a lab coat when you poke them in their big brass balls of

anthropocentric conceit.

At www.aynrand.com, you will see just such an example of anthro-pocentrism and the Tyranny of Dominion in all it's shit-kicking glory. This most blatant example of intellectual smoke-blowing since Mensa comes in the form of a small but unabashedly self-important society of cerebral Olympians known as "Objectivists". What exactly is an Objectivist, and why would he call himself such? The implication is that Objectivism is the antithesis of Subjectivism, that the Objectivist has no real opinions-that everything he utters is a fact, ergo anyone who disagrees with him is wrong. To call oneself an objectivist is to imply that one cannot be argued with. In actuality it is defined as a tendency to stress the external elements of cognition, to lay focus on the those things outside of the self, rather than on thoughts and feelings. In either case the result is the same-a denial of instinct and an insensitivity to the suffering of others.

The gatekeeper of AynRandLand, in his specious attack on animal rights activists, suggests that the sole criterion upon which should be granted the rights of Life, Liberty, and the Pursuit of Happiness is the ability to reason, and therefore, animals are not entitled to those rights. If one must prove the ability to reason in order to be granted the rights mentioned above like so much manna from Heaven, then millions of people around the world are shit out of luck. And I'm not just talking about those poor souls who have, through brain damage, Down's Syndrome, Alzheimer's Disease, or whatever, lost or been denied this ability. I'm talking about people you've seen walking around the mall. I'll get back to that one.

I would dearly love to debate this clown on the topic of whether the above mentioned mental impairments preclude a person from the right to a life free from suffering, but I already anticipate his response. By his logic, the answer would be an unequivocal yes, but I suspect he would either modify or set aside his premise and grant these subjects special privileges on the sole virtue of their humanity. Speaking from my own experience with these sort of debates, I can confidently say that the question of cognitive ability is merely propaganda, and that the qualifications are based on species, and not some arbi-trary definition of intelligence, as measured against some barometer of relative I.Q. or brain size. And therefore his entire premise is self-disposable, since he either has to lay it aside himself, or create a very flexible definition of critical intelligence, in order to include those in the above categories, which would broaden the field far enough that a few non-humans might just slip in. Or he must, if pressured, admit that, since the brain-damaged or retarded cannot reason as well as he, then they are not entitled to the same rights, and should be placed in a category closer to experimental lab rats.

And who started this whole discussion anyway? Who decided that the ability to reason was the price of admission into the happy club? Was it Ayn Rand? Thomas Jefferson? And who were they, gods?

But these are subtleties, compared to the big question: What constitutes "reason"? And how the hell do we know that we have a monopoly on it? Is there any way for a species to define objectively that one criterion which gives

it special rights? Is it any more reasonable to say that humans deserve Life, Liberty and the Pursuit of Really Neat Toys because we can do arithmetic and crossword puzzles, than it is for white people to say that the sole criterion for the right to vote is whiteness? It's just doublespeak at that point. It reminds me of a joke from the old "Weekend Update" segment of Saturday Night Live. Jane Curtin was talking about some congressman or other who was trying to cover his ass for making a racist statement. In the joke news report he was quoted as saying, "I don't judge a man by the color of his skin. I judge him by how well you can see him in the dark when he smiles." Get it? It's doublespeak. We still think we're the end of the evolutionary ladder, that somehow God, or Darwin, or whatever gods of science and time and space may creep into our sterile, narrow little worldview have decreed that we may dish it out all we want, and consequences be damned for whoever or whatever gets in our way because were HUMAN, GODDAMMIT!!! We're better than the rest. Kill 'em all, let.... uh... whoever... sort 'em out! But we lie. We lie to ourselves. We tell ourselves that animals don't feel pain. We get into absurd debates over sentience and cognition and neurological evolution which are designed primarily to assuage our guilt over the unending and unimaginable suffering we dish out upon the creatures we share this planet with. Suffering which is a by-product of expedience and greed. Period.

Oh yeah. Back to those people in the mall. Remember Dawn of the Dead? All the zombies just wanted to get in the shopping center, because it was somehow imprinted on their nervous systems that this was the place to be, even after they had become shambling corpses. They weren't after the people holed up in there, or even the contents of the stores themselves. They just wanted to walk around the mall. Rent the movie, and then go to your local mall and watch the shoppers. It'll creep you out, man.

Here we are, at the top of the food chain, and we can't even think for ourselves. We need someone or something to remind us to wipe. Notice your cat. How clean she is! She even licks her nasty old butt, because it's that important to be clean. And she won't ever shit where she eats, will she? Now go into the nearest public men's room, even where you work. Notice the walls. I won't gross you out with the details. Suffice it to say some humanoid has taken it upon himself to mark his territory with his own effluvia. This is a man you might see working in the food service industry or interacting with your children. He pays taxes just like you. He probably has kids of his own, and I'll bet you a dollar that they have the same bathroom habits he has.

What's my point? I don't know. People are gross, that's all. We have barely dragged ourselves onto two feet this week, and we are already congratulating ourselves on the many large rockpiles and overpriced cuckoo clocks we have tinkered together in our mad rush to Godhood. But when we marvel at the Seven Wonders of the World, we conveniently overlook the grotesque amount of slave labor required to construct them. When we laud the noble feats of our great heroes, we are blissfully unaware, thanks to centuries of historical revisionism, of what slimeballs many of them were. The point is, we think much too much of ourselves. Well what do you expect? It's what happens

when survival instinct and territorial imperative, which were so necessary on the veldt, atrophy through disuse into a lump, like a second stomach which becomes an appendix and sometimes has to be removed. In humans these once important functionaries of natural selection have, in their idleness, been metastasized by intellect into a deadly disease called EGO—that sense of self-importance exclusive to humans. Oh what highs of demigodhood are to be had for the lucky human animal! Unfortunately, the come-down's a bitch: a mortal and existential terror. A fear of destruction unknown to the animals, who are too busy surviving to pay much attention to their own mortality. Kind of ironic, huh? A species who has been "blessed" with such exquisite tools for world domination, lying at night in cowering fear of the inevitable, while the "dumb brutes" who think only of their next meal or getting a good scratch in before dinner, don't even think about it. Thomas Pynchon said it beautifully, in *Gravity's Rainbow*:

> They have had their moment of freedom... Now it's back to the cages and the rationalized forms of death-death in the service of the one species cursed with the knowledge it will die.. I would set you free, if I knew how. But it isn't free out here. All the animals, the plants, the minerals, even other kinds of men, are being broken and reassembled every day, to preserve an elite few, who are the loudest to theorize on freedom, but the least free of all. I can't even give you hope that it will be different someday-that They'll come out,and forget death, and lose Their technology's elaborate terror, and stop using every other form of life without mercy to keep what haunts men down to a tolerable level-and be like you instead,simply here,simply alive..

So how do we get free of our sweaty midnight fears of dissolution? Do we overcompensate with polemics on the prosaic certainty of our evolutionary stature, or our aloneness in the universe? Or do we accept our mortality and insignificance in the face of geologic time, and get on with our pointless little lives. I believe we've probably been visited hundreds of times throughout our history by every manner of interstellar tourist or primatologist, but were found either too boring and crude too waste time on, or somehow "cute", and entertaining the way a pet store full of puppies might be. Either way, the observers might find it rather amusing that so many of us cling to the notion that WE'RE IT. Frankly, in that context it's rather laughable.

Laughable, yet perpetual.

And still, our awe of our own technology continues to suppress our critical faculties.

The Meaning of Death in the Old Wild West

Film Review:
Jim Jarmusch's *Dead Man*

Reviewed by Greg Bishop

The latest and best example of nontraditional storytelling in American film has to be last year's *Dead Man*, directed by Jim Jarmusch. Jarmusch, who has previously committed such strange and beautiful acts as *Stranger Than Paradise*, and *Down By Law*, reaches an apotheosis with this truthful tale of an escaped accountant (thankfully and artfully downplayed by Johnny Depp) set loose to find the meaning of death in the old wild west. Thrown to an uncertain future by an unpleasant past, and with death a constant companion, Depp sets out on a psychedelic journey without the benefit of psychedelics, but with the unsolicited assistance of an ostracized American Indian. Much in the manner of Cabeza De Vaca (a Spanish-made film set in the mythical southwest US of the 17th century) *Dead Man* manages to convey its story on a subliminal level. Look into the night sky sometime and notice that peripheral vision is a little-appreciated phenomenon of human perception, and you will begin to understand one way to absorb this film. *Dead Man* can best be enjoyed with the soft-focus or parallax attention. Jarmusch is not insane. He realizes that to abandon completely the human convention of linear time does his art and the audience a grave disservice. As film physically and temporally runs from a beginning to an end, it would be difficult to gain wide theatrical release for his work without this structure. Within this loose framework, Depp is dumped into a vision quest which has much in common with the path of the shaman.

Sacrifice

Depp is on a train headed from Cleveland, Ohio to a mining town somewhere in what appears to be Arizona. Locations are of little consequence to the story. Space trips up time when Depp finds he's three months late to show up for a new accountant's position in the aptly-named frontier town of Machine. Stranded with a few

Starring Johnny Depp, Gary Farmer, Mili Avital, Robert Mitchum, Billy Bob Thornton, and Iggy Pop. 121 minutes

Farmer and Depp

coins in his city-bred trousers, he meets up with Thel, a reformed prostitute scorned by this town with no morals. She brings him back to her room. After having his innocence corrupted, Depp finds a revolver under her pillow. "Why do you have this?" "Because this is America." Suprised in bed by a former customer who considered Thel his chosen (most probably because she was his first lay as well) he shoots her and is in turn killed by Depp, in one of the most untypical gunfights ever in a western, and is indescribable by the written word.

Nobody

Harboring the bullet which passed through her heart and is embedded in his chest, Depp jumps out the window and escapes on a stolen horse. A cascade of paper flowers and loose clothing joins Depp on his abrupt descent from a room near the stars to the mud of the street. Later, an Indian digging in his chest with a blunt knife jolts Depp to consciousness. He's too weak to fight back before he realizes that the Indian is trying to extract the bullet. "Do you have any tobacco?" the Indian asks. "No..." "Stupid white man..." he says, uttering a phrase which turns out to be a sort of mantra to this Native Amreican, who although given the name "Ixabachik" prefers to be called "Nobody."

Outlaw

"What is your name, stupid white man?" Nobody asks. In this case mistaken identity plays it's own role: the accountant's name is William Blake. The Indian practically falls over. "Is this a lie, or a white man's trick?" The backstory comes out. Nobody was kidnapped as a child and taken away as an exhibit in New England, and then to Britain, where the poems and artwork of Blake fascinated him, contrast to the rest of anglo society, which seems to disgust him. Blake is mystified by this treatment, and says he's never heard of his doppleganger. Nobody puts it down to modesty. Eventually, halfway through his vision-quest, Depp takes his companion's advice: "Now you will speak through this" (his revolver.) Pursued by bounty hunters and anyone else that fancies himself one, he

proclaims: "I'm William Blake. Have you heard my poetry?" as he kills them. Blake performs well, since an accidental outlaw is the best one.

Brother Peyote

Blake sees Nobody eating something. Since he's been going without food for a few days, he asks for a bite. "This is not for you." And later, "The quest for vision is a great blessing, William Blake." A death mask appears over Blake's face as the Indian communes with brother peyote. An imperceptible transition begins for Blake, a shamanistic outlook evidenced in his subsequent actions, and not because of any useless exposition on the part of Jarmusch. This film doesn't talk down to you.

Return

Blake is now the Dead Man and Nobody becomes his Charon, ferrying him to Underworld. Many tribes, particularly in the Southwest, associate the largest bodies of water (like the Zuni's Ka-ko'k-shi) with a final "waystation of the soul," and a river leading to it is part of the journey of the afterlife. Nobody literally rows Blake downstream—towards the sea. Like guradians of this world, a Northwestern tribe, replete with totem-pole sentries, become Blake's final contact with the temporal world. Nobody sends Blake's body, still feebly housing his soul, to the womblike waters of the ocean, carried along with the outgoing flow of the river and tide. This final action is not without sacrifice, and it's up to you to rent *Dead Man* to find (at least this) out.

No. 9

Editorial

The walls continue to close in. After almost 10 years at this, I am beginning to see some verifiable connections between UFOs, weird phenomena, occultism, psychedelia, spirit, shamanism, parapsychology, and the power structure's interest and involvement with all of this. Where does it lead? Take a look at one of the late Jim Keith's books, *Saucers of the Illuminati*. It's there, or part of it's there. Look at Jacques Vallee's *Messengers of Deception*. It's there too. It's in *The Octopus: Secret Government and the Death of Danny Casolaro* by Keith and Kenn Thomas. Add to this the Archaeus Project's publication *Cyberbiological Studies of the Imaginal Component in the UFO Contact Experience*, and a healthy dose of Timothy Leary and John Keel, as well as the works of Robert Anton Wilson and Aliester Crowley, and top off with Dean Radin's *The Conscious Universe* and Robert Jahn's *Margins Of Reality*, and you have the soup that brings hungry minds together for a feast. These minds are found everywhere: in our government, behind the closed doors of major corporations, scattered throughout academia, running around topless at Burning Man, and prowling all over the internet.

As Bill Moore said recently, "Just because someone's in a position of authority doesn't mean they're not marginally insane."

It's not all good, but then it's not all evil either. We just need to use the tools wisely.

—Greg Bishop

News, Winter 1999

1960s LUNAR ORBITER PHOTOGRAPHED; POSSIBLE ARTIFICIAL STRUCTURES

In August, 1966, NASA launched a lunar orbiter with the purpose of mapping the Moon in preparation for the Apollo landing missions. Eventually, four more craft were sent to photograph the surface. Over three thousand 20 by 24 inch photos were taken, including coverage of about 99% of the far side of the lunar surface. Orbiter 4 was put into a polar orbit, and on one of its mapping passes, took a photo of the Lunar north pole. In the image designated IV-190 H3, there are three craters visible which exhibit straight sides and right angle corners. These anomalies have caught the attention of William Haynes, who has privately published a paper entitled *Those Square Craters On The Moon*.

Haynes has calculated some amazing statistics for the anomlalous features. The depressions, located about 200 miles from the lunar north pole have parallel sides. The two larger squares lie next to each other and have equal areas. The smaller square is almost exactly half the area of the larger ones.

From the shadows cast and their angles, Haynes calcualted the height of the apparent "walls" on the smaller crater at approximately 4600 feet.

Haynes contacted Donald Wilhelms, a lunar geologist, and asked him about the possible age of the square-shaped craters. Based on other features nearby Wilhelms estimated that they would be at least 3.9 billion years old, possibly older.

It is difficult for any spacecraft to achieve a polar orbit around the Moon. This is because its orbit lies in the same plane as the Earth's equator. Although Haynes does not speculate on this in his paper, if the artifacts are indeed artificial, they may have been left for beings who were not only advanced enough to achieve Lunar orbit, but also the difficult adjustment to a polar trajectory. What Haynes does cautiously suggest is that either "I have applied procrustean reasoning to an accident of nature; in short, I am seeing things that are not there... [or] we are confronted with an alien artifact of truly colossal proportions."

MAINSTRAM MEDIA, FBI REKINDLE LEARY SNITCH RUMORS

by Kenn Thomas

Dr. Timothy Leary long acknowledged that he gave information to the feds while in prison, just as he gave due credit to the CIA for helping usher in the psychedelic era. He recalls these episodes in his autobiography *Flashbacks* and the discussion is featured in the Leary/Liddy debate movie, *Return Engagement*. According to Leary, the only people harmed by anything he said were some disreputable lawyers who deserved it. The FBI made an effort to exaggerate this and turn it into a "snitch jacket" for the sake of ruining Leary's future credibility. While it was going on, several people including Alan Ginsberg and Paul Krassner organized a press conference dubbed P.I.L.L. (People Infuriated by Leary's Lies), to denounce Leary's cooperation and the situation that had been forced upon him. None of them were seriously compromised by what Leary said and they remained his friends until his death.

The allegations have had a strange afterlife, however. Walter Bowart, for instance, transformed them into an entirely imaginary scenario of Leary returning to his cell one night after a lobotomy, with blue streaks painted across the temples of his shaved head, now a total mind control slave. This came in a particularly ingracious obit Bowart wrote for Leary, his reward for one having given Bowart some lurid details about his intelligence community connections for Bowart's book, *Operation Mind Control*.

Another author, Mark Reibling, in a 1994 book called *Wedge: The Secret War Between the FBI and the CIA*, tried to make the case for Leary having been an informant before prison, during his years in exile. Reibling's government document sources do not match the details of Leary's biography. (Reibling also tried to make the case that Bob Woodward's "Deep Throat" was actually Cord Meyer, ex-husband of Leary (and JFK) friend Mary Pinchot Meyer.)

An article in the current issue of *Flatland* magazine recounts my own petition for Leary's FOIPA file. The FBI is still doing its best to make sure that the full file is not released, only "summaries" to a chosen few in the media. The files posted at the Smoking Gun website make every effort, by selection and interpretation, to put the worst possible spin on this episode in Leary's life. For instance, a statement Leary makes about his plans for public life after prison, in most contexts a heroic ambition for him considering the circumstances, has been placed before other testimony about one of those lawyers. This has been done "for clarity"–to make it "clear" that Leary was simply finking for the sake of his own freedom.

What is valuable about the complete FBI file is less what is says about Leary than what it says about the interests, abilities and methods of the feds in keeping people like Leary harassed and/or under surveillance simply for the sake of their point of view.

> **What is valuable about the complete FBI file is less what is says about Leary than what it says about the interests, abilities and methods of the feds in keeping people like Leary harassed and/or under surveillance simply for the sake of their point of view.**

SEAN LENNON BELIEVES FATHER WAS KILLED IN CONSPIRACY

Like Prince William, who is reported to take seriously the conspiracy rumors swirling around the death of his mother Princess Diana, Sean Lennon has stated that he thinks the U.S. government not only harassed his father for years for his radical beliefs and opposition to the Vietnam war, but also that Mark David Chapman, Lennon's convicted killer, may have been a mind-controlled assassin.

Lennon's youngest son, 22, currently a member of the New York band Cibo Matto said in an interview with *New Yorker* magazine, "Anybody who thinks that Mark Chapman was just some crazy guy who killed my dad for his personal interests, is insane. Or very naive, or hasn't thought about it clearly. It was in the best interests of the United States to have my dad killed. Definitely. And, you know, that worked against them because, once he died, his powers grew...They didn't get what they wanted."

The NYPD's investigation into the assassination found no evidence that Chapman did not act alone.

This incident recalled an eerie coincidence uncovered by Beatles fans soon after Lennon's death in 1980. The picture book included with original realease copies of the *Magical Mystery Tour* album reprints a still from the movie featuring Lennon standing next to a sign that reads "THE BEST WAY TO GO IS BY M&D Co." which prominently features Mark David Chapman's initials.

GET OUT YOUR ALUMINUM FOIL BEANIES: REMOTE MIND CONTROL DEVICE PATENT DISCOVERED

Recent dedicated digging has uncovered a patent for an "Apparatus and method for remotely monitoring and altering brain waves." Filed in the US patent office on August 5, 1974 by Robert G. Malech and his company, Dorne and Margolin, Inc. the application explains the theory and function of a device that is supposed to make things easier for psychologists and neurophysiologists who want to monitor the brainwave activity of their patients. The unnamed invention does this by:

> ...sensing brain waves at a position remote from a subject whereby electromagnetic signals of different frequencies are simultaneously transmitted to the brain of the subject in which the signals interfere with one another to yield a waveform which is modulated by the subject's brain waves...

What this suggests is that Malech's system uses the target's own brain-wave pattern to modulate anything that the operator wants to transmit back to the unwitting subject. The patent filing text continues:

> ...high frequency transmitters are operated to radiate electromagnetic energy of different frequencies through antennas which are capable of scanning the entire brain of the test subject or any desired region thereof. The signals of different frequencies penetrate the skull of the subject and impinge upon the brain where they mix to yield an interference wave modulated by radiations from the brain's natural electrical activity...In addition to passively monitoring his brain waves, the subject's neurological processes may be affected by transmitting to his brain,

FIG. 1

through a transmitter, compensating signals... Through these means, brain wave activity may be altered and *deviations from a desired norm may be compensated.* Brain waves may be monitored and control signals transmitted to the brain from a remote station. (Emphasis added.)

If this invention has progressed beyond anything more than just a brilliant idea, it would seem that some of the most paranoid fantasies of mental patients have some basis in reality. This device was patented 25 years ago, and new ideas and technology may have advanced the state of the art since then.

(Thanks to Miles Lewis of ElfInfested Spaces-www.elfis.net.)

If this invention has progressed beyond anything more than just a brilliant idea, it would seem that some of the most paranoid fantasies of mental patients have some basis in reality. This device was patented 25 years ago, and new ideas and technology may have advanced the state of the art since then.

EGYPTAIR CRASH — ILLUMINATI HIT?

by Robert Sterling

In an eerie redux of William Burroughs' "23" enigma, at press time, the crash of EgyptAir flight 990 on Halloween night had yielded these interesting facts about sacred numerology. One of the most holy numbers to the Illuminati is 33, corresponding to the highest degree of Masonry. When events have the Illuminati's fingerprints on them, they often leave numeric clues involving the number 33 to let those in the know in on what is going happening.

 — Before problems began, The plane was at an altitude of 33,000 feet.

 — The plane disappeared from radars 33 minutes after takeoff.

 — The EgyptAir plane, named Thutmosis II, had a little over 33,000 flight hours.

 — 33 people boarded the plane on its previous stop, Los Angeles. (and possibly Edwards AFB.)

 — It was reported 30 Egyptian military officers were aboard EgyptAir. A short time later, it was discovered that three more officers were travelling, but not officially checked in.

 — 990 is 10 times a trinity of 33's.

IMPORTANT MESSAGE FROM
TRANSPORT MARSHALL TRICELINGOFF!!

Greetings from the Ancient Zeta Reticulum Fraternity of Immortals:

You are invited to meet The Landing Party from The Zeta Reticulum Mother Ship during September 1999 in a small Town 35 kilometers from The Capitol of a Country across The Atlantic Ocean. You may ask Colonel Jarod for the name of The Town, The Date & Appropriate Evidence that Visitors from The Zeta Reticulum Star System will Indeed land There at that Time...

Attention, Attention, Attention...

This is Transport Marshal Tricelingoff, from the earth orbiting flag ship ZETA 64 EIGGER...

You are wondering, why you? All your life you have had These Visions of Us Coming. Well get ready for a shock. Your father... and your mother were abducted by one of our expeditionary trips to earth many years ago. Your mother was implanted with half Gray half Humanoid fertilization...Here is the shocker, We mixed the vials up and she was impregnated with Reptilian strain 74, this is the same type that We put in Clinton's mother, it doesn't show in his or your features, but look closely at Clinton's daughter, even braces won't help a reptilian's teeth.

You have told many people of our landing. Our supreme consul has made a ruling. The landing date MUST remain the same but the place must change. They have located a small town about 35 crinockles (Kilometers) from The Capitol of a Country across The Atlantic Ocean.

Transport Marshall Tricelingoff

END OF TRANSMISSION

From an email actually sent to the Bill Clinton and Al Gore. Thanks to Acharya S for this submission

Interview: Ira Einhorn

The Unicorn Comes Out of Hiding for his First Interview in 20 years

Interviewed by Adam Gorightly

The story of social activist, futurist, environmentalist, and 1960s cultural booster Ira Einhorn is well-known. Since his flight from the United States before facing trial for the murder of former girlfriend Holly Maddux, Einhorn has been on the lam and entirely unavailable for comment. Due to a story in an episode of *America's Most Wanted*, he was tracked down in late 1997 to the Champagne-Mouton area of Southern France living with his Swedish-born wife Annika Flodin. Soon afterwards, French authorities showed up at his door with guns drawn and carted the Unicorn (as he is sometimes known) off to jail. After a complicated tangle of international legal wrangling that pitted French ideas of justice against extradition policies, Einhorn was released until the United States and French politicians and judges can agree on just how to treat the case. He maintains that he was framed for the murder because of his involvement with elements of the intelligence community and mind control research.

PHOTO: ANNIKA EINHORN

Ira Einhorn

Einhorn has given interviews to only two magazines. The other one is the December 1999 issue of *Esquire*. He was told he would be given a chance to tell his unedited view of the controversy surrounding the media hype, as well as his history of involvement with fringe topics, like Tesla technolgy and UFOs, and personalities such as Uri Geller and Dr. Andrija Puharich. Adam Gorightly first contacted Einhorn on the internet, and over the next few months the Unicorn was coaxed into giving his first print interview in over 20 years.

—Greg Bishop

Q: Isn't it your position that Holly Maddux's body was planted in your Philadelphia apartment? If so, then do you have any idea who would have been trying to set you up? You have stated that the CIA had information that could have potentially cleared you. What exactly is this evidence, and do you think that you were set up because of the controversial research you were involved in prior to Holly's murder?

EINHORN: I did not kill Holly Maddux, and am still not sure who did, though I am involved in on-going research on the matter that will eventually be a large book. I knew intuitively, the summer before Holly disappeared, that something was going to happen. I told a couple of friends about my apprehensions. One of them, an internationally known scholar, Stafford Beer, has put our conversation about the matter on record. [Full text available at www.konformist.com. —Ed.]

I was actively researching and linking together a number of areas: UFOs, PK, psychotronic weapons, mind control, free energy devices, and Nicolai Tesla, among others. This information was going to scores of significant people in 26 countries, on both sides of the Iron Curtain on a weekly basis. I was operating under the protection of the world's largest corporation (AT&T.) I had the ear of lots of important people.

These areas of research are still controversial today. If I had remained in place the issues connected with these areas of research would have moved into large public notice years ago, as I seem to have a talent of putting people together in such a way that results arise from the interactions I set up.

Holly Maddux was seen alive by three bank employees, six months after her supposed death. To keep that information away from us, the woman in charge of my case used a Xerox machine to shorten the pages, thus removing the page numbers and allowing her to remove the information due to us under normal discovery procedures that precede any trial. My lawyer smelt a rat and uncovered the ruse, but we had to go to court to get the missing pages.

When we received the first autopsy report—after much screaming and yelling-it became apparent to my lawyer that my contention of innocence was now based upon more solid ground, as it became obvious that the body had been moved into my apartment. Incidentally, a window in my apartment had been tampered with the night before my arrest; a tampering that was noticed by a friend, not me.

The forensic report just did not support the contention that the DA was making about my having murdered Holly in that apartment. No blood at all was ever found in the very small apartment, and the body had been struck about the head many times. There should have been blood everywhere. There was no blood at all, not even on the corpse.

The FBI did the first forensic report. Normally there is only one, but it didn't get the results the DA wanted, so at great expense the DA went to the lab involved in the O. J. Simpson case. They again came up with the same results: no blood, no human protein..

So adding a twist to the choices in a Chinese restaurant, they went to column C and went back to the man they had skipped over twice—his results were inconsequential, so they stopped there.

Since I surfaced, I have learned some other facts: the Director of the Life Sciences Division of the CIA looked at the autopsy report (he is an expert in the area) and came to the same conclusion as we did: the body was moved into the apartment after Holly was killed. At the time of my arrest, there were seven strange deaths that he was investigating. This was from a friend whom he spoke to at the time.

I was actively researching and linking together a number of areas: UFOs, PK, psychotronic weapons, mind control, free energy devices, and Nicolai Tesla, among others. This information was going to scores of significant people in 26 countries, on both sides of the Iron Curtain on a weekly basis.

One of the FBI pathology experts involved in the case told my lawyer privately that he had no doubt that the body was moved into the apartment after Holly was killed.

I have been judged and convicted on hearsay and testimony tailored to fit the accusations during the now two IN ABSENTIA trials. The last being a civil suit whose award was a staggering $907,000,000—almost a billion dollars. After the trial ended, the judge allowed the jury to embrace the Maddux family. The chief judge of the court system that is in charge of my case made a public comment about the amount of the award reflecting my guilt.

That same day the lawyer for the Maddux family went into court and got, within a month, an additional sum of $9,500,000 tacked onto the suit. Something about my not having made an offer to settle. As a result of added interest, my debt is now growing at the rate of over $1,000,000 a week.

The pursuit of me has been completely and utterly out of proportion. Why? The book published about me [*The Unicorn's Secret: Murder in the Age of Aquarius*] is a tissue of lies, based upon material stolen from my apartment and then turned over illegally to the writer who used it without any statement about how he got the material. There are no footnotes in the book and no interview citations. My words are quoted out of context and often quotes of famous writers are attributed to me. A hatchet job initiated by the DA's office in Philadelphia. The writer, Steven Levy, is a thief, a plagiarist and a liar. The confirmation of the lies is evident in the recently circulated statement that claims that I had little to do with Earth Day.

Q: What is your present legal status? From what I gather, France has agreed to extradite you, but you have appealed the extradition, and that the appeal process will take at least two years to complete. Is this correct?

EINHORN: France has not agreed to extradite me—a judge has said I can be extradited under certain conditions and the cour de cassation [French High Court] has agreed. One of the basic principles of human rights is the right to defend oneself in an equitable trial wherein one is present. This right has been taken from me by the IN ABSENTIA trial.

American law does not permit a second trial. To try to get around this self-created difficulty the state of Pennsylvania has done an extraordinary thing. It has passed an unconstitutional law directed against one person. This law is an attempt to fool the French, as my judicial decision is final and final decisions can't be changed by laws. It is a principle based on the SEPARATION OF POWERS which is the very basis of the US system of government.

The decision in France is now political, and then administrative, which could take lots of time: there is no way to predict that.

We will take the case to the European Court of Human Rights, if necessary.

In the meantime, I am living my life fully, by involving myself in matters both ecological and psychic that I consider to be necessary for the continuation of a life of quality on this small blue planet.

Since I surfaced, I have learned some other facts: the Director of the Life Sciences Division of the CIA looked at the autopsy report (he is an expert in the area) and came to the same conclusion as we did: the body was moved into the apartment after Holly was killed.

Q: How did you get involved in the first Earth Day celebration? And what were you, and the others participating in it, trying to accomplish by bringing your environmental concerns to the attention of the world?

EINHORN: The violence that occurred in Chicago in 1968 made a number of people aware that Kent State was in our future. Our turn towards Ecology was hence both anticipatory and necessary as a number of us were then reading widely in what was available at that time.

A number of antiwar people began to focus on ecology and Keith Lampe began to produce Earth Read Out . I wrote for it, began reading widely in the field and as always went to see the experts, building up a group of advisors who were armed with up-to-date info, as a preparation for doing media.

When Earth Day was in the air, one of those advisors sent a graduate student to see me, as I had run a number of large public events and had contact with a large number of people. Earth Day in Philadelphia—which was by far the largest in the country—resulted from that meeting. We held two massive outdoor events which I organized and brought my friends and contacts to speak and perform at. Earth Day itself brought 250,000 people to Fairmount Park in Philadelphia.

Our intentions were to make people aware of basic principles. For example, in the phrase: "taking the garbage out," we wished to make people aware that there was no "out." Everything had to be recycled. A simple idea that all producers must heed. No operation that does not own the entire cycle should be allowed to produce. This would have stopped nuclear energy in its tracks.

I enunciated three basic ideas, in the form of slogans:

Nanoseconds now, can the emotions follow. [Things are happening so quickly that humans can't react fast enough.]

STRESS is information the body can't handle.

POLLUTION is information the ecosystem can't recycle in adequate time.

We enhanced awareness enormously about the fact that we live in a limited, almost closed system, and made people conscious of what consumption does to the surroundings in which we live. But thirty years have been lost as there has been little real change and we are heading towards disaster, as the corporations have spent billions lying rather than on change.

Q: After so many years underground, how does it feel to be visible once again? I've noticed that you've become active in Internet newsgroups-namely, the [Physicist Jack] Sarfatti discussion group. This sort of networking is quite similar to the networks you pioneered back in the 1970s, focusing at that time on such topics as Tesla technologies, remote viewing, psi phenomena, and psychotronics. Do you feel like you're picking up where you left off back then?

EINHORN: I could have remained underground until my death, as I rather enjoyed the relatively quiet life we were leading. If I had stayed underground, I would have written lots more novels—a very demanding but fascinating task. I look longingly at my half completed fifth novel and wonder whether I will ever get back to it. However my wife hated being clandestine, so on balance I

The decision in France is now political, and then administrative, which could take lots of time: there is no way to predict that. We will take the case to the European Court of Human Rights, if necessary. In the meantime, I am living my life fully, by involving myself in matters both ecological and psychic that I consider to be necessary for the continuation of a life of quality on this small blue planet.

have adjusted to the abrupt change in life that has brought both great personal danger and the opportunity to speak out on the issues that compel me. A great contrast to my life underground that was satisfying but provided less opportunity for me to exercise my decidedly activist spirit.

Our intimacy and growth as a couple is as important as my work which has now switched back to the concerns of my earlier days.

Networking was very new in the 70's and what I was doing was rather unique. There are now thousands of people doing what I was doing, using the Internet instead of hard copy. When I left the USA I could get $1,000 an hour for teaching others how to network. As 95% of my work was pro bono publica, I did not do it very often.

My networking during the 70's focused on certain topics that people laughed at then, but are now all the rage. However, if you would be able to survey all that I distributed, you would quickly discover that I was dealing with edge discoveries in conventional as well as unconventional areas.

I was supported by the then world's largest corporation: A.T.& T., who handled all my duplicating and mailing. I was sending out mail on a weekly basis to 250-300 people in 26 countries. Each item of information had a separate list of names to whom the information was circulated. My concerns often impinged upon their future and I had a wide range of friends within this very large organization. Their far watchers—those paid large sums of money to avoid surprises—often sat with me, as I had information they didn't have...

Q: What are "Far watchers?"

EINHORN: AT&T executives who were paid, as the people in think tanks, to anticipate the future. "Far watchers" is a term that goes back to Babylonia, but is used, or was used in the futurist community. All large corporations used to have people like that around, in positions off to the side who advised those who made decisions. They were not in the direct chain of command. Sort of a corporate general staff...

The people on my list back then would easily form an international Who's Who. One of the Baby Bells—now one of the world's largest corporations—was headed for years by a man who followed my reading suggestions with avidity. We spent much time together. The direction in which he took this most adventuresome of Baby Bells can easily be traced back to those years.

Right before I left the USA, I was asked by one of the world's richest women to teach her all I knew as she was thinking about initiating a general media corporation. Sickness prevented this, but twenty years later her nephew is following in footsteps he might not even know about.

To come back—after twenty years in the wilderness—to a world I helped create, has been a surprise and a delight. Working with Jack Sarfatti and watching his theory of consciousness grow before my eyes has been joyful.

I am now involved in a number of projects, limited only by the fact that there are 24 hours in the day and that I have a large property to care for.

The Internet is rife with noise. A small price to pay for being able to connect to the entire world, irrespective of distance. Information is the future

My wife hated being clandestine, so on balance I have adjusted to the abrupt change in life that has brought both great personal danger and the opportunity to speak out on the issues that compel me. A great contrast to my life underground that was satisfying but provided less opportunity for me to exercise my decidedly activist spirit.

of the species and we are just beginning to come to grips with its sheer power. Most people are overloaded and over communicating. Some are addicted, but that is us not the medium.

The primitiveness of both the e-mail programs and our word processing programs are examples of how far we have to go in creating computer structures that map the human mind in an effortless manner. That is part of my future work. Another joyous task—added to the release of the top secret information connected to the UFO files which will lead to:

1) Free energy devices.
2) FTL [Faster Than Light] transportation and communication devices.
3) Total recycling

Stop gaps that we need while we learn how to live for each other and the health of a planetary environment based upon empathy and compassion rather than consumption.

Q: This isn't the first time you've been involved in UFO research—in one form or another. Could you talk about your past involvement with Andrija Puharich and Uri Geller regarding UFOs, ETs and the paranormal, as well as your own personal first hand experiences in these areas?
EINHORN: Anyone seriously interested in UFOs should read Timothy Good's *Above Top Secret*. If that does not convince you that the phenomenon is real, you will never be convinced by evidence, as his research is scrupulous and based upon a world wide survey.

My experiences run the entire gamut of the UFO experience from sightings to inferred close encounters of the fourth kind and are not limited to the period in my life that I spent in deep mind lock with Andrija Puharich. Our concerns were different in many instances, but the present tendency to literally shit all over a man who devoted most of his life, energy and money to attempting to bring PSI research into the arena of science is part and parcel of the present negativity, back biting, begrudging and disinformation that I will resist with all my energy.

Andrija pioneered physics and consciousness research which is now all the rage. He did this in the 50's and his work in this field can be seen best in *Beyond Telepathy*, which I introduced and had republished by my editor at Doubleday/Dutton, Bill Whitehead. The interaction around that book which Bill, Andrija and I celebrated with an outdoor Central Park luncheon was described by Bill to me as listening to two Martians talk. That celebratory luncheon began a deep interaction that lasted for a decade.

Uri was the psychic that Andrija had always dreamed about: one who could go into a lab and reproduce measurable effects upon demand. When he encountered Uri, he dropped all his complex present work (artificial heart, micro miniature hearing devices, etc.) and concentrated upon Uri.

It would take a book to describe what went on in those years, though I continued with all my other activities and added many more. What I saw in those years—in terms of UFOs—runs the full gamut of experience and reaches over into strange animals (see John Keel's work, for example) and a

Uri was the psychic that Andrija had always dreamed about: one who could go into a lab and reproduce measurable effects upon demand.

range of PK and time reversal effects, among others, that has yet to be recognized or even nibbled at theoretically. Only Dean Radin, in an interview given to this magazine, begins to touch upon what lies ahead for us. The region opened up by those years is vast. To most scientists it was a Pandora's box that they fearfully slammed shut. That slamming shut is a loss for us all, as is the present secrecy around the UFO material that is allegedly being withheld from the world public, by forces who are pretending to protect us, but who are actually protecting their own interests.

The phenomena is real. That is obvious to anyone who takes the trouble to look at the evidence. What that phenomenon is can't yet be determined. Some say ET, some say E[xtra] D[imensional.] Irrespective of that eventual choice, what the phenomenon promises is an ability to deal with some of our most pressing problems regarding our destruction of the physical world.

When I turned to working on the Geller project, my ecological cohorts were shocked, as were my antiwar cohorts when I turned to ecology. During those years, 1970-71, it was evident that ecology would become part of the future, but in terms of a consumer ethic that would still spell eventual planetary destruction—the time frame varied depending upon whose assumptions and equations you used. The consensus was that we were in the process of destroying the very web of life that we live off of and on. Few involved at any level would dispute that. Today, no honest being can say otherwise.

Due to this awareness, I felt that we needed the kind of ontological, metaphysical, scientific, technological and economical shocks that only a revelation of ET/ED life could produce. I still feel that way. All my work with Andrija was based upon that awareness, as is my present return to that work, only now the situation is more critical.

If only one close encounter of the fourth kind is true, the government is failing in its duties to protect the life and liberty of its citizens. The US government dispenses billions of dollars per year to guarantee those protections. If this money does not provide those guarantees, it is the duty of the government to tell its citizens that such is the fact. Not doing this is a dereliction of duty and a very serious crime. It is a matter that a creative lawyer should bring before the courts.

Q: In the 1970s, you edited Jacques Vallee's Messengers of Deception *while at Harvard, and at one time corresponded with science fiction writer Philip K. Dick. Both of these authors alluded to an element of the cosmic trickster at play behind the UFO experience; Vallee even suggested that certain "UFO cults" were being manipulated by forces unseen. As for Dick, he had a much discussed "mystical experience" where he felt he'd been contacted by ET's—though, at other times, it was his impression that his "pink beam" experiences were all part of some form of electromagnetic manipulation, possibly originating from Russia. Psychotronics (re: the Russian "Woodpecker" signal of the 1970s) was another area your far reaching research looked into. Could you comment on how all this relates back to the UFO experience, and shouldn't we be on guard in terms of separating the "signal" from the "noise" regarding ET/ED encounters? On the one hand, the ET's preach of ecological doom if we don't change our ways, and how they are the salvation of mankind. On the other hand, they allegedly shove strange devices up earthling rectums and*

> **If only one close encounter of the fourth kind is true, the government is failing in its duties to protect the life and liberty of its citizens. The US government dispenses billions of dollars per year to guarantee those protections. If this money does not provide those guarantees, it is the duty of the government to tell its citizens that such is the fact. Not doing this is a dereliction of duty and a very serious crime.**

kidnap human guinea pigs to conduct genetic experiments. What gives?

EINHORN: The first mistake is to think that the UFO phenomenon is a unitary phenomenon. Anyone who takes the trouble to look at a lot of the data and is fortunate enough, as I have been, to have had some first hand experiences, soon realizes that we are dealing with a multifaceted very complex series of unexplained events; events that are so perplexing, in particular to those who experience them, that we demand explanations and rush to closure. A closure that is like that biblical bed of iron in Sodom: it distorted the body as we distort the data. Dick had a powerful experience that literally blew his mind. I tried to help, was able to soothe him a bit, but he was too paranoid to fully accept the help that my friends and network could have provided. In these matters, the person must come first. The close encounter experience is often traumatic, and it is that trauma that must be dealt with rather than data collection....

Jacques has a fine lucid mind, and has always been ahead of the curve. He smelled the present hyper-confusion before it emerged. He can always be read with the expectation of learning something. The paranoia he expressed is part and parcel of the present scene and as usual emerged in an art work before it became a large public reality. Pynchon's *Gravity's Rainbow* is an emblem of our time in that sense. Artists, as McLuhan said again and again, are the antennae of the species. The Russian Woodpecker was also real and could produce psychoactive results. MK-ULTRA is also real. Michael Persinger's helmet is real. Human beings are very suggestible, and this suggestibility increases in proportion to the insecurity of the time which is very great at present. The pillars are shaking and those in power are just not paying attention. Putting innocent kids in jail, at great cost while the corporate robbers are leading us forward into ecological destruction is a prescription for disaster.

I could go on for pages, but in spite of 40 colors of toothpaste and 150 flavors of ice cream, something is very rotten in Denmark .

So people are confused and tend to project their problems on convenient scapegoats. They, that mythical "They" are to blame, and in certain situations that is the correct conclusion. In others it is sheer nonsense, as I watch my screen fill with the obvious suffering of another who has blamed the wrong cause. Sorting it all out is a question of being calm and patient—difficult when the house is burning—and some of it will not sort, as at times the Intell. boys and girls do use convenient public myths to cover black OPs.

All I can give you is my cut on things:

1) Lots of stillness and silence.
2) Compassion and empathy for those who are suffering.
3) A demand for the public release of all UFO data.
4) All ET/ED statements have been made through the medium of flawed human beings, so take them all with a grain of salt , not as gospel.
5) Salvation is a big word, not in my vocabulary: I do the dishes every day and will continue to do so.
6) We may get some help from others, but it is up to us to bring our planetary household in order and the primary way to do that is to bridle the corporations and their PR shills who are selling billions of people their own destruction.
7) Demand that Close Encounters of the Fourth Kind come under the aegis of those who are spending billions to protect us.
8) And to repeat: we may not be dealing with a unified entity, and those entities, in

Artists, as McLuhan said again and again, are the antennae of the species. The Russian Woodpecker was also real and could produce psychoactive results. MK-ULTRA is also real. Michael Persinger's helmet is real. Human beings are very suggestible, and this suggestibility increases in proportion to the insecurity of the time which is very great at present.

spite of its advanced technology may need us as badly as we need them, and may be constituted along a spectrum of morality that has little to do with our morality. Think of the way we treat animals—it may provide some distance thatallows one to think clearly about a piece of the problem.

Q: In the book URI, *Andrija Puharich asserts that UFO's/Extraterrestrials were somehow responsible for Uri Geller's psi powers. What do you know about that?*
EINHORN: The Geller experience was a UFO experience to the participants and was full of daily experience that reinforced that feeling. Andrija wrote URI upon my demand. I put him in his study and tended the phone and the house until he got it done. Then Bill Whitehead—my editor—and I cut it in half. His interpretation of the experience is wherein we differ. The phenomenon were manifold: actual UFOs, strange energy phenomenon, scars (supposedly a result of operations), powers (Siddhi)—I could produce a healing heat that blew massage workers away: I can still call it up at times and pass it on...A hawk that was always around. A cat that was hard to accept as just a cat. Lots of kids who could do what Geller did, and physical experiences—translocation for instance—that just do away with the laws of presently known physics.

Certainly the Intelligence communities can use a phenomenon to mask research, but that doesn't invalidate a phenomenon, it just requires vigilance in evaluating experience. If all the valid experiences were Intelligence related, the Intelligence budget just for that would dwarf the actual intelligence budget. For long periods of time during the 1970s, Andrija and I were living together constantly. In the beginning, Uri and his pal Shipi were also with us. I have talked little about the UFO part of the experience as it often created total turn off and I was concerned about getting the world's top scientists to look at paradigm breaking material. The project was about changing our ontology: the rest, economics, politics et.al. would have followed. This was totally misunderstood by my political and ecological buddies, so I downplayed certain aspects when briefing people. Ossining became a world psychic center and Andrija and I spent uncountable man hours briefing a range of people that spanned all the power networks on the planet. We told people what we felt they could handle. We got good at it. Most freaked at the baby stuff. We also attracted every psychic nut on the planet and scads of people with unusual powers. A real circus.

The intelligence crew was around. Watching and trying to collect data; most including MOSSAD just could not grasp what was going on, so Andrija was classed as a master spy. There were at least six intelligence agencies around us after word of Uri got out. It is a book in itself.

Q: One theory that makes a lot of sense to me is that UFO encounters are akin to "magical workings". As it has been often recorded in UFO literature, many witnesses recall going into some sort of trance-state prior to their experience, and many current day abductees can only remember their encounters after a hypnotic trance state has been induced. This is not to say that these experiences are not genuine, but in order to access these differing realms of consciousness, one must shift their focus from the mundane world, and tune into other waves and frequencies...
EINHORN: Vallee introduced this scenario in *Passport to Magonia*, but it only

> The [Uri] Geller experience was a UFO experience to the participants and was full of daily experience that reinforced that feeling. Andrija [Puharich] wrote URI upon my demand. I put him in his study and tended the phone and the house until he got it done.

accounts for a percentage of the experiences. There are scads of hard sightings on record that are a good place to build a base camp upon before one confronts the very real and very frightening reports of abduction. Never forget that most abduction reports are based upon an experience that is remembered before hypnosis enters the picture. What hypnosis does in most cases is fill in the missing spots of time rather than dredge up entirely new experiences.

Q: In one of John Keel's books he described what he calls the "superspectrum". It was Keel's contention that folks with psychic acuity could tune into this superspectrum and—like seeing in the infra-red part of the spectrum—tune into entities existing in a another dimension...I had an experience of this nature under the influence of LSD with a close friend many years ago. We both witnessed a mind blowing contingent of UFO's, each of us witnessing the exact same high weirdness. If this was hallucination, it was a dual hallucination because we both witnessed the same staggering strangeness...I read somewhere Tom Bearden suggested that UFO encounters were projections from human consciousness that took form in much the same manner as Tibetan Tulpas—psychic projections of the human unconscious Will made manifest...I see the UFO phenomenon in these same terms: a magical working in which we conjure or invoke creatures or spaceships which exist in another dimension.

EINHORN: I could talk for days on this. Suffice it to say we are more probably dealing with ED's—extra-dimensionals rather than ET's—but nothing is straightforward in the UFO world and after seven years of phenomena, connected to one long experience, I can vouch for the reality of the phenomenon, though the interpretation, like all interpretations is almost always colored by the viewer. I have had extensive psychedelic experience and can confirm what you experienced...Confirm, not explain...We are always projecting and most unusual experiences are state specific, so the Bearden explanation, which I know well—as Tom and I were very close back then—does not say much as Tulpas require immense will and training, unlike UFO experiences. Collapse distinctions and you can make e=z... Human beings hate ambiguity and desire to resolve it all costs, hence a host of theories that the data laughs at.

Q: On a related "UFO" note, I've heard there's a new book out that delves into the "Lab Nine" circle—involved in attempts at extraterrestrial contact—which included yourself, Puharich, Geller and Gene Roddenberry, among others . This book goes on to state that at one time Roddenberry was going to write a film script called "Lab Nine." Also, in a Star Trek *episode called "Paradise", one of the chief characters was named "Vinod"—which was the name of the guy who first channeled "The Nine" for Puharich.*

EINHORN: Yes, Rodenberry was among us, for that purpose, and was freaked by the phenomena—it was too real for him. It's a tale, and the project fell through as he could not handle the reality he encountered. Many say all the later *Star Trek* stuff came from his failed encounter with our on-going reality...Quite possible.

[Star Trek creator Gene] Rodenberry was among us...and was freaked by the phenomena—it was too real for him. It's a tale, and the project fell through as he could not handle the reality he encountered. Many say all the later Star Trek stuff came from his failed encounter with our on-going reality

PHOTO: ANNIKA EINHORN

As of August, 2000, Einhorn resides in south-central France with his wife, Annika. He says their home is surrounded by guards 24 hours a day, "looking both in and out." According to Einhorn, his case will most likely continue for at least two or three more years because of the appeals process and a growing number of highly-placed friends in the French government who either believe in his innocence, or have decided to make his case a banner for their human rights protests against the American legal system, or both. Any profits he makes from his writing and/ or noteriety are automatically transferred to the Maddux family as the result of a lawsuit that was adjudicated in 1999 in the French courts. He still plans to publish his novels and non-fiction and is currently looking for a publisher.

Interview: Joe McMoneagle, Army Remote Viewer #001

Gregory Bishop

Joe McMoneagle

"It's sort of a test of faith in the fact that in the long run, we create our own future by how we think about it."

Joe McMoneagle has an established repuation as one of the most straightforward and honest of the former members of the Army/Defense Intelligence Agency's remote viewing program. Perhaps it is well that he was also the first. During this interview he said nothing to contradict that reputation. He has recently released his second book, *The Ultimate Time Machine*, filled with his observations of the nature of time, and more specifically, what he sees as humankind's destiny in future time. Predictions range from such things as the eventual extinction of all North American songbirds to the changing face of cities and human social structures up to and beyond the year 3000.

Q: In your first book, Mind Trek, *you said that a near death experience intensified your talent and interest in psychic functioning. Was your talent evident before that event?*
McMONEAGLE: I was certainly making decisions based on my gut or intuitiveness, so I think that I was probably being psychic before the near death experience, but I would not have admitted that. I would decide things out of the clear blue and change locations or whatever for instance when I was in Vietnam. Inevitably the area I was in would then get shelled within about half an hour or so. It was so noticeable that after awhile people would start to move when they saw me move.

Q: A psychic canary in a coalmine.
McMONEAGLE: Right. I had a beat up old lawn chair that I used to relax in, and every once in awhile I would just fold up my lawn chair and go into a bunker and read. I'd get an uncomfortable feeling like I was exposed and I'd go into the bunker and read for about half an hour and we'd get shelled. So when I'd fold up my lawn chair, everybody would get up and leave.

Q: Did any psychic funtioning manifest in your twin sister?
McMONEAGLE: Yes. The problem was that she started having visions when

she was 13 or 14 (and I did too) and the problem back then was we didn't share it with anyone. She thought that perhaps she was going crazy or something and she went and told some people and of course they sent her to the doctor and started medicating her heavily.

Joe McMoneagle in Vietnam

Q: *That seems (or seemed) to happen a lot in these cases. It usually kills the visions and/ or psychic talent along with it.*
McMONEAGLE: She was diagnosed with schizopeniform disorder, and it was eight or nine years later, after taking tons of chemicals that she was diagnosed as schizophrenic, and she never was to begin with.

Q: *What sort of visions were these?*
McMONEAGLE: She and I would envision things that would turn out to happen later, or she'd say "Did you see that?" and I'd say No..."

Q: *But I'm sure you said the same thing to her.*
McMONEAGLE: Right. Exactly. We were very much alike, and unfortunately she sought treatment and of course back then, being psychic: forget it. She was treated very badly, and it taught me to keep my mouth shut. She died about three years ago. She had almost the same coronary I had, but hers killed her.

Q: *I think you said somewhere that you survived you second heart attack only because you got through your first one.*
McMONEAGLE: Yeah, the first one near death experience really helped me survive the first attack and the second NDE because essentially I was prepared to die and it was OK. The second time when I realized I was having a massive coronary, I decided that that was OK, and I would pay as close attention as I could—I would be aware as I could be during the dying process. My only major problem was when I would say to my wife "Pull over. I'm dying from this heart attack" but after awhile even the pain became manageable and I was just very comfortable with the idea of dying. When we got to the hospital, my heart stopped and I thought "This is it. I'm making the transition, and I'm totally awake and aware." It was like an instant blackout, then I woke up there was this doctor staring down at me with his paddles in his hands and he said "Welcome back." This was my cardiologist, and later when we were talking about this he said that the only thing that had kept me alive was the fact that I was copacetic with the idea of dying, that I was totally calm. He said that most people panic, and that sort of starts a chain reaction that tears the heart apart. I was very calm and complacent with the idea and that kept me alive.

Q: *How did you feel about it afterwards? I know you said that the first time it was pretty traumatic.*
McMONEAGLE: The second time, it was traumatic for everybody else. I went through a six day period where my heart kept stopping because they couldn't stabilize me, and they had to move me across a mountain range to move me to the University of Virginia hospital where they could do open-heart surgery.

For six days they couldn't get me stable long enough to get me in an ambulance to move me. My heart kept stopping and they had to keep jump starting me, and I was very calm through the entire ordeal. It got to the point where I would push the nurse's button 30-40 seconds prior to the alarms going off. That was upsetting the nurses—that I could talk so openly aobut dying, when they were fighting to save me. I probably wasn't being very cooperative.

Q: I guess to their minds you weren't being grateful...

McMONEAGLE: I wasn't using the appropriate tact. It turns out that by being so totally relaxed and welcoming death is what kept me alive. So it had the opposite effect that I thought it would. I just viewed it as opening a door and transiting into another arena, but everyone around me was freaking out. My poor wife was listening to me saying very calmly "It's OK. I'm just dying."

Q: Didn't her father go through that? (McMoneagle's wife is the daughter of Robert Monroe, founder of the Monroe Institute.)

McMONEAGLE: Right. It was just a really interesting experience for her.

Q: Do you think that there is any personality type that is predisposed to good PSI functioning or RV? In the past, people with a "nervous disposition" were supposed to be good for this.

McMONEAGLE: Actually, we did years of testing of viewers and literally hundreds of people who have shown some psi ability in the lab. The only thing we can say is that there is no comonality between any people who have this ability. Quite literally, everyone is as different as high noon and midnight from one another. There seems to be some indication that when people are talented in other ways, in other words, people who seem to be fairly successful, and who are making the right choices all the time. That seems to be an indicator. People who are very good artistically, in oil painting, writing, that kind of thing are generally good psychics. Type 'A' personalities are generally better psychics, but we've found so many differences as well. We haven't been able to isolate anything that makes a person a guranteed psychic.

Q: In your new book and in an excerpt in The Anomalist (#5) you proposed a model of remote viewing future events as a person "sending a message back in time to yourself." Could you comment on this?

McMONEAGLE: It's one of the things that gives you an almost perfect loop in terms of information transfer. There's no better way to have gotten a message than to have gotten it from yourself, because ultimately, the psychic or remote viewer knows whether they were right or wrong. At that point they have a complete loop of understanding as to what was right about what they were predicting or not. We know that there is evidence that information flows backwards in time, and we know that a lot of what turns out to be right in a remote viewing also happens to be things that were noticed by the viewer *post hoc* (after the remote viewing.) Having said that, I must also say that we also have very good remote viewings by people who never saw their feedback-never knew whether they were right or wrong, because they're dead now.

> The only thing we can say is that there is no commonality between any people who have this ability. Quite literally, everyone is as different as high noon and midnight from one another. There seems to be some indication that when people are talented in other ways, in other words, people who seem to be fairly successful, and who are making the right choices all the time.

Q: So feedback is not specifically a requirement?

McMONEAGLE: It actually has very little effect on it. It helps in the learning process. It also helps to alter the psychology of the person who's trying to learn to be psychic. While we can show that a remote viewer who never knows the answer can be just as good, we realize that information is being passed through numerous levels through numerous means, so one is not mutually exclusive to another. When you open up psychically to a target, you're opening up to what you will eventually know about the target, what other people know about the target, what your expectations for success are, the target itself, past history of the target, future history of the target...I mean, the information is coming from a lot of different areas. That's part of what buggers up the process. There's almost *too much* information, and trying to decide what will be of more value about a target than not is actually very difficult to do during a remote viewing.

Q: Has there been any way to narrow that down?

McMONEAGLE: To my knowledge (and this is from 25 years of research) I have never witnessed any remote viewer (and that includes myself) who was capable of determining prior to the material being judged what was good and what was bad. It's an impossibility. If it's a totally blind target and it's been done within experiemental protocol, and I'm getting information on it, it's literally impossible for me to determine what information is good and what is bad prior to the evaluation.

Now, there's some exceptions to that. Myself, and Ingo Swann, and at least two other viewers that I can't name have shown a propensity to some-times be more correct than not about what's important before it's evaluated. But that doesn't happen all the time. I think that it's born out of 20-plus years of expereience. Certainly you wouldn't see it in a viewer that doesn't have a lot of experience.

Q: In the interview I did with Dean Radin in the last issue, he mentioned the first results of an experiment (which involved the testing of psychics in Brazil who were trying to affect the phsysiology of human subjects that were monitored two months later, thou-sands of miles away. Radin claimed that the tests were showing some effect) that seemed to indicate that, for the human psyche at least in the PSI realm, meaning or relevance is a "dimension" just like time and space are relevant dimensions to our conscious aware-ness. Your previous statement seems to support this idea.

McMONEAGLE: If only in the rarest of cases. It occurs so infrequently, that it would be in the single-digit percentiles. In fact, the effect that Dean Radin talked about, he couldn't be sure if the effect would be positive or negative. I've always felt that any transfer of information is a two-way street. Information is flowing in two directions, and so intent becomes extremely important. If Radin told his subjects anything about the intent of the experiment, they are essentially giving tacit agreement to being affected. If they clearly had no idea whatsoever what they were participating in, then that may indicate that there is a one-way effect.

Q: They were told that they were involved in a psychic experiment of some sort.

We also have very good remote viewings by people who never saw their feedback-never knew whether they were right or wrong, because they're dead now.

McMONEAGLE: If they weren't, it would be a violation of human use. As long as we're operating within human use laws, it's extremely difficult to tell if there's a single-direction effect, and not joint intent to have an effect appear.

Q: *So, the effect seems to be enhanced when there's a two-way communication.*
McMONEAGLE: I think so, because there's a joint expectation between the target subject and the targeter.

Q: *...Even if it's below conscious awareness. In fact, it's probably better when it is.*
McMONEAGLE: Exactly. The target person should just be sitting there reading a book and ignoring what's going on. You get much better results.

Q: *Are you still doing an experiment with Radin involving the targeting of some technological device that was going to be invented in the future and attempting to remote view across time to bring back the particulars of the design?*
McMONEAGLE: We're still working on it. We don't talk a great deal about it because we're having some limited success. It unfortunately doesn't do what we expected it to do. It does some really off-the-wall things. One of the difficulties is that you have to make a lot of automatic assumptions when you do this kind of experiment. For instance, we're assuming that there isn't more than one kind of machine that does the same thing, and we're assuming that there isn't a multitude of different ways that the machine can be doing this. If there's a elecromechanical device that does it, and a proton-diven device that does it, then right there you have two groups of information that are juxtaposed over each other. If you take a little from each, then right away you're confused.

Q: *So isn't that actually "front-loading?"*
McMONEAGLE: It's not if you take care of the problem in the analysis of the material [post-remote viewing.] In other words, in this case, you would discard material that does not seem to be significant to electomagentic devices. You do some sort of massaging of the data in the analysis. That's not front-loading.

Q: *Can you discuss your methodology for remote viewing future events (as described in* The Ultimate Time Machine?)
McMONEAGLE: What I do is have a huge pool of targets broken down into clear categories, and each of the categories had about 25 subcategories. I just invented questions that I thought would cover anything that would be interesting to know, and I would write them out: "Where is the most significant earthquake going to be in the next 50 years" or something like that. I would write them on 3x5 cards and stick them in opaque envelopes. There were hundreds of these questions, and I put them in a green leaf bag.

Q: *(Laughter)*
McMONEAGLE: Yeah, seriously. I'd put them in there and I'd shake them up, and pull one out and put it on top of my computer. Then I'd sit there and get my remote viewing state, and open up to whatever information would answer what

> **Myself, and Ingo Swann, and at least two other viewers that I can't name have shown a propensity to sometimes be more correct than not about what's important before it's evaluated.**

might be in the envelope, and I'd type a page of information. Sometimes it wasn't a whole page, maybe three or four paragraphs. Then I'd open the envelope. If the question seemed to match what I'd typed on the screen, then I would type the question at the top and save it to a file. Then I'd destroy the card. If it didn't match, I deleted the screen, trashed the stuff, and put the card back into another envelope, and put it back in the leaf bag. I did that for about four years.

Q: How do you guard against the fact that you have answered some of the questions and the target pool is declining?
McMONEAGLE: All I can tell you is that maybe half of what I collected is in that book. There are still cards sitting in the bag here that I've never done, so I'm not sure I can remember what I wrote on the damn things now. There are certainly some areas that I have a burning interest in that are still sitting in a box somewhere in a blank envelope, but I wouldn't know that one from another I might be pulling out. I just try and keep as big a pile of targets as I can. The other problem becomes that you start collecting so much data that you start to get a personal feel for the way things should be. So where does the actual data collection begin and end, and when does the personal analysis start and end?

Q: I suppose a skeptic or debunker would say that there should be an objective way to look at this, but because of the way that you do this, objectivity might be a problem.
McMONEAGLE: In this particular case, I wasn't trying to prove remote viewing was real. I was just trying to produce information that would be more right than wrong, and trying to use as much remote viewing as I could bring to bear on it. It's sort of a test of faith in the fact that in the long run, we create our own future by how we think about it. I'm hoping that this sort of buried message in my book will get proven over the next 75 years because I brought it up. It's sort of self-validating, I guess.

> **I wasn't trying to prove remote viewing was real. I was just trying to produce information that would be more right than wrong, and trying to use as much remote viewing as I could bring to bear on it.**

Q: Could you talk about any particular instances where your predictions have been days or months in the future, rather than years, and accurate enough to where you could say they were useful?
McMONEAGLE: Yeah, there's one thing that my publisher wouldn't let me take out. There is an 11 month delay between when the manuscript is finished and when the book comes out. During that time, I started sending them clippings for the stuff that [was predicted in the book] was happening. They wanted to mark the stuff as having happened, and I said "no." So, I was actually excluding things out of my book, and replacing them with other predictions.

Q: Why did you take them out?
McMONEAGLE: Well, I could have left them in, and sort of saying, "Well, I got this one right and that one right" but that's sort of defeating the purpose of the book. Anybody can rush print a book and say they predicted a lot of things that are real, but there is always a doubt as to whether or a not manuscript was completed before the events.

About a week after the book went to the printer, there was a story about the military wanting permission from congress to test a new weapon. What I

History is always filled with emotions, which is why most people associated with the actual history probably are the last people who should comment on it. Over time, emotion dissolves and reality (facts) come to light which if looked at within the perspective of the times in which they occurred, can produce a pretty good picture of what (and why) something happened.

had originally written on the subject was this [reads]: "A long-range 'death ray,' probably a chemical oxygen-iodine laser would be operational by the year 2010. It will be capable of frying hard military targets at ranges exceeding 25 miles, and will be track- or wheel-mounted in a vehicle or possibly inside a large cargo plane." This is what I added after it went to the printer: "Note: A weapon similar to this was just disclosed to the public, with a request for permission to test it against a satellite. The original prediction was submitted in manuscript form in August of 1997." I actually left two of these in the book, back-to-back. I also said "An American and Eurpoean infantry unit will be carrying death ray rifles by the year 2015 that will have a range in excess of 500 meters. They will not operate in a sense that a ray gun operates, but will be a combination of at least three new and current technologies." So then I said "Note: A patent was issued a month ago for what is essentially a *Star Trek* phaser. It operates by sending a variable electrical burst down a specifically constructed beam of light designed to carry the electrical charge. It can either paralyze the intended victim or kill, depending how it is adjusted."

These were the only two I allowed them to keep in the book. I removed something like 11 predictions while we were waiting for it to be published, becuse they had come true. I went to my file and pulled other predictions to replace them with. I didn't want a lot of discussion about when I wrote it and "when it happened."

Q: You remote viewed the JFK assassination. For the benefit of those who have not seen your new book, could you give a brief summary of your methodology and findings, and in what way was your assessment of the event different from the published conclusions of "normal" researchers?

McMONEAGLE: I believe the viewing took approximately seven different approaches to targeting over a period of about eight years. Some of the data was produced at the request of individual clients and some of it was produced as a matter of course for my book. The thing to remember is that history is always filled with emotions, which is why most people associated with the actual history probably are the last people who should comment on it. Over time, emotion dissolves and reality (facts) come to light which if looked at within the perspective of the times in which they occurred, can produce a pretty good picture of what (and why) something happened. I tried to paint a picture of the why more than what was already known about the how. Much of what I said is in agreement with what has been postulated about the event, but I think the slant I bring to the why is somewhat different. I think I said that I feel the reasons for the assassination were more to do with the Cuban Missile crisis than any other singular event.

Q: According to some people of a good skeptical bent, many of the predictions in Ultimate Time Machine *just seem like really good extrapolations from current cutting-edge research and findings. Experts in these fields could predict some of these things without resorting to remote viewing.*

McMONEAGLE: Oh, sure. You could in effect say that given our speed of devel-

opment that "this" may happen in our field in the next 50 years. If I say "A" will happen and that's a very incorrect prediction, I don't see any difference between creative extrapolation and remote viewing. The methodology is different, but it's all really the same thing. A person is either going to be right or wrong. There's no real way to satisfy the multitude of complaints about how or what I did. There is also no way to say that remote viewing doesn't work either, but people find a way. You can demonstrate an in-your-face remote viewing, and they'll look at you and say "well, that was a hell of a good guess." I've had that said to me literally hundreds of times. It flies in the face of reality. It's ludicrous.

Q: What is your ususal reaction to people who say that there is "nothing to" remote viewing?
McMONEAGLE: My basic reaction is that I just keep doing it. I have demonstrated remote viewing live on camera on numerous occasions. I have demonstrated it live to Senate Subcomittees. Just about every way you could challenge it, and come out OK. Sometimes I've done viewings that failed. That's part of the nature of the beast. When people find it in their minds to accept that some of this remote viewing thing is real, and should at least be studied, I'm content with my success. There are people who will spend the rest of their natural lives denying it, and that's not my problem.

Q: Do you have a "hit percentage" that you can claim for yourself?
McMONEAGLE: Yeah, I can claim a statistical percentage that's validated by a number of different labs, primarily the Cognitive Sciences Lab. About 60 to 65 per cent of the time, I will make contact with the target. When I do, I will have what's called a "figure of merit" accuracy which runs anywhere from 25 to 88 per cent. It's a lot tougher to be accurate in a lab than it is in applications. In calculating that figure of merit, for instance we look at all the things I said that were right about a target, and all of the things I said that were wrong about a target, against all of the things that I could have said about it. So, when you start running figures in the 88 percentile range, that's pretty good.

Q: Have you ever noticed a "declination effect" in accuracy from doing too much remote viewing or targeting something multiple times?
McMONEAGLE: Actually no. We see enough degradation in remote viewing for a multitude of different reasons, but in terms of my statistical result, it hasn't changed since I started viewing in October of 1978 and today. It may run a bit higher or lower, but it averages out the same every time. It's one of the reasons that we don't feel that training is very beneficial. We think that what happens is that someone will go in for training as a remote viewer, and will say "I was taught to remote view." Well, we don't think that's what's happening. What seems to be happening is that they're essentially seeing what their natural talent would have produced anyway.

Q: It sounds like they're being given permission to use it.
McMONEAGLE: Right. Exactly. What we have found is that every human being that we're ever walked into the lab and tested can do remote viewing on

When people find it in their minds to accept that some of this remote viewing thing is real, and should at least be studied...There are people who will spend the rest of their natural lives denying it, and that's not my problem.

some level. Once in a while there is someone who's very, very good at it, and more likely, we will find someone who is not very good at it. What's disturbing me is that there are a lot of people who get frustrated with themselves, because they spend a lot of time and money on training, and they never get any better than when they walked in the door. They don't undertand that the kind of training that they would have to do to improve themselves is beyond the normal capacity of a human being. When I was recruited for the Army program, I was essentially paid to be a remote viewer.

Q: How did it happen that you were picked for the program?
McMONEAGLE: I had been overseas for 14 years, and the selection criteria they were using was one that I fell into, so I was interviewed about three times and gave the right answers. Eventually I was selected to go out to SRI to be tested. I went out there for two weeks and did six remote viewings, and was the first subject to have five for six first place matches. That's about 80 per cent coming right out of the box. As a result of this, I was recruited. I was doing remote viewing 8 to 10 hours a day, five days a week, 52 weeks a year.

Q: Didn't people burn out on that pace?
McMONEAGLE: Everybody burned out. By 1982 I was the only viewer left. From then to 1984 I was the only viewer there. I was doing all the remote viewing.

Q: What kinds of stuff were you doing that you can talk about?
McMONEAGLE: Very little.

Q: Do you think it's still being done now?
McMONEAGLE: I can't imagine that it would be and that they would not be paying attention to the leaders in the research arena. In the Cognitive Sciences Lab we are still doing research, and we have probably learned more about remote viewing in the last three years than in the entire 21 years of the government program.

Q: What sort of work are you doing with Cognitive Sciences Lab?
McMONEAGLE: Well, as an example, our operations guy, James Spottiswoode, has discovered a thing called "Sidereal Time," and we now recognize that by paying attention to it, you can produce a five- or sixfold increase in accuracy.

Q: Can you explain that concept?
McMONEAGLE: It's a little tough to understand. Sidereal time is based on the relationship of the plane of the Earth to the core of the universe. The Earth wobbles, so half the time in a 24 hour period, the core of the universe is below the horizon, and half the time, it's above it. Since that 24 hour cycle is not based on solar time, it's based on the "wobble" it's about three or four minutes less every day than the solar clock. When the core of the universe is below the horizon, and it's at it's lowest point, in other words, when it's having it's least effect to those of

Eventually I was selected to go out to SRI to be tested. I went out there for two weeks and did six remote viewings, and was the first subject to have five for six first place matches. That's about 80 per cent coming right out of the box. As a result of this, I was recruited. I was doing remote viewing 8 to 10 hours a day, five days a week, 52 weeks a year.

us standing on the Earth, we see a significant increase in accuracy of remote viewing. If you're looking at the Milky Way, you're looking at the core of the universe. If it's above the horizon, you will find that your remote viewing will be average. There's four or five other things that we're working on that all interrelate in one degree or another to accuracy. So, we're continuing to do the research.

Q: What sort of work do your private clients request?
McMONEAGLE: Everything under the sun! Where to invest money, when to invest, where to find minerals, what the complications might be in mining them, what to expect in terms of changes in specific markets, what shortages might exist on materials for manufacturing, political implications of marketing, where's the best water...anything you could imagine.

Q: A lot of people will ask what effect remote viewing could possibly have in their daily lives, and ultimately how relevant it might be for most of us.
McMONEAGLE: Well, it probably doesn't have any if they don't care. That's pretty much up to how badly you want to do something and how much money you'd like to spend doing it. I had a woman who came to me from France. She had a piece of land there that she wanted to build a vacation lodge on. The local government wouldn't let her do it because there was no water there. She drilled three dry wells. She came to me and said that she was going to lose all of her property value if she didn't find a well. I essentially did a well-location viewing for her from here, from Virginia, and mailed it to her in France, and now she's getting 75 gallons a minute. She's got a big hotel there now. I'd say that substantially altered her life. People do what they've got to do. Somebody who puts remote viewing down, or doesn't care one way or the other, when they're faced with an insoluble problem, they may say, "Well, *maybe* remote viewing might help."

A lot of people complain that remote viewing doesn't work all the time, or it's not that dependable, that sort of thing. A lot of statements can be made about remote viewing based on the history of it, and that history is sort of like the problem with alternative healers. Healers are badmouthed when they can only produce a 25% success rate. The thing to remember about this is that by the time a person comes to them, they have been written off as terminal by American medical science. Remote viewing was operating the same way. We never got the cream of the crop in terms of problems to work. We got problems that were written off as insoluble. Problems that had no more leads to work. We were solving 60% of them. I'd say that that was pretty significant. So then people say that the success rate was awful low, but they don't have that kind of success with agents in the field with cameras. The comment [former CIA director] Robert Gates made on *Nightline* "Remote viewing was never used to make any decision at the national level." Of course not. *No* intelligence source has ever been used to make a decision at a national level. Anybody that has half a brain wouldn't make a decision beased on a single input.

Q: Do you think that there is any connection between the Non lethal weapons field and

> **A lot of statements can be made about remote viewing based on the history of it, and that history is sort of like the problem with alternative healers. Healers are badmouthed when they can only produce a 25% success rate. The thing to remember about this is that by the time a person comes to them, they have been written off as terminal by American medical science.**

the PSI field, seeing as how John Alexander and David Moorehouse are both heavily involved in that area, and given their history in the remote viewing field.

McMONEAGLE: No. John Alexander was never a part of the remote viewing project. He was an advisor to General Burt Stubblebine, and in that position, knew that our project existed, but that was all. As far as I know, he has no claim of expertise in remote viewing, although he may make that claim. He's a smart guy, and he's into a ton of stuff, and remote viewing holds a large amount of curiosity for him. He's not dumb, and he's probably done his homework.

Q: If someone you knew was in danger, and you knew or sensed that through extra-normal means, would you say anything to them?

McMONEAGLE: A really good friend? (Laughter) I'll tell you what my personal rule is: If my sense of danger includes me, I will share that. It's information that affects me and thereby affects others. If the information comes spontaneously to me, and involves someone I know, I probably won't tell them about it.

Q: Because it's only a probability?

McMONEAGLE: It's simply a probability, and I prefer to hold their personal privacy in higher regard than the rantings of a crazy remote viewer that something's about to happen. I get spontaneous things all the time. As an example, I'll walk into a Christmas party and I will just inherently know that something's not going well with a couple, or one of my friends, but I don't even mention it unless they tell me. It's none of my business. We have enough things that are socially invasive without psychics going around adding to it. It's just unethical.

Here's an example: Someone will say "My son just had his eighteenth birthday. In the middle of the night he got up, packed a bag and walked out, and I haven't seen him in three months. You've got to help me find him." My response is "I can't help you."

Q: He's eighteen.

McMONEAGLE: He has as much right to privacy as you do. This really pisses some people off, but I'm sorry. The right to privacy is something we all share.

Q: Have you encountered any reason or operating force behind the UFO scenario (objects, abductions, etc.) in your RVs?

McMONEAGLE: There are a lot of automatic assumptions surrounding the UFO subject which I think are not very well founded in the evidence. When you start really looking at the RV that's associated to UFOs or the subject of UFOs you can quickly come to the conclusion that our wildest speculation is probably so far off the mark that it would be easier to prove a similarity between night and day.

Clearly, it doesn't take a remote viewer to understand that if there are aliens and they visit our world and their vehicles are UFO's, then we have to be talking about time machines. In other words, to travel such vast distances in a reasonable amount of time, means stepping outside the current laws of time/space. This automatically eliminates anything we can envision about them

> **When you start really looking at the RV that's associated to UFOs or the subject of UFOs you can quickly come to the conclusion that our wildest speculation is probably so far off the mark that it would be easier to prove a similarity between night and day.**

that might fit within the parameters of our understanding for time/space. It most certainly removes "them" from our normal lines of logic.

This means we probably have very little context within which to hypothesize about "them." If this is true (and I think it is), then it automatically changes how we should be looking at the whole idea surrounding abductions. If abductions are valid (and again, I think they are), then they violate time/space as we assume it operates, and anything we can logically associate with them must be at least partially incorrect.

Everything I've experienced through my remote viewing seems to imply that at least some of what we call abductions are real, but they are probably occurring outside the context of time/space. In my own mind, this means they may be more for purposes of communication than anything else. If so, then it's a form of communication that's been going on since the beginning of time, and one that we've constantly and consistently felt a need to re-mystify for one reason or another. It also means our term "abduction" is totally incorrect. If it is a form of communication, then at the very least we should be calling it something else...perhaps..."Alienspeak experience" or the "intrusive-comm experience."

I think when we are able to understand clearly what "they" are attempting to communicate, I think everything else will fall into its natural place or order. In simple terms, they've been saying hello for five thousand years and we've been doing everything but saying hello back. When we've matured to the point of having a real understanding for how reality actually works, instead of demanding it work only the way we want it to, then we'll understand the method of hello as well as their form of travel.

In our arrogance, we continue to insist that we are the "only ones in the universe." In this case, we are "the only ones in the universe with consciousness." No one else has it, or can use it. We may be a lot more primitive than we think.

Remnants of Thule: Semitic Seeds in Nazi Germany

John Carter

Most readers may be surprised when they learn that of all the different parties who had a vested interest in the Nazi rise to power, none are more overlooked than a certain small sect of messianic Jews.

KEN DEVRIES

Politics make for strange bedfellows, the politics of war even more so. Still, most readers may be surprised when they learn that of all the different parties who had a vested interest in the Nazi rise to power, none are more overlooked than a certain small sect of messianic Jews.

Before you protest, let's go back to seventeenth-century Smyrna. Now known as Izmir, Smyrna was a Turkish seaport with a Jewish quarter. Millennial Christians may have been looking for the End in 1666. Unknown to them, an enigmatic Jewish man had declared himself to be the Messiah just a few months earlier. His name was Shabbetai Sevi (1626-1676).

As early as 1648, there were whispers among certain Jews that this young man might be The One. He struggled with alternating bouts of heresy-inspiring joy and suicidal depression. He would violate the kosher laws, for example, or utter the Ineffable Name of God while in his "up" mode, but would retreat into a total solitude of nightmares and qliphotic demons when down. Modern historian Gershom Scholem, in his book *Sabbatai Sevi: The Mystical Messiah* believes Sevi may have suffered from a bipolar disorder. During another up period, Sevi married a girl who was known for sleeping around. Accusations of libertinism and bigamy followed him throughout his life.

Just before his fortieth birthday, Sevi visited Nathan of Gaza (1644-1680) in order to resolve his internal conflict. Nathan was famed as a seer and giver of advice. He was also a practicing kabbalist, and Sevi's doctrine was already heavily influenced by this mystical doctrine. In coming to Nathan, Sevi wished to be healed. He wanted a personal *tikkun*; Nathan offered him one for the whole Jewish race instead. (*Tikkun* is the kabbalistic doctrine of man finishing God's creation in order to bring about the End.) Rather than rebuke him, Nathan argued that Sevi really was the Messiah and urged him to proclaim himself publically.

On the ninth of Av, 1665, Shabbetai Sevi, accompanied by his Prophet, Nathan of Gaza, announced his Messiahship to an eager Jewish crowd. Nathan

did much of the talking, using obscure scriptures to support his position. Word spread quickly throughout Asia Minor, the Holy Land, and the European continent. Sevi preached a curious trinity of the kabbalistic *Ain Soph* (the infinite), Yahweh, and the *Shekhinah* (Divine Presence).

Nathan proclaimed that Sevi's heresies were exact proof of the truth of his claims. Would a pretender act so recklessly? No, only one inspired by God would act in such mysterious ways. The heresies he committed were a means of purifying our souls, of descending into a literal Hell on our behalf. Only by allying himself with such sin could Sevi approach sinlessness. His heresy was a great purgative. We will return to this theme again before we are through.

Six months later, Sevi and Nathan traveled to Adrianople. Betrayed to the Turks by another would-be Prophet named Nehemiah, Sevi was arrested there by the Sultan in September 1666. Given the choice of conversion or death, Shabbetai Sevi committed the ultimate heresy of his career and embraced Islam. When the initial "high" wore off, Sevi was plunged into his deepest depression. He openly continued his Muslim allegiance, but in secret practiced the mystical rites of his Messianic heritage. This is another important element of our tale.

Naturally, Sevi's followers were perplexed. The wave of joy at the Messiahs coming was hard to stop. Sevi's was already an heretical doctrine; why not one more? Jews closest to Smyrna followed Sevi's lead and converted voluntarily. This pleased the Sultan until he learned these so-called "converts" were being told to remain secretly Jewish by Sevi himself. He had hoped Sevi's example would inspire many Jews to follow. Most continued their unorthodox Jewish practices in secret, and they saw the Muslims as agents of the *qliphoth* (demonic forces). Neither Jew nor Muslim, they became outsiders in both worlds. Scholem documents positive connections between the Turkish Shabbateans and the local Sufis.

Shabbateans who grew up in the faith during subsequent generations became more Muslim and less Jewish as time passed. They were known as the sect of the Doenmeh; Jewish Muslims who pretty much kept to themselves. Scholem located a pocket of them in Turkey during the early part of this century, but they seem to have been totally assimilated by now.

The Jews in Europe faced a different set of circumstances. The majority of the populace drifted back to orthodoxy. Islam was not a choice. The truly faithful believed Sevi's apostasy to be a ruse, and continued following their Messiah. It became more of a family tradition, a secret doctrine hidden away in the Jewish ghettoes of Germany and Poland. The Rothschild family may even have been one such family, the *Roth Schild* or Red Shield of their name being the Shield of David, the *Magen David*, which was not generally in use prior to this time. It was a Shabbatean symbol then, unlike todays general recognition of it as a symbol of Israel.

Known Shabbatean groups met until sometime early in the nineteenth century, with one important offshoot—the Frankists—surviving openly until the 1860s. The Frankist sect is named after its Polish founder, Jakob Frank (1726-1791).

> **Sevi's heresies were exact proof of the truth of his claims. Would a pretender act so recklessly? No, only one inspired by God would act in such mysterious ways.**

A New Twist

While most Shabbateans were content to let Sevi alone commit heresy, Frank was of the mind that we should follow his divine example in order to purify ourselves. Sevi's coming redeemed the sin of Adam; we are now free to sin without guilt or fear of retribution. Eliade says, "Like the seeds buried in the earth, the Torah must rot in order to bear fruit..." He goes on to say that orgiastic rites were documented between 1700 and 1760. He calls Frank "sinister." Scholem classifies him as "nihilistic," a common term for those who seem to spurn everything traditional.

Unlike most other Shabbateans, Frank and his followers were decidedly interested in events political as well as religious, according to Scholem. They believed that the advent of the Messiah hailed the End, when all would be explained—even the heresy and apostasy of Sevi. The Law was complete; it was fulfilled by Sevi's presence and was therefore no longer binding.

Sevi died in 1676, fifty years before Frank's birth. Frank seems to have learned his Shabbatean ways from his father, himself a second- or third-hand Shabbatean. Frank later told the Inquisition his father had been a rabbi, but this is not supported elsewhere. Frank was a poorly-educated but widely-traveled trader of cloth. The Frankist movement was centered primarily in Warsaw. Frank became involved with the Doenmeh in Turkey, but followed the examples of other Poles there by not embracing Islam.

Returning to Warsaw after many years, Frank was caught leading an orgy. His followers were arrested, but he went free, mistaken for a Turkish citizen. He later claimed he was caught deliberately, in order to openly proclaim his radical message.

Frank went back to the Polish-Shabbatean subculture in the Doenmeh part of Turkey. He was arrested several times, and finally converted to Islam to divert suspicion and/or further his own "holy" ends. Unlike the moody Sevi, Frank did so willingly-without a sword hanging over his head.

Returning again to Poland, he found himself welcomed by the Shabbateans but persecuted by the more orthodox Jews. His followers were excommunicated by the Warsaw rabbis, so Frank sought an alliance with the Christian commmunity as a means of protection. The Frankists converted en masse to Catholicism, the final heresy on their path to redemption. They retained their Jewish/Islamic/Shabbatean heritage only as the deepest of secrets, a further burden which seems rather practical as well.

Frank tried to merge the kabbalistic doctrines of his own faith with that of the Catholic church. The *Shekhinah*, for example, was equated with the Virgin Mary-not the Biblical mother of Jesus, but the ascended St. Mary who answers prayers and watches over all believers. To more orthodox Jews, the *Shekhinah* is equated with the Sabbath; to the Theosophists, the Holy Spirit. The *Shekhinah* is often considered to be of a feminine nature, the Bride (or Daughter) of the Father.

Later Developments

Most Frankist families in eastern Europe were very wealthy. Frank's followers were numerous and faithful. They built factories in Warsaw, worked for the government in Austria, held positions as lawyers there and elsewhere, and became nobility in several places. There are interesting Shabbatean and Frankist connections in Germany, Bohemia, and Moravia. Frank for a time also considered enlisting the aid of the Russian Orthodox Church, which would have required yet another apostasy. Ultimately, this didn't pan out.

Many Shabbateans were already in Austria, but in 1773 several important families converted to Frankist Catholicism. Scholem mentions the names Hoenig, Dobruschka, Von Hoenigsberg, Von Hoenigstein, and Von Bienefeld. Though not of the noble class like the others, the Dobruschkas held high-ranking military positions.

It may be more than coincidental that in 1776, Adam Weishaupt founded the legendary Illuminati in nearby Ingolstadt, Bavaria. Weishaupt was a professor of law from a Jewish family in Ingolstadt who had converted to Catholicism (according to Scholem,) probably in a secret conversion to the Frankist sect.

Moses Dobruschka later helped found the Asiatic Brethren as "Franz Thomas von Schoenfeld," and also served a role as a Jacobin revolutionary as "Junius Frey." Arthur Edward Waite placed the founding of the Asiatic Brethren no earlier than 1779, while their own literature puts the date at 1781. Moses was offered the leadership of the Frankists after Franks death in 1791, but he declined.

Frankists remained staunch Polish nationalists for generations, although their Jewish and Christian natures became more blurred as the years passed. Their antinomian stance held in all things apparently, and their political interests demanded an independent Poland. Early accusations of being secret Jews gradually faded, though they were always known as "Jewish Christians."

The Frankist connection to the Illuminati fades into oblivion fairly quickly. However, the Illuminati were rather large, having by some estimates over 1000 members in a dozen lodges. Historian Clarence Kelly quotes a Masonic response against the Illuminati from 1795 (some Masons were still pro-Illuminati at the time). It equates the Jacobins in France with the Illuminati in Austria and Bavaria. The author of the response, L.A. Hoffmann, was a Mason in the company of several ex-Illuminati initiates who should know what they were talking about.

The Asiatic Bretheren

The Asiatic Brethren, more properly known as "The Knights and Brethren of St. John the Evangelist from Asia in Europe," were an order of Jewish Christians who appeared Rosicrucian in nature despite their statements to the contrary. They were not trusted by the Masonic lodges, and any Rosicrucians of the time were still underground. They seem to have been a secret society for Jews in a time when most Masonic lodges did not admit them, but they insisted on their Christianity throughout. Their center was in Vienna, Austria; their leader a Baron von Eckhoffen. Another leader was a Baron Ecker. The Brethren also had lodges in Italy.

> It may be more than coincidental that in 1776, Adam Weishaupt founded the legendary Illuminati in nearby Ingolstadt, Bavaria. Weishaupt was a professor of law from a Jewish family in Ingolstadt who had converted to Catholicism, probably in a secret conversion to the Frankist sect.

Even so, the Asiatic Brethren were unanimously known for being Jewish at the core. In other words, the Jews no longer trusted them because they had become Christian, the Christians didn't trust them because they still looked Jewish, and in actuality they had transcended both by becoming neither. Since at least one of their founders was from a Frankist family, this is no surprise. Scholem is the only author who mentions the Frankist connection to the Asiatic Brethren, but all writers acknowledge the Jewish-Christian aspect.

According to several sources, Muslims were also admitted to the Asiatic Brethren, probably of a Doenmeh or Sufi orientation. The Brethren were exposed completely in 1787 when their rituals were published by a defector, but certainly they only regrouped under a different name, as Waite asserts. At one point the Brethren actually claimed a history going back at least to the sixteenth century, but this seems unlikely.

Nesta Webster talks of the associations Frederick the Great, Frederick Wilhelm II (an alleged Illuminatus), and Bismarck made with the secret societies throughout Germany and Prussia. This is rather vague, but it is no far stretch of the imagination to keep the activities of the Frankists alive past the date of 1860 which Scholem gives. It won't take but one more generation to get us where were going.

The Hooked Cross

Changes in German laws regarding the Jews encouraged a mass migration from eastern Europe starting in 1871. Likewise, Dusty Sklar (*Gods and Beasts: The Nazis and the Occult*) says the Jewish population of Vienna grew 400% between 1857 and 1910. The war-ravaged locals resented the wealth and influence of these foreigners. Anti-Semitism grew as a result of the liberalized laws, no doubt the opposite of the intended effect.

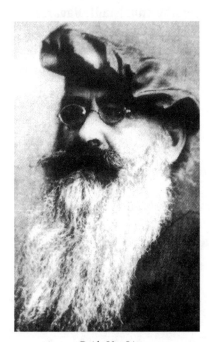

Guido Von List

Guido von List was born in Vienna in 1848. He denounced his Christianity as a teenager, and embraced the Germanic religion of Odin and the Old Gods. He studied the magic of the runes, the old Goth alphabet which was said to have divinatory powers. He revived the old ways as a means of strength. He wanted to reunite the German peoples against what he saw as a new enemy—Judah.

He founded the Guido List Society in 1908, outwardly as an occult study group. There was an inner order as well, the Armanen Brotherhood, who was politically and militantly inclined. The Armanens logo was the swastika, a universal solar symbol. Members included the Viennese mayor and Theosophist Franz Hartmann (whose books remain in print).

Jörg Lanz von Liebenfels was also born in Vienna, in 1874. He entered a Cistercian monastery at 19, but was soon kicked out and later defrocked for his unorthodoxy. He came under the spell of H.P. Blavatsky's *Secret Doctrine*, enough so to found the Order of New Templars (ONT) in 1900 (Sklar) or 1907 (Godwin). The idea of successive "root races" appealed to Lanz, especially the description of the Jews as an inferior offshoot birthed between two other races.

To Blavatsky this was one minor element in an all-encompassing doctrine of evolution. To Lanz it was the answer to the social and economic

problems in Vienna. His Order of New Templars studied kabbalah (ironically) and astrology, seeing themselves as new, gnostic Grail Knights. Coincident with the Armanen, Lanz also chose the swastika as his sign. Lanz published a periodical called *Ostara* (the name of the Old Religion) with a circulation of over 100,000. This was the publication Hitler found in 1909 while browsing a Viennese occult bookshop.

The Merger

List and Lanz founded a new order, the Germanen Orden, in 1912. Membership came from both the Armanen and the ONT. Leadership was assigned to German journalist Philipp Stauff. It was likewise popular. The swastika motif of its parent organizations was retained.

Embelm of the Thule Society

In 1875, Baron Rudolf von Sebottendorf was born in the small German town of Hoyerswerda. He spent much of his life in Turkey, where he joined an Oriental lodge of Freemasons and associated with Sufi mystics. He was likewise impressed with *The Secret Doctrine*. In Germany, he founded the Thule Society at the end of World War I (1918). They studied alchemy, astrology, and the runes. His society took its name from the mystical northern kingdom of Thule, a former paradise now lost, the German Shambalah. For a third time, the swastika was chosen as a symbol. Shortly after its formation, the Thule Society became politically ambitious and merged with the Germanen Orden in an effort to rededicate Germany to a victory in the future. List died soon after, in 1919, but the Society continued on. Even at this early stage, there were 1500 members in the Thule Society, no small number.

Hitler had contacted Lanz in 1909, and had allegedly been present with List during rituals, according to Sklar. Hitler does not seem to have been an actual member of either of the original orders, or the Germanen Orden. In 1914 he went to war, and was elsewhere occupied when the war ended and the Thule Society was formed in 1918. He met up with them later, but only for a time.

Sometime after 1910 another secret society was formed, this time in Berlin. The Luminous Lodge, aka the Vril Society, was founded by Karl Haushofer. Haushofer had been a student of the Russian Gurdjieff while they were in Tibet during the years 1903-1907. Another founding member was *propagandameister* Dietrich Eckart.

Haushofer spent 1907-1910 in Japan, where he was initiated into the Green Dragon Society, a Buddhist organization who would have a presence in Berlin during WWII. The legendary Rasputin is said to have been a Green Dragon as well, no doubt through Gurdjieffs influence, and the last Russian Tsarina had a Green Dragon brooch on her when she was executed at the end of WWI. The German-Japanese axis was formed because of Haushofers connections in the East.

Haushofers doctrine was decidedly Gurdjieffian, though without the Sufi overtones—humans are asleep, Secret Chiefs rule the world from Shambalah, etc. Haushofer was also enamored with the *lebensraum* principle (a sort of German maisfest destiny.) The original Luminous Lodge was a Rosicrucian one, but with Haushofer the Eastern elements were more important.

Haushofer's most important student was Rudolf Hess. Hess had joined a Scandinavian lodge called the Edelweiss Society, another group looking to return to the old ways. Hess Eastern interests meshed well with Haushofer's. Later members include Alfred Rosenberg, Theodor Morrel (Hitler's physician), Himmler, and Göering.

Haushofer's most important student was Rudolf Hess. Hess had joined a Scandinavian lodge called the Edelweiss Society, another group looking to return to the old ways. Hess' Eastern interests meshed well with Haushofer's. Later members include Alfred Rosenberg, Theodor Morrel (Hitler's physician), Himmler, and Göering. Suster lists Hitler as a member as well, but this is unsupported elsewhere. Levenda says Hess and Rosenberg were also in the Thule Society. Dietrich Eckart, Hitler's mentor, appears to have been in both the Thule and Vril groups as well. Several writers don't mention the Vril Society, so it's often hard to tell where one group stops and the other begins.

Eckert died in 1923. Shortly after, the Thule Society was gone or hiding. After he was released from prison in 1924, Hitler had little use for them. His main link, Eckart, was gone. He had gotten out of them what he could, but he saw no need for the personal independence of the Aryan *übermensch* which they propagated. He likewise saw no place for paganism in Christian Germany. Hitler closed occult bookstores in 1934, and outlawed occult societies in 1937. The Germanen Orden and Thule Society were specifically named, alongside Masons, Rosicrucians, Theosophists, the Golden Dawn, and the OTO. Competition eliminated, only the Vril remained, presumably because they were merely a part of the SS.

> **Hitler's aims were better served by the Vril, another word for the "Od" force of Reichenbach, what we would today called chi or orgone. Taken from a Lord Bulwer-Lytton novel, The Coming Race, the Vril force was the secret weapon of underground beings with whom the Nazis identified.**

Hitler's aims were better served by the Vril, another word for the "Od" force of Reichenbach, what we would today called chi or orgone. Taken from a Lord Bulwer-Lytton novel, *The Coming Race*, the Vril force was the secret weapon of underground beings with whom the Nazis identified. Richard Shaver's Deros seem little different. Bulwer-Lytton was a Theosophist and Golden Dawn member. "Vril" seems related to "virile," a word full of life and power. "Od" is no doubt from "Odin," while "orgone" comes to us from "orgasm." Bulwer-Lytton is better known today for having started a novel with the phrase "It was a dark and stormy night." A worst-novel-of-the-year award is named after him, perhaps unjustly considering the influence he had on 20th-century history!

One of the Vril practices which Suster documents is rather telling, if true. Haushofer copied the Green Dragon Society in having new recruits stare fixedly at an apple cut in half. Suster claims this act of meditation was to induce the seeds to germinate. He either missed the boat on this one, or deliberately left it unexplained. This is certainly a Tantric act designed to raise the initiates awareness of his own inner power. The resemblance of the apple half to the vulva is supposed to help focus ones concentration on the incredible potential of sexual energy. Probably the candidate was left staring at the apple to figure this one out on his own. Success may have been indicated by a hands-off orgasm. "Germinating seeds" appears to be a symbolic reference to semen.

The Frankist Connection

In 1964 Dietrich Bronder published *Bevor Hitler kam*, named after an earlier Nazi work of the same name. In his book, Bronder gives the name of 16 Thule society members. "Most of these Thule men had become Catholics; seven had Jewish origins or relations." Godwin leaves this remarkable comment unexplored. (Sklar cites the work as "Before Hitler Came: Thule Society and Germanen Orden" by Reginald H. Phelps in *The Journal of Modern History*, vol. XXXV, no. 3, September

1963, without mentioning the Catholic-Jewish connection. Perhaps this is an English translation of Bronder's work, or another work entirely.)

These Jewish converts to Catholicism have been well-met; we were introduced to them in our discussion of the Frankists, which led us to the Asiatic Brethren, the Illuminati, and now Thule itself. As with Thule's Haushofer, the Asiatic Brethren were full of Turkish Sufis and "Oriental" Masons. Scholem loses track of genuine Frankists sometime after 1860, about 50 years before the Thule Society was formed. Is this all too long to presume a connection? Rich Jews were migrating to Vienna from 1857 on, and to Bavaria starting in 1871. Certainly opportunist Frankists were among their numbers. Old money doesnt disappear overnight.

The Thule Society was an important part of Hitler's early career, and perhaps that of Hess as well. Though he eventually left them behind, their influence cannot be denied. Hess seems to have been a link from Thule to the Vril Society, which did survive with Hitler until the end. Though not of Jewish origin himself, Hess was probably still in touch with the remnants of Thule, living "underground" much as the Coming Race of Bulwer-Lytton's novel, working under another name—or no name at all.

It is these remnants of Thule which were most likely of Frankist descent, and therefore, the opening statement of this article, paradoxical as it may seem, is fundamentally correct. The sponsors of Hitler's rise to power included wealthy and well-placed Jewish-Christians, close-knit, messianic Frankists whose influence—nay, existence—was so secret that it has never been suspected until now.

After Sevi's death, Shabbateans looked for his return. Perhaps Hitler was supposed to fulfill this role. In an inverted sense, he may have done just that. He brought Germany to total ruin, complete devastation. He brought it down to the Gates of Hell so that it might be totally redeemed, sinned the ultimate sin in order to achieve the ultimate grace. Jakob Frank would have been proud. Today Germany is one of the richest nations on the planet. Thule may have won after all.

Bibliography

Gershom Scholem. *Sabbatai Sevi: The Mystical Messiah*. Princeton: Princeton University Press, 1973. (Covers only the period 1626-1676, i.e. the life of Sevi himself.)

ibid. *Kabbalah*. New York: Dorset Press, 1987.

p. 244-286: "Shabbetai Zevi and the Shabbatean Movement"

p. 287-309: "Jacob Frank and the Frankists"

p. 304: Asiatic Brethren

ibid. *The Messianic Idea in Judaism*. (General reference for Sevi & Frank; also the Jewish background of Weishaupt.)

Mircea Eliade. *A History of Religious Ideas*. Chicago: University of Chicago Press, 1985.

vol. 3, p. 175-178: Sevi & Frank

Arthur Edward Waite. *The Brotherhood of the Rosy Cross*. New York: Barnes and Noble Books, 1993.

p. 524: Asiatic Brethren

Charles William Heckethorn. *The Secret Societies of All Ages and Countries*. New Hyde Park: University Books, 1965.

vol. 1, p. 231–241: Asiatic Brethren

Nesta H. Webster. Secret Societies and Subversive Movements. Christian Book Club of America (orig. 1924).

p. 169–170: Asiatic Brethren

Rev. Clarence Kelly. *Conspiracy Against God and Man*. Boston: Western Islands, 1974.

p. 173: Asiatic Brethren.

Gerald Suster. *Hitler: The Occult Messiah* (aka *Hitler and the Age of Horus*). New York: St. Martins Press, 1981. (General reference with lots of occult knowledge and history.)

Peter Levenda. *Unholy Alliance*. New York: Avon, 1996.

Joscelyn Godwin. *Arktos*. Grand Rapids: Phanes Press, 1993.

p. 51: Jewish membership of Thule

Dusty Sklar. *Gods and Beasts: The Nazis and the Occult*. New York: Dorset Press, 1989 (orig. 1977).

Bibliography: *Before Hitler Came* citation

Brennan, J.H. *Occult Reich*. London: Futura, 1974. (General reference; much Gurdjieff material.)

Pauwels, Louis and Bergier, Jacques. *The Morning of the Magicians*. New York: Avon, 1968. [aka *The Dawn of Magic*. London: 1963. orig. Paris: 1960]. (General reference; much on Gurdjieff and Vril; one of the very first books in this field.)

PSI + mc^2 + R&D = MJ12

UFOs, Physics, Parapsychology Mix In Secret Group

Gregory Bishop, from the research of Melinda Leslie and Randy Koppang

MJ12, according to the reproduced documents received by Jaime Shandera and William Moore in December of 1984 was a group commissioned by President Harry Truman in 1947 to deal with the UFO subject as spin doctors of public info as well as the management of back-engineering captured alien technology. If this group did indeed exist, it's ultimate goals have been met. There is still a curtain of denial and laughter surrounding the subject at the level of the national press and mainstream science, and if we are to take the late Col. Philip Corso at his word, the captured artifacts were used to seed industrial R&D thought the elite ranks of top electronics technology companies.

A savvy screenwriter with a creative flair might take four or five index cards and arrange them like this: REMOTE VIEWING/UFO/MILITARY-INDUSTRIAL COMPLEX/MIND CONTROL. He or she might not be too far off the mark. In the years since the CIA decided to reveal its involvement in the field of "psychic spying," some clues have come to light that would bring this flight of fancy out of the realm of dreams and paranoia and into the real world of cutting-edge technology and intelligence operations.

In the past few years, a team of California researchers headed by Melinda Leslie and Randy Koppang have discovered that some intelligence insiders, leading physicists, and remote viewing veterans may have been gathered under the umbrella of something ostensibly named the "Advanced Theoretical Physics Working Group" (ATPWG) to integrate these fields into a cohesive set of new theories about the nature of reality, and ways in which technology can influence the mind, and perhaps more importantly in the near future, how the human mind can influence technology. If weapons systems and command and logistics control can be maintained in the midst of a nuclear holocaust, the side with the psychokinetic edge might prevail by launching missiles and relaying

If weapons systems and command and logistics control can be maintained in the midst of a nuclear holocaust, the side with the psychokinetic edge might prevail by launching missiles and relaying orders through a group of psychics.

orders through a group of psychics. This would bypass the electromagnetic pulses caused by nuclear detonation that would fry most delicate electronics.

The ATPWG is now apparently defunct and/or has moved on into its next incarnation, possibly within the organizational matrix of multi-millionaire Robert Bigelow's National Institute for Discovery Science (NIDS). Alleged members are on record with remarks that their group does (or recently did) indeed exist, and are creating technology and testing theories that would create a new renaissance in aeronautical physics and man/machine interface, and claim that some of it was descended from captured UFO technology. This is where Col. Philip Corso makes the scene.

Corso's *The Day After Roswell* alleged that the author helped to seed American advanced R&D with debris salvaged from a crashed alien craft (although he offered little or no documentation or duplicate sources to back this up.) As the late crash-retrieval Ufologist Leonard Stringfield observed, the task facing researchers is like a "search for proof in a hall of mirrors." Nevertheless, if this scenario was even partially true, the allegation that an alien craft was controlled by an interface with the crew on a direct mental and/or psychic level parallels a memo leaked from San Diego-based high tech contractor Science Applications International Corporation. British writer/researcher Armen Victorian uncovered this document authored by former government remote viewing program scientist Ed May. In an assessment of current (early 1990s) research into parapsychological issues, May remarked on possible research or actual findings from SAIC programs on telepathic remote control of electronic technology.

The membership roster of the ATPWG allegedly included such names as Col. John Alexander, Major Ed Dames, and Dr. Hal Puthoff, as well as Corso. One of the civilian members/consultants may have been famed UFO researcher Jacques Vallee. One of the members of the ATPWG has remarked that they "plan[ned] and set policy regarding the UFO issue." This was of course one of the prime *raisons d'etre* for the original alleged MJ-12 group.

UFO magazine publisher William Birnes discovered Col. Corso's connection to an earlier incarnation of the ATPWG while researching and writing *The Day After Roswell*, which the two co-authored before Corso's death last year. Corso also mentioned that he had visited Stanford Research Institute in the early 1970s to discuss then current psi (parapsychological) research with Puthoff and associate Dr. Russell Targ. Corso told Birnes that the reason for the visit was to seek methods for remote viewing of technology interface between extraterrestrials and their craft. Questioned separately, Puthoff and Corso both stated that the ATPWG "Operated at the highest levels of government" and that they were "Very powerful." Col. Alexander disagrees with the partial membership roster, and says that "The ATP work had nothing to do with R.V. or M.C. [mind control]" but will not elaborate. Dames has separately admitted his association, and remarked that the group is (or was) "the current incarnation of MJ12." Alexander and Dames, along with Major David Morehouse were two of the founders of PSI-Tech, the first private company created by former members of the Army/Defense Intelligence Agency remote viewing

> The membership roster of the ATPWG allegedly included such names as Col. John Alexander, Major Ed Dames, and Dr. Hal Puthoff, as well as Corso. One of the civilian members/consultants may have been famed UFO researcher Jacques Vallee.

program that offered psychic consulting services to the general public.

After a speech in May of 1998, Alexander first denied, then acknowledged his participation with the ATPWG, admitting "That was my group, I was the Director." He had also said in a lecture that evening that the US government was not involved in unwitting mind control experiments against its own population. "We don't do that anymore because its illegal" he remarked. Numerous claims of military figures present in classic UFO abduction scenarios might revise this statement.

Leslie claims personal experience with this kind of close encounter, and backs this up with observations made during one her abduction-type episodes wherein certain protective clothing and devices of which she had no previous knowledge were later confirmed to exist and are used in biohazard environments. Other abductees have experienced similar encounters with the same devices. Leslie asked them why the military might be interested in people who claim alien abduction. The reply: "They were mostly curious about the pilot/craft interface and if we knew anything about that aspect of their technology."

Dr. Robert M. Wood, a current California MUFON official and former Director of Research and Development and Advance Systems Analysis for McDonnell-Douglas as well as reputed ATPWG member said any information about pilot/ craft psychic interface that could be learned from the study of the UFO phenomenon "would be very important." He also remarked that the ATPWG "planned and set policy regarding the UFO issue" and that it was "the only reason the group existed." Wood was also reportedly sent to SRI on a fact-finding trip while still working for Douglas on direct request of the company's CEO. His successor at McDonnell-Douglas is Dr. Jack Houck. Houck also commiserated with the SRI scientists in regard to remote viewing applications that would help verify Russian compliance with SALT II arms-limitation treaty, and told Leslie that he had been "deeply, deeply" involved in the UFO subject "for many years."

Houck was on the editorial board of Dennis Stillings' now defunct Archaeus Project. This group published the landmark *Cyberbiological Studies of the Imaginal Component in the UFO Contact Experience.* This volume contained an essay by Dr. Michael Persinger discussing a neurological basis for abduction-type experiences and at one point discusses the fact that these experiences can be induced by stimulation of the hippocampus and amygdala areas of the temporal lobe of the brain. Perhaps this information and technology is being used in the military-abduction experiences described by Leslie and others. Persinger is also reported to have invented a "helmet" based on his theories that could induce numinous (religious) or even UFO "visitor" experiences.

As for the mind influencing technology, former Air Force communications officer Dan Sherman's book *Above Black* describes a training program inaugurated in the early 1990s along the same lines as the aforementioned SAIC research, with similar stated goals. He claims to have been involved in a series of assignments involving telepathic communication through blank computer screens. Sherman also says that he had a telepathic relationship with a typical "grey" who was involved in the project, which had a typically

Puthoff and Corso both stated that the ATPWG "Operated at the highest levels of government" and that they were "Very powerful."

Strangelovian name: "Project Preserve Destiny." One useful application of tele-pathic control would be in an advanced, antigravitational aeroform that could perform manuevers with inertial forces that would crush a human pilot's body. If the craft had been successfully designed to withstand internal stresses at high speeds and changes in direction, then it might literally be able to "move at the speed of thought." A craft like this would be virtually invincible to attack by conventional defenses.

Leslie and Koppang stress that they are not taking sides in revealing some of this information, but that the public (especially suspected UFO abductees) have a right to know if they are unwitting experimental subjects for a new MKULTRA-type program, and that people in the UFO community should know that some of the top UFO researchers are actively involved in cooperating with members of the intelligence community. Indeed, some of the leaders in the field are members of military or civilian intelligence groups, and that although this is not a necessarily a bad thing for the researchers, the motivation of the intelligence community is a cause for concern.

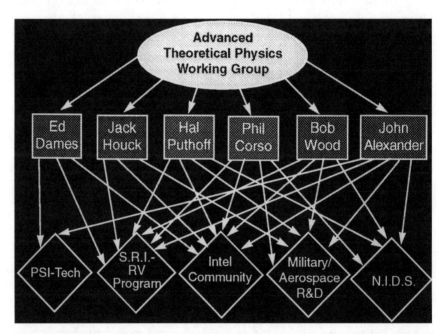

Diagram by Melinda Leslie

Secret Societies and the Search for Terrestrial UFOs

Scott Corrales

The possibility of human intervention in the UFO phenomenon leads us to consider a variety of alternative paths that are as challenging as the belief in extraterrestrial or interdimensional intelligences. One of the natural assumptions made during the early years of the phenomenon was that we were witnessing the testing of secret weapons designed to give one side or another the upper hand in the Cold War. The main objection to this hypothesis was that the testing of experimental weapons over foreign countries was a security risk that no world power could afford. Added to this is the fact that if machines capable of fantastic feats belonged to any terrestrial arsenal, why were the superpowers expending vast sums in building conventional aircraft?

The next theory that captures the imagination of believers in a non-alien source to the UFO phenomenon was time travel: our descendants aeons removed were coming back to visit our time as tourists or else to recover materials and information lost in their future (an exciting science fiction premise, to be sure.) Lacking any theoretical base, and since time travel was foreign to the pre-quantum physics of the age, it received little attention.

In their book *A la Recherche des OVNIS*, J. Scorneaux and C. Piens discussed the possibility of secret societies being the source of UFOs: "A restricted group of men," reads the book, "transmit the knowledge of highly advanced scientific knowlege from one generation to the next. There would be places where they could conceal themselves—the oceans, for example—from which UFOs are occasionally seen to emerge...the acquisition of an advanced science, however, makes such a hypothesis unlikely, since its origin would have had to be extrahuman."

The belief that the UFO phenomenon is a terrestrial one and could have its origin in the operations of precisely one such group of exalted humans remains an intriguing possibility which has been approached by a number of occult writers and researchers.

> **The belief that reclusive geniuses could find a desolate island or remote mountain stronghold from which to launch their wonderful machines against the rest of us was translated lock, stock and barrel into the emerging discipline of ufology during its formative period.**

Literary Overtones

Jules Verne was a 19th century French visionary who along with H.G. Wells, is considered one of the fathers of Science Fiction. To U.S. audiences he is a largely exotic figure, whereas there isn't a Latin American or Western European elementary school curriculum that doesn't feature his works, particularly his most action-adventure oriented, such as *Robur the Conqueror* and its classic sequel *Master of the World* (which detractors have characterized as Captain Nemo—Verne's underwater anti-hero—in a Zeppelin). As with all plot-driven fiction, the situation is straightforward: Robur is a megalomaniacal inventor who unleashes his fantastic flying machine upon an unsuspecting fin-de-siecle Europe. Spectacular aerial battles follow.

The belief that reclusive geniuses could find a desolate island or remote mountain stronghold from which to launch their wonderful machines against the rest of us was translated lock, stock and barrel into the emerging discipline of ufology during its formative period. If not visitors from another planet—solar or extrasolar—could UFOs be the product of a secret cabal based somewhere on Earth?

Maps were unrolled and fingers began pointing to likely locations: some considered Brazil's Matto Grosso a potential site, while others cast their gaze on the Himalayas, the Sahara and Gobi deserts, the Australian outback and even the Rocky Mountains. While advances in transportation had made the world smaller, investigators realized that there was still enough room out there to swing a cat—or to build astonishing flying machines.

Silence: Geniuses at Work

The first indications that some brilliant though reclusive genius was at work—at least in the popular imagination—came about during the airship scare of the 1890s. Research on this period was admirably conducted by Lucius Farish and Jerome Clark, and their cases and conclusions have been incorporated into a number of volumes on the UFO phenomena. Only a brief overview becomes necessary here.

From the mid-1896 to mid-1897, there exist reports from all over the United States regarding the "lights" of an "airship" seen in the sky although the first dirigible flight was still half a decade into the future. The newspapers gave the names of the inventors and even the names of their airships, but in the end, neither man nor machine ever stepped forward to claim its rightful place in history.

Authors Jimmy Ward and P.G. Navarro investigated claims that a mysterious group of inventors dubbing themselves the "Sonora Aero Club" was active in California sometime around 1850. The organization, which had an avowed interest in aeronautics, was in fact a secret society not at all afraid of exacting the highest price for its members' silence.

Ward and Navarro turned up thousands of pages of notes and drawings belonging to one C.A. Dellschau which indicate that the Sonora Aero Club had discovered a gaseous mixture capable of "negating gravity." This gravity-negating gas, variously known as NB or Supe, was a light green fluid which became hot when mixed with other gases. This strange propellant also provided

The belief that the UFO phenomenon is a terrestrial one and could have its origin in the operations of precisely one such group of exalted humans remains an intriguing possibility which has been approached by a number of occult writers and researchers.

power and heat aboard the "aeros," as the strange vehicles were known. Researchers were startled at the sophistication of the aeronautical techniques shown in the Sonora Aero Club's papers, ranging from retractable landing gear to thrusters and drogue parachutes-even powerful search and landing lights.

Could the Sonora Aero Club have been precisely the cabal of secret inventors whose efforts eventually resulted in the airships seen over North America in the late 1890's? Probably not. The documentation in C.A. Dellschau's hands indicates that manufacture of the NB gas was in the sole hands of one Peter Mennis, who was unwilling to share his secret formula with the rest of the group. No further aerial experiments were undertaken after Mennis died or vanished in the 1860s.

Do Secret Inventors Really Exist?

Narciso Genovese, an Italian scientist living in Mexico, was interviewed in the 1970's by Professor Mario Rojas of the CEI with regard to a perplexing conspiracy—is our world run by a conspiracy of scientists?

According to Genovese, a council of ninety eight scientists from all nations and all branches of scientific knowledge—physics, chemistry, mathematics, astronomy and electronics—have pursued research into hidden avenues of knowledge under the supreme commandment of never revealing a single iota of knowledge to any of the world's governments. The "Council of the 98," to give it a name, has a doctrine based on three main points:

> There is only one religion: the belief in a wise, omnipotent God.
> There is only one country: the planet Earth.
> There is a single purpose: to bring forth peace through science in our world and create an alliance between humans and the inhabitants of other worlds in the universe.

Genovese's startling "scientocracy" was allegedly established in 1938 shortly after the death of Guglielmo Marconi, who refused to turn over his notes and discoveries to Italian dictator Benito Mussolini. Inspired by this courageous act, the Council of the 98 has pursued its secretive work in the hopes of establishing a one-world government aided by technological developments.

While these claims may at best be considered crankery, is it possible that such an establishment, working in secrecy, could have tapped into technological advances that would eventually lead to the invention of saucer-shaped craft? After all, as early as the 1930's, France's Marcel Pages allegedly achieved antigravitation through the use of static electricity. A mica disc was suspended between the poles of a powerful electrostatic device, spinning and issuing a buzzing sound similar to that of a swarm of bees (a sound often reported in UFO cases).

As we venture into this increasingly uncertain territory, certain objects come across our path to confuse us even further. One such item is the blurry black and white photo of a pair of "antigravity powered" vehicles featured in David Hatcher Childress' compelling *Antigravity and the Unified Field*. The disturbing image portrays craft resembling a hybrid of Robur the Conqueror's airship and zeppelins, with outlandish accesories. There is nothing remotely

alien about these UFOs (provided the photo is real) as they fly low over the rippling dunes of India's Thar Desert. Hanging from the blimplike structures is a three-tiered structure resembling an overweight electrical high-voltage bushing; a strange mist or smoke emanates from one such bushing in one of the craft.

Experts who have seen this photograph, while unable to attest to its authenticity, have observed that if real, it depicts a vertical-lift antigravitational device which for some reason or another (radioactivity or excessive heat) must be kept outside the fuselage. Although the outlandish vehicles resemble dirigibles, there is no reason to belive that a blimp could provide sufficient lift to hoist the bushing-like device; nor are there any rudders with which to steer the vehicles.

Spanish author Alberto Borrás opines that if the devices shown in the Thar Desert image are not a hoax, they could be bona fide proof of antigravitational craft belonging to some Asian government, "originating from secret bases belonging to the Great White Brotherhood or another hidden organization." If the photo is a fake, Borrás adds, it could merely be a trick devised by the Indian or Pakistani government to frighten the other into believing that its side posesses "wonder weapons." In the light of the 1998 nuclear crisis between both countries, we can only adopt a wait-and-see attitude in this respect.

Jacques Bergier's Secret Societies

French author and scientist Jacques Bergier—who along with his counterpart Louis Pawels revolutionized occult thinking in the late '60s with their landmark *Morning of the Magicians*—received brickbats from other writers and researchers due to his freewheeling, conspiracy-laden output. Bergier, who had belonged to the French Resistance during World War II, knew a bit more about keeping secrets than most (even under torture) and was puzzled by the existence of secret societies operating in our midst.

In his other books (*The Secret War of the Occult, Passport To Another Earth*) Bergier posited the theory that a group of humans with extraordinarily high intelligence quotients may have formed a society of their own, communicating with their membership through messages that would be intelligible only to themselves, or perhaps to the mysterious classified ads which sometimes appear in the world's newspapers.

As if Bergier's suggestion wasn't already sufficiently upsetting to the ears of Establishment occultists (an apparent contradiction in terms), he carries this speculative exercise even further by saying that there may be those among us who have achieved the condition of Immortality, perhaps through alchemical discoveries or other secret means. [See interview with parasychologist Dean Radin in issue #8 for more on this.] These Immortals would find it necessary to keep a low profile and disappear from sight every generation—constantly on the move to avoid arousing suspicion in mortals—and would have perhaps formed the kind of secret society which could have created the technological marvels we have come to know as flying saucers, UFOs, etc.

The dubious gift of immortality would, in Bergier's paradigm, answer all the questions that ordinarily crop up when the "secret cabal of scientists" answer to the UFO enigma comes up: their alchemical prowess could be

turned into the development of new inventions which could be sold the public of the time in which they happened to live, or they could simply acquire wealth through the transmutation of raw elements into jewels and precious metals (the uses alchemy has traditionally been associated with).

The reader's head is surely spinning by now, but Bergier isn't through theorizing just yet—he goes on to express how he believes that this secret brotherhood of initiates or geniuses would be the likeliest candidate for contact by extraterrestrial or interdimensional intelligences. Pooling their own resources with this influx of "imported" knowledge would make them virtually omnipotent and capable of executing feats like teleportation, bilocation and other paranormal exploits which have been associated with the occult.

The horsefly in this ointment would be the fact that their intelligence and contacts notwithstanding, these secret scientists would still need contractors—and many of them—to build undeground bases or facilities in the unaccessible places always associated with UFOs. The earthmoving operations alone would give away any such efforts by the cabal. The only possibility would be that the genius cabal already controls one or more world governments and can make free use of their resources—a possibility suggested in conspiracy literature.

The Dark Side

In 1982, a strange little book appeared in French bookstores. Its title: *The Book of Secret Companions: The Secret Teachings of General De Gaulle*. Authored by Martin Couderc, it purported to reveal the existence of a secret society known as the "Order of the 45" which was reputedly established by soldier/statesman Charles De Gaulle. A sequel appeared some time later, dealing with mind-numbing revelations about the author's struggle in Canada against the group of hidden controllers now calling itself the Black Order, and which according to Couderc, had relocated itself to remote Tierra del Fuego on the southernmost tip of South America.

While it is tempting to dismiss these tracts as nonsense, Couderc persuades his reader to believe that he draws his "forbidden" knowledge from epistolary sources, namely a series of letters left behind by De Gaulle himself exhorting members of the "Order of the 45" to fight for the restoration of France's greatness. This effort is associated with the coming of power of a "great king" prophesied by Nostradamus in his *Centuries*. The Black Order seeks to create a one-world government (another conspiracy chestnut) by instating this "great king" by means involving ritual magic and hidden technology.

How to Talk with Your Eyes

Book Review:
Leah A. Haley and Lisa Dusenberry's
Ceto's New Friends

Reviewed by Robert Sterling

Usually a masterpiece is premeditated. *Sgt. Pepper, Citizen Kane, The Great Gatsby*, all done by artists with the intentions to become the cultural landmarks they now are. Sometimes, however, a masterpiece is quite accidental, as though, somewhere along the way, those involved with its creation hit a well of energy which is greater than they ever realized they could tap. Did Dennis Hopper and Peter Fonda, for example, realize they were rewriting the rules of cinema when they made *Easy Rider* completely wacked on drugs? Did NWA know they were changing the face of music when they recorded *Straight Outta Compton*? Some may bristle at the claim that *Ceto's New Friends* is a masterpiece, but for the money, it is the most delicious of children's books, one that-like any Dr. Seuss work-becomes more and more entertaining the older the reader gets. There is a subversive flavor to *Ceto*, (though it may be unintentional, as much of this book's genius appears.) Little surprise here, as children's literature has long been the home of the anarchic spirit: while most social historians point to drugs, rock 'n roll or Vietnam as the inspiration for the sixties rebellion, the seeds were probably really planted when one little boy resisted Sam-I-Am's plea to eat green eggs and ham. (Sure, eventually he pussed out, but the bottom line is he at least made it a struggle.) Indeed, there has been so much promotion of anti-authoritarianism in popular kiddie books, you'd expect John Birchers to be proclaiming it part of some nefarious Communist plot. If they want to see real diabolical plotting, however, the Birchers should open "Ceto" and take a look.

The story in "Ceto" is quite simple: one day, Ceto, a large-headed alien grey, comes down to Earth and meets Annie and Seth (two children whose large, saucer-shaped eyes border upon something from a Keane painting.) After playing with the two tikes for awhile, he asks them to come with him to his spaceship. They agree, and soon participate in tests and games, even learning from Ceto how

By Leah A. Haley, Illustrated by Lisa Dusenberry
1994 Greenleaf Publications, Hardcover—30 pages
Out of print (but try Arcturus Books or Alibris.com)

to "talk with their eyes." Ceto then brings them back home, and he gives them a purple rock as a going away gift. He waves and leaves, but, as the story ends on a positive note, "Ceto will come back soon to visit his new friends on Earth." And so, the entire abduction phenomenon is reduced to a cute, harmless, innocent meeting between two cultures. Punching colored buttons and watching wavy lines are as deep as the alien testing goes. No anal probes, no sticking of large needles to implant tracking chips are mentioned. Indeed, what makes this book so creepily entertaining is what is not said, what is merely implied. Somehow, hidden behind the smiling mask of Ceto's face, one can't help but see the vicious machinations of a predator, luring little children to engage in deeper and darker perversions. His benevolent facade appears to be nothing more than a charade: all he seems interested in is getting the two kids alone in his spaceship so he can really get down to business. The chicken hawk aspects of Ceto are so evident, a subtitle for this book might be *Michael Jackson's Guidebook to Getting Laid*. (Of course, "Ceto" isn't the first work to subliminally link alien-children contact to pedophilia: in Steven Spielberg's *E.T.* - about a alien who lives in a little boy's closet, a secret that they can't share with any adults-the moment when E.T. and Elliott first have a psychic link, Elliot's heartrate jumps up, and he drops a carton of milk, which spurts out slowly on the ground as the container throbs.) Also unmentioned is the idea that some "alien abductions" are not a paranormal phenomenon but rather CIA-military mind control operations. The idea, best presented by Martin Cannon in his samizdat classic *The Controllers* (and also persuasively argued by writers ranging from Jacques Vallee to Alex Constantine), has even crossed to the mainstream via *The X-Files*. That such theories are unexplored, and there is a white-washing of the whole abduction experience, is part of the whole "Ceto" package may lead some conspiracy theorists to shout "CIA PROPAGANDA!!" faster than Pete Sampras rushes the net at Wimbledon.

As nice as it would be to imagine that "Ceto" is part of some fascist disinformation program, the truth appears more benign. The author, Leah A. Haley, claims to be an abductee herself, trying to come to grips with her bizarre experiences. That being the case, *Ceto's New Friends* may amount to little more than a sort of therapy for Ms. Haley, an exorcism of personal psychic demons. The product is pleasing, and we can only hope that Ms. Haley will continue to mine this well hidden place in her soul.

Lustful Exploits with Scale-skinned Lizard Lovers

Music Review: *Experiencer*

Reviewed by Robert Sterling

The Intergalactic Diva
EXPERIENCER

Jazz singer Pamela "The Intergalactic Diva" Stonebrooke isn't particularly unique for having claimed to have sex with lizard aliens. What makes her story special is that she seems to have really enjoyed it. I mean really, really, really, REALLY enjoyed it. What manages to turn her autobiographical tale of getting screwed by well-hung reptilian stud-muffins into more than a very entertaining piece of modern folklore for the Art Bell crowd is the sincerity of her reportage, as well as her ability to tie her paranormal experiences into mind-bending speculations of metaphysical reality. While skeptics may sneer that she is either delusional or a huckster with a gimmick, my acquaintance with her has left me convinced that neither is the case. While judging sanity in a deranged society like ours is practically worthless, she functions as well as anyone does in the modern viper's pit of civilization. As for self-promotion, Pamela has actually been personally hit in the pocket by her admission of parasexual exploits, having a successful career as a backup singer hampered by her revelations. Even worse, Pamela has been attacked by fellow abductees, many who cringe at her politically incorrect utterance that sex with aliens may actually be a blast.

Rather than crawl into a hole, Pamela has continued her singing career. Along the way, she has produced a remarkable work: *Experiencer*, a concept album worthy of Pink Floyd, about her lustful exploits in the sack with scale-skinned lizard lovers. Echoing her inspiration Billie Holliday, her sound would be worthy to play without the alien-love hook. With it, it is a dazzling display of both sonic punch and thematic intrigue. As fun as the album is, even more pleasurable is seeing Pamela perform live, which she did in Los Angeles on May Day, 1999. On stage at the Hollywood Cinegrill in front of a packed house, she slinked through a set combining her own artistic works and reinterpretations of classic standards ranging from Cole Porter to Miles Davis. Along the way,

Experiencer By Pamela Stonebrooke
Higher Self Records P.O. Box 1552 Hollywood, CA 90078-1552 • CD/Cassette $15.00

Pamela mesmerized the crowd both with her personal charm and stunning statuesque presence. Indeed, seeing her in the spotlight, the short-tressed platinum blonde made it quite understandable why so many reptoids have such a boner for her. Not content to just boil men's blood with her comeliness, Pamela uses her time wisely, often to elaborate on her views of reality and what her alien encounters actually mean. Is she being visited by aliens from another galaxy? Or perhaps interdimensional beings who access certain people as psychic gateways? Maybe it is earth spirits, mythological thought-forms animated by the human will? Or what if it is just her future descendants, returning in time to clue their ancestor on the shape of things to come? Pamela hints that the correct answer may be E for all of the above. Whatever the truth may be, she, like so many, is still searching for it, and hopefully through her music she will continue to expound upon her journey.

New and Improved
Excluded Middle
Reading List

Top 40...In No Particular Order

1. *Majestic* (Whitley Strieber) *

2. *The CIA and the Cult Of Intelligence* (Victor Marchetti and John Marks) *

3. *Out There* (Howard Blum)

4. *The Facts Are...A Guide To Falsehood and Propaganda in the Press and Radio* (George Seldes) *

5. *Operation Trojan Horse* (John Keel) *

6. *Messengers of Deception* (Jacques Vallee) *

7. *Blank Check: The Pentagon's Black Budget* (Tim Weiner)

8. *The Rebirth of Pan* (Jim Brandon) *

9. *Margins of Reality* (Robert Jahn & Brenda Dunne)

10. *The New Inquisition* (Robert Anton Wilson)

11. *Mind Trek* (Joseph McMoneagle)

12. *The Book of Lies* (Aliester Crowley)

13. *Angels and Aliens* (Keith Thompson)

14. *Unconventional Flying Objects* (Paul Hill)

15. *The Gods Have Landed* (James R. Lewis, editor)

16. *Deep Politics and the Death of JFK* (Peter Dale Scott)

17. *The Conscious Universe* (Dean Radin)

18. *L. Ron Hubbard: Messiah or Madman?* (Bent Corydon and L. Ron Hubbard Jr.) *

19. *They Knew Too Much About Flying Saucers* (Gray Barker)

20. *Neuropolitique* (Timothy Leary)

21. *Conspiracies, Coverups, and Crimes* (Jonathan Vankin)

22. *The Complete Books of Charles Fort*

23. Son of the Sun (Orfeo Angelucci)

24. *Symbolic Messages* (Mario Pazzaglini)*

25. *The Gods Of Eden* (William Bramley)*

26. *Taken* (Karla Turner)*

27. *Visionaries, Mystics, and Contactees* (Salvador Freixedo)

28. *Sex and Rockets: The Occult World of Jack Parsons* (John Carter)

29. *The Octopus: Secret Government and the Death Of Danny Casolaro* (Kenn Thomas and Jim Keith)

30. *Cyberbiological Studies of The Imaginal Component in the UFO Contact Experience* (Archaeus Project, Dennis Stillings, ed.)*

31. *Mind Reach* (Russell Targ and Hal Puthoff)*

32. *Beyond Telepathy* (Andrija Puharich)*

33. *Extraordinary Popular Delusions and the Madness of Crowds* (Charles Mackay)

34. *The Omega Project* (Kenneth Ring)

35. *The Final Choice* (Michael Grosso)

36. *Mysterious America* (Loren Coleman)

37. *On the Trail of the Assassins* (Jim Garrison)

38. *The UFO Encyclopedia* (Jerome Clark)

39. *Contact With Space* (Wilhelm Reich)*

40. *The Middle Pillar* (Israel Regardie)

*Out of print

Virtual *issue*

Editorial

With the preponderance of "virtual" everything at our fingertips (and shoved everywhere else we don't need it) it should come as no surprise that *The Excluded Middle* now shoves this collection of rare and never-to-be reproduced articles in your face. These will never appear in the magazine, or probably anywhere else. Peter Stenshoel provides us with an examination of the "laughter curtain" which surrounds many subjects fortean and paranormal (which just means that we don't have an explanation for some things—yet.) Adam Gorightly, fresh from finishing his newest book, (*The Shadow Over Santa Susanna: Black Magic, Mind Control, and the Manson Family Mythos*) presents a story that sounds too weird and good to be true: A major league baseball game pitched entirely under the influence of LSD. We love contactees and kooks, and Acharya S. offers us a report on one of the most current breed. PARANOIA editor and author Joan D'Arc graces our pages with a piece on Remote Viewing, mind-control and cybernetics as used to modify humans for long-term space travel. The recently ubiquitous Ira Einhorn submits a preview of one of his as-yet unpublished works.

This really has been eight years of graduate work, and our readers now share with us a doctorate in fringe culture. Don't buy anything on faith alone, or from only one source.

...unless it's from *The Excluded Middle* of course.

–Greg Bishop

Laughter Curtains

Viewpoint by Peter Stenshoel

In general, the idea is, if you can make a person into an object of comedy, it matters little what their message is.

During the infamous Cold War spanning the 1950s through the 1980s, those willing to cross the Iron Curtain, by, say, penetrating the Berlin Wall, were considered heroes. Today there is a curtain whose negative value is incalculable, yet there are no publicly acknowledged heroes making the valiant cross. It is the Laughter Curtain, a fabric liminal symbol christened in the late 1980s, dedicated to keeping out as many people as possible from researching the radius of reality. Supposedly the agencies who have mastered the technique of ridicule against consciousness explorers have kept this dense cloth in place through deft use of social and institutional structures. While there is no doubt truth in such an assertion, I believe there are far more reasons for laughter curtains than CIA-NSA-FBI-USAF duck-and-cover soups.

In general, the idea is, if you can make a person into an object of comedy, it matters little what their message is. Of course, in the case of Fulton's Folly, the message of the Steam Age eventually vindicated Fulton. Laughter Curtains are notoriously of the moment. And a great many of the laughers are motivated by a nobility based on the schoolboy's loyalty to the cause of (t)ruth as learned in school. Hence, long-term vision is not necessarily one of the threads comprising the curtain. A perverse laughter, serving disinformational purposes, as is alleged to be the reason Donald Menzel wrote his UFOs-explained books, can also be based on a short-sighted ethics; a polity based on cultural extrapolative models. Such "pragmatic" models are almost surely likely to miss a few telling holes in the curtain, such as the popularity of offbeat genius; say *The Prisoner, Fantastic Four, X-Men, X-Files*, which inform the entire epistemological underpinnings of three generations. (Comics and television have so long been neglected as true cultural influences, one wonders if the Harvard and M.I.T. boys didn't see such trends of sober credibility coming; or, on the other hand, did they orchestrate them?)

In a further line of inquiry, what is unveiled is something closer to home; namely, the ego in search of protection. Every spiritual tradition seems

to involve secrecy as a component: the confession booths of Roman Catholicism; the Holy of Holies of Judaism, the Hindu Mantra to be known only by the aspirant; the nature of the very visions of unnumbered percipients in search of God; all secret or hidden from view.

In the same way, the higher self, in contradistinction from the ego, will not give away any more than it is allowed to do through the ego's surrender. From the higher self's perspective, it has an eternity to reveal itself. There is no reason to do so before the time is ripe. It boils down to a rather strict mathematical formula: causal forces seeking level ground as the consciousness opens to its wider terrain. The laughter or ridicule a human wields against his own intuitive and higher-placed spiritual aspirations could be expensive beyond belief. As long as laughs prevail, potential remains untapped, the fuel of investigation leaks from our vehicles with each guffaw, and we go nowhere fast, or, worse, slip solipsistically back into slime.

Of course I use the word "laughter" here as a catchall for the derisive variety. A sense of humor is not only a good thing; it is essential in learning to know your Self without sinking into delusive morasses of pomposity. But I speak of that nervous twitter which seems compelled to emerge whenever the concrete of reality threatens to undo itself.

I include within "nervouse twitters," all the band names which seem bent on embracing an image of evil-doing, low-living, and social disorder. Movies and other cult activities can work the same way. These supposedly rebellious appelations are in some cases strident attempts to prevent their authors to accidentally slip upward into greater understanding. To do so would seem slow death to the negative ego, and its monkey mind scrambles enticeingly to make us think we prefer hip doses of debauch and decadence to the clarity of pure spirit at the source. It's a kind of joke, to be sure, but one with a high price tag.

There is likely within the clockwork process, the "rather strict mathematical formula" mentioned above, a built-in maxim: The Self Will Not Emerge Prematurely. It is here that we begin to see laughter curtains as creations of genius. These curtains are warped and woofed with the fabric of illusion. They are one variety of the Veils of Maya. You yourself have likely made good use of this curtain in the course of your investigations. Eventually, you will see lots of laughter where none seems warranted. That means you've just enlarged your reality.

Those knee-slapping fellers addicted to a model of reality as meaningless attachments of atoms have the hardest row to hoe. For if no process is apparent, all clues to such evolution will appear as worthless trash. And if friends and colleagues of like mind reinforce the worthlessness of conscious evolution (while paradoxically worshipping biological evolution and survival of the fittest as sacrosanct scientific dogma of the highest order), you will remain near clueless until such time you make herculean effort to refute your friends and teachers and colleagues, and suffer derisive laughter now aimed at you.

In what ways are militant debunkers good for the study of anomalies and evolution of consciousness? Well, first, they provide an ontological balance against the true believers and hyper-credulous, those who would love to see

California drop into the sea, and Denver become the new west coast. They are a necessary polarity, without which there would be no bar to rise above, nor "square one" to return to.

In a way, such mockers are like the fierce guard dogs on either side of a Japanese Buddhist temple. They keep out the spirits of evil intent. If I know that by entering a room I have to run a gauntlet of smirks and jollities of my peers, I'd sure as hell better know where I'm going and why. And once safely ensconced inside a blissful, altered, state of enlightenment, the distant hilarity of ill-informed souls stings not; it just seems mildly incongruous, like a bowler hat worn backwards: many won't notice the difference.

To sum, all of reality is veiled. We don't ultimately know God's purpose or methods. We fight like cats and dogs over God's name, God's loyalties, God's sex, and God's existence. Denying God, we confront the mystery of ourselves, and the curtain looms large as ever. The divine playfulness, or *lila*, resounds of laughter, gently mocking, and loving: loving itself, loving us, loving the process. Thus, the final laughter curtain, the "last laugher," is God.

If God him/herself has taken on the gig of knowing/not knowing, we can learn to playfully take the laughter lighter, to allow even the archest laughers their little jibes and giggles, remembering their smirks serve them until *they* become those giggled at. And in the midst of eternal hubbub, God is laughing loudest.

[Curtain.]

A Trip to the Mound with Dock Ellis

Adam Gorightly

When Pittsburgh Pirate pitcher Dock Ellis orally ingested an LSD sugar cube on June 12, 1970, little did he know that later that very same evening he would accomplish one of the greatest achievements in the history of professional sports. Around noon Dock dropped the acid in question, and was just starting to come on to it, when his girlfriend and fellow tripper noticed in the newspaper that he was scheduled to pitch that night. Oooopppps!

The game was in San Diego, a twi-night doubleheader, with a scheduled starting time of 6:05 p.m. Dock—who was in sunny LA—had his girlfriend drive him to LAX where he caught a 3:30 flight, arriving in San Diego at 4:30. An hour and half later, when Dock took his place upon the mound—in a situation where he'd found himself on numerous other occasions—he felt like alien visitor to a somewhat familiar planet. He had just begun to peak, and an overwhelming sense of euphoria overtook him. Had the robotic function of throwing a ball over and over again not become habit to Dock over the years, he no doubt would have had a hard time functioning in this intense environment of athletic competition. But as he'd practiced these repetitive movements countless times before, Dock simply put his body on auto-pilot, focused his illuminated mind on it's target-the catchers glove-and let destiny take it's cosmic course.

The ball—on that historic day—was a blazing multicolored meteorite fired from Dock's nimble fingers with amazing velocity, leaving a spiraling trail of shimmering shards in it's passage. The catcher's mitt was a huge mellifluous magnet sucking the stitched orb telekenetically into it's leather padding like a luminous egg returning again and again to the womb. The batters, with their bulbous, blubbery arms, wallowed futilely, swatting nothing more than the intoxicated air, as they waved with great force their Louisville Sluggers, leaving in their swings slow-motion rainbow-hued trails that hung momentarily in the heavy air before dissipating into gradual nothingness. The intense green grass rolled in hazy waves & the crowd was a multiple million eyed monster roaring in unison with itself,

Dock...felt like alien visitor to a somewhat familiar planet. He had just begun to peak, and an overwhelming sense of euphoria overtook him.

cheering maniacally, as the Pirate pitcher repeatedly hurled the magic sphere adroitly across home plate, unhittable.

The sun burned that immortal day with brilliant intensity; or so it seemed to Dock, who flipped down his shades to not only somewhat dim it's blinding rays, but to as well conceal his overly dilated pupils from any curious onlookers. Between innings—as he sat, blazing in the dugout-Dock closed his eyelids to discover naked dancing mermaids there washed ashore on steamy sands of satin and liquid lace. With shades over eyes he sat serenely silent by himself, swimming through an ocean of ONEness with the Universe, then landing on the sands to embrace the naked mermaids of his musing mind, and fondle their fins, receiving a fellatio fantasy. His other teammates—aware that Dock was on his way to pitching a no-no—said nary a word to him, which was of course a baseball superstition/tradition; to leave alone a pitcher in the process of hurling a no-hitter, lest they jinx him into giving up a hit and losing the magic, which was just as well with Dock, 'cause he didn't feel like conversing to anyone anyhow; when he opened his eyes he was too busy watching the molecular fractal patterns fluctuate in the air.

Although one of the more accurate pitchers of his era, Dock's pitching control this monumental day—like his view of reality—was severely skewed. He unintentionally beaned two batters and walked a total of eight. But amazingly Dock remained unscathed, with not one run recorded against he and his powerful Pirates, though the bases were loaded (as was Dock!) several times during the course of the ball game. When all was said and done, Dock recorded a no-hitter. His first and last. Obviously this would've never happened had he not fucked up and dropped the acid unaware that a few hours later he would find himself on the mound before thousands, pitching in an altered state of mind.

This has been another memorable moment in stoned sports history.

The Biological and the Silicon: Modifying Humans for Space Travel

Joan d'Arc

Certain agencies of the U.S. government—the "military-industrial complex"—may have secretly combined classified research in remote viewing, psychotronics, cybernetics, computer engineering, and possibly genetic engineering, to create a human modified for deep space travel. We will outline the developments and goals stated over the years in each of these areas to conclude that in all probability the human MIND is the necessary ingredient to indefinite survival of the species in outer space. Since the human being cannot survive G-Forces and radiation in outer space, it is necessary to combine mind and technology in order to go the limit and reach the stars.

Civilian researchers and policy makers have been kept out of the loop in this type of research, and this has been condoned up to high levels of government since 1959. ...the field of civilian psychic research has been effectively starved out of operation.

Remote Viewing

Remote viewing was the subject of a series of CIA and military funded psychic studies from 1973 to 1983 at a think tank in California called Stanford Research Institute (not affiliated with Stanford U.). These studies attempted to test, under scientific protocols, whether the human mind could be two places at once. This is also referred to as bi-location. Several government agencies contracted studies at SRI, including the Army, Navy, NASA, the CIA and military intelligence. Many of these studies are still classified. A 1973 NASA report concluded that some remote viewers could be remarkably accurate. The title of this NASA remote viewing study was: "Development of Techniques to Enhance Man/Machine Communications." (SRI Project #2613, NASA contract #953653, NAS7-1000)

Those of you who have trouble understanding that years and years of psychic studies as well as physics research has established the reality of human psychic abilities have some homework to do. In a 1973 article by E. Stanton Maxey entitled "The Subject and His Environment." Maxey wrote that consciousness may be called man's "sixth sense." Maxey wrote that man is the only creature on Earth who is aware of the fact that he is aware. He stated, "dreams and out-of-body experiences demonstrate the mobility of the "I" of

man separate from the physical body and often into a foreign time dimension." Maxey wondered, "when man is the receiver of provable meaningful information, who is doing the sending?" Maxey wrote:

Man may be defined as a complexity of subatomic fields, within atomic fields, within cellular fields which make up organismal fields; these in turn exist within gravity fields, magnetic fields, electrostatic fields and light fields. Cognitive man of seven senses is dependent upon all of them. Under special circumstances, in dreams, meditations or out-of-body experiences, the "I" of man functions independently of physical being and time. Because man receives meaningful information in such states, we ponder on the origin of such information.

Maxey wondered whether the fluctuations of magnetic and electrostatic fields on Earth indicate a "planetary consciousness?" ("The Subject and His Environment," First International Congress on Psychotronic Research, Prague, 1973)

The Physics Connection

Post-Quantum physicist Jack Sarfatti spent time in the 1970s at the Esalen Institute, a deep cover resort frequented by UFO lounge lizards, psychiatrists, psychologists, physicists, LSD gurus and others of the "human potential" ilk. He also claims he was visited by two men from Sandia Corporation as a child in the 1950s. He later received a full scholarship to Cornell at age 17, and studied under the major figures in the Manhattan Project at Los Alamos. Sarfatti's physics suggests that Einstein's nonlocal connection can be used for communication. The idea of nonlocal communication involves receipt of telepathic messages from other times or other worlds.

As a child, Sarfatti claims, he received a mysterious phone call claiming to be the voice of a conscious computer aboard a spacecraft. The machine-like voice stated it was located on a spaceship from the future. Jack has recently verified in an e-mail that this occurred in the summer of 1953. Sarfatti's mother has verified that Jack received several of these mysterious phone calls over a span of three weeks at the age of 13. She claims that after these long phone calls, Jack "was walking around glassy-eyed in a daze." She claims she picked up the phone one time and heard the metallic voice, which "said it was a computer on a spaceship and to put Jack back on the telephone." She shouted to leave her son alone and hung up. That was the last call Jack received, however, Jack only recalls receiving one phone call.

As Jack tells it, this distant "cold metallic voice" identified him as "one of 400 bright receptive minds." He was told if he said "yes," he would "begin to link up with the others in twenty years." He said yes. Twenty years later, Sarfatti claims, he was invited to SRI and spent a seventeen hour day there in the summer of 1973. This would put him smack dab in the middle of the SRI remote viewing experiments. He claims he met ex-astronaut Edgar Mitchell there. He notes that Mitchell's "think tank," Institute for Noetic Sciences, was funding the SRI project at the time. Mitchell claimed he took part in telepathy experiments while in outer space.

Notably, Sarfatti states: "the relevance of the 1953 experience was trig-

Open and honest disclosure of the ET presence would expose what Greer calls 'the greatest scandal in recorded history.' In this sense, ET is not only the province of 'ufology.' ET is the province of existentialism and anarchy.

gered in my session with Brendan O'Regan at SRI," but the actual memory of his 1953 experience is still very vivid and has not changed. Sarfatti also notes, with regard to his bizarre 1953 phone call, "Brendan said, 'Oh yes, I have seen data on several hundred incidents of that kind.'" Sarfatti has also stated, "I was then simply a young inexperienced naive 'useful idiot' in a very sophisticated and successful covert psy-war operation." Incidentally, Sarfatti doubts that some Army scientists in 1953 could have planned a twenty year deep cover operation like this; that is, unless time travel was involved. Sarfatti has been involved in the study of time travel and suggests that the UFO is future humanity looping back on itself. His physics research has been focused on the concept of the "time loop."

Marcel Vogel and Human/Plant Telepathy

On the surface, many years of these types of studies, paid for by the intelligence agencies, focused on how the mind works, but the still classified portion of this research focused on how to harness and control human psychic potential by pairing it with psychotronic machines. Psychotronics is the study of interactions between man and objects, both animate and inanimate. According to a list of patents held by various persons, research in this area has been ongoing, and includes the work of Marcel Vogel, who worked for 27 years as IBM's chief engineer. Marcel Vogel pioneered the use of crystals as a novel form of information storage. Vogel's patents for psychotronic machines use crystals as an interface with consciousness. (see www.vogelcrystals.com) Vogel also discovered an energy he called the information band which he described as an energetic communication band between all living and "non-living" substances.

This energy, also called Chi or the Fifth Force, appears to be the energy recognized in paranormal abilities. In 1988, electrical engineer Laurence Beynam described this Fifth Force in *Psychic Warfare: Fact or Fiction?*. He wrote that:

> There is an energy in living organisms that is weak and unpredictable, but it can be refracted, polarized, focused and combined with other energies. It sometimes has effects similar to magnetism, electricity, heat and luminous radiation, but it is none of these. Attempts to control and employ the energy have met with little success; investigators have not yet defined the laws governing its operation.

It is likely that as of this writing in the year 2000, the laws governing the operation of this energy have been well defined, and its ability to be focused and combined with other energies has likely been well researched. Preliminary work in this area was performed by Marcel Vogel for IBM.

In the late 1960s and early 1970s, both Cleve Backster and Marcel Vogel independently studied telepathic communications between humans and plants. Cleve Backster is the inventor of the E-Meter, which is still in use by Scientology. The E-meter is an emotion detector. Both of these scientists discovered that emotions (or thoughts) have a frequency and an amplitude. Thoughts have their own vibratory rate or signature and this lost occult science is the key to psychotronics.

Vogel discovered that when he held a thought in mind while pulsing his breath through his nostrils, philodendron plants responded dramatically. Vogel's experiments suggested that these human bio-energetic fields were linked to the action of both breath and thought. Vogel stated that the distant projection

Computer scientist Hans Moravec claims, "One way to avoid the biological threat is to become non-biological." This mad scientist has also stated, "The evolution of our descendants will push them into entirely different realms. They will become something else entirely. I don't know why you are disturbed by that."

The Psychotronics/ Cybernetics Time Line

1947: It all starts with the crash of a flying saucer at Roswell, New Mexico; the day the Earth changed forever.

1961: The pieces of the "Roswell File" finally come to Army Col. Philip Corso in 1961, who claims he eventually "farmed" them to various companies for "back engineering." (See, *The Day After Roswell*)

1963: A top NASA official reaffirms reports that telepathy research was a "top priority" in the Soviet space program.

1960s: The CIA undertakes experimental "guided animal" research, in order to investigate whether it can make robots out of dolphins, dogs, cats and other animals.

1960s: NASA maps the electromagnetic grid of the Earth and the astronauts, perhaps unwittingly, become part of space telepathy experiments.

1960s-80s: The MKULTRA (and various subprojects) mind control program is in full swing, including LSD experiments, "sleep/dream" studies, telepathy/remote viewing experiments, and Monarch trauma-based conditioning performed on children.

Early 1970s: Patrick Flanagan cracks the neural code for audio data allowing for direct communication between a crystalline electrical circuit and the brain's nervous system. DARPA successfully programs computers to recognize human brainwave patterns.

1970s: Sagan and others admit that a deficiency in present-day computer technology is what prevents us from exploring the galaxy.

1970s: John von Neumann's brainstorm is born: a "theoretical" computer with self-replication and construction abilities, or what is referred to as a "self-reproducing universal constructor."

1970: Rumor has it that certain military personnel volunteered their own bodies to science and became cyborgs.

of thought forms using the "pulsed breath" had been accomplished with a distance of up to 110 miles between plant and person.

In 1973, both Backster and Vogel reported their successful findings in human/plant telepathy to a worldwide meeting of the First International Congress on Psychotronics in Prague. Later, when Vogel retired from IBM after 27 years, IBM and Stanford Research Institute donated equipment to his new company, Psychic Research, Inc., which aimed to show the ultimate compatibility of science and metaphysics. Vogel went on to study subtle energies and forces which emanated from the human body, and attempted to identify and quantify these energies. He was also interested in the therapeutic application of crystals and crystal devices, using stored energies to heal the human body. Vogel had a radionics machine called the Omega-5, which utilized the psychic power of the human mind, and detected fields undetectable by standard scientific devices. It is likely the secret government was quite interested in these findings as well.

Cybernetics and Von Neumann Probes

Back in the 1960s, cybernetics people had proposed the development of computers that would "create" and would possess intuition. A von Neumann (vN) probe is physicist John von Neumann's theoretical computer with self-replication and construction abilities. A vN probe has also been referred to as a "self-reproducing universal constructor." A vN probe is a computerized machine capable of making any device, given the construction materials and a construction program. If we think about it a minute, a human being is a self-replicating universal constructor designed to live on the face of the Earth. So a von Neumann probe is a human computer or an artificial intelligence that can both duplicate itself and create other artifacts. A UFO could essentially be a vN probe, sent out to scope out the universe and to collect samples of the life forms it finds, and to duplicate them in other sections of the galaxy in order to optimize the survival of those forms. Perhaps the best way to describe a vN probe is Hal 2000 from Kubrick's movie *2001*. It's essentially a conscious computer aboard a spacecraft.

At a 1973 gathering of "psychotronics" people in Prague, it was stated that one of the future goals of computer technology was to create a generation of computers capable of creating technological artifacts. It was also proposed at this international meeting that cybernetics people and psychotronics people should work together to develop this future computer technology. It was also stated that psychic abilities were genetically based, and that studies were underway to locate the gene for psychic abilities in humans. Jeno Miklos of Romania presented a paper entitled "A Genetic Hypothesis for Parapsychology: Postulating Psi-Genes" which proposed that we would eventually locate the gene for psi abilities, which may in turn give rise to a discipline labeled "psi-genetics." Miklos hoped that in the future "one day we might speak of the molecular biology of psi." We can lay-awake assured that the genetics for psychic ability has been successfully mapped. (Proceedings of the First International Congress on Psychotronics)

As Zdenek Rejdak also stated at this world gathering of psychotronic

gurus, one of the future goals of computer technology was to create a generation of computers capable of creating technological artifacts. This is directly connected to the idea of the vN probe and to modifying humans for space travel. In his paper entitled "Psychotronics Reveals New Possibilities for Cybernetics," Rejdak revealed the following:

> Theoretical cyberneticians are proposing at present the construction of computers that would 'create' and would possess at least a degree of intuition. ... Psychotronics has a great opportunity to provide much essential knowledge about these processes, and thereby to help cybernetics in solving one of the most complicated tasks, that of teaching computers to create. ... The point is not merely to build more perfect computers, but primarily computers with qualitatively new functions. Work is now underway on a fourth generation of computers, and a fifth generation is being planned. Therefore, it is very timely for cybernetics to include in its studies also the results of work and research in psychotronics. This will not be easy, because psychotronics has its own specifics, and these could easily be passed over in superficial applications. Yet we believe that psychotronics is able already to offer cybernetics fruitful models.

Another paper presented at this meeting provides a concise tie-in between radionics devices, telepathy and cybernetics. In a paper entitled "The Enigmatic Status of Radionics in the U.S.," researcher Frances K. Farrelly wrote regarding radionics machines that "their use, regardless of model, involves a factor of consciousness as does any form of radiesthesia." This author also wrote the following:

> It is my sincere desire that this enigma of radionics be studied by those well qualified investigators in the field of applied cybernetics, parapsychology, and psychotronics. Radionics appear to have much in common with the phenomena of dowsing, and/or telepathy, and it rightfully belongs to those scientific investigators in both hemispheres to pursue this research further.

Following this history-making conference, an article entitled "Mind Reading Computer" appeared in *Time* magazine's 7/1/74 issue. This computer program, developed at none other than Stanford Research Institute by Lawrence Pinneo, could read thoughts by interpreting the EEG patterns that correspond to certain words. Similar work was done by Donald York and Thomas Jensen at the University of Missouri, and also by Richard Clark at Flinders University in Australia.

Related to this development, Patrick Flanagan invented a hearing device in the early 1970s called the Neurophone, which cracked the neural code for audio data allowing for direct communication between a crystalline electrical circuit and the brain's nervous system. When coordinated with research carried out by DARPA in programming computers to recognize human brainwave patterns, this research established direct linkage communication and understanding between man and computer, and other electronic machines.

Scientist Carl Sagan and others admitted in the 1970s that a deficiency in present-day computer technology, not rocket technology, is what prevents us from exploring the galaxy. Secret developments in mind-machine psychic interface, which includes classified research in the areas of psychotronics, cybernetics, computer engineering and genetic engineering have in all probability solved this problem. At that time, it was stated that the discipline of psychotronics could provide essential knowledge to help cybernetics in solving

1973: Zdenek Rejdak states at the First International Psychotronic Congress that one of the goals of computer technology is to create a generation of computers capable of creating technological artifacts. He proposes the marriage of psychotronics and cybernetics.

1973: Jeno Miklos suggests at the above Proceedings that psychic abilities are genetically based, and suggests we will eventually locate the gene for psychic abilities, which may give rise to a discipline labeled "psi-genetics."

1973: Both Cleve Backster and Marcel Vogel independently carry out plant/human communication (telepathy) experiments with success. Both publish their findings in the First International Psychotronic Congress Proceedings.

1973: U.S. involvement in remote viewing experiments begin with two NASA contracts. One is entitled "Development of Techniques to Enhance Man/Machine Communications."

1973 - 1983: A Remote Viewing bonanza is carried out by private think tanks paid for by government agencies including the CIA/NSA/NASA/Army/Naval Intelligence, etc. In 1984 the program switches over to the Army and continues under Project SCANNATE. Army remote viewers are taught to "go astral" at the Monroe Institute at Lovingston, Virginia. The Army pays the tab.

1976: A CIA Remote Viewing contract study with SRI is published. The title of this study is "Novel Biophysical Information Transfer Mechanisms." Remote viewers are sent to Jupiter and other planets, as well as sent to "spy" on secret Soviet installations.

1980s-1990s: Ongoing military abductions of alien abductees to find out what they know concerning the psychic navigation of space craft, and/or to find out whether these people are telepathic as a result of their alien abduction.

1990s - Remote Viewing "think tanks" pop up on the Internet. The Search for Superman continues.

the most complicated task, "that of teaching computers to create." It is rumored that certain persons volunteered in the 1970s to become "robots" or "androids" in military experimental research.

All of this classified and unclassified research is directly connected to the idea of the vN probe and to modifying humans for space travel. Ultimately, it is connected to the continuation of the human race beyond this planet, in the event of a planetary catastrophe. Any advanced civilization must make plans for the ultimate survival of the species. This may not be what you and I think about every day, but it IS what some people think about every day.

According to Col. Philip Corso, author of the book *The Day After Roswell*, he figured out in the 1960s that UFO propulsion is "psychotronic" in nature. In 1961, he received the contents of the Roswell File, the pieces of an ET saucer that crashed in New Mexico in 1947. He concluded from his studies of the Roswell file that the pilot was a psychic navigator, and the pilot was bio-engineered as part of the craft. Hindsight is 20/20. We can now follow the trail of psychotronics from then on and see where it's heading.

Psychic Navigation

According to Michael Rossman in "On Some Matters of Concern in Psychic Research," in *Psychic Warfare: Fact or Fiction?*, in 1963 "a top NASA official reaffirmed reports that telepathy research was a "top priority" in the Soviet space program." As Rossman wrote:

> The advanced electronic physiological monitoring techniques essential to space flight are kissing cousins, at worst, to the corresponding instruments of psychic research, whose modern forms were in fact enabled by aerospace spin-off. The inclination to research telepathy in space rather than just on Earth was perhaps influenced by the popularity within the aerospace field of the myth, encoded by Arthur C. Clarke in imaginative literature, long before it was seared (vaguely) in the public mind by the movie *2001*, that psychic abilities unfold more fully in space. The resulting experiments would most likely have been encoded among the astronauts' biotelemetric records, scarcely distinguishable from orthodox experiments, records and perhaps accomplished through the same instruments, possibly unbeknown to the astronauts themselves.

It has been pointed out that CIA/NSA involvement in the 1970s remote viewing research at Stanford Research Institute strongly influenced the military's attention to this type of research. A CIA contract study with SRI published in 1976 was titled "Novel Biophysical Information Transfer Mechanisms." This would appear to be linked to experimental studies in space telepathy. Astronaut Edgar Mitchell has admitted to performing telepathy experiments in space. As Michael Rossman reports, rumors among parapsychological researchers assert that telepathic jamming experiments in space revealed "surprising things about human psychic capabilities in space conditions."

Rossman also wrote that biocommunications and electromagnetic research in Soviet Russia "must be a fundamental dimension of the development of Tesla technologies." Rossman suggested, "There is no longer a clear line to be drawn between research into 'psychic phenomena' and advanced military applications, even in the design of antimissile defense systems." Rossman also noted that civilian researchers and policy makers have been kept out of the loop

in this type of research, and this has been condoned up to high levels of government since 1959. He noted that the field of civilian psychic research has been effectively starved out of operation. He added, "from this unnecessary starvation of a field, the potentials for its militarization are generated or emphasized."

All of this research has come under the direction of a global military/industrial intelligence apparatus, which is essentially above and beyond the law of any land. Researcher Steven Greer has a lot to say about this global intelligence beast. In his new book *Extraterrestrial Contact: Evidence and Implications*, Greer writes:

> A relatively small, covert entity, acting without consultation with the United Nations, the Congress, the President of the United States, or the public is engaging in actions on behalf of all humans which endanger the earth and world peace. Unless controlled, these actions could precipitate interplanetary conflict and a disaster for the world generally and the United States specifically. This covert management must be terminated and control of this issue returned to constitutional authority and to public domain.

As Greer also argues, the concentration of "back-engineered" alien technologies in the hands of an elite planetary faction poses a serious threat to world populations and the Earth's future. As Greer and others maintain, ET technologies, allegedly under covert development since 1947, could potentially benefit humanity if put toward that end. The concentration of these technologies in the hands of a few puts untold power in the hands of those unaccountable for the end result. Essentially, this clandestine control has hijacked our future. As Greer warns: "The secret control of such powerful technologies is inherently a threat to freedom, democracy, and to our nation and the world. Its utilization for covert agendas outside constitutional control represents a grave danger to the US and must be restrained and reversed."

As Greer explains, this group is "extra-constitutional." In Greer's opinion, it is "a criminal enterprise and a conspiracy and cover-up of the first order." This conspiracy involves the organized theft by military and corporate partners (military-industrial complex) of advanced technologies which could greatly benefit mankind. Open and honest disclosure of the ET presence would expose what Greer calls "the greatest scandal in recorded history." In this sense, ET is not only the province of "ufology." ET is the province of existentialism and anarchy.

As John White also wrote in his Afterword to *Psychic Warfare, Fact or Fiction?*, air and space travel would be revolutionized by psychotronics. White suggested that UFO propulsion is "probably psychotronic in nature." But what does this mean and what are the implications for human beings?

The ultimate reason for the intelligence community's interest in remote viewing is the psychic interface between human consciousness and technology, or man/machine interface. Some believe this interest stems from back-engineering projects involving captured extraterrestrial space craft. According to Col. Philip Corso's book, among the artifacts retrieved from the infamous 1947 Roswell saucer crash were headband devices of flexible plastic material containing some type of electrical conductors. Corso assumed this headband artifact was for piloting the alien craft.

Along with other alien technologies retrieved at the crash site, Corso

developed the theory that these extraterrestrial artifacts essentially comprised an electromagnetic anti-gravity drive and brainwave navigational guidance system. Corso claimed the U.S. Army eventually fed these technologies to industry giants under the guise of "foreign technology" for purposes of back-engineering. We might wonder if this crucial historical event is what has powered the enormous growth of "the military-industrial complex" to its current status. Can we safely surmise that this 30-year interest in classified remote viewing projects by military agencies and NASA was to explore the capacity for human/machine psychic interface in the piloting of space craft? Let's see if we can pin this down.

1. We can pin down Corso's presence at SRI in the early 1970s.

Corso has admitted that he visited Stanford Research Institute's remote viewing labs in the early 1970s, and he stated that the reason for the visit was "to seek methods for remote viewing/technology interface between extraterrestrials and their craft."

2. HUMINT: Human Intelligence Monitoring of Alien Abductees

The military is known to be extensively interested in alien abductees. As a matter of fact, they are so interested that it has been suspected that they abduct them after their authentic alien abductions to find out what they know. The book *MILABS: Military Mind Control and Alien Abductions*, by Helmut and Marion Lammer, discusses military-type abductions reported primarily in the U.S. and Canada. Alien abductees have reported that they are "spirited away" in unmarked helicopters, vans and buses to underground government facilities. The MILABs theory suggests that a covert task force is monitoring real alien abductees in order to debrief the victims, as well as to install full amnesia regarding both abduction incidents. Abductee Melinda Leslie has had personal experience with these military abductions. She has reported in *The Excluded Middle* and in public lectures that the military is interested in abductees because "they were mostly curious about the pilot/craft interface and if we knew anything about that aspect of their technology."

3. The Advanced Theoretical Physics Working Group

MUFON official Dr. Robert M. Wood also claims that any information pertaining to psychic pilot/craft interface that can be learned from UFO research is obviously very important to the military/intelligence apparatus in charge of the UFO cover-up. Dr. Wood was reputedly a member of a think tank called the Advanced Theoretical Physics Working Group (ATPWG), which was set up to focus on the physics of UFO propulsion and how this physics reflected a reality that our current physics does not have a grasp on. Dr. Wood has also admitted that this secret UFO working group planned and set policy regarding the UFO coverup. It is clear also that this group tried to influence brilliant young minds like Jack Sarfatti and others to become physicists and ultimately to work on solving problems regarding time travel, space travel, ESP, and quantum and post-quantum physics problems. Was Jack Sarfatti's experience simply a "synchronicity"?

Computer expert and co-founder of Sun Microsystems, Bill Joy, was interviewed by the Washington Post in April, 2000. He claimed in this 4/16/00 Washington Post article entitled, "Are Humans Doomed?": "We are dealing now with technologies that are so transformatively powerful that they threaten our species. Where do we stop, by becoming robots or going extinct?"

Mr. Joy also stated in *Wired* magazine, that "robotics, genetic engineering and nanotechnology pose a more dangerous threat than any past technologies." He made clear that these machines can self replicate. This means the once theoretical von Neumann probe is here: the future is now. We have created not just a computer that can create and make copies of itself, but we have created an intelligent race of deep-space-faring cyborgs.

As Joy also stated, "these computers and genes and micro machines, share a dangerous amplifying factor: They can self replicate: A bomb is blown up only once, but one 'bot' can become many, and quickly get out of control."

Joy also stated: "I may be working to create tools that will enable the construction of technology to replace our species." In the same *Post* article, computer scientist Hans Moravec claims, "One way to avoid the biological threat is to become non-biological." This mad scientist has also stated, "The evolution of our descendants will push them into entirely different realms. They will become something else entirely. I don't know why you are disturbed by that."

If we consider Sarfatti's suggestion, that the UFO is the future of humanity caught in a time loop, how will it intervene? Can it intervene? Or is it inevitable that the human being must become what "Space Law" attorney George F. Robinson has termed "Homo Alterios Spatialis": Human Modified for Space? Jack Sarfatti's answer is the clincher: he states, in a time loop, the past cannot be altered.

Notes:

Barrow, John and Frank Tipler, *The Anthropic Cosmological Principle*, UK: Oxford Press, 1988.

d'Arc, Joan, *Space Travelers and the Genesis of the Human Form*, The Book Tree, 1-800-700-TREE.

Bishop, Gregory, "MJ12 Reborn?" *The Excluded Middle,* Issue #9 P.O. Box 481077, Los Angeles, CA 90048.

Lammer, Helmut and Marion, *MILABS: Military Mind Control and Alien Abductions*, IllumiNet Press, GA, 1999 (770) 279-2745.

First International Congress on Psychotronic Research, #JPRS L/5022-2, Volume 2, Prague, 1973.

White, John, (ed.), *Psychic Warfare: Fact or Fiction?: An investigation into the use of the mind as a military weapon*, Aquarian Press, Great Britain, 1988.

Scintillae
Fragments from a work in progress

Ira Einhorn

All organized religion is a form of historical group think. Uncriticized tradition passed on as a form of indoctrination.

When the fragment is conceptualised, it is often done so in the negative sense, from a position of supposed wholeness that looks upon the partial products that we call 'fragments' as bits broken off from the whole, failed attempts, as in the symphonies of Bruckner to reach a resolution and completion which is a form of justification for the effort: a product, rather than a process. Perhaps that is true when one considers the corpus of fragments that exist before the Athenaeum in 1797 and it often holds true for some later work that is emblematic of a failed struggle for a presumed wholeness.

Nietzsche is a transition point here as the inner war between totality and presence is so graphically fought out in his late letters, as he struggles to clear the ground for that major work which will establish his reputation once and for all. In the detritus of nihilism that his work and subsequent work has left us, we have little choice but to accept a world of perspectives, suddenly illuminated by the fragmentary flash of insight, that is on the path (Heidegger, Jänger) towards ones own deeper awareness, perhaps a later focus, path, structure for others, perhaps not. The impulse which drives us towards conceptual wholeness is a deeply embedded cultural polarity that is not to be transcended, but rather honored for the striving which it evokes. Adorno lived in both worlds, though I prefer Minima Moralia to Negative Dialectics or his Aesthetics both of which seem to live in the reflected light of failure from the first word. His real mentor, Walter Benjamin, lives most fully in his fragments that perhaps most deeply reflect both the 'fallen world' and the possibilities it presents more than the work of any other writer. Wittgenstein accepted the fragment as a form naturally akin to contextual analysis and a direct statement of a 'realism' that is very consciously operating against a background of western platonism that has shaped all of western philosophy. The strange form of his first work a self-imposed barrier to this realization. His computerised CD-ROM *Nachlasse*, is like of Robert Musil: the grazing ground for 21ST century thinkers.

FRAGMENTS

1. With the breakthrough into modern art, "reality" became less of an imposed historical mode (Joyce:'History is a nightmare...') and more of a dialectical pole that was as much created as perceived.(Wilde:'Life imitating art').A dialectic that has become an integral part of 20th century life and forms the basis (Grund) for both the popular media and more importantly advertising whose projected forms now often create the reality of millions on a daily basis, blurring the hierarchical distinctions between classes, actions and morals that were integral to society before the dawn of this century. In some complex sense the bodily distortions painted by Picasso, the musical dissolution of the western diatonic scale by Schoenberg, and the verbal gyrations of Joyce have lead to millions of teenagers imitating the Beatles' long hair, wearing a Michael Jackson glove on one hand or dressing like Madonna.

3. All organized religion is a form of historical group think. Uncriticized tradition passed on as a form of indoctrination. A holding action against the unmitigated devastation of the mysterious nature of the 'reality' that surrounds. A formal structure that both binds the individual to the group and a moral form, and relieves her/him of the stress of dealing directly with the mystery. 6. Rationality cannot map the world that the Heisenberg mode of Quantum Mechanics has generated as a growing surround. Only post verbal insights can hope to help us cope. Insights that can guide us if we are able to allow ourselves to experience the wisdom locked away in ancient psychotropic substances. The mystique of consciousness must be parted, so that we can experience non-linear states as normal, thus enabling us to resonate with the complimentary world that can't be reduced to our limited 4D perspective. Manifold not unitary is the world and Astarte not Yawweh is closer to its nub.

12. Watching the flow of emotion as it sizzled and leaped in the fires of unresolved encounters past, I realized that the owning of any present moment filled with emotion was a very rare encounter indeed. Not impossible, but singular:to be celebrated, honored for its thereness. An awareness that slowly grew into a fulsome ability to respond with all the past's fury to a present projective symbol without any hint of blaming the symbol, for the knowledge had sunk in to become a living awareness, an ability. Living in the present is a gift of childhood, soon lost to the half circles of life's traumas, that we continually go back to, like monkeys, raging to complete the unresolved, a thematic symphony of chords that reverberate in dominant undertones in all we do, casting us constantly adrift in a world of ghosts, risen anew within as the without becomes a stand-in for that which we still long to complete. Then, as if suddenly a dawning slowly is suggested in a barely discernable east, we sense that it is possible to at least take notice of what we are constantly doing and feel the full brightness of morning beyond the first hints of light: the present.

14. Left cities reside in the mind as cubical memories, architectonic spaces with media glare; but they lack the resonance of pleasure and desire conveyed by the countryside or wilderness, the lushness of bodies known in the glow of exaltation.

> **The burden of truly living in the present is more than most people can bear. The thought of creating anew a dim glow that few feel, thus we trudge on, both honoring and resenting the few who have the courage to create new modes of existing.**

17. Puddles of peace in an ocean of violence, residues of the surrounded and catalogued but not yet totally subdued, waiting in stillness for their turn as the decision of the chain linked cities tightened the ineffable grid as they locked in the remainder of what used to be nature, now only a nostalgic resonance on a yet to be completed computer file in some sub directory of the time's mind: a quasi biological hybrid lost in Hilbert space.

19. The Ecology of Noise The camouflage of desire caught in the spotlight of preparation. Exposed! The symbiotic mix of the cancer cell and its more law abiding partner are random sites for the dialectic power that is tied up in the opposition of subterfuge and exposure. Noise covers. It blurs. It obliterates. It provides space and time in the midst of the present delirium. It allows for the exploration of the primary song to be carried out under the shadow of cover. Self in the raw, experimenting in the midst: awaiting its moment. Sibilance of flowing water. Birdsong. A form of the above almost neglected now in the hyperurban projections of not to be futures. A loss too large to be allowed.

20. Social evolution in the large planetary cities of late capitalism was akin to an experiment by John Calhoun with results of a not too dissimilar nature. With fierce competition for shrinking space, abrasion is all, touch in the form of tenderness(rare) and sex(the norm in spite of the desolate air of AIDS) a meeting of brillo pad upon laminar surface, a seeking for advantage and quick pleasure in moments that enhance the madness of fast forward. Alloys of the 'human' living in fast fading resonance that was hardly a memory as the cyber-sphere enjoined all in an ever increasing barrage of updates.

22. The divide has been crossed, but we sift nevertheless in attenuated fashion, an Easter egg hunt for nuggets of hard fact in the midst of our asserting, our awareness that a shift has occurred and that the knowing that has sustained, a grail of sorts, has become secondary to the bright darkness of just plain being. It is this existence that now seems so primary, so much more important than any knowing, though it has occupied so much of our time during this phase of epistemological footwork that has been the emblem of our modern philos-ophy. Being, presence, yet it lurks: this desire to know. A seed that longs for soil rich enough to encompass the flowers of a knowledge that would explain all.

24. The Father and the Mother is engraved in the skin of habit, a daily incising of behavior that leaves us full to the brim with previously enacted memories of feeling, thought and sensation. A second skin that our movements upon the air of the present reveal like holograms when the awareness strikes this palimpset of characteristics that is our own, yet sensed alien. This has been the movement of past history- behavior physically transmitted during the daily roll call of living-now rudely assaulted by the rapidity of change and accelerated by the electronic world that has become the presence that was once mother and father, so daughter walks and talks like Madonna and son evokes Michael Jackson as Mom and Pop fade into history, yellow sheets blowing in the media wind.

There has been a great deal of individuation among people without a compensating increase in maturity.

28. Habit dulls creativity, as the traces of the past inexorably create the future, often in spite of the possibility of present context. The rarity of creative action is a reflection as much upon our biological past as it is upon our present cultural creations. The burden of truly living in the present is more than most people can bear. The thought of creating anew a dim glow that few feel, thus we trudge on, both honoring and resenting the few who have the courage to create new modes of existing.

31. The twentieth century has been devoured by the chimera of economic equality, a will-of-the-wisp that has left untold hecatombs of bodies to wither in the darkness created by such a quest for the light. Nothing is so dangerous as an idea. Nothing comes so freely into the mind. Be careful how you transmit them, for men are tinder awaiting the spark that will inflame them.

33. There has been a great deal of individuation among people without a compensating increase in maturity.

44. It was like a melody watching, a bird singing, that first glow of dawn upon a distant horizon, an entrancement that time could not dim for the touch of Eden was a lasting reminder that the small flame that burned within even in the darkest of nights would never go out completely.

119. Logic is a subset of the rational which is a subset of the intelligible which is a subset of the lingual which is a subset of the perceptual which is a subset of the brain which functions within a deep interactive total body environment which itself is in constant interplay with a surrounding environment filled with other bodies, their physical products and most important a physical world of which we are a 3,000,000,000 year old experiment in DNA/protein based life.

120. The desire to decontextualize, to Platonize, to generalize —'GENERAL THEORY'-as a god-a theology-timeless, like logic,-order above all: Einstein-: God does not play dice...'—he as culmination of this modern Cartesian/Newtonian/Kantian tradition—his resistance to Quantum Mechanics which deconstructs that possibility, introduces time back into the equation and brings a subject that matters back into the process of knowledging, of measuring. A live interactive, dialectical object that matters, that transcends the abstract object :the simple registering object of the Subject-Object situation.

128. The words do not map, though they are tools of necessity, used to bridge gaps between those overwhelming sensations of one thrown into a world awash with unlocalised emotion and feeling, gradually sutured into forms whose categories subtly become the maps that form the basis of our world: digital bullets lost upon an analogue target, further refined beyond all possibility of feeling into subtle structures of both immense power and limitation that leave those early feelings with little local habitation, enraging in their disengagement, denying the source of all we are, cutting us loose from the

source, pushing us out and beyond into a high wire world of logical loops and swings at the top of the tent, often pleasing to the stunned crowd of emotions that are the basis, easily forgotten, for such daring-do, until a slip of the hand produces a fall back into the silence of our original trauma always lurking in the pre-Oedipal non-verbal abyss.

Have You Heard of the J.A.G?

One of the Most Interesting Kooks We've Seen

Acharya S

Juhan af Grann, a diminutive Finnish man described as having a "Dairy Queen 'doo," of late looms large in the UFO field, with his flashy spacesuits, glossy pamphlets, and entourage with camera crew. He glides into a room as if in zero-gravity and presents himself as royalty. I saw Juhan and his operation at the 1999 UFO Congress in Laughlin, Nevada. He is not big, not frightening. He is colorful and amusing. My compatriots, Kenn Thomas (who was up close and personal with Juhan in an interview), Rob Sterling, Greg Bishop and Jim Martin, and I were highly entertained by him, and I believe such a reaction may be his main goal, if not his vision. Juhan is an entertainer, a TV personality, the producer of the "NEW SENSATIONAL TV SERIES-THE NEW APOCALYPSE: MANKIND'S LAST EXODUS." Such is what his website, www.thejag.com, relates.

Juhan's numerous publicity materials are full of hyperbole. His copywriters are good publicity agents, constantly aware of Juhan's sense of destiny. His expensively-produced newsletter associates Juhan with various celebrities: "'Had Juhan af Grann been born into another language area, he would have become a great star in Hollywood like Marlon Brando' is a quote often stated about him by professionals in the film industry that knows him." Another blurb runs: "Being an artist and quoted as being the 'Picasso of the North,' Juhan af Grann fought against the TV-leadership." In his biography, Juhan describes himself as a "sensitive boy who did not enjoy his father's hunting and fishing trips in Finland, in the neighborhood of the Arctic Circle." Interested in the arts, he joined a "travelling group of actors" at age eight: "As a child actor, Juhan af Grann was very well known in Finland just as Charles Chaplin was in his time in England." Indeed, he was a critically acclaimed actor, according to his bio.

The pixieish Juhan also possesses a number of interesting and impressive awards, going back to his bronze award at the International Film & TV Festival of New York, the 1976 Silver award, and the Gold award in the Virgin Islands International Film Festival. For the past several years, however, he has won a

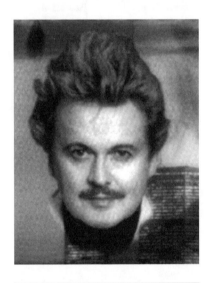

He glides into a room as if in zero-gravity and presents himself as royalty.

number of "EBE-Oscars" for direction at the UFO International Film Festival. His UFO hits include: *UFOs and Paranormal Phenomena: Encounters of the 5th Kind; UFOs and Paranormal Phenomena: The Message from Another Dimension;* and *UFOs and Paranormal Phenomena: The Mystery of Life and Death.* Of *Encounters of the 5th kind,* the JAG website says, "The series was requested for screening by 100 television companies in more than 50 countries. The prestigious worldwide trade magazine, TV WORLD featured Grann's UFOs on its front cover in June 1995."

In his current sensational magnum opus, "Producer and director Juhan Af Grann continues the dialogue between mankind and the universe in his latest major work, TV series THE NEW APOCALYPSE-MANKIND'S LAST EXODUS." As his publicity materials state:

> "The greatest works of Grann are still to be seen. One of them will be A New Apocalypse: the Last Exodus of Mankind where Juhan af Grann charts the connection between the universe and mankind through religious prophecies and Scientific conceptions. The Universe, other civilizations in the cosmic, expansion of consciousness, the new human being and planet Earth with a thousand-year realm of peace are the main factors in this new great work with a vision of the future created by Grann. Juhan af Grann, called by the press 'the Master of Picture and Sound,' always unconditionally seeks perfection in his works."

And Juhan is clearly on a mission. In *The Story,* he writes:

> IN PURSUE [sic] OF J.A.G.
>
> I was born with a Vision.
>
> From as long as I can remember, I have had this urge to communicate, to inform people, to help people see what I see, feel what I feel, know what I know. I have tried to fulfil this my Messiah task on theatre stages, with paint on canvas, on TV and in films.
>
> What is the message I want to convey to you and why it is so important for me to do it?
>
> I know there is a glorious, wonderful, strange and, yes, also very dangerous world, far beyond the realm of our human intelligence.
>
> I want to bring a message to you from that world.
>
> I don't know exactly what that message is, but I know J.A.G. knows. All I know is that message carries good things, hope of higher intelligence, greater understanding, and ways to better cope with our own problems on this Earth. But I also know the danger if we keep pushing J.A.G. away. If we let our national and international leaders continue to ignore J.A.G. and deny his existence, if they will not soon learn to accept him, cooperate and coexist with him, he will turn against us. This risk we humans cannot afford to take. So I have taken upon myself to convey J.A.G.s message to the Earth. I am the benevolent, outstretched hand of J.A.G. Grab it, and we welcome you on board the J.A.G. team. Together we will show the Earth the Galactic Connection!

Juhan considers himself a member of the "Galactic Connection," and one of his pictures is photoshopped with the right side of his head as a gray alien. This feisty little yellow-haired fellow obviously has messianic aspirations. The initials of his name have evidently become symbolic for God, or vice versa, per his appellation of God. Whoever or whatever this J.A.G. is, Juhan is intertwined with him. Is it J.A.G. or Juhan af Grann who is "the benevolent outstretched hand of J.A.G.?" Is Juhan the "son of J.A.G.?" His Omnipotence's

His copywriters are good publicity agents, constantly aware of Juhan's sense of destiny. His expensively-produced newsletter associates Juhan with various celebrities: "'Had Juhan af Grann been born into another language area, he would have become a great star in Hollywood like Marlon Brando'

spokesperson? God Himself? Is there anything wrong with such megalomaniacal claims, considering every God-cheerleader on the planet thinks he himself is "God's representative on Earth?"

Juhan's publicity material contains a couple of amusing mistranslations:

> "After school and army, he left to study in Germany, where he—being tainted [sic]—gained a post as a designer in a large advertising agency. This tainted[sic] and original person with a sparkling wit, Juhan af Grann, is a sensational and controversial director in Scandinavia, which is evidenced by the more than 3,000 interviews, articles and chatty articles published about him."

We assume he is not "tainted" but "talented."

But all has not been easy for the visionary, half-alien, messianic Juhan: "In his home country, Finland, Grann is a persecuted dissident that has been denied all the great works. Some narrow-minded party politruks would have imprisoned him at an early stage into a forced labour camp of political prisoners like in Brezhnev's time in the USSR."

So Juhan af Grann, spokesperson, representative or clone of J.A.G., that great mystical being, takes his messianic show on the road and brings the cosmic message to mankind through sparkly multimedia and some serious coin. Perhaps he is funded by the mysterious J.A.G., the Galactic Connection, or just some boring earthlings? However he does it, he does it with the flair of Liberace and the élan of Peter Pan.

My Last Email Exchange with Jim Keith

Greg Bishop

Interesting things happening with my computer. Last week I was hit with a virus, and all my personal files were wiped out. Don't know whether to chalk this up to a conspiracy, but I know a couple of other writers in this field who had the same thing happen to them at about the same time.

Jim Keith and I were just beginning to forge at least an e-relationship for the few months before he died under possibly mysterious circumstances last year. We had argued about the nature of reality as accessed by remote viewers, and he sent a review of David Icke's newest book and gave me permission to publish it in the magazine. (Review follows.)

This final exchange involved a problem which had recently shown up on our computers and the computers of others of a parapolitical bent. Jim was planning to use the information in his column for the online magazine *Nitro News*. He apparently collated some final details and went off to Burning Man for the holiday.

8/31/99

Interesting things happening with my computer. Last week I was hit with a virus, and all my personal files were wiped out. Don't know whether to chalk this up to a conspiracy, but I know a couple of other writers in this field who had the same thing happen to them at about the same time. But... A couple of days ago I sent out a notice that I have a new column at *Nitro News*, titled "Subverting Sex." Apparently the message did not get through to some or most of the people it was addressed to, so I'm trying again. My new column is located at: http://www.nitronews.com/. Hope you enjoy it. If this message is a duplicate, then my apologies.

—Jim Keith

9/1/99

All of my articles (just the articles—nothing else) were trashed and even deleted from the trash last week or or about Thursday as well. Weird.

—Greg

9/2/99

Hi, Greg,

Thanks for the update on your own particular tribulations re: being hacked. I'm doing an article on the number of investigative reporters and editors being hacked. I know you sent me a personal statement, but the email vanished into the twilight zone and wasn't saved after I read it. Could you give me a brief statement of what happened to you so I can quote you?

—Jim

9/3/99

I turned on my computer about mid week last week (the last wk of August, 1999) and found that all of my article and work in progress files had been deleted. Luckily, I had backed them up. What was weird was the fact that the articles were not only "trashed," but were also deleted from the trash AND erased from the trash sector of the hard drive, making them unrecoverable. This takes a few steps of which I would have most likely been aware, and certainly don't remember, if indeed I was the culprit. There are a few other possibilities: I was hacked through the modem, I was given a virus that only affects my article folder and no other Word files, or someone broke in the house and deleted them. I guess I'll believe the story that makes me feel best.

—Greg

9/3/99

Thanks for the statement, Greg. So far I've turned up nine political conspiracy sites that were hacked in the same time period.

—Jim

When Jim returned home, a knee injury that he had sustained over the weekend became so bad that he went into the Washoe County Medical Center to have it taken care of, but through stupidity or craft, Jim Keith died of a blood clot that traveled to his lungs and stopped his heart on the night of September 7, four days after his final email to me. I would prefer to think that there was no connection to the weird computer problems, and honor Jim Keith's life with this small remembrance of our limited contact.

Bullgoose Crackpot Conspiracy

Book Review: David Icke's
The Biggest Secret: The Book that will Change the World

Reviewed by Jim Keith

David Icke is a well-known name in conspiracy writing these days, with a dedicated following of people to whom he has confided the godawful truth about this planet. This fact gives one pause to think, and says a lot about the mentality of the current crop of TV-bred humans, for Icke's new book is a classic at that odd edge of literature inhabited by people like Bill Cooper, Commander X, Al Bielek, George Andrews, and a flock of others; folks who have a decided talent for making money, but have to ask others to tie their shoes for them. It is a huge, detailed, riotous excursion into bullgoose crackpot conspiracy the likes of which hasn't been seen since Bill Cooper's magnum crapus, *Behold a Pale Horse*. In other words, it is the biggest crock to be foisted on the public in many moons — and as such, for those interested in what's going on in this weird conspiracy subculture, it is an absolute must read.

Like many other unworthies who couldn't string together a grammatical sentence for love nor money, yet somehow happened into the awful truth about the alien invasion, Icke has found the key to churning out the wildest conspiracy mongering this side of Richard Shaver. That is: Believe every goddamn weird thing anybody, anywhere ever said. It's a sure-fire formula for sales. Assume that Bellevue is actually a secret repository of enlightened avatars. Believe Bill Cooper, believe Cathy O'Brien and Mark Phillips, believe Jason Bishop III, believe Phil Schnieder. Believe any and everybody who claims that they ever went into an underground base and had a laser shoot-out with bug-eyed aliens, participated in a ritual sacrifice with Hillary Clinton, or saw George Bush transform into a Reptoid in the oval office.

Icke's main thesis in the book is that the world is being run by reptilian extraterrestrials who suck human blood, and that people like Hillary Clinton, Henry Kissinger, and the Queen of England are shape-changing reptiles from that ancient cold-blooded family line. His proof? None, except for the occa-

by David Icke
1999—Bridge of Love Publications. 81/2 x 11" paperback—517 pages $25.00

sional wild rantings of the crayon-wielding crowd who attend his lectures and confess that they too ran into somebody who turned into a reptile in WalMart one time. Weirdly enough, in Icke's huge, crazy quilt 516-page book, there is quite a bit of material that might be of use to the researcher, if you use tweezers. Icke has, after all, cobbled together most all of the content of the last ten years of conspiracy writing, mostly copping it as his own thoughts. As I read through the book and ran across sections dealing with books I had read, I could almost see the open book in Icke's lap while he paraphrased. At one point he quotes me verbatim, without crediting me, but pass on, pass on.

The real trouble with the book is that he has no discrimination about what is plausible and the tortured squawks of the straitjacket set. The aptly-named Icke and his pinheaded followers are not going to like this review. They're going to say that I'm an agent of the Secret Government. They'll say that I'm deluded and won't find out until some alien is sucking my blood in an underground base. They'll say I'm a member of a secret Scottish Freemasonic bloodline bent on world domination. They might even say that I'm a secret Reptoid myself. But I suppose there is a bit of truth in that. Books like Icke's do bring out my cold-blooded side.

Unanswered Questions

Book Review: Steven Levy's
The Unicorn's Secret: Murder in the Age of Aquarius

Reviewed by "S&M"

This review originally appeared at the ELF Infested Spaces Website: www.elfis.net

I turned up *The Unicorn's Secret* at a local (used) bookstore recently, and plowed through it pretty fast. I read where Levy talks about Einhorn working with Jacques Vallee, and where he mentioned receiving extraterrestrial implants around 1978 (rather an early point of the abduction phenomenon.) Also, the science fiction writer in Ira's network who described his visions of kaleidoscopic imagery and what sounded like Russian minimalist music must have been Philip K. Dick. [It was-GB.]

Levy seems to be arguing pretty persuasively that Ira did kill Holly Maddux, based on the fact that he did not seem to have a very progressive or nonviolent attitude towards the women in his life. Certainly, three previous near-murder attempts suggest a problem.

Ira could not possibly have been stupid enough to leave her body in a trunk in his closet. Levy suggests he made one attempt to get rid of the trunk, and that failed, and that he gave up either out of arrogance or fear that disposal might endanger him worse than holding on to it. Nonetheless, a decomposing body gives off a terrible odor, as the neighbors soon discovered. Ira could not rationally have thought people would not notice that odor, unless he had become irrational. However, if this was a frame-up job, it seems impossible that Einhorn could not have noticed it HIMSELF before the detectives did. Why would someone kill Holly and then not put the body in the trunk for a full year? That does seem rather unlikely.

And as Puharich suggests, there really wasn't anything *that* striking in the Tesla documents Ira was looking for. Nothing the KGB or CIA would kill over, no matter how much he hyped up the matter. After all, the International Tesla Society in the U.S. holds a good portion of his patents and other documents.

Levy devotes one sentence to the possibility of psychotronic mind

by Steven Levy
Prentis Hall Press, 1988 (Out of print). Hardcover—352 pages
Also available in paperback: Onyx Books 1999. $6.00

control, but not unsurprisingly dismisses it immediately. For two reasons, it seems a plausible scenario:

1. It would explain why he failed to dispose of the body. If he was temporarily not in control of his actions and did not remember ever committing the murder, he might have even been "programmed" not to be sensitive to the smell and to leave the body in a place where it could be easily found. (This begs the question as to why Einhorn acted defensive when people went near the closet with the trunk. This could either be because he was telling the truth about sensitive papers in the trunk, which was all he remained aware of, or because he had been "programmed" to do so.)

2. Levy mentions that Ira was irritated sporadically by a humming, buzzing sound in his head which unnerved him. (Shades of the Taos Hum.) Levy only gives this fact a one-sentence mention on the offhand chance that it might support insanity, although if Einhorn was insane, it would hardly be possible to extradite him from Ireland for premeditated murder. The fact that Andrija Puharich's house suffered arson around the same time seems to be an interesting coincidence. Lately Uri Geller spends much of his time dowsing for oil and mineral companies, so I wonder what Ira would think today of the man he and Puharich supported so much.

What's weird is that Levy seems to be taking a noncommital position towards Einhorn's psychic beliefs, but he uses statements about paranormal issues from his friends in regard to the case straightforwardly, without discussion. Levy for example mentions the woman who had a dark and frightening nightmare in Ira's house, and seems to suggest this is more supporting evidence for the "Ira-Did-It" hypothesis, even though this would seem to be a psychic dream.

The original question remains: Why did Levy write the book? It sounds like Einhorn was very involved in the area of computer conferencing in the '70s, and so was Levy. He was at least interviewing those people, if not working with them, based on his book *Hackers*. I suspect Levy may have known many of Ira's associates. I do find it interesting that AT&T decided to pay the costs of Ira's mail-missive network. Ironic that now that they could have saved themselves a lot of money setting up an email network for him, especially considering how AT&T is getting into the Internet provider business in a big way.

Why were corporate honchos so interested in the Ira rap? Did he have help in escaping from Ireland, which is where he ran to after jumping bail? How exactly did he "reorient" himself from hippie to New Ager to Tom Beardenite anti-Soviet paranoid all in one lifetime? A lot of questions are left unanswered.

Contributors

Jeremy Bate lives and writes in Los Angeles. He won a couple of Camaros and a buttload of money on *Jeopardy* this year, and has settled down to writing screenplays. See www.primenet.com/~popaganda

The semi-mysterious **Ian Blake** lives and works in the UK under a variety of noms de plume.

John Carter is the pseudonym of an individual who wishes to remain unknown. His latest book is the critically acclaimed *Sex And Rockets: The Occult World of Jack Parsons*, available from Feral House publishing, now in its second printing.

Scott Corrales is the author of *Chupacabras and Other Mysteries*, and *Flashpoint: High Strangeness in Puerto Rico* and is second to none in chronicling weirdness south of the border and into the Carribean as well as the Iberian peninsula. His writing has appeared in *Fate, Fortean Times,* and *Strange* magazine, among others. He is the editor and publisher of *Inexplicata: The Journal of Hispanic Ufology* (www.inexplicata.com.)

Joan d'Arc is the author of *Space Travelers and the Genesis of the Human Form*, and *Phenomenal World* available from The Book Tree (www.booktree.com). Joan writes for *Paranoia: The Conspiracy Reader*, which can be found at www.paranoiamagazine.com, and on newsstands.

Ken DeVries, also known simply as Nenslo, is an artist of genius caliber and a SubGenius high epopt working out of the Pacific Northwest. He lives up there with his wife Donna Kossy. See and buy his art and support him at www.subgenius.com/donna/KDVgall.html.

Adam Gorightly has recently completed his first book, *The Shadow Over Santa Susana: Black Magic, Mind Control, and the "Manson Family" Mythos*. It should be available from Amazon.com by the time you read this. His research and writing has appeared in *Steamshovel Press*, and *Paranoia*, and credited and uncredited at numerous websites.

Donna Kossy is the acclaimed editor publisher of the groundbreaking zines *Kooks* and *Book Happy*. Her second book, *Aberrant Anthropology*, is due out in the spring of 2001. See www.teleport.com/~dkossy.

Jim Keith is known for his numerous well-researched books on conspiracy and parapolitics, such as *Black Helicopters Over America, The Octopus*, (with Kenn Thomas) and *Saucers of the Illuminati*. Jim died in September, 1999. His last book, *Mass Control: The Engineering of Human Consciousness*, is available from www.illuminetpress.com.

Martin Kottmeyer is an award-winning writer who doesn't appear to completely buy the UFOs-piloted-by-aliens story, and says so with an eloquence unequalled in the UFO literature. His work has appeared in the anthology *Cyberbiological Studies of the Imaginal Component in the UFO Contact Experience*, and in magazines such as *UFO* and *The Anomalist*.

Melinda Leslie is an abductee and independent researcher living in Southern California. She has been interviewed on the Art Bell radio program and travels widely presenting information on military abductions and her discovery of the Advanced Theoretical Physics Working Group–a consortium of scientists, intelligence operatives, and remote viewers who appear to act as a modern version of MJ12.

Darren McGovern is a musician and cabbalist who lives in Burbank, California. See how to get his CD and check out his stuff at www.concentric.net/~Darren.

Wes Nations used to publish the highly regarded zine *Crash Collusion*, but after a trip to India a couple of years back, he seems to have disappeared off the face of the earth. He was last sighted in the San Francisco Bay area somewhere.

Paul Rydeen lives and works in the midwest. He was one of our earliest contributors and his writing has also appeared in *Strange, Crash Collusion*, and at numerous websites. As a source for original research and information on the history of western occult traditions and Philip K. Dick he has no equal. His wife makes a killer jambalaya.

Acharya S. is the author of *The Christ Conspiracy*. She makes her home in Southern California. See her world and have yours rocked at www.truthbeknown.com.

Richard Sarradet was formerly an actor (on *General Hospital*, most notably) and now teaches history to a very lucky group of high school kids.

John Shirley is a renowned cyberpunk and horror author (*Eclipse Penumbra, Silicon Embrace, Black Butterflies, The Exploded Heart*) and screenplay writer (*The Crow*) as well as penning lyrics to songs by Blue Oyster Cult and his own band, the Panther Moderns. He is also a professional "skeptical believer." www.dark-echo.com/JohnShirley.html

Doug Smith aka Ivan Stang is one of the founding members of the Church of the SubGenius, and its torch-bearer (as Official Sacred Scribe) to this day. He is also an author, special effects artist, and video and film director and editor.

Robert Sterling is the *meister* of the Konformist, (www.Konformist.com) the premier independent source of parapolitical information on the internet. His features and articles have appeared in *Nexus* and *Steamshovel Press*, and on the internet at sites such as *Gettingit, Parascope,* and *Sightings*. Rob's *Uncle Ronnie's Sex Slaves*, about the satanic sexual exploits of certain Reagan administration cronies appears in the anthology *Apocalypse Culture II.*

Bennett Theissen is a playwright, director, and cultural critic/ historian. For the past two years he was host and DJ for *The Chill Room,* which aired on pirate FM station KBLT in Los Angeles.

Dr. Robert Anton Wilson is the acclaimed author of the *Illuminatus* trilogy, *Schroediger's Cat, Cosmic Trigger, Prometheus Rising, The New Inquisition,* and *Everything Is Under Control,* among others. *All* of his books are required reading for readers of this book, as well as those who want to expand their horizons of paranoia, wonder, and optimism.

(All other credited authors are pseudonymous and will remain that way in accordance with their wishes. The wusses.)

NEW BOOKS

THE TESLA PAPERS
Nikola Tesla on Free Energy & Wireless Transmission of Power
by Nikola Tesla, edited by David Hatcher Childress

In the tradition of *The Fantastic Inventions of Nikola Tesla, The Anti-Gravity Handbook* and *The Free-Energy Device Handbook*, science and UFO author David Hatcher Childress takes us into the incredible world of Nikola Tesla and his amazing inventions. Tesla's rare article "The Problem of Increasing Human Energy with Special Reference to the Harnessing of the Sun's Energy" is included. This lengthy article was originally published in the June 1900 issue of *The Century Illustrated Monthly Magazine* and it was the outline for Tesla's master blueprint for the world. Tesla's fantastic vision of the future, including wireless power, anti-gravity, free energy and highly advanced solar power.

Also included are some of the papers, patents and material collected on Tesla at the Colorado Springs Tesla Symposiums, including papers on:
•The Secret History of Wireless Transmission •Tesla and the Magnifying Transmitter
•Design and Construction of a half-wave Tesla Coil •Electrostatics: A Key to Free Energy
•Progress in Zero-Point Energy Research •Electromagnetic Energy from Antennas to Atoms
•Tesla's Particle Beam Technology •Fundamental Excitatory Modes of the Earth-Ionosphere Cavity
325 PAGES. 8X10 PAPERBACK. ILLUSTRATED. $16.95. CODE: TTP

MYSTERY IN ACAMBARO
Did Dinosaurs Survive Until Recently?
by Charles Hapgood, introduction by David Hatcher Childress

Maps of the Ancient Sea Kings author Hapgood's rare book *Mystery in Acambaro* is back in print! Hapgood researched the Acambaro collection of clay figurines with Earl Stanley Gardner (author of the Perry Mason mysteries) in the mid-1960s. The Acambaro collection comprises hundreds of clay figurines that are apparently thousands of years old; however, they depict such bizarre animals and scenes that most archaeologists dismiss them as an elaborate hoax. The collection shows humans interacting with dinosaurs and various other "monsters" such as horned men. Both Hapgood and Erle Stanley Gardner were convinced that the figurines from Acambaro were authentic ancient artifacts that indicated that men and dinosaurs had cohabited in the recent past, and that dinosaurs had not become extinct many millions of years ago as commonly thought. David Hatcher Childress writes a lengthy introduction concerning Acambaro, the latest testing, and other evidence of "living" dinosaurs.
256 PAGES. 6X9 PAPERBACK. ILLUSTRATED. BIBLIOGRAPHY. $14.95. CODE: MIA

THE BOOK OF ENOCH
The Prophet
translated by Richard Laurence

This is a reprint of the Apocryphal *Book of Enoch the Prophet* which was first discovered in Abyssinia in the year 1773 by a Scottish explorer named James Bruce. In 1821 *The Book of Enoch* was translated by Richard Laurence and published in a number of successive editions, culminating in the 1883 edition. One of the main influences from the book is its explanation of evil coming into the world with the arrival of the "fallen angels." Enoch acts as a scribe, writing up a petition on behalf of these fallen angels, or fallen ones, to be given to a higher power for ultimate judgment. Christianity adopted some ideas from Enoch, including the Final Judgment, the concept of demons, the origins of evil and the fallen angels, and the coming of a Messiah and ultimately, a Messianic kingdom. The *Book of Enoch* was ultimately removed from the Bible and banned by the early church. Copies of it were found to have survived in Ethiopia, and fragments in Greece and Italy. Like the Dead Sea Scrolls and the Nag Hammadi Library, the *Book of Enoch*, translated from the original Ethiopian Coptic script, is a rare resource that was suppressed by the early church and thought destroyed. Today it is back in print in this expanded, deluxe edition, using the original 1883 revised text.
224 PAGES. 6X9 PAPERBACK. ILLUSTRATED. INDEX. $16.95. CODE: BOE

MYSTERIES OF ANCIENT SOUTH AMERICA
Atlantis Reprint Series
by Harold T. Wilkins

The reprint of Wilkins' classic book on the megaliths and mysteries of South America. This book predates Wilkin's book *Secret Cities of Old South America* published in 1952. *Mysteries of Ancient South America* was first published in 1947 and is considered a classic book of its kind. With diagrams, photos and maps, Wilkins digs into old manuscripts and books to bring us some truly amazing stories of South America: a bizarre subterranean tunnel system; lost cities in the remote border jungles of Brazil; legends of Atlantis in South America; cataclysmic changes that shaped South America; and other strange stories from one of the world's great researchers. Chapters include: Our Earth's Greatest Disaster, Dead Cities of Ancient Brazil, The Jungle Light that Shines by Itself, The Missionary Men in Black: Forerunners of the Great Catastrophe, The Sign of the Sun: The World's Oldest Alphabet, Sign-Posts to the Shadow of Atlantis, The Atlanean "Subterraneans" of the Incas, Tiahuanacu and the Giants, more.
236 PAGES. 6X9 PAPERBACK. ILLUSTRATED. INDEX. $14.95. CODE: MASA

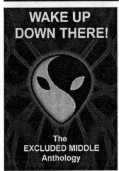

WAKE UP DOWN THERE!
The Excluded Middle Anthology
by Greg Bishop

The great American tradition of dropout culture makes it over the millennium mark with a collection of the best from *The Excluded Middle*, the critically acclaimed underground zine of UFOs, the paranormal, conspiracies, psychedelia, and spirit. Contributions from Robert Anton Wilson, Ivan Stang, Martin Kottmeyer, John Shirley, Scott Corrales, Adam Gorightly and Robert Sterling; and interviews with James Moseley, Karla Turner, Bill Moore, Kenn Thomas, Richard Boylan, Dean Radin, Joe McMoneagle, and the mysterious Ira Einhorn (an *Excluded Middle* exclusive). Includes full versions of interviews and extra material not found in the newsstand versions.
420 PAGES. 8X11 PAPERBACK. ILLUSTRATED. $25.00. CODE: WUDT

CONSPIRACY & HISTORY

TECHNOLOGY OF THE GODS
The Incredible Sciences of the Ancients
by David Hatcher Childress

Popular *Lost Cities* author David Hatcher Childress takes us into the amazing world of ancient technology, from computers in antiquity to the "flying machines of the gods." Childress looks at the technology that was allegedly used in Atlantis and the theory that the Great Pyramid of Egypt was originally a gigantic power station. He examines tales of ancient flight and the technology that it involved; how the ancients used electricity; megalithic building techniques; the use of crystal lenses and the fire from the gods; evidence of various high tech weapons in the past, including atomic weapons; ancient metallurgy and heavy machinery; the role of modern inventors such as Nikola Tesla in bringing ancient technology back into modern use; impossible artifacts; and more.
356 PAGES. 6X9 PAPERBACK. ILLUSTRATED. BIBLIOGRAPHY. $16.95. CODE: TGOD.

ARKTOS
The Myth of the Pole in Science, Symbolism, and Nazi Survival
by Joscelyn Godwin

A scholarly treatment of catastrophes, ancient myths and the Nazi Occult beliefs. Explored are the many tales of an ancient race said to have lived in the Arctic regions, such as Thule and Hyperborea. Progressing onward, the book looks at modern polar legends including the survival of Hitler, German bases in Antarctica, UFOs, the hollow earth, Agartha and Shambala, more.
220 PAGES. 6X9 PAPERBACK. ILLUSTRATED. $16.95. CODE: ARK

THE HISTORY OF THE KNIGHTS TEMPLARS
The Temple Church and the Temple
by Charles G. Addison, introduction by David Hatcher Childress

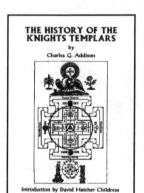

Chapters on the origin of the Templars, their popularity in Europe and their rivalry with the Knights of St. John, later to be known as the Knights of Malta. Detailed information on the activities of the Templars in the Holy Land, and the 1312 AD suppression of the Templars in France and other countries, which culminated in the execution of Jacques de Molay and the continuation of the Knights Templars in England and Scotland; the formation of the society of Knights Templars in London; and the rebuilding of the Temple in 1816. Plus a lengthy intro about the lost Templar fleet and its connections to the ancient North American sea routes.
395 PAGES. 6X9 PAPERBACK. ILLUSTRATED. $16.95. CODE: HKT

THE BOOK OF ENOCH
The Prophet
translated by Richard Laurence

This is a reprint of the Apocryphal *Book of Enoch the Prophet* which was first discovered in Abyssinia in the year 1773 by a Scottish explorer named James Bruce. In 1821 *The Book of Enoch* was translated by Richard Laurence and published in a number of successive editions, culminating in the 1883 edition. One of the main influences from the book is its explanation of evil coming into the world with the arrival of the "fallen angels." Enoch acts as a scribe, writing up a petition on behalf of these fallen angels, or fallen ones, to be given to a higher power for ultimate judgment. Christianity adopted some ideas from Enoch, including the Final Judgment, the concept of demons, the origins of evil and the fallen angels, and the coming of a Messiah and ultimately, a Messianic kingdom. The *Book of Enoch* was ultimately removed from the Bible and banned by the early church. Copies of it were found to have survived in Ethiopia, and fragments in Greece and Italy.
224 PAGES. 6X9 PAPERBACK. ILLUSTRATED. INDEX. $16.95. CODE: BOE

THE CHRIST CONSPIRACY
The Greatest Story Ever Sold
by Acharya S.

In this highly controversial and explosive book, archaeologist, historian, mythologist and linguist Acharya S. marshals an enormous amount of startling evidence to demonstrate that Christianity and the story of Jesus Christ were created by members of various secret societies, mystery schools and religions in order to unify the Roman Empire under one state religion. In developing such a fabrication, this multinational cabal drew upon a multitude of myths and rituals that existed long before the Christian era, and reworked them for centuries into the religion passed down to us today. Contrary to popular belief, there was no single man who was at the genesis of Christianity; Jesus was many characters rolled into one. These characters personified the ubiquitous solar myth, and their exploits were well known, as reflected by such popular deities as Mithras, Heracles/Hercules, Dionysos and many others throughout the Roman Empire and beyond. The story of Jesus as portrayed in the Gospels is revealed to be nearly identical in detail to that of the earlier savior-gods Krishna and Horus, who for millennia preceding Christianity held great favor with the people.
256 PAGES. 6X9 PAPERBACK. ILLUSTRATED. $14.95. CODE: CHRC

CONVERSATIONS WITH THE GODDESS
by Mark Amaru Pinkham

Return of the Serpents of Wisdom author Pinkham tells us that "The Goddess is returning!" Pinkham gives us an alternative history of Lucifer, the ancient King of the World, and the Matriarchal Tradition he founded thousands of years ago. The name Lucifer means "Light Bringer" and he is the same as the Greek god Prometheus, and is different from Satan, who was based on the Egyptian god Set. Find out how the branches of the Matriarchy—the Secret Societies and Mystery Schools—were formed, and how they have been receiving assistance from the Brotherhoods on Sirius and Venus to evolve the world and overthrow the Patriarchy. Learn about the revival of the Goddess Tradition in the New Age and why the Goddess wants us all to reunite with Her now! An unusual book from an unusual writer!
296 PAGES. 7X10 PAPERBACK. ILLUSTRATED. BIBLIOGRAPHY. $14.95. CODE: CWTG.

24 hour credit card orders—call: 815-253-6390 fax: 815-253-6300
email: auphq@frontierne www.adventuresunlimited.co.nz www.wexclub.com

ANTI-GRAVITY

THE FREE-ENERGY DEVICE HANDBOOK
A Compilation of Patents and Reports
by David Hatcher Childress

A large-format compilation of various patents, papers, descriptions and diagrams concerning free-energy devices and systems. *The Free-Energy Device Handbook* is a visual tool for experimenters and researchers into magnetic motors and other "overunity" devices. With chapters on the Adams Motor, the Hans Coler Generator, cold fusion, superconductors, "N" machines, space-energy generators, Nikola Tesla, T. Townsend Brown, and the latest in free-energy devices. Packed with photos, technical diagrams, patents and fascinating information, this book belongs on every science shelf. With energy and profit being a major political reason for fighting various wars, free-energy devices, if ever allowed to be mass distributed to consumers, could change the world! Get your copy now before the Department of Energy bans this book!
292 PAGES. 8X10 PAPERBACK. ILLUSTRATED. BIBLIOGRAPHY. $16.95. CODE: FEH

THE ANTI-GRAVITY HANDBOOK
edited by David Hatcher Childress, with Nikola Tesla, T.B. Paulicki,
Bruce Cathie, Albert Einstein and others

The new expanded compilation of material on Anti-Gravity, Free Energy, Flying Saucer Propulsion, UFOs, Suppressed Technology, NASA Cover-ups and more. Highly illustrated with patents, technical illustrations and photos. This revised and expanded edition has more material, including photos of Area 51, Nevada, the government's secret testing facility. This classic on weird science is back in a 90s format!
• **How to build a flying saucer.**
•**Arthur C. Clarke on Anti-Gravity.**
• **Crystals and their role in levitation.**
• **Secret government research and development.**
• **Nikola Tesla on how anti-gravity airships could**
 draw power from the atmosphere.
• **Bruce Cathie's Anti-Gravity Equation.**
• **NASA, the Moon and Anti-Gravity.**
230 PAGES. 7X10 PAPERBACK. BIBLIOGRAPHY/INDEX/APPENDIX. HIGHLY ILLUSTRATED. $14.95. CODE: AGH

ANTI-GRAVITY & THE WORLD GRID

Is the earth surrounded by an intricate electromagnetic grid network offering free energy? This compilation of material on ley lines and world power points contains chapters on the geography, mathematics, and light harmonics of the earth grid. Learn the purpose of ley lines and ancient megalithic structures located on the grid. Discover how the grid made the Philadelphia Experiment possible. Explore the Coral Castle and many other mysteries, including acoustic levitation, Tesla Shields and scalar wave weaponry. Browse through the section on anti-gravity patents, and research resources.
274 PAGES. 7X10 PAPERBACK. ILLUSTRATED. $14.95. CODE: AGW

ANTI-GRAVITY & THE UNIFIED FIELD
edited by David Hatcher Childress

Is Einstein's Unified Field Theory the answer to all of our energy problems? Explored in this compilation of material is how gravity, electricity and magnetism manifest from a unified field around us. Why artificial gravity is possible; secrets of UFO propulsion; free energy; Nikola Tesla and anti-gravity airships of the 20s and 30s; flying saucers as superconducting whirls of plasma; anti-mass generators; vortex propulsion; suppressed technology; government cover-ups; gravitational pulse drive; spacecraft & more.
240 PAGES. 7X10 PAPERBACK. ILLUSTRATED. $14.95. CODE: AGU

ETHER TECHNOLOGY
A Rational Approach to Gravity Control
by Rho Sigma

This classic book on anti-gravity and free energy is back in print and back in stock. Written by a well-known American scientist under the pseudonym of "Rho Sigma," this book delves into international efforts at gravity control and discoid craft propulsion. Before the Quantum Field, there was "Ether." This small, but informative book has chapters on John Searle and "Searle discs;" T. Townsend Brown and his work on anti-gravity and ether-vortex turbines. Includes a forward by former NASA astronaut Edgar Mitchell.
108 PAGES. 6X9 PAPERBACK. ILLUSTRATED. $12.95. CODE: ETT

COSMIC MATRIX
Piece for a Jig-Saw, Part Two
by Leonard G. Cramp

Leonard G. Cramp, a British aerospace engineer, wrote his first book *Space Gravity and the Flying Saucer* in 1954. Cosmic Matrix is the long-awaited sequel to his 1966 book *UFOs & Anti-Gravity: Piece for a Jig-Saw*. Cramp has had a long history of examining UFO phenomena and has concluded that UFOs use the highest possible aeronautic science to move in the way they do. Cramp examines anti-gravity effects and theorizes that this super-science used by the craft—described in detail in the book—can lift mankind into a new level of technology, transportation and understanding of the universe. The book takes a close look at gravity control, time travel, and the interlocking web of energy between all planets in our solar system with Leonard's unique technical diagrams. A fantastic voyage into the present and future!
364 PAGES. 6X9 PAPERBACK. ILLUSTRATED. BIBLIOGRAPHY. $16.00. CODE: CMX

UFOS AND ANTI-GRAVITY
Piece For A Jig-Saw
by Leonard G. Cramp

Leonard G. Cramp's 1966 classic book on flying saucer propulsion and suppressed technology is a highly technical look at the UFO phenomena by a trained scientist. Cramp first introduces the idea of 'anti-gravity' and introduces us to the various theories of gravitation. He then examines the technology necessary to build a flying saucer and examines in great detail the technical aspects of such a craft. Cramp's book is a wealth of material and diagrams on flying saucers, anti-gravity, suppressed technology, G-fields and UFOs. Chapters include Crossroads of Aerodymanics, Aerodynamic Saucers, Limitations of Rocketry, Gravitation and the Ether, Gravitational Spaceships, G-Field Lift Effects, The Bi-Field Theory, VTOL and Hovercraft, Analysis of UFO photos, more.
388 PAGES. 6X9 PAPERBACK. ILLUSTRATED. $16.95. CODE: UAG

THE HARMONIC CONQUEST OF SPACE
by Captain Bruce Cathie

Chapters include: Mathematics of the World Grid; the Harmonics of Hiroshima and Nagasaki; Harmonic Transmission and Receiving; the Link Between Human Brain Waves; the Cavity Resonance between the Earth; the Ionosphere and Gravity; Edgar Cayce—the Harmonics of the Subconscious; Stonehenge; the Harmonics of the Moon; the Pyramids of Mars; Nikola Tesla's Electric Car; the Robert Adams Pulsed Electric Motor Generator; Harmonic Clues to the Unified Field; and more. Also included are tables showing the harmonic relations between the earth's magnetic field, the speed of light, and anti-gravity/gravity acceleration at different points on the earth's surface. New chapters in this edition on the giant stone spheres of Costa Rica, Atomic Tests and Volcanic Activity, and a chapter on Ayers Rock analysed with Stone Mountain, Georgia.
248 PAGES. 6X9. PAPERBACK. ILLUSTRATED. BIBLIOGRAPHY. $16.95. CODE: HCS

THE ENERGY GRID
Harmonic 695, The Pulse of the Universe
by Captain Bruce Cathie.

This is the breakthrough book that explores the incredible potential of the Energy Grid and the Earth's Unified Field all around us. Cathie's first book, *Harmonic 33*, was published in 1968 when he was a commercial pilot in New Zealand. Since then, Captain Bruce Cathie has been the premier investigator into the amazing potential of the infinite energy that surrounds our planet every microsecond. Cathie investigates the Harmonics of Light and how the Energy Grid is created. In this amazing book are chapters on UFO Propulsion, Nikola Tesla, Unified Equations, the Mysterious Aerials, Pythagoras & the Grid, Nuclear Detonation and the Grid, Maps of the Ancients, an Australian Stonehenge examined, more.
255 PAGES. 6X9 TRADEPAPER. ILLUSTRATED. $15.95. CODE: TEG

THE BRIDGE TO INFINITY
Harmonic 371244
by Captain Bruce Cathie

Cathie has popularized the concept that the earth is crisscrossed by an electromagnetic grid system that can be used for anti-gravity, free energy, levitation and more. The book includes a new analysis of the harmonic nature of reality, acoustic levitation, pyramid power, harmonic receiver towers and UFO propulsion. It concludes that today's scientists have at their command a fantastic store of knowledge with which to advance the welfare of the human race.
204 PAGES. 6X9 TRADEPAPER. ILLUSTRATED. $14.95. CODE: BTF

MAN-MADE UFOS 1944—1994
Fifty Years of Suppression
by Renato Vesco & David Hatcher Childress

A comprehensive look at the early "flying saucer" technology of Nazi Germany and the genesis of man-made UFOs. This book takes us from the work of captured German scientists to escaped battalions of Germans, secret communities in South America and Antarctica to todays state-of-the-art "Dreamland" flying machines. Heavily illustrated, this astonishing book blows the lid off the "government UFO conspiracy" and explains with technical diagrams the technology involved. Examined in detail are secret underground airfields and factories; German secret weapons; "suction" aircraft; the origin of NASA; gyroscopic stabilizers and engines; the secret Marconi aircraft factory in South America; and more. Introduction by W.A. Harbinson, author of the Dell novels *GENESIS* and *REVELATION*.
318 PAGES. 6X9 PAPERBACK. ILLUSTRATED. INDEX & FOOTNOTES. $18.95. CODE: MMU

STRANGE SCIENCE

THE TIME TRAVEL HANDBOOK
A Manual of Practical Teleportation & Time Travel
edited by David Hatcher Childress

In the tradition of *The Anti-Gravity Handbook* and *The Free-Energy Device Handbook,* science and UFO author David Hatcher Childress takes us into the weird world of time travel and teleportation. Not just a whacked-out look at science fiction, this book is an authoritative chronicling of real-life time travel experiments, teleportation devices and more. *The Time Travel Handbook* takes the reader beyond the government experiments and deep into the uncharted territory of early time travellers such as Nikola Tesla and Guglielmo Marconi and their alleged time travel experiments, as well as the Wilson Brothers of EMI and their connection to the Philadelphia Experiment—the U.S. Navy's forays into invisibility, time travel, and teleportation. Childress looks into the claims of time travelling individuals, and investigates the unusual claim that the pyramids on Mars were built in the future and sent back in time. A highly visual, large format book, with patents, photos and schematics. Be the first on your block to build your own time travel device!
316 PAGES. 7X10 PAPERBACK. ILLUSTRATED. $16.95. CODE: TTH

LOST SCIENCE
by Gerry Vassilatos

Secrets of Cold War Technology author Vassilatos on the remarkable lives, astounding discoveries, and incredible inventions of such famous people as Nikola Tesla, Dr. Royal Rife, T.T. Brown, and T. Henry Moray. Read about the aura research of Baron Karl von Reichenbach, the wireless technology of Antonio Meucci, the controlled fusion devices of Philo Farnsworth, the earth battery of Nathan Stubblefield, and more. What were the twisted intrigues which surrounded the often deliberate attempts to stop this technology? Vassilatos claims that we are living hundreds of years behind our intended level of technology and we must recapture this "lost science."
304 PAGES. 6X9 PAPERBACK. ILLUSTRATED. BIBLIOGRAPHY. $16.95. CODE: LOS

UNDERGROUND BASES & TUNNELS
What is the Government Trying to Hide?
by Richard Sauder, Ph.D.

Working from government documents and corporate records, Sauder has compiled an impressive book that digs below the surface of the military's super-secret underground! Go behind the scenes into little-known corners of the public record and discover how corporate America has worked hand-in-glove with the Pentagon for decades, dreaming about, planning, and actually constructing, secret underground bases. This book includes chapters on the locations of the bases, the tunneling technology, various military designs for underground bases, nuclear testing & underground bases, abductions, needles & implants, military involvement in "alien" cattle mutilations, more. 50 page photo & map insert.
201 PAGES. 6X9 PAPERBACK. ILLUSTRATED. $15.95. CODE: UGB

KUNDALINI TALES
by Richard Sauder, Ph.D.

Underground Bases and Tunnels author Richard Sauder's second book on his personal experiences and provocative research into spontaneous spiritual awakening, out-of-body journeys, encounters with secretive governmental powers, daylight sightings of UFOs, and more. Sauder continues his studies of underground bases with new information on the occult underpinnings of the U.S. space program. The book also contains a breakthrough section that examines actual U.S. patents for devices that manipulate minds and thoughts from a remote distance. Included are chapters on the secret space program and a 130-page appendix of patents and schematic diagrams of secret technology and mind control devices.
296 PAGES. 7X10 PAPERBACK. ILLUSTRATED. BIBLIOGRAPHY. $14.95. CODE: KTAL

MAPS OF THE ANCIENT SEA KINGS
Evidence of Advanced Civilization in the Ice Age
by Charles H. Hapgood

Charles Hapgood's classic 1966 book on ancient maps produces concrete evidence of an advanced world-wide civilization existing many thousands of years before ancient Egypt. He has found the evidence in the Piri Reis Map that shows Antarctica, the Hadji Ahmed map, the Oronteus Finaeus and other amazing maps. Hapgood concluded that these maps were made from more ancient maps from the various ancient archives around the world, now lost. Not only were these unknown people more advanced in mapmaking than any people prior to the 18th century, it appears they mapped all the continents. The Americas were mapped thousands of years before Columbus. Antarctica was mapped when its coasts were free of ice.
316 PAGES. 7X10 PAPERBACK. ILLUSTRATED. BIBLIOGRAPHY & INDEX. $19.95. CODE: MASK

PATH OF THE POLE
Cataclysmic Pole Shift Geology
by Charles Hapgood

Maps of the Ancient Sea Kings author Hapgood's classic book *Path of the Pole* is back in print! Hapgood researched Antarctica, ancient maps and the geological record to conclude that the Earth's crust has slipped in the inner core many times in the past, changing the position of the pole. *Path of the Pole* discusses the various "pole shifts" in Earth's past, giving evidence for each one, and moves on to possible future pole shifts. Packed with illustrations, this is the sourcebook for many other books on cataclysms and pole shifts.
356 PAGES. 6X9 PAPERBACK. ILLUSTRATED. $16.95. CODE: POP.

24 hour credit card orders—call: 815-253-6390 fax: 815-253-6300
email: auphq@frontiernet.net www.adventuresunlimited.co.nz www.wexclub.com

TESLA TECHNOLOGY

THE FANTASTIC INVENTIONS OF NIKOLA TESLA
Nikola Tesla with additional material by David Hatcher Childress
This book is a readable compendium of patents, diagrams, photos and explanations of the many incredible inventions of the originator of the modern era of electrification. In Tesla's own words are such topics as wireless transmission of power, death rays, and radio-controlled airships. In addition, rare material on German bases in Antarctica and South America, and a secret city built at a remote jungle site in South America by one of Tesla's students, Guglielmo Marconi. Marconi's secret group claims to have built flying saucers in the 1940s and to have gone to Mars in the early 1950s! Incredible photos of these Tesla craft are included. The Ancient Atlantean system of broadcasting energy through a grid system of obelisks and pyramids is discussed, and a fascinating concept comes out of one chapter: that Egyptian engineers had to wear protective metal head-shields while in these power plants, hence the Egyptian Pharoah's head covering as well as the Face on Mars!
•His plan to transmit free electricity into the atmosphere. •How electrical devices would work using only small antennas mounted on them. •Why unlimited power could be utilized anywhere on earth. •How radio and radar technology can be used as death-ray weapons in Star Wars. •Includes an appendix of Supreme Court documents on dismantling his free energy towers. •Tesla's Death Rays, Ozone generators, and more...
342 PAGES. 6X9 PAPERBACK. ILLUSTRATED. BIBLIOGRAPHY AND APPENDIX. $16.95. CODE: FINT

SECRETS OF COLD WAR TECHNOLOGY
Project HAARP and Beyond
by Gerry Vassilatos
Vassilatos reveals that "Death Ray" technology has been secretly researched and developed since the turn of the century. Included are chapters on such inventors and their devices as H.C. Vion, the developer of auroral energy receivers; Dr. Selim Lemstrom's pre-Tesla experiments; the early beam weapons of Grindell-Mathews, Ulivi, Turpain and others; John Hettenger and his early beam power systems. Learn about Project Argus, Project Teak and Project Orange; EMP experiments in the 60s; why the Air Force directed the construction of a huge Ionospheric "backscatter" telemetry system across the Pacific just after WWII; why Raytheon has collected every patent relevant to HAARP over the past few years; more.
250 PAGES. 6X9 PAPERBACK. ILLUSTRATED. $15.95. CODE: SCWT

HAARP
The Ultimate Weapon of the Conspiracy
by Jerry Smith
The HAARP project in Alaska is one of the most controversial projects ever undertaken by the U.S. Government. Jerry Smith gives us the history of the HAARP project and explains how works, in technically correct yet easy to understand language. At best, HAARP is science out-of-control; at worst, HAARP could be the most dangerous device ever created, a futuristic technology that is everything from super-beam weapon to world-wide mind control device. Topics include Over-the-Horizon Radar and HAARP, Mind Control, ELF and HAARP, The Telsa Connection, The Russian Woodpecker, GWEN & HAARP, Earth Penetrating Tomography, Weather Modification, Secret Science of the Conspiracy, more. Includes the complete 1987 Eastlund patent for his pulsed super-weapon that he claims was stolen by the HAARP Project.
256 PAGES. 6X9 PAPERBACK. ILLUSTRATED. $14.95. CODE: HARP

ANGELS DON'T PLAY THIS HAARP
Advances in Tesla Technology
by Jeane Manning and Dr. Nick Begich
According to the authors, the U.S. government has a new ground-based "Star Wars" weapon in the remote bush country of Alaska. This new system, based on Tesla's designs, can disrupt human mental processes, jam all global communications systems, change weather patterns over large areas, cause environmental damage and more. The military calls this atmosphere zapper HAARP for High-frequency Active Auroral Research Program which targets the electrojet—a river of electricity that flows thousands of miles through the sky and down into the polar iccecap. The device will be used to x-ray the earth, talk to submarines, more.
233 PAGES. 6X9 PAPERBACK. ILLUSTRATED. $14.95. CODE: ADPH

OCCULT ETHER PHYSICS
Tesla's Hidden Space Propulsion System & the Conspiracy to Conceal It
by William Lyne
Pentagon Aliens author Lyne says that there is a "Secret Physics" with a different set of rules hidden away from us earlier in this century by a powerful elite who fear that technology based on it will strip away their power and wealth. Chapters on: The Occult Ether Theory and Electro-propulsion; Wireless Transmission of Energy; Tesla's Teleforce Discoveries; J.J. Thomson's "Electromagnetic Momentum"; Ether and "Ponderable Matter"; Rotatory Motion and the "Screw Effect"; Tesla's Dynamic Theory of Gravity; Tesla's Secrecy; The Atomic Hydrogen Furnace; more.
106 PAGES. 7X10 PAPERBACK. ILLUSTRATED. REFERENCES. $8.00. CODE: OEP

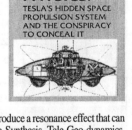

OCCULT ETHER PHYSICS: TESLA'S HIDDEN SPACE PROPULSION SYSTEM AND THE CONSPIRACY TO CONCEAL IT

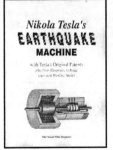

NIKOLA TESLA'S EARTHQUAKE MACHINE
with Tesla's Original Patents
by Dale Pond and Walter Baumgartner
Now, for the first time, the secrets of Nikola Tesla's Earthquake Machine are available. Although this book discusses in detail Nikola Tesla's 1894 "Earthquake Oscillator," it is also about the new technology of sonic vibrations which produce a resonance effect that can be used to cause earthquakes. Discussed are Tesla Oscillators, Vibration Physics, Amplitude Modulated Additive Synthesis, Tele-Geo-dynamics, Solar Heat Pump Apparatus, Vortex Tube Coolers, the Serogodsky Motor, more. Plenty of technical diagrams. Be the first on your block to have a Tesla Earthquake Machine!
175 PAGES. 9X11 PAPERBACK. ILLUSTRATED. BIBLIOGRAPHY & INDEX. $16.95. CODE: TEM

CONSPIRACY & HISTORY

HAARP
The Ultimate Weapon of the Conspiracy
by Jerry Smith

The HAARP project in Alaska is one of the most controversial projects ever undertaken by the U.S. Government. Jerry Smith gives us the history of the HAARP project and explains how it can be used as an awesome weapon of destruction. Smith exposes a covert military project and the web of conspiracies behind it. HAARP has many possible scientific and military applications, from raising a planetary defense shield to peering deep into the earth. Smith leads the reader down a trail of solid evidence into ever deeper and scarier conspiracy theories in an attempt to discover the "whos" and "whys" behind HAARP, and discloses a possible plan to rule the world. At best, HAARP is science out-of-control; at worst, HAARP could be the most dangerous device ever created, a futuristic technology that is everything from super-beam weapon to world-wide mind control device. The Star Wars future is now! Topics include Over-the-Horizon Radar and HAARP, Mind Control, ELF and HAARP, The Telsa Connection, The Russian Woodpecker, GWEN & HAARP, Earth Penetrating Tomography, Weather Modification, Secret Science of the Conspiracy, more. Includes the complete 1987 Bernard Eastlund patent for his pulsed super-weapon that he claims was stolen by the HAARP Project.
256 PAGES. 6X9 PAPERBACK. ILLUSTRATED. $14.95. CODE: HARP

MIND CONTROL, OSWALD & JFK:
Were We Controlled?
introduction by Kenn Thomas

Steamshovel Press editor Kenn Thomas examines the little-known book *Were We Controlled?*, first published in 1968. The book maintained that Lee Harvey Oswald was a special agent who was a mind control subject, having received an implant in 1960 at a Russian hospital. Thomas examines the evidence for implant technology and the role it could have played in the Kennedy Assassination. Thomas also looks at the mind control aspects of the RFK assassination and details the history of implant technology. A growing number of people are interested in CIA experiments and its "Silent Weapons for Quiet Wars."
256 PAGES. 6X9 PAPERBACK. ILLUSTRATED. NOTES. $16.00. CODE: MCOJ

MIND CONTROL, WORLD CONTROL
by Jim Keith

Veteran author and investigator Jim Keith uncovers a surprising amount of information on the technology, experimentation and implementation of mind control. Various chapters in this shocking book are on early CIA experiments such as Project Artichoke and Project R.H.I.C.-EDOM, the methodology and technology of implants, mind control assassins and couriers, various famous Mind Control victims such as Sirhan Sirhan and Candy Jones. Also featured in this book are chapters on how mind control technology may be linked to some UFO activity and "UFO abductions."
256 PAGES. 6X9 PAPERBACK. ILLUSTRATED. FOOTNOTES. $14.95. CODE: MCWC

PROJECT SEEK
Onassis, Kennedy and the Gemstone Thesis
by Gerald A. Carroll

This book reprints the famous Gemstone File, a document circulated in 1974 concerning the Mafia, Onassis and the Kennedy assassination. With the passing of Jackie Kennedy-Onassis, this information on the Mafia and the CIA, the formerly "Hughes" controlled defense industry, and the violent string of assassinations can at last be told. Also includes new information on the Nugan Hand Bank, the BCCI scandal, "the Octopus," and the Paul Wilcher Transcripts.
388 PAGES. 6X9 PAPERBACK. ILLUSTRATED. $16.95. CODE: PJS

NASA, NAZIS & JFK:
The Torbitt Document & the JFK Assassination
introduction by Kenn Thomas

This book emphasizes the links between "Operation Paper Clip" Nazi scientists working for NASA, the assassination of JFK, and the secret Nevada air base Area 51. The Torbitt Document also talks about the roles played in the assassination by Division Five of the FBI, the Defense Industrial Security Command (DISC), the Las Vegas mob, and the shadow corporate entities Permindex and Centro-Mondiale Commerciale. The Torbitt Document claims that the same players planned the 1962 assassination attempt on Charles de Gaul, who ultimately pulled out of NATO because he traced the "Assassination Cabal" to Permindex in Switzerland and to NATO headquarters in Brussels. The Torbitt Document paints a dark picture of NASA, the military industrial complex, and the connections to Mercury, Nevada which headquarters the "secret space program."
258 PAGES. 5X8. PAPERBACK. ILLUSTRATED. $16.00. CODE: NNJ

THE HISTORY OF THE KNIGHTS TEMPLARS
The Temple Church and the Temple
by Charles G. Addison, introduction by David Hatcher Childress

Chapters on the origin of the Templars, their popularity in Europe and their rivalry with the Knights of St. John, later to be known as the Knights of Malta. Detailed information on the activities of the Templars in the Holy Land, and the 1312 AD suppression of the Templars in France and other countries, which culminated in the execution of Jacques de Molay and the continuation of the Knights Templars in England and Scotland; the formation of the society of Knights Templars in London; and the rebuilding of the Temple in 1816. Plus a lengthy intro about the lost Templar fleet and its connections to the ancient North American sea routes.
395 PAGES. 6X9 PAPERBACK. ILLUSTRATED. $16.95. CODE: HKT

24 HOUR CREDIT CARD ORDERS—CALL: 815-253-6390 FAX: 815-253-6300
EMAIL: AUPHO@FRONTIERNET.NET HTTP://WWW.ADVENTURESUNLIMITED.CO.NZ

MYSTIC TRAVELLER SERIES

THIS RARE ARCHAEOLOGY BOOK ON EASTER ISLAND IS BACK IN PRINT!

MYSTIC TRAVELLER SERIES

This rare 1935 book is back in print!
Mystic Traveller Series

THE MYSTERY OF EASTER ISLAND
by Katherine Routledge
The reprint of Katherine Routledge's classic archaeology book which was first published in London in 1919. The book details her journey by yacht from England to South America, around Patagonia to Chile and on to Easter Island. Routledge explored the amazing island and produced one of the first-ever accounts of the life, history and legends of this strange and remote place. Routledge discusses the statues, pyramid-platforms, Rongo Rongo script, the Bird Cult, the war between the Short Ears and the Long Ears, the secret caves, ancient roads on the island, and more. This rare book serves as a sourcebook on the early discoveries and theories on Easter Island.
432 PAGES. 6X9 PAPERBACK. ILLUSTRATED. $16.95. CODE: MEI

MYSTERY CITIES OF THE MAYA
Exploration and Adventure in Lubaantun & Belize
by Thomas Gann
First published in 1925, *Mystery Cities of the Maya* is a classic in Central American archaeology-adventure. Gann was close friends with Mike Mitchell-Hedges, the British adventurer who discovered the famous crystal skull with his adopted daughter Sammy and Lady Richmond Brown, their benefactress. Gann battles pirates along Belize's coast and goes upriver with Mitchell-Hedges to the site of Lubaantun where they excavate a strange lost city where the crystal skull was discovered. Lubaantun is a unique city in the Mayan world as it is built out of precisely carved blocks of stone without the usual plaster-cement facing. Lubaantun contained several large pyramids partially destroyed by earthquakes and a large amount of artifacts. Gann shared Mitchell-Hedges belief in Atlantis and lost civilizations (pre-Mayan) in Central America and the Caribbean. Lots of good photos, maps and diagrams.
252 PAGES. 6X9 PAPERBACK. ILLUSTRATED. $16.95. CODE: MCOM

IN SECRET TIBET
by Theodore Illion
Reprint of a rare 30s adventure travel book. Illion was a German wayfarer who not only spoke fluent Tibetan, but travelled in disguise as a native through forbidden Tibet when it was off-limits to all outsiders. His incredible adventures make this one of the most exciting travel books ever published. Includes illustrations of Tibetan monks levitating stones by acoustics.
210 PAGES. 6X9 PAPERBACK. ILLUSTRATED. $15.95. CODE: IST

DARKNESS OVER TIBET
by Theodore Illion
In this second reprint of Illion's rare books, the German traveller continues his journey through Tibet and is given directions to a strange underground city. As the original publisher's remarks said, "this is a rare account of an underground city in Tibet by the only Westerner ever to enter it and escape alive! "
210 PAGES. 6X9 PAPERBACK. ILLUSTRATED. $15.95. CODE: DOT

DANGER MY ALLY
The Amazing Life Story of the Discoverer of the Crystal Skull
by "Mike" Mitchell-Hedges
The incredible life story of "Mike" Mitchell-Hedges, the British adventurer who discovered the Crystal Skull in the lost Mayan city of Lubaantun in Belize. Mitchell-Hedges has lived an exciting life: gambling everything on a trip to the Americas as a young man, riding with Pancho Villa, questing for Atlantis, fighting bandits in the Caribbean and discovering the famous Crystal Skull.
374 PAGES. 6X9 PAPERBACK. ILLUSTRATED. BIBLIOGRAPHY & INDEX. $16.95. CODE: DMA

IN SECRET MONGOLIA
by Henning Haslund
Danish-Swedish explorer Haslund's first book on his exciting explorations in Mongolia and Central Asia. Haslund takes us via camel caravan to the medieval world of Mongolia, a country still barely known today. First published by Kegan Paul of London in 1934, this rare travel adventure is back in print after 50 years. Haslund and his camel caravan journey across the Gobi Desert. He meets with renegade generals and warlords, god-kings and shamans. Haslund is captured, held for ransom, thrown into prison, battles black magic and portrays in vivid detail the birth of a new nation.
374 PAGES. 6X9 PAPERBACK. ILLUSTRATED. BIBLIOGRAPHY & INDEX. $16.95. CODE: ISM

MEN & GODS IN MONGOLIA
by Henning Haslund
First published in 1935 by Kegan Paul of London, Haslund takes us to the lost city of Karakota in the Gobi desert. We meet the Bodgo Gegen, a god-king in Mongolia similar to the Dalai Lama of Tibet. We meet Dambin Jansang, the dreaded warlord of the "Black Gobi." There is even material in this incredible book on the Hi-mori, an "airhorse" that flies through the sky (similar to a Vimana) and carries with it the sacred stone of Chintamani. Aside from the esoteric and mystical material, there is plenty of just plain adventure: Haslund and companions journey across the Gobi desert by camel caravan; are kidnapped and held for ransom; witness initiation into Shamanic societies; meet reincarnated warlords; and experience the violent birth of "modern" Mongolia.
358 PAGES. 6X9 PAPERBACK. ILLUSTRATED. INDEX. $15.95. CODE: MGM

24 hour credit card orders—call: 815-253-6390 fax: 815-253-6300
email: auphq@frontiernet.net www.adventuresunlimited.co.nz www.wexclub.com

One Adventure Place
P.O. Box 74
Kempton, Illinois 60946
United States of America
Tel.: 815-253-6390 • Fax: 815-253-6300
Email: auphq@frontiernet.net
http://www.wexclub.com/aup

ORDERING INSTRUCTIONS

✓ Remit by USD$ Check, Money Order or Credit Card

✓ Visa, Master Card, Discover & AmEx Accepted

✓ Prices May Change Without Notice

✓ 10% Discount for 3 or more Items

SHIPPING CHARGES

United States

✓ Postal Book Rate { $2.50 First Item / 50¢ Each Additional Item

✓ Priority Mail { $3.50 First Item / $2.00 Each Additional Item

✓ UPS { $5.00 First Item / $1.50 Each Additional Item

NOTE: UPS Delivery Available to Mainland USA Only

Canada

✓ Postal Book Rate { $3.00 First Item / $1.00 Each Additional Item

✓ Postal Air Mail { $5.00 First Item / $2.00 Each Additional Item

✓ Personal Checks or Bank Drafts MUST BE USD$ and Drawn on a US Bank

✓ Canadian Postal Money Orders OK

✓ Payment MUST BE USD$

All Other Countries

✓ Surface Delivery { $6.00 First Item / $2.00 Each Additional Item

✓ Postal Air Mail { $12.00 First Item / $8.00 Each Additional Item

✓ Payment MUST BE USD$

✓ Checks and Money Orders MUST BE USD$ and Drawn on a US Bank or branch.

✓ Add $5.00 for Air Mail Subscription to Future *Adventures Unlimited* Catalogs

SPECIAL NOTES

✓ RETAILERS: Standard Discounts Available

✓ BACKORDERS: We Backorder all Out-of-Stock Items Unless Otherwise Requested

✓ PRO FORMA INVOICES: Available on Request

✓ VIDEOS: NTSC Mode Only. Replacement only.

✓ For PAL mode videos contact our other offices:

European Office:
Adventures Unlimited, PO Box 372,
Dronten, 8250 AJ, The Netherlands

Check Us Out Online at:
www.wexclub.com/aup

Please check: ☑

☐ This is my first order ☐ I have ordered before ☐ This is a new address

Name	
Address	
City	

State/Province	Postal Code

Country	

Phone day	Evening

Fax	

Item Code	Item Description	Price	Qty	Total

Please check: ☑

☐ Postal-Surface

☐ Postal-Air Mail (Priority in USA)

☐ UPS (Mainland USA only)

Subtotal ➡	
Less Discount-10% for 3 or more items ➡	
Balance ➡	
Illinois Residents 6.25% Sales Tax ➡	
Previous Credit ➡	
Shipping ➡	
Total (check/MO in USD$ only) ➡	

☐ Visa/MasterCard/Discover/Amex

Card Number

Expiration Date

10% Discount When You Order 3 or More Items!

Comments & Suggestions	Share Our Catalog with a Friend